# HEAV'NLY TIDINGS FROM

# THE AFRIC MUSE

The Grace and Genius of Phillis Wheatley

# HEAV'NLY TIDINGS

# FROM

# THE AFRIC MUSE

## The Grace and Genius of Phillis Wheatley

Richard Kigel

Paragon House

First Edition 2017

Published in the United States by
Paragon House
www.ParagonHouse.com

Note on Primary Source Documents: Since no formal system of rules governing spelling, punctuation, capitalization, and sentence structure existed in the eighteenth century, some primary source documents have been lightly edited for the sake of clarity.

Library of Congress Cataloging-in-Publication Data

Names: Kigel, Richard, author. | Giovanni, Nikki, writer of foreword.
Title: Heav'nly tidings from the Afric Muse : the grace and genius of Phillis
    Wheatley / by Richard Kigel ; [foreword by Nikki Giovanni].
Description: First edition. | Saint Paul, MN : Paragon House, 2017. |
    Includes bibliographical references and index.
Identifiers: LCCN 2016032519 | ISBN 9781557789280 (pbk. : alk. paper)
Subjects: LCSH: Wheatley, Phillis, 1753-1784. | African American women
    poets--Biography. | Poets, American--Colonial period, ca.
    1600-1775--Biography.
Classification: LCC PS866.W5 Z644 2017 | DDC 811/.1 [B] --dc23 LC
    record available at https://lccn.loc.gov/2016032519

The paper used in this publication meets the minimum requirements of American National Standard for Information Sciences—Permanence of Paper for Printed Library Materials, ANSI Z39.48-1984.

Manufactured in the United States of America
10 9 8 7 6 5 4 3 2 1

For current information about all releases from Paragon House,
visit the web site at http://www.ParagonHouse.com

*With Gratitude*

To Kathy: the wind that powers my wobbly wings, the sunshine on my face, the hurricane that unclutters my work place and my brain, and the great love of my life. Her unfailing support was never more appreciated than the day we wandered among rows of graves at Boston's Granary Burial Ground, trying to decipher the faded lettering on hundreds of tombstones while searching for John Wheatley's final resting place. When I spotted his name and turned to look for her she was halfway across the cemetery, busy studying gravestones. Our eyes met and a moment later she was standing beside me, just as she has been doing for the past forty-six years. And for that steadfast devotion I am grateful beyond words.

To Dayniah: the hardest working middle school English teacher in the Bronx who inspires me every day just by getting up in the morning to be with her students—and to her daughter Akasha, poet-at-heart and math whiz, who, like Phillis Wheatley, is a young woman determined to follow her passion.

To Professor Vincent Carretta, whose meticulous research produced the first-ever biography of the Boston slave poet, Phillis Wheatley: Biography of a Genius in Bondage: my book stands on the shoulders of yours.

To Phillis Wheatley: whose passion for poetry and determination to share her writing with her fellow Americans in the face of considerable resistance serves to inspire young intelligent, creative minds like hers throughout the country. Her story forces us to confront the question: if someone like Phillis Wheatley was born today in Boston, or anywhere in America, would she—or he—be able to develop those natural gifts to the fullest? Even today we still struggle to answer "yes." Maybe this book will help.

# Contents

*About Nikki Giovanni*

Nikki Giovanni, one of our most-celebrated and beloved poets, has been a defining African-American voice since the 1960s. Recipient of seven NAACP Image Awards, the Rosa Parks Woman of Courage Award, the Langston Hughes Medal for Outstanding Poetry, she was named as one of Oprah Winfrey's twenty-five "Living Legends." The author of twenty-eight books and a Grammy nominee for *The Nikki Giovanni Poetry Collection,* she is the University Distinguished Professor of English at Virginia Tech in Blacksburg, Virginia.

# Foreword by Nikki Giovanni

## Phillis Wheatley

First you could take a letter
It's the easiest thing to do
Bee...Me...See...though
Those are more than A letter
They are a bunch
But then you only pronounce them
once

How do you find a language

Maybe you see the sky
Blue but sometimes gray
And often with clouds
Because we are...after all...in
Boston

But what is Sold
Is that my name
I was Sold and taken some place
They were nice
Though they called me
Phillis

I like Sold...too... because my mother
called me Nooooo

I remember that

If I could dance on words
I'd dance Freedom
But what would that mean

They say I should be Free
But I'm Sold
Called Phillis

I wish I knew what it feels like

I married a nice man
But we had problems which we called
Children
Then I went Abroad which was called
Freedom

But all I wanted  was
Unslavery
For my children

Maybe I could be Free
Who is named Sold
Called Phillis
Who had another name in
Another time

I had to learn
The language
That gave love
To me
And my children
And all the folks who wanted
To Love me
I don't know
What language to use
For my Heart or my Speech

I write
Poetry

Sold!

# I. Boston 1761 – 1771

*When my thoughts in gratitude imply*
*Mental imaginations give me joy;*
*Now let my thoughts in contemplation steer*
*The footsteps of the Superlative Fair.*

~ Phillis Wheatley, July 15, 1769

# CHAPTER 1.

"TO BE SOLD:  A parcel of likely Negroes, imported from Africa, cheap for cash or short credit with interest."

SHE EMERGED FROM THE DARK, naked and frightened. Taking her first wary steps in daylight after eight months of barbaric confinement, the young girl raised her hand instinctively to shield her eyes from the summer sun. Seventy-five souls came out with her, pushing their vanquished bodies along the wharf in a listless stoop-shouldered march toward yet another indignity. Weak and hungry, numb from exhaustion, they could barely muster the strength to keep their feet from scraping against the rough wooden planks.

There were twenty-one more of them when they began their forced voyage in Africa. Some died along the way and their bodies were tossed overboard. Others escaped by choosing suicide.

"Two of my wearied countrymen who were chained together (I was near them at the time), preferring death to such a life of misery, jumped into the sea," said Olaudah Equiano, who wrote of his own experience on an earlier slave ship.[1]

Those watching the sad procession disembarking from the ship could easily have missed the unobtrusive little girl in the shuffling crowd. Like the others, she had been taken from home and family, crammed into a pit of unimaginable squalor, and left to languish there, sickened by the stench of disease and death, lonely, terrified, and utterly deprived of any human comfort. Their weeping and lamentations had long since faded as rage and fear turned to sullen despair.

The frail little girl had arrived in America. She could not have been more than seven years old.

This heartbreaking scene was one episode in what W. E. B. Du Bois called "the most magnificent drama in the last thousand years of human history." In his 1935 essay Du Bois observed that those who came to America

after surviving the Middle Passage found that their agony was only begin-ning. "They descended into Hell," he wrote.[2]

Among the untold millions who suffered the atrocity of the Middle Passage, there is only one slave whose arrival and destination in America is documented. History knows her as Phillis Wheatley.

The slave ship *Phillis* under Captain Peter Gwin arrived in Boston harbor on July 11, 1761. Boston merchant Timothy Fitch, owner of sev-eral boats including the *Phillis,* gained much of his wealth from the slave trade. Before the mission began, ship owner Fitch wrote his instructions to Captain Gwin stating his expectations for the venture. His aim was to maximize profits.

> Boston, November 8, 1760
>
> Capt. Peter Gwin:
>
> You having the command of my Brigg Phillis, your orders are to embrace the first favourable opportunity of Wind & Weather to proceed to the Coast of Africa, touching first at Sinagall...
>
> I hope you'll purchase One Hundred or One Hundred & Ten Prime Slaves & have considerable money left to Bring home with you...
>
> Now in regard to your purchasing slaves, you'll observe to get as few Girl Slaves as possible & as many Prime Boys as you can. After you're completely slaved, you are to come off, & if early you may fall into the southward & go to Philadelphia or York or Jerseys, where I hear there is no duty on slaves & there dispose of as many Slaves as you can for cash immedi-ately & when the sail grows dull, proceed with the remainder to Boston...
>
> According to Agreement, keep good & exact account of your Cargo & what you expend on the voyage that your Cargo may hold out. I recommend to you frugality, industry, & dispatch great care of your Slaves, a constant watch & guard over them both night & day.
>
> I am wishing you a good voyage & safe return.
>
> Your Friend & Owner,
> Timothy Fitch[3]

The captain and his crew of eight set out for "Sinagall" (modern day Senegal and Gambia) on the west coast of Africa, where they most likely stopped at the notorious slave-trading factories on the islands of Goree and James.

The endeavor turned out to be an economic disaster. "The 1760-61 voyage that brought the child known to us as Phillis Wheatley from Africa to Boston took about 240 days," says Wheatley biographer Vincent Carretta. "Only 75 of the 96 enslaved Africans survived to be sold in Boston, a mortality rate of nearly 25 percent. That was twice the average death rate on the Middle Passage."[4]

Delays forced Gwin to cut short his itinerary, limiting his selling opportunities. After leaving Africa, Fitch had instructed Gwin to stop in Philadelphia, New York, and New Jersey to peddle his human merchandise before returning to Boston. But, pressed for time, Gwin took the *Phillis* directly from Africa to Boston.

How long was the young girl held on the ship? "If Phillis had been among the first slaves purchased at Senegal, she would have remained captive as the schooner sailed to other ports in search of enough slaves to make up the complement of seventy or eighty," says Dr. William Robinson, regarded as our most authoritative Wheatley scholar. "She would not have been free of this boat until some eight months later, in Boston, in July of 1761, when she was purchased by Mrs. Susanna Wheatley."[5]

Boston did not have a separate marketplace where slaves could be bought and sold. Typically, the sale of African labor took place on the Long Wharf at the end of King Street. The human cargo was sold directly from the ships that carried them.

The first advertisement for the merchandise aboard the *Phillis* appeared in the *Boston Gazette* on July 13, 1761.

> Just Imported from Africa
> A Number of prime young Slaves from the Windward Coast
> And to be Sold on board.
> Capt. Gwin lying at New Boston.[6]

Ads in the *Boston Evening Post* and the *Boston Gazette and Country Journal* ran for several weeks. Prime male slaves sold quickly. What

remained were leftovers—the sick, the unfit, and children.

In an effort to salvage what remuneration he could, Fitch turned to slave dealer John Avery. On August 3, 1761 his advertisement ran in the *Boston Evening Post*.

> TO BE SOLD: A parcel of likely Negroes, imported from Africa, cheap for cash or short credit with interest. Enquire of John Avery at his house next door to the White Horse (Tavern).

His marketing plan included this startling offer:

> If any persons have any Negro men, strong and hearty, tho' not of the best moral character, which are proper subject for transportation, may have an exchange for small negroes.[7]

Fitch and Avery were hoping to trade their remaining stock of undesirables, mostly children, for mature African males. They were even willing to acquire slaves who displayed what was called a deficiency of "moral character," their euphemism for one who was rebellious and uncooperative. Fitch knew this sort of merchandise would not sell in Boston, but he could still turn a profit by reselling them down south or in the West Indies.

Slave Trader Fitch was so disappointed by the quality of the merchandise Gwin brought back, he updated his instructions. For the next expedition to Africa, Fitch ordered Captain Gwin to purchase more desirable goods.

"You are not to take any children and especially girls," Fitch demanded. "As few women as possible. Likely but as many Prime Young men, boys as you can get from 14 to 20 years of age. Take no slave on board that has the least defect or sickly....I had rather you would be two months longer on the coast than to bring off such a cargo as your last which were very small and the meanest cargo I ever had come."[8]

Fitch found the economic reality irritating—his "small and mean cargo" severely reduced his profits. He wanted no more slaves like that frail little girl who would soon become the most celebrated African-American of her time. Though small and sickly, the resilient young girl managed to survive one of the most devastating of all holocausts, the African Slave

Trade. More than two hundred and fifty years later, Phillis Wheatley would join the canon of American poets and claim her rightful place as one of the Founding Mothers of the nation.

"More than any other single event, the Middle Passage—the transit from Africa to America—has come to epitomize the experience of people of African descent throughout the Atlantic world," wrote historian Ira Berlin. "The transatlantic journey from Africa to the Americas forcibly propelled some eleven million Africans across the Atlantic between the sixteenth and nineteenth centuries."[9]

In 1789, *The Interesting Narrative of the Life of Olaudah Equiano* gave us the most authoritative report on that infernal drama by one who experienced it firsthand. One of the earliest damning memoirs to expose the evils of slavery, it became a classic and created a new literary genre—the Slave Narrative.

Olaudah Equiano was a contemporary of Phillis Wheatley. Both were kidnapped and enslaved as children, within five years of each other. "Equiano certainly knew of Wheatley," Carretta says, "and had read at least some of her poems."[10] He was familiar with British abolitionist Thomas Clarkson's popular 1786 *Essay on the Slavery and Commerce of the Human Species, Particularly the African* which featured a brief story on Phillis Wheatley and offered excerpts from three of her poems.

"I was born in the year 1745," Equiano began, describing a happy childhood, and admitting that "I had never heard of white men or Europeans, nor of the sea."[11]

He was eleven when he was kidnapped.

> One day, when all our people were gone out to their work as usual, and only I and my sister were left to mind the house, two men and a woman got over our walls and in a moment seized us both and without giving us time to cry out or to make any resistance. They stopped our mouths and ran off with us into the nearest wood. Here they tied our hands and continued to carry us as far as they could.[12]
>
> The next day proved one of greater sorrow than I had yet experienced; for my sister and I were separated, while we lay

clasped in each other's arms. It was in vain that we besought them not to part us. She was torn from me and immediately carried away while I was left in a state of distraction, not to be described. I cried and grieved continually; and for several days did not eat anything but what they forced in my mouth.[13]

Six or seven months after I had been kidnapped, I arrived at the seacoast...The first object which saluted my eyes when I arrived on the coast was the sea, and a slave-ship, which was then riding at anchor, and waiting for its cargo.... I was beyond measure astonished at this as I had never before seen any water larger than a pond or a rivulet.[14]

His own personal revelation of the trauma he experienced surely captured what it must have been like for Phillis Wheatley.

When I was carried on board I was immediately handled and tossed up to see if I were sound by some some of the crew. I was now persuaded that I was got into a world of bad spirits, and that they were going to kill me. Their complexions too differing so much from ours, their long hair, and the language they spoke, which was very different from any I had ever heard, united to confirm me in this belief.[15]

I now saw myself deprived of all chance of returning to my native country, or even the least glimpse of hope of gaining the shore.[16]

Equiano witnessed scenes of cruelty, degradation, and death, experiences that young Phillis Wheatley would certainly share five years later.

When I looked round the ship too, and saw a large furnace of copper boiling, and a multitude of black people of every description chained together, every one of their countenances expressing dejection and sorrow, I no longer doubted of my fate, quite overpowered with horror and anguish.[17]

I was not long suffered to indulge my grief; I was soon put down under the decks, and there I received such a salutation in my nostrils as I had never experienced in my life; so that

with the loathsomeness of the stench, and crying together, I became so sick and low that I was not able to eat, nor had I the least desire to taste anything. I now wished for the last friend, Death, to relieve me.[18]

The stench of the hold while we were on the coast was so intolerably loathsome, that it was dangerous to remain there for any time, and some of us had been permitted to stay on the deck for the fresh air; but now that the whole ship's cargo were confined together, it became absolutely pestilential. The closeness of the place, and the heat of the climate, added to the number in the ship, which was so crowded that each had scarcely room to turn himself, almost suffocated us. This produced copious perspirations, so that the air soon became unfit for respiration, from a variety of loathsome smells, and brought on a sickness among the slaves, of which many died, thus falling victims to the improvident avarice, as I may call it, of their purchasers.[19]

The shrieks of the women, and the groans of the dying, rendered the whole a scene of horror almost inconceivable.[20]

He saw desperate acts of suicide by unfortunate captives who concluded that ending their lives was the only way out of their horror. It was a drastic course of action. His despair was so deep he thought about it for himself.

I began to hope that death would soon put an end to my miseries. Often did I think many of the inhabitants of the deep much more happy than myself.... Although, not being used to the water, I naturally feared that element the first time I saw it. Yet, nevertheless, could I have got over the nettings, I would have jumped over the side. But I could not.[21]

In this manner we continued to undergo more hardships than I can now relate; hardships which are inseparable from this accursed trade.[22]

The white people looked and acted, as I thought, in so savage a

manner; for I had never seen among any people such instances
of brutal cruelty.[23]

Phillis Wheatley never mentioned the Middle Passage in any of her
writings. Childhood trauma is often blocked out of conscious memory.
Robinson points out that it may have been the particular circumstances
of her Middle Passage experience that ultimately saved her. Since she was
"purchased with a total of fewer than 100 other slaves for stowage in a typi-
cal Yankee slaver, she was part of a cargo that was loose packed," he explains.
"If she had been part of the '140 to 150 Prime Slaves' whom Captain Gwin
would be directed to purchase on his voyage after delivering [Phillis] to
Boston in July of 1761, she would then have been part of a tight packed
cargo in a sloop about 67 feet long, 20 feet wide and 9 feet deep."[24]

Somehow, the frail seven year old girl endured. Robinson concludes
that if Phillis Wheatley had not been on a slave ship with "loose packed"
cargo, she "might not have even survived the voyage across more than 4000
miles of Atlantic Ocean."[25]

# CHAPTER 2.

## "Aunt Wheatley was in want of a domestic."

AN ADVERTISEMENT FROM SLAVE TRADER Fitch caught the eye of Mrs. Susanna Wheatley, fifty-three-year-old wife of wealthy Boston businessman John Wheatley. This latest shipment of African slaves offered a rare opportunity to acquire new workers. Recent fighting between the English and the French over supremacy in North America had so disrupted travel and trade that the *Phillis* was probably the only slave ship to arrive in Boston that year.[1]

"She visited the slave market, that she might make a personal selection from the group of unfortunates offered for sale," wrote Susanna Wheatley's great-grandniece Margaretta Matilda Oddell. "Mrs. Wheatley wished to obtain a young negress, with the view of training her up under her own eye that she might, by gentle usage, secure to herself a faithful domestic in her old age."[2]

In her introduction to the 1834 edition of Phillis Wheatley's poems, Oddell offered the most extensive biography of the poet yet. Written fifty years after her death, it was the only serious effort by a Wheatley family member to share what they knew of the personal history of the extraordinary woman who came to their house as a child, served as their slave, and later gained fame on two continents.

"Oddell's memoir contributes twenty-five pages of information about the life of Wheatley, the longest account of her biography available in the eighteenth and nineteenth centuries," writes Wheatley scholar John Shields. "Her account is probably the most reliable life sketch because its author was, according to her own testimony, 'a collateral descendent of Mrs. Wheatley.'"[3]

Oddell assured readers "as to the authenticity of the facts" because her information was "derived from grandnieces of Phillis' benefactress who are still living, and have a distinct and vivid remembrance both of their

excellent relative [Mrs. Wheatley] and her admired protégée [Phillis]."
She asserted that "their statements are corroborated by a granddaughter of
[Susanna Wheatley] now residing in Boston."[4]

The Wheatleys already owned several slaves. But, according to Oddell,
their slave women had grown old, "beyond the active periods of life," and
were no longer able to work with the energy of someone much younger.[5]

"Aunt Wheatley was in want of a domestic," Charles Stratford, grand-
son of Susanna Wheatley's aunt Elizabeth Wallcut, wrote in his journal.
"She went on board to purchase."[6]

On the deck of the slave ship *Phillis*, Susanna Wheatley examined the
human merchandise all cleaned, scrubbed, and greased to make a better
appearance. "She found several robust, healthy females exhibited at the
same time with Phillis, who was of a slender frame and evidently suffering
from change of climate," Oddell said. "She is supposed to have been about
seven years old, at this time, from the circumstance of shedding her front
teeth."[7]

"In looking through the ship's company of living freight, her attention
was drawn to that...child, which at once enlisted her sympathies," Stratford
wrote. "Owing to the frailty of the child, she procured her for a trifle, as
the captain had fears of her dropping off his hands without emolument, by
death."[8]

The captain was so desperate to sell his sorry merchandise, he slashed
his prices.

According to Oddell, she was "influenced to this decision by the hum-
ble and modest demeanor and the interesting features of the little stranger...
the poor, naked child," adding that "she had no other covering than a quan-
tity of dirty carpet about her like a 'filibeg.'"[9]

That "dirty carpet" Odell said Phillis had wrapped around her middle
(*filibeg* was an eighteenth century term for a skirt-like Scottish kilt) was
probably an invention. "Phillis was most likely completely naked when
she arrived," Carretta says. "Oddell probably claimed otherwise out of a
Victorian sense of modesty. Eighteenth century slave buyers expected to
see exactly what they were buying."[10]

Why did the wealthy Mrs. Wheatley choose this sickly young girl to
employ as a slave? Surely she was aware that her new acquisition might not

be robust enough to be an effective worker around the house. There may have been a sentimental reason why Mrs. Wheatley chose a little girl rather than a mature woman. "Just a few weeks before the Wheatleys purchased Phillis they had observed the ninth anniversary of the death of their daughter Sarah," Carretta points out.[11] Their new house slave may have appealed to Susanna and John Wheatley as a surrogate for their late beloved daughter. When seven-year-old Sarah Wheatley died on May 11, 1752, she was almost the same age as Phillis.

Once she arrived at the Wheatley home, the first order of business for the new girl was to receive her new name. Susanna Wheatley decided to call her Phillis after the ship that carried her from Africa to Boston.

The Wheatley mansion on the northeast corner of King Street and Mackerel Lane (State and Kilby Streets in today's Boston) would be her new home. One of the finest dwellings in town, it was located in the bustling heart of Boston, "then noted as much for its grand residences as it now is under the name of State Street, for its commercial and banking offices," wrote Dr. Nathaniel B. Shurtleff in 1863, soon-to-become mayor of Boston.[12]

John Wheatley was a tailor whose clients included Boston's elite, including the wealthy and stylish John Hancock. Blessed with a hard-driving entrepreneurial spirit, he became one of Boston's most prosperous merchants. With his privately owned three-masted schooner, the *London Packet*, making regular transatlantic trips, John Wheatley was able to expand his business into Europe. "Wheatley imported a wide range of raw materials and manufactured goods from London," Carretta says.[13] The thriving high-end Wheatley store on King Street sold luxury items such as Chinese tea, rum, molasses, sugar, coffee, chocolate, candles, fine linen, glass globe lamps, and excellent Lisbon wine.

Susanna Wheatley was a deeply religious woman. "The earnest of the Spirit and foretaste of the Glory which shall be reveal'd has long been the subject of my pursuit," she wrote in 1766.[14]

The Wheatley twins, Nathaniel and Mary, were eighteen when Phillis arrived. Nathaniel, blessed with that keen Wheatley business sense, took over his father's affairs after the elder Wheatley retired. Mary Wheatley was a "simple, sickly girl who enjoyed being Phillis' childhood tutor and lifelong

friend," says William Robinson.[15] She would later marry prominent Boston minister the Reverend John Lathrop.

Where was Phillis born and where did she spend the first years of her life? "Although it is impossible to identify exactly where Wheatley's journey from Africa to America began," says Carretta, "some commentators have asserted with varying degrees of conviction that she was born in Senegal. Others say Gambia."[16]

Carretta suggests that "an experienced slaver like Gwin was extremely unlikely to have procured the least desirable slaves (the "small and the meanest cargo") as soon as he reached Senegal," his primary destination. He believes that Gwin "bought refuse slaves, particularly young girls, only as a last resort...just before he had to return to Boston." Therefore, Carretta concludes, "Gwin probably acquired the future Phillis Wheatley near the end of the months he spent along the coast of Africa."[17]

Carretta admits that "even if Gwin bought her at 'Sinigall', we should not assume that she was a native of the area," explaining that "African entrepreneurs sometimes brought enslaved fellow Africans to the coast from hundreds of miles inland."[18]

"We cannot know how early a period she was beguiled from the hut of her mother or how long a time elapsed between her abduction from her first home," Oddell admitted. Yet, sensitive to her ordeal, Oddell acknowledged that Wheatley "must have felt like one awaking from a fearful dream...filled, as it must have been, with various degrees and kinds of suffering [that] might naturally enough obliterate the recollection of earlier and happier days."[19]

"Because she has left regrettably few details of the land of her origin," says Shields, "concentration beyond the acknowledged fact of her birth in Africa necessarily leads into speculation."[20]

Nevertheless, after examining the relevant historical facts, we can offer some fascinating theories.

Oddell recalled that Phillis shared one striking detail of her former life in Africa with the Wheatleys. Phillis "does not seem to have preserved any remembrance of the place of her nativity, or of her parents excepting the simple circumstance that her mother *poured out water before the sun at his rising*—in reference, no doubt, to an ancient African custom....The solitary

exception which held its place so tenaciously in her mind, was probably renewed from day to day through this long season of affliction; for, every morning, when the bereaved child saw the sun emerging from the wide waters, she must have thought of her mother, prostrating herself before the first golden beam that glanced across her native plains."[21]

This hazy memory of her mother kneeling in prayer before the early morning sun provides a significant clue. "That direction would, of course, have been toward the east, hence toward Mecca," says Shields. "This ritual strongly suggests the first of Islam's five daily prayers and Islam had indeed penetrated the Gambia region some two and a half centuries before Wheatley's birth."[22]

Home for Phillis Wheatley, Shields reasons, was Gambia in West Africa. "Owing to her particularly fine features, thin lips, narrow nose and high forehead, as revealed in the portrait that introduces the 1773 volume (her first book of poems), she may well have been of the Fulani people, who lived on the meadow lands along the Gambia River....It was the Fulani who were responsible for introducing and spreading Islam throughout much of western Africa."[23]

In a poem published in 1774, when she was twenty-one, Phillis wrote longingly of what Shields suggests may be a memory of her African birthplace. Wheatley "names Gambia as the land of her birth and writes a poetic description of it which plausibly resembles today's Gambia."[24]

"Not at any other time," he says, "is Wheatley so specific about her origins."[25]

> *In fair description are thy powers display'd*
> *In artless grottos amid the sylvan shade;*
> *Charm'd with thy painting, how my bosom burns!*
> *And pleasing Gambia on my soul returns,*
>
> *With native grace in spring's luxuriant reign,*
> *Smiles the gay mead and Eden blooms again.*
> *The various bowers, the tuneful flowing stream,*
> *The soft retreats, the lovers golden dream,*
>
> *Her soil spontaneous, yields exhaustless stores;*
> *For Phoebus revels on her verdant shores.*[26]

"What I see clearly in her poetry," writes Shields, "is the memory... almost a reverence, for her African homeland."[27]

It is natural to assume that a young woman as intensely curious and intellectually vibrant as Phillis would want to know where she came from. She would have echoed the same burning question millions of Africans persisted in asking as they searched, mostly in vain, for family torn from them by the cruelties of slavery: "Who are my people? What was the land of my birth?"

Phillis may have asked the Wheatleys. Probably they did not know. But there were people living in Boston at the time who would have had access to that information. The owner of the *Phillis*, the businessman behind the slave trading operation that brought her, lived nearby. Robinson speculates that "She might have inquired of Timothy Fitch."[28]

An unsourced story in the 1836 *Anti-Slavery Record* describes a visit by Phillis to the Fitch home shortly after she returned from her triumphant trip to London in 1773. She was a free woman at the time, and the report shows the high regard many Bostonians felt for her, including the wealthy Fitch family. The story also highlights the unseemly racial animosities commonly practiced at the time.

> Mrs. Fitch was a very kind woman and invited Phillis to spend the afternoon with her. The daughters, though they were glad to see her, could not imagine how she would be disposed of at tea time. For like many persons at the present day, they could not bear the idea of sitting down at table with a colored person...They were, therefore, very anxious to learn of their mother, what she should do with Phillis at tea time.
>
> Mrs. Fitch told them at once that she was to be seated with them. They pouted a little, but submitted to their mother's directions.
>
> When tea was brought in, Phillis took her seat with the fair daughters of Col. Fitch. She soon began to give an account of her visits at various places in England and describe the persons and things she had seen...St. Paul's Cathedral, one of the largest churches in the world, of Westminster Abbey and of London Bridge...

As she went on with her pleasant and entertaining stories, the young ladies became delighted with Phillis. They became more and more inquisitive to learn what she had seen and found that with all their wealth and advantages, she knew more than they did.

As she went on with her stories, they forgot she had been a slave. They felt no prejudice against her because she was black and they felt ashamed they had ever made any objections to her having a seat at the tea table.[29]

Professor Shields expresses confidence in his theory about Phillis' origins. After much study and consideration, he has come to accept "Gambia as the land in which Wheatley spent the first seven years of her life....The Gambia River's easy navigability suggests it made Blacks living along its banks the relatively defenseless prey of unscrupulous white and black slavers."[30]

In the absence of any definitive evidence, Shields admits that his speculation may be off base. "I should be delighted to have some better prepared student of Wheatley prove me wrong. But for now," he insists, "I am going to assume that Wheatley was of the Fulani peoples."[31]

# CHAPTER 3.

*"The Salem ship the Desire, returned from the West Indies, brought some cotton, and tobacco, and Negroes."*

ON FEBRUARY 28, 1638, THE governor of the Massachusetts Bay Colony recorded a noteworthy event in his journal: "Mr. Pierce, in the Salem ship the *Desire*, returned from the West Indies after seven months. He brought some cotton, and tobacco, and Negroes."[1]

The first African slaves had arrived in Massachusetts.

Three years later, the Massachusetts Bay Colony adopted a code of laws. It was the first legal protection of individual rights in America. The 1641 *Massachusetts Body of Liberties*, written by Puritan leaders, contained ideas later included in the Bill of Rights: freedom of speech, the right to bail and a jury trial, and prohibition of cruel and unusual punishment.

The law did not guarantee these rights for all. Certain people were exempt—"lawful captives taken in just wars, and such strangers as willingly sell themselves *or are sold to us*"—and could be purchased as property.[2] This effectively legalized the enslavement of Africans and Native Americans.

Massachusetts Bay became the first colony in British North America to legitimize slavery in law. For those unfortunate individuals who could be possessed in the same way as a man owns his horse, there was no recourse. "This exempts none from servitude who shall be judged thereto by authority," said Massachusetts law.[3]

Keeping slaves was entirely consistent with Puritan fundamentalist Protestant belief. Slavery was written in the Law of God. Bible passages like these were used to justify slavery for the next two hundred and twenty years:

> Moreover of the children of the strangers that do sojourn among you, of them shall ye buy, and of their families that are with you, which they begat in your land: and they shall be your possession. And ye shall take them as an inheritance for

your children after you, to inherit them for a possession; they shall be your bondmen forever. Leviticus 25: 45-46.

Servants, be obedient to them that are your masters according to the flesh, with fear and trembling, in singleness of your heart. Ephesians 6:5.

Exhort servants to be obedient unto their own masters and to please them well in all things, not answering again. Titus 2:9.

The 1641 law included specific language asserting biblical authority to keep slaves: "And these shall have all the liberties and Christian usages which the law of God established in Israel concerning such persons doth morally require."[4]

The Puritan effort to align slavery and scripture had the effect of granting certain rights to Massachusetts slaves. The "liberties and Christian usages" phrase meant that slaves could be baptized and their marriages recognized by law. In order to read the Bible, slaves were taught to read and write. The law granted one crucial right that would lead to the abolition of slavery in Massachusetts a hundred and forty years later: slaves had access to the legal system. A slave could testify in court and seek redress of grievances. This laid the groundwork for a series of fateful court decisions that would guarantee their freedom.

Since the Puritans modeled their version of slavery on the "law of God established in Israel," slaves were considered as property and also persons before the law. According to black history scholar Lorenzo Greene, the "slave held a position somewhere between that of a plantation slave and an indentured servant. This was due to the influence of Jewish slavery after which the Puritans patterned their system of involuntary servitude."[5]

Following the ancient Hebrew tradition, they were called "servants" rather than slaves. Most slaves lived in their owner's home and fit into the domestic routine of the family. Rarely did an owner possess enough slaves to justify building separate living quarters.

In 1750 the population of the Massachusetts Bay Colony was 184,000 white residents and 4,100 African slaves. Compared to the exploding slave population in the Deep South—South Carolina had 25,000 whites and

39,000 slaves; Virginia had 130,000 whites and 101,000 slaves—the number of slaves in Massachusetts was so small there was little reason to fear a rebellion.[6]

Since the Massachusetts Bay Colony was not well suited for agriculture, there was no need for slaves to work the fields. The economy was driven by the maritime industry. Slaves were used as shipbuilders and deck hands. Most slave owners lived in cities. "It was fashionable to own servants for those who could afford it," says Robinson. "It was a status symbol. They were carriage drivers, butlers, valets, domestics, menials."[7]

Boston, the largest city in New England with the greatest slave population, made laws restricting their movement. A 1723 law prohibited slaves from "idling or lurking together."[8]

On November 13, 1761 the Constable of the Watch ordered his men to "Take up all Negroes, Indians and Mollotta Slaves that they may be absent from Masters houses after 9 o'clock at night unless they can give good account of business."[9]

The seven-year-old girl who came to Boston as a slave became part of an economic system that was not based primarily on slave labor. Her experience was radically different from the millions of Africans in the southern colonies who toiled endlessly on huge plantations in exhausting, backbreaking manual labor.

Slavery in the South dominated the culture so completely they went to war to defend it. By 1860 there were roughly one hundred Virginians, four hundred South Carolinians, and five hundred Louisianans who reported owning as many as five hundred slaves each. Georgia and South Carolina had eight plantations with more than five hundred slaves.[10]

New England slavery was never a strong institution. In 1771 Boston, 183 masters owned 261 slaves. Most had one slave; a handful owned three or four slaves and nobody owned more than six.[11] By 1860, slavery in the North had been abolished for two generations.

In 1771, official records listed John Wheatley's property as one horse and one "servant for life." "Oddell may be correct that the Wheatley family owned several slaves in 1761," says Carretta, "but ten years later Phillis was their only 'Servant for Life.'"[12]

The main challenge to our understanding of Phillis Wheatley has

been acknowledged for as long as people have been reading her poetry. "Although Wheatley's historical and literary significance is now rarely questioned, much of her life has remained a mystery," writes Carretta. "She left no autobiography and rarely writes about her own life in the surviving documents."[13]

From her meager personal writings, some two dozen letters, and by extrapolating biographical significance from certain lines in her poetry, can we get to know the real Phillis Wheatley?

Reconstructing the complexities of a life through the mists of history nearly two hundred fifty years past is always problematic. By making an effort to understand the forces at play that impacted her life and by close examination of her own words and personal observations by those who knew her, we can gain insight into her character and personality.

A good place to start is by recognizing that Phillis Wheatley was a real woman, a living, breathing, thinking, feeling person. Looking beyond the facts of history and the social dynamics of the time, we can come close to seeing Phillis Wheatley as she was.

\* \* \*

In *The Hemingses of Monticello: An American Family,* Annette Gordon-Reed makes the case that in order to understand the life of a Revolutionary War era slave woman like Sally Hemings—and Phillis Wheatley as well— we must first acknowledge their humanity.

Sally Hemings and Phillis Wheatley were contemporaries; Hemings was born in Virginia about twenty years after Phillis was born in Africa. They grew up at a time when the new American nation was forming. Both women were legally owned by wealthy men, and for both, their experience of slavery was far from typical.

Sally Hemings and Phillis Wheatley were "born into a cohort— eighteenth-century enslaved black women—whose humanity and femininity were constantly assaulted by slavery and white supremacy," says Dr. Gordon-Reed. "While experiences typical to that cohort are highly relevant as a starting point, they can never be an end in themselves. For Hemings lived in her own skin and cannot simply be defined through the enumerated experiences of the group—enslaved black females."[14] We can

say the same for Phillis Wheatley—she lived in her own skin, an individual greater than the social forces that fixed her station in life.

As a slave in New England, Phillis Wheatley was sheltered from the brutal treatment that was typical throughout the colonies. Yet she was someone's legal property and, as an African, she was subject to the cultural biases of the society. A closer look at the "experiences typical to that cohort" opens a window into her psychology, giving us a feel for the daily stresses and emotional suffering she had to face. For most slaves in the American colonies, life was a nightmare of unmitigated agony; every day was a life and death struggle. "The plantation was a battlefield where slaves fought masters for physical and psychological survival," John Blassingame writes in his groundbreaking 1979 study, *The Slave Community: Plantation Life in the Antebellum South*.[15]

Professor Blassingame used principles from the psychology of human development to help us understand the emotional lives of those who were enslaved. "In analyzing slave behavior, it is possible to utilize several psychological theories," he says. "The most useful of them, however, is Harry Stack Sullivan's 'interpersonal theory.' Sullivan argued that the 'significant others' or persons with most power to reward and punish are primarily responsible for the way people behave."

> Crucial to Sullivan's theory is the concept of the self which he defined as 'the content of consciousness at all times when one is thoroughly comfortable about one's self-respect, the prestige that one enjoys among one's fellows, and the respect and deference which they pay one.'[16]

"According to black autobiographers," says Blassingame, "one of the most important factors affecting their struggle for personal autonomy was the frequency and the nature of the punishment meted out by masters and overseers."[17]

In his 1849 *Narrative of the Life and Adventures of Henry Bibb, An American Slave,* fugitive slave Henry Bibb wrote that his life had become one of "utter helplessness."[18]

"Work, work, work, was scarcely more the order of the day than of the night," wrote Frederick Douglass. "I was whipped, either with sticks

or cowskins, every week. Aching bones and a sore back were my constant companions…. My natural elasticity was crushed. My intellect languished; the disposition to read departed, the cheerful spark that lingered about my eye died out; the dark night of slavery closed in upon me and behold a man transformed to a brute!"[19]

In 1850, former slave Thomas Jones asked: "Is it any wonder that the spirit of self-respect of the poor, ignorant slave is broken down by such treatment of unsparing and persevering cruelty?"[20]

Phillis Wheatley lived for thirty-one years and was enslaved for twelve in a mansion where she was expected to perform only light domestic duties. She was nurtured, educated, and given a rare degree of personal autonomy that allowed her to make her own decisions about how to use her time and energy. With the Wheatley's encouragement, she had permission to spend most of her time reading and writing.

"She was treated more like a member of the Wheatley family than as a servant, let alone as a slave," says Carretta. "Unlike most slaves she may have been allowed to share their table."[21]

"Hers was an education that would have been prized in many a Boston family, even among its elite," writes Wheatley scholar Julian Mason.[22]

"All indications are that little actual work (cleaning, dusting, etc.) was exacted from Wheatley," says Shields.[23]

"Was Phillis blessed?" the African-American scholar W. E. B. Du Bois asked in his 1941 essay, *The Vision of Phillis the Blessed*. "Yes!" he answers, "with security and affection, with education beyond her status, by contact with cultured folk."[24]

Soon after arriving in her new homeland, Phillis taught herself to read and write. Four years later, she was writing poetry and impressing her owners so much they arranged to have her work published in local newspapers. They gave Phillis the freedom to allow her creative heart to soar.

"I prefer the verse," the teenager told an inquiring "New York Gentleman."[25] It was as if she knew her destiny all along.

The Wheatleys encouraged her immersion in the timeless wisdom of great literary classics and the spiritual truths of the Bible. She was exposed to a culture of intellectual stimulation, with opportunities to converse freely with an ever-widening circle of clergymen, scholars, merchants, and

political leaders, the cream of Boston's educated elite, who became her staunchest admirers.

Among those supporters were eighteen prominent Boston men who signed a statement attesting to Phillis's authorship of her poems, including the governor and lieutenant governor of Massachusetts, John Hancock, the first signer of the Declaration of Independence and the wealthiest man in Boston, and Reverend Mather Byles, a prominent clergyman and poet.

She won the respect of General George Washington, who wrote a personal letter of appreciation to Phillis for a poem she wrote in his honor and took the extraordinary step of inviting her to visit him at his headquarters. She met Benjamin Franklin in London. "I went to see the black poetess," Franklin wrote, "and offer'd her any services I could do for her."[26]

Can we imagine the young poet, even in her slave state, growing more and more self-assured as she displayed her literary gifts, basking in the "prestige that one enjoys among one's fellows," which she unquestionably received from those at the highest levels of her society?

"Reverence, affection, friendship—all these were hers," Du Bois wrote.[27] It had to be immensely satisfying for Phillis to read the Boston newspapers announcing her departure for London, where she went to promote her new book, offering their glowing reports on "the extraordinary poetical genius" and "celebrated young negro poetess, Phillis."[28]

For Phillis Wheatley, her strong "concept of the self" became evident in her poetry. She could be bold and buoyant, philosophical and profound. Ambitious in her artistry, she reached for worlds beyond the earthly one we know. She chose words carefully and crafted clear images to help us understand the ineffable Divine Mystery.

She knew who she was and declared it proudly and often. "One cannot help but note her fairly frequent references to herself as an 'Ethiop' or 'African,' especially in her early poetry," says Professor Mukhtar Ali Isani.[29]

"She injected her racial identity into a poem, often gratuitously," Robinson writes, sometimes in contexts "not even remotely concerned with her racial identity."[30] The audacious poet charmed her readers with "heav'nly tidings from the Afric muse."[31]

The reality of her situation was more sobering. No matter how well she was treated in the Wheatley household, the central fact of her existence

was that Phillis was the legal property of another human being. She was forced to confront the social reality of her time—that many of her neighbors believed she was unworthy of being treated with dignity and decency and that her sensibilities, opinions, and needs did not matter.

"She was young, black, female, a slave, a pious Christian, clever, talented and astute," writes Mason. "She understood the various aspects of her position in society and the need to be alert, decorous, open, careful and nimble of mind."[32]

A powerful psychological burden weighing on the mind of every black man and woman was the widespread belief in white supremacy. "The idea of the superiority of whites was etched into the slave's consciousness by the lash and the ritual respect he was forced to give every white man," Blassingame writes.[33] While Phillis may never have received physical punishment, she certainly felt the sting of knowing that her African heritage was thoroughly devalued and dishonored, and she was compelled to show proper deference to the white people around her.

"In spite of the ritual deference they gave to whites, the slaves frequently rejected the arguments of the Negro's inferiority and tried to prove they were false," says Blassingame.[34] Phillis countered this woeful devaluation of African dignity and intelligence head-on in her poetry. But, like many African-Americans, even after slavery was abolished, she was compelled to find ways to cope with an unequal system of separation and demonization.

> It is obvious that many of the slaves recognized the customary deferential act for what it was, a ritual. It was so customary for many of them that they thought little about it. Since it was a habitual mode of behavior, many did not view the deferential act as a symbol of their degradation.[35]

Phillis "made a strange and lonesome figure in the America of the day just before the Revolution," said Du Bois. "In the only home she knew... she was always partly a stranger."[36]

Oddell, who wrote her 1834 memoir of Phillis to promote the Abolitionist cause, sympathized with Phillis's plight. "Whenever she was invited to the houses of individuals of wealth and distinction (which frequently happened), she always declined the seat offered her at the board

and, requesting that a side table might be laid for her, dined modestly apart from the rest of the company."[37]

Oddell considered Phillis's conduct "both dignified and judicious."[38]

> By respecting even the prejudices of those who courteously waived them in her favor, she very delicately expressed her gratitude; and following the counsel of those Scriptures to which she was not a stranger, by taking the lowest seat at the feast, she placed herself where she could certainly expect neither to give nor receive offence."[39]

For Phillis, and for most black slaves, studied deference was a useful coping strategy, a way to maintain their dignity when their humanity was assailed.

"Very much an alert woman of her times," says Robinson, "she was familiar with the various necessities of Black survival in a racist world."[40]

Since white supremacy was accepted without question throughout the European world, it had to be deeply wearing on a woman of Phillis Wheatley's intelligence and literary gifts to face widespread doubts about her innate abilities. How debilitating for her to be compelled to "prove" that she was capable of doing what came so naturally; how galling for her to be expected to assure skeptics that she really did compose every line, make every rhyme, invent the phrases and create the imagery in her poems. As popular as she was in her town and among those readers who appreciated her work, she was not able to generate enough interest to have her books published in America.

According to Blassingame, the most traumatic aspect of slavery "was the dread of being separated from loved ones. To be sold away from his relatives or stand by and see a mother, a sister, a brother, a wife or a child torn away from him was easily the most traumatic event of his life."[41]

Phillis knew the horror of being dragged away from her family. Separation from those she loved upended her life on two separate occasions. Her first experience of slavery's oppression jolted the little girl when she was kidnapped and forced into the brutal Middle Passage. Her second collision with the trauma of separation came after she gained her freedom and, one by one, the members of the Wheatley family died. First to

go was her mentor, the source of her nurturing care, her mistress, Susanna Wheatley. According to Margaretta Oddell, they shared a special bond of affection. "Phillis ate of her bread and drank of her cup and was to her as a daughter," she said.[42]

Phillis revealed her profound sadness to her "sister-friend" Obour Tanner on March 21, 1774, shortly after becoming a free woman. "I have lately met with a great trial in the death of my mistress," wrote Phillis. "Let us imagine the loss of a parent, sister or brother; the tenderness of all these were united in her...I was treated by her more like her child than her servant."[43]

Benevolent masters created a very particular dynamic among slaves. "Generally," writes Blassingame, "the master's kindness, confidence and trust was repaid by faithful work on the part of the slave."[44]

Former slave Henry Clay Bruce observed that "The master who treated his slaves humanely had less trouble, got better service from them and could depend upon their doing his work faithfully."[45]

Robert Anderson agreed. On his plantation, slaves "were willing to put our best into the tasks when we were treated humanely."[46] He recalled that his master was "a very easygoing man, kind and generous and loved by all the plantation people. We colored folks did what he asked us to because we liked him."[47]

Blassingame notes that "one of Frederick Douglass' mistresses was so 'kind, gentle and cheerful' that he 'soon learned to regard her as something more akin to a mother than a slave-holding mistress.'"[48]

Describing his mistress, Douglass wrote:

Mrs. Sophia was naturally of an excellent disposition—kind, gentle and cheerful.

Why should I hang down my head and speak with bated breath when there was no pride to scorn me, no coldness to repel me, and no hatred to inspire me with fear? I therefore soon came to regard her as something more akin to a mother than a slaveholding mistress. So far from deeming it impudent in a slave to look her straight in the face, she seemed ever to say, 'Look up, child; don't be afraid.'"

If little Thomas was her son and her most dearly loved child, she made me something like his half-brother in her affections. If dear Tommy was exalted to a place on his mother's knee, "Freddy" was honored by a place at the mother's side. Nor did the slave-boy lack the caressing strokes of her gentle hand, soothing him into the consciousness that, though motherless, he was not friendless.[49]

# CHAPTER 4

"Massachusetts Bay from whence issued all the
smoak, flame & lava which hath enveloped the whole
British American continent."

FROM THE SAFETY OF HER house on King Street, Phillis Wheatley could watch the town of Boston exploding around her. She was twelve when the first clashes broke out, igniting the long struggle that would change the course of history and bring a new nation, the United States of America, into the world.

"In this year 1765 began the violent outrages in Boston," wrote Peter Oliver, one of the city's leading citizens, former Chief Justice of the Colony of Massachusetts Bay, and author of the first history of the American War for Independence.[1]

Marauding mobs wreaked havoc in the streets, slashing a path of devastation that sent the city spinning out of control. The Revolution had begun.

Oliver, a Boston Tory who fled to Britain in 1776, wrote his book in a small, quiet cottage outside London. Peter Oliver knew the fury of Boston all too well; the city where he was born had become Ground Zero for the American resistance. He pointed to "the province of Massachusetts Bay" as "the volcano from whence issued all the smoak, flame & lava which hath since enveloped the whole British American continent."[2]

It was only after their victory in the French and Indian War (1756-1763) that most of North America came under British control. That brutal conflict in what is now the United States and Canada left Great Britain deeply in debt. To avoid economic ruin and pay for their newly expanded empire, Parliament levied taxes on the colonies. The 1764 Sugar Act created an extensive list of taxable items, including critical products like lumber, the backbone of New England's growing shipbuilding industry, and popular items like molasses. The burden of collecting the tax was placed on merchants. To enforce the new law, the Royal Navy was empowered to

search all ships for smuggled merchandise. The Sugar Act marked the first time Britain used her distant colonies to raise money.

The Stamp Act became law on March 22, 1765 and was scheduled to take effect on November 1. Its wide reach would touch the lives of nearly everyone in the colonies. Citizens were required to buy a stamp for almost anything written on paper—newspapers, handbills, pamphlets, broadsides, legal documents, wills, deeds, licenses, college degrees, even playing cards. The act specified more than fifty items needing stamps.

Entrepreneurs like John Wheatley, like many in the colonies, chafed at these oppressive new demands. Boston native Benjamin Franklin recognized the principle at stake. "It is suppos'd an undoubted Right of Englishmen not to be taxed but by their own Consent given thro' their Representatives" even though everyone knew that "the Colonies have no Representatives in Parliament."[3]

When Phillis went to the marketplace for her mistress, Susanna Wheatley, she would be required to purchase a stamp for nearly every product. Surely, she was aware of Boston's rising anger. An avid reader, Phillis probably kept abreast of the volatile political scene by following accounts in Boston newspapers. She certainly came across some of the pamphlets and broadsides urging resistance to the British oppressors.

"Phillis' new American home was situated in the very heart of colonial Boston's political, social and commercial bustles," says Robinson. "At the southern end of her street, a few short blocks from her home, was the Old Colony House, the administrative unit for the town."[4]

The Old Colony House—Boston residents called it the Town House—was built in 1713 at the head of King Street as the capitol of the Massachusetts Bay colony. Known in today's Boston as The Old State House, it remains the oldest standing structure in the city.

The Town House was the headquarters of British Authority. It was home to the Massachusetts Supreme Court. The Royal Governor had his office there.

The Massachusetts Assembly, the oldest elected body in the United States, deliberated, debated, and passed laws there. The Assembly chamber in the Town House was the first in the English-speaking world to include a gallery where the public could observe the proceedings. It was a popular

feature, since Bostonians had a keen interest in their government.

The house on the corner of King Street and Mackerel Lane put Phillis near the center of some of the most significant events in Boston's glorious and tumultuous history. Conversations within the Wheatley household would have told the story of a city in strife. Certainly she would have heard the indignant frustrations voiced by her neighbors. She could easily have experienced the uproar of unruly mobs, the jarring slurs, shouted curses, and vicious threats.

In the summer of 1765, Boston erupted. From her house on King Street, Phillis Wheatley witnessed the violent convulsions that gave birth to a new nation.

"The worst riots in the riotous history of pre-Revolutionary War Boston would explode on or quite near King Street," writes Robinson. "Although eleven or twelve years old in 1765, Phillis could hardly forget that summer's mob-sprawling Stamp Act riots against the British imposed act."[5]

On the morning of August 14, 1765, residents of Boston woke to find what looked like the body of a man hanging from a large stately elm tree at the corner of Essex and Orange Streets. "Yesterday morning we had something so rare as to draw the attention of almost the whole town," wrote Cyrus Baldwin to his brother the next day. "It was no less than the effigy of the honorable Stamp Master of this Province hanging on one of the great trees at the south end directly over the main street."[6]

> On the Effigies Right arm was writ and sew'd on the letters "AO". On his left arm was wrote these words: "What greater Joy Can New England see than Stamp men hanging on a tree."

It was an ominous warning directed at the recently appointed Distributor of Stamps for Massachusetts, Andrew Oliver, brother of Peter Oliver.

Behind the effigy was "a Boot hung up with the devil crawling out, with the pitchfork in his hand," Baldwin wrote. The boot with an emerging devil was a play on the name of the Earl of Bute, a former Prime Minister for King George III.

A chilling hand-drawn message was attached to the effigy.

Fair Freedoms glorious Cause I meanly Quited,
Betrayd my Country for the Sake of Pay.
But at Length the Devil has me outwitted.
Insted of stamping others have hangd myself.

On the effigy someone scrawled a grim warning: "Whoever takes this down is an Enemy to his Country."[7]

That night a group of influential shopkeepers, artisans, and tradesmen gathered around the giant elm. Sam Adams and his cousin John Adams were there, along with Paul Revere and *Boston Gazette* publisher Benjamin Edes. They called themselves the Sons of Liberty. The tree became "The Liberty Tree."

When Lieutenant Governor Thomas Hutchinson ordered the sheriff to remove the offending effigy, a crowd fought them off. Instead, they took the effigy of Andrew Oliver and flung it onto a makeshift bier to form a mock funeral procession. The demonstrators carried the effigy along King Street, past the Wheatley mansion to the Town House, where Royal Governor Francis Bernard had his headquarters.

King Street became the stage for a chilling piece of street theater.

> Growing uglier by the stomping footstep, the crowd picked up speed and swarmed down King Street, yelling "Liberty! Property! And no stamps!" over and over again. They veered to their right into Mackerel Lane—just past the Wheatley household.[8]

The mob made their way to a new structure under construction, intended to be the office of the Stamp Master.

> In a few noisy, cursing minutes, the mob barehandedly tore the office to pieces, some of them jubilantly carrying away souvenir planks.[9]

Next stop was the residence of Andrew Oliver on Kilby Street. The mob beheaded the effigy and stoned the house while its occupants fled in terror. The rioters built a huge bonfire with wood from Oliver's dismantled headquarters and threw what was left of the effigy into the flames.

The crowd meant to intimidate the Stamp Master and, according to his

brother, Peter Oliver, they succeeded. "The Secretary of the Province also, who was appointed a Stamp Master (Andrew Oliver), was attacked and his house much damaged. He was carried to the Tree of Liberty by the mob and a justice of the Peace provided to swear him and there he was obliged, on pain of death, to take an oath to resign his office."[10]

For the next two weeks the town smoldered. Then, on August 26, a crowd whipped into a wild frenzy "frightened the entire town and much of the province with the imminent threat of violent mob rule."[11]

The carnage began on King Street.

> Milling about the Old Colony House [The Town House], a crowd suddenly spurted across the street and with bare fists and staves attacked the home of William Story, registrar for the Court of the Admiralty, smashing his windows, flinging official papers to the alleys and streets.

Boston's night of fury was just beginning.

> Another mob raced to the Hanover Street home of Benjamin Hallowell, a customs official, rampaged his place, and drank up most of the wines and liquors in the basement. Then, some of them almost falling down drunk, the mobs joined and stormed up Hanover Street until they reached Fleet Street, where they wheeled down one block to Garden Court and the resplendent town mansion of the heartily detested, officious Lieutenant-Governor Thomas Hutchinson.[12]

Hutchinson described the horror that befell him and his family.

> In the evening whilst I was at supper and my children round me, somebody ran in and said the mob were coming...The hellish crew fell upon my house with the rage of devils and in a moment with axes, split down the doors and entered.
>
> My son, being in the great entry, heard them cry, 'Damn him! He is upstairs! We will have him!'
>
> Some ran immediately as high as the top of the house. Others filled the rooms below and the cellars and others remained within the house...[13]

Marauders tore through the house, scattering papers and books, destroying furniture, tearing down walls, tossing away clothing, and finally emptying the wine cellar.

> All night long, the howling, cursing, wild-eyed mobs almost completely tore to the ground, from its cupola down to its much-admired and well-tended lawns of lovely flowers and fruit trees, one of the most splendid mansions in all of New England.[14]

"If the devil had been here the last night, he would have gone back to his own regions, ashamed of being outdone," Peter Oliver lamented.[15] "Such was the frenzy of anarchy, such was the political enthusiasm that the minds of the most pious men seemed to be wholly absorbed in the temper of riot."[16]

Historian Gary Nash writes: "Behind every swing of the ax and every hurled stone, behind every shattered crystal goblet and splintered mahogany chair, lay the fury of a plain Bostonian who had read or heard the repeated references to impoverished people as 'rable.'"[17]

"The next morning," says Robinson, "thousands of gathered spectators, beholding the ruins, were stunned, revolted and frightened."[18]

Thomas Hutchinson described his misfortune. "Such ruin was never seen in America."

> Beside my plate and family pictures, household furniture of every kind and servants apparel, they carried off 900 pounds sterling in money and emptied the house of everything whatsoever, except a part of the kitchen furniture, not leaving a single book or paper in it and have scattered or destroyed all the manuscripts and other papers I had been collecting for thirty years.

> Many articles of clothing a good part of my plate have since been picked up in different quarters of the town but the furniture in general was cut to pieces before it was thrown out of the house and most of the beds cut open and the feathers thrown out the windows.[19]

After the mob's orgy of mayhem and ruin, Boston struggled to return to normal. When Lieutenant Governor Thomas Hutchinson showed up to preside at the Supreme Court the day after his house was destroyed, a young lawyer named Josiah Quincy described how the dignified Hutchinson faced his colleagues.

> The next day saw his Honor the Chief Justice come into court, with a look big with the greatest anxiety, clothed in a manner which would have excited compassion from the hardest heart...With tears starting from his eyes, and a countenance which strongly told the inward anguish of his soul, what must an audience have felt, whose compassion had before been moved by what they knew he had suffered?[20]

Hutchinson apologized for his appearance. "Destitute of everything, no other shirt, no other garment but what I have on, and not one in my whole family in a better situation than myself," he said, "I am obliged to borrow part of this clothing."[21]

Thomas Hutchinson aptly summed up the mood in Boston. "Such is the resentment of the people against the Stamp Duty."[22] He concluded his only public comments on his misfortune with a plaintive appeal. "I pray God give us better hearts!"[23]

"The court then adjourned," lawyer Quincy wrote, "on account of the riotous disorders of the preceding night, and universal confusion of the town."[24]

As news of the Boston street protests spread throughout the colonies, resistance to British rule grew. Groups calling themselves "Sons of Liberty" formed in many cities, rallying around a "Liberty Tree." Violence flared in New York and Philadelphia. Protests erupted in Newport, Rhode Island; Portsmouth, New Hampshire; Annapolis, Maryland; Wilmington, Delaware; and Charleston, South Carolina.

Fourteen boxes of stamps arrived in Boston on September 23, 1765 and were immediately stored in the fortified Castle William, about three miles outside of town. "Otherwise," said Judge Oliver, "they would have been involved in the general destruction."[25]

Stamp Administrators, intimidated by the fierce Boston protests, all

resigned. The Stamp Act was supposed to go into effect on the first day of November. The law required a stamp for nearly every transaction. Yet the stamps were hidden away and stamp distributors were nowhere to be found. How could citizens possibly comply with the new law?

Nobody knew what would happen. Without stamps, people could not pay their debts. Courts would have to close. The port would shut down. Ships bringing food and merchandise would be barred from unloading. All business and trade would cease. The colonists worried about whether they would be able to purchase the provisions they needed for the winter. Would they all starve?

The official debut of the Stamp Act hung over the city like a shroud. John Hancock, one of the most prominent citizens of Boston, hated the Stamp Act. "It is universally determined here never to submit to it," he said.[26]

Yet all of Boston knew the stamps were coming.

"I dread the event," said Hancock.[27]

# CHAPTER 5

*"She soon gave indications of uncommon intelligence and was frequently seen endeavoring to make letters upon the wall with a piece of chalk or charcoal."*

NOT LONG AFTER PHILLIS WHEATLEY arrived in Boston, the Wheatley family began noticing something startling about their new slave girl.

"She soon gave indications of uncommon intelligence," Oddell wrote, "and was frequently seen endeavoring to make letters upon the wall with a piece of chalk or charcoal."[1]

John Shields believes that Phillis could have been recalling early lessons from her homeland. "She may have come to America carrying with her a rudimentary knowledge of Arabic script adapted to the Fulani language... given the spread of Arabic literacy into the Gambia region just before Wheatley's infancy."[2]

The Wheatleys encouraged these explorations in her new language. According to Oddell, "A daughter of Mrs. Wheatley, not long after the child's first introduction to the family, undertook to learn her to read and write."[3]

Mary Wheatley took Phillis under her wing. "Phillis was sent to school and educated with Miss Mary," wrote Hannah Mather Crocker, a young Boston girl about the same age as Phillis. "She soon acquired the English language and made some progress in the Latin."[4]

Hannah Mather Crocker surely knew Phillis well. Her father was the Reverend Samuel Mather, son of famed preacher Cotton Mather and pastor of Boston's Tenth Congregational Society. Her uncle was Thomas Hutchinson, the Royal Governor of the Massachusetts Bay Colony. Both men were familiar with Phillis and her poetry and were among the eighteen "respectable characters" who signed their names attesting to Wheatley's authorship of her first book.

In Phillis, Mary Wheatley found an eager student. An inner drive propelled Phillis to acquire sophisticated language skills few of her contemporaries possessed. She was on fire to learn.

"As to her writing, her own curiosity led her to it," her master John Wheatley said.[5]

"By seeing others use the pen, she learned to write," said Mary Wheatley's husband, Rev. John Lathrop.[6]

In the preface to Phillis's 1773 book of poems, John Wheatley offered his own testimony to confirm his slave's exceptional abilities.

> Phillis was brought from Africa to America in the year 1761, between seven and eight years of age. Without any assistance from school education, and by only what she was taught in the family, she, in sixteen months time from her arrival, attained the English language to which she was an utter stranger before, to such a degree, as to read any most difficult parts of the sacred writings to the great astonishment of all who heard her...She has a great inclination to learn the Latin tongue and has made some progress in it.[7]

An astounded John Wheatley described what he believed to be Phillis's first piece of writing. "She learned in so short a time that in the year 1765, she wrote a letter to the Reverend Mr. Occom, the Indian Minister, while [Occom was] in England."[8]

Reverend Samson Occom, a Presbyterian minister, was one of the Mohegan people of Connecticut who converted to Christianity and became something of a celebrity preacher. The renowned British evangelical Reverend George Whitefield, then touring the colonies, invited Occom to join him in New England. Mrs. Wheatley, a devotee of Reverend Whitefield and friend of Reverend Occom, gave generous financial support to their cause.

Phillis probably met Reverend Occom when he and Reverend Whitefield came to Boston in 1764. "Occom subsequently corresponded with both Phillis and Susanna Wheatley. He often stayed with the Wheatleys when he visited Boston," says Carretta.[9]

The Occom letter of 1765 has been lost to history.

In his 2011 biography, Carretta reveals his own "strong candidate for Phillis's first known piece of writing."[10] Recently discovered among the papers of New Hampshire Congregationalist minister and prominent historian Jeremy Belknap was a short poem in his own handwriting, included on the last page of his 1773 diary.

> *Mrs. Thacher's son is gone*
> *Unto salvation*
> *Her daughter too, so I conclude*
> *They are both gone to be renewed.*

Belknap wrote this identifying note beside the poem: "Phillis Wheatley's first Effort—A.D. 1765."[11]

"There are many reasons to accept Belknap's attribution of the verses on the deaths of Mr. and Mrs. Thacher to a young Phillis Wheatley," says Carretta. He points out that Belknap must have known Wheatley because several years later she sent him a copy of her elegy on the death of Reverend Joseph Sewall.[12]

Since Belknap lived in New Hampshire, Carretta believes the poem was passed along to him by Wheatley neighbor Reverend Mather Byles, who was Belknap's uncle. Byles was a poet himself and soon became Phillis's special tutor. In 1773, when Belknap wrote his journal entry about Phillis, he was working on his book, the *History of New Hampshire,* which was published in 1784.

Perhaps Belknap, whom Alexis de Tocqueville would later call America's best native historian, was compiling notes on the young poet-slave from Boston to include in his book on prominent Americans. Phillis Wheatley never appeared in his two-volume work *American Biographies* (1794 and 1798), but this prominent historian valued her poetry enough to copy it in his own personal journal.

Phillis surely knew the Thacher family because they were prominent members of the Old South Church, which Phillis later joined. Sarah Thacher died July 4, 1764; Oxenbridge Thacher died the next year, July 9, 1765.

"Writing an elegy on their deaths effectively highlighted the spiritual community the author shared with them," says Carretta. "The brevity, style,

genre, content and allusions of the poem on the Thachers all point to Phillis Wheatley as its author in 1765."[13]

This brief elegy, designed to give spiritual comfort to someone she knew, was the prototype of what would become a hallmark of Wheatley's works.

"Assuming that the lines Jeremy Belknap recorded in his diary in 1773 are indeed by Phillis Wheatley and that she composed them shortly after the death of Oxenbridge Thacher in 1765," Carretta concludes that "they constitute Wheatley's earliest known piece of writing of any kind."[14]

By any measure, Phillis Wheatley's rapid mastery of English and her natural gift for writing, emerging without the benefit of any formal education, was nothing short of extraordinary.

"By comparing the accounts we have of Phillis's progress with the dates of her earliest poems we find that she must have commenced her career as an authoress as soon as she could write a legible hand," writes Oddell, "and without being acquainted with the rules of composition."[15]

The Wheatley family quickly recognized the unique abilities of their young slave. "She is indeed a singular genius," Rev. Lathrop declared in a letter to a friend.[16]

"Mrs. Wheatley may have imagined when she purchased Phillis that she was thereby providing for the comfort of her own old age," says Robinson. "But as matters quickly turned out, she would spend the rest of her life assisting Phillis' fame in every way she could."[17]

Young Phillis quickly came under the watchful and protective care of Susanna Wheatley.

"She was a pretty smart sprightly child," observed her young friend Hanna Mather Crocker. "They grew very fond of her and treated her as well as if their own."[18]

"While she astonished her instructress by her rapid progress, she won the good will of her kind mistress by her amiable disposition and the propriety of her behavior," Oddell wrote.[19] "She was not devoted to menial occupations, as was at first intended; nor was she allowed to associate with the other domestics of the family, who were of her own color and condition, but was kept constantly about the person of her mistress."[20]

Oddell relates one occasion when Phillis was visiting the home of some

distinguished Boston citizen and Mrs. Wheatley sent her slave Prince with the family carriage to bring her home.

> The weather changed during the absence of Phillis; and her anxious mistress, fearful of the effects of cold and damp upon her already delicate health, ordered Prince (also an African and a slave) to take the chaise, and bring home her protegee.

> When the chaise returned, the good lady drew near the window, as it approached the house, and exclaimed—'Do but look at the saucy varlet—if he hasn't the impudence to sit upon the same seat with my Phillis!'

> And poor Prince received a severe reprimand for forgetting the dignity thus kindly, though perhaps to him unaccountably, attached to the sable person of 'my Phillis.'[21]

"She never was looked on as a slave," said Mrs. Crocker.[22]

To their great credit, the Wheatleys established an atmosphere in their home that would support and encourage their gifted young slave as she progressed in reading and writing. "Phillis was obviously precocious," says Carretta, "and the Wheatleys offered her an extraordinary opportunity to develop her talents and interests."[23]

"Mrs. Wheatley did not require her services as a domestic," Oddell wrote, "but she would sometimes allow her to polish a table or dust an apartment, or engage in some other trifling occupation. But not unfrequently, in these cases, the brush and the duster were soon dropped for the pen, that her meditated verse might not escape her."[24]

Few Bostonians had the luxury of light in their bedrooms. Only the most fortunate had the comfort of warmth during those brutal New England winters. Yet 'Phillis the Blessed' had both. "Her kind mistress indulged her with a light and in the cold season with a fire in her apartment during the night," said Oddell. "The light was placed upon a table at her bedside, with writing materials, that if anything occurred to her after she had retired, she might, without rising or taking cold, secure the swift-winged fancy, ere it fled."[25]

Despite her legal status as property of the Wheatleys, she had

considerable freedom to pursue her own inspirations in her writing. "She was allowed, and even encouraged, to follow the leading of her own genius," said Oddell. "But nothing was forced upon her, nothing suggested, or placed before her as a lure; her literary efforts were altogether the natural workings of her own mind."[26]

For young Phillis, still a slave, it seemed as though her main jobs in the Wheatley house were reading and writing and knitting. "Her time, when she was at home," according to Oddell, "was chiefly occupied with her books, her pen, and her needle."[27]

"She could work handsome (fine sewing and needlework)," said her friend Hannah Mather Crocker, "and could read and write well for that day."[28]

"It must not be forgotten," Oddell pointed out, "that the opportunities of education allowed females at this early period were few and meager.... The great mass of American females could boast of few accomplishments save housewifery. They had few books beside their Bibles. They were not expected to read—far less to write."[29]

Hannah Mather Crocker remarked that during their lifetime "if women could even read and badly write their name it was thought enough for them, who by some were esteemed as only mere 'domestick animals.'"[30]

Phillis learned by listening and watching. She read everything she could get her hands on. When the young writer felt the urge to express her fascination with something she saw in the world around her, she turned to poetry.

One day two gentlemen, Mr. Hussey and Mr. Coffin, came to visit the Wheatley home. At dinner they told a harrowing tale. While sailing from Nantucket to Boston, they were overtaken by a ferocious storm and narrowly escaped death.

She was probably serving dinner as the men relived their life and death drama. She must have followed every detail because sometime later, alone in her room, she took pen to paper and scratched out a few lines to memorialize the event.

"Already discernible," says Professor Robinson, "is her profound spirituality, a sense that she would manifest in her life, poems and letters throughout her years."[31]

Susanna Wheatley was so impressed by Phillis's writing that she submitted the poem to a local newspaper. Mrs. Wheatley enclosed a letter explaining the extraordinary circumstances that gave birth to the poem.

*To The Printer:*

*Please to insert the following lines, composed by a Negro Girl (belonging to one Mr. Wheatley of Boston) on the following occasion. Messrs Hussey and Coffin, belonging to Nantucket, being bound from thence to Boston, narrowly escaped being cast away on Cape-Cod in one of the late Storms. Upon their arrival, being at Mr. Wheatley's, and, while at dinner, they told of their narrow escape. This Negro Girl at the same time tending the table, heard the relation, from which she composed the following Verses.[32]*

The poem appeared in the *Newport Mercury* on December 21, 1767. At the age of fourteen, Phillis Wheatley became a published poet.

### ON MESSRS HUSSEY AND COFFIN

*Did Fear and Danger so perplex your Mind,*
*As made you fearful of the Whistling Wind?*
*Was it not Boreas knit his angry Brow*
*Against you? or did Consideration bow?*

*To lend you Aid, did not his Winds combine?*
*To stop your passage with a churlish Line,*
*Did haughty Eolus with Contempt look down*
*With Aspect windy, and a study'd Frown?*

*Regard them not; — the Great Supreme, the Wise,*
*Intends for something hidden from our Eyes.*
*Suppose the groundless Gulph had snatch'd away*
*Hussey and Coffin to the raging Sea;*

*Where wou'd they go? Where wou'd be their Abode?*
*With the supreme and independent God,*
*Or made their Beds down in the Shades below,*
*Where neither Pleasure nor Content can flow.*

*To Heaven their Souls with eager Raptures soar,*
*Enjoy the Bliss of him they wou'd adore.*
*Had the soft gliding Streams of Grace been near,*
*Some favourite Hope their fainting hearts to cheer,*

*Doubtless the Fear of Danger far had fled:*
*No more repeated Victory crown their Heads.*

*Had I the Tongue of a Seraphim, how would I exalt thy*
*Praise; thy Name as Incense to the Heavens should fly, and*
*the Remembrance of thy Goodness to the shoreless Ocean of*
*Beatitude! — Then should the Earth glow with seraphick*
*Ardour.*

*Blest Soul, which sees the Day while Light doth shine,*
*To guide his Steps to trace the Mark divine.*

*—Phillis Wheatley*[33]

# CHAPTER 6

## "On Being Brought From Africa to America."

BY THE TIME PHILLIS SAW her first poem published in 1767, she had been writing poetry for at least two years. We know the composition dates for many of her poems because they were noted in her 1772 proposal for a planned book of poems that ran in Boston newspapers.

The first poem listed in her proposal was *On the Death of the Rev. Dr. Sewell When Sick*—1765. Phillis was twelve when she composed this heartfelt elegy to honor a man she considered her spiritual mentor and guide.

> *Mourn him, ye youth, to whom he oft has told*
> *God's gracious wonders, from the times of old.*
> *I, too, have cause, this mighty loss to mourn,*
> *For he, my monitor, will not return.*[1]

For fifty-six years, Rev. Joseph Sewall (1688-1769) served the Old South Congregational Church as pastor. Phillis was drawn there on Sundays, walking several blocks from the Wheatley home to attend worship services. Following custom, Phillis sat in the balcony with the other slaves and free blacks. There she experienced her first yearnings for Christian fellowship.

At the time she wrote the poem, Rev. Sewall was nearly eighty and so seriously ill people thought the end was near. He recovered, but after he passed away in 1769, Phillis rewrote the poem. The original 1765 version was lost, but her revised poem was widely circulated in Boston and later appeared in her 1773 book.

*ON THE DEATH OF THE REV. DR. SEWELL, 1769*

> *ERE yet the morn its lovely blushes spread,*
> *See Sewell numbered with the happy dead.*
> *Hail, holy man! arrived the immortal shore;*
> *Though we shall hear thy warning voice no more,*

*Come, let us all behold, with wishful eyes,*
*The saint ascending to his native skies:*
*From hence the prophet winged his rapturous way,*
*To the blest mansions in eternal day.*

*Then, begging for the Spirit of our God,*
*And panting eager for the same abode,*
*Come, let us all with the same vigor rise,*
*And take a prospect of the blissful skies;*

*While on our minds Christ's image is impressed,*
*And the dear Saviour glows in ev'ry breast.*
*Thrice happy saint! to find thy heaven at last,*
*What compensation for the evils past!*

*Great God! incomprehensible, unknown*
*By sense, we bow at thine exalted throne.*
*Oh, while we beg thine excellence to feel,*
*Thy sacred Spirit to our hearts reveal,*

*And give us of that mercy to partake,*
*Which thou hast promised for the Saviour's sake!*
*"Sewell is dead." Swift-pinioned Fame thus cried.*
*"Is Sewell dead?" my trembling tongue replied.*
*Oh, what a blessing in his flight denied!*

*How oft for us the holy prophet prayed!*
*How oft to us the word of life conveyed!*
*By duty urged my mournful verse to close,*
*I for his tomb this epitaph compose.*

> Lo, here, a man, redeemed by Jesus' blood,
> A sinner once, but now a saint with God.
> Behold, ye rich, ye poor, ye fools, ye wise,
> Nor let his monument your heart surprise;

*Twill tell you what this holy man has done,*
*Which gives him brighter lustre than the sun,*
*Listen, ye happy, from your seats above.*
*I speak sincerely, while I speak and love.*

*He sought the paths of piety and truth,*
*By these made happy from his early youth.*
*In blooming years that grace divine he felt,*
*Which rescues sinners from the chains of guilt.*

*Mourn him, ye indigent, whom he has fed,*
*And henceforth seek, like him, for living bread;*
*Ev'n Christ, the bread descending from above,*
*And ask an int'rest in his saving love.*

*Mourn him, ye youth, to whom he oft has told*
*God's gracious wonders, from the times of old.*
*I, too, have cause, this mighty loss to mourn,*
*For he, my monitor, will not return.*

*Oh, when shall we to his blest state arrive?*
*When the same graces in our bosoms thrive?*[2]

The second poem listed in her 1772 proposals was *On Virtue*, composed in 1766, when she was thirteen. Inspired by a Bible passage (*Proverbs 1:7—*The fear of the Lord is the beginning of knowledge, but fools despise wisdom and instruction), it was the earliest expression of her lifelong interest in the pursuit of wisdom.

Here, the young poet experimented with a different style. It is one of only two poems she wrote in blank verse.

This poem shows the growing depth of her spiritual inquiry and her ease in blending Classical and Christian themes. A revised and polished version appeared seven years later in her 1773 book of poems. Wheatley scholars regard "On Virtue" as one of her finest poems.

*ON VIRTUE.*

*O THOU bright jewel, in my aim I strive*
*To comprehend thee. Thine own words declare*
*Wisdom is higher than a fool can reach.*
*I cease to wonder, and no more attempt*
*Thine height to explore, or fathom thy profound.*
*But O my soul, sink not into despair;*
*Virtue is near thee, and with gentle hand*
*Would now embrace thee, hovers o'er thine head.*
*Fain would the heaven-born soul with her converse,*
*Then seek, then court her for her promised bliss.*
*Auspicious queen! thine heavenly pinions spread,*
*And lead celestial Chastity along.*
*Lo! now her sacred retinue descends,*
*Arrayed in glory from the orbs above.*
*Attend me, Virtue, through my youthful years;*
*Oh, leave me not to the false joys of time,*
*But guide my steps to endless life and bliss.*
*Greatness, or Goodness, say what shall I call thee,*
*To give an higher appellation still:*
*Teach me a better strain, a nobler lay,*
*O thou, enthroned with cherubs in the realms of day.*[3]

The other poem in which Phillis used blank verse was "To The University of Cambridge, 1767." Here we see an extraordinarily confident young woman, all of fifteen, boldly offering wisdom and advice to a class of scholars at what would soon become Harvard University. It was a literary tour de force. The young slave girl delivered what amounted to a commencement address to the intellectual elite of the American colonies. The poet took on the role of Teacher, Mentor, Minister, and Counselor to the young men destined to become the nation's leaders.

## TO THE UNIVERSITY OF CAMBRIDGE, 1767

WHILE an intrinsic ardor prompts to write,
The Muses promise to assist my pen.
'T was not long since, I left my native shore,
The land of errors and Egyptian gloom:
Father of mercy! 'twas thy gracious hand
Brought me in safety from those dark abodes.

Students, to you 'tis given to scan the heights
Above, to traverse the ethereal space,
And mark the systems of revolving worlds.
Still more, ye sons of science, ye receive
The blissful news by messengers from heaven,
How Jesus' blood for your redemption flows.

See him, with hands outstretched upon the cross!
Immense compassion in his bosom glows;
He hears revilers, nor resents their scorn.

What matchless mercy in the Son of God!
He deigned to die, that they might rise again,
And share with him, in the sublimest skies,
Life without death, and glory without end.

Improve your privileges while they stay,
Ye pupils; and each hour redeem, that bears
good or bad report of you to heaven.

Let sin, that baneful evil to the soul,
By you be shunned; nor once remit your guard:
Suppress the deadly serpent in its egg.

Ye blooming plants of human race divine,
An Ethiop tells you, 'tis your greatest foe;
Its transient sweetness turns to endless pain,
And in immense perdition sinks the soul.[4]

Phillis is entirely comfortable in asserting her racial identity. "An Ethiop tells you," she proclaims, trumpeting her black pride and claiming the highest moral authority from the "Father of mercy" whose "gracious hand brought me in safety from those dark abodes." She insists that she can be a trusted advisor to the students. In her wisdom, the poet warns them to beware of their "greatest foe," attacks on their spiritual well-being. She reminds them to avoid life's greatest pitfall, how "transient sweetness turns to endless pain" when "immense perdition sinks the soul."

"Audaciously," writes her biographer Carretta, "the teenaged, enslaved, self-educated, female, and formerly pagan poet of African descent assumes a voice that transcends the 'privileges' of those who are reputedly her superiors in age, status, abilities, authority, race and gender."[5]

Handwritten copies of Phillis's poems circulated around Boston, especially among the extended Wheatley family. Susanna Wheatley's niece, Elizabeth Wallcut, sent two Wheatley poems to her son Thomas, then a student at Dartmouth College. "According to your desire I have sent you Dr. Sewall's picture and the verses on his death composed by Phillis Wheetly (sic)," she wrote on January 30, 1773. She included a copy of *To The University of Cambridge, 1767*, "a piece she made on our college," which "she sends as a present to you."[6]

By today's standards, Phillis and Thomas could be called friends. They genuinely cared about each other and made efforts to communicate over the years. Thomas Wallcut, five years younger than Phillis, "was one of the earliest (and youngest) admirers of Wheatley's poetry and she actively promoted his education," according to Carretta.[7]

These two inquisitive teenagers shared books of mutual interest. Phillis "gave him the copy of Rev. Thomas Amory's *Daily Devotion Assisted and Recommended in Four Sermons* that Rev. Charles Chauncy had given her, as well as a copy of Rev. John Lathrop's *The Importance of Early Piety*."[8]

Thomas Wallcut never lost his passion for research and reading and made collecting antiquarian books his life's work. Along with Jeremy Belknap, he became one of the founding members of the Massachusetts Historical Society.

"The relationship between Phillis Wheatley and Thomas Wallcut," Carretta observes, "is a rare instance of a woman of African descent who,

when she was enslaved as well as free, was a mentor to a white youth."[9]

Wheatley's shortest work—one of two poems only eight lines long—is perhaps her most notorious. According to Professor Shields, *On Being Brought From Africa to America* is "Wheatley's most frequently anthologized poem," and "perhaps her least understood."[10]

## ON BEING BROUGHT FROM AFRICA TO AMERICA

*TWAS mercy brought me from my pagan land,*
*Taught my benighted soul to understand*
*That there's a God—that there's a Saviour too:*
*Once I redemption neither sought nor knew.*

*Some view our sable race with scornful eye—*
*"Their color is a diabolic dye."*
*Remember, Christians, Negroes black as Cain*
*May be refined, and join the angelic train.*[11]

In 1928, Benjamin Brawley, the first black literary critic to seriously examine Wheatley's work, called it a "pathetic little juvenile poem."[12]

"I am not the only scholar who has wished the teenage poet had found a more veiled way to express her gratitude to Susanna Wheatley for saving her from a worse form of slavery and for expressing her genuine joy at her full embrace of Christianity," writes Dr. Henry Louis Gates.[13] "To speak in such glowing terms about the 'mercy' manifested by the slave trade was not exactly going to endear Ms. Wheatley to black power advocates....This, it can be safely said, has been the most reviled poem in African-American literature," says Dr. Gates.[14]

The young poet seems to be celebrating her enslavement as a blessing of good fortune. According to Julian Mason, "the poem almost sounds like a product of missionary propaganda."[15]

Recent scholarship and careful readings have come up with a very different interpretation. According to William Robinson, the poet's intent has been misconstrued. "Often cited as an instance of Phillis' Negrophobic denigration of her native African homeland, this poem is rather to be read as a terse refutation of some white Christians' racist notions that by biblical

mandate, the souls of black people were everlastingly doomed."[16]

"Indeed," writes Shields, "*On Being Brought From Africa to America*, revised, can now be viewed as another sign of her rejection of white folks' Christianity—but not necessarily Christianity itself."[17]

Shields observes that "the poem seems to extol the Christian message but then sharply criticizes an evidentiary hypocrisy, one promising equality for all but then denying that equality to persons of color...This young black poet challenges—blatantly—white insidiousness evident in the Boston public she knew and then rebukes those same authors of deceit with an unmistakable assertion of equality."[18]

In this poem, the young African publicly confronts her bondage for the first time. Considering her unfortunate situation as a slave, her youth, her lack of formal education, and the fact that her status in the social hierarchy could not be any lower, it is a wonder that the poem exists at all.

"As this poem's first version was written in 1768 when she was four-teen or fifteen, this piece is indeed a bold expression for a young slave girl," says Shields.[19] "In addition to challenging the injustice of the status quo," he says, "Wheatley is here in the act of determining her role as a poet. Not at all content with resignation, she steadfastly, even at this early moment, confronts those who would condemn her and her race and challenges their tyranny over her."[20]

In the opening stanza, Wheatley credits "mercy" for bringing her from a "pagan land."

According to Robinson, "Phillis is not disparaging Africa because of its black populations but because it is pagan, not Christian."[21]

Here Phillis proclaims her emerging faith, acknowledging the Supreme Authority of God in all earthly things and accepting her savior Jesus Christ.

In the second stanza, the tone shifts; what began as an innocent per-sonal confession now becomes a sober rebuke. Phillis dares to address her white oppressors.

"Some view our sable race with scornful eye" she chides the so-called Christians of Boston.

Note the pronouns. "Some" refers to those white folks whose scorn is based on nothing more than skin color. "Our" is an inclusive pronoun—she counts herself in. "This poet is under no delusion that she, a black woman,

has herself somehow merited exclusion from the gaze of this collective 'scornful eye,'" says Shields.[22]

Wheatley describes herself and her black brothers and sisters with beauty and dignity — "our sable race"— countering the common and wholly outrageous claim by white supremacists that their dark color somehow signifies evil — "a diabolic dye."

Then Phillis issues a stark challenge. Grammatically, she uses an imperative: *"Remember, Christians"* to point a finger at those who aspire to follow the teachings of Christ.

And what does this young black slave girl want them all to remember?

"According to the Christian message as this young girl has received it," Shields writes, "God makes no distinction between white and black; and just as white believers are promised 'redemption', conversion has taught this black poet that, contrary to those whites whose racial bigotry would consign all of her color to hell, implied by the word 'diabolic', believers, all true believers, alas, even 'negroes', 'may be refin'd' or raised to a higher spiritual state equal to that of any white believer."[23]

In eight short lines, Phillis Wheatley managed to assert the all-embracing truth, grace and love in the universal body of Christ while sharply criticizing the ignorance and hypocrisy of those who profess to be Christians and still deny that divine blessing for all God's children.

# CHAPTER 7

## "On the Arrival of the Ships of War and the Landing of the Troops."

ON MAY 16, 1766 ONE of John Hancock's merchant ships arrived in Boston harbor six weeks after departing London. The captain rushed ashore to share the momentous news from Britain: Parliament had repealed the hated Stamp Act.

The festivities started almost immediately.

"The bell on the Hollis Street church began to ring," the *New England Magazine* wrote. "Christ Church in the North End soon replied and in a few minutes every bell in Boston was ringing. Ships in the harbor displayed their colors and bonfires were kindled in different parts of the town... The Liberty Tree was hung with banners and streamers and every house in the vicinity was decorated with flags, portraits of America's friends in Parliament and mottoes suitable to the occasion."[1]

Leading the celebration was John Hancock, perhaps the wealthiest man in Boston. He set out a pipe (125 gallons) of his favorite Madeira wine he imported from Portugal and invited ecstatic Bostonians into his home for toasts.

"John Hancock...gave grand and elegant entertainment to the genteel part of town," the *Massachusetts Gazette Extraordinary* reported on May 22, 1766.[2]

Twenty-three-year-old Nathaniel Wheatley was probably there, carousing with his father John. Since the Wheatleys were among the town's leading merchants, they had to be thrilled with the Stamp Act's demise. Surely they joined the throng of thousands that evening for a fireworks exhibition in Boston Common. Perhaps Phillis was there with Mrs. Wheatley. It was, at the time, the greatest celebration in the history of Boston.

The Sons of Liberty savored their victory. John Adams joined them for a festive dinner and later wrote in his diary:

I spent the evening with the Sons of Liberty at their own appointment, in Hanover Square, near the 'Tree of Liberty.' It is a counting-room in Chase and Speakman's distillery. A very small room it is...We had punch, wine, pipes and tobacco, biscuit and cheese, etc. They chose a committee to make preparation for a grand rejoicing upon the arrival of the news of the repeal of the stamp act.[3]

Phillis Wheatley knew the anguish the Stamp Act had brought to her town. Parliament's change of heart moved her to write a poem for the occasion. Speaking for all of Boston, she heaped praises on the King.

> *May George, beloved by all the nations round,*
> *Live with heav'ns choicest constant blessings crown'd.*[4]

The poet blessed their monarch as a loyal British subject would.

> *The crown upon your brows may flourish long,*
> *And that your arm may in your God be strong!*
> *O may your sceptre num'rous nations sway,*
> *And all with love and readiness obey!*[5]

But she took care to make sure readers knew the reason for the overwhelming gratitude in the colonies.

> *Midst the remembrance of thy favours past,*
> *The meanest peasants most admire the last*[*6]

Phillis added an asterisk with a note of explanation: *"The Repeal of the Stamp Act."*

The last line of the poem carries a pointed message. The young slave poet offers a reminder to the King that in his beneficent powers he alone has the authority to grant the blessing of liberty to his subjects—and she means ALL his subjects, including African slaves.

> *Great God, direct, and guard him from on high,*
> *And from his head let ev'ry evil fly!*
> *And may each clime with equal gladness see*
> *A monarch's smile can set his subjects free!*[7]

"Wheatley's argument and choice of imagery indicate that she was very familiar with contemporaneous political rhetoric," says Carretta.[8]

Her 1772 proposal listed the date of the poem as 1768. A revised version, with deletions and additions to make it even more favorable to the King, appeared in her 1773 volume of poetry as *To the King's Most Excellent Majesty, 1768,* which was published in England.

The joyful colonists barely had time to savor their victory. The same day the Stamp Act was repealed, Parliament passed the Declaratory Act reasserting British authority over the colonies. This new law stated that Parliament "hath, and of right ought to have, full power and authority to make laws and statutes of sufficient force and validity to bind the colonies and people of America ... in all cases whatsoever."[9]

The British were determined to maintain complete control over their American subjects. On June 29, 1767 Parliament tightened the noose. Chancellor of the Exchequer Charles Townshend devised a plan to place new duties on necessities the colonies imported from Britain, including paper, paint, lead, glass, and tea. The purpose of the Townshend Acts was to firmly establish the precedent that the British Parliament had the right to tax the colonies. "The superiority of the mother country can at no time be better exerted than now," Charles Townshend told Parliament.[10]

Boston was left to fume once again at the increasingly heavy-handed moves of Parliament. Town leaders plotted remedies that would be effective and far-reaching. In February 1768 Sam Adams, leader of the Sons of Liberty, wrote a sharply worded letter addressing all the colonies. He called for a common response to the British challenge. "Several acts of Parliament, imposing duties and taxes on the American colonies...with the sole and express purpose of raising revenue, are infringements of their natural and constitutional rights," he wrote, "because they are not represented in the British Parliament."[11]

Boston merchants organized a boycott of British goods, and the idea spread to New York and Philadelphia. George Washington became one of the leaders of the boycott in Virginia. "At a time when our lordly masters in Great Britain will be satisfied with nothing less than the deprivation of American freedom," Colonel Washington wrote, "it seems highly necessary that something should be done to avert the stroke and maintain the liberty which we have derived from our ancestors."[12]

When the Virginia House of Burgesses passed a resolution stating that Parliament had no right to tax Virginians without their consent, the Royal Governor dissolved the legislature. Virginia's leaders, emboldened by the feisty Bostonians, met at a nearby tavern where they voted to adopt a boycott agreement.

The Royal Governor of Massachusetts Bay, Francis Bernard, fearing the growing defiance instigated by Sam Adams' Circular Letter, demanded that the Massachusetts Assembly repeal it. The Assembly voted 92-17 against revoking the letter and went on to prepare a list of charges against Governor Bernard that they hoped would lead to his removal.

Governor Bernard responded by dissolving the Massachusetts Assembly. Boston plunged into mass protests, civil unrest, and mob rule. With no clear government in power, the city was in chaos.

On September 28, 1768, six British warships and two armed schooners joined *HMS Romney* and five other British vessels already at anchor in the harbor. Two days later the fleet maneuvered close to shore, lining up in siege formation.

"At noon on Saturday October 1, the 14th and 29th Regiments, a detachment from the 59th Regiment and a train of artillery with the pieces of cannon, landed on Long Wharf," wrote Paul Revere. "They formed and marched with insolent parade, drums beating, fifes playing, colors flying up King Street."[13]

The extraordinary show of military might continued all afternoon. Two regiments of British infantry, looking sharp in their flashy red coats, marched through the center of Boston in rigid and disciplined lines that seemed to go on endlessly. Leading the troops were a corps of Afro-Caribbean drummers, smartly dressed in bright yellow coats with red trim, a stunning sight for Americans who had never seen Africans in the military.

"The streets and the doors and windows of the houses were crowded with spectators to view the procession," wrote Peter Oliver.[14]

What could be going through the mind of the bright, inquisitive, and observant young girl of sixteen, a slave to one of Boston's most prominent families, as she witnessed this fearsome display that day? Phillis probably watched the troops thundering past the Wheatley mansion on the corner

of King Street and Mackerel Lane, amazed at the powerful procession of highly trained soldiers marching in unison, muskets poised, bayonets ready.

"Phillis would not have overlooked the eight or ten black drummer boys of the 29th Regiment with their brown bearskin pointed hats, their yellow coats faced with red, their drums trimmed in the regimental yellow," says William Robinson. "About fifteen at this time, she was not much younger than most of the boys. It was all frightening and thrilling enough to move Phillis, later that year or early in 1769, to react poetically."[15]

Phillis titled her poem "On the Arrival of the Ships of War and the Landing of the Troops." The title appears among the poems in her first proposal for her book. The poem was not included in the published version, however, and has since been lost. Most likely, it was a sober reflection of the terror and uncertainty Boston was feeling as the city confronted the grim reality of living under an occupying military force.

Boston was now an armed camp. Massive artillery was wheeled into position at the Town House, home of the Massachusetts Legislature. For a proud city used to managing its own affairs, British domination of their town was a profound humiliation.

The city of Boston, population 15,520, came under the command of two thousand soldiers. Redcoats swarmed every corner of Boston. Armed militiamen stood guard at checkpoints all over town. They were unavoidable. Troops were stationed at the Custom House and the Town House on King Street. Patrols stopped carriages and carts on roads into the city.

"Boston in 1768 was a much smaller city than we know it today," writes historian Richard Archer. "Its entire circumference was merely four miles."[16]

The citizens of Boston deeply resented the outsiders. They vented their ire by loudly and profanely heckling, razzing, and cursing the soldiers. Sentries became easy targets for verbal abuse. "Bloody backed scoundrels, lobsterbacks, thieving dog, red herring" the people jeered. They aimed their most vile insults at the British. "Damn the King!"[17]

The soldiers' overwhelming presence became a daily irritant. Reverend Andrew Eliot of New North Church raged against the occupation in his Sunday sermon. "To have a standing army! Good God!! What could be worse to a people who have tasted liberty!"[18]

For John Adams, it was personal. "Through the whole succeeding fall and winter a regiment was exercised...in Brattle Square directly in front of my house. The spirit stirring drum and ear piercing fife aroused me and my family early enough every morning."[19]

Escalating tensions between the Mother Country and the colonies became a hot topic of the day, affecting British citizens in Boston and all of North America.

Phillis Wheatley was fifteen when she wrote her poem *America*. "This may be the earliest poem we have which shows her awareness of general public affairs and events," says Julian Mason. "It also suggests an awareness of the public press and its satiric methods."[20]

Keenly aware of the inflammatory rhetoric swirling around her, Phillis describes the explosive unrest in the colonies in allegorical terms. She constructs the poem as a fable, telling the story of America from the beginning, when the Pilgrims came to New England to tame a wild continent. (Note how the young girl misspelled the word "*field*" in this preliminary draft.) A revised version was listed in the 1772 proposal for her volume of poetry as *On America, 1768*, but it was not included in her book and has never been found. Her original handwritten poem was not published until 1970.

> *New England first a wilderness was found*
> *Till for a continent 'twas destin'd round.*
> *From feild to feild the savage monsters run,*
> *E'r yet Brittania had her work begun.*

Her grand theme was freedom, an ideal she saw as the most significant force in human affairs. The poet made an eloquent case that the freedom sought by white Americans, liberation from metaphorical slavery under British rule, also applies to Africans suffering under the burdens of actual slavery.

> *Thy Power, O Liberty, makes strong the weak*
> *And (wond'rous instinct) Ethiopians speak;*

The teenager adroitly included herself and her people in the American story. She knew that her readers would be unaccustomed to heeding the

voice of an African. Yet she proceeds anyway—"*And Ethiopians speak*"—feigning shock that some people would doubt that such a person has something worth saying. She offered a simple explanation for her forwardness: it is "wond'rous instinct."

In her allegory, the Mother Country Great Britain is depicted as a "certain lady" who "had an only son"—the American colonies. Then, something comes between mother and son—a plague of taxes and more taxes.

> *He grew up daily, virtuous as he grew.*
> *Fearing his strength which she undoubted knew.*
> *She laid some taxes on her darling son*
> *And would have laid another act there on.*

The poet, like most Americans, did not trust the British response to the colonists' ferocious protest.

> *Amend your manners. I'll the task remove,*
> *Was said with seeming sympathy and love.*

She condemns British policies, depicting a mother who punishes her son despite his innocence. As the cruelties of Parliament broke the hearts of the colonists, so this fictional mother made her own child weep.

> *By many scourges she his goodness try'd*
> *Until at length, the best of infants cry'd*

The young poet captured the frustration and anguish she saw in Boston, the fury directed at the British government. She shows the colonies begging for relief. And she depicts a scornful and dismissive British response.

> *He wept. Brittania turn'd a senseless ear*
> *At last awaken'd by maternal fear.*
> *Why weeps Americus? Why weeps my child?*
> *Thus spake Brittania, thus benign and mild.*
>
> *My dear mama, said he, shall I repeat—*
> *Then prostrate fell, at her maternal feet.*[21]

She concludes with an appeal for reconciliation, hoping that Mother and Son will come together to bring a new prosperity to the colonies as well as the British Empire.

> *To raise their own profusion, O Brittain, See*
> *By this, New England will increase like thee.*[22]

Finally, the young woman offers the audacious expectation that the art of a poet can change the course of history.

> *Sometimes by simile, a victory's won.*[23]

Note how Phillis misspells the word "smile." It was, after all, "only a rough first draft," says Mason.[24] Clearly she intended the line to read: "Sometimes by a smile, a victory's won." A similar idea appeared in another poem: "A monarch's smile can set his subjects free!"[25]

By the summer of 1769, the Royal Governor of Massachusetts Bay had enough of the city of Boston and its mobs, mayhem, riots, and defiance. On August 1, a jeering horde of Bostonians watched from the wharf as the ship carrying Sir Francis Bernard set sail for England. Church bells rang as ecstatic citizens celebrated by firing their rifles in the air. It was a great day for the colony of Massachusetts Bay.

"Almost all the people...absolutely hate him," John Adams wrote of Governor Bernard.[26]

The King appointed Lieutenant Governor Thomas Hutchinson to replace him as Governor. Hutchinson knew only too well the volatile situation facing him. "The spirit of anarchy which prevails in Boston is more than I can cope with," he wrote.[27]

# CHAPTER 8

## "On the Death of The Rev. Mr. George Whitefield."

THE GREAT AWAKENING HAD COME to America.

A new spiritual fervor sweeping through Britain quickly spread across the Atlantic. Inspired by the Protestant Reformation theology of John Calvin, the religious movement was brought to the colonies by the charismatic British preacher George Whitefield.

The Wheatleys were longtime admirers of Reverend Whitefield. According to Dr. Robinson, "Susanna and John Wheatley may have been among the transfixed congregation at the New South Church in September of 1740 when, as a guest speaker, Whitefield preached so fiery a sermon that so galvanized the excited assembly that five members were reportedly trampled to death."[1]

The wealthy Susanna Wheatley became a generous financial supporter of Whitefield's mission to bring the Gospels to America. When he returned to Boston on his preaching tour of New England in 1764, he stayed with the Wheatleys. It was an opportunity for the young poet to strike up a personal relationship with the dynamic preacher. "Phillis and Whitefield may well have met twice and talked socially while under the same roof," says John Shields.[2]

Reverend Whitefield was one of the most widely known Christian ministers in America. Over thirty years he returned to the colonies seven times, traveling on horseback from New England to Georgia preaching the Gospel of Love. Heeding the call of their awakening spirits, throngs by the thousands gathered shoulder to shoulder in grassy fields to hear his passionate, high-energy performances and stirring sermons. He was known as "the people's preacher." His revival meetings were open to all, especially those who did not normally attend church, mostly the poor, uneducated, and illiterate. Unheard of for the time, he welcomed slaves and free blacks as brothers and sisters in Christ.

Reverend Whitefield often observed that the colonies were marked for a special destiny in God's plan. "Had I a thousand lives, had I a thousand tongues, they should be employed in inviting sinners to come to Jesus Christ!" he bellowed to his assembled congregation.[3] "Surely, our Lord intends to set America in a flame."[4]

George Whitefield was one of America's first celebrities. He used the growing print media to promote his appearances, advertising in local newspapers and sending advance men to distribute posters and handbills. He had his sermons printed for wide circulation.

Benjamin Franklin attended a Whitefield revival meeting in Philadelphia and was deeply moved. "He had a loud and clear voice," Franklin wrote, "and articulated his words and sentences so perfectly that he might be heard and understood at a great distance."[5]

Following his penchant for scientific inquiry, Dr. Franklin conducted an impromptu experiment to put the reverend's speaking prowess to the test. "He preached one evening from the top of the Court House steps, which are in the middle of Market Street, and on the West Side of Second Street which crosses it at right angles. Both Streets were filled with his hearers to a considerable distance," Franklin wrote. "Being among the hindmost in Market Street, I had the curiosity to learn how far he could be heard, by retiring backwards down the street towards the river and I found his voice distinct till I came near Front Street.... I computed that he might well be heard by more than thirty thousand."[6]

Some years later, in 1766, the slave Olaudah Equiano was in Philadelphia, shortly before he purchased his freedom. There he witnessed an unforgettable Whitefield sermon and recalled the experience in his narrative.

> When I got into the church I saw this pious man exhorting the people with the greatest fervor and earnestness and sweating as much as ever I did while in slavery. I was very much struck and impressed with this. I thought it strange. I had never seen divines exert themselves in the manner before.[7]

Whitefield's nineteenth-century biographer, David Addison Harsha, described his spellbinding oratorical skills.

The awe—the silence—the attention which sat upon the face of the great audience was an argument how he could reign over all their powers. Many thought he spake as never a man spake before him. So charmed were the people with his manner of address that they shut up their shops, forgot their secular business and laid aside their schemes for the world.[8]

David Garrick, the greatest English actor of his time and a follower of Reverend Whitefield, once admitted "I would give a hundred guineas if I could only 'Oh' like Mr. Whitefield."[9]

Even Samuel Johnson, England's most distinguished man of letters, weighed in on the charismatic power of George Whitefield. "He would be followed by crowds were he to wear a nightcap in the pulpit or were he to preach from a tree."[10]

According to Whitefield's 2001 biographer, Stephen Mansfield, "He could move people to tears simply by the way he said 'Mesopotamia.'"[11]

Seventeen-year-old Phillis was an aspiring Christian and not yet baptized when she saw Reverend Whitefield for the last time.

"It is probable that both Phillis and her mistress were in attendance at the Old South Church one or more of the four times that the Reverend George Whitefield preached there throughout the month of August, 1770," says William Robinson.[12]

A few weeks later, on September 30, 1770, the good preacher suffered a fatal asthma attack. It was devastating news for Susanna Wheatley and the Reverend's loyal following in Boston. Seeing her mistress in mourning and sharing grief with so many in the Old South congregation, Phillis was inspired to write an elegy to the fallen spiritual leader.

> *Behold the prophet in his towering flight!*
> *He leaves the earth for heaven's unmeasured height.*
>
> *But though arrested by the hand of death,*
> *Whitefield no more exerts his lab'ring breath,*
>
> *Yet let us view him in the eternal skies,*
> *Let ev'ry heart to this bright vision rise;*

For Phillis, the loss was deeply personal. She wrote as an African and as an American, appealing for all to heed Reverend Whitefield's message of God's saving grace.

> *Take him, ye wretched, for your only good,*
> *Take him, ye starving sinners, for your food;*
> *Ye thirsty, come to this life-giving stream,*
> *Ye preachers, take him for your joyful theme;*
> *Take him, my dear Americans, he said,*
> *Be your complaints on his kind bosom laid:*
> *Take him, ye Africans, he longs for you;*
> *Impartial Saviour is his title due:*
> *Washed in the fountain of redeeming blood,*
> *You shall be sons, and kings, and priests to God.*[13]

Her poem *On the Death of The Rev. Mr. George Whitefield—1770* was published in Boston as a broadside on October 11, 1770 and sold for "7 coppers."[14] Soon it appeared in New York, Philadelphia, Newport (Rhode Island), Portsmouth (New Hampshire), and New London (Connecticut).

In their October 19, 1770 issue, the *New Hampshire Gazette* praised the work as "first, a remembrance of the great and good man Mr. Whitefield, and second on account of its being wrote by a native of Africa and yet would have done honor to a Pope or Shakespeare."[15]

Reverend Ebenezer Pemberton, pastor of Boston's New Brick Church, included the poem along with his sermon in a pamphlet memorializing Reverend Whitefield.

"The poem's various printings gave Wheatley her first wide fame as a poet," says Julian Mason.[16]

Near the end of the poem, Phillis offered her personal condolences to the great British patron of "The Great Awakening," Selina Hastings, Countess of Huntingdon, a major religious figure in eighteenth-century England. A woman of great wealth, she used her fortune to advance a new Christian evangelical revival, opening sixty-four new chapels in England and starting a college to train ministers.

Interested in spreading the Gospel to the English colonies, the countess bankrolled each of George Whitefield's transatlantic journeys. Her

Christian Methodist followers in England and America became known as the "Countess of Huntingdon's Connexion."

"Lady Huntingdon is indeed a mother in Israel," Whitefield wrote. "She is all in a flame for Jesus."[17]

"Great Countess," Phillis wrote, "we Americans revere thy name, and mingle in thy grief sincere."[18]

At the urging of Susanna Wheatley, Phillis sent her elegy for Reverend Whitefield along with a cover letter to the Countess of Huntingdon in London on October 25, 1770.

> *To the R. Hon'ble the Countess of Huntingdon*
>
> *Most noble Lady,*
>
> *The occasion of my addressing your Ladiship will, I hope, apologize for this my boldness in doing it. It is to enclose a few lines on the decease of your worthy chaplain, the Rev'd Mr. Whitefield, in the loss of whom I sincerely sympathize with your Ladiship; but your great loss which is his Greater gain, will, I hope, meet with infinite reparation, in the presence of God, the Divine Benefactor, whose image you bear by filial imitation.*
>
> *The tongues of the learned are insufficient, much less the pen of an untutor'd African, to paint in lively characters, the excellencies of this Citizen of Zion!*
>
> *I beg an interest in your Ladiship's Prayers, and am*
>
> *With great humility*
> *Your Ladiship's Most Obedient*
> *Humble Servant*
> *Phillis Wheatley*[19]

On the other side of the Atlantic, the countess took notice. "She became familiar with the young African and was fascinated by her work," writes scholar Sara Dunlap Jackson.[20]

"The Countess, touched by Phillis' eulogy of the Reverend Whitefield, her one-time personal chaplain, would eventually serve as Phillis' English patron," says Robinson.[21]

Her elegy to Reverend George Whitefield gained wide readership

throughout the colonies and in London. For Phillis Wheatley, it was her first taste of growing international recognition.

Shortly before Phillis Wheatley was baptized in 1771, she sat with someone identified only as "a New York Gentleman" who interviewed her on the subject of her religious beliefs. Titled "A Conversation between a New York Gentleman & Phillis," this remarkable hand-written document, nearly two and a half centuries old, appears to be a verbatim transcript of their conversation as it occurred. This extraordinary dialogue allows us to look backward through the centuries, offering a rare opportunity to eavesdrop on a rather personal interview.

What comes through clearly is the unique voice of eighteen-year-old Phillis Wheatley. Her unique speech patterns and personal syntax are on display as the young woman speaks in real time. Besides giving us valuable insight into Phillis's religious knowledge and literary erudition, we see her verbal dexterity, a glimpse of her keen mind at work. We can't help but notice a mature self-confidence shining through her polite and humble demeanor. Immediately we recognize that a woman of intelligence, complexity and depth is talking to us as if we were in the room.

> Q:    Was you ever baptiz'd Phillis?
>
> A:    No sir, I was not & fear it is a great neglect not to be baptiz'd when I know 'twas a command of Christ.
>
> Q:    What do you think of the Sacrament of the Lord's Supper? Did you ever partake of it? Do you think that you are actually eating the body & drinking the blood of the Lord or take it only in a spiritual manner?
>
> A:    I suppose it is receiv'd in a spiritual manner, sir.
>
> Q:    But we read, "when he took the bread, he bless'd it & brake it & gave it to his disciples & said Take, Eat, This is my Body & ought we not to take it so?
>
> A:    A person who observes the bare words only, may take it so. But I take it as offer'd spiritually, to commemorate his Death & Love till he appears to judge the World.

Q:        You are right, Phillis.[22]

Professor Carretta discovered this document in London while research-
ing his 2011 Wheatley biography. His diligence brought him to the Dr.
Williams' Library founded by Protestant theologian Reverend Dr. Daniel
Williams (1643-1716). The Wheatley interview was brought to his atten-
tion by Senior Cataloguer David Powell, who explained that he came upon
it "in a box of miscellaneous small items, none of which have any obvious
connection with the Wheatley item."[23] There was no interest in the docu-
ment for decades. It remained in the box until Professor Carretta arrived.

"The document is a single fold of paper, written on three sides, with a
blank final page," said Mr. Powell. At the top of the first page is written a
heading: "A Conversation between a New York Gentleman & Phillis," add-
ing, "There is no other title or explanation of any kind."[24]

"Much of the 'conversation' sounds like a catechist's preparation or
examination of candidate for baptism," notes Carretta.[25]

Since Phillis was well known in Boston particularly for her poetry and
religious piety, it is easy to see why a record of such a conversation would be
of great interest to members of the Old South religious community. There
would be a natural curiosity about the Christian sensibility and theological
knowledge of their new candidate for baptism, especially for someone like
Phillis, an uneducated African slave. In order to evaluate her properly, they
would need an accurate report of the conversation. Clearly, someone took
great care in writing it all down.

"It is very much a fair copy," said Powell, "not something scribbled
down during an interview."[26]

Carretta established the likelihood that copies of the dialogue between
Phillis and the New York Gentleman circulated around Boston. In a
February 24, 1773 letter to his brother-in-law, Boston lawyer John Andrews
wrote about his anticipation of Phillis's upcoming volume of poetry. "In
regard to Phillis's poems they will originate from a London press," he said.
Then he referred to a written copy of a certain conversation with Phillis
that he has been trying to obtain. He promised to share it when he does get
it. "I have not as yet been able to procure a copy of her dialogue with Mr.
Murry. If I do, will send it."[27]

The examination of faith tested her familiarity with the Bible.

Q:      Do you read the Bible, Phillis?

A:      I do, Sir.

Q:      Which do you think the best, the Old or New Testament?

A:      The new, Sir. However, they are the same only as the old foretold what should come to pass in order to fulfill it, namely the coming of the Messiah.

Q:      Do you read the New Testament more than the old?

A:      I do, Sir.

Q:      Are you fond of reading the Bible?

A:      I am, Sir.[28]

The Gentleman from New York (probably Mr. Murry) probed deeper into her religious beliefs. Every answer was accompanied by a follow-up question. In this documented examination, Phillis Wheatley accomplished something that was exceedingly rare for a woman and unheard of for a slave—she was able to expound thoughtfully on the most profound spiritual matters.

Q:      Do you imagine that we shall certainly rise from the dead at the last day?

A:      I believe we shall, sir.

Q:      With what bodies do you think we shall rise at the last day?

A:      I believe we shall rise with these bodies at the last day, that we may receive judgment in them according to the works that have been done in them whether they be good or evil.

Q:      But how can this gross & mortal body inherit eternal life?

A:      It shall not then be gross & mortal, for it shall have put on immortality: it's sown a natural body but it shall be rais'd a spiritual body & so then it shall not longer be a gross & mortal but a spiritual body.

Q:      But it is said flesh & blood cannot inherit the Kingdom of Heaven & if we have flesh & blood at the Resurrection how shall we inherit the Kingdom of Heaven?

A:      By Flesh & Blood I suppose is meant the corrupt affections, but these separated from the Body will render it spiritual.

Q:      Where do you think the Soul will be during its separation from the body?

A:      I believe the Spirits of the just will be with God 'till the Resurrection.

Q:      Do you think there will be any difference in the happiness of the just?

A:      According to their works, Sir.

Q:      But how will a body dismembered & cast to distant parts of the world be gathered together?

A:      Tho' a limb were cut off, a hand or foot & cast to the uttermost parts of the world, yet the same Power that made it shall gather it to its proper body.[29]

Suddenly the New York Gentleman threw Phillis a curveball, posing a provocative question. Twenty-first-century readers will find it shocking and ridiculous; but in the eighteenth century it was a serious issue. Even enlightened thinkers at the time cast doubt on the humanity of people from Africa, and women were regarded as mere property.

For Phillis it was a challenge. Like a modern graduate student facing oral exams, she would have to take a clear stand. When pressed further, she would be expected to offer supporting evidence to argue for her position.

Q:      Do you think that a woman has a soul, Phillis?

A:      I do, Sir,

Q:      What makes you think that a woman has a soul? Of man, it is said, when God created Man he breath'd into his nostrils the breath of life & Man became a living soul; but nothing of all this is said of the woman's creation. Do you think it would not have

been mention'd of her as well as it was of Adam & would not you suppose from that, that a woman has a soul?

A:        Not from that Sir, but here's a proof that a woman has a soul; when one came to our Lord to heal her of a disease he said to her, Daughter, thy sins are forgiven thee. Now Sir, if a woman has no soul any more than the brutes, why should what she does amiss be accounted sin, more than the rimes of the brute creation? & we know the brute creation have no souls.

Q:        A very right answer, Phillis.[30]

For the final question, the interviewer threw another curve. Only this was more lighthearted and probably reflected the needs of the church choir.

Q:        Can you sing, Phillis?

A:        No, Sir.[31]

We can almost see a shy sweet smile forming on the teenager's face as she has to admit that her formidable talents have a limit.

# CHAPTER 9

"Baptised: 18 August 1771. Phillis servt. of Mr. Wheatley."

FOR PHILLIS WHEATLEY, HER CHRISTIAN faith remained a constant source of spiritual strength and comfort throughout her life. As a young girl, churches, ministers, and the Bible had profound meaning for her.

"Shortly after arriving in Boston, Phillis would become, predictably enough, a committed lifelong Christian," writes William Robinson.[1]

The Wheatleys were devout Congregationalists—Protestants who rejected the authority of the Pope and the Church Fathers. They maintained that a Christian believer had direct access to God through the Bible. "Susanna Wheatley dealt with Phillis' religious education, as conscientiously as she did that of her own children," says Carretta.[2]

Mrs. Wheatley kept Phillis "close beside her mistress reading and discussing the Bible or visiting among ladies of Boston's first families, holding forth on 'feminine topics.'"[3]

Surrounding the Wheatley house were Boston's most prominent churches. Eminent pastors often dropped by to visit the family. Young Phillis was eager to absorb their guidance on scripture and literature.

Meanwhile, Phillis kept writing poetry. Her early poems, *Atheism* and *Deism*, which she later revised in 1767 as *An Address to the Atheist* and *An Address to the Deist*, gave the young seeker an opportunity to explore her emerging religious beliefs.

From *An Address to the Atheist*:

> *...If there's no God, from whom did all things spring?*
> *He made the greatest and minutest thing...*
>
> *With vast astonishment, my soul is struck;*
> *Have reason'g powers thy darken'd breast forsook?*
>
> *Atheist! Behold the wide extended skies,*
> *And Wisdom infinite shall strike thine eyes.*

*Lo! How the stars all vocal in His praise,*
*Witness His Essence in celestial lays.*[4]

A second religious-themed poem written at about the same time was *An Address to the Deist*. Spawned by the Age of Enlightenment, Deists believed that understanding the Divine Nature came through reason and observation of the natural world. They questioned biblical accounts of miracles, rejected religious doctrine, and gave no authority to scripture, prophecy, or faith. They denied the Divinity of Christ and the Trinity. In this poem Phillis mounted a sophisticated challenge to one of the most prominent religious philosophies of the eighteenth century.

She begins the poem with a bold self-reference:

*Must Ethiopians be emply'd for you?*
*Much I rejoice if any good I do.*[5]

"Appropriating the term 'Ethiopians' does much more than simply reveal Wheatley's complexion, ethnicity and probable status to her readers," says Carretta. "By calling herself an Ethiopian rather than an African or a black in a religious poem, she claims an identity that grants her biblical authority to speak to her readers."[6]

Phillis expected her readers to know that Ethiopians held an exalted position in the Bible. After all, Moses married an Ethiopian woman in Numbers 12:1, and Psalm 68:31 predicts that "Ethiopia shall soon stretch out her hands unto God."

These poems, written by a fourteen-year-old girl, "have the 'look' of exercises in catechism," says Shields.[7] "The poems on Atheism and Deism strike me as attempts to convince Congregationalists, especially someone like Joseph Sewall...that she was fit to be baptized in the church and perhaps even to become...a member."[8]

Various drafts of the poems circulated around Boston in manuscript form. Revised versions of *An Address to the Atheist* and *An Address to the Deist* were listed in Wheatley's 1772 proposals, but they were never published.

The Old South Meeting House Church, with its majestic 183-foot steeple, was the tallest building in Boston. Located on the corner of

Washington and Milk Streets in downtown Boston, a few blocks from the Wheatley mansion, the Old South Meeting House was the scene of some of largest and most consequential public gatherings in the city's history. Thousands came to vent their anger after the Boston Massacre. The Boston Tea Party began there when a group of patriots left the church and marched to the harbor dressed as Indians. Old South could claim the allegiance of two Founding Fathers, both signers of the Declaration of Independence: Benjamin Franklin was baptized there and Samuel Adams was a regular worshipper.

Their beloved pastor, Reverend Joseph Sewall, led the congregation for fifty-six years until his death in 1769. The teenaged Phillis felt such a close spiritual connection with Reverend Sewall she wrote a widely shared elegy in his honor.

"Wheatley's next close mentor in the evolution of her intellectual identity was America's first native-born composer," wrote John Shields.[9]

William Billings was known as the father of American choral music. The Boston native ran a singing school at the Old South Meeting House. "Wheatley and Billings probably met as early as 1769," says Professor Shields. That year, "Billings entered a notice in the *Boston Gazette*" inviting "any person inclining to learn to sing may be attended upon at said school....It is most likely that Susanna Wheatley and Phillis herself would have taken an interest in this notice," Shields wrote.[10]

Though Phillis admitted to the New York Gentleman that singing was not her strong suit, we will never know if the singing school was any help.

By now, Phillis was eager to be baptized. The usual age for baptism was eighteen which was her assumed age in the summer of 1771.

Reverend Samuel Cooper, popular pastor of the Brattle Street Congregational Church, did the honors at the Old South Congregational Church after Rev. Sewall died. Church records duly noted her baptism. "18 August 1771. Phillis servt. Of Mr. Wheatley."[11]

It was not uncommon for slaves to receive baptism in the churches of Boston. "Long before Phillis's time in Boston, most denominations of Christian churches had ruled that while black slaves might be baptized and receive religious freedom thereby, such baptism in no way changed their civil status as black slaves," William Robinson writes.[12] "However widely

known a poet she might become, Phillis was black and as such she, with other blacks in this and other Boston churches, would be baptized only after the regular services were concluded."[13]

In Boston at the time, "all blacks, including Phillis Wheatley, were relegated to either the rear of first floor congregations, or, usually, the galleries of the second floors," says Robinson.[14]

"As was customary in records of slaves," explains Carretta, "Phillis had no surname."[15]

The Wheatley family attended a different church. John and Susanna Wheatley were married at the New South Congregational Church. All five of their children were baptized there, and the three who died had their funerals there. Mary Wheatley, Phillis's childhood friend and tutor, was married at that church.

It is a fascinating fact that Phillis was allowed to join a church of her choosing. Professor Robinson offers the suggestion that Susanna Wheatley may have arranged for Phillis to attend the Old South Meeting House "in deference to Phillis' chronically fragile health." He explains that "Old South was several blocks closer than the New South Church to the Wheatley home on King Street. This meant that frail Phillis would not have to contend with Boston's bone-numbing winters on Sundays."[16]

Carretta attaches more significance to the decision and believes that it was Phillis's preference. "Being baptized at Old South, rather than at New South, the Wheatley family church may have been one of Phillis Wheatley's earliest acts of independence, though she was still a slave."[17]

No doubt Phillis was attracted to Old South Church because of her affection for Reverend Sewall and because it was supportive of Reverend George Whitefield and his mission.

"Wheatley has been called a typical New Englander of the eighteenth century in her pious religious views," Mason says.[18]

"It is not at all strange that one who attended Boston's Old South Meeting House should show such firm Christian convictions and concern with the soul," said Mason. "She had definite, if stereotyped, ideas that Heaven is a place of halos, angels, and reunion with God and His beloved and she used these ideas with the same seriousness of purpose that surrounds her classical material...For her, heaven was more to be desired than

earthly toil, not so much for the physical rewards which many later slaves would emphasize, but rather for its spiritual rewards."[19]

Benjamin Mays, in his classic 1938 study of black religion, observed that:

> Miss Wheatley's religion is one of sweetness and affection. Her ideas of God help one to endure suffering and to bear up under it. They are capable of lending sweetness to life, giving it an elegant tone...She is hardly concerned about transforming society. She is more interested in the individual and his soul's salvation.[20]

Phillis loved the Bible. Its grand poetic language fed her appetite for great literature, and she took its wisdom to heart. "I thank you for recommending the Bible to be my chief study," she wrote to an English supporter. "I find and acknowledge it the best of books."[21]

Her two longest poems, *Goliath of Gath* and *Isaiah LXIII* were profound meditations on the meaning of scripture. "She is constantly aware of God, His Son, His beneficence, and His power, and she intends that her readers be aware of them too," writes Mason. Her religious beliefs, he said, "seem to crop up everywhere."[22]

Phillis often described the depth of her spiritual feeling in her private letters.

"Dear Sister," she wrote to her good friend Obour Tanner on May 19, 1772.

> I greatly rejoice with you in that realizing view, and I hope experience, of the saving change which you so emphatically describe. Happy were it for us if we could arrive to that evangelical repentance and the true holiness of heart which you mention. Inexpressibly happy should we be could we have a due sense of the beauties and excellence of the Crucified Savior. In his Crucifixion may be seen marvelous displays of Grace and Love, sufficient to drawn and invite us to the rich and endless treasures of His mercy.[23]

Robinson calls Obour Tanner a "lifelong friend and soul mate to

Phillis."[24] She was a fellow slave, referred to as "servant" in the lexicon of the time, owned by the wealthy Tanner family of Newport, Rhode Island. Obour was several years older than Phillis, and like her friend, she was born in Africa.

"I will hazard a guess that Tanner may have crossed the Atlantic with our poet," Shields theorizes, "and may have served the young girl as her protector on the horrific Middle Passage....[25] I will venture that these two women both arrived in Boston on the same slaver, the *Phillis*."[26]

Obour Tanner, baptized in the first Congregational Church of Newport on July 10, 1768, shared a deep Christian faith with Phillis.[27] Both women could read and write, and they used their literacy skills to keep in touch throughout Phillis's adult life. Their intimate letters reveal a deep affection and a strong sisterly bond. When the Revolutionary War was heating up, with Boston under siege by British troops, the Wheatleys with Phillis moved to Newport, where she and Obour could spend time together.

"When or how Phillis and Obour first met is unknown but their friendship endured, as is testified to by seven letters from Phillis to Obour between 1772 and 1779," says Robinson. Most of their letters were "delivered through the kindness of a friend or a travelling black servant."[28]

"There is no trace of correspondence with any other blacks," notes Wheatley scholar Merle Richmond, "no trace, indeed, that she had any other black friends with the sole exception of the man she later married."[29]

"Dear Obour," Phillis wrote on March 21, 1774. "I recd. your obliging letter, enclosed in your Revd. Pastor's & handed me by his son."[30]

The pastor of Obour Tanner's church was Reverend Samuel Hopkins, noted antislavery preacher and sponsor of Christian missions to Africa. "During 1769 he preached several times at Boston's Old South Church where he probably met Wheatley," writes Mason.[31]

"On one known occasion, an especially noteworthy friend delivered a letter from Obour in Newport to Phillis in Boston," Robinson says. "In her reply of October 30, 1773, Phillis...a nineteen or twenty year old young lady, commented twice on the mailman."[32]

For all her poetic eloquence, Phillis was not above sharing with her friend what we would recognize today as "girl talk."

"Dear Obour," she wrote. "I rec'd your most kind epistles of Augt. 27th & Oct.13th by a young man of your acquaintance, for which I am obligd to you....The young man by whom this is handed you seems to me to be a very clever man," Phillis confided to Obour. "[He] knows you very well and is very complaisant and agreeable."[33]

According to Robinson, "This young man may have been the handsome, ambitious John Peters, a free black whom Phillis would marry five years later."[34]

Obour Tanner outlived Phillis by fifty years. She died in 1834 as a free woman. "In 1793 she was recorded as free but how long she had been free is not known," Mason writes.[35]

Obour treasured her correspondence with her dear friend and preserved the letters for decades. "It was Obour who saved the seven known Wheatley letters to her and gave them to the wife of the Reverend William Beecher who, in turn, gave them to the Reverend Edward A. Hale, who donated them to the Massachusetts Historical Society," says Robinson. "Although it is clear that Obour wrote Phillis as many, if not more, letters than Phillis wrote to her, not one Tanner letter to Phillis is known."[36]

All seven Wheatley letters were published by the Society in November 1863.

Mrs. Beecher, sister-in-law of writer Harriet Beecher Stowe, author of *Uncle Tom's Cabin,* recalled the woman who personally handed her the writings of this gifted young poet.

"They were given to me ages since by the person to whom they were addressed," Mrs. Beecher wrote on October 23, 1863. "She was then a very little, very old, very infirm, very very black woman with a great shock of the whitest wool all over her head, a picture well photographed on my mind's eye...an uncommonly pious, sensible and intelligent woman, respected and visited by every person in Newport who could appreciate excellence, she recalled, noting that "Obour gave me also one of Phillis' books which I read with pleasure."[37]

The President of the Massachusetts Historical Society remembered discovering another letter written by Phillis Wheatley. "This recalled to my mind a letter of hers placed in my hands some years ago which seemed to

me at the time, to indicate much maturity of mind and her refinement of delicacy of feeling and character."[38]

For years, scholars knew of nineteen letters Phillis wrote, including the seven to her friend. Then, in 2005, an eighth letter to Obour Tanner turned up. "It was not previously known to exist and has never been published," says Jeremy Markowitz, an Americana specialist a New York auction house.[39]

Historians are confident the letter is genuine. "We not only had it authenticated by a Wheatley scholar, but also analyzed the handwriting, the paper and the ink," Mr. Markowitz says. "You can tell a period letter by the way the ink lies on the paper, the fluid style and the paper itself."[40]

The letter sold for $253,000, the highest amount ever paid for a letter written by an African-American, and possibly the highest price ever for a letter written by a woman.[41]

# CHAPTER 10

### "Mental imaginations give me joy."

BRIGHT, VIBRANT, AND FASCINATED BY the power of words, young Phillis Wheatley loved how she could weave rich strands of meaning into exquisite phrases to express her ideas in verse. "Mental imaginations give me joy," the fifteen-year-old poet wrote. "Now let my thoughts in contemplation steer."[1]

She found herself in a situation that encouraged her to develop her natural gifts. "As Phillis increased in years, the development of her mind realized the promise of her childhood," wrote Wheatley family member Margaretta Oddell.[2]

She was made to spend most of her waking time either reading or writing," says Professor William Robinson.[3]

"Little actual work (cleaning, dusting, etc.) was exacted from Wheatley," Shields notes, giving her "ample time to study and then to contemplate the results of her study."[4]

The teenager became something of a curiosity—the Wheatley's African slave could do things nobody had ever seen before. Not only could the girl read and write but she was creating exquisite poetry. Skeptics and the curious came to the Wheatley mansion to see for themselves.

"Visitors to the Wheatley home would be obliged by a persuasive Mrs. Wheatley to listen to her little black genius recite an original poem or two, or three," writes Robinson.[5]

"Wheatley appears to have been touted as some sort of public entertainment," according to John Shields. "The poet 'performed' her so-called occasional poems for guests in the Wheatley mansion.[6] I suspect Phillis came to feel that she was on display because of her precocity, not unlike a circus sideshow."[7]

"She became an exotic curiosity in Boston's fashionable drawing rooms," says Wheatley scholar Merle Richmond, "invited there to converse

with learned men about literature and significant topics of the day, gaining a reputation as a lively and brilliant conversationalist."[8]

"She was, in short, a sensation," Richmond writes, "the more so, of course, because she was a black African."[9]

One poem Phillis likely shared with her guests was called *On Friendship*. It was one of her shortest poems, only eight lines long. Her 1772 proposal gave the date of composition as 1768, when Phillis was fifteen. That early version no longer exists. According to her handwritten notes, she revised the poem on July 15, 1769. It was not published in her lifetime.

*On Friendship* showed the young poet's emerging knowledge of Latin (*amicitia* for "friendship" and *amor* for "love.")

### ON FRIENDSHIP

*Let amicitia in her ample reign*
*Extend her notes to a Celestial strain*
*Benevolent far more divinely Bright*
*Amor like me doth triumph at the sight*
*When my thoughts in gratitude imply*
*Mental imaginations give me joy*
*Now let my thoughts in contemplation steer*
*The footsteps of the Superlative Fair.*[10]

The notoriety of the Wheatley family slave grew as more and more people discovered her wondrous talents. "Fortunately, she was encouraged to converse freely with the wise and the learned," said Oddell.[11] "She was now frequently visited by clergymen, and other individuals of high standing in society."[12]

"In such ways, Phillis got to be known to Governor Thomas Hutchinson, Lieutenant Governor Andrew Oliver, John Hancock...and many eminent divines," Robinson writes.[13]

"She soon attracted the attention of the literati of the day, many of whom furnished her with books. These enabled her to make considerable progress," said Oddell. "Such gratification seems only to have increased her thirst after knowledge, as is the case with most gifted minds."[14]

"Visitors who courteously wished to convey the proper encouragement

to the pious little poet often left her with books," says Robinson. "The Revered Charles Chauncy, for instance, inscribed a gift copy of Thomas Amory's Daily Devotions Assisted and Recommended in Sermons with "The gift of Dr. Charles Chauncy to Phl. Wheatley, Boston, Oct. 14, 1772."[15]

"Phillis Wheatley's writings reveal a familiarity with Classical literature," says Carretta, "as well as geography, history, politics, and English literature, unusual subjects for girls at the time."[16]

"Few colonial men—and far fewer women—could boast her intellectual attainments in English, let alone her knowledge of Latin," observes Wheatley scholar Paula Bennett.[17]

She studied and mastered the great literary works of her time. "Wheatley, like all literate American colonists, had access to the major eighteenth century texts produced in Great Britain and the Continent," writes Shields.[18]

Speaking for the Wheatley family, Oddell shared their observations on her remarkable education. "We very much doubt if she ever had any grammatical instruction or any knowledge of the structure or idiom of the English language, except what she imbibed from a perusal of the best English writers and from mingling in polite circles."[19]

"What induc'd you to write Phillis?" the New York Gentleman asked her during their interview.

"Seeing others write made me esteem it a valuable art, sir," the teenager explained.[20]

Her progress was astounding. "This immensely talented and gifted child came to surpass all members of the Wheatley family in her retention of knowledge," writes Shields, "evidencing an apparently unlimited capacity for absorbing new learning."[21]

"We gather from her writings that she was acquainted with astronomy, ancient and modern geography and ancient history," Oddell continued. "She was well versed in the scriptures of the Old and New Testament. She discovered a decided taste for the stories of Heathen (Greek) Mythology and Pope's Homer seems to have been a great favorite with her."[22]

The New York Gentleman was interested in her reading habits.

Q:      What authors have you (read), as Ovid, Horace, Virgil, &c.?

A:      No other Sir, than Pope's Homer.

Q:      Did you ever read Pope's own works?

A:      I have seen the first volume of his works, his juvenile poems.

Q:      How did you like them?

A:      Very well, Sir.[23]

From later references in her poetry we can conclude that Phillis read Shakespeare, Horace, Virgil, Ovid, Terrence, and Milton.

The New York Gentleman asked her about a play that was enormously popular in the colonies at the time, Joseph Addison's *Cato: A Tragedy*. The play dealt with themes such as individual liberty versus government tyranny and logic versus emotion. Cato, the main character, held fast to his beliefs while facing death. General Washington was so inspired by the play he arranged to have it performed for the Continental Army at Valley Forge.

Q:      Did you ever read Cato, a play?

A:      I have, sir.

Q:      How did you like it?

A:      Like it very well.[24]

We know from her poems on the tumultuous events unfolding around her that Phillis Wheatley kept abreast of the latest developments. "Wheatley would have known the numerous American pamphlets, which preceded the Revolutionary War," wrote Shields, "treatises by the Brits Thomas Hobbes and John Locke."[25]

Living across the street from the Wheatley mansion was the Reverend Mather Byles, a Congregational minister and nephew of the famous preacher Cotton Mather. Reverend Byles, well-known in the colonies as a poet, had exchanged letters with the great English poet Alexander Pope. He owned a personal library of well over two thousand books, one of the largest book collections in the colonies. Scholars believe that he made his

huge library available to young Phillis to further her education.

"A probable scenario is that the young and talented girl received instruction in Latin and in poetics from Mather Byles," says Shields. "A champion of poets in his younger days, it is plausible that Byles took an interest in helping to shape Wheatley's budding talent."[26]

Another prominent Wheatley neighbor, Massachusetts Governor Thomas Hutchinson, also possessed a large library with nearly as many books as Byles.

Wheatley also had access to the library of Thomas Prince, a Harvard classmate and friend of Reverend Joseph Sewall. When Prince passed away he bequeathed his famous library, over 1,500 volumes, to the Old South Church. "It is certain that Wheatley was well aware of this collection and would have been encouraged to use it," writes Shields. "Wheatley had easy access to three of the largest libraries in Colonial America,"[27] he notes, concluding that "She made excellent use of these resources."[28]

Immersion in the Classics stoked the fires of Phillis's considerable intellect and creative powers. Almost from the time she began writing, sweet verses flowed from her poet's heart.

> Q:     How wou'd you like a subject best, in prose or verse?
>
> A:     If it be a good subject 'tis all the same. But I prefer the verse.[29]

The Wheatley family knew their young slave was unique and extraordinary. She seemed to have dropped into their Boston home from some celestial world. The source of her prodigious talents became a subject of speculation. "We are at a loss to conjecture how the first strivings of her mind after knowledge—her delight in literature, her success even in a dead language, the first bursting forth of her thoughts in song—can be accounted for," Oddell wrote, "unless these efforts are allowed to have been the inspirations of that genius which is the gift of God."[30]

# CHAPTER 11

## "She was very gentle-tempered, extremely affectionate, humble, unassuming and dignified."

PHILLIS WHEATLEY: WHAT WAS SHE like? What do we know about her as a woman? She produced no autobiography, left barely any record of her thinking; there is no personal account of her feelings, concerns, hopes or plans. Her letters offer only the slightest opening to her inner life. And we have her poems, her glorious words flowing from deep places in her soul.

What can we make of this gifted eighteenth-century black woman as a living, breathing human being?

Margaretta Matilda Oddell's 1834 biographical essay is the foundation for everything we presume to know about Phillis Wheatley. According to Professor Eileen Razzari Elrod:

> Oddell remains among a handful of early sources widely presumed to be reliable, in part, because she proclaims her own authority in the text of the Memoir on the basis of her personal connection to the Wheatley family...and in part, surely, because of Wheatley's early death (at about age 30 in 1784), the absence of any contemporary public life-writing and the dearth of other biographical accounts.[1]

Oddell never met Phillis Wheatley. Writing more than fifty years after Phillis left the Wheatley household, she relied on what Wheatley family members could recall. So what do the people who knew Phillis in the flesh have to say about this mystery woman?

"She was very gentle-tempered," Oddell wrote, "extremely affectionate,"[2] "humble,"[3] "modest," "unassuming," and "dignified."[4] Wheatley relatives spoke of her "amiable disposition,"[5] her "innocence" and the "purity of her heart."[6]

Family friend Bernard Page dined with the Wheatleys and conversed with Phillis. "I'll delineate her in few words," he wrote, "humble, serene, graceful, luminous and ethereal."[7]

By studying her poetry and letters, William Robinson believed that Phillis had a rather reserved temperament. "Modest, shy, reverent, gentle and unpretentious," all personal qualities he found in her writing.[8]

"A soberly pious young lady who took her poetry writing quite seriously, Phillis never gave public vent to impulse for ribaldry or uninhibited laughter," he concluded. "She seems to have been constitutionally disposed to no-nonsense earnestness that would have been expressed even if she had remained in her native Africa."[9]

One reason Phillis may have appeared stoic and shy was probably the same reason the Wheatleys protected her from physical exertion. As Oddell reported, a constant factor in her life was "the delicate constitution and frail health of Phillis."[10]

Phillis Wheatley suffered from chronic asthma and according to Dr. Robinson, "a probable case of tuberculosis."[11] Her attacks were severely disabling and lasted for months at a time.

"During the winter of 1773," writes Oddell, "the indications of disease had so much increased that her physician advised a sea voyage."[12]

Her condition was so serious that Mrs. Wheatley sent her away from the boisterous city to recuperate in the peace and quiet of the countryside. "I have been in a very poor state of health all the past winter and spring and now reside in the country for the benefit of its more wholesome air," Phillis wrote to her friend Obour Tanner.[13]

"I am at present indisposed by a cold and since my arrival have been visited by the asthma," she wrote the next year.[14]

Then a few months later: "I have been unwell the great part of the winter but am much better as the spring approaches."[15]

By all accounts she was a natural genius. Her contemporaries continually remarked upon her exceptional intellect. However, her extraordinary development came at a price. "The cost of being a child prodigy was incalculable," said Merle Richmond, "for as she grew into adolescence, it fashioned a special—and peculiar—status."[16]

Richmond believes that her situation was "difficult and cruel" in some

respects. "She could not mingle with other black slaves as equals, nor could she encounter whites on terms of equality." Her unusual status contributed to a sense of isolation.

> She inhabited a strange, ambiguous twilight zone between black society and white society, cut off from any normal human contact with either, denied the sustenance of group identity, doomed to a loneliness that, being particular and peculiar, was more tragic than the existentialist, generalizations about the human condition.[17]

"She made a strange and lonesome figure," W. E. B. Du Bois wrote.[18] What did Phillis Wheatley look like?

Although she lived in an era before cameras, we have a contemporary image as revealing as any photograph. Months before her 1773 book was published in London, Phillis sat for a portrait. It was such "an elegant engraved likeness" that her publisher used it as the frontispiece to her book.[19]

"A striking representation of the original," Oddell said.[20]

The Wheatleys kept a copy of the portrait on display over the fireplace. It was so realistic Susanna Wheatley could not withhold her astonishment. "See!" she exclaimed, "Look at my Phillis! Does she not seem as though she would speak to me!"[21]

There she is, a lifelike image within an oval frame. We see a lovely twenty-year-old woman sitting alone, left elbow resting on a desk, her head in her hand with her index finger pointing up against her face, fingers curled under her cheek. She is wearing a white lace bonnet of pleats and ribbons with a dainty bow on top. The sleeves of her simple dress leave her arms bare almost to the elbow. She is sitting at a desk, the quill pen in her right hand hovering over a piece of paper already showing several lines of writing. At her elbow beside the page sit an inkwell and a book.

We see her face in profile. Her features are pleasantly symmetrical— smooth, dark brown skin, high forehead, thin lips, small straight nose. Her wide eyes gaze upward, looking toward heaven. Deeply engaged in the act of composition, she has paused for a moment after a short burst of writing, a bow to the Gods of Poetry, as she waits for the stream of wondrous word images to flow through her pen to the page.

Inside the oval frame the text in capital letters identifies her as "PHILLIS WHEATLEY, NEGRO SERVANT TO MR. JOHN WHEATLEY OF BOSTON."[22] Even as her plain apparel marks her as a lowly slave, her natural intelligence, dignity, and grace shine through. It is a picture of an educated woman.

What would we think of such a woman if we came upon her sitting in that chair, writing poetry at that table?

In her time, the men and women who interacted with Phillis Wheatley responded with affection, admiration, and generosity, much as we would today. Clearly she possessed a special quality that does not show up in history books, a quiet charisma, a light and winsome manner that touched people who knew her and made her irresistibly appealing. From Susanna Wheatley and the circle of women who befriended her to Boston's most prominent ministers, merchants, and leaders, people felt called to shower her with praise, encouragement, support, and even gifts. We know from her surviving correspondence that Phillis Wheatley maintained numerous fond relationships with a wide variety of prominent people on both sides of the Atlantic who were impressed by her abilities and enthralled by her charms. By all accounts she was a delightful young woman with a sweet and gracious nature. No wonder her friendship was highly prized by nearly all who met her.

The kind and magnanimous treatment she received from nearly everyone she met certainly enabled Phillis to reach a higher level of confidence and self-esteem than most of her contemporaries, especially those who were enslaved. "Intelligent and perceptive as she was," said Richmond, "the poet must surely have known that she was at least equal and most often superior, to the Boston Brahmins in conversation and intellectual accomplishment" even as she had to accept society's determination that "she was not their social equal."[23]

One revealing relationship shines a bright light on Phillis's extraordinary ability to captivate her contemporaries. A year after her book was published—Phillis was then a free woman—she participated in a fascinating exchange of poems with a British seaman. Their correspondence reads like a kind of competition in verse, an eighteenth-century "poetry slam."

How Phillis came to know John Prime Iron Rochfort is a mystery. The

nature of their interactions, what they may have said to each other when they were together, remains unknown. The only evidence of their relationship is the artifact they left for history—the poems they wrote to each other.

Vincent Carretta supplied some background information on Seaman Rochfort. He arrived in Boston during the summer of 1774 on the *Preston,* part of a British fleet converging on Boston in response to the Boston Tea Party. Originally from Dublin, Ireland, he was about two years older than Phillis.[24]

Whatever Phillis and Seaman Rochfort said to each other in their private conversations, their writing had nothing to do with history, politics, hostility, conflict, or social strife. Their literary vision reached for grand themes: the art of poetry, the beauty of Africa, and high praise for one another.

Phillis wrote *To A Gentleman of the Navy* on October 30, 1774 to honor the "celestial friendship" between Rochfort and his friend and shipmate Lieutenant John Graves (she called him "Greaves").

> *Cerulean youths! Your joint assent declare,*
> *Virtue to rev'rence, more than mortal fair;*
> *A crown of glory, which the muse will twine,*
> *Immortal trophy! Rochfort shall be thine!*
> *Thine too O Greaves! For virtues offspring share,*
> *Celestial friendship and the muse's care.*

Phillis imagines—or maybe she recalls—that delightful moment when her new friend and his buddy show their appreciation for her poem:

> *Yours is the song and your's the honest praise,*
> *Lo! Rochfort smiles and Greaves approves my lays.*[25]

Rochfort responded to Phillis with a poem of his own, titled *The Answer.* Boston's *Royal American Magazine* published both poems in their December 1774 issue.

"What tribute can I bring?" Rochfort wonders, comparing his own poor attempt at poetry to the artistry of Phillis. He follows with a reverent outpouring of high esteem. To Carretta, it was "the greatest public praise Wheatley received during her lifetime."[26]

*Celestial muse! Sublimest of the nine,*
*Assist my song and dictate every line.*
*Inspire me once, now with imperfect lays,*
*To sing this great, this lovely virgin's praise...*

*Behold, with reverence and with joy adore,*
*The lovely daughter of the Afric shore,*
*Where every grace and every virtue join*
*That kindles friendship and makes love divine...*

*Th' immortal wreathe, the muse's gift to share,*
*Which heav'n reserv'd for this angelic fair...*[27]

He goes on to assert that her literary artistry is as fine as anything pro-
duced in Europe: "her flowing pencil Europe to excel." He compares the
poet he calls "Wheatly" quite favorably to the giants of England's literary
tradition—"great Sir Isaac, whose immortal name still shines the brightest
on the seat of fame" and "where those lofty bards have dwelt so long, that
ravished Europe with their heavenly song."

*For softer strains we quickly must repair*
*To Wheatly's song, for Wheatly is the fair*
*That has the art, which art could ne'er acquire,*
*To dress each sentence with seraphic fire.*[28]

Delighted by Rochfort's adoring appreciation, Phillis composed her
response a few days later in a poem dated December 5, 1774. *Phillis' Reply
to the Answer in our Last by the Gentleman in the Navy* appeared in the next
issue of the *Royal American Magazine*, January 1775.

Now it was Phillis's turn to shower her poet-friend with praise for his
artistry.

*The generous plaudit 'tis not mine to claim,*
*A muse untutor'd, and unknown to fame.*
*The heavenly sisters pour thy notes along*
*And crown their bard with very grace of song.*
*My pen, least favour'd by the tuneful nine,*
*Can never rival, never equal thine;*[29]

Some of Rochfort's passages shook Phillis to the core, stirring her emotions with his luxuriant descriptions of idyllic African scenes.

> *Blest be the guilded shore, the happyland,*
> *Where spring and autumn gently hand in hand;*
> *O'er shady forests that scarce know a bound,*
> *In vivid blaze alternately dance round...*[30]

Seaman Rochfort was writing about the African coast he saw with his own eyes. His "guilded shore" is a poetic term for the Gold Coast, well known in Europe as a destination in Africa where slave merchants acquired their human cargo. The British fleet in Boston under Vice Admiral Samuel Graves had recently returned from a mission to Africa. "A good many men in the Royal Navy in the eighteenth century, including Samuel Graves, had served along the coast of Africa because of the trading done by the English in the Senegambia and Gold Coast areas," writes Mason.[31]

Rochfort described his African experience by painting a romantic picture of an idealized paradise filled with wondrous treasures and natural charm.

> *Far from the reach of Hudson's chilly bay,*
> *Where cheerful phoebus makes all nature gay*
> *Where sweet refreshing breezes gently fan;*
> *The flow'ry path, the ever verdant lawn,*
> *The artless grottos and the soft retreats;*
> *At once the lover and the muse's seats.*[32]

Rochfort was certainly one of the few individuals she met who had actually been to Africa. He could tell Phillis what her homeland was like. Rediscovering the lush richness and beauty of Africa even in the world of fantasy touched her deeply. She wrote:

> *Struck with thy song, each vain conceit resign'd*
> *A soft affection seiz'd my grateful mind,*
> *While I each golden sentiment admire*
> *In thee, the muse's bright celestial fire.*[33]

In appreciation for Rochfort's poetic skills, she responded in kind.

> *In fair description are thy powers display'd*[34]

She makes it clear that his verses sparked an aching passion within her.

> *Charm'd with thy painting, how my bosom burns!*[35]
> *And pleasing Gambia on my soul returns.*[36]

She sighs. She pants. She yearns to go back to the place on Earth she holds most dear. The word "return" indicates that, to Phillis Wheatley, it was home.

"Wheatley let her imagination roam admiringly over the environs of the Gambia, the region she took to be the land of her birth," says Mukhtar Ali Isani.[37] Lovingly, longingly, she used her astounding gift of invention to create an image of a world she once knew.

> *Pleas'd with the theme, see sportive fancy play,*
> *In realms devoted to the God of day.*

The scene opens before her on the vast screen of her mind, and she sketches her own poetic vision of her Africa:

> *With native grace in spring's luxuriant reign,*
> *Smiles the gay mead and Eden blooms again;*
>
> *The various bower, the tuneful flowing stream,*
> *The soft retreats, the lover's golden dream,*
> *Her soil spontaneous, yields exhaustless stores;*
> *For phoebus revels on her verdant shores.*
>
> *Whose flowery births, a fragrant train appear,*
> *And crown the youth throughout the smiling year.*
> *There, as in Britain's favor'd isle, behold,*
> *The bending harvest ripen into gold!*
>
> *Just are thy views of Afric's blissful plain,*
> *On the warm limits of the land and main.*[38]

It was a glorious, resplendent, adoring view of Mother Africa, an unprecedented celebration of an unknown homeland by an African-American. "Such poetic praise of Africa was not written by many other American Blacks until the Harlem Renaissance," writes William Robinson.[39]

Phillis closed her poem with high praise and encouragement for her new friend.

> *Muse, bid thy Rochfords matchless pen display*
> *The charms of friendship in the sprightly lay.*[40]

There is no other documentary evidence linking Phillis Wheatley to Seaman Rochfort. If they had any further interactions, wrote any letters or exchanged additional poetic fancies, they remain lost. The only knowledge we have of their relationship is contained in the words of their poems.

What can we make of this extraordinary paper trail? Can we extract any meaningful insights from their intriguing communication?

At times, Rochfort's verse soars beyond the expected conventions of a praise poem. He writes with doting warmth, exuding deep affection and good will for this "lovely daughter of the Afric shore." His aim was to celebrate Phillis for her poetry. But he is just as eager to appreciate her as a woman, "lovely... fair... angelic...wondrous." His effort veers close to what any reasonable reader might take as a sincere romantic poem.

We can only wonder what effect these enchanting words had on the woman to whom they were addressed.

> *Her wondrous virtues I could ne'er express!*
> *To paint her charms, would only make them less...*[41]

Rochfort imagines—or recalls—with evident satisfaction, her delight as she reads his poem.

> *WH—TL—Y but smiles, whilst I thus faintly sing.*[42]

Significantly, Rochfort acknowledges the reality of her skin color. His line "In hue as diff'rent as in souls above," celebrates physical diversity as divinely inspired, elevating outward appearance to a spiritual realm under heaven's sway.[43]

For her part, Phillis wanted Rochfort to know that he had a profound effect on her. Metaphorically, she just about grabs him by the lapels:

*Rochford, attend. Beloved of Phoebus! Hear.*
*A truer sentence never reach'd thin ear.*[44]

Although there is scant evidence to draw any meaningful conclusions, their exchange of poems reveals a pattern of mutual affection that looks suspiciously like garden variety flirtation. We can safely assume that a twenty-two-year-old navy man would behave very much like the twenty-two-year-old navy men we know today. Do we really need to wonder why this virile and passionate young man would write flattering and flowery verses bathed in feelings of tenderness and warmth to this lovely and very special twenty-year-old woman? What time-tested motivation could attract a young man with greater potency than a woman with looks and personality and star power?

Apparently Rochfort fancied himself a poet of some talent, and Phillis was a celebrity on two continents. Like many a man before him—and after him as well—he was more than willing to exert himself to impress a certain woman.

In her astute analysis of the complicated relationship between Thomas Jefferson and his slave Sally Hemings, Professor Annette Gordon-Reed explored the natural dynamics at play.

> Males and females, even of different rank and race, engage in light banter that acknowledges the other's gender. That is one of the ways that relationships—licit and illicit—are formed. Sometimes male-female small talk rises to the level of flirting, especially when no one else is around. Male-female banter and flirting are usually totally meaningless and innocent—empty, stylized—perhaps even biologically influenced, faux mating rituals.[45]

The bond between Jefferson and Hemings intensified in Paris when he took his teenage slave to the finest dress shops in town so she could choose an elegant wardrobe. Gordon-Reed noted the effect of this kindness on young Sally Hemings, how such a gracious gesture "raises the intimacy level

between him and the female recipient of his gifts in ways that can make it much more difficult for the two to keep a safe emotional distance from each other."[46]

A similar case can be made for the impassioned dynamic between these two twenty-something poets at the height of their sexual energy as they share heartfelt expressions of mutual admiration in verse. What Gordon-Reed pointed out in relation to Jefferson and Hemings could easily apply to Phillis Wheatley and Seaman Rochfort: "It too much resembles what happens between couples who are romantically involved with each other for the participants not to make that connection, even if just for fleeting moments."[47]

For Gordon-Reed, biology trumps sociology.

> Neither the dynamic between master and slave nor the separate spheres of black and white (artificially created conceptions both) could override the meaning this activity carried in the complex dance between male and female.[48]

Was there anything more to the relationship between British Seaman John Prime Iron Rochfort and Phillis Wheatley? Social constraints in place at the time make it unlikely. Practical circumstances would have presented considerable obstacles.

Unless additional evidence turns up, we will never know.

# II. Boston 1770 – 1773

*Me snatch'd from Afric's fancy'd happy seat*
*Impetuous—Ah! What bitter pangs molest.*
*What sorrows labour'd in the parent breast!*

~ Phillis Wheatley, October 10, 1772

# CHAPTER 12

### "On the Affray in King Street."

THROUGHOUT 1769, THE BOSTON MERCHANTS' Non-Importation Agreement boycotting all trade with Great Britain remained in force. Any merchant caught violating the boycott would be shamed before the community. A sign would appear on the door to the offending business, picturing a large hand with an accusing finger pointing to the word "IMPORTER." A gang of schoolboys would gather to enforce the boycott, taunting anyone who dared to enter.

On February 22, 1770, one of those warning signs was posted on the door to the shop of Theophilus Lillie, a Tory who adamantly refused to sign the Non-Importation Agreement. A crowd appeared and began harassing his customers. His neighbor, a fellow Tory named Ebenezer Richardson, tried to tear down the sign but the crowd turned on him, battering him with dirt, stones, and sticks. Richardson was already notorious in Boston as one of the hated customs officials responsible for collecting taxes for the British government.

When Richardson ran they chased him through the streets and back to his house. The *Boston Gazette* reported that Richardson "threatened to fire upon them and swore by God that he would make the place too hot for some of them before night."[1]

A barrage of rocks battered his house, crashing through windows, shattering the glass. His wife and daughters, cowering inside, were struck by flying debris.

Richardson grabbed his musket, swearing "that he would make a lane through them if they did not go away."[2] Resting the barrel of his gun on the windowsill, he fired.

At that moment eleven-year-old Christopher Seider was bending down to pick up a rock he intended to throw. Eleven slugs of swanshot (pea-sized pellets) tore through his chest and stomach. The boy fell, badly

wounded. Bystanders quickly carried him to safety but at nine o'clock that night he died.

"On Thursday last in the forenoon a barbarous murder attended with many aggravating circumstances was committed on the body of a young lad of about eleven years of age, son to Mr. Snider of this town," roared the *Boston Gazette*.

> One Ebenezer Richardson, who has been many years employ'd as an under Officer of the Customs, long known by the name of an INFORMER, and consequently a person of a most abandon'd character, it seems, took umbrage at the suppos'd indignity offer'd to the importers and soon became a party in the affair.[3]

"Town church bells tolled mournfully," writes Professor Robinson. "Broadsides and newspapers lamented the death in heroic and propagandistic terms; fiery sermons against the British were preached on the following Sunday."[4]

The boy's funeral took place at Faneuil Hall on Monday, February 26. "Led by six of Seider's schoolmates, who bore the casket featuring patriotic Latin inscriptions on each of its sides and followed by the family and friends of the deceased, 400 or 500 other schoolchildren, and thousands of mourners, the funeral procession was almost one mile long from its symbolic starting place at the Liberty Tree," Robinson continues. "It was the largest such procession in Boston's history."[5]

Wealthy Boston merchant John Rowe was there that day. "This afternoon, the boy that was killed by Richardson was buried," he wrote. "I am very sure two thousand people attended his funeral."[6]

John Adams described the scene in his diary. "A vast number of boys walked before the coffin, a vast number of women and men after it and a number of carriages. My eyes never beheld such a funeral. The procession extended further than can be well imagined."[7]

Like most Bostonians, John Adams found inspiration in the shocking murder of an innocent boy. "This shows there are many more lives to spend if wanted in the service of their country," he wrote. "The ardor of the people is not to be quelled by the slaughter of one child."[8]

The huge funeral procession followed the casket from Faneuil Hall past the Liberty Tree and along King Street to the Old Granary Burial Ground, where the boy was laid to rest. Phillis Wheatley could not possibly have missed the spectacle proceeding on King Street past the Wheatley mansion. She likely attended the burial with members of the Wheatley family and almost all of Boston.

The killing of a child unnerved the poet, and soon she put her thoughts on paper. We imagine the seventeen-year-old girl alone in her room, sitting at her desk and reflecting on the tumultuous events of the past several years. With this tragic killing, she knew something had changed in the relationship between the colonies and the Mother Country.

In the opening couplet, the poet sees cosmic significance in this tragedy. Wheatley bestows on the boy the sacred honor of becoming "the first martyr for the cause."

> *In heavens eternal court it was decreed*
> *How the first martyr for the cause should bleed*[9]

*On the Death of Mr. Snider Murder'd By Richardson* reaches for clear and vivid images to depict the main characters in the drama, so familiar to the people of Boston. Parts of the poem read almost like an eyewitness narration. Phillis describes the scene as sympathetic bystanders lift the boy's wounded body from the street, removing him from "the watry bower." As Robinson notes, the streets were "becoming slushy from snow that was falling at the time."[10]

> *The generous sires behold the fatal wound*
> *Saw their young champion gasping on the ground.*
> *They rais'd him up but to each present ear*
> *What martial glories did his tongue declare...*
>
> *We bring the body from the watry bower*
> *To lodge it where it shall remove no more;*
> *Snider, behold with what Majestic Love*
> *The illustrious retinue begins to move;*[11]

To Phillis, the patriots of Boston were "generous sires" who attended to "the young champion" with "Majestic Love." To anyone who read the poem, the enemy was clear. The child-murderer Richardson symbolized all that the Tories, those "grand usurpers," stood for.

> *When this young martial genius did appear*
> *The Tory chiefs no longer could forbear....*
>
> *Be Richardson forever banish'd here,*
> *The grand usurpers bravely vaunted heir;*[12]

Phillis saw the boy as a Greek hero, like "Achilles in his mid-career," who gave his life as a sacrifice for the patriots' cause. She hopes the dead body of this innocent young boy will persuade even those still loyal to the crown to see nobility and righteousness in his sacrifice for freedom.

> *To clear the country of the hated brood*
> *He whet his courage for the common good....*[13]
>
> *With Secret rage fair freedom's foes beneath*
> *See in thy corpse evn' majesty in Death.*[14]

The poem was one of a series of patriotic poems in which Phillis captured the revolutionary spirit of the emerging nation. "Phillis speaks from the dead center of the seething, partisan crowd," says Robinson.[15] "This piece is the strongest of several pro-American and anti-British statements by Wheatley."[16]

Professor Shields called it "the first poem of the Revolution."[17] It was probably shared among the Wheatley circle of friends, whose sympathies ran toward the patriots. The manuscript was discovered in the collection of the Historical Society of Pennsylvania by researcher Robert Kuncio, who published it in 1970.[18]

Following the death of the boy Christopher Seider, Boston was seething. A sense of dread hung over every interaction. For the past seventeen months the people of Boston had put up with a humiliating military occupation. The hated Townshend Acts allowed customs officials to demand the Crown's share of taxes. Angry British troops patrolled the streets, bitterly

resenting their harsh treatment by the townspeople, who persisted in spewing the vilest scorn at them at every opportunity.

Monday, March 5, 1770, was a cold clear night, still dead of winter in Boston. A foot of snow covered the ground. Streets were frozen and slippery; it was hard to walk.

A wild brawl broke out between workers and soldiers at Gray's Ropewalk, a factory where they twisted strands of hemp into ropes for the boats manufactured in Boston shipyards. Rumors of fights between soldiers and residents swirled in alleys and street corners. Groups of armed soldiers and townspeople roamed the city, stalking each other.

An innocent remark sparked the inevitable explosion.

Edward Gerrish, a wigmaker's apprentice, testified that "On the evening of March 5th I saw a British soldier at his guard post beside the Custom House on the corner of King Street and Royal Exchange Lane. I decided to give him a good natured teasing but when I did he struck me in the face with the butt of his musket."[19]

The soldier on guard was Captain John Goldfinch. "I was in King Street," the Captain testified, "and was accosted by a barber's boy, who said: 'There goes the fellow who hath not paid my master for dressing his hair.' Fortunately for me, I had his receipt in my pocket...I passed on without taking any notice of what the boy said."[20]

Another guard, Private Hugh White, took umbrage at the offense. "Just after dark several wigmaker's apprentices began to insult me and my fellow soldiers," Private White testified. "One, an Edward Gerrish, was especially insulting. I decided to teach him a lesson so I told him to step closer and repeat his insult. When he did I struck him in the face with the butt of my musket. He squealed and ran away."

"I ran," Edward Gerrish recounted, "but another soldier, a sergeant, ran after me and would have stabbed me with his bayonet if I had not ducked. Then Private White caught up with me and together they beat me up. I cried for help and two of my friends came. They began to yell and within fifteen minutes other citizens arrived. Shortly after that a crowd of maybe fifty people gathered and began to yell at him and throw snowballs at him."[21]

"I ran back to my post to protect the Custom House," said a besieged Private White, "but a crowd gathered and began to threaten me and throw

ice and snowballs. I warned them that I would shoot but they only yelled more."[22]

"Soon more and more citizens came," said Gerrish. "They were very angry and began to throw snowballs, ice chunks and roof tiles at him. After about thirty minutes a squad of soldiers marched through the crowd."[23]

Robert Goddard saw "eight or nine soldiers with bayonets charged breast high, the officer holding a naked cutlass in his hand, swinging and calling, 'Stand out of the way' and the soldiers cursing and damning and pushing their bayonets to clear the way. They went down to the Custom House and placed themselves just above the sentinel box. The officer then ordered the soldiers to place themselves in a half circle."[24]

At about 9:15, the cold night air reverberated with the peal of bells from Boston churches. The Old Brick Church, the Brattle Street Church, and the Old South Church sounded their alarms, routinely used as a fire warning.

"On Monday evening, the 5th of March 1770, between the hours of nine and ten o'clock, I heard the bells in the center of the town ring and fire cried," recalled Benjamin Burdick. "Ran immediately for King Street where I supposed it was and to my great astonishment I saw a number of soldiers with presented bayonets commanded by an officer whom I did not then know. The soldiers formed a semi-circle round the sentinel box to the Custom House door."[25]

Said Richard Palmes, "I heard one of the bells ring, which I supposed was occasioned by fire and enquiring where the fire was, was answered that the soldiers were abusing the inhabitants. We were told there was a rumpus at the Custom House door."[26]

"I went immediately up to them and spoke to the fourth man from the corner who stood in the gutter," said Benjamin Burdick. "Asked him if the soldiers were loaded. He replied, 'yes!' I then asked if they intended to fire. Was answered positively, 'Yes, by the Eternal God!'"[27]

Richard Palmes joined them. "I immediately went there and saw Capt. Preston at the head of six or eight soldiers in a circular form with guns breast high and bayonets fixed. I went immediately to Capt. Preston and asked him if their guns were loaded. His answer was they are loaded with powder and ball."[28]

"I then looked round to see what number of inhabitants were in the street," said Burdick, "and computed them to be about fifty."[29]

At the center of the uproar was Captain Thomas Preston. "The mob still increased and were outrageous," he said, "striking their clubs or bludgeons one against another, and calling out, come on you rascals, you bloody backs, you lobster scoundrels, fire if you dare. God damn you! Fire and be damned."[30]

"The Soldiers were pushing to keep the people off," testified William Sawyer. "They came as close as they could. The people kept huzzaing. Damn 'em. Daring 'em to fire. Threw snowballs. I think they hit 'em."[31]

Jane Whitehouse lived near King Street. "Heard a noise. Went out," she said. "Some people came and said there's the sentinel, the bloody back rascal. Let's go kill him. They kept gathering, throwing snowballs, oyster shells and chunks of wood at the sentinel...I saw one man take a chunk of wood from under his coat, throw at a soldier and knocked him. He fell on his face."[32]

"I saw one soldier knocked down," said James Woodall. "His gun fell from him. I saw a great many sticks and pieces of sticks and ice thrown at the soldiers."[33]

Newton Prince, identified in the testimony as "a Negro member of the South Church," described how he "saw the soldiers planted by the Custom House two deep. The people were calling them Lobsters, daring 'em to fire, saying 'damn you why don't you fire.'"[34]

"I saw a number going up Cornhill and the Mulatto fellow headed them," said James Bailey. "Betwixt twenty and thirty. They appeared to be sailors. Some had sticks, some had none. The Mulatto fellow had a large cord wood stick...They were huzzaing, whistling and carrying their sticks upright over their heads."

Bailey added that "I did not see the Mulatto afterwards till I saw him dead."[35]

"I saw something resembling snow or ice strike the Grenadier on the Captain's right hand," said Richard Palmes. "He instantly stepped one foot back and fired the first gun. I had then my hand on the Captain's shoulder. After the gun went off I heard the word 'fire.'"[36]

"The next gun fired and so they fired through pretty quick," said William Sawyer.[37]

"After the word 'fire,' in about six or seven seconds, the Grenadier on the Captain's left fired and then the others, one after another," said Richard Palmes.[38]

"At the time I observed a tall man standing on my left hand who seemed not apprehensive of the danger he was in," reported Benjamin Burdick. "And before I had time to speak to him I heard the word 'Fire!' And immediately the report followed. The man on my left hand dropped. I asked him if he was hurt but received no answer. I then stooped down and saw him gasping and struggling with death."[39]

The first victim that night at what came to be known as the Boston Massacre was Crispus Attucks. Called the "tall man," and the "mulatto," Crispus Attucks was a seaman passing through Boston who became one of the leaders of the protest.

"I went and helped the Mulatto man who was shot into Mr. Stone's house," said Robert Goddard. "After we got him in there, I saw him give one gasp. I then opened his breast and saw two holes, one in each breast, where the balls had entered."[40]

"I looked back and saw three persons laying on the ground," said Richard Palmes. "Perceiving a solider stepping around the corner as I thought to shoot me, I ran down Exchange Lane and so up the next into King Street."[41]

"The whole of this melancholy affair was transacted in about twenty minutes," Captain Thomas Preston wrote from prison while awaiting trial. "The mob then ran away, except the unhappy men who instantly expired."[42]

Governor Hutchinson arrived at the Town House on King Street and immediately went upstairs to the second-floor council chamber and stepped outside to the balcony, overlooking the chaotic scene below. In a dramatic appeal to reason, he addressed the crowd. "The law shall have its course," he promised the residents of Boston.[43]

"The people were enraged to a very great degree," he wrote later, "and could not be pacified until I assured them immediate inquiries should be made by Civil Magistrates."[44]

Hutchinson and the other town magistrates began immediately taking witness statements "which lasted till three or four o'clock in the morning," he said.[45]

"It is certain that nothing more unfortunate could have happened," wrote Governor Hutchinson, "for a very great part of the people are in a perfect frenzy by means of it."[46]

"Tuesday morning presented a most shocking scene," the *Boston Gazette* raged, "the blood of our fellow citizens running like water through King Street."[47]

Like all of Boston, seventeen-year-old Phillis was deeply affected by the troubling events that traumatized her city. On the night of March 5th she was certainly at home in the Wheatley mansion on the corner of King Street and Mackerel Lane, just two blocks from the Town House, where British soldiers faced the fury of a Boston crowd. She could not avoid the desperate shouting, the madness, and panic that ruled the night. Shortly after nine o'clock, when the town bells began their frantic clanging, she would have known that something was wrong. Surely she heard the gunfire that left four dead in the street and moments later, the chaos of people scattering in horror as fleeing crowds ran past her house.

"It is probable that she was an eyewitness of this momentous event of the American Revolution," says Shields.[48]

With the city reeling from the deadliest crisis in its history, Thursday was a day of mourning. "Most of the shops in town were shut," the *Boston Gazette* reported. "All the bells were ordered to toll a solemn peal, as were also those in the neighboring towns."[49]

The town government arranged a public funeral service. Just two weeks earlier Boston had buried young Christopher Seider, who was murdered by a British sympathizer. Now these four deaths—a fifth, Patrick Carr, wounded that night, died nine days later—were more than the city could bear. The funeral on March 8, 1770 would be a civic event like nothing Boston had ever seen.

The *Boston Gazette* described the sad events of the day.

> The procession began to move between the hours of four and five in the afternoon, two of the unfortunate sufferers, Messrs. James Caldwell and Crispus Attucks who were strangers, borne from Faneuil Hall attended by a numerous train of persons of all ranks; and the other two, Mr. Samuel Gray, from the house of Mr. Benjamin Gray (his brother) on the north

side the Exchange, and Mr. Maverick, from the house of his distressed mother, Mrs. Mary Maverick, in Union Street, each followed by their respective relations and friends.

Several hearses forming a junction in King Street, the theatre of the inhuman tragedy, proceeded from thence through the Main Street, lengthened by an immense concourse of people so numerous as to be obliged to follow in ranks of six, and brought up by a long train of carriages belonging to the principal gentry of the town.

The bodies were deposited in one vault in the middle burying ground. The aggravated circumstances of their death, the distress and sorrow visible in every countenance, together with the peculiar solemnity with which the whole funeral was conducted, surpass description.[50]

"I attended the funeral of the four unhappy people that were killed on Monday last," John Rowe wrote in his diary. "Such a concourse of people I never saw before—I believe ten or twelve thousand."[51]

Was Phillis Wheatley among the "ten or twelve thousand" Bostonians present at the Granary Burial Ground to watch the four bodies laid to rest alongside the recently buried Christopher Seider? News accounts indicated that the funeral procession passed her house on King Street and noted that nearly every resident of Boston was there that day.

Professor Robinson believes that she attended the funeral.

Three days later, on Sunday, March 11, Reverend John Lathrop, pastor of the Old North Church, delivered a fiery sermon condemning the brutal slaughter of innocents. Reverend Lathrop, husband of Mary Wheatley, Phillis's childhood tutor, was known as an outspoken patriot.

"Phillis' relationship with the Lathrops was both religious and personal," writes Robinson. "As Lathrop often preached emotion-laden sermons on several Tory or British military provocations, he may well have inspired Phillis' poetic pieces on the same events, such as the slaying of the young Seider boy, and the 'Boston Massacre.'"[52]

His sermon was titled *Innocent Blood Crying to God From the Streets of Boston.* "If anyone by design slay another, or any way cause an innocent

person to be put to death, that innocent blood crieth unto God from the ground. It crieth for vengeance," Reverend Lathrop roared.[53]

"Shortly after witnessing the ceremony," says Robinson, "Phillis hurriedly wrote out a metrical response."[54]

On March 12, 1770, Wheatley's poem on the Boston Massacre appeared unsigned in the *Boston Evening Post.*

> *ON THE AFFRAY IN KING STREET*
> *ON THE EVENING OF THE 5TH OF MARCH*
>
> *With Fire enwrapt, surcharg'd with sudden Death,*
> *Lo, the pois'd Tube convolves its fatal breath!*
> *The flying Ball with heaven-directed Force,*
> *Rids the Spirit of the fallen corse.*
> *Well sated Shades! let no unwomanly Tear*
> *From Pity's Eye, disdain in your honour'd Bier;*
> *Lost to their View, surviving Friends may mourn,*
> *Yet on thy Pile shall Flames celestial burn;*
> *Long as in Freedom's Cause the wise contend,*
> *Dear to your unity shall Fame extend;*
> *While to the World, the letter'd Stone shall tell,*
> *How Caldwell, Attucks, Gray, and Mav'rick fell.*[55]

Shortly after the massacre, John Adams declared that "the 5th of March, 1770 ought to be an eternal warning to this nation. On that night the foundation of American independence was laid."[56]

# CHAPTER 13

## "Heav'nly Tidings From the Afric Muse."

"PHILLIS WHEATLEY'S FIRST EFFORT," Jeremy Belknap noted in his diary, was an elegy.[1]

Twelve-year-old Phillis was moved to write about the sad deaths in the Thacher family. She knew them as fellow worshippers at the Old South Church. In her simple, childlike way, the young poet tried to comfort a heartbroken mother by offering her best spiritual wisdom.

That essential empathy, her sincere desire to lift the spirits of those suffering the pain of losing a loved one, seemed to spring naturally from a well of compassion in the soul of Phillis Wheatley. Throughout her career as a poet, Phillis kept producing elegies—it was her genre of choice. One third of the poems in her 1773 book are elegies. "Wheatley wrote twenty of her fifty-five extant poems in this form," writes Professor Paula Bennett.[2]

"Phillis Wheatley not only gained her initial fame with an elegy, the celebrated poem on George Whitefield's death in 1770, but over the remaining years of her life retained her place in the public eye in no small part because of her facility with the elegy," says Professor Mukhtar Ali Isani.[3]

Her elegies were widely shared in Boston and beyond. Handwritten and printed Wheatley productions eagerly passed from hand to hand, especially among those who knew the people she wrote about.

Elegies were a popular form of poetry in the late eighteenth century. Thomas Gray's 1751 meditation on death and remembrance, *Elegy Written in a Country Churchyard,* was one of the most widely read poems of its time. Poet and critic Samuel Taylor Coleridge would later observe that "Elegy is the form of poetry natural to the reflective mind."[4]

Elegies written by ordinary folks honoring dear departed loved ones appeared frequently in colonial newspapers and magazines. High literacy rates and the proliferation of print media in New England allowed elegies to become a popular genre for aspiring writers and a source of interest for readers.

"Phillis, as an occasional poet, often commemorated the death of a relative of a friend or some ranking personality," writes William Robinson.[5]

"This is probably the reason why so many of her pieces are funeral poems," Oddell wrote, "many of them, no doubt, being written at the request of friends."[6]

In his 1931 survey of African-American authors, Vernon Loggins complained, "What one most wishes Phillis Wheatley had done, she left undone: she wrote too rarely about herself. Her intimate personal interests were ignored. She composed verses on the deaths of those who meant little to her."[7]

Professor Robinson responds by suggesting, "Any examination of the charge that Phillis did 'compose verses on the deaths of those who meant little to her' must try to determine just who these subjects were and how they related to Phillis personally."[8]

Robinson found that Phillis wrote elegies for people who mattered to her. "Phillis Wheatley was much more personal than is commonly noted.... She composed verses *only* for people who meant much to her in a practical way."[9]

Wheatley scholars believe that Phillis wrote her elegies for people in her life, those she cared about. "There is no evidence that they were written on request," says Isani. "It is clear that the poet wrote about people she knew and thus did not make a gesture devoid of feeling or calculated to enhance her fame.... They are not artificial exercises."[10]

Her motive for writing these poems were almost priestly and ministerial. "Wheatley avowedly hopes in her elegies to raise the souls of her readers, and finally her own, to empyreal bliss," says Shields.[11]

A striking quality apparent in the Wheatley elegies is her sincere affection for her subjects and their families, heartfelt outpourings of sympathy and love. "The purpose of Wheatley's elegies was, in most cases, the provision of emotional support," says Isani. "The better elegies owe much of their strength to the sense of personal loss and to a substantial discussion of the attributes of the deceased."[12]

"Her elegies never represent attempts to whitewash the deceased," Shields writes. "Quite the contrary, she confines her attention almost wholly to instruction of the living."[13]

Even as she sought to bring solace to grieving friends and their families, she wrote as personal therapy to help her deal with the emotional pain. "The elegies of Wheatley also express her own sense of loss," Isani writes.[14]

Her elegies were much more than expressions of condolence. The poet reached for something deeper. In Wheatley's vision, her elegies became profound reflections on the meaning of life, death, and immortality. "She composes her eighteen or so elegies, indeed, most of her extant mature poems, as self-conscious exercise or speculative mediations aimed toward discovering herself and to her serious readers, the meaning of life's vicissitudes and contradictions," writes Shields.[15]

"Both thought and feeling blend in her elegies," adds Isani.[16]

In order to serve effectively as solace for the mourners, those stricken with the death of a loved one had to read the poem while their loss was still fresh. Thus, "the elegy had to be written relatively quickly," Isani says.[17]

Reverend George Whitefield died on September 30, 1770; Wheatley's elegy appeared as a broadside the following week in Boston.

Thankfull Hubbard Leonard died on December 29, 1772. Almost immediately, Phillis wrote *To the Hon'ble Thomas Hubbard, Esq; On the Death of Mrs. Thankfull Leonard* for the father of her good friend. It was published as a broadside on January 2, 1773, four days later.

On September 3, 1772, Boston's John Andrews wrote to his brother-in-law sharing news of the death of their young nephew Charles Eliot. He sent his brother-in-law a handwritten copy of Phillis's elegy on September 22.

Reverend John Moorhead died on December 3, 1773. Her elegy came out as a broadside by December 15.

Mary Sanford Oliver died on March 17, 1773. Phillis completed her elegy on March 24.

Dr. Samuel Marshall died on September 29, 1771. Her elegy appeared in the *Boston Evening Post* on October 7.

"It is a poetic virtue of Phillis that, composing as quickly as she did for a standard poetic format, she was able to vary her elegies as well as she did," William Robinson observes.[18]

Phillis, the artist, was not satisfied with her first drafts. She continually sought to revise her work, refining images, clarifying themes, cutting phrases, polishing lines.

"Miss Wheatley was a careful craftsperson," observed Professor Gregory Rigsby.[19] "Changes in language and punctuation and grammar show an artist seeking precision in thought and meaning."[20]

"Phillis herself was forever rewriting her manuscripts so that there is today a sizeable array of her own manuscript variants," says Robinson.[21]

"Her changes range from the alteration of a few words to the addition of enough matter to almost double the original length," Isani notes. "Wheatley's artistic concern is evident in the variant versions available, showing how painstakingly she developed the poems and the care with which she returned to the elegies even after the original publication."[22]

"Because she wrote so many funeral pieces, Phillis might easily have fallen into clichéd expressions of death. Instead, she repeatedly found creatively different ways of describing the same phenomenon," says Robinson.[23]

Of the fourteen elegies in her 1773 book *Poems on Various Subjects, Religious and Moral,* the first is *On the Death of the Rev. Dr. Sewell, 1769.* She wrote the original version four years earlier, when her beloved pastor was sick.

The second elegy in her book paid homage to a man she admired. *On the Death of the Rev. Mr. George Whitefield* was widely read in Boston as a broadside. The newspaper *Massachusetts Spy* published it on October 11, 1770, and it appeared in a pamphlet with Reverend Ebenezer Pemberton's sermon on the death of Rev. Whitefield.

Less than five weeks later, her elegy had crossed the Atlantic. London's *Gazeteer and New Daily Advertiser* touted Phillis's Whitefield elegy, "composed in America by a Negro Girl seventeen years of age and sent over to a gentleman of character in London."[24]

By the end of the year, Wheatley's elegy for Whitefield was circulating as a broadside in New York, Philadelphia, and Newport, Rhode Island. Four more versions showed up in Boston.

The *New Hampshire Gazette* praised her poem "on account of its being wrote by a native of Africa and yet would have done honor to a Pope or Shakespeare."[25]

*On the Death of the Rev. Mr. George Whitefield* made Phillis Wheatley famous throughout New England and beyond. She began writing more

elegies for prominent members of the community and their families. It was the most productive period of her life.

She wrote *To a Lady on the Death of Her Husband* in 1771. It was published in Boston as a broadside.

> *Fair mourner, there see thy lov'd Leonard laid,*
> *And o'er him spread the deep impervious shade;*
> *Clos'd are his eyes and heavy fetters keep*
> *His senses bound in never waking sleep.*
>
> *But see the softly stealing tears apace*
> *Pursue each other down the mourner's face;*
> *But cease thy tears, bid ev'ry sigh depart,*
> *And cast the load of anguish from thine heart.*
>
> *From the cold shell of his great soul arise,*
> *And look beyond, thou native of the skies;*
> *There fix they view, where fleeter than the wind*
> *Thy Leonard mounts, and leaves the earth behind.*
>
> *Thyself prepare to pass the vale of night*
> *To join for ever on the hills of light.*
> *He welcomes thee to pleasures more refin'd,*
> *And better suited to th' immortal mind.*[26]

The "fair mourner" to whom the poem was addressed was a dear friend. "This was Thankfull Hubbard Leonard, of whom Phillis was especially fond," says Robinson.[27] "Phillis's fondness for Thankfull Hubbard Leonard developed from the late 1760's when the Hubbards were her King Street neighbors."[28] When Thankfull's husband, Dr. Thomas Leonard, died on June 21, 1771, Phillis shared her friend's sorrow in verse.

And when her friend Thankfull Hubbard Leonard herself died the following year at the age of twenty-seven, Phillis wrote "To the Hon'ble Thomas Hubbard, Esq; On the Death of Mrs. Thankfull Leonard" to help Thomas Hubbard channel his grief and her own. Phillis certainly knew her friend's father, a longtime deacon in the Old South Church.

*Let Recollection bear a tender part*
*To sooth and calm the tortures of your heart...*

*Ah! Cease, no more her unknown bliss bemoan!*
*Suspend the sigh and check the rising groan...*

*She leaves her earthly mansion for the skies*
*Where new creations feast her won'dring eyes.*
*To heav'n's high mandate cheerfully resign'd*
*She mounts, she flies, and leaves the rolling Globe behind.*[29]

Phillis ends her elegy by imagining the eternal spirit of her late friend Thankfull returning to address her parents. It is a notable literary innovation, a theatrical touch she tried in other elegies. "Like strong poets of every era, Wheatley adapted the conventions of her day to her own uses," writes Professor Bennett.[30]

"She goes so far as to have the departed spirits in four of her elegies speak aloud, giving dramatized comfort to the living and assuring them of the deceased's attainment of the promised raptures in heavenly life," says Shields.[31]

*She who late sigh'd for Leonard to return*
*Has ceas'd to languish and forgot to mourn*
*Since to the same divine dominions come*
*She joins her spouse and smiles upon the Tomb...*

*Could our fond parents view our endless joy,*
*Soon would the fountain of their sorrows dry...*

*Amidst unutter'd pleasures whilst I play,*
*In the fair sunshine of celestial day...*

*As far as grief affects a deathless soul,*
*So far doth grief my better mind control;*
*To see on Earth my aged Parents mourn,*
*And secret wish for Thankfull to return!*
*Let not such thought their latest hours employ*
*But as advancing fast, prepare for equal joy.*[32]

Bennett traces Phillis Wheatley's literary technique of taking on the voice of the departed to her African roots. "In West African cultures, a conjurer is one who plays with words as well as one who acts as a medium or channel for the spirit," she says. "Wheatley's role as a medium between the living and the dead puts her in a quasi-shamanistic position that has obvious parallels in West African religious practices and that recalls the role of the conjure woman exploited by African American women writers from Jarena Lee to Toni Morrison to empower their speakers."[33]

Shields found that "Wheatley's motive for writing elegies probably derived from her experience in her native Gambia. That experience almost certainly taught her that, then as now, women in Africa held or hold the responsibility for delivering elegies. In other words, Wheatley felt an obligation to compose elegies."[34]

Phillis wrote *A Funeral Poem on the Death of C. E. an Infant of Twelve Months* in 1772. Clearly, the child and his parents had a special place in her heart. She took the trouble to send the poem to Samuel Eliot, the boy's father. "It was folded several times, sealed with red wax and addressed to him by Wheatley," says Mason.[35]

John Andrews, prominent Boston merchant, whose wife Ruth was the sister of the dead infant's grieving mother, was "very familiar with Phillis and her poems," Robinson writes.[36] Andrews shared a copy of the poem with another member of the family in a letter dated September 22, 1772. "I wrote you by the post, acquainting you with the death of little Charles," John Andrews wrote. "Ruthy has inclos'd you by this opp. A Poem by P. Wheatly (sic) addressed to the father on this melancholy occasion which I think is a masterly performance."[37]

"Phillis' closeness to the Andrews-Eliot family can be deduced from her note on the outside of this manuscript: *'My Dear Polly, I take this opportunity to write to you...'* Polly being an 18th century term of familiar endearment," says Robinson.[38]

> *Through airy roads he wings his instant flight*
> *To purer regions of celestial light;*
> *Enlarg'd he sees unnumber'd systems roll,*
> *Beneath him sees the universal whole;*

*Planets on planets run their destin'd round,*
*And circling wonders fill the vast profound.*
*Th' ethereal now, and now th' empyreal skies*
*With growing splendors strike his wond'ring eyes.*

*The angels view him with delight unknown,*
*Press his soft hand and seat him on his throne...*

*Say, parents, why this unavailing moan?*
*Why heave your pensive bosoms with the groan?*
*To Charles, the happy subject of my song,*
*A brighter world and nobler strains belong...*

*To yon bright regions let your faith ascend,*
*Prepare to join your dearest infant friend*
*In pleasures without measure, without end.*[39]

Phillis wrote an elegy for Dr. Samuel Marshall, a Boston physician who was a relative of Susanna Wheatley. Phillis knew the Marshalls from their visits to the Wheatley home. Samuel's wife, Lucy Marshall, became a member of Boston's Old South Church on August 8, 1771, the same day as Phillis. *On the Death of Dr. Samuel Marshall, 1771* was published in the *Boston Evening Post* on October 7, 1771.

*Thro' thickest glooms, look back, immortal Shade!*
*On that confusion which thy flight has made.*
*Or from Olympus height look down and see*
*A town involv'd in grief for thee;*

*His Lucy sees him mix among the dead.*
*And rends the graceful tresses from her head;*
*Frantic with woe, with griefs unknown, oppres'd,*
*Sigh follows sigh, and heaves the downy breast...*

*The loss of thee on Tyler's soul returns,*
*And Boston too, for her Physician mourns.*
*When sickness call'd for Marshal's kindly hand,*
*Lo! With pity would his heart expand...*

> *Yet in our hopes, immortal joys attend*
> *The sire, the Spouse, the universal Friend.*[40]

*To a Clergyman on the Death of His Lady* was dated June 16, 1772 and published in Boston as a broadside with an accompanying note: "The above Phillis Wheatley, is a Negro Girl, about 18 years old, who has been in the country 11 years."[41]

The clergyman was Rev. Timothy Pitkin, trustee at Dartmouth College and associate of the Christian Indian minister Samson Occom. His wife, Temperance, died in childbirth on May 19, 1772.

> *Where contemplation finds her sacred spring,*
> *Where heav'nly music makes the arches ring,*
> *Where virtue reigns unsully'd and divine,*
> *Where wisdom thron'd and all the graces shine,*
> *There sits thy spouse amidst the radiant throng,*
> *While praise eternal warbles from her tongue...*
>
> *While thy dear mate, to flesh no more confin'd,*
> *Exults a blest, an heav'n ascended mind...*
>
> *Amid the seats of heav'n a place is free,*
> *And angels ope their bright ranks for thee;*
> *For thee they wait, and with expectant eye...*

For the following fourteen lines in the poem, Wheatley imagines a dramatic dialogue as the immortal spirit of the departed Mrs. Pitkin speaks to her husband on earth, offering the grieving widower words of comfort and wisdom.

> *Thy spouse leans downward from th' empyreal sky:*
> *"O come away," her longing spirit cries,*
> *"And share with me the raptures of the skies."*
> *"Our bliss divine to mortals is unknown;"*
> *"Immortal life and glory are our own."*
> *"There too may the dear pledges of our love"*
> *"Arrive and taste with us the joys above."*[42]

"To His Honour the Lieutenant Governor on the Death of His Lady" was written to Lieutenant Governor Andrew Oliver—the same AO who was humiliated and forced to resign as Stamp Tax collector during the riotous Boston upheavals of 1765. His wife, Mary Sanford Oliver, died on March 17, 1772, and Phillis wrote the poem a week later.

*There sits, illustrious Sir, thy beauteous spouse;*
*A gem-blaz'd circle beaming on her brows.*
*Hail'd with acclaim among the heav'nly choirs,*
*Her soul new-kindling with seraphic fires,*
*Top notes divine she tunes the vocal strings,*
*While heav'n's high concave with the music rings.*
*Virtue's rewards can mortal pencil paint?*
*No—all descriptive arts and eloquence are faint;*
*Nor canst thou, Oliver, assent refuse*
*To heav'nly tidings from the Afric muse.*[43]

"Wheatley's basic strategy in all these elegies is the same," says Bennett. "Young or old, famous or anonymous, male or female, the dead are brought back to admonish the living, either in their own voices, which she ventriloquizes, or in the voice of the poet-medium, who speaks for and about them."[44]

For Phillis Wheatley, the creative act of composing poetry was transformational—it changed her in profound ways. "No longer the abjected African or even the neoclassical poet, her speaker becomes the 'heav'nly muse,' a medium between the spiritual and material worlds," Bennett writes.[45]

Isani concedes, "The elegies of Wheatley are not her finest poems." However, the professor points out that "both the poet and her age saw much merit in them." He concludes, "They are serious poetic efforts...strong in their sincerity and the spontaneity of utterance from a feeling heart."[46]

Phillis Wheatley weighed in to characterize her own poetry. In her elegy to Andrew Oliver, she inserted a line that reveals how she viewed her mission as a poet. Today it stands as a fitting description of her work. The young artist saw her poetry as a gift of divine grace for a troubled world; she called it "heav'nly tidings from the Afric muse."[47]

# CHAPTER 14

"Thoughts on the Works of Providence," "On Recollection," "On Imagination," "An Hymn to Humanity."

SOMETIME TOWARD THE END OF 1771, a group of intelligent, passionate, and deeply religious young women gathered, as they often did, to discuss "feminine topics." Phillis Wheatley was there, along with her friend and tutor Mary Wheatley Lathrop, daughter of the man who owned her.

What did the women talk about? Julian Mason imagined an intense free-flowing conversation on Christian teachings and their "struggles with the catechism and the fervent preaching in Old South."[1]

The meetings were known as "salons," a popular pastime in France and England that spread to America. "These gatherings consisted of family and friends who met to discuss news, pleasure and entertainment," says Professor Zach Petrea.[2]

"Until the turn of the nineteenth century and the advent of mass printing and cheap distribution, an elaborate and extensive manuscript culture of written letters and notebooks sent from friend to friend constituted everyday communication for the literate class," Petrea writes.[3] "The salons provided a place where women were able to share their ideas on literature and art."[4]

"The purpose of a salon," explains Professor Karin Wulf, "was to provide an available space for the inspiration, discussion, circulation and presentation of *belles lettres*—that literature created for the purpose of pleasurable reading rather than strictly educational or religious instruction. Manuscript literature was particularly well suited for the intimate setting of the salons."[5]

"Often held in the home of a wealthy female member of the literati, salons welcomed and promoted aspiring writers as well as more established authors," Professor Wulf continues. "Friends shared with one another their

manuscript diaries of spiritual thoughts and experiences. Letters were read over and over to groups large and small....[6] Manuscripts could reach wide audiences as friends of friends borrowed and lent, read, recommended, and copied commonplace books, diaries, individual manuscript pages of poetry and prose, and letters."[7]

At this particular gathering in Boston, something extraordinary happened. Phillis picked up the thread of an idea that emerged from the conversation and transformed it into exquisite literary art. In that exclusive circle of young women, the sudden manifestation of Phillis's astonishing gift helped solidify her growing reputation as a serious poet. As Oddell later noted, "If anyone requested her to write upon any particular subject or event, she immediately set herself to the task and produced something upon the given theme."[8]

One of the women, identified only as "L" (most likely Mary Wheatley Lathrop), explained how Phillis delighted the women with her "most surprising genius."

> The following was occasioned by her being in company with some young ladies of family. One of them said she did not remember among all the poetical pieces she had seen, ever to have met with a poem upon Recollection. The African (so let me call her, for so in fact she is) took the hint, went home to her master's and soon sent what follows.[9]

What followed was a gem considered to be among Phillis Wheatley's finest poems. Phillis dedicated *On Recollection* to the young woman who issued the challenge. "To Miss A—M—, humbly inscribed by the Authoress," she wrote under the title.[10]

"The 'A.M.' of the dedication might have been Abigail May," says Mason, "who became a member of Boston's Old South Church in the same year that Phillis did—Abigail in February and Phillis in August of 1771."[11]

Phillis explained why she dedicated the poem to her friend.

> *Agreeable to your proposing Recollection as a subject proper for me to write upon, I enclose these few thoughts upon it; and as you was the first person who mentioned it, I thought none more proper to dedicate it to, and if it meets with your approbation,*

*the poem is honored and the authoress satisfied. I am, Madam,*

*Your very humble servant, Phillis.*[12]

The poem was published in the "Poetical Essays" section of the *London Magazine: Or Gentleman's Monthly Intelligencer* in March 1772, along with an introductory letter by "L" (Mary Wheatley Lathrop).

> There is in this town a young Negro woman who left her country at ten years of age and has been in this eight years. She is a complete seamstress, an accomplished mistress of her pen and discovers a most surprising genius. Some of her productions have seen the light, among which is a poem on the death of the Rev. Mr. George Whitefield.[13]

"On Recollection" later appeared in the *Massachusetts Gazette and Post Boy and Advertiser* on March 1, 1773, the *Essex Gazette* on March 16-23, 1773, and in London's *Annual Register or a View of the History, Politics and Literature for the Year 1772.*

"On Recollection" was "a striking departure from Wheatley's previously published works," says Carretta. "All of those had been occasional pieces written in response to contemporaneous events, such as Whitefield's death."[14]

This one was different. According to Carretta, it was her most "literary poem to date...."[15] Commissioned as a performance piece, "On Recollection" is clearly intended to demonstrate the aesthetic value of Wheatley's poetry more openly than she had tried to do in her earlier work."[16]

Unlike many of her previous poems that were steeped in Christian faith and doctrine, here she sprinkles references from Greek and Roman classical thought. Christian symbols are nowhere to be found. She opens with an invocation, a prayer to "Mneme," the Greek Goddess of Memory and mother, with Zeus as father, of the Nine Muses in Greek mythology, who ruled over literature, science, and the arts.

> *Mneme, begin. Inspire ye sacred nine,*
> *your vent'rous Afric in her great design.*
> *Mneme, immortal pow'r, I trace thy spring;*
> *Assist my strains, while I thy glories sing.*[17]

She marvels at how the sacred power of memory can bring long past deeds back to life.

> *The acts of long departed years, by thee*
> *Recover'd, in due order rang'd we see:*
> *Thy pow'r the long-forgotten calls from night,*
> *That sweetly plays before the fancy's sight.*[18]

The poet trains her penetrating gaze within, reflecting on how the mysterious workings of mind and memory inspire her poetry.

> *Mneme, in our nocturnal visions pours*
> *The ample treasure of her secret stores...*
>
> *And in her pomp of images display'd,*
> *To the high-raptur'd poet gives her aid;*
> *Through the unbounded regions of the mind,*
> *Diffusing light celestial and refin'd.*[19]

Wheatley informs us that she was eighteen when she wrote the poem. Older and wiser now, she has matured enough to realize how swiftly life moves, amazed at the relentless whirlwind of passing time.

> *Now eighteen years their destin'd course have run,*
> *In fast succession round the central sun.*
> *How did the follies of that period pass.*[20]

A salon culture that encouraged sharing ideas and personal writings provided fertile ground for Phillis Wheatley and her poems. Through these salons the young women of Boston became Phillis Wheatley's most appreciative audience. "Wheatley performed her poems before groups of women gathered in private homes in Boston," writes Professor Joanna Brooks. "White women circulated Wheatley's manuscript poems in Boston and beyond as a currency of friendship, familial relationship, education, and consolation."[21]

Brooks notes that "Boston poet Jane Dunlap may have attended one of these performances, because in her own *Poems upon Several Sermons Preached by the Rev'd and Renowned George Whitefield While in Boston* (1771), she praises the 'young Afric damsel's virgin tongue.'"[22]

The salon network spread to other cities. Brooks found evidence that "Wheatley also established an audience among white women in Philadelphia."[23] One of her admirers was Julia Rush, wife of prominent Philadelphian, Founding Father, and signer of the Declaration of Independence Dr. Benjamin Rush. According to nineteenth-century literary critic Rufus Griswold, dozens of Wheatley poems intended for publication before her death were held by the Rush family. "The M.S.S. however are still in existence," Griswold wrote in his 1849 anthology *The Female Poets of America*, published in Philadelphia. "They are owned by an accomplished citizen of Philadelphia whose mother was one of the patrons of the author."[24]

Manuscripts for five Wheatley poems were discovered in 1970 among the papers of Benjamin Rush that had been donated to the Historical Society of Pennsylvania in 1869 by his son.[25] This led Brooks to conclude that "Julia Stockton Rush was one of Wheatley's patrons."[26]

Dr. Rush had read Wheatley and was impressed by her "singular genius and accomplishments." His essay, published in Philadelphia in 1773, noted that "her poems have been printed and read with pleasure by the public."[27] We know that Wheatley corresponded with Rush; her letter to him, now lost, was listed in her 1779 book proposal.[28]

When Wheatley wrote her 1772 elegy, *A Poem on the Death of Charles Eliot, Aged 12 Months*, the boy's uncle, John Andrews, was so impressed by the "flowry language that runs through the whole of it" that he sent the poem to his brother-in-law, a Philadelphia merchant.[29] According to Brooks, "The infant's mother and her sister Ruthy Barrell Andrews circulated the manuscript among family and friends of the Eliot and Andrews families in Boston and Philadelphia."[30]

Wheatley poems have turned up in the personal possession of some highly educated Philadelphians. The Quaker poet Hannah Griffitts, lifelong Philadelphian and contemporary of Phillis Wheatley, kept a copy of her poem *Atheism*.[31] The same poem was found in one of the journals of a student at a Philadelphia Quaker school in the 1770s.[32]

"In the late 1970s," added Brooks, "a manuscript copy of the poem *Deism* written in Wheatley's hand was discovered among the papers of Philadelphia naturalist Pierre Eugene du Simitiere at the Library Company

of Philadelphia."[33] Du Simitiere was member of the American Philosophical Society and a Wheatley contemporary.

In her hometown of Boston, Phillis Wheatley had a small group of followers who appreciated her artistry. They knew her personally, conversed with her, mentored her, advised her, read handwritten drafts of her work, and listened to her poetic performances. Professor James Levernier notes that Phillis "maintained an extensive network of connections with several prominent members of the New England clerical establishment."[34]

Her supporters among Boston clergy were:

- Rev. Dr. Joseph Sewall, long-time pastor of Old South Church for whom twelve-year-old Phillis wrote one of her earliest poems: *On the Death of the Rev. Dr. Sewell When Sick, 1765*, which she rewrote in 1769;
- Rev. Dr. Samuel Cooper, minister of the Brattle Street Church who baptized Phillis at Old South. Phillis would write an elegy upon his death in 1784;
- Rev. John Lathrop, pastor of Old North, the Second Congregationalist Church, who married her friend and tutor Mary Wheatley in 1771;
- Rev. Charles Chauncy, minister at the First Unitarian Church, an author himself who wrote on religious subjects;
- Rev. Mather Byles, Congregational minister, widely read poet, and neighbor of the Wheatleys who often visited Phillis and tutored her in poetry;
- Rev. Ebenezer Pemberton, pastor at the Congregational New Brick Church, who included Phillis Wheatley's elegy to Rev. George Whitefield in the pamphlet featuring his own sermon on Whitefield's death in 1771;
- Rev. Andrew Elliot, Congregational minister and pastor at New North Church;
- Rev. Samuel Mather, Minister Tenth Congregational Church, son of famed preacher Cotton Mather, cousin of Mather Byles, and Hannah Mather Crocker's father;
- Rev. Mr. John Moorhead, minister at Federal Street Presbyterian

Church and friend to the Wheatley family. When Rev. Moorhead died in late 1773, Phillis wrote a poem to his daughter: *An Elegy, to Miss Mary Moorhead on the Death of her Father, the Rev. Mr. John Moorhead.*

- Rev. Samson Occom, Presbyterian minister and member of the Mohegan people who converted to Christianity at the age of seventeen, was a friend of the Wheatley family and frequent correspondent with Phillis.

By 1772 Phillis Wheatley was proving herself to be an eloquent, versatile, and popular poet. She was writing heartfelt elegies, poems with Christian themes and classical imagery, political poems, philosophical poems, and topical poems on current events. The poems considered among her finest include: *Thoughts on the Works of Providence, An Hymn to the Morning, An Hymn to the Evening, On Recollection, On Imagination,* and *An Hymn to Humanity.*

"In the year preceding publication of *Poems,* Wheatley was at the height of her poetic powers," says Shields.[35]

"In her better work," writes Mason, "she is much more in control of the syntax and rhythm and employs them with unobjectionable diction and figures."[36]

"Not surprisingly," observes Carretta, "these were the works most often cited and quoted by the earliest reviewers of Wheatley's *Poems on Various Subjects, Religious and Moral.*"[37]

*On Imagination* is probably her finest work. Today it is one of her most frequently anthologized poems. At the Boston Women's Memorial, the lifelike statue of Phillis Wheatley sits at a writing table, pen in hand. She remains deep in thought with the text of her poem *On Imagination* etched in stone beside her.

> *Imagination! Who can sing thy force?*
> *Or who describe the swiftness of thy course?*
> *Soaring through air to find the bright abode,*
> *Th' empyreal palace of the thund'ring God...*
>
> *Thy various works, imperial queen, we see,*

*How bright their forms! how deck'd with pomp by thee!*
*Thy wond'rous acts in beauteous order stand,*
*And all attest how potent is thine hand.*[38]

"Clearly, Wheatley's imagination is a regal presence in full control of her poetic world, a world in which her 'wond'rous act' of creation stands in harmony, capturing a 'beauteous order,'" Shields writes. "These acts themselves give testimony to the queen's creative power."[39]

The poet describes the inner workings of this mysterious gift.

*Now here, now there, the roving fancy flies,*
*Till some lov'd object strikes her wandr'ing eyes*
*Whose silken fetters all the senses bind,*
*And soft captivity involves the mind.*[40]

She sees the imagination as joyful, expansive, and limitless. In one of her most profound insights, the young slave poet revels in her freedom to employ this spiritual faculty—it lets her escape all earthly bonds.

*At thy command joy rushes on the heart,*
*And through the glowing veins the spirits dart.*
*Fancy might now her silken pinions try*
*To rise from earth, and sweep th' expanse on high;*[41]

*Thoughts On The Works Of Providence* is also among her finest poems. Says Robinson, "The nearest she got to anything like rapt lyricism was in passages of *Thoughts on the Works of Providence*."[42]

*Arise, my soul, on wings enraptur'd, rise*
*To praise the monarch of the earth and skies,*
*Whose goodness and benificence appear*
*As round its centre moves the rolling year,*[43]

The poet sings of a stirring dawn and a night of repose,

*Or when the morning glows with rosy charms,*
*Or the sun slumbers in the ocean's arms.*[44]

and sees an ineffable and loving Creator.

> *Ador'd for ever be the God unseen,*
> *Which round the sun revolves this vast machine,*
> *Though to his eye its mass a point appears:*
> *Ador'd the God that whirls surrounding spheres,*
> *Which first ordain'd that mighty Sol should reign*
> *The peerless monarch of th' ethereal train:*[45]
>
> *True to her course th' impetuous storm derides,*
> *Triumphant o'er the winds, and surging tides.*
> *Almighty, in these wond'rous works of thine,*
> *What Pow'r, what Wisdom, and what Goodness shine!*
> *And are thy wonders, Lord, by men explor'd,*
> *And yet creating glory unador'd!*[46]

In the concluding stanza, she finds the secret to nature's universe—the divine power of boundless love.

> *Infinite Love wher'er we turn our eyes*
> *Appears: this ev'ry creature's wants supplies;*
> *This most is heard in Nature's constant voice,*
> *This makes the morn and thus the eve rejoice;*
> *This bids the fost'ring rains and dews descend*
> *To nourish all, to serve one gen'ral end,*
> *The good of man: yet man ungrateful pays*
> *But little homage and but little praise.*
> *To him, whose works array'd with mercy shine,*
> *What songs would rise, how constant, how divine!*[47]

For *An Hymn to Humanity*, Phillis tried a different style, her most complex poetic pattern yet—the use of ballad stanzas.

> *I.*
> *Lo! For this dark terrestrial ball*
> *Forsakes his azure-paved hall*
> *A prince of heav'nly birth!*

*Divine Humanity behold.*
*What wonders rise, what charms unfold*
*At his descent to earth!*[48]

*VI.*
*Can Afric's muse forgetful prove?*
*Or can such friendship fail to move*
*A tender human heart?*
*Immortal friendship laurel-crown'd*
*The smiling graces all surround*
*With ev'ry heav'nly Art.*[49]

Phillis wrote one poem just for the fun of it. It was inspired by James Bowdoin, one of Boston's intellectual leaders who later would become a founding member of the American Academy of Arts and Sciences. He wrote a poem as a rebus, a kind of word-puzzle with clues that challenge readers to guess its meaning.

When Phillis read Bowdoin's brain teaser of a poem she must have been greatly amused. The creative artist in her got her thinking that perhaps she could write one in the same vein. It would be a daunting test. Such a poem calls for extraordinary verbal skill, ingenuity, and adroitness. It would have to be serious and intellectually stimulating, yet also light-hearted and entertaining. Could she compose that kind of poem?

We imagine the audacious young poet alone in her room, letting the free flow of ideas run through her fertile mind. We picture her as she appears in her memorable image, sitting at her desk, pen in hand, eyes lifted to eternity...until finally she says to herself, "Yes, I will try this."

Moving to her own rhythms, Phillis played with words and toyed with meanings until she produced a short poem that celebrates the art of ingenuity itself.

*The Poet asks and Phillis can't refuse*
*To shew th'obedience of the Infant muse.*

*She knows the Quail of most inviting taste*
*Fed Israel's army in the dreary waste;*

*And what's on Britain's royal standard borne,*
*But the tall graceful rampant Unicorn.*
*The Emerald with a vivid verdure glows*
*Among the gems which regal crowns compose;*
*Boston's a town, polite and debonair*
*To which the beaux and beauteous nymphs repair,*
*Each Helen strikes the mind with sweet surprise,*
*While living lightning flashes from her eyes.*
*See young Euphorbus of the Dardan line*
*By Menelaus' hand to death resign*
*The well known peer of popular applause*
*Is C—m zealous to support our laws.*
   *Quebec now vanquish'd must obey,*
   *She too must annual tribute pay*
   *To Britain of immortal fame.*
   *And add new glory to her name.*[50]

By design, the words "Quail," "Unicorn," "Emerald," "Boston," "Euphorbus," and "C—m" were clues. The final clue was one her New England readers would recognize as "Chatham," or more properly, William Pitt, the Earl of Chatham, who colonists believed was sympathetic to their cause.

The solution to the riddle is formed by the first letters of the clue words: Q-U-E-B-E-C, which spells out the city of Quebec.

The poem is a tour de force. When Phillis and her printer decided on the order of poems in her book it was chosen to be the final poem on the last page. This is the poem that would remain with readers after they closed the book. In his review of the poem, one nineteenth-century literary critic noted: "Phillis...excelled particularly in acrostics and in other equally difficult tricks of literary dexterity."[51]

*An Answer to the Rebus* is Phillis Wheatley's monument to poetic virtuosity. It stands as a fine testament to her literary skill and reflects the joy of wordplay. It was a poem she created because she could.

# CHAPTER 15

"A collection of poems by Phillis, a Negro Girl, from the strength of her own genius."

A TEENAGE GIRL ALONE IN bed, her body coiled in fetal position. Dizzy and nauseous, every breath a low growling wheeze, she struggles desperately to throw off what feels like an unseen hand jamming an invisible wet cloth over her nose and mouth. Rib muscles aching from the stress of expanding her chest, she knows instinctively that unless she works to push the air out of her lungs she will not be able to take in her next breath. She is fighting for her life.

It was like that for Phillis Wheatley. Her debilitating asthma attacks were serious and frightening, even life-threatening. "It has pleas'd God to lay me on a bed of sickness," she wrote, "and I knew not but my deathbed."[1]

"I am at present indisposed by a cold," she told a friend, "and since my arrival have been visited by the asthma."[2]

Asthma is a chronic disease affecting the passages in the lungs that carry air. Those air passages become inflamed and swollen. Extra mucus created to protect those pathways only narrows them even more, causing severe obstruction that interferes with the flow of air. Asthma flare-ups may be triggered by cold, dust, smoke, or pet dander in the environment. There is no cure.

"I haven't stopped choking," French novelist Marcel Proust wrote in 1907, "gasping for breath so continuously, incessant attacks of asthma for several days, that it is not very easy for me to write."[3]

"On a bad day I feel like I'm drowning and I can't reach the surface of the water and I am going to burst," one asthma sufferer wrote. "A tiny, tiny bit of air keeps me alive. It's very scary—I feel like I'm living with a time bomb and if I have a bad attack I say to myself: 'Is this the one that will kill me?'"[4]

"I have been in a very poor state of health all the past winter and spring," Phillis confided to Obour Tanner in July 1772. "My being much indispos'd this winter past was the reason of my not answering yours before now."[5]

Spring came but she had not fully recovered. "I am still very weak and the physicians seem to think there is danger of a consumpsion."[6]

In the spring of 1772 Susanna Wheatley devised her plan to have Phillis's poems published in a book. By then her young slave had produced so many fine poems that were popular with the reading public, it seemed like the next obvious step.

Susanna Wheatley had Phillis go through her writings to choose her best poems, and they wrote up a book proposal. Among the offerings she included in her proposal were her earlier published works, *On Recollection, On Virtue, On Friendship, To the University of Cambridge, Thoughts on Being Brought from Africa to America, On the Arrival of the Ships of War and Landing of the Troops, On the Affray in King Street on the Evening of the 5th of March,* and many of her popular elegies.[7]

Mrs. Wheatley called on the person her husband trusted most to handle his international business affairs. "Captain Robert Calef appears to have acted as a kind of literary agent for Phillis Wheatley," says Isani.[8]

According to Robinson, "Robert Calef, who for years regularly captained John Wheatley's ship the London Packet between Boston and London, carried the manuscript volume to several Boston printers, only to be repeatedly told that in spite of Phillis' well-known reputation, they simply would not 'credit the performances to be by a Negro.'"[9]

"It is clear enough," says Robinson, "that for reasons of plain racism, other Boston newspaper publishers and printers refused to publish even Phillis' proposals."[10]

Finally Boston printer Ezekiel Russell agreed to produce the book. It was Russell who had published her elegy *On the Death of the Rev. George Whitefield* two years earlier.

According to the proposal, the volume "will contain about 200 pages" printed in "beautiful types." The price for this "handsomely bound and lettered" volume "will be four shillings" and "stitched in blue, three shillings." Following standard industry practice at the time, the books had to be paid for in advance by wealthy patrons or individual readers—printing by subscription. "This work will be put to the press as soon as three hundred copies are subscribed for and shall be published with all speed," Russell wrote.[11]

The proposal opened with an acknowledgement of the unconventional

origin of the poet. The book was advertised as "A collection of POEMS, wrote at several times and upon various occasions, by PHILLIS, a Negro Girl, from the strength of her own genius, it being but a few years since she came to this town, an uncultivated barbarian from Africa."[12]

Russell's marketing strategy for the book was to stoke the curiosity of the reading public and appeal to their generosity. "It is hoped encouragement will be given to the publication as a reward to a very uncommon genius, at present, a slave," he stated in the proposal.[13]

According to Carretta, he "hoped to profit from the growing interest in...ethnically exotic origins of literary works."[14]

For residents of Boston, reading about people of African descent in their newspapers was not unusual. They appeared frequently in advertisements where they were for sale and notices to look out for runaways, and sometimes there was troubling news of a slave insurrection. But this was a book of poems written by an African slave—definitely something new.

The publisher Russell, seeking to enhance the book's market value, included a statement designed to reassure potential buyers that a woman of African birth, and a slave for life, was capable of writing such exquisite poetry. "The poems have been seen and read by the best judges, who think them well worthy of the publick view; and upon critical examination, they find that the declared author was capable of writing them."[15]

The identities of the "best judges," those who thought Phillis's poetry was "well worthy," remains unknown. But, as Carretta points out, this statement was noteworthy "because it was the first in what would soon become a tradition of having white commentators or editors attest the authenticity of works by people of African descent."[16]

The proposal featured a list of the twenty-eight Wheatley poems intended for publication. As an added bonus for historians and Wheatley scholars, Phillis dated the poems so we know when they were composed.

We do not know who wrote her proposal. Clearly it required Phillis's cooperation and input. There is reason to presume that Phillis wrote much of the text herself. "She was very likely responsible for it," suggests Carretta.[17]

Phillis Wheatley's book proposal appeared in Russell's newspaper, the *Boston Censor*, on February 29, 1772 and again on March 14 and April 18. "Publication of the proposals in the *Boston Censor* was apparently part of

a sophisticated transatlantic publicity campaign," says Carretta.[18] Shortly after the book proposal appeared in the *Boston Censor*, Phillis's poem *On Recollection* was published in London, probably arranged by Susanna Wheatley.

"No one would ever do as much for the poet as would her mistress," insists Robinson.[19] "Her persistent efforts to bring Phillis' works before the public were bearing much fruit."[20]

Phillis and Susanna Wheatley had every reason to be optimistic. "By the time these 1772 proposals were published Wheatley had enjoyed a growing reputation for her poetic precocity," says Robinson, "and had published poems, one of which had appeared in two or three different versions in Boston, Philadelphia, New York and London."[21]

But by the end of summer, her book had not attracted enough subscribers to go to print.

One supporter eager to purchase her book was Boston merchant John Andrews, "a friend and student of Phillis' earliest manuscript poems."[22] He wrote to his brother-in-law in Philadelphia, also interested in Wheatley's poems, complaining that "It is above two months since I subscribed for Philllis' poems which I expected to have sent you long ago but the want of spirit to carry on anything of the kind here has prevented it as they are not yet published."[23]

What did he mean by this "want of spirit to carry on anything of the kind?"

Andrews surely knew why the Wheatley manuscript failed to attract subscribers. He explained to his brother-in-law that they "did deliver it to Capt. Calef who could not sell it by reason of their not crediting the performance to be by a Negro."[24]

Robinson attributes this failure to racial stereotyping, which was rampant at that time.

> She nevertheless met racist resistance from piqued Boston whites who "not crediting the performances to be by a Negro," refused to subscribe to her volume, which they could not or would not believe had been written by a black slave girl, especially a pure black African-born girl who only a few years earlier could not read or write a word of English.[25]

Other factors were at play as well. According to Professor Kathrynn Seidler Engberg, "Some critics attribute the lack of support to the political climate of Boston at the time. Publishers were focusing more on printing pre-Revolutionary propaganda pamphlets than books of poetry."[26]

At that time, the colonies were torn by intense turmoil. People were deeply polarized—loyalists versus patriots. Ground zero in the conflict was beleaguered Boston. Ezekiel Russell, the only publisher willing to print Wheatley's book proposal, was a Tory whose *Boston Censor* was sympathetic to the British crown. "Much supported by Loyalist Governor Hutchinson and his equally Loyalist brother-in-law Lieutenant Governor Andrew Oliver, it was pointedly ignored by hostile patriot Bostonians," Robinson writes, "and ceased publication after only seven months."[27] It is likely that many of Phillis Wheatley's patriot supporters never saw the ad.

The dismal economic situation certainly contributed to the "want of spirit" depressing demand for a book of Phillis Wheatley poems. "The rising cost of manufacturing and purchasing goods also attributed to the lack of interest in publishing a full-length volume," Professor Engberg writes, "since readers did not have extra money to spend on books. Broadsides were cheap in comparison."[28]

The advertised price for subscribers, four shillings bound and three shillings for the paperback, could well have offended Bostonians' pocketbooks. It was sticker shock, says Boston historian J. L. Bell. "Russell's proposed price for Wheatley's volume was two to three times as expensive as similar material he was offering." Bell writes that "Three or four shillings for a book of poetry looks like an unusually hefty investment for Bostonians in 1772."[29]

Of course it is impossible to avoid the most obvious reason the book did not sell—racism, plain and simple. Every person of African descent, slave or free, had to confront the prevailing myth of white supremacy and its tragic corollary, black inferiority. Many whites found it hard to fathom how a black person, someone who they believed was born for manual labor, who had never been to school, could possibly possess the literary abilities so richly evident in these poems.

"Although Boston readers, specifically elite Bostonians, enjoyed Wheatley as an anomaly, they were not ready to support the notion that people of color could produce books," says Engberg.[30]

"Not enough Boston subscribers...could or would agree that the poems of the proposals were written by a Negro," Robinson wrote.[31] Phillis Wheatley's book was not published in Boston because there were "too many whites who could not believe that a black person could produce such work."[32]

# CHAPTER 16

"We whose names are under-written, do assure the world,
that the poems specified in the following page, were
written by Phillis, a young Negro girl."

WITH A HOST OF FACTORS conspiring against her in Boston, the book failed to materialize. But that was not the end of the story. "Stung by the public rejection of Phillis Wheatley's proposals of 1772, Mrs. Wheatley resolved that the young black poet would most assuredly be published," says Robinson,[1] "if not in bigoted Boston then in the more civilized, sophisticated London."[2]

Her Boston supporters were not surprised. "She was blamed by her friends for printing them here," Boston merchant John Andrews wrote, knowing that many in Boston were not ready for poetry written by a teenage African slave girl.

"Happily," says Robinson, "she was still encouraged in her poetic ambitions by a handful of staunch white friends, most especially the protective Mrs. Susanna Wheatley."[3]

Susanna Wheatley shifted her strategy. She withdrew the book from Russell's print shop and started looking in a new direction. Mrs. Wheatley knew from her husband's transatlantic business dealings and her own contacts with religious figures in Britain that London offered greater marketing opportunities than Boston. It was the capital of the British Empire. Works emanating from London would be distributed throughout Britain and the colonies.

"In regard to Phillis's poems, they will originate from a London press," Andrews told his brother-in-law, explaining that she was "made to expect a large emolument if she sent a copy home (meaning England)."[4]

Susanna Wheatley had already taken steps to make Phillis's poetry known beyond Boston. The Wheatley matriarch was always willing to use her connections to help Phillis. "It would be Mrs. Wheatley who would help

to internationalize Phillis' poetic reputation by putting her in correspondence contact with such influential persons as the wealthy Selina Hastings, Countess of Huntingdon, as early as 1770," writes Robinson.[5] That was the year Phillis dedicated her elegy *On the Death of The Rev. Mr. George Whitefield* to the countess and sent it to her, along with a personal letter.

It was an audacious move. Considering the conventions of the time, such a letter could have been regarded as a breach of proper behavior. For an adolescent slave to take the initiative in reaching out to a British noblewoman was indeed an act of sheer boldness.

No doubt, Susanna Wheatley encouraged the move. "She had long enjoyed an especially trusting relationship with the Countess," Robinson reports. "She had often housed and hosted visiting English ministers who were members of the Countess's Connexion."[6] Since Mrs. Wheatley considered herself part of the Countess of Huntingdon's circle in America, she thought the countess might be a willing supporter of Phillis's book.

Mrs. Wheatley knew from her friend Samson Occom that the countess eagerly supported endeavors by American Indians and freed slaves. When former slave James Albert Ukawsaw Gronniosaw had his autobiography, *A Narrative of the Most Remarkable Particulars in the Life of James Albert Ukawsaw Gronniosaw, An African Prince, as Related by Himself*, published in London in 1772, the Countess of Huntingdon lent her financial support to the project, and he dedicated the book to her.

Now that they were looking across the Atlantic for a publisher, Susanna Wheatley had Phillis sit down with her poems once more. "Some of the poems listed in the Proposals were too American, too politically oriented in sensitive times, for England and the Wheatley's friends there," Mason says. "Some were simply made more generic for an audience for whom many of the local names would mean nothing."[7]

Phillis began rewriting her poems, inserting and deleting lines, changing words, altering phrases. Some poems were eliminated and some were added. Her goal was to shape her writing for an English audience. Elegies addressed to particular individuals who were well known to Boston readers had their titles altered so they would make sense to the British.

- *To Mrs. Leonard On the Death of Her Husband* became *To a Lady on the Death of Her Husband*.

- *To Mrs. Boylston and children on the Death of her Son and their Brother* was revised to the more general: *To a Lady and her Children on the Death of her Son and their Brother.*
- *To the Rev. Mr. Pitkin on the Death of his Lady* became *To a Clergyman on the Death of His Lady.*
- *To James Sullivan Esq. and Lady on the Death of her Brother and Sister and a Child, Avis aged 12 months* was now *To a Gentleman and Lady on the Death of the Lady's Brother and Sister and a Child of the Name Avis, aged One Year.*

They decided to leave out *On the Death of Master Seider Who Was Killed by Ebenezer Richardson* because of its powerful anti-British sentiments. Other poems omitted for political reasons were the angry *On the Arrival of the Ships of War and Landing of the Troops* and the inflammatory *On the Affray in King Street on the Evening of the 5th of March,* honoring the American martyrs who died at the hands of British soldiers in the notorious Boston Massacre.

Pointedly included was *To the King's Most Excellent Majesty, 1768* praising King George and his wisdom for repealing the hated Stamp Act.

"The total number of poems increased by approximately one-fourth," says Mason, "and the book as a whole took on an even more religious cast."[8]

The poems Phillis added and reconfigured were consciously designed to appeal to the tastes and religious sensibilities of one reader—the Countess of Huntingdon.

Says Robinson: "Both Phillis and Mrs. Wheatley knew exactly what they were doing."[9]

Mrs. Wheatley encouraged Phillis to reach out to others in the countess's circle, including "English millionaire and Christian philanthropist John Thornton," who, Robinson notes, was a "financial supporter and religious follower of the Countess of Huntingdon."[10]

The Wheatleys knew Thornton as a generous source of funding for their great friend the Mohegan Christian minister Reverend Samson Occom. When Reverend Occom was in London for a fundraising mission several years earlier, John Thornton had been his host. It was during Occom's stay in London that twelve-year-old Phillis wrote her first letter,

"to the Rev. Mr. Occom, the Indian minister, while in England," according to John Wheatley.[11] That was probably the first time John Thornton became aware of Phillis Wheatley.

Phillis wrote her first letter to John Thornton toward the end of 1771, and he responded two months later. It was one of four letters Wheatley wrote to Thornton that we know of.

Since Phillis wrote to the countess in 1770, she had not received a response. According to Carretta, "Wheatley knew through intermediaries, however, that the Countess had received the letter and copy of the poem she had sent her. The countess was so intrigued by what she had read that she turned to members of what was commonly called her Huntingdonian Connexion to try to learn more about the young poet's Christian piety and authenticity."[12]

One of the countess's New England followers visited the Wheatleys and met Phillis. On May 25, 1772, Richard Cary of Charlestown reported back to the countess: "The Negro Girl of Mrs. Wheatley's, by her virtuous behavior and conversation in life, gives reason to believe she's a subject of Divine Grace—remarkable for her piety, of an extraordinary genius and in full communion with one of the churches, the family & girl was affected at the kind enquiry your ladiship made after her."[13]

Mindful of the reasons for the failure of their Boston proposal, Susanna and Phillis sought to address the apparent problems with her public image, knowing full well that such prejudice was based on false ideas about the natural abilities of African people. "Aware of the obligatory incredulity of some Boston whites and duly suspect of whites elsewhere, Phillis Wheatley and Mrs. Wheatley determined to meet and overcome obstacles between them and the publication of the book," Robinson writes.[14]

All her adult life Susanna Wheatley had been a dutiful helpmate to her enterprising husband as their business interests expanded and the family fortune grew. Now that John Wheatley, nearing seventy, had fully retired, he turned over management of his affairs to his son Nathaniel. Meanwhile, Susanna Wheatley embarked on her own retirement project by redoubling her efforts to push for the publication of Phillis's poems. Clearly she had absorbed lessons of entrepreneurship from her wheeler-dealer family. Taking advantage of the Wheatley business contacts in Boston and her own

connections in the religious community, she devised a shrewd public relations campaign to refine the image of her young protégée with the singular goal of making the poet more marketable.

They began by seeking out Boston's most influential citizens, the political, business and religious leaders of the city, all those whose opinions mattered. "She has had a paper drawn up and signed by the Gov. Council, Ministers and most of the people of note in this place certifying the authenticity of it," declared Wheatley friend John Andrews.[15]

Their marketing strategy was simple: collect a wide variety of celebrity endorsements for the poet. "The two of them drew upon their warm relationship with many prominent divines and leaders and obliged eighteen of them to sign an attestation of authenticity of authorship," says Robinson.[16]

This "Attestation" revised and expanded a similar claim in their failed proposal of eight months earlier. That simple declaration hadn't been persuasive enough. This time they added an explanation so readers would understand why this sort of statement was necessary. They offered more details about the extraordinary background of the author. They highlighted the stellar qualifications of the endorsers, the "most respectable characters in Boston," leaving no room for doubt that the judgment of these men was beyond reproach.

The "Attestation" was addressed to all readers. Emphasizing its importance, they wrote it in capital letters:

TO THE PUBLICK.

As it has been repeatedly suggested to the Publisher, by Persons, who have seen the manuscript, that numbers would be ready to suspect they were not really the writings of PHILLIS, he has procured the following Attestation, from the most respectable characters in Boston, that none might have the least ground for disputing their Original.

We whose names are under-written, do assure the world, that the POEMS specified in the following page, were (as we verily believe) written by PHILLIS, a young Negro girl, who was but a few years since, brought an uncultivated barbarian from Africa, and has ever since been, and now is, under the

disadvantage of serving as a slave in a family in this town. She
has been examined by some of the best judges, and is thought
qualified to write them.[17]

The signers represented an improbable collection of Boston's most elite
citizens. They were patriots and loyalists, slave owners and abolitionists,
businessmen and clergy. Most were Harvard graduates. Several were poets
themselves.

"Some of the best judges" who thought Phillis was "qualified" to write
the poems she wrote were:

- Thomas Hutchinson, Governor of Massachusetts. As Chief Justice
  during the 1765 Stamp Act riots, he suffered the destruction of
  his stately mansion by an angry mob. Shortly after the Boston
  Massacre, he calmed the crowd by declaring on the balcony of the
  Town House overlooking the murder scene that "The law shall
  have its course." At the time of the signing the "Attestation," he was
  locked in a power struggle with town leaders who viewed the gov-
  ernor as a puppet of Parliament. Two years later, with the rebellion
  heating up, Governor Hutchinson would flee Boston for London,
  where he lived the rest of his life.
- Lieutenant Governor Andrew Oliver. In 1765 he was forced to
  resign in disgrace as Stamp Act Official. The year after signing the
  "Attestation," Phillis would write an elegy for him as he mourned
  the death of his wife.
- John Hancock, one of the wealthiest men in Boston. He knew the
  Wheatleys quite well as fellow merchants. John Wheatley was his
  personal tailor. Two years after signing the "Attestation" he would
  give the eulogy at Susanna Wheatley's own funeral. As a patriot
  leader he was elected to represent the Massachusetts Bay colony
  in the Continental Congress. After the War for Independence he
  became the first governor of the Commonwealth of Massachusetts.
  History will remember John Hancock as the first signer of
  Declaration of Independence.
- Thomas Hubbard, prominent merchant and treasurer of Harvard
  College. Phillis probably knew him as deacon at Old South

Church. The Hubbards were neighbors of the Wheatleys. His daughter, Thankfull, was Phillis's friend. Phillis wrote two poems for the family: *To a Lady on the Death of Her Husband* as her friend Thankfull mourned; after Thankfull died, *To the Honourable T. H. Esq; on the Death of his Daughter*.

- James Bowdoin, published poet and first president of the American Academy of Arts and Sciences. Bowdoin College was named for him. His poem, *A Rebus*, was published in Phillis's book and inspired her to write *An Answer to the Rebus*. He went on to become governor of Massachusetts.

- Richard Carey, prosperous merchant and member of the Countess of Huntingdon's Connexion. He visited Phillis and wrote to the Countess in praise of her poetry.

- Harrison Gray, a prominent merchant known for his antislavery views, who tried, unsuccessfully, to pass laws banning slavery in Boston.

- John Erving, prominent merchant and father-in-law of James Bowdoin.

- James Pitts, brother-in-law of James Bowdoin.

- Joseph Green, merchant and poet, owner of one of the largest libraries in Boston.

- Rev. Charles Chauncy.

- Rev. Mather Byles.

- Rev. Ebenezer Pemberton.

- Rev. Andrew Elliot.

- Rev. Samuel Cooper.

- Rev. Samuel Mather.

- Rev. Mr. John Moorhead.

- Finally, the "Attestation" was signed by Phillis's legal owner, John Wheatley.

"The original Attestation, signed by the above Gentlemen, may be seen by applying to Archibald Bell, Bookseller, No. 8, Aldgate-Street," the published document declared.[18]

"This attestation was first printed separately in London newspapers as

part of a promotional campaign staged by Archibald Bell, Phillis' London publisher, anxious to make sales of his printing of the book to London readers," Robinson reports.[19] "In one of the newspaper ads (in *Lloyd's Evening Post* and *British Chronicle,* September 10-13) this statement is dated October 28, 1772."[20]

That original signed attestation was "last known to have been in the possession of Archibald Bell, the London publisher of Phillis's volume," says Robinson.[21] Unfortunately, nobody has seen the document since then.

# CHAPTER 17

## "She was auditioning for the humanity of the entire African people."

"THE ONLY KNOWN DATED COPY of the attestation appears in an advertisement in *Lloyd's Evening Post and British Chronicle* in September 1773," Professor Joanna Brooks declares in her 2010 examination of the attestation and its origin. "It is dated 28 October 1772."[1]

Although the attestation states that "She has been examined by some of the best judges," there is no evidence that Phillis faced the challenge of rigorous questioning by a sitting panel. The mythical interrogation known as "The Wheatley Court" is most likely a modern invention.

"None of those men left accounts of such a meeting," writes J. L. Bell. "Nobody else in Boston in 1772 reported that it happened. None of the early 1800's accounts of Phillis Wheatley's life includes that moment."[2]

"There is in fact no known record of such an event," says Professor Brooks.[3]

"This scenario would have been extremely difficult for the Wheatleys to stage," agrees Professor Gay Gibson Cima.

> Setting aside the challenge of finding such a public room and finding a date and time that eighteen ambitious men would set aside their own private concerns to validate the work of a young slave girl, one must still confront the fact that the men who "authenticated" Wheatley's volume were divided by fierce political animosities. They were Whigs as well as Tories. In 1772 it would have been a Herculean task to gather them together in one place for any endeavor.[4]

Wheatley's most recent biographer, Vincent Carretta, agrees. "It is very unlikely that the attesters made Wheatley undergo an oral examination to convince them that she was capable of writing the poems to be published under her name. Such an examination would have been unnecessary....

Most of the men named in the attestation had demonstrable direct as well as indirect ties to Phillis Wheatley herself. They already had ample evidence of her abilities."[5]

Dr. Cima supports this view:

> Many of the signatories had already met Phillis at one time or another, either in the Wheatley home upon a social visit, or at religious services or in the marketplace. She had been publishing individual poems in the newspapers and performing her poetry for small gatherings for some time. So it would have been possible for the Wheatleys to ask those who already knew Phillis's abilities well to sign the attestation without a public trial or reviewing of her skills.[6]

"By 1772, printers in Boston were already publishing Wheatley's poetry, crediting her for it and highlighting her status as a young African slave," says Bell. "People in Boston could visit the Wheatley household or speak to the growing number of people who had met the girl."

"Furthermore," he notes, "in nearly two centuries of research about Wheatley, no one has yet found any Bostonian expressing doubt that she composed her own verses."[7]

"It appears that the eighteen 'most respectable characters in Boston,' so described in the attestation, were willing on their knowledge of the Wheatley family and the strength of Phillis Wheatley's reputation to state that 'we verily believe' she wrote the poems herself," concludes Professor Brooks.[8]

The question of the origin of the attestation remains a source of intrigue. "How, then, if not through oral examination, might the attestation have come into being on 28 October 1772?" Brooks asks. "How were the signatures of eighteen prominent Bostonians collected that day?"[9]

Accounting for relevant new evidence, she offers a more plausible theory. "Consider what was taking place in Boston on Wednesday, 28 October 1772," she writes.

> On that very day, at Faneuil Hall, the freeholders of Boston convened an emergency meeting to investigate reports that the salaries for colonial judges would no longer be paid by

the colony but by the Crown. John Hancock, a signer of the Wheatley attestation, was "chosen Moderator" of the meeting.[10]

Boston was in an uproar that day. Outraged once again by the actions of the British Parliament, town leaders sought a meeting with Governor Hutchinson to discuss their grievances. He refused to meet with them, inflaming passions even further. The town government faced another crisis.

During that emergency meeting in Faneuil Hall, Sam Adams proposed an extraordinary step. According to Revolutionary War historian Robert Middlekauff, Boston then established a Committee of Correspondence "to state the rights of the colonists and of this province in particular, as men, as Christians and as subjects; to communicate and publish the same to the several towns in the province and the world."[11]

Adams called for Committees of Correspondence to be set up by towns and legislatures throughout the colonies to fortify their common resolve in the struggle against British rule. According to historian Harlow Giles Unger, "The Intercolonial Committee of Correspondence that resulted was the first permanent system of communication between the American colonies and their first union of sorts."[12]

"On 28 October 1772, with most of the prominent male citizens of Boston gathered at Faneuil Hall, it appears that Wheatley recognized an excellent opportunity to obtain signatures for this attestation," says Brooks.[13] John Andrews, who was close to the Wheatleys, maintained that Phillis herself was instrumental in completing the attestation. "She has had a paper drawn up and signed by the Gov. Council, Ministers and most of the people of note in this place certifying the authenticity of it," he declared.[14]

"If, as Andrews's letter relates, she 'had a paper drawn up and signed by the Gov. Council, Ministers and most of the people of note in this place,'" Brooks reasons, "then the attestation was probably circulated by Wheatley or an associate sometime before, during, or after the freeholders' meeting at Faneuil Hall....[15] His letter suggests an alternative narrative of the making of Wheatley, one that assigns her a commanding role in the early stages of her public career."[16]

Carretta agrees that "Phillis played a very active role in getting her

poems into print by gathering signatures of Boston dignitaries attesting to her authenticity."[17]

Although the driving force behind the effort to publish her book of poems was Susanna Wheatley, Phillis was always there marching beside her. After they decided to solicit the signatures of Boston's leading citizens, these two formidable women went after their targets with fierce determination. Armed with acute intelligence, delightful charm, and an appealing cause, their campaign proved to be compelling.

"It could not have been the simplest of matters for Mrs. Wheatley to secure the names of these men to the attestation," writes Robinson. "It is a tribute to her persuasiveness and sophistication that she was able to get a diametrically opposed lot of men to sign a common paper, even one as innocuous as one that simply testified to the authenticity of a slave poet's genuineness...."[18] That these men all signed, or agreed to have signed, this nonpolitical attestation is something of a tribute to Mrs. Susanna Wheatley's unrelenting persistence and Phillis' respected reputation."[19]

When the people of Boston saw the signatures of the two most powerful men in town on the attestation, it had to be a real head-scratcher. Thomas Hutchinson and John Hancock agreed on very little. As leaders of opposing political movements, they detested each other and were actively pursuing, from opposite sides, a course of action that would steer the colonies toward armed conflict. Two years later, loyalist Governor Hutchinson would be tasked by His Majesty's Secretary of State for North America Lord Dartmouth to arrest John Hancock.

The Phillis Wheatley "Attestation" turned out to be a document of major significance, its impact reaching into the next century. Its immediate goal—to affirm the credibility of the poet in the eyes of a skeptical public to increase book sales—was eminently successful. "In the language of modern book marketing," says Bell, "Phillis Wheatley had the best 'blurb' Boston could provide."[20]

Beyond the publisher's aim, the Wheatley "Attestation" would become a persuasive weapon used by the abolitionist movement in the years before the Civil War to argue for an end to the inhuman institution of slavery. Those eighteen gentlemen, "the most respectable characters in Boston," not only verified what should be self-evident—the plain fact that the author

of the poems was the author of the poems—but, according to Dr. Henry Louis Gates, they served "to answer a much larger question: was a Negro capable of producing literature?"[21]

"To understand why Wheatley's achievement prompted such incredulity, it helps to know something about the broader discourse of race and reason in the eighteenth century," says Gates.[22]

Africans presented an existential problem for Europeans. What sort of creatures were they? The question perplexed the greatest philosophers of the Enlightenment—Francis Bacon, David Hume, Immanuel Kant, and Georg Frederick Hegel. Were they human beings like Europeans, descended from a common ancestor? Or were they a lower, inferior animal species?

"Since the beginning of the sixteenth century," explains Gates, "Europeans had wondered aloud whether or not the African 'species of men,' as they were most commonly called, could ever create formal literature, could ever master 'the arts and sciences.' If they could, the argument ran, then the African variety of humanity was fundamentally related to the European variety. If not, then it seemed clear that the African was destined by nature to be a slave."[23]

In 1753 Hume concluded:

> I am apt to suspect the Negroes, and in general the other species of men (for there are four or five different kinds) to be naturally inferior to the whites. There never was a civilized nation of any other complexion than white, nor even any individual eminent either in action or speculation. No ingenious manufacturers amongst them, no arts, no sciences...[24]

Ten years later Kant wrote:

> The Negroes of Africa have by nature no feeling that rises above the trifling...Not a single one was ever found who presented anything great in art or science or any other praiseworthy quality, even though among the whites some continually rise aloft from the lowest rabble, and through superior gifts earn respect in the world.[25]

"This was the burden shouldered by Phillis Wheatley when she successfully defended herself and the authorship of her book against counterclaims and doubts," writes Gates.[26]

"Wheatley's appearance before the Boston luminaries—however it was staged—was only part of her performance literacy," says Dr. Cima.[27] Throughout her career, beginning in the Wheatley home and continuing with her live readings in London, it was her poetry performances that moved her audiences, inspiring their loyalty, affection, and support.

"Those who had not yet observed Phillis might have received invitations to the Wheatley home," writes Cima. "Phillis might have been ushered into the parlor to demonstrate her skills to one or two visitors at a time, in the same fashion as recorded in her interview that same year with Thomas Wooldridge, emissary to Lord Dartmouth."[28]

It was in the comfort of the Wheatley home, with Phillis reading her exquisite lines and stirring her receptive audiences, that old racial attitudes and deeply held prejudices began to fade.

"The Wheatley parlor arguably functioned as a scientific laboratory," suggests Cima. "An invited public investigated Wheatley's capabilities and contemplated the humanity of all slaves. It was also an intimate theatre in which a curious and voyeuristic few could experience the thrill of watching a young slave girl feel and think."[29]

If the dominant culture came to accept that a young slave poet named Phillis Wheatley had conceived, created, and written her poems, it would demonstrate that Africans were capable of producing fine art and literature. It would mean that Africans were fully rounded human beings, possessing a complete range of intellectual power, emotional depth, and self-awareness. They could no longer be considered as some lower form of creature, suitable only for the burdens of a slave. It would mean that the institution of slavery was an abomination, a crime against humanity. The only solution was immediate abolition.

After attending a poetry performance by Phillis Wheatley, "everyone had to acknowledge Wheatley's literacy and education," says Cima.[30]

"Essentially," Gates maintains, "she was auditioning for the humanity of the entire African people".[31]

# CHAPTER 18

*"She immediately wrote a rough copy of the enclosed address and letter. I was astonished and could hardly believe my own eyes."*

ON AUGUST 27, 1772, THE citizens of Boston picked up their newspapers to read the eye-popping news from London. Everyone knew it would change the lives of thousands in England, and its impact would soon reach the colonies. If Phillis Wheatley read the newspaper that day, she certainly took note of these startling developments, well aware of the ramifications for her and for her fellow slaves.

*The Massachusetts Spy* reported on a June 22 ruling by Lord Mansfield: "The Court of King's Bench gave judgment in the case of Somerset the Negro, finding that Mr. Stewart, his master, had no power to compel him on board a ship, or to send him back to the plantations."[1]

Several days later, the *Boston Evening Post* quoted the judge in the case.

> Lord Mansfield stated the matter thus: "The only question before us is: is the cause returned sufficient for remanding the slave? If not, he must be discharged....We cannot say the cause set forth by this return is allowed or approved of by the laws of this kingdom: therefore, the man must be discharged."[2]

On September 21, 1772, the *Boston Gazette* became one of the first colonial newspapers to discuss the implications of this momentous decision in Britain. "As blacks are free now in this country (England), gentlemen will not be so fond of bringing them here as they used to be."[3]

Both friends and foes of slavery recognized the stunning significance of the Mansfield decision. It was widely considered to be the moment slavery was abolished in England.

Throughout late summer and fall, eighteen articles on the Mansfield decision appeared in Boston newspapers, highlighting the consequences for slave owners and slaves who came to England.[4]

"Published reports of Lord Mansfield's decision trickled into the colonies through weekly newspapers," writes historian Alfred W. Blumrosen. "There were at least forty-three stories about Somerset in at least twenty newspapers, all of which made clear in different ways that black slaves in England had been freed by that decision."[5]

The case of Somerset the Negro began somewhere in West Africa about five years before Phillis Wheatley was born. Their stories were distressingly similar and relived by millions of others—a child, about nine, kidnapped from his village, led to the coast in chains and forced into the hold of a slave ship with dozens of other unfortunate souls for the horrific Middle Passage across the Atlantic to face a lifetime of slavery.

The boy arrived in Virginia in March 1749 and was given his slave name—Somerset. He was purchased by Charles Stewart, a high-ranking customs official for the British Crown, who brought him to the port of Boston. Stewart, and probably his slave Somerset, worked at the Custom House on King Street, around the block from the Wheatley home.

Stewart left Boston and moved to London in 1769, bringing Somerset with him.

On October 1, 1771, Somerset ran away. He was recaptured on November 26 and dragged into the hold of a ship bound for Jamaica, where Stewart planned to sell him. Somerset's abolitionist friends argued for his freedom and persuaded Granville Sharp to take the case. Although he was not a lawyer, Granville Sharp had earned a reputation as London's most powerful advocate for slaves, successfully securing freedom for several runaways who had been recaptured by their masters.

A strong foundation for the case against slavery came from Sir William Blackstone in his influential *Commentaries on the Laws of England*, which was highly regarded throughout North America.

> And this spirit of liberty is so deeply implanted in our constitution and rooted even in our very soil, that a slave or a Negro, the moment he lands in England, falls under the protection of the laws and so far becomes a freeman.[6]

The Mansfield decision did not abolish slavery in England by law—yet the ruling effectively undermined slavery in practice. From this point

forward, anyone held as a slave in the colonies or anyplace where it was legal, could emancipate himself once he arrived on English soil by simply walking away from his master, since slave owners could no longer enforce their claims of possession.

Did Phillis Wheatley learn about the highly controversial Mansfield decision when the news broke in Boston? As an avid reader and close follower of current events, it is highly likely that she came across one of the many articles covering the issue in Boston newspapers.

"The Somerset case was a subject of sufficient prominence and controversy in the Boston press that Wheatley must have heard about Mansfield's decision," writes Kirsten Wilcox. "Reports from London, commentary, reactions and miscellaneous anecdotes from the trial ran in the three Boston weeklies from late July of 1772, when a report of this 'remarkable Cause pending in the King's Bench' appeared in the *Massachusetts Gazette and Boston Weekly News-Letter,* through mid-October."[7]

Vincent Carretta reached the same conclusion. "Given the press coverage of the significance of the Mansfield ruling, as well as the local connection to Boston of Somerset and his master, Mansfield's judgment was very likely the talk of the town....[It was] almost certainly known to Phillis Wheatley and her owners....[8] The familiarity with current events that Wheatley frequently displays in her writings indicates that she was well aware of the rapidly evolving attitude about slavery in Massachusetts."[9]

Slavery became a hot topic in Boston. "The Mansfield ruling and revolutionary rhetoric together energized the abolitionist movement in New England that had been developing since the 1760's," notes Carretta. "The abolitionist movement was increasingly conflated in the northern colonies with opposition to imperial rule."[10]

The Massachusetts legislature attempted to abolish slavery several times, without success. Finally, in 1771 they passed "An Act to Prevent the Importation of Negro Slaves into this Province." However, Governor Hutchinson refused to sign it because it challenged the authority of Parliament.

The year after the Mansfield decision, on April 20, 1773, four slaves petitioned the Massachusetts legislature to argue for their freedom.

Sir, The efforts made by the legislative of this province in their last sessions to free themselves from slavery, gave us, who are in that deplorable state, a high degree of satisfaction. We expect great things from men who have made such a noble stand against the designs of their fellow-men to enslave them... We acknowledge our obligations to you for what you have already done, but as the people of this province seem to be actuated by the principles of equity and justice, we cannot but expect your house will again take our deplorable case into serious consideration, and give us that ample relief which, as men, we have a natural right to.

In behalf of our fellow slaves in this province, And by order of their Committee,

PETER BESTES, SAMBO FREEMAN, FELIX HOLBROOK, CHESTER JOIE.[11]

Slavery would finally be abolished in Massachusetts in 1783 after Chief Justice William Cushing ruled in favor of a slave named Quock Walker who ran away from his master after a brutal beating. "Perpetual servitude can no longer be tolerated in our government," Justice Cushing wrote. "Liberty can only be forfeited by some criminal conduct or relinquished by personal consent or contract."[12]

By the time of the Mansfield decision, the institution of slavery in the Massachusetts Bay colony was already moving toward extinction. Phillis Wheatley had every reason to believe that that the growing opposition to slavery in Boston would increase the pressure on the Wheatleys to set her free.

Several weeks after the Mansfield decision became known throughout Boston, a prominent visitor from England showed up at the Wheatley home. On October 9, 1772, Thomas Wooldridge, representing the Earl of Dartmouth, came to call on Phillis. Lord Dartmouth had just been named Royal Secretary of State for the colonies and was a religious follower of the Countess of Huntingdon and her Connexion. Already familiar with Wheatley's poems, Wooldridge was particularly impressed by her elegy to Reverend George Whitefield, who was deeply revered by the Earl of Dartmouth himself.

Several artifacts of their meeting are now considered to be among the most revealing primary source documents we have illuminating the gifts and genius of Phillis Wheatley. Thomas Wooldridge left us an extraordinary eyewitness account—the only one we know of—describing the young poet actively engaged in her writing process as she completes one of her most significant and enduring poems.

Wooldridge reported on his meeting with Phillis in a letter to Lord Dartmouth. "While in Boston, I heard of a very extraordinary female slave who made some verses on our mutually dear deceased friend Rev. Whitefield. I visited her mistress and found by conversing with the African that she was no imposter. I asked if she could write on any subject. She said yes."[13]

Wooldridge later related his story to the *New York Journal* which published an account of the meeting. "She told him she was then busy and engaged for the day but if he would propose a subject and call in the morning, she would endeavor to satisfy him. Accordingly, he gave for a subject—'The Earl of Dartmouth.'" Wooldridge left—but when he returned, the poet was ready. "Calling the next morning, she wrote in his presence."[14]

Wooldridge watched intently as the nineteen-year-old woman sat at a desk in front of a blank sheet of paper. He watched as words began flowing from her pen, filling the pages. "She immediately wrote a rough copy of the enclosed address and letter," he told Lord Dartmouth. "I was astonished and could hardly believe my own eyes."[15]

"Thus," writes J. L. Bell, "we have a contemporaneous account of how Phillis Wheatley responded to a stranger skeptical about her ability to write poetry."[16]

Wooldridge witnessed Phillis in the act of composition. He observed her writing a brief autobiography of herself—the only one she ever wrote. A month later, according to Professor Robinson, "Phillis would revise this sketch, sign John Wheatley's name to it, date it November 14, 1772."[17] Phillis added two details—her "inclination to learn the Latin tongue" and a statement by her master "who bought her and with whom she now lives." This is the version that later appeared in her book.[18]

This autobiography, currently among the papers of the Earl of Dartmouth, was composed "in the handwriting of Phillis Wheatley," Robinson reports.[19]

Phillis was brought from Africa to America in the year 1761, between seven and eight years of age. Without any assistance from school education and by only what she was taught in the family, she in sixteen months time from her arrival, attained the English language to which she was an utter stranger before, to such a degree as to read any, the most difficult parts of the sacred writings, to the great astonishment of all who heard her. As to her writing, her own curiosity led her to it and this she learnt in so short a time that in the year 1765 she wrote a letter to the Rev. Mr. Occom, the Indian Minister, while in England. This account is given by the mistress who bought her and with whom she now lives.

Boston, New England, Oct. 12, 1772.
Nathaniel Wheatley.[20]

As Woolridge looked on, Phillis wrote a cover letter to the Earl of Dartmouth and a poem.

Boston,
October 10, 1772

My Lord,

The joyful occasion which has given me this confidence in addressing your Lordship in the enclos'd piece, will, I hope, sufficiently apologize for this freedom from an African, who with the (now) happy America, exults with equal transport, in the view of one of its greatest advocates, Presiding, with the special tenderness of a fatherly heart, over the American department.

Now can they, my Lord, be insensible of the friendship so much exemplified in your endeavors in their behalf, during the late unhappy disturbances. I sincerely wish your lordship all possible success in your undertakings for the interest of North America.

That the united blessings of Heaven and Earth, may attend you here and the endless felicity of the invisible state in the presence of the Divine Benefactor, may be your portion here after, is the hearty desire of, My Lord.

Your Lordship's most Obt. & devoted Humbl. Servt.
Phillis Wheatley[21]

The "joyful occasion" she referenced was the August 1772 appointment of William Legge, second Earl of Dartmouth, as Secretary of State for the American colonies. Lord Dartmouth was known as a moderate who opposed the Stamp Act and sympathized with the colonists' complaints. In her letter, a buoyant Phillis captures the high hopes of a "(now) happy America," hoping that after years of struggle, frustration, and fury, they could rely on someone in authority as "one of its greatest advocates."[22]

For the Americans, their faith in Lord Dartmouth turned out to be wishful thinking. Two years later, when Governor Thomas Hutchinson went to London to consult with British leaders on a strategy for handling the rebellion in Massachusetts, he reported that Lord Dartmouth "wished to see Hancock and Adams brought to the punishment they deserved."[23]

After General Thomas Gage replaced Hutchinson as Governor in 1774, it was Lord Dartmouth who gave the order to "arrest and imprison the principle actors and abettors," John Hancock and Sam Adams.[24]

But in October 1772, the colonists were optimistic. They believed Lord Dartmouth would be a valuable ally to help persuade Parliament to ease their oppressive rule. Phillis Wheatley shared the strife-weary aspirations of her American compatriots longing for freedom from tyranny.

# CHAPTER 19

### "Me snatch'd from Afric's fancy'd happy seat."

IT IS REGARDED AS ONE of her finest poems. A bold celebration of the universal desire for freedom, the poem Phillis Wheatley wrote for Lord Dartmouth is a powerful and poignant affirmation of the "self-evident truths" Jefferson would immortalize four years later with his declaration "that all men are created equal, that they are endowed by their Creator with certain unalienable rights."

Phillis Wheatley offers her own forceful declaration that the glorious cause of the aggrieved colonists, their liberation from bondage, was her cause as well. "Phillis was plainly a Whig or American patriot in her deepest political sympathies," says Robinson.[1]

Carretta believes that *To the Right Honourable William, Earl of Dartmouth, His Majesty's Principal Secretary of State for North America* is "one of the most carefully crafted poems in the 1773 volume."[2]

"I was present when she wrote and can attest that it is her own production," Wooldridge stated. "They are all wrote in her own hand."[3]

The poem opens with Phillis offering hearty congratulations to Lord Dartmouth for his royal appointment as Secretary of State for North America. She speaks for many in troubled New England who are grateful for his "blissful sway" in securing the "Fair Freedom" they fervently desire.

Phillis Wheatley is also writing as an enslaved African who personifies the American yearning for freedom. When she declares that "her race no longer mourns," she means to include herself and her people in that cohort—the heavily freighted noun "race" covers all the patriots of New England. Phillis sees herself and her fellow Africans, slave and free, as part of that oppressed population. In this poem, Phillis Wheatley became the voice for an emerging nation.

"It was precisely the tragedy of her situation in the African diaspora

that enabled Wheatley to comprehend and support the white colonists' struggle against a perceived enslavement," writes Professor Rafia Zafar.[4]

"Each soul expands," and "each grateful bosom burns," she writes to describe the exhilarating fire now shaking New England to the core. All are lifted by the intoxicating prospect of "Freedom's charms," the greatest of gifts, exalted and divine, the "Goddess long desired."

"Wheatley re-appropriates the concept of *slavery* from its common metaphorical use in the colonial rhetoric of discontent, which described any perceived limitation on colonial rights and liberty as an attempt by England to 'enslave' (white) Americans," says Carretta.[5]

He points out that the rhetoric in the colonies decrying oppression, asserting rights, and clamoring for freedom made many, especially in New England, see the absurdity of chattel slavery. "Accusations against the British authorities of the illegality and immorality of their alleged attempts to 'enslave' the (white) colonists may have contributed to the decline in the number of 'Servants for Life' in Boston from just over eight hundred in 1761 to 261 ten years later."[6]

The poet, looking toward the coming relief from the affliction of bondage for all, aggressively challenges the moral values supporting this abhorrent institution. She uses highly charged signifiers to convey the evils of slavery: "wrongs, grievance, dread, tyranny."

She dares to associate the iconic image of an iron chain with the heinous and heartless act of enslavement, an unambiguous reference to the horror she herself experienced, along with millions of her fellow Africans. She makes the case that these "iron chains" of "wanton tyranny" also "enslave" her white neighbors and fellow Americans.

> *No more, America, in mournful strain,*
> *Of wrongs and grievance unredressed complain;*
> *No longer shall thou dread the iron chain*
> *Which wanton Tyranny, with lawless hand,*
> *Had made, and with it meant t' enslave the land.*[7]

*To the Right Honourable William, Earl of Dartmouth, His Majesty's Principal Secretary of State for North America* was Phillis Wheatley's clearest, most assertive condemnation of slavery so far.

Where did this frank and unequivocal protest language come from? What inspired Phillis to raise such a potent and personal censure of slavery in what was, ostensibly, a poetic tribute to their newly appointed leader, Lord Dartmouth?

"Phillis evidently felt that she could be more self-assertive in her London poems," Robinson writes, "for she sent, with a covering letter to the Earl of Dartmouth, a poem that has since been recognized as her most outspoken piece of black protest."[8]

Did Lord Mansfield's Somerset decision play a role in the sudden awakening of Phillis Wheatley as an eloquent antislavery agitator? "With such clamor circulating about Boston, Wheatley surely must have heard about the Somerset case," Kathrynn Seidler Engberg writes. She "would certainly have understood the implications of it for herself."[9]

The issue was electric in Boston and sent shock waves throughout the colonies. Those who owned slaves or benefitted from slave labor would certainly want to discuss the potential ramifications of the Mansfield ruling for the colonies. For those suffering under the yoke of slavery, the news must have hit like a lightning bolt. Suddenly there was a real path to freedom. The informal and highly effective communication network among free and enslaved blacks would have followed every twist and turn in the case; they would have been keen to learn of any change in their legal status that would impact their lives.

In early October, when Phillis Wheatley sat down to write her poem to Lord Dartmouth, the momentous issue of slavery and the newly heightened potential for freedom were very much on her mind.

"Read in the light of Somerset," Carretta believes that "several of Wheatley's poems demonstrate a nuanced treatment of slavery." It is particularly true of this poem. "Anticipation of the application of Somerset to the colonies would have enabled Wheatley to condemn both metaphorical and real slavery."[10]

One striking passage marks the poem as one of the most extraordinary in the Wheatley canon. Phillis shares the anguish she knew as a young girl, suffering the fate of a barbarous kidnapping and the pain of cruel separation from her family. Such an intimate disclosure was the one and only occasion when Phillis Wheatley addressed the devastating emotional toll of slavery.

In all of Phillis Wheatley's writings, "it is the only personal reference to her servitude," says Engberg.[11]

For most of the poem, Phillis refers to slavery in broad terms that apply to her African brothers and sisters as well as her New England neighbors and all Americans. Suddenly her tone shifts. She addresses Lord Dartmouth directly. Her sharp change of focus is as intense as if she were looking him right in the eye.

> *While you, my Lord, read o'er th'advent'rous song*
> *And wonder whence such daring boldness sprung:*
> *Hence, flow my wishes for the common good*
> *By feeling hearts alone best understood.*
> *From native clime, when seeming cruel fate*
> *Me snatch'd from Afric's fancy'd happy seat*
> *Impetuous—Ah! What bitter pangs molest.*
> *What sorrows labour'd in the parent breast!*
> *That more than stone, ne'er soft compassion mov'd*
> *Who from its father seiz'd his much belov'd.*
> *Such once my case.—Thus I deplore the day*
> *When Britons weep beneath tyrannic sway.*[12]

There are two versions of this poem. The original manuscript Phillis wrote for Thomas Wooldridge on October 10, 1772 is now among the Earl of Dartmouth's papers in Stafford, England. It was later published in the "Poet's Corner" of the *New York Journal* on June 3, 1773.

Later Phillis revised the poem for her book. But her first version, an authentic recapitulation of her lived experience, retains something of her raw fragments of dim and distant memory. "Because the manuscript version of this passage is more spontaneous and direct than the formal and correct one printed in the 1773 volume," says Shields, "it may be thought, consequently, more closely to approximate the poet's true feeling."[13]

The following year, when Phillis prepared her book for publication, she tweaked the language and polished her lines to make sure her meaning was crystal clear.

> *Should you, my lord, while you peruse my song,*
> *Wonder from whence my love of Freedom sprung,*

*Whence flow these wishes for the common good,*
*By feeling hearts alone best understood.*[14]

Essentially, she confronts Dartmouth and, by extension, her readers, with a pointed question. "Do you wonder where my love of freedom comes from? Do you understand that freedom for the enslaved is good for all?"

It is a striking challenge to Dartmouth and to all Americans—the self-evident proposition that only those who know the difference between right and wrong, those who have a conscience, the human ability to empathize, are the only people who can understand her position on slavery and freedom. It requires only a "feeling heart."

According to Margaretta Oddell, the only Wheatley family member to record any details about Phillis, "she does not seem to have preserved any remembrance of the place of her nativity or of her parents." At least, she did not share any of her treasured memories with the Wheatleys, except for one powerful image: "that her mother poured out water before the sun at his rising."[15]

We know that Phillis had a mother and a father. She had a home and a family, possibly brothers and sisters and certainly aunts, uncles, and grandparents who probably lived nearby.

"She belonged to a people who spoke a language, worshiped the deity, observed common rituals and customs and worked together toward the achievement of common goals," Shields writes. "In short, for the first seven years of Wheatley's life, we can almost certainly posit that she was a nurtured member of a specific African culture."[16]

Since news of the fateful Mansfield decision hit Boston, the volatile issues of slavery and freedom would inevitably be weighing on her mind.

That night in October 1772, after Wooldridge suggested that she write something on Lord Dartmouth, Phillis returned to her room. We see the nineteen-year-old woman sitting at her desk, alone. She gazes upward, seeking inspiration. Something deep in her mind carries her back to her African beginnings. She recalls her childhood, a time of innocence twelve years earlier. In the quiet of her solitude, traces of images come back to her, remnants of long-forgotten moments—the warmth of her mother's arms, the music of her voice, her father's aroma, the feel of his strong arms, playful romps

with the other children. She sees glimpses of a lost world, sights and sounds from her village as seen through the eyes of a seven-year-old girl.

Phillis begins writing. Her heart opens, and the whirl of emotions stirred by deep memories come pouring out in words. She relives her nightmare that began when:

> *I, young in life, by seeming cruel fate*
> *Was snatch'd from Afric's fancied happy seat:*
> *What pangs excruciating must molest,*
> *What sorrows labour in my parent's breast!*[17]

The poet saves her most pointed rebuke for the slave traders, those directly responsible for the atrocities, whose stone-cold hearts are so "steeled" and unmoved "by no misery." Not even the mournful cries of a father when his baby is taken will prod their unfeeling hearts.

> *Steeled was that soul, and by no misery moved,*
> *That from a father seized his babe beloved.*[18]

Firm and unflinching, Phillis Wheatley is determined to tell her own story. "The personal reference in this poem makes it as strong a protest against slavery as a slave could utter and expect to have his work published in a slave-holding community," wrote Wheatley scholar Arthur Davis.[19]

By presenting her own case, Phillis Wheatley compels the reader to look directly into the hearts of those devastated by slavery. Anyone who recognizes their common humanity surely must taste the "cruel fate," sense the "pangs excruciating," and know "what sorrows labour in my parent's breast!" With a prayer for compassion and faith in the power of empathy, the poet forces a moral question into the American consciousness so that no one will ever again experience such tyranny.

> *Such, such my case. And can I then but pray*
> *Others may never feel tyrannic sway?*[20]

# CHAPTER 20

*"She pray'd him to read them, and often would break
in upon him and say, 'is not this, or that, very fine?
Do read another.'"*

BY FALL OF 1772, SUSANNA Wheatley was informing friends
that they were looking to London to publish Phillis's book. "The carefully
prepared manuscript of thirty-nine poems (including the poem "A Rebus"
written by James Bowdoin) was completed," says Robinson.[1] "Finally, hav-
ing gathered the preface, the revised biographical sketch, the attestation
and manuscripts for 39 poems, Mrs. Wheatley gave the entire package to
Captain Calef for delivery to Archibald Bell in London."[2]

Robert Calef sailed for London on November 15, 1772, arriving in
mid-December. His primary mission was to look after the Wheatleys' busi-
ness interests, but Mrs. Wheatley had given him the additional task of
delivering the manuscript of Phillis's poems to the publisher connected to
the Countess of Huntingdon. "Acting as her literary agent, Calef enlisted
Archibald Bell to publish her book if a patron could be found," says
Carretta.[3]

According to Robinson, Captain Calef had "instructions to urge Bell
to seek the permission of the countess to allow Phillis to dedicate the vol-
ume to her ladyship."[4]

On January 7, 1773, Captain Calef reported back to Susanna Wheatley
that his mission had been successful. "Mr. Bell [the printer] acquaints me
that about five weeks ago he waited upon the Countess of Huntingdon with
the poems," Calef wrote. The countess "was greatly pleas'd with them," Bell
told Captain Calef. She "pray'd him to read them, and often would break in
upon him and say, 'is not this, or that, very fine? Do read another.'"[5]

Not only did Calef succeed in persuading the countess to help publish
Phillis's poems, but there was more good news. "I had like to forget to men-
tion to you," he wrote, "she is fond of having the book dedicated to her."[6]

This would give Phillis a huge boost in prestige and add to the book's market appeal. "Dedicating the book to the countess was a shrewd move," Engberg writes. "The countess' endorsement elevated the status of the book and of Wheatley as a writer and made it easier for Wheatley to 'sell' herself to readers. Being publicly associated with the countess, a figure of great prominence, gave Wheatley authority with readers. To the reader she appeared as more than just a slave or a prodigy; she was part of the countess' inner circle."[7]

One more suggestion by the countess would have momentous consequences. Not only did it enhance the prospect for book sales, it helped build an enduring legacy for Phillis Wheatley.

"One thing she desired which she said she hardly thought would be denied her," Captain Calef told Mrs. Wheatley, "was to have Phillis' picture in the frontispiece." He added that "if you would get it done, it can be engraved here (in London). I do imagine it can be easily done and think would contribute greatly to the sale of the book."[8]

"Accordingly, Phillis sat for her portrait," says Robinson. "Mrs. Wheatley engaged Scipio Moorhead, black artist and servant to the Reverend and Mrs. John Moorhead of Boston's Long Lane Presbyterian Church, to paint Phillis' picture." But, he cautions, this conclusion "is most probable but undocumented.... Phillis certainly knew the Moorhead family," he explains. "Her friend, the Indian minister Samson Occom, was a Wheatley houseguest when he preached, in January of 1773, at Moorhead's church."[9]

When John Wheatley became incapacitated after injuries suffered in a fall several weeks later, John Moorhead was a frequent visitor. "He is very kind to Mr. Wheatley," Susanna Wheatley wrote, "and visits him almost every day."[10]

After Reverend Moorhead died in December 1773, Phillis wrote a poem for his daughter. *An Elegy to Miss Mary Moorhead on the Death of her Father, the Rev. Mr. John Moorhead* was published as a broadside.

The connection between the Moorheads and their talented slave was through art. "John Moorhead's wife, Sarah, was a well-known Boston art teacher, who may have instructed Scipio Moorhead," notes Carretta.[11]

One piece of evidence strongly suggests that it was indeed Scipio Moorhead who painted the famous portrait of Phillis Wheatley. A

handwritten note on the same page as the poem in a copy of her book now in the possession of the American Antiquarian Society identifies S.M. as: "Scipio Moorhead—Negro Servant to the Rev'd Mr. Moorhead of Boston, whose Genius inclined him that way."[12]

Clearly, Phillis wrote *To S.M., A Young African Painter, on Seeing His Works* to honor Scipio Moorhead. It would certainly be a fitting gesture, a way for her to express her appreciation after he painted her portrait.

> *To show the lab'ring bosom's deep intent,*
> *And thought in living characters to paint,*
> *When first thy pencil did those beauties give,*
> *And breathing figures learnt from thee to live,*
> *How did those prospects give my soul delight,*
> *A new creation rushing on my sight!*[13]

She felt a powerful connection to the black artist, acknowledging the common creative spirit in a painter and a poet. As she did so often, her main purpose for writing the poem was to encourage, inspire, and elevate her subject, pointing toward a spiritual path, the way to eternal bliss and salvation for the soul.

> *Still, wondrous youth! each noble path pursue;*
> *On deathless glories fix thine ardent view:*
> *Still may the painter's and the poet's fire,*
> *To aid thy pencil and thy verse conspire!*
> *And may the charms of each seraphic theme*
> *Conduct thy footsteps to immortal fame!*[14]

For the artist, she wishes him continued success in his artistic pursuits. Keeping with her strong spiritual leanings, she hopes he will attain that deep sense of inner peace a soul knows when it touches the divine.

> *Calm and serene thy moments glide along,*
> *And may the muse inspire each future song!*
> *Still, with the sweets of contemplation blessed,*
> *May peace with balmy wings your soul invest!*[15]

The portrait is the only image we have of Phillis Wheatley. According to Wheatley family member Margaretta Oddell, it was "a striking representation of the original."[16]

"See! Look at my Phillis!" an amazed Susanna Wheatley exclaimed. "Does she not seem as though she would speak to me!'"[17]

When the portrait of Phillis Wheatley appeared in her book of poems, and according to Mason, "was available for separate purchase," it was a significant milestone in African-American history.[18]

In their study *American Colonial Portraits 1700-1776*, Richard H. Saunders and Ellen G. Miles found that "less than one percent of the population of the period was represented in portraits." Mostly, those who sat for portraits "were merchants or landowners and their families. Others were professional men, including lawyers and ministers."[19]

"There is no direct precedent for this image," says art historian Gwendolyn DuBois Shaw. "Not only was Wheatley the first person of African descent from New England to have her poetry published in English in the British public sphere, but she was also the first colonial American woman of any race to have her portrait printed alongside her writings."[20]

A mass-produced image of an African-born woman depicted as a participant in high culture was revolutionary. Nobody had ever heard of such a thing before. It was a direct challenge to the dominant and deeply held belief in white European supremacy and its corollary, black inferiority. "The fact of a black woman reading, writing and publishing was in itself enough to splinter the categories of white and black and explode a social order grounded in notions of racial difference," writes Professor Betsy Erkkila.[21]

For the average person in the American colonies, the existence of a slave-poet like Phillis Wheatley was a disorienting notion, an idea so strange it seemed unfathomable. Suddenly people had to consider new ways of thinking about Africans in America—and for many this radical new idea brought resistance and denial. "The representation of Wheatley may confound the frameworks readers bring to the text," writes scholar Robert Kendrick, "leading them back to the limits of their own horizons of understanding."[22]

The picture that introduced Phillis Wheatley to the world presented a thoughtful, dignified, highly educated woman engaged in the creative act

of writing poetry. "She is shown in the portrait as a part of the literary world of her time, not as a commodified object to be taken or traded," says Dr. Shaw.[23] "Wheatley is pictured as a respectable young woman who, despite her enslaved condition, is the epitome of learning and refinement."[24]

"We might, indeed, visualize the young poet there thanks to an unprecedented image," muses Marilyn Richardson, former curator of the Museum of African American History in Boston. "Her book's engraved frontispiece shows Wheatley, following the artistic conventions of the day, with the attributes of her gift—quill pen, ink pot, writing paper and a bound volume. Above all, the artist has evoked the contemplative stillness of her intense concentration. He shows her at once vividly alert and yet deep in thought."[25]

Looking at the portrait, we notice her "upward gaze that so powerfully animates the sitter." This striking "expression of intelligence," says Shaw, "establishes Wheatley as a divinely inspired, reflective individual rather than as an enslaved person."[26]

Thus did Phillis Wheatley introduce herself to the American public. She could hardly have chosen a more striking image, a dignified young woman of intelligence and learning, though still a slave—a woman who was clearly and unmistakably black.

By February 24, 1773, John Andrews could tell his brother-in-law that Phillis Wheatley's book of poems was finally on its way. "We may expect it in print by the spring ships."[27]

But in mid-February 1773, all was not well in the Wheatley household. Susanna Wheatley wrote of the "sad accident which befell Mr. Wheatley from a fall." The situation was so dire that "he has never been able to get out of his bed without the assistance of 5 or 6 men; and it is now near five weeks since it happened."[28]

Mrs. Wheatley, nearing sixty-four, was also in failing health. "I am very weak and low, my old indispositions returning upon me and to such a degree as makes me doubtful whether I shall live to see you once more in this world," she wrote to her friend the Reverend Samson Occom. "I must beg your earnest prayers to God for Mr. Wheatley and me and when death comes he may not be a terror but as the outward man decays the inward may be strong in faith."[29]

Meanwhile, "in her determined effort to get Phillis' poems into print in London, Mrs. Wheatley made the most of her warm correspondence with the countess," says Robinson. "In February 1773, she had written to the countess and noted that she would gladly welcome into her Boston home any of the countess's itinerant preachers whom she might send her way."[30]

She sent the countess a glowing report on one of her emissaries who had recently come to Boston to preach the Gospel.

> I have the pleasure to acquaint your Ladiship of the safe arrival of the Reverend Mr. Page. Have been several times favored with his conversation, from which I believe him a very serious good man and one who has the interest of the religion at heart and I doubt not but will be made a great and rich blessing.[31]

Doubling down on her strategy to trumpet her membership in the Countess of Huntingdon's Connexion, Mrs. Wheatley emphasized her personal commitment to the countess and her allies, reinforcing the idea that she was in complete accord with the countess's spiritual mission.

Mrs. Wheatley reminded the countess that on several occasions she had the great honor of hosting their mutual friend Reverend Occom at their home.

> I sincerely hope that your Ladiship's endeavors for the interest of religion in this part of the world will be crowned with great success.... I shall think myself greatly honoured in entertaining those who are devoted to the cause of Christ. We have had the pleasure of the reverend Mr. Occum's company in Boston, and he resided at my house during his stay. His preaching was universally admired and I have reason to hope was attended with divine blessing.[32]

She closed her letter with a note of praise for the late Reverend George Whitefield, the countess's dear friend and personal chaplain. This was Mrs. Wheatley's rather unsubtle way of reminding the countess of Phillis's touching elegy to Reverend Whitefield, which she had sent three years earlier.

> Since the reverend and worthy Mr. Whitefield has ascended to the mansions of glory, I hope the ministers will catch his

mantle, and receive a double portion of the Spirit of Grace conspicuous in him. It is my hearty desire that your Ladiship's life may be continued to be still a Mother in Israel. I have reason to hope that Phillis has chosen the better part, and I have a great deal of comfort in her.[33]

Mrs. Wheatley concluded her letter with a gracious and most respectful closing.

Begging an interest in your Ladiship's prayers,
I am, with utmost Respect,
Your Ladiship's most obedient servant,
Susanna Wheatley
Boston, February 20, 1773.[34]

Persistent as ever, she added a postscript, in case the countess somehow missed her point, reminding her once again that the Wheatleys were strong supporters of her evangelical mission and would gladly provide her representatives with a place to stay when they come to Boston.

PS: When your Ladiship finds any of those gentlemen this way, please to direct them to John Wheatley, Merchant in King Street, Boston.[35]

Soon, an emissary from the countess did visit the Wheatley home. It was Reverend Page, who Susanna Wheatley praised as a "serious good man and one who has the interest of the religion at heart."

Bernard Page wrote to the countess on March 19, 1773. "I have dined at Mr. Wheatley's and seen Phillis, whose presence and conversation demonstrate the written performances with her signature to be hers."

He reported that Phillis had richly demonstrated her ability to write on religious subjects with deep scriptural insight and unwavering Christian faith. "I have again seen Phillis," he said, "who showed me a letter from a Minister to her and her answer to the same."

Then Reverend Page shared his own observation of Phillis at work. "I myself saw her write several lines and then took the opportunity to watch her narrowly." He was particularly impressed by the meticulous care she gave to forming her letters and words. "I found she wrote a good and expeditious hand."

He found that Phillis shared the strong motivation with writers everywhere to seek exactly the right words to convey their intended meaning: "She frequently made use of a quarto dictionary and well she deserves the use thereof."

After sitting with Phillis, conversing with her, studying her humble demeanor, and stirred by the spark of brilliance in her eyes, he was able to experience the charms of this young woman in person.

He gave the countess what was probably the most astute description we have of Phillis Wheatley. "I'll delineate her in few words," he wrote: "her aspect, humble, serene and graceful; her thoughts, luminous and sepulchral, ethereal and evangelical and her performances most excellent, yea almost inimitable."

His verdict on Phillis Wheatley was a marker left for history: "A wonder of the age indeed!"[36]

# CHAPTER 21

*"What felt those poets but you feel the same?*
*Does not your soul possess the sacred flame?"*

SPRING 1773 BROUGHT A SEASON of surprises for Phillis Wheatley. Good fortune followed her through summer and fall. She found herself riding a magical wave that carried her across the Atlantic and raised her to such heights she not possibly imagine.

The Muses continued blessing her artistic vision. Glorious words poured out of her in classic crystalline images that soothed wounded spirits and inspired deep thoughts while reaching for the sublime. 1773 was the year her poetry raised her to the pinnacle of literary achievement.

More than a century and a half after Phillis Wheatley found success as a writer, her literary heir, the woman who most represents the African-American creative spirit, began her own writing career. An exuberant Zora Neale Hurston, describing how she felt when she finally "made it," captured what it must have been like for Phillis Wheatley. "Life has picked me up bodaciously and throwed me over the fence," Zora wrote.[1]

The fence that Phillis Wheatley crossed was a notorious barrier—no one had done it before. She became the first African-American to publish a book of original writing.

During the spring and summer of 1773, doors opened all around her. The African slave poet kept rarefied company. Her circle of friends included the leaders of British society, the cultural elite of the English-speaking world. Her poetry continued to earn accolades. When her book was finally published it was a critical and commercial success.

Before the year was over, Phillis Wheatley's magical ride came to its glorious culmination when her most cherished dream came true. She became a free woman.

Sometime in April of 1773 Phillis Wheatley began making preparations for the adventure of a lifetime. "Susanna and John Wheatley, and

presumably Phillis, decided that Phillis should go to London to promote the forthcoming publication of her collected poems," says Carretta.[2]

"From the start," writes Robinson, "it would be Mrs. Susanna Wheatley who would bear much of the financial burdens required to promote the career of her beloved black protégée."[3] Now the Wheatleys were ready to bankroll her transatlantic trip.

Mrs. Wheatley wrote to the countess on April 30 to inform her that the poet was coming and to convey her gratitude to the countess for supporting Phillis's book. "Phillis being in a poor state of health, the physicians advise to the sea air and as my son is coming to England upon some business and as so good an opportunity presented I thought it my duty to send her.... Your Ladiship has condescended to take so much notice of my dear Phillis as to permit her book to dedicate to you, and desiring her picture in the frontispiece."[4]

It is important to note that the reason Mrs. Wheatley gave for sending Phillis to London was to restore her health. Later Phillis told a friend that "I went for the recovery of my health as advised by my physician."[5]

Throughout the spring Phillis kept busy composing new and more sophisticated poems. "Moving the publication of the book from Boston to London was therefore more than a shift to a different and bigger market," explains Professor Wilcox.

> To appeal to the broader, more diffuse and more disinterested reading public with London at its center, "Poems on Various Subjects, Religious and Moral" would have to become a different book from that figured by the list of occasions and dates in the Boston Censor.[6]

A different book indeed. Of the thirty-eight Wheatley poems named in the *Boston Censor* proposal the previous year, only fifteen appeared in her published book—and many of those had been revised. From the last day of February 1772, when her book proposal first appeared, through May 8, 1773, when Phillis Wheatley sailed for London, her book constantly changed.

Spring of 1773 saw Phillis Wheatley at her most prolific. She experienced a burst of creative fervor and sustained effort that produced inspired poetry, what Shakespeare called "the poet's eye in a fine frenzy rolling."

"The year that elapsed between the Boston proposals and the delivery of a completed manuscript to Archibald Bell may have been an unusually creative one for Wheatley," says Wilcox. "She would have produced and revised in that period twenty-three new poems, among them some of her best and lengthiest work."[7]

These poems were not listed in her Boston proposals and were probably composed after Captain Calef brought her manuscript to London in November. According to Shields, "*Thoughts on the Works of Providence, To Maecenas, the Hymns to the Morning and Evening, Isaiah LXIII. 1-8, On Recollection, On Imagination, Ode to Neptune, An Hymn to Humanity, Niobe in Distress, To S.M. a Young African Painter, A Farewell to America...* all display a clear self-conscious preoccupation with aesthetics."[8]

Shields describes the literary mastery these poems reveal. Her "poetics evolves rapidly from 1770 until it reaches mature expression in such poems as *Thoughts on the Works of Providence, To Maecenas, On Recollection and On Imagination.*"[9] "It is in these last named poems," he says, "the poems of her maturity," where we find her "most exalted expression."[10]

Her poems from late 1772 to early 1773 show Phillis Wheatley as a self-assured artist in control of her gifts. "She chooses the subject matter of these poems, the tools for expressing that subject, the form in which to cast it, and most crucially, she chooses the poetics, for all her poems, by which she allows them to become enactments of her poetic process," Shields writes. "The power of her imagination enables her, along with her readers, to discover, even if only temporarily, and in the moment of philosophic/aesthetic contemplation 'Th' empyreal palace of the thund'ring God,'" as she asserts in *On Imagination*.[11]

"This transformation accompanies an expansion in Wheatley's versatility and mastery of lyric and epic expression," writes Wilcox. "The local prodigy of the Boston proposals is shown in London to be an accomplished woman of letters."[12]

In April 1773, when Phillis learned that she would be going to London, she began working on what would be her book's introductory poem *To Maecenas*. Following classical form in the spirit of Roman poets Horace (65–8 B.C.) and Virgil (70–19 B.C.), she gave thanks to her patron for supporting her work.

The name Maecenas carries historical significance along with rich symbolic meaning. Gaius Cilnius Maecenas (born 70 BC and died 8 BC) was a trusted advisor to Caesar Augustus, the first Emperor of Rome. As the Roman minister of culture, Maecenas was a great friend of the ancient Roman writers Virgil, who wrote *Georgics* in his honor, and Horace, who dedicated several poems to him. Maecenas became known as an enlightened patron of young poets.

Phillis took great care in composing this poem. It was designated to be the first poem in her book. This would be her opportunity to introduce herself to readers encountering her for the first time. She knew that the audience for her poetry would be growing beyond New England. Now she would be performing on the world stage. This poem made a bold statement: "I, Phillis Wheatley, want to assure you, dear reader, that you are about to discover a poet of the highest order."

She begins by addressing Maecenas directly: "Maecenas, you, beneath the myrtle shade / Read o'er what poets sung, and shepherds play'd."[13] By extension, she is really calling on her potential readers to consider the verses she has composed. Her opening addresses "the largely white audience who she hopes will purchase her volume," says Shields, hoping that by reading her poems they will be "providing her the patronage for which Maecenas was famous."[14]

> *What felt those poets but you feel the same?*
> *Does not your soul possess the sacred flame?*
> *Their noble strains your equal genius shares*
> *In softer language, and diviner airs.*[15]

Phillis boldly asserts that she feels what all poets feel, possessing the same "sacred flame" and "noble strains." She feels so confident in her art that she includes herself among the finest poets who share in "your equal genius."

"Next," writes Shields, "Wheatley, in a fourteen line stanza which we may call an embedded sonnet, celebrates Homer, whom she names 'Great Sire of verse'; his Iliad appears to have been favorite reading for her."[16]

The poet writes of experiencing some unnamed difficulty, a kind of writer's block. Suddenly, she feels inadequate to the task as she struggles to compose her next verse.

*And, as the thunder shakes the heav'nly plains,*
*A deep felt horror thrills through all my veins.*
*When gentler strains demand thy graceful song,*
*The length'ning line moves languishing along.*[17]

But she gains strength and courage from the great Homer.

*Great Sire of verse, before my mortal eyes,*
*The lightnings blaze across the vaulted skies...*[18]

Wheatley appropriates Greek mythology for motivation. "The poet paraphrases the first lines of Pope's translation of the *Iliad*, book 16," says Shields.[19] This is the passage where Patroclus begs Achilles for permission to wear his warrior/ lover's armor to intensify his ferocity in the battle against the Trojans.

*When great Patroclus courts Achilles' aid,*
*The grateful tribute of my tears is paid;*
*Prone on the shore he feels the pangs of love,*
*And stern Pelides tend'rest passions move.*[20]

Phillis calls on Maro, the grandson of Dionysus and Ariadne and priest of Apollo, and invokes the Nine Muses (from the Greek word *mousa*, which means "art" or "poetry"), the goddesses who inspire literature and the arts to strengthen her verses to "rival Virgil's page." The brash young poet claims as much right to "the Muses" as the ancient Roman poet Virgil did, referring to him as the sage from the Italian city of Mantua.

*Great Maro's strain in heav'nly numbers flows,*
*The Nine inspire, and all the bosom glows.*
*O could I rival thine and Virgil's page,*
*Or claim the Muses with the Mantuan Sage;*[21]

Demonstrating such strong familiarity with ancient classical literature assures her readers that "she has read the best poets of the ancient Western world and she has found them not just palatable but a major source of profound inspiration," says Shields.[22] The poem serves as testimony that Phillis Wheatley has "received instruction and inspiration from the ancient world's best practitioners."[23]

Blessed by inspiration from the Muses, the confident poet maintains that the world will see in her poems "the same beauties" and "the same ardors" that grace the immortal verses of Homer and Virgil.

> *Soon the same beauties should my mind adorn,*
> *And the same ardors in my soul should burn:*
> *Then should my song in bolder notes arise,*
> *And all my numbers pleasingly surprise;*[24]

After that display of bravado, the poet turns again to writing. She confronts the blank page—and suddenly finds that words aren't coming. Her creative flame has burned out. In the shadow of the towering literary giants Homer and Virgil, she can only feel the deepest humility. Grief overtakes her as the Muses seem to have fled, abandoning her and the legendary Mount Helicon where they dwell.

> *But here I sit, and mourn a grov'ling mind,*
> *That fain would mount, and ride upon the wind.*
> *Not you, my friend, these plaintive strains become,*
> *Not you, whose bosom is the Muses home;*
> *When they from tow'ring Helicon retire,*
> *They fan in you the bright immortal fire;*[25]

"Wheatley does seem quite painfully aware in *To Maecenas* that she is in a precarious position as an African slave," says Professor Eric Ashley Hairston. "She ends her celebration of Horatian and Virgilian poetic powers with a plaintive assessment of her predicament."[26]

"I, less happy, cannot raise the song," she laments, as "the fault'ring music dies upon my tongue."[27]

Then a sudden shift, a dramatic turning point; new inspiration arrives to empower her pen. The striving poet conjures up the spirit of her African predecessor "the happier Terence* all the choir inspir'd/ his soul replenish'd, and his bosom fir'd." Phillis carefully asterisked the name Terence, adding a special note: "He was an African by birth."[28]

The Roman playwright Publius Terentius Afer, known as Terence, was widely known throughout the classical world. Like Phillis, he was a

former slave whose literary gifts delighted his city, enriched his culture, and endured through the centuries. Born in 195 or 185 BC in Carthage (now Tunisia in North Africa), he was taken as a child to become a slave in Rome. Like Phillis herself, he showed impressive literary ability and was given a classical education. Terence wrote comedies that became so popular his owner was persuaded to grant him his freedom.

His plays remained popular throughout the Middle Ages and into the Renaissance. A Terence play was among the first to be printed just fifteen years after the Gutenberg Bible. In the sixteenth century, German theologian and Protestant reformer Martin Luther frequently quoted Terence and recommended that his comedies be taught in schools. All six of his known plays survive.

The great African-American poet and writer Maya Angelou, like Phillis Wheatley, found comfort and inspiration in Terence. "I agree with Terence," Ms. Angelou told George Plimpton in a 1990 interview for the *Paris Review*. "Terence said *homo sum: humani nihil a me alienum puto*. I am a human being. Nothing human can be alien to me."[29]

Newly encouraged and energized, Phillis confronts the mercurial Muses with a challenge: you have given your valued inspiration to only one African, Terence alone.

> *But say, ye Muses, why this partial grace,*
> *To one alone of Afric's sable race?*[30]

Why, she demands to know, wouldn't other African writers be equally deserving, namely Phillis Wheatley? She acknowledges the Muses' great sway as they conveyed the work of Terence to future generations. By celebrating the virtues of the ancient African writer Terence, the glory and honor of the "Great Maecenas," benefactor and supporter of artists, "shall be sung."

> *From age to age transmitting thus his name*
> *With the finest glory in the rolls of fame;*
> *Thy virtues, great Maecenas! shall be sung*
> *In praise of him, from whom those virtues sprung.*[31]

Heartened by the literary virtuosity of her African predecessor, Wheatley makes a bold assertion. Brimming with the confidence of a poet who knows the Muses are with her, the determined poet discloses her artistic vision in an emphatic triplet, the only one she used in the poem. Now the world will know that Phillis Wheatley fully intends to produce poems worthy of the Great Maecenas. She will reach out and grab the crown of literary excellence bestowed upon Terence by the Muses. And in the end, Terence and the Muses and Maecenas—and all who read the poetry of Phillis Wheatley—will look on with a smile.

> *While blooming wreaths around thy temples spread,*
> *I'll snatch a laurel from thine honour'd head,*
> *While you indulgent smile upon the deed.*[32]

"At least two remarkable developments emerge from this passage," suggests Hairston. "Wheatley is the first African American writer to deploy European heraldic elements to describe and valorize African heritage."[33]

> By penning Terence into her eighteenth-century discourse, Wheatley connected herself to a world beyond American slaveholding culture and found an experience that gave new meaning to her own. In Terence, she could identify a fellow African slave who employed the pen (or stylus) to defy the limitations of slavery and gain his freedom."[34]

"The passage reflects Wheatley's admiration and pride in how Terence, a Roman poet of African descent, was able to use his oratorical skills in order to inspire the world and achieve his freedom," writes Professor Babacar M'Baye.[35]

"She praises Terence, the Roman playwright," says Shields, "because of his African descent. So Wheatley obviously takes pride in her origins in Africa."[36]

"She used the classics to penetrate the white intellectual world and Terence in particular to inject a resonant black presence there that authorized her own presence," says Hairston.[37] "Wheatley writes Africa back into the classical world."[38]

With this poem Phillis Wheatley laid down a marker for all to see. From this moment on, Africans like her could claim their place in western

literary tradition. "*To Maecenas* speaks powerfully of Wheatley's determination to participate in western culture," argues Paula Bennett. "She wanted to be acknowledged, even in her difference, as a legitimate member of the society in which she lived."[39]

The poem closes with a final appeal to the highest cosmic powers. It is a rousing finale, a prayer to the divine source of all inspiration. She calls out to her patron Maecenas, her voice forceful, commanding, and determined. The poet figuratively grabs hold of her patron, the honored Maecenas—and by extension, her readers—seizes him by the collar, and looks him square in the eye. Then the poet demands support for her efforts.

> *As long as Thames in streams majestic flows,*
> *Or Naiads in their oozy beds repose*
> *While Phoebus reigns above the starry train*
> *While bright Aurora purples o'er the main,*
> *So long, great Sir, the muse thy praise shall sing,*
> *So long thy praise shal' make Parnassus ring:*
> *Then grant, Maecenas, thy paternal rays,*
> *Hear me propitious, and defend my lays.* [40]

The inspiration and success of Terence gave her all the confidence she needed to make her daring appeal to Maecenas, to the Muses, and to her readers. "Wheatley creates within the world of Neoclassical verse a kindly African literary father who will 'defend (her) lays,'" says Cima.[41]

When Phillis Wheatley wrote *To Maecenas* to honor her mentor, her patron, her source of support and encouragement, did she have anyone in particular in mind?

Surely she did, although the identity of her "Maecenas" remains ambiguous. As poets often do, Phillis left only hints. "The reference to 'Thames' in the stanza's opening line, however, clearly suggests that the dedicatee is English," Carretta theorizes. "A more appropriate and likely candidate for 'Maecenas' is the dedicatee of Wheatley's poems, the Countess of Huntingdon."[42]

Hairston thinks that Phillis kept the identity vague for a good strategic reason, one that could only enhance her market appeal. "Because

she cultivated fruitful acquaintances and relationships with a number of powerful men and women, those individuals could have freely imagined themselves as Maecenas. In addition to creating a desirable identity for her readers, one that could encourage even greater support from them, she could also thank her actual indulgent patron in the process."[43]

Who was her Maecenas? Since Phillis had many patrons, mentors, teachers, admirers, and supporters, there are a good number of candidates for the position. The way she left it, we can only guess.

# CHAPTER 22

"Adieu, New-England's smiling meads,
Adieu, th' flow'ry plain;
I leave thine op'ning charms, O spring,
And tempt the roaring main."

SPRING WAS IN FULL BLOOM when Phillis began thinking about her upcoming trip to London. The anticipation of a transatlantic voyage—her second after the horrific Middle Passage twelve years earlier—inspired her to verse. Alone in her room upstairs in the Wheatley mansion, she could contemplate navigating the uncharted waters of her life.

The prospect of sailing across the ocean again would certainly stir up a whirl of emotions for Phillis. Memories of her slave ship nightmare would surely come flooding back: haunting cries, anguished faces, limp bodies, crushed souls. She could also look ahead to see the extraordinary opportunities waiting for her. Phillis Wheatley would have known that her most cherished prize, freedom, was now in sight.

In his 1931 groundbreaking book *The Negro Author: His Development in America to 1900,* the first serious study of African-American literature, Dr. Vernon Loggins called Phillis Wheatley's poem *A Farewel to America* "perhaps her most graceful achievement in versification."[1]

It was written as "a fitting tribute from Phillis to Susanna Wheatley, her mistress, who had done so much for her personally and to encourage her writing," says Mason,[2] and it was the only poem where Phillis mentioned her mistress by name.

"Her *Farewel to America* was inscribed to her mistress, indicated by the initials S. W." wrote Oddell.[3]

"*Farewel to America* is also her most direct expression of resistance to enslavement," says Wilcox.[4]

"*Farewel to America, to Mrs. S.W.* is one of her most allusive expressions regarding her resistance to slavery," Professor Engberg maintains.[5]

The poet opens with a simple "goodbye," expressing a note of sadness at all she would be leaving behind. But her sadness doesn't linger. The opening verse hints at her conflicted feelings about leaving Boston.

> *Adieu, New-England's smiling meads,*
> *Adieu, th' flow'ry plain:*
> *I leave thine op'ning charms, O spring,*
> *And tempt the roaring main.*[6]

The second stanza alludes to the nature of this 'temptation."

> *In vain for me the flow'rets rise,*
> *And boast their gaudy pride,*
> *While here beneath the northern skies*
> *I mourn for health deny'd.*[7]

"Knowing that Wheatley suffered from poor health, the reader assumes that the final line of stanza two is her hope that the salty seas and fresh air will renew her," Engberg explains. "However, when the word 'health' is coupled with the verb 'deny'd,' it becomes apparent that Wheatley is alluding to an affliction other than her chronic illness; she is mourning her 'freedom deny'd.'"[8]

Carretta supports this view. "The health that Wheatley locates in England in *A Farewel to America* is not only physical. It is also social and political because in England she will face the opportunity to resurrect herself from the social death of slavery."[9]

The object of her longing becomes clear in the third stanza.

> *Celestial maid of rosy hue,*
> *Oh let me feel thy reign!*
> *I languish till thy face I view,*
> *Thy vanish'd joys regain.*[10]

She addresses the "celestial maid of rosy hue," her description of the beautiful goddess Freedom. The poet longs for her presence and remains languishing in misery until she appears. More than anything, Phillis wants to "regain" the "vanish'd joys" she once knew. In her symbolic language, that could only mean freedom.

"In the next several quatrains," Engberg writes, "Wheatley imagines the grief of her mistress, as she describes how 'Susannah mourns' with 'tender falling' tears 'at sad departure's hour.' Capturing the landscape of New England in spring, Wheatley also imagines how she will miss the 'feather'd warblers sing,' 'the garden blooms,' and 'sweet perfumes'".[11]

> Susannah mourns, nor can I bear
> To see the crystal shower
> Or mark the tender falling tear
> At sad departure's hour;
>
> Not regarding can I see
> Her soul with grief opprest
> But let no sighs, no groans for me
> Steal from her pensive breast.
>
> In vain the feather'd warblers sing
> In vain the garden blooms
> And on the bosom of the spring
> Breathes out her sweet perfumes.[12]

Wilcox wonders "if Wheatley wept as well" because "she does not tell her readers." It is revealing to note that "Susannah mourns" the poet's departure but Phillis herself admits: "I mourn for health deny'd.'"[13]

Now the poem turns to her destination across the ocean. It is still too far off to be real, yet it fills her with wonder.

> While for Britannia's distant shore
> We weep the liquid plain,
> And with astonish'd eyes explore
> The wide-extended main.

Suddenly Phillis practically leaps up in jubilation; all that she has wished for came true. "Health appears!" The "celestial dame," the goddess Freedom, has come, "complacent and serene," with "soul-delighting mien."

> Lo! Health appears! celestial dame!
> Complacent and serene,

*With Hebe's mantle oe'r her frame,*
*With soul-delighting mien.*[14]

"The 'health' that greets Wheatley in England is spiritual rather than physical," says Wilcox, "just as her illness is the source of 'mourning' rather than bodily discomfort. Health is figured as a 'celestial dame' whose appearance delights the soul rather than the body.

"Moreover, the arrival of health is represented as a sudden occurrence; it is announced with an emphatic 'Lo!' and an exclamatory sentence that suggests a sudden transformation rather than a gradual return to physical well-being."[15]

Phillis Wheatley had to know what was commonly accepted in Britain and the colonies—the historic Mansfield decision meant that the moment she stepped on British soil she would be free.

Now the poet sees the British shoreline in her mind's eye. Bursting with joy, she can hardly wait to get there. "Why, Phoebus, moves thy car so slow?" she complains. "Give us the famous town to view!"[16]

But the reality is not so simple. "For Wheatley these conflicted feelings are much deeper," writes Engberg, "because for her 'Britannia' is 'freedom,' and she knows that if she is going to be relieved of the afflictions of slavery, she may never return to New England."[17]

*For thee, Britannia, I resign*
*New-England's smiling fields;*
*To view again her charms divine,*
*What joy the prospect yields!*[18]

Here, the poet returns to the problem she hinted at earlier in the poem, confessing to a powerful ambivalence pulling her in a direction she isn't sure she wants to go.

"In 1773, England presented a particular kind of temptation for enslaved visitors," said Wilcox.[19]

"The Somerset case caused controversy, especially in Boston, where it was the subject of press publications, commentary and editorial reactions," writes Engberg. "When the historical context of the Somerset case is taken into consideration, the poem presents a specific 'temptation' for

Wheatley."[20] The crucial temptation looming before her was the prospect of returning to America without seizing the opportunity for freedom in Britain.

> *But thou! Temptation hence away,*
> *With all thy fatal train,*
> *Nor once seduce my soul away,*
> *By thine enchanting strain.*
>
> *Thrice happy they, whose heavenly shield*
> *Secures their souls from harm,*
> *And fell Temptation on the field*
> *Of all its pow'r disarms.*[21]

Phillis Wheatley was on the cusp of making a radical decision that would affect the trajectory of her life. Despite her reservations about leaving America to avoid slavery forever, she knew what she had to do.

The poem ends on a note of resolve. Admitting that she is troubled by emotional conflict, she refuses to give in to self-pity, paralysis, or woe. She leaves us with a heart-wrenching enigma. The nature of her conflict remains hidden in poetic imagery. We can only guess what prompted her "secret falling tear."

> *But cease thy lays; my lute forbear;*
> *Nor frown, my gentle Muse,*
> *To see the secret falling tear,*
> *Nor pitying look refuse.*[22]

These final lines were included in her original poem that was published in four different Boston newspapers in May 1773. Weeks later, when Phillis was in London preparing the final version of her poems for publication, she left them out.

Although she couched her emotional turmoil in metaphor and allusion, the pull of her temptation was clear. Two paths appeared in front of her. She could choose one or the other: return to Boston because of her emotional attachment to Susanna Wheatley, or remain in London to secure her freedom.

"The extensive public attention given to the [Somerset] case and its implications for American slaves in England may explain the 'temptation' alluded to in *Farewel to America,* the temptation to seek asylum in London, forsaking the legal and affectionate—and perhaps religious and moral— bonds that tied Wheatley to her mistress," says Wilcox. "Many elements of the poem support such an interpretation."

> The poem describes Wheatley's journey as a quest for relief from the illness that plagues her in New England, where 'here beneath the Northern skies/I mourn for health deny'd." In the course of the journey, Wheatley does find health, but not, as was assumed in the correspondence surrounding her trip through exposure to sea air. Instead, health comes with the sight of land—the proverbial English soil on which enslaved Negroes could become free.[23]

When she finished her poem *A Farewel to America, To Mrs. S.W.,* she added the date at the bottom: May 7, 1773. The next day she set sail for London.

# III. London 1773

*"Since my return to America, my Master,
has at the desire of my friends in England,
given me my freedom."*

~ Phillis Wheatley, October 18, 1773

# CHAPTER 23

### "Saturday last, sailed for London."

"SATURDAY LAST, SAILED FOR LONDON, the ship *London,* Capt. Calef, in whom went passengers Mr. Nathaniel Wheatley, merchant; also Phillis, the extraordinary negro Poet, servant to Mr. John Wheatley," the *Boston Gazette and Country Journal* reported on May 10, 1773.[1]

"Notices of her departure from Boston were printed at least six times among four Boston newspapers," says Robinson.[2]

Newspapers throughout New England carried the story: *Connecticut Journal and New Haven Post Boy,* May 7; *Connecticut Courant,* May 11; *Providence Gazette,* May 8; *New York Gazette and Weekly Mercury,* May 17; *New York Journal and Weekly Post Boy,* May 27; *New York Journal,* June 3; *Pennsylvania Chronicle,* May 17; *Pennsylvania Packet,* May 24; *Salem Essex Gazette,* May 18; and *New Hampshire Gazette,* June 18.[3]

With newspapers describing her as "the extraordinary Negro poetess," "the ingenious Negro poet," or "the extraordinary poetic genius," Robinson maintains that "Phillis' trip to London and the publication of her book there became something of colonial American and British media events."[4]

"The fact that they chose Wheatley news over much that was happening in those eventful days speaks for the young poet's appeal," Isani notes.[5] "Wheatley's departure, though a quiet one, was a newsworthy event."[6]

"It reflected how the young writer had become a local celebrity," echoes J. L. Bell.[7]

Phillis Wheatley's trip to London was so widely covered that Boston Customs Commissioner Henry Hulton, writing to a friend in England, alerted him to the imminent arrival of the young poet.

> There is a negro girl born in Africa going from hence to England by desire of Lady Huntingdon. She has shown a great genius for poetry and her works are to be published in

London. She is certainly an extraordinary instance of natural genius. She has only been eight or nine years from Guinea. I have not seen her but I am told she has read some of the best English books and translations from the ancients and that she converses upon them with great propriety.[8]

"Even after Phillis actually sailed on May 8, Mrs. Wheatley contrived to keep her name before the public," Robinson writes.[9] Newspapers throughout the northern colonies picked up her latest poem. The *Boston Post-Boy* published *Farewel to America, To Mrs. S.W.* on May 10, just three days after it was completed. Soon it was picked up by other colonial newspapers: "*Boston Evening Post*, May 10; *Boston News-Letter*, May 13; *Essex Gazette*, May 18; *Pennsylvania Packet*, May 24; *Connecticut Courant*, May 25; *Massachusetts Spy*, May 27; and *New Hampshire Gazette*, June 18."[10]

"In a particularly brilliant marketing move, shortly after Phillis Wheatley's departure Susanna Wheatley sent the poem and notice to the editor of the *London Chronicle*, where the poem appeared in July, coinciding with the young poet's arrival in London," says Wilcox.[11]

Mrs. Wheatley's letter to the editor was another effort to promote the author.

You have no doubt heard of Phillis, the extraordinary negro girl here, who has by her own application, unassisted by others, cultivated her natural talents for poetry in such a manner as to write several pieces which (all circumstances considered) have great merit. This girl, who is a servant to Mr. John Wheatley of this place, sailed last Saturday for London, under the protection of Mr. Nathaniel Wheatley: since which the following little piece of hers has been published here: the poem, Farewell to America, addressed to Mrs. Susanna W—. By Phillis Wheatley follows."[12]

"By the time Phillis Wheatley traveled to London in 1773 to publicize *Poems on Various Subjects Religious and Moral,* she and her mistress, Susanna Wheatley, were already familiar with the problems of selling these poems to the reading public," Wilcox writes. "They had learned the power of a good press release and *Farewell to America*, frequently accompanied by

an announcement of Wheatley's departure for England, spread the word about her journey."[13]

"Clearly," Mason asserts, "it was part of a publicity campaign in anticipation of the publication of Phillis's book."[14]

"It became the third Wheatley poem published outside America," writes Isani.[15] "With the possible exception of the elegy on George Whitefield, *Farewell to America* may be Phillis Wheatley's best known poem prior to publication of *Poems on Various Subjects* late in 1773."[16]

From the morning of May 8 and for the next forty-one days, Phillis Wheatley rode the high seas. Any time she came out on the deck of the ship she could look toward the distant horizon and see only vast blue ocean and boundless sky. Although she was accompanied by her master, Nathaniel Wheatley, along with Captain Calef and his ten-man crew, most of her time on the three-masted schooner, she was alone. There was nothing much for her to do. With no responsibilities aboard ship, how did she fill all that free time?

Most writers, given the luxury of nearly limitless hours, would go back to their writing. We might see her in her quarters, pouring over her manuscripts, rereading, revising, refining, sharpening phrases, reworking lines, seeking clearer ways to express her meanings.

Typically, writers about to deliver manuscripts for publication are suddenly gripped with a sense of urgency bordering on panic. Faced with the hard reality of the printed page, writers know that the words they have spent so much time manipulating, modifying, and nurturing, would become fixed and frozen, unchanged forever. Those words, now in print, would become the standard to be judged by the world. Like any writer, Phillis would want her poems to reflect her finest craftsmanship, demonstrating her most skillful and artistic effort.

"She was an exacting and picky writer," observes poet Rowan Ricardo Phillips.[17] "She knew precisely what she was doing in a poem and how she wanted to go about doing it."[18]

*Farewel to America* was one of the poems she continued to work on. "It was on board the *London Packet* that Wheatley revised her poem in preparation for adding it to the book that would appear in a few months," says Isani. "The revision appears to have been undertaken on a line by line basis.

The revised version generally shows a gain in clarity, vigor and directness. The book version is shorter by eight lines."[19]

The drive for excellence would mean new inspiration for Phillis and new poems for her upcoming book. "Certainly, the May 1773 dateline of *Farewel to America* suggests that Wheatley might have added poems to the collection as late as her arrival in London just a few months before the finished book appeared," maintains Wilcox.[20]

By the time Phillis arrived in London on June 17, 1773, advertisements for her upcoming book had already appeared two days earlier in the *Morning Post and Daily Advertiser*.[21] Two weeks later, the *London Chronicle* published *A Farewell to America*, along with Susanna Wheatley's cover letter.

Clearly, the main reason Phillis went to London was to promote her book and oversee its production. "Everything related to Wheatley's time in London suggests that a marketing mastermind lay behind its preparation and execution," says Carretta. "Phillis's owners were making an extraordinary investment in her celebrity and taking a considerable risk that her health and the ship would survive an always dangerous transatlantic voyage."[22]

Phillis brought a number of items with her, including several new poems to add to her manuscript. One important item she transported from Boston was her portrait requested by the countess. "Probably Wheatley carried the drawing to England when she went and it was engraved and printed there," says Mason.[23]

Also, she had a letter from Susanna Wheatley to the countess, requesting that she look after Phillis while the young poet was in London. "I flatter'd my self that your good advice and counsel will not be wanting," Mrs. Wheatley wrote. "I tell Phillis to act wholly under the direction of your Ladiship."

Mrs. Wheatley arranged for Phillis to buy appropriate apparel in London. "I did not think it worthwhile nor did the time permit to fit her out with cloaths," she told the countess, "but I have given her money to buy what you think most proper for her."

Since Mrs. Wheatley was paying for Phillis's new wardrobe, she made her preferences known. "I like she should be dress'd plain," she said, in keeping with New England Puritan tradition and Phillis's status as a slave.

Phillis would need a place to stay so Mrs. Wheatley asked "your Ladiship to advise my son to some Christian home for Phillis to board at."[24]

For part of her London visit, Phillis was a guest of the wealthy banker John Thornton, who wrote to a friend that "Phillis the African girl...was over lately from Boston and staid with me about a week."[25]

Thornton had known the Wheatley family for years, collaborating with them on many evangelical missions in America sponsored by the countess. He and Phillis had exchanged several letters.

During her stay with the Thorntons, Phillis developed a particularly fond rapport with their three children. "Please to give my best respects to Mrs. & Miss Thornton and masters Henry and Robert who held with me a long conversation on many subjects," she wrote to John Thornton after her return to Boston.[26] "I thank them for their kindness to me."[27]

After corresponding with Phillis by letter across the Atlantic, John Thornton finally had the opportunity to meet the young poet in person and was highly impressed. "She has surprising natural parts and they are sanctified by Grace," he told a friend.

Thornton went on to describe something of her extraordinary background. "She is indeed a prodigy. She was brot (sic) to Boston in 1761, being betwixt 7 & 8 and has been a slave in a family at that place ever since. With but a little aid she has made an uncommon progress in learning; writes an uncommon good hand, understands Latin, is conversant with scripture, very humble and teachable."[28]

Phillis was to deliver another letter to the countess. It was another glowing report from Richard Cary, a member of the countess's Connexion in Boston.

> This will be deliver'd Your Ladiship by Phillis the Christian Poetess whose behavior in England I wish may be as exemplary as its been in Boston. This appears remarkable for her humility, modesty and spiritual mindedness. I hope she will continue an ornament to the Christian name and profession as she grows older and has more experience. I doubt not her writings will run more in an evangelical strain. I think your ladyship will be pleas'd with her."[29]

The countess replied to Mrs. Wheatley on May 13, 1773. "Your little poetess (Phillis) remember me to her. May the Lord keep her heart alive with the fire of that other that never goes out."[30]

Shortly after she arrived in London, Phillis learned that the Countess of Huntingdon was not in London but at her home in Wales, recovering from a serious illness. Phillis wrote to the countess wishing her a speedy recovery and to make sure the countess knew how eager she was to convey her gratitude in person.

"It is with pleasure I acquaint your Ladyship of my safe arrival in London after a fine passage of 5 weeks," Phillis wrote from London on June 27. "I should think my self very happy in seeing your Ladyship, and if you was so desirous of the image of the Author as to propose it for a Frontispiece I flatter myself that you would accept the Reality."

> I conclude with thanking your Ladyship for permitting the dedication of my Poems to you; and am not insensible, that under the patronage of your Ladyship, not more eminent in the Station of Life than in your exemplary piety and virtues, my feeble efforts will be shielded from the severe trials of uppity criticism and, being encourag'd by your Ladyship's indulgence, I the more feebly resign to the world these Juvenile productions, and am Madam, with greatest humility, your Dutiful Huml Sert. Phillis Wheatley.[31]

Carretta called the letter to her esteemed patron "a model of tact, politeness and flattery," giving Phillis full credit for her skillful touch since "neither Susanna nor Mary Wheatley could have played a role in its composition."[32]

As relentlessly as Susanna Wheatley campaigned for the countess to meet Phillis, she also pushed for an audience for her son Nathaniel, hoping that while he was in London he would receive the benefit of her good counsel. "And as you are so dispos'd to promote the good of souls," she wrote to the countess, "I hope you will not be wanting in your advices to my Dear Son."[33]

Nathaniel Wheatley's trip to London was a mix of business and romance. Newly appointed as CEO of Wheatley Enterprises to replace

his retired father, his main responsibility was to manage their commercial interests. But he had other compelling reasons to be in London. He was there to court his future wife, "planning even then for his November wedding to Mary Enderby of the wealthy and successful mercantile London firm," writes Robinson.[34]

Phillis Wheatley's time in London was one of the most thoroughly documented periods of her life. The reason we have more details about her London visit than almost anything else about her is due to Phillis herself. She gave us a full report in her own words.

# CHAPTER 24

"The friends I found there among the nobility and
gentry, their benevolent conduct towards me,
fills me with astonishment."

ABOUT A MONTH AFTER SHE returned to Boston, Phillis
Wheatley sat down to write about her London experience. She listed the
names of prominent people she met and the amazing places she went. She
even described the wonderful gifts she received. Relating the story of her
adventures in London had Phillis gushing like a schoolgirl.

Phillis wrote two letters concerning her London trip. Her three-page
letter to Colonel David Wooster, a supporter in New Haven, Connecticut,
is "perhaps the most notable item in her extant correspondence," writes
Mukhtar Ali Isani. Professor Isani discovered the handwritten letter at the
Massachusetts Historical Society in 1979. "It illuminates this less-known
side of the poet and provides much-needed information on the climactic
year of her literary career."[1]

Even though she misspelled his name, addressing the letter to "Col.
Worcester," (Phillis used the New England spelling of the town of Worcester,
about fifty miles from Boston. The locals pronounce it "Wuhstah," an
understandable mistake with someone named "Wooster"), Mason insists
that "she knew him, or knew about him, well enough to engage him in the
business of her book."[2]

Phillis thought so highly of him that four years later, after Wooster was
killed in action during the Revolutionary War, she wrote an elegy, *On The
Death of General Wooster,* for his widow. That time, she got his name right.

Her letter to Wooster showed how profoundly the London adven-
ture changed her life. It was an exhilarating interlude that lifted her out
of her familiar day-to-day existence. Phillis was introduced to a new class
of influential people and astonishing scenes. She experienced breathtaking
cultural events that were not available to people from the colonies. Even

though her primary mission was to get her poems ready for publication, the demands on her time were overwhelming. So many prominent Londoners wanted to meet her, she was "treated like an exotic visiting celebrity," says Carretta.[3]

"When she was not correcting and/or revising the signatures of her manuscript, which had been in the printing process since before she left Boston, she was visiting and being visited by several of London's most famous personalities," Robinson explains.[4]

"The friends I found there among the nobility and gentry, their benevolent conduct towards me, the unexpected and unmerited civility and complaisance with which I was treated by all, fills me with astonishment," Phillis marveled to her friend Obour Tanner. "I can scarcely realize it."[5]

London was the cultural, intellectual and political capital of the British Empire. Poet and essayist Samuel Johnson, arguably the most distinguished man of letters in English history, once exclaimed to friend and biographer James Boswell, "Sir, when a man is tired of London, he is tired of life."[6]

Dr. Johnson celebrated the city's unmatched intellectual vitality. "I will venture to say, there is more learning and science within the circumference of ten miles from where we now sit, than in all the rest of the kingdom."[7]

Phillis Wheatley had never seen anything like it. The numbers gathered in the mobs she witnessed in Boston protests were dwarfed by the massive crush of humanity crowded into such a small space. "A million people swarmed in the metropolis by the end of the eighteenth century," claims British writer Peter Ackroyd.[8]

The population of Phillis Wheatley's Boston was then about 20,000.[9]

Visitors from colonial towns and villages found the London experience chaotic and confounding, a kind of culture shock. Wheatley friend Reverend Samsom Occom noted in his journal: "saw such confusion as I never dreamed of...cursing, swearing & damning one another...poor beggars praying, crying and begging upon their knees."[10]

New Yorker Ebenezer Hazard wrote: "Was so confused that I scarcely knew how to proceed or what to do. I felt as I had never felt before...You would have laughed to see me walk the streets of London. I walked as I had used to do at New York, but was soon convinced I was in an error, for half a dozen busy mortals on whose brow sat care and in whose face was

eagerness had like to run over me. I quickened my pace and was very near being knocked on the head by a porter with a heavy load. In short, I met with many difficulties."[11]

Dr. Johnson understood just how unsettling the city of London could be to a newcomer.

> Those who have past much of their lives in this great city look upon its opulence and its multitudes, its extent and variety, with cold indifference; but an inhabitant of the remoter parts of the kingdom is immediately distinguished by a kind of dissipated curiosity, a busy endeavor to divide his attention amongst a thousand objects and a wild confusion of astonishment and alarm.[12]

For Phillis, a stroll along London's old stone streets, teeming with every variety of human activity, could easily have become repulsive and appalling. As Dr. Johnson remarked, "The attention of a newcomer is generally first struck by the multiplicity of the cries that stun him in the street."[13]

No doubt her senses were bombarded by sights and sounds she never knew in Boston. Writes Ackroyd, "An eighteenth century traveler remarked that 'If towns were to be called after the first words which greeted a traveler on arrival, London would be called Damn it!'"[14]

> As London grew larger and noisier, the cries became louder— perhaps even, more desperate and more hysterical. From a distance of half a mile, they were a low, steady and continuous roar much like a fall of water; they became a Niagara of voices. But in the middle of the city, they were a great turmoil of notes.[15]

In his poem *London,* William Blake has his narrator wandering bleak London's streets wallowing in a vortex of despair: "And mark in every face I meet/ Marks of weakness, marks of woe... Infants cry of fear...Soldiers sigh...Harlots curse...new-born Infants tear."[16]

Walking among the multitudes, browsing in the shops, Phillis would certainly have been dazzled by "the innumerable occupations among which the thousands that swarm in the streets of London are distributed," and "the

variety of merchandize and manufactures which the shopkeepers expose on every hand."[17]

When Phillis visited people in their homes she would have noticed the extraordinary craftsmanship in their everyday objects, implements, and utensils commonly in use. Even the furniture, plates, cups, and tableware were works of art.

According to British historian A. N. Wilson:

> Though Londoners of the period lived cheek by jowl, many of them in abject poverty, none of them looked on anything that was visually ugly. The humblest tavern chair was well turned and chastely designed. The pewter or earthenware pot from which a poor man drank his ale had a simplicity of design that reflected the excellence of the apprentice system by which craftsmen learnt over many years how to make things that were visually satisfying and physically useful.[18]

Phillis may have marveled at the quality of her hosts' cabinets, cupboards, bureaus, tables, and chairs. At the time, Thomas Chippendale was producing his finely crafted pieces in his London workshop not far from where Josiah Wedgwood was creating his exquisite pottery and delicate ceramics.

Phillis probably noticed that many London homes had lush and flowery backyards. "A very distinctive and revealing feature of eighteenth century life is the garden," says Wilson. "This has, ever since the reign of the first three Georges, been a feature of London life—that Londoners have been able to look out on their own back gardens and on the multifarious back gardens of others".[19]

"What a merry morning it is!" wrote Fanny Boscawen in May 1795, from her house at 14 South Audley Street. "I set all my windows open and 'tis well I have some trees, whose leaves wave close by me and that at once I behold purple lilacs, white lilacs, yellow laburnums in my own or my neighbour's garden."[20]

In her excursions around the city, Phillis would surely have enjoyed some of the many natural parks. "By the late 1770's there were more than two hundred pleasure gardens in or around London," says Wilson.[21]

Vauxhall Gardens, on the south bank of the River Thames, was one of London's most popular leisure sites, a refuge where ordinary citizens could go for relaxation. People could meander along sculpted pathways among acres of trees and shrubs, while tightrope walkers, hot air balloonists, musicians, and fireworks displays entertained them.

Many of the best known musicians and singers of the day appeared at the Gardens. Handel had performed his rousing *Music for the Royal Fireworks* there for 12,000 Londoners twenty-four years earlier. If she wandered through the Gardens, Phillis would certainly have come across the marble statue of Handel erected to commemorate the occasion. In his biography of Dr. Johnson, James Boswell wrote:

> Vauxhall Gardens is peculiarly adapted to the taste of the English nation; there being a mixture of curious show, — gay exhibition, musick, vocal and instrumental, not too refined for the general ear; — for all of which only a shilling is paid; and, though last, not least, good eating and drinking for those who choose to purchase that regale.[22]

If Phillis went out after dark, she would have seen something extraordinary, nothing like the pitch-dark streets of Boston. "Not a corner of this prodigious city is unlighted," wrote a London journalist in 1784.[23]

"Light had become fashionable," writes Ackroyd. "Indeed, in the first decades of the eighteenth century, as part of the general 'improvements' in the condition of London, the illumination of the streets became of paramount importance. The Kensington Road, a notorious haunt of highwaymen, was the first to introduce oil lamps with glazed lights, as early as 1694."[24]

In his "Miscellaneous Observations and Reflections Made in a Tour Through London in December 1784," William Hutton described how hundreds of oil lamps flooded the streets with light. "They have everywhere a surprising effect; and in the straighter streets, particularly in the west end of the town and where these streets cross each other at right angles, the sight is most beautiful... The whole city enjoys a nocturnal illumination; the prospects are preserved and mischief prevented."[25]

In her jaunts around the town, Phillis was likely to see more black people than she'd ever seen before. "She joined the thousands of blacks already

resident in England," Carretta observes. "The estimated number of people of African descent living in England during the last quarter of the eighteenth century ranges from five to twenty thousand."[26]

The single most significant fact underlying Phillis Wheatley's London visit was the newly redefined legal status of slaves from the colonies. One year earlier Granville Sharp argued the Somerset case before the highest court in England and won the ruling granting that no slave brought to England from the colonies could be forced to return to the colonies.

For the twenty-year-old poet, enslaved as a child, her arrival in London could not have come at a more fortuitous moment. "Slaves who set foot on English soil were free and could, as James Somerset did, refuse to return to bondage in the colonies," writes Cima. "In London, she was legally free—as long as she stayed there."[27]

# CHAPTER 25

*"I take the freedom to transmit to you a short sketch
of my voyage and return from London."*

"SIR…" PHILLIS WHEATLEY BEGAN HER letter to Colonel
Wooster. "Having an opportunity by a servant of Mr. Badcock's who
lives near you, I am glad to hear you and your family are well."[1]

Clearly there had been prior communication between Phillis and
Wooster; she knew his family well enough to send her regards. There was
no mail service at the time, so people commonly used intermediaries. Phillis
passed her letter to Wooster through a slave belonging to his New Haven
neighbor who happened to be in Boston at the time.

This extraordinary document offers an intimate look into the most
pivotal weeks of her life. The letter highlights her cultural sophistication
and allows us a glimpse of her character. "She was precocious and extraordi-
narily mature for her years," Isani writes. "She also had a breadth of interest
and an inquiring mind."[2] The letter reveals "an ambitious and worldly-wise
woman, acquainted with notables of her time, and capable of unabashedly
representing her own interests."[3]

Of all her correspondence, this is certainly "one of her most personal
and secular in tone," Mason writes. "This is a letter of a young lady of about
twenty who has been made much of in the city of London and has seen 'the
world' and she still finds that heady enough to boast of."[4]

Her unbridled and genuine outpouring of enthusiasm suggests that
Phillis felt comfortable opening up to Wooster. "She understood that he
(unlike the more pious Tanner and Thornton) was a person who could
appreciate such worldly excitement as leaps from her frenetic account of
her London activities," says Mason. "She needed someone to share this
experience with who would understand it."[5]

"I take the freedom to transmit to you a short sketch of my voyage and
return from London," she told him.[6]

As she described her adventures in the greatest city in the English speaking world, she seemed to be riding an extended emotional high.

"The events described were fresh in Wheatley's mind," notes Isani.[7]

PHILLIS: "I was receiv'd in England with such kindness, complaisance, and so many marks of esteem and real friendship, as astonishes me on the reflection."[8]

"Phillis was instantly swept up into exciting whirlwind circles of visits to and from ranking English peers," says Robinson.[9]

According to Dr. Henry Louis Gates, "Phillis was the toast of London."[10]

Phillis identified some of the esteemed London gentry she met, "a varied group of political, religious, artistic, scientific, scholarly and abolitionist interests," notes Mason.[11]

PHILLIS: "Was introduced to Lord Dartmouth and had near half an hour's conversation with his Lordship, with whom was Alderman Kirkman."[12]

Meeting Lord Dartmouth was a remarkable opportunity for the young poet. During their half hour together, surely the Secretary of State for the Colonies spoke about the poem she had written for him the previous year. She also met John Kirkman, a prosperous silk merchant then serving in the city government.

It was while she was visiting Lord Dartmouth that she most likely saw the work of art that inspired her newest poem. English landscape artist Richard Wilson created three paintings based on the tale of Niobe and her children from Ovid's *Metamorphoses*. The Roman poet's epic narrative poem, completed in 8 A.D., remains one of the most widely read works of classical literature. Surely Phillis was familiar with the story of Niobe—that would explain her attraction to the painting.

Engravings from Wilson's paintings were popular in England at the time. Gwendolyn DuBois Shaw suggests that "while Wheatley was in London, she may have viewed one of Wilson's Niobe paintings in the collection of the Earl of Dartmouth."[13]

Her poem, *Niobe in Distress for her children slain by Apollo, from Ovid's Metamorphoses, Book IV, and from a view of the painting of Mr. Richard Wilson*, was one of her longest. As one of the last poems she wrote for her book, it was placed toward the end.

"She may not have composed the poem until after her arrival in London, which would push the date of the poem's composition to that summer," says Shaw. "It is unlikely that Wheatley saw the painting in person before she left for England in July 1773....There is no evidence that any of the three versions of Wilson's *Apollo Destroying the Children of Niobe* were ever in Boston or the American colonies during the eighteenth century."[14]

Phillis opened the poem with an invocation to the Muses, a prayer to inspire creative energy and glorious imagery.

> *Apollo's wrath to man the dreadful spring*
> *Of ills innum'rous tuneful goddess sing!*
> *Thou who did'st first th' ideal pencil give,*
> *And taught'st the painter in his works to live,*
> *Inspire with glowing energy of thought,*
> *What Wilson painted and what Ovid wrote.*
> *Muse! Lend thy aid, not let me sue in vain,*
> *Tho' last and meanest of the rhyming train!*
> *O guide my pen in lofty strains to show*
> *The Phrygian queen, all beautiful in woe.*[15]

Niobe, the main character of the narrative, was a proud woman who celebrated the joys of her seven sons and seven daughters.

> *Seven sprightly sons the royal bed adorn,*
> *Seven daughters beauteous as the op'ning morn*
> *From their bright eyes the living splendors play,*
> *Nor can beholders bear the flashing ray.*
> *Wherever, Niobe, thou turn'st thine eyes,*
> *New beauties kindle and new joys arise!*[16]

Niobe was so full of herself that she got into trouble. Foolishly, she ridiculed Latona because she had only two children, boasting that even if several of her children died she would still have more than Latona.

> *Round me what a large progeny is spread!*
> *No frowns of fortune has my soul to dread.*

*What if indignant she decrease my train*
*More than Latona's number will remain?*[17]

As punishment for Niobe's hubris, Latona's two children, the twin gods Apollo and Artemis, killed all of Niobe's sons and daughters.

*Niobe now, less haughty than before,*
*With lofty head directs her steps no more.*

*How strangely chang'd!——yet beautiful in woe,*
*She weeps, nor weeps unpity'd by the foe.*[18]

In a verse that would haunt her years later as the poet faced the heartbreaking loss of her own children, she wrote:

*On each pale corse the wretched mother spread*
*Lay overwhelm'd with grief, and kiss'd her dead.*[19]

During her time in London, Wheatley continued to work on her manuscript, refining her poems, adding to her numbers. "Certainly, the May 1773 dateline of *Farewell to America* suggests that Wheatley might have added poems to the collection as late as her arrival in London just a few months before the finished book appeared," Wilcox believes.

> If Wheatley was able to add poems to the collection up until the time it went to press, then it might be the case that the encouragement of a London publisher and her influential (and growing) British patronage gave her the confidence necessary for a creative efflorescence, particularly in her forays into the high literary realms of classical allusion, biblical paraphrase, and lyric exposition.[20]

She continued to list the dignitaries she visited.

PHILLIS: "Then to Lord Lincoln, who visited me at my own lodgings with the famous Dr. Solander, who accompany'd Mr. Banks in his late expedition round the world."[21]

Lord Lincoln was an Oxford-educated politician who married the daughter of the English prime minister. Botanist Dr. Daniel Solander

accompanied Captain James Cook on his famous three-year-exploration of the South Pacific.

PHILLIS: "Then to Lady Cavendish, and Lady Carteret Webb."[22]

These women were sisters, and devotees of the Countess of Huntingdon.

PHILLIS: "Mrs. Palmer a Poetess, an accomplish'd Lady."[23]

Mary Reynolds Palmer, sister of artist Sir Joshua Reynolds, was a published author who had written two books. However, Phillis was mistaken in calling her a poetess. Robinson notes that "Both are in prose."[24]

PHILLIS: "Dr. Thos. Gibbons, Rhetoric Professor."[25]

Thomas Gibbons was an English minister and longtime associate of the Countess of Huntingdon. The Wheatleys may have known him as one of the financial supporters of their friend Reverend Samson Occom. Gibbons was a poet and, like Phillis, he dedicated his only published book to the countess. After the death of George Whitefield, Gibbons wrote a poem in his honor. No doubt he had read Phillis's elegy to Reverend Whitefield. These two poets would find much to talk about.

Gibbons was so impressed by the African poet he noted the meeting in his diary. July 15, 1773: "Was visited this morning by Phillis Wheatley, a negro young woman from Boston in New England, a person of fine genius and very becoming behavior."[26]

PHILLIS: "To Israel Mauduit Esqr."[27]

This was one of Phillis Wheatley's most fortuitous connections. Israel Mauduit was a classical scholar and the London agent representing the province of Massachusetts Bay.

"Israel Mauduit goes unmentioned in most histories of England and the United States, for his part in the Revolution was a minor one, largely played behind the scenes," wrote Robert J. Taylor in *The New England Quarterly*.

> Still, he was well known to Lord North, George Grenville and Thomas Hutchinson and other men on both sides of the water. In modern parlance, Mauduit was both a contact man and a lobbyist, a go-between for those who had axes to grind or who needed help in getting a hearing from the Ministry or from members of Parliament.[28]

For American colonists, Israel Mauduit was one of the most influential officials in the British government. "Among the Tory clique in London, 'See Mr. Mauduit' was something of a by-word for those who had taken shelter there from the stormy rebellion overseas," says Taylor.[29]

Mauduit would have been sympathetic to Phillis and her plight. "Frequently," Taylor notes, "he refused money for his services when he thought the cause was just."[30]

As a scholar, Israel Mauduit had the respect of his peers and was chosen to be a Fellow of the Royal Society. The Royal Society, a prestigious association of scientists, physicians and natural philosophers founded in 1660, is the oldest scientific society in existence. Today, FRS members include such giants as naturalist Charles Darwin, philosopher Bertrand Russell, physicist and Nobel Prize winner Albert Einstein, founder of psychoanalysis Sigmund Freud, DNA discoverer Francis Crick, and American molecular biologist James D. Watson.

Phillis Wheatley may have heard of several celebrated members of the Fellowship of the Royal Society: botanist and zoologist Carl Linnaeus, philosopher John Locke, and physicist, mathematician, and astronomer Sir Isaac Newton.

Another member of the Fellowship of the Royal Society whom Phillis Wheatley had the opportunity to meet was Benjamin Franklin. His groundbreaking experiments with electricity led Franklin to become one of the first Royal Society members from the colonies.

Phillis noted the meeting by mentioning his name and his honorific titles. "Benjamin Franklin Esqr. F.R.S," she wrote.[31]

Robinson suggests that Susanna Wheatley was largely responsible for arranging the poet's meeting with Franklin. It came about, he says, because "Mrs. Wheatley's promotion of Phillis did not cease." After Phillis sailed for London, she continued to pursue every opportunity to campaign for her protégée. "She urged Jonathan Williams, a Boston neighbor, to mention Phillis in his letters to his uncle-in-law, Benjamin Franklin, colonial agent for Pennsylvania, then in London," he writes.[32] "Jonathan Williams in turn urged his celebrated uncle-in-law Benjamin Franklin to visit with Phillis in London."[33]

Dr. Franklin, then one of the most famous of all Americans, had been

in London since 1757 representing the interests of the colonies. After meeting Phillis Wheatley in the summer of 1773, he wrote to his nephew. "Upon your recommendation," he said, "went to see the black poetess and offer'd her any services I could do her."[34]

It turned out to be a strange meeting. Robinson theorizes that "Phillis may never have learned that Franklin had been indeed perturbed."[35]

"Before I left the house," Franklin told his nephew, "I understood her Master was there and had sent her to me but did not come into the room himself, and I thought was not pleased with the visit. I should perhaps have enquired first for him, but I had heard nothing of him. And I have heard nothing since of her."[36]

Professor Eric Ashley Hairston noted that "Wheatley traveled with her owner's son, Nathaniel, who has remained largely voiceless in the critical history surrounding Wheatley and her Poems. He was so voiceless that Benjamin Franklin expressed annoyance that, during his visit with Phillis Wheatley, Nathaniel did not come downstairs to greet him."[37]

Clearly, the reason for Franklin's ire had to do with the actions of Nathaniel Wheatley. It wasn't about Phillis—rather, it was Nathaniel Wheatley's standoffish behavior that made Franklin think he had offended Phillis's owner in some way. Apparently, Franklin believed that Mr. Wheatley did not approve of him visiting his slave.

"Some have suggested that the question of Wheatley's liberty was so uncertain in the aftermath of the Somerset legal decision that Nathaniel was not comfortable meeting with Phillis' visitors in England," Hairston explains. "Wheatley's reputation and open discussions of slavery in England might well have exposed him to difficult inquiries about her."[38]

Isani agrees. "Nathaniel Wheatley's aloofness toward him [Franklin], which he goes on to mention, was perhaps the result of the young man's nervousness at having brought a famous slave to England so soon after the Somerset decision."[39]

Perhaps Franklin was uncomfortable in the presence of an educated and articulate woman; it was something quite rare for the time and seemingly impossible for a slave. Certainly, Franklin had never met a slave remotely like Phillis Wheatley. Her very presence may have unsettled him.

Franklin was notoriously ambivalent about slavery. A slave-owner

himself, he carried advertisements for the sale of slaves in his newspaper, the *Pennsylvania Gazette*. "When Phillis Wheatley met Franklin, she may also have met his slave, Peter, whom he had brought with him to England," says Carretta. "King, the other slave he had brought to England, ran away two years after arriving there. Franklin took Peter with him back to America in 1775 where he remained his slave."[40]

However, as an old man, shortly before he died, Franklin published several essays supporting the abolition of slavery. In the first Congress after ratification of the United States Constitution he introduced a petition to "devise means for removing the inconsistency from the character of the American people," and to "promote mercy and justice toward this distressed race."[41]

No matter what Benjamin Franklin thought about their meeting, it delighted Phillis Wheatley. "Phillis was pleased and flattered that Benjamin Franklin had visited with her in her London apartment," writes Robinson.[42] She was so impressed by the meeting that several years later she dedicated her proposed second volume of poems to "The Right Honourable Benjamin Franklin."[43]

The next person she met was "Mr. Brook Watson."[44]

Brook Watson was a prosperous businessman and one of the founders of Lloyds of London. He had actually grown up in Boston, where he lived with an aunt and uncle after his parents died, although he left before Phillis arrived. Later he would serve as a member of Parliament and Sheriff of London. In 1796 he became London's Lord Mayor.

Finally, Phillis revealed the most fateful and consequential contact she made during her time in London: "Grenville Sharp Esqr."[45] Isani described him as "her chaperon" and "a friend of the slaves," the "dedicated laborer behind the Somerset decision of 1772" and "also an advocate of the cause of the American colonies."[46]

The Mansfield ruling made it impossible for colonial slave owners to bring their human property to London and expect them to return. Phillis Wheatley could not have found a more passionate and potent enemy of slavery in Britain than Granville Sharp.

# CHAPTER 26

### "I was no more than six weeks there."

WHEN PHILLIS TOLD HER FRIENDS about her trip to London she turned absolutely giddy. Just thinking about her experience "fills me with astonishment," she raved to Obour Tanner. "I can scarcely realize it."[1]

"Phillis's brief month-and-a-half visit in London was one of the most exciting times of her short life," says Robinson.[2] To Phillis it must have felt like she was living in a dream.

Her hosts kept her constantly entertained, treating her to all the high-lights London had to offer. Many of the sites she visited are considered tourist attractions to this day. The detailed itinerary of her London travels that she disclosed to Colonel Wooster started with an eventful outing to the Tower of London. Her escort was the abolitionist hero of the Somerset decision, Granville Sharp.

PHILLIS: "Grenville Sharp Esqr. who attended me to the Tower & Show'd the Lions, Panthers, Tigers, &c. the Horse Armoury, small Armoury, the Crowns, Sceptres, Diadems, the Font for christen-ing the Royal Family."[3]

The Tower of London was home to one of the world's oldest zoos. The wild animals of the Royal Menagerie had been kept at the Tower of London since the reign of King John in 1210 and had grown continually from gifts of exotic animals given by foreign diplomats. By the eighteenth century it had become a popular tourist attraction. The admission price was three half-pence. Visitors to the Royal Menagerie could see strange beasts, some they had never seen before: lions, tigers, elephants, kangaroos, leopards, panthers, grizzly bears, baboons, boa constrictors, anacondas, condors, ostriches, and a gigantic crane. By 1828 the London Zoo housed over 280 animals representing at least sixty species.[4]

To enter the zoo Phillis had to cross a stone causeway spanning the moat built by Edward I in 1283. She would proceed over a drawbridge at the Lion Gate "distinguished by a painted Lion placed over the door of the

building, for the purpose of attracting the notice of strangers," according to an early nineteenth-century guidebook.[5]

During her visit to the Horse Armoury, Phillis would have seen actual armor used from the fifteenth through the seventeenth centuries. The exhibit featured the figure of a large mounted knight in full armor, his lance held ready for tilting. She could browse through rows of showcases containing richly ornamented helmets, spurs, and stirrups. There was a brass gun belonging to Charles I, armor worn by James II, and a small cannon made for Charles II when he was a boy.

She beheld the great Crown Jewels, housed in the Tower of London since the reign of Henry III in the thirteenth century. Phillis could admire some of the finest gems known to the world—the shining ruby given to the Black Prince by Peter the Cruel after the battle of Navarette in 1367, the same ruby worn on the helmet of Henry V at the battle of Agincourt in 1415 and later in the Queen's Crown for the coronation of Mary II with William III in 1689.

She most certainly saw the glittering pearls and diamonds on the gold crown made for the coronation of Mary of Modena, the queen and wife of James II in 1685. There was St. Edward's Staff, a golden scepter more than four feet long, symbolizing the temporal authority of the British Crown under the Cross, originally made for the coronation of King Charles II in 1661 and held by the monarchs during every coronation thereafter.

Phillis said she saw the Royal Baptismal Font and Basin of silver-gilt made for Charles II in 1660 and later used for the christening of princes and princesses in the royal family. Phillis was probably told by her guide that although King George III himself was not baptized in this font, it was used for his children, including his son, born in 1762, who would become King George IV in 1820.

Certainly, she heard the London Tower ghost stories: Anne Boleyn, beheaded in 1536 for treason against Henry VIII, supposedly seen carrying her head under her arm; the spirits of the two Princes, the only sons of King Edward IV, nine and twelve years old, supposedly murdered by their Lord Protector, the future Richard III in 1483; and the ghosts of Henry VI, Lady Jane Grey, and Lady Margaret Pole, the niece of King Edward IV and King Richard III.

PHILLIS: "Saw Westminster Abbey, British Museum, Coxe's Museum, Saddler's Wells."[6]

Westminster Abbey offered a deeply moving experience for the pious young woman. As she approached the imposing structure, the two white stone towers guarding the entrance would have been an overwhelming sight. At 225 feet they dwarfed the wood frame of the Old South Church and its 183-foot steeple. It was the tallest building she would ever see.

We can imagine Phillis meandering through the medieval halls and chapels, her footsteps echoing off the cold stone floors. Looking up, she would marvel at the soaring gothic arches, ribbed vaulting, and flying buttresses high overhead. Every shiny polished marble surface featured intricate carvings. The stained glass rose window, completed in 1722, would have inspired a sense of awe with its detailed designs and brilliant colors.

She could easily picture herself worshiping under such a richly ornamented ceiling a hundred feet over her head, imagining that her prayers would reach the heights of heaven.

As a lover of art, Phillis would have enjoyed the stunning wall paintings all over the Abbey—a thirteenth century picture of Christ with St. Thomas and St. Christopher, and a series of paintings of the Apocalypse and the Last Judgment from the fourteenth century.

Even then, Westminster Abbey was regarded as an architectural masterpiece and cultural touchstone, presenting the rich pageant of British history. Phillis would have learned that every monarch since William the Conqueror in 1066 had been crowned in the Abbey, including the current King George III in 1761. When his father, George II, died in 1760, he was buried in a vault at Westminster Abbey beside his beloved Queen Caroline. Phillis may have heard that the king's last wish was to have the sides of their coffins removed so their dust could mingle after death.

A special joy for the young poet would be the famous Poets' Corner in Westminster Abbey, where many of the finest English poets, playwrights, and writers were buried and memorialized.

We can almost see Phillis Wheatley strolling through Poet's Corner, absorbing the significance of the scene, thrilled to walk among the literary giants honored there. She would stop at the final resting place of Geoffrey Chaucer, author of *The Canterbury Tales,* considered "The Father of English

Poetry," who was buried there in 1400. The inscription in Latin, etched in marble, would challenge Phillis's Latin skills. Translated into English, the inscription reads:

> *Of old the bard who struck the noblest strains*
> *Great Geoffrey Chaucer, now this tomb retains.*
> *If for the period of his life you call,*
> *the signs are under that will note you all.*
> *In the year of our Lord 1400, on the 25th day of October.*
> *Death is the repose of cares.*[7]

After Elizabethan poet Edmund Spencer died in 1599 and was buried near Chaucer, the "Poets' Corner" was established. His 1620 memorial reads:

> Heare Lyes (expecting the second comminge of our Savior Christ Jesus) the body of Edmond Spencer, the Prince of Poets in his Tyme, whose Divine Spirit needs no other witness then the works which he left behind him.[8]

Phillis may have lingered at the monument to John Milton, author of *Paradise Lost,* who died in 1674 and was buried at a nearby church. It was not until 1737 that a memorial to Milton was erected at Westminster Abbey. Phillis could view the grey and white marble bust of the poet above a relief depicting his vision of heaven and hell, featuring a lyre among palm branches and a snake with an apple in its mouth.

When Phillis stood before the memorial of William Shakespeare, she would certainly have bowed her head in silent admiration, as so many others had before her. After Shakespeare died and was buried in his hometown of Stratford-upon-Avon in 1616, his life-size white marble statue was added to the Poets' Corner in 1740. The Latin text, inscribed in gold above the head of the statue, translates as: "William Shakespeare, 124 years after death by public esteem."

She could study the standing figure of the Bard, right leg crossing in front of his left, his elbow leaning on a pile of books. At the base of the pedestal she would see the carved heads of Queen Elizabeth I, Henry V, and Richard III.[9]

At some point during her tour of Poets' Corner, Phillis may have wondered: where was Alexander Pope, her favorite English poet? She regarded Pope as her mentor and teacher; she fell in love with his poetry and studied it. But at the time of Phillis's visit, there was no sign of Alexander Pope at Westminster Abbey. Surely, it had to be surprising to her that one of England's greatest poets would be missing from Poets' Corner and she may have wondered why.

One reason for Pope's exclusion may have been that he was Catholic in Protestant England. After he died in 1744, Pope was buried at St. Mary's Church in Twickenham, beside his mother. In 1761 a friend erected a monument near his grave with the inscription: "To one who would not be buried in Westminster Abbey."[10]

It was not until 1994 that Alexander Pope was honored at Westminster Abbey. A line from one of his verses was featured in a new stained glass window above Chaucer's monument.

What London visit would be complete without a night at the theater? Phillis's hosts took her to Sadler's Wells, one of the most popular entertainment centers in town. It opened as a "Musick House" in 1683, just outside the city near a spring known since the Middle Ages for its miraculous healing power. Owner Richard Sadler advertised the spring's amazing properties, claiming the waters were effective against "dropsy, jaundice, scurvy, green sickness and other distempers to which females are liable, ulcers, fits of the mother, virgin's fever and hypochondriacal distemper."[11]

Londoners came by the hundreds to sample the medicinal healing of Sadler's Wells. Sadler turned impresario and arranged musical shows for the crowds. In 1684, a popular song celebrated the Musick House for "'sweet gardens and arbours of pleasure' filled with the airs of pipe, tabor and dulcimer."[12] Performances at Sadler's Wells ran during the summer season and were so popular they built a new stone theater in 1765.

"Everything was done to attract the public," writes British actor Dennis Arundell. "The theatre was newly decorated and the orchestra enlarged. A seat in a box plus a pint of Port, Lisbon, Mountain or Punch, was 3s.; one in the pit 1s. 6d. and in the gallery, 1s."[13]

Phillis came to Sadler's Wells for an evening of "light entertainment," what we would consider "cabaret" or old style "vaudeville," featuring songs,

dances, comedy skits, and acrobatic feats. "The weight of her prestige and piety did not inhibit the nineteen-year-old from tasting of the novel and the profane," says Isani.[14]

"At Sadler's Wells...the plays thrown in were necessarily...trivial and trumpery in character—mere sketches, in fact, while songs, dances and turns of every description formed the staple of the entertainment," said one nineteenth century critic.[15]

A Sadler's Wells playbill from May 24, 1773 listed some of the acts Phillis may have seen that summer, including "various pleasing and surprising performances in ladder dancing...vocals, tumbling and rope dancing."[16]

The featured performance Phillis probably attended was a "new entertainment" written by popular singer-songwriter Charles Dibdin. "For 1773 he wrote *Vineyard Revels or Harlequin Bacchanal* with specially designed scenery," says Arundell, who reported that it "was received by a crowded audience with universal applause."[17]

The show began with a rousing opening number sung by a full throated chorus:

> *Come away! Come away!*
> *Sons of Rapture, come away!*
> *Laugh and love and sport and play,*
> *This is Bacchus' holiday!*

A solo by the character Silenus set the uproarious and slightly naughty tone for the evening:

> *Ever banish'd till to-morrow,*
> *Be the thought of pain and sorrow.*
> *Bacchus, child of Jove, to thee,*
> *All the present I decree.*
> *In thy still replenished bowl,*
> *Let me leave my thirsty soul.*
> *Bid thy wreaths my temples twine;*
> *Give me rivers, floods of Wine!*[18]

About the time of Phillis's visit, one Sadler's Wells reviewer defended the show from the snobbery of the elite classes:

> *The nice coxcomb, and the beau*
> *Say all its phizgigs are so so.*
> *The entertainment's horrid low.*
> *May all such false refiners swing,*
> *And every British spirit sing*
> *Of Sadler's Wells.*
> *God save the King.*[19]

As she sat laughing and clapping with the audience, Phillis had to have been thoroughly enchanted by the electricity of live theater. "They understandably dazzled the young woman from the colonies who had never before seen a performance on stage," says Carretta.[20]

Undoubtedly, the highlight of her London visit was a tour of Cox's Museum, "the most elegant of eighteenth century London exhibitions in respect to both contents and clientele," writes art historian Robert Altick. "The museum was the talk of London for three full years."[21]

"Londoners poured into the three daily shows," says New York Metropolitan Museum of Art historian Clare Le Corbeiller.[22]

James Cox promoted himself as creator of a "Great Variety of Curious Wares in Gold, Silver and other Metals, Also, Amber, Pearl, tortoiseshell and Curious Stones."[23]

His specialty was producing intricate and elegant automata, complex self-operating machines such as watches, clocks, and mechanical curios whose uncanny movements seemed to make them come alive. There is no evidence that Cox himself ever made any of the elaborate pieces displayed under his name. He was an entrepreneur who employed between eight hundred and a thousand craftsmen to design and build a stunning variety of distinctive "toys," or "sing songs" as they were called.

James Cox rose to sudden fame in 1772 when the emperor of China, fascinated by his lavishly ornamented mechanical creations, acquired nearly all his inventory. According to Le Corbeiller, "From 1772 to 1775 Cox's Museum, exhibited at the Great Room in Spring Gardens near Charing Cross, was the rage of fashionable London."[24]

Cox featured "automatons that were also splendid works of art," says Altick. "They included gigantic examples as much as sixteen feet in height" of what were called "self-acting 'bijoux'" (delicate ornamental pieces of fine workmanship), which were "the special province of Cox's Museum." The exhibition was "so memorable that for many years the building was customarily identified as 'The Great Room, Spring Gardens, formerly Cox's Museum.'"[25]

According to Le Corbeiller, the elaborate catalogue Cox printed for the museum described "twenty-three mechanical objects, all originally designed for the China trade (and perhaps duplicates of those recently added to the emperor Ch'ien Lung's collection). Displayed in a room hung with crystal chandeliers and crimson curtains, the pieces—which ranged from nine to sixteen feet in height—were enclosed by white and gilded balustrades."[26]

The most striking creation was a life-sized copper figure of a gardener's boy whose hat was crowned with a large silver-gilt pineapple that concealed musical chimes; when the chimes played the pineapple suddenly burst open, revealing a nest of young birds being fed pearls by their mother fluttering among them until the chimes finished and the pineapple closed up.

"This piece was the principal wonder of the tour," says Le Corbeiller, "which concluded with a performance of "God Save the King" by a mechanical band of kettledrums, trumpets and an organ while curtains parted to reveal portraits of George III and Queen Charlotte."[27]

In May 1773, Cox added thirty-three more pieces, including this one described in his catalogue:

> The piece is a cabinet, one of a pair, of the finest and most beautiful red onyx: it is overlaid and mounted in every part with ornaments of gold, richly chased in festoons of flowers and other fine designs. In the front are folding doors lin'd with mirrors, which when opened, discover the draws of the Cabinet; the upper draw contains the key of a most curious time piece, which when wound up gives motion to a sphere of gold, revolving on its axis during the going of the time-piece. At the corners of the Cabinet are golden vases fill'd with flowers of pearls and jewellers' work, above which, on spiral springs

of temper'd gold, are insects that move with the smallest touch as if hovering over the flowers; above the sphere is a larger nose-gay suitable to those at the corners and terminating the whole. In the bottom part of the Cabinet is a most curious chime of bells, playing various tunes; at the four corners are four bulls that support it; they stand on a gilt rock, in the front of which is a cascade and running stream of artificial water, where swans are seen swimming in contrary directions; at the corners of the rocks are Dragons with extended wings.[28]

This exquisite cabinet is currently on display at New York's Metropolitan Museum of Art. "The Museum's cabinet is no longer, alas, supported by dragons and swimming swans and the mirrors and 'fine instruments and essence bottles' are now missing," says Le Corbeiller, but "it matches the description in other details."[29]

"A visit to Cox's Museum, the air filled with the warble of mechanical birds and the many-voiced tinkle and clangor of splendidly elaborated clocks, was an experience not to be missed," writes Altick.[30]

"Its contents were valued at the astounding sum of 197 pounds, equivalent to approximately 26.4 million dollars in today's money," Carretta notes. "Someone other than Phillis presumably paid the 10 shillings, 6 pence (equivalent today to about $66) for her admission ticket to Cox's Museum."[31]

James Boswell visited Cox's Museum on April 6, 1772, soon after it opened. "The mechanism and rich appearance of the jewels were both very wonderful and very pleasing," he reported to his friend Samuel Johnson, who agreed that "it was a very fine exhibition."[32]

Phillis mentioned other places she visited: "Greenwich Hospital, Park and Chapel, The Royal Observatory at Greenwich." But she ended the account of her London escapades with a hint that much more happened than she was willing to say. "&c. &c," Phillis summed up her astounding adventures, "too many things & places to trouble you with in a letter."[33]

# CHAPTER 27

"The ship is certainly to sail next Thursday on which
I must return to America."

FORTUNE SMILED ON THE YOUNG woman W. E. B. Du Bois
called "Phillis the Blessed."[1] She found doors opening all around her lead-
ing to boundless opportunity. In Boston and London, Phillis Wheatley
hobnobbed with some of their most eminent citizens, scholars, clergy,
political leaders, and wealthy elite. She received a crash course in cultural
enrichment that was rare for a woman and unheard of for a slave.

But the real marvel of Phillis Wheatley is the effect she had on the reli-
gious and cultural notables around her. She attracted a small army of men-
tors, supporters, advocates, and patrons who showered her with tangible
signs of their favor. By sheer talent and intelligence, her sublime character,
and personal charm, she was able to inspire these luminaries—all white
men—to champion her cause.

Some of the prominent dignitaries Phillis met in London gave her
gifts. Phillis wrote:

- "The Earl of Dartmouth made me a compliment of 5
  Guineas and desir'd me to get the whole of Mr. Pope's
  Works, as the best he could recommend to my perusal.
  This I did."

- "Was presented with a Folio Edition of Milton's Paradise
  Lost, printed on a Silver Type, so call'd from its elegance
  (I suppose) by Mr. Brook Watson, Mercht., whose Coat
  of Arms is prefix'd."

- "Also got Hudibrass, Don Quixot & Gay's Fables."[2]

"Most of the books she mentions acquiring are extant," says Mason.
"The five volumes of Pope's translation of *The Iliad* are at Dartmouth

College and his four volume translation of *The Odyssey* and the nine volumes of Pope's own writing are at the University of North Carolina at Charlotte."[3]

Book lovers like to sign their books as a way of personalizing them, and Phillis was no different. "Each volume is inscribed by Phillis," says Robinson.[4]

She cherished her books and was clearly pleased and honored to receive them from such prominent people. "Each one of the handsome eighteen volumes," according to Mason, was "identified by her as from Dartmouth's gift to her."[5]

Other books were addressed to Phillis and signed by delighted donors. Robinson notes "The London 1770 edition of *Don Quixote*, inscribed 'The Earl of Dartmouth/ to Phillis Wheatley/ London, July 1773,' is at the Schomburg Center for Research in Black Culture."[6]

The 1770 edition of John Milton's *Paradise Lost* given to Phillis is currently in the possession of Harvard University. On the flyleaf is written: "Brook Watson to Phillis Wheatley/ London, July 1773." On the lower right-hand side is another note: "This book was given by Brook Watson, formerly Lord Mayor of London, to Phillis Wheatley—and after her death was sold in payment of her husband's debts. It is now presented to the library of Harvard University at Cambridge by Dudley L. Pickman, of Salem, March 1824."[7]

*Hudibras* is a narrative poem by Samuel Butler published in three parts from 1663 to 1678. Butler wrote it as satire, mocking the fanaticism, pretentiousness, and hypocrisy of Oliver Cromwell and the Puritans during the seventeenth-century English Civil War. Butler's hero, Hudibras, was a Presbyterian knight who roamed the English countryside with his trusted squire Ralpho, a literary device borrowed from Cervantes' *Don Quixote*. Throughout their adventures they constantly squabble over religious questions and generally behave like ignorant buffoons. *Hudibras* was so popular that pirated copies circulated throughout England.

John Gay, who wrote his *Fifty-one Fables in Verse* in 1727, was an English poet and friend of Alexander Pope.

Mason points out that "there is a book which she acquired during her London visit which is not mentioned in this letter or elsewhere by her, but

which has now turned up at the Essex Institute—a copy of Granville Sharp's *Remarks on Several Very Important Prophecies in Five Parts*, (London, 1768), in which she wrote 'To Phillis Wheatley from the Author' and he wrote his name and 'London July 21.'"[8]

This impulse to furnish her with books, particularly some of the greatest classics of the English-speaking world, was a recurring theme in her young life. Studious Phillis deeply appreciated her growing personal library, relishing the opportunity to open her inquiring mind to the highest levels of culture. She expressed her gratitude for such "kindness, complaisance" and "so many marks of esteem and real friendship."[9]

How did Phillis Wheatley manage to inspire these prominent men, pillars of society, to open their hearts to her? We can't know what transpired in their private conversations. We can only presume that she brought a kind of natural sweetness and magnetism to their interactions. This much is clear: she possessed something we might call charisma.

In her dealings with the crème of English society, the greatest personal asset Phillis could offer, along with her poetic heart and literary artistry, was her own self. For almost the entire time she was in London, Phillis was on her own.

Professor Hairston notes that "Susanna Wheatley was not in London with Phillis Wheatley as she made the grand tour of private parlors and tourist sights. Neither was Selina Hastings." Even Nathaniel Wheatley, her legal owner, kept a low profile while she was busy cultivating a wide variety of relationships with London's privileged class. He concludes that "Whatever advances Wheatley made by diplomacy, charm, wit, guile and intelligent conversation, were her own."[10]

What was it about Phillis Wheatley? Her sharp intelligence? Her verbal brilliance? Her genial nature? Her joyous smile? The twinkle in her eye? Whatever it was, prominent men on both sides of the Atlantic fell under her spell. At a time when millions of her fellow Africans were cruelly enslaved and dehumanized, why did so many white men show such gratuitous kindness to a young slave woman? What was their motivation?

One thing they shared was a strong revulsion for the institution of slavery. Many were faithful Christians who believed the admonitions of the Bible in Acts 20:35 that "it is more blessed to give than to receive." These

men read Phillis's poetry and admired her literary gifts. They had met with Phillis and conversed with her. The men were certainly in a position to know the real Phillis Wheatley as she was.

Whatever their reasons, these honorable men of Boston and London gave the slave Phillis Wheatley such a powerful boost to her budding literary career that her legal status as a piece of property would soon change.

"Her facility in charming and using British and American elites indicates that, beyond the notoriety her classical applications gained, her study authorized her to live and write in a fashion unimaginable to black slaves and most whites," writes Hairston.[11]

"Literacy, as Wheatley's life demonstrated, established a path to freedom, a path which was, at least in Wheatley's case, dependent upon being visibly intelligent," says Cima.[12]

Several weeks into her London stay, the poet received important news she had been waiting for. The Countess of Huntingdon sent a message through an intermediary that she would be pleased to grant Phillis an audience. She was invited to visit the countess at her estate in South Wales, where she was recuperating from illness.

Phillis received another message from a friend, this one bestowing an even greater honor. "Several of Phillis's London acquaintances are said to have begun preparations for her to be presented to the King and Queen of England," Robinson writes.[13]

She never did meet King George III. Four weeks after she arrived in London, Phillis was told that it was time to return to Boston. On July 17 she wrote to the countess informing her of the unfortunate news.

> Madam, I rec'd with mixed sensations of pleasure & disappiontment your Ladiship's message favored by Mr. Rien acquainting us with your pleasure that my Master & I should wait upon you in So. Wales, delighted with your Ladiship Condescention to me so unworthy of it. Am sorry to acquaint your Ladiship that the Ship is certainly to Sail next Thursday[on] which I must return to America.

Phillis emphasized that she was "extremely reluctant to go without having first seen your Ladiship."

I rejoice with your Ladiship in that Friend of Mental Felicity which you cannot but be possessed of, in the consideration of your exceeding great reward. My great opinion of your Ladiship's goodness, leads to believe, I have an interest in, your most happy hours of communion, with your most indulgent Father and our great & common Benifactor.

With greatest humility I am most dutifully Your Ladiship's obed't Sevt.

Phillis added a revealing postscript. "My master is yet undetermined about going home," she said "and sends his dutiful respects to your Ladiship."[14]

When Phillis made the return trip from London to Boston, she traveled alone. "Nathaniel did not return with Phillis," says Robinson. The young businessman, still pre-occupied with "planning even then for his November wedding to Mary Enderby of the wealthy and successful mercantile London firm," remained in London for more than a year, returning to the colonies with his bride in September 1774.[15]

Why did Phillis end her London trip so abruptly? Some Wheatley historians theorize that Phillis received a summons to come home because Susanna Wheatley was seriously ill and, as her slave, she was bound to obey. Unfortunately, there is no direct evidence to support this notion.

When Phillis wrote her letter to the countess on July 17, she knew she would be sailing for Boston "next Thursday." At the time she wrote the letter she had been in London for 29 days (four weeks). Typically a transatlantic voyage took about six to eight weeks. In order for a letter from the colonies to reach her in London it would have had to be sent from Boston shortly after she departed on May 8. Therefore it is highly unlikely that she received a message from Boston while she was there.

The explanation Phillis gave to the countess was that she would be returning to America because "I long to see my friends there."[16]

We may never know the real reason for her quick departure. Carretta reminds us that Captain Calef's primary purpose for the trip was "to acquire goods as soon as possible for the Boston market and to set sail for home as quickly as he could." As the ship's captain, he would have been "keen to

leave before the onset of the hurricane season." Otherwise, it would "force him to delay his departure for months," which would have been a financial disaster. Carretta suspects that "The timing of Phillis' return voyage had probably been planned before she left Boston."[17]

The key to understanding the circumstances of Phillis's departure from London rests with the most profound and explosive issue of the time—slavery and freedom. Lord Mansfield's 1772 ruling in the Somerset decision was in force; while she was in London Phillis Wheatley was a free woman.

"Was Wheatley aware of the status of slavery in England before she reached London on June 17, 1773?" Carretta asks. "Colonial newspapers, including ones that had advertised and published Wheatley's poems since 1767, were reporting and discussing the possible significance of the Mansfield decision by the end of the summer of 1772...."[18] Given the press coverage," he notes, "Mansfield's judgment was ... almost certainly known to Phillis Wheatley and her owners."[19]

Sometime before May 8, 1773, when Phillis boarded the ship to London, one of the Wheatleys would have had to sit down with Phillis to discuss her upcoming trip. A transatlantic voyage was a dangerous enterprise. There were logistics to discuss, plans to formulate. It is unthinkable that before departing Phillis and Susanna Wheatley would not have talked about the London trip.

We can imagine how the conversation might have gone. The two women are alone, sitting together in the family's common room, or in the kitchen, or perhaps even upstairs in Phillis's room. Susanna would dutifully inform Phillis of the arrangements she had made for the trip. After all, the Wheatleys were footing the bill. They would have to discuss when she would leave, where she would stay, and what she should wear. Like any young woman traveling abroad, Phillis probably heard the lecture about how to conduct herself.

Perhaps a moment in the conversation became emotional when both women realized the enormous consequences of this trip. They had to acknowledge the real possibility that Phillis would not return, that under English law Phillis might remain in London as a free woman.

"Susanna mourns," Phillis wrote while admitting at the time that she

also became deeply emotional. "Nor can I bear/To see the crystal shower/ Or mark the tender falling tear/At sad departure's hour."[20]

In that private moment, what could they say to each other?

It is not far-fetched to suppose that Phillis reached an understanding with the Wheatleys, forging an agreement that would change her legal status. As entrepreneurs who routinely dealt in cost/benefit analysis, the Wheatleys had to consider that offering Phillis her freedom would give her a powerful incentive to return to their King Street house in Boston.

For her part, Phillis Wheatley was certainly astute enough to realize that she was in an advantageous position. The law now offered a real opportunity to secure her freedom.

"There was another side to Wheatley," Isani declares. "She was also an ambitious and worldly-wise woman, acquainted with notables of her time, and capable of unabashedly representing her own interests."[21]

"Wheatley was, after all, a strong and intelligent woman who fought for her own rights," Professor Petrea agrees.[22]

"She prompted her own emancipation, on her own terms," says Cima.[23]

Maybe she took it upon herself to propose the idea: if the Wheatleys were to free her, she would return. It should not be surprising that Phillis would take a determined stand on a matter so crucial to her. It is entirely possible that Phillis Wheatley sought and received a commitment from the Wheatleys that would guarantee her freedom when she came back to Boston.

What did Phillis have to say about winning her freedom? "Since my return to America, my Master, has at the desire of my friends in England, given me my freedom," she told Wooster.[24] In a letter to Thornton she made it clear that Susanna Wheatley, always her strongest supporter, was all for it. "This he did about three months before the death of my dear mistress & at her desire," she wrote.[25]

Isani believes that "Susanna Wheatley's wishes doubtless played a major role in influencing John Wheatley."[26]

Whether it was Susanna Wheatley who pushed for Phillis's freedom or her "friends in England," in the end it was Phillis Wheatley who was most responsible for engineering her own liberation. The "extraordinary poetical genius," the "celebrated Negro Poetess," the "Wonder of the Age" earned all

the praise she received in recognition of the value of her work. With her literary gifts and personal grace, dedication to her art, and determination to keep the verses flowing, Phillis Wheatley compelled the dominant white culture to acknowledge her humanity, forcing her owners to come to terms with the inequity of her status.

"By letting the contradictions in her master's position speak for themselves," says literary critic Barbara Johnson, and "by making explicit her history and her status and her right to speak, Wheatley, in a sense, wrote her way to freedom."[27]

# CHAPTER 28

## "My Master has, at the desire of my friends in England, given me my freedom."

PROFESSOR CARRETTA HAS A THEORY about the emancipation of Phillis Wheatley. "We have increasingly come to appreciate Wheatley as a manipulator of words; perhaps we should have more respect for her as a manipulator of people as well," he writes. "Rather than being a gift passively received from her master 'at the desire of my friends in England,' the promise of freedom was probably a concession Phillis Wheatley coerced from Nathaniel Wheatley in exchange for her promise to return to Boston: one promise for another."[1]

A telltale clue that offers fascinating insight into when Phillis Wheatley actually attained her freedom is the mystifying behavior of Nathaniel Wheatley in London. Phillis maintained that while she was in London she could go wherever she wanted with whomever she pleased. That included spending time with Britain's most prominent abolitionists. There is no evidence that Nathaniel Wheatley placed any restrictions on her. This suggests that he had some measure of respect for her free will and no longer regarded her as personal property subject to his supervision and control. Clearly, by this time he thought of her as a free woman.

Would Nathaniel Wheatley have allowed Phillis the privilege of defacto freedom while she was in London if he did not intend to grant her legal emancipation when she returned to Boston? Would he let Phillis travel back to Boston alone if her freedom had not already been decided?

Questions remain. The field is ripe for speculation.

When Phillis declared that "my Master has, at the desire of my friends in England, given me my freedom," to whom was she referring?[2] Two friends immediately come to mind: Granville Sharp and John Thornton. Both men were deeply religious and antagonistic to slavery. Did either of them—or perhaps both—speak to Nathaniel Wheatley about liberating

his slave? Whoever these "friends in England" were, we know that Phillis Wheatley had a considerable number of them, and their arguments proved to be successful.

Phillis had been corresponding with wealthy evangelical Christian John Thornton for more than a year before she finally met him in London. While staying with the Thorntons she met his sister, Hannah Wilberforce, and her fourteen-year-old nephew William, then living with his aunt since his father's death several years earlier. We can imagine an earnest conversation between the twenty-year-old slave poet and the teenager and future abolitionist. Perhaps the meeting had an impact on the young man and spurred him to intensify his efforts to end slavery.

Phillis knew Hannah Wilberforce well enough to continue their correspondence after returning to Boston. "I have written to Mrs. Wilberforce," she assured Thornton.[3] This may be the letter she listed in her 1779 proposals as "To Mrs. W—e in the County of Surrey."[4]

Another prominent abolitionist Phillis Wheatley could count on as "a friend" was Reverend John Newton, composer of the hymn *Amazing Grace,* whom she may have met in person. Carretta cites evidence that "On March 31, 1774 and October 13, 1774, Thornton showed Newton correspondence between himself and Wheatley."[5]

"The two men corresponded often," adds Professor Petrea, "and they so frequently discussed Wheatley that they dropped all formality and began to simply refer to her as 'Phillis.'"[6]

"Thornton's references to her simply as 'Phillis' suggest that Newton knew her as well," Carretta maintains. "Newton no doubt shared Thornton's opinion that 'she is a blessed girl & has been marvelously preserved' in having survived her voyage back to Boston."[7]

"There is much left to say about the importance of Sharp's meeting with Wheatley," writes Petrea. "Granville Sharp had, in the previous year, represented James Somerset in the trial heard by Lord Mansfield whose decision set free all slaves who set foot on English soil."[8]

Isani describes him as "Granville Sharp, her chaperon, a friend of the slaves."[9]

Phillis singled out Granville Sharp as one of her escorts around town. We can't know how many hours or days they spent together, visiting the attractions

of London. But we can be sure these two intelligent, erudite, and socially aware individuals had some fascinating and wide-ranging conversations.

To Granville Sharp, ending the abomination of slavery was a sacred moral crusade. He felt duty-bound to provide whatever assistance he could to those oppressed by slavery. "The glorious system of the gospel destroys all narrow, national partiality and makes us citizens of the world, by obliging us to profess universal benevolence: but more especially are we bound, as Christians, to commiserate and assist to the utmost of our power all persons in distress or captivity," he wrote.[10]

At the time, Sharp was the most passionate enemy of slavery in Britain and Phillis Wheatley was the most famous slave in the British Empire. He certainly knew that securing her freedom under the provisions of the Somerset ruling would encourage many more slaves to take advantage of the law to gain their liberty.

Nobody in London could advise Phillis Wheatley on the complex legal issues surrounding slavery with greater authority than Granville Sharp. Surely they discussed her freedom and plotted strategies for achieving it. Sharp, with his shrewd legal mind, would have outlined various options for Phillis: she could emancipate herself by refusing to return to Boston and remain in London instead; or if she wanted to return to Boston, she could obtain her owner's agreement to sign her manumission papers.

Following the best legal advice, Phillis made sure that her legal manumission papers were documented in writing, a course of action that would allow her to live freely in the colonies. "The instrument is drawn so as to secure me and my property from the hands of the executrs, administrators & c. of my master & secure whatsoever should be given me as my own," Phillis wrote. "A copy is sent to Isra. Mauduit Esqr."[11]

"She used Mauduit as the equivalent of a safe deposit box for her manumission papers so that she could live legally free as either an African-Briton or an African-American," writes Carretta.[12]

We know this document exists only because Phillis mentioned it. Unfortunately, this crucial evidence has been lost in the clouds of history. "Her manumission papers are, reportedly, not to be found among Mauduit's papers in either the British Library or the Public Records Office in London," Robinson says.[13]

"Accompanying the copy of the emancipation document sent to Israel Mauduit must have been a letter of thanks," Isani presumes. "Among the thirteen letters Wheatley included in her proposals of October 1779, is one listed as 'To I.M.-Esq. London.' Evidently, 'I.M.' is Israel Mauduit."[14]

So when was Phillis Wheatley actually liberated? We can only speculate about the date and the circumstances of her emancipation. What do we know for sure?

- She told Wooster on October 18, 1773: "my master has, at the desire of my friends in England, given me my freedom."[15]
- She offered a vague sense of the timing: "since my return to America," which occurred on September 13, 1773.[16]
- We know that the legal document assuring her freedom was "sent to Isra. Mauduit Esqr."[17]
- We know that by 1773, John Wheatley had retired, ceding control of his business interests to his son. Carretta reports that Wheatley family lawyer Samuel Quincy "signed a deposition regarding the transfer of the vast bulk of John Wheatley's property to Nathaniel in 1771 and 1774 for token sums."[18] The Wheatley property, of course, would include their slave.
- We know that Nathaniel Wheatley traveled to London with Phillis to attend to family business (and to court his future wife) but made no effort to exert control over his slave. We have it from none other than Founding Father Benjamin Franklin that Nathaniel Wheatley was nearly invisible in matters concerning Phillis.[19]
- We know from Phillis' statements, her busy itinerary and the extraordinary variety of her experiences, that she had nearly total freedom of movement and freedom of association while she was in London.[20]
- We know that Nathaniel Wheatley remained in London after Phillis left, choosing not to accompany Phillis for the return trip to Boston. Like much of her time in London, she traveled on her own, unsupervised.[21]

Using what we know to be true, we can consider several likely scenarios. The broad time-frame Phillis offers, that she had been freed "since my return to America," is maddeningly obscure. By avoiding a precise date, was she trying to be cagey or discreet? It was common for freed slaves to conceal the circumstances by which they gained their freedom because they knew they could be recaptured and re-enslaved. Either she was advised to remain vague about the actual date of her freedom or she may have believed that the information was too sensitive to reveal.

Phillis has said little about the circumstances of her emancipation. She wrote about her own freedom only twice—first in her letter to Colonel Wooster weeks after her return from London, then a year later, in her letter to Thornton, when she placed the timing of her freedom at "about three months before the death of my dear mistress."[22]

Mason notes that in her letter to Thornton, Phillis gets the timing of her emancipation wrong. Mrs. Wheatley died on March 3, 1774. "She had been freed earlier than she says here." In fact, she told Wooster on October 18, 1773 that she was already free. Mason places the date of her freedom "sometime between September 13 and October 18."[23]

We are left with some compelling questions: What effect did the change in her legal status have on Phillis Wheatley? How did she feel about her newfound freedom?

She never said. She left no account revealing what her emancipation might mean to her. But we can get a feel for the kind of thoughts that might have gone through her mind by looking at the testimony of African-Americans who, like Phillis, suffered under bondage and rejoiced at their freedom. History has left us a treasure trove of statements by newly freed slaves describing the sacred moment when they realized their nightmare of oppression was over. To them, freedom was like a second birth. After a life of brutality and degradation, they could live with dignity and purpose. The moment they realized that freedom had finally come was such a meaningful experience and left such an indelible mark, they would never forget it.

"I have often been asked how I felt when first I found myself on free soil," Frederick Douglass wrote in his autobiography.

A new world had opened upon me... I lived more in one day than in a year of my slave life. It was a time of joyous excitement which words can but tamely describe....

For the moment, the dreams of my youth and the hopes of my manhood were completely fulfilled. The bonds that had held me to 'old master' were broken. No man now had a right to call me his slave or assert mastery over me...I felt as one might feel upon escape from a den of hungry lions....My chains were broken and the victory brought me unspeakable joy."[24]

Harriet Tubman explained to her interviewer: "I had reasoned dis out in my mind.

There was one of two things I had a right to—liberty or death. If I could not have one I would have de oder. For no man should take me alive. I should fight for my liberty as long as my strength lasted and when de time came for me to go de Lord would let dem take me."[25]

Following the North Star, walking at night, hiding by day, sleeping only on the cold ground, Harriet Tubman revealed the poignant moment when she passed the "magic line which then divided the land of bondage from the land of freedom." She described how she knew she had reached the Promised Land. "I looked at my hands to see if I was the same person now that I was free. There was such a glory over everything, the sun came like gold through the trees and over the fields and I felt like I was in heaven."[26]

Surely Phillis Wheatley had a similar reaction.

Even though Phillis Wheatley never shared her views on her newly-won freedom, we know that she thought about the moment. She offered a glimpse of her own deep feelings on freedom in the last poem she wrote before she left for London. She was still legally a slave in May 1773 when she wrote *A Farewel to America*. But Phillis Wheatley allowed herself to imagine her future in a world where she could live as a free woman.

The evidence suggests that Phillis Wheatley knew before she left Boston that her emancipation was near. Whether she received a promise from the Wheatleys or had resolved to remain in London, either way,

Phillis Wheatley sailed from Boston fully expecting that her dream of free-
dom was about to come true. She certainly knew how it would feel when
Hebe, the Greek goddess of youth, came to bring her the "soul delighting"
gift of liberty.

> *Lo! Health appears! celestial dame!*
> *Complacent and serene,*
> *With Hebe's mantle oe'r her frame,*
> *With soul-delighting mien.*[27]

# CHAPTER 29

"A poem by Phillis in her handwriting made
on her return from England."

PHILLIS WHEATLEY AND THE *LONDON* Packet departed
London on July 26, 1773 and remained at sea for seven weeks. This leisurely
interlude gave Phillis an opportunity to reflect on her London adventure
and look toward the uncharted waters ahead with renewed confidence and
boundless hope.

So many memories could replay in her mind. A lifetime's worth of
wondrous experiences could flash before her; she could replay so many
inspiring conversations with a wealth of extraordinary new friends. She
was bringing home new treasures; the edifying and valuable gifts she had
received were so numerous she had to carry them in a barrel.

By the time she left London she knew that the blessing of her own free-
dom was imminent. It would be the most gratifying gift of all.

But for the young writer, the most exciting outcome of her London trip
had to be the thrill of anticipating the arrival of her first book of poems, due
to come out in a matter of weeks. Her spirits buoyed by the enthusiastic
reception she had received, Phillis Wheatley could take immense satisfac-
tion in the prospect that her writing career was about to take off.

During the long sea voyage there wasn't much to do, so Phillis could
fill the idle hours just thinking, planning, and dreaming. If we could have
been on the boat with her, we would have seen a cheerful and mellow young
woman strolling on deck outside, stopping to lean on the railing as she
gazed across the seemingly infinite expanse of water. With blasts of salt air
stinging her face, she might have turned toward the wind to feel the cool
ocean spray on her skin. For Phillis Wheatley, this was a time to enjoy life.

It was during her time at sea that Phillis Wheatley wrote the poem
*Ocean*. The title was all we knew of its existence after it was listed in her
1779 proposal for a second book. The poem was lost to history for nearly

two hundred and twenty years. Then, on May 29, 1998, the original hand-
written manuscript turned up at Christie's auction house in New York. This
newly discovered Phillis Wheatley poem sold for $68,500.[1]

It was "an important and welcome find," says Julian Mason, "one that
not only adds yet another poem to the Wheatley canon but also provides
additional insight into her life and ideas and into her writing itself."[2]

The manuscript is four pages long with writing on both sides of two
sheets of paper. "The handwriting itself does not seem rushed but is in the
same flowing style we usually associate with her," he writes. "On page four
of the manuscript, below the final line of the poem there is this note in
someone else's hand: 'OCEAN/ A poem by Phillis in her handwriting
made on her return from England in Capt. Calef, Sept. 1773.'"[3]

The notation confirms that Phillis Wheatley wrote the poem during
her "sea voyage which lasted from near the end of July to September 13,
1773," Mason continues. "The wording of this note suggests that the note
was made by a member of the Wheatley family."[4]

After an opening invocation to the muses, the poet describes the
moment she was standing outside on deck, letting "my Eyes explore the
wat'ry reign." Then, as poets do, she lets her imagination run free. Phillis
Wheatley invents a new creation story to show how God made the world.

> *When first old Chaos of tyrannic soul*
> *Wav'd his dread Sceptre o'er the boundless whole,*
> *Confusion reign'd till the divine Command*
> *On floating azure fix'd the Solid Land,*
> *Till first he call'd the latent seeds of light,*
> *And gave dominion o'er eternal Night.*
> *Yet when the mighty Sire of Ocean frownd*
> *"His awful trident shook the solid Ground."*
> *The King of Tempest thunders o'er the plain,*
> *And scorns the azure monarch of the main,*
> *He sweeps thy surface, makes thy billows rore,*
> *And furious, lash the loud resounding shore.*
> *His pinion'd race his dread commands obey,*
> *Syb's, Eurus, Boreas, drive the foaming sea!*
> *See the whole stormy progeny descend!*

> *And waves on waves devolving without End,*
> *But cease Eolus, all thy winds restrain,*
> *And let us view the wonders of the main[5]*

The poem shows the influence of her favorite poet and artistic mentor, a bond that deepened during her London experience. "While she had been in England, Wheatley had acquired eighteen volumes of the works of Alexander Pope," Mason says, "and now had them on board the ship."[6]

Phillis put one line in quotation marks: "His awful trident shook the solid Ground." It is a passage from Pope's translation of Homer's *The Iliad*. Clearly, she'd been reading it. According to Mason, it is "our only specific acknowledgement directly from her of Pope's influence on her work."[7]

The poem is uneven and unrefined. Professor Mason thinks the poem is "probably the uncorrected first draft" and "appears to have been written in several stages during the voyage back to Boston....[8] The first stage of the poem is much more fully finished, cohesive, elevated in tone and polished than the later two stages."[9]

In the final section, Phillis relates a strange narrative that has little connection to earlier themes. It appears out of the blue and could very well stand on its own as a separate poem. Here Phillis writes about a disturbing scene she witnessed while at sea. She watched as an eagle was shot dead. The event troubled her so much she had to pick up her pen. In her poetic vision she laments its demise and finds communion of spirit with the free soaring bird. She describes the scene in painful detail, and identifies the shooter as Captain Calef.

> *T'was but e'er now an Eagle young and gay*
> *Pursu'd his passage thro' the aerial way.*
> *He aim'd his piece, would C—f's hand do more*
> *Yes, him he brought to pluto's dreary shore*
> *Slow breathed his last, the painful minutes move*
> *With lingring pace his rashness to reprove.[10]*

She imagined the eagle's protective parent dispensing fatherly wisdom to his young son, offering helpful advice to keep him safe in a dangerous world: fly on until you reach land. Now the son, fatally wounded, cries out

in distress—he knows he has disobeyed his father and now he is paying the price.

> *Perhaps his father's just commands he bore*
> *To fix dominion on some distant shore*
> *Ah! me unblest he cries Oh! Had I staid*
> *Or swift my Father's mandate had obey*
> *But ah! too late. —Old Ocean heard his cries*
> *He strokes his hoary tresses and replies*
> *What mean these plaints so near our wat'ry throne,*
> *And what the Cause of this distressful moan![11]*

In a striking rebuke of the young bird's misbehavior, the poet wonders how the poor eagle could have ignored the instrument of his own demise— how did he ever miss seeing the boat? It is a sad condemnation, rich in irony. The murderous vessel is none other than the *London Packet*, the very ship carrying her to Boston.

> *Saw you not Sire, a tall and Gallant ship*
> *Which proudly scims the surface of the deep*
> *With pompous form from Boston's port she came*
> *She flies, and London her resounding name.[12]*

The surviving version of the poem *Ocean* is nowhere near a polished piece of work. We imagine the poet dashing it off quickly, her words flowing in hot creative frenzy, especially the part where she describes Captain Calef shooting the eagle. "This section clearly seems more rushed and unfinished," Mason says. "Note the failure to supply punctuation and to complete a rhyme word."[13]

What was her intended theme? The tragic situation, the slaying of an eagle, is fraught with layers of meaning. It is tempting to suppose that Phillis was trying to make the connection to her own slave experience. Was Phillis trying to craft a metaphor to show the senseless brutality that murders freedom for her people? Was she calling out the town of Boston for its "pompous form"? Or was it a heartfelt cry of revulsion from a sincere conscience over the senseless killing of an innocent creature?

The poem *Ocean,* revised and reworked, was advertised for publica-
tion in 1779, but we have never seen it. Maybe one day her finished version
will turn up and we will have the opportunity to assess her artistic aim.
"Surely, in various ways, it would have been made more suitable and better,
smoother, clearer and more polished," says Mason.[14]

"As the variants of her published poems and letters leave clear, she was
an exacting and picky writer," writes Stony Brook University Professor
Rowan Ricardo Phillips.[15] "She knew precisely what she was doing in a
poem and how she wanted to go about doing it."[16]

When Phillis Wheatley arrived back in Boston on September 13, she
returned to the same house to live with the same family who had been hold-
ing her in legal bondage. But by that time, the formal process of granting
her freedom was nearly finalized. A year later she told John Thornton that
she was deeply grateful for "my old master's generous behavior in granting
me my freedom—and still so kind to me," expressing her gratitude to John
Wheatley for allowing her to remain at their King Street mansion after he
freed her. She vowed to "treat him with that respect which is ever due to a
paternal friendship."[17]

"Wheatley did not flee from her master's home," says Professor Jennifer
Rene Young. "She did not move out of her master's house as soon as she was
emancipated either."[18]

But when she came back to the home where she had lived as a slave since
she was a child, her situation had completely changed. Phillis Wheatley was
a different woman. She had the power to make decisions for herself about
how to live her life. "When she returned to Boston, it was as a woman who
had possessed the legal power to refuse to return to Susanna Wheatley's
side," Cima contends.[19]

In the long and troubling history of American slavery, it is a matter
of record that some freed slaves went to live with their former masters,
choosing to remain in the place where they were enslaved. Why would an
enslaved person given the opportunity for freedom even consider return-
ing to the home of her slave master? Why would former slaves not want to
move far away from their oppressor to start a new life? From our twenty-
first-century perspective this is inexplicable.

In her Pulitzer Prize-winning examination of the relationship between

Thomas Jefferson and his slave Sally Hemings, Professor Annette Gordon-Reed looks deeply at these haunting questions. "When we encounter some of those spirits responding to their circumstances as human beings respond and using whatever means available to them to maintain or assert their humanity in the face of the onslaught, their individual efforts should not be minimized," she writes.[20]

Phillis Wheatley and Sally Hemings were two young, intelligent, attractive African-American women, both trapped in the legal morass of slavery as nothing more than property owned by wealthy men. In 1787 Sally Hemings left Virginia to join Jefferson in Paris where she was legally free. Two years later, when Jefferson wanted her to return with him to Virginia, Sally Hemings faced a decision: stay in France as a free woman or go back to Virginia where she would remain enslaved.

Hemings examined her options and decided to return with Jefferson. Gordon-Reed makes it clear that Hemings knew the law was on her side and used that leverage to win significant concessions from Jefferson—freedom for her children. "She refused to return with him," declared Madison Hemings, Jefferson's son with Hemings. "To induce her to do so he promised her extraordinary privileges and made a solemn pledge that her children should be freed at the age of twenty-one years. In consequence of his promises, on which she implicitly relied, she returned with him to Virginia."[21]

It is likely that Phillis Wheatley came to a similar agreement with the Wheatleys. She would return to Boston in exchange for her freedom.

For both Sally Hemings and Phillis Wheatley, the stakes were extremely high. Hemings "knew all too well what slavery meant and she lived with the hard knowledge that, were she to return to Virginia, every child from her womb would follow her condition," writes Gordon-Reed. "In this moment and place, she was in the best position she would ever be in to walk away from *partus sequitur ventrem* forever."[22] *Partus sequitur ventrem,* "that which is brought forth follows the womb," was the legal doctrine assuring that any child born to a woman who was a slave must also be a slave.

Phillis Wheatley certainly "knew all too well what slavery meant." For this twenty-year-old woman, the fate of her future children had to weigh heavily on her mind. Like Sally Hemings, Phillis "lived with the hard knowledge" that if she returned to Boston without the legal protection

that freedom provides, "every child from her womb would follow her condition." Phillis Wheatley would surely realize that "she was in the best position she would ever be in to walk away from *partus sequitur ventrem* forever."

Phillis Wheatley had her career to consider. As a published poet, securing her legal freedom was the only way to make sure that her poems, manuscripts, notebooks, and any income from her books would go to her alone. "Phillis apparently already had property, besides her own person, to protect," says Carretta, "and she clearly expected to gain more, all of which she sought to keep out of the hands of John Wheatley and his heirs."[23]

In her insightful meditation on the complicated calculations behind Sally Hemings' decision to return to Virginia, Gordon-Reed allows us to see that it was an utterly human response to unbearable circumstances. "Like other enslaved people when the all too rare chance presented itself, Hemings seized her moment and used the knowledge of her rights to make a decision based upon what she thought was best for her as a woman, family member and a potential mother in her specific circumstances," she writes.[24]

That strategic choice by Sally Hemings makes Phillis Wheatley's decision to return to Boston understandable. Gordon-Reed asserts that Sally Hemings "had the capacity to know her circumstances and to intelligently use her knowledge to assess the risks and possible rewards of taking a particular action—in other words, to think."[25]

The same can be said for Phillis Wheatley.

# IV. Boston 1773 – 1776

*"The world is a severe schoolmaster, for its frowns are less dang'rous than its smiles and flatteries and it is a difficult task to keep in the path of wisdom."*

~ Phillis Wheatley, October 30, 1773

# CHAPTER 30

### "I am now upon my own footing and whatever I get by this is entirely mine."

ON SEPTEMBER 13, 1773, THE *London Packet* and Phillis
Wheatley arrived back in Boston. "Wheatley's return to America was widely
noted," Isani writes. "Eight local and regional newspapers announced the
poet's return."[1]

- September 16; the *Boston News-Letter* and the *Massachusetts Spy*
  noted the landing of "the extraordinary Poetical Genius" and the
  "celebrated young negro poetess, Phillis."[2]
- September 20; the *Boston Evening-Post* declared that "the extraor-
  dinary poetical Genius, negro Servant to Mr. John Wheatley of
  the town" had come home. The *Boston Gazette* announced the
  return of "the extraordinary Poetical Genius" with the *Boston Post-
  Boy* also reporting on the "extraordinary negro Poetess, Servant of
  Mr. John Wheatley."[3]
- September 21; the *Connecticut Courant* carried this news item
  from Boston: "Monday last (Sept. 13) arrived here Capt. Calef"
  with passengers including "the celebrated young negro Poetess,
  Phillis."[4]
- September 24; the *New Hampshire Gazette* described the return
  of "the extraordinary poetical Genius, Negro Servant to Mr. John
  Wheatley." Commenting on her return to Boston, the *New London
  Gazette* described her as "the extraordinary poetical Genius, Negro
  Servant to Mr. John Wheatley."[5]
- September 25; the *Providence Gazette* announced the return to
  Boston of "the extraordinary poetical Genius."[6]
- September 27; the *Newport Mercury* reported the arrival of "the
  extraordinary poetical Genius."[7]

"Recognition among the common populace, as evident in the newspapers and magazines of the time," added to her growing fame, writes Isani, as news of her return spread to four New England colonies. "These commonplace and public documents effectively shows the reach and the recognition of the poet."[8]

When Phillis left Boston on May 8, she knew that Susanna Wheatley was in failing health. Six weeks earlier, on March 29, Mrs. Wheatley had confided to Reverend Samson Occom, "I am very weak and low...to such a degree as makes me doubtful whether I shall live to see you once more in this world."[9]

"Mrs. Wheetly lies near her end," Elizabeth Wallcut wrote her son Thomas on September 9. "Mr. Nat and Phillis is gone to England and not returned yet."[10]

Phillis was in transit at the time. She arrived in Boston a few days later, on September 13. In the four months Phillis had been away, Mrs. Wheatley had taken a turn for the worse. "I found my mistress very sick on my return," she told Colonel Wooster.[11]

"When I first arrived at home my mistress was so bad as not to be expected to live above two or three days," Phillis wrote.[12] "My mistress has been very sick above fourteen weeks & confined to her bed the whole time."[13]

A few months later, her condition appeared to stabilize. "Through the goodness of God she is still alive," Phillis told their mutual friend John Thornton in December, "but remains in a very weak & languishing condition."[14]

Even as she cared for her gravely ill mistress, Phillis struggled with her own health demons. "I am at present indisposed by a cold," she told Obour Tanner shortly after returning from London, "and since my arrival have been visited by the asthma."[15]

Once again, the harsh New England weather proved difficult for Phillis. She complained to Reverend Samuel Hopkins how she had been feeling "much indispos'd by the return of my asthmatic complaint" while troubled by "the sickness of my mistress who has been long confin'd to her bed & is not expected to live a great while."[16]

Since leaving London on July 26, Phillis had not been able to follow the exciting developments leading to the publication of her book. A little

more than a week after she departed, printer Archibald Bell kicked off a promotion campaign in advance of the appearance of her poems. The first advertisements for her book ran in the *London Morning Post and Advertiser* on August 6, continuing through August 9, 11, 12, and 16.

> Just published. PROPOSALS for printing by subscription. A Volume of POEMS written by PHILLIS, A Negro Servant to Mr. Wheatley of Boston in New England. The real author of these poems is properly attested by the Governor, Lieutenant-Governor, and great part of the council in Boston. Proposals at large, with an account of this surprising girl may be had by applying to A. Bell, bookseller, No 8, Algate Street...The original attestation signed by the above gentlemen may be seen by applying to Archibald Bell as above.[17]

Finally, in early September 1773, Phillis Wheatley's book *Poems on Various Subjects Religious and Moral* was ready for sale in London. The first advertisement offering the book appeared in the *London Chronicle or Universal Evening Post* on September 9 and ran through September 14.

> Dedicated by Permission to the right Hon. The Countess of Huntingdon.

> This day was published. Price 2s. sewed or 2s. 6d. adorned with an elegant engraved likeness of the author.

> A volume of POEMS on various subjects, RELIGIOUS and MORAL. By PHILLIS WHEATLEY, negro servant to Mr. John Wheatley of Boston.

> London: Printed for A. Bell, Bookseller, Aldgate and at Boston, for Messrs. Cox and Berry in King Street.

> TO THE PUBLIC:

> The book here proposed for publication displays perhaps one of the greatest instances of pure, unassisted genius that the world ever produced. The author is a native of Africa, and left not that dark part of the habitable system till she was eight years old. She is now no more than nineteen, and many of the poems were penned before she arrived at near that age.

They were wrote upon a variety of interesting subjects and in a stile rather to have been expected from those who, a native genius, have had the happiness of a liberal education, than from one born in the wilds of Africa.

The writer while in England a few weeks since, was conversed with by many of the principal nobility and gentry of this country, who have been signally distinguished for the learning and abilities, among whom was the Earl of Dartmouth, the late Lord Lyttleton, and others who unanimously expressed their amazement at the gifts with which infinite Wisdom has furnished her.

But the publisher means not, in this advertisement, to deliver any peculiar eulogiums on the present publication; he rather desires to submit the striking beauties of its contents to the unabashed candor of the impartial public.[18]

A sharp marketing strategist, Archibald Bell made sure to note that Wheatley's book was being sold in the colonies as well by naming its Boston distributor.

- September 11 and 14; The *London Chronicle* announced "this day was published" Phillis Wheatley's *Poems on Various Subjects*.[19]
- September 13 and 15; *Lloyd's Evening Post and British Chronicle* published the full advertisement for the Wheatley book, including the Attestation, dated "Boston, Oct. 28, 1772."[20]
- September 13; The *Public Advertiser of London* ran Bell's ad announcing the publication of *Poems on Various Subjects*.[21]
- September 18; The *London Morning Post and Daily Advertiser* ran the advertisement.[22]
- September 18; The *London Chronicle* carried a brief version of the ad along with two poems from the book, *On Being Brought From Africa to America* and *Thoughts on the Works of Providence*.[23]

"Because she was back in Boston when her volume of poems finally appeared in London, Phillis could not then have read the many English and Scottish notices and reviews of the collection," Robinson writes. "A dozen newspapers and magazines made note of the publication, many of them excerpting over a half-dozen poems from the book for display."[24]

Isani observes that "Almost every reviewer made it a point to note the precociousness of the poet and a number noted, in the words of the books' prefatory 'Attestation' by Boston dignitaries, that she had but a few years earlier been brought 'an uncultivated barbarian from Africa.'" Another point reviewers emphasized was "the shame of slavery as illustrated by her case."[25]

The September 1773 issue of the *Critical Review* included the poem *To Maecenas*, accompanied by a favorable review: "The Negroes of Africa are generally treated as a dull, ignorant and ignoble race of men, fit only to be slaves and incapable of any considerable attainments in the liberal arts and sciences." In the eyes of this critic, Wheatley was a "literary phenomenon." He backed up his praise by noting that "there are several lines in this piece which would be no discredit to an English poet. The whole is indeed extraordinary, considered as the production of a young Negro, who was, but a few years since, an illiterate barbarian."[26]

That same month the *London Magazine* offered a mixed assessment, along with Wheatley's *Hymn to Morning*. "These poems display no astonishing power of genius; but when we consider them as the productions of a young untutored African...we cannot suppress our admiration of talents so vigorous and lively. We are the more surprised too, as we find her verses interspersed with the poetical names of the ancients, which she has in every instance used with strict propriety."[27]

Also in September, the *Gentleman's Magazine* reprinted *On Recollection*, along with a pointed critique of slavery in the colonies. "Youth, innocence and piety, united with genius, have not yet been able to restore her to the condition and character with which she was invested by the Great Author of her being. So powerful is custom in rendering the heart insensible to the rights of nature and the claims of excellence."[28]

The verdict from the December 1773 *Monthly Review* was rather harsh. "The poems written by this young negro bear no endemic marks of solar fire or spirit," the critic wrote. "They are merely imitative; and indeed, most of those people have a turn for imitation, though they have little or none for invention," although the reviewer did acknowledge that the poet "has written many good lines and now and then one of superior character."[29]

As many Britons were wont to do, the reviewer turned his ire directly to the institution of slavery in the colonies. He wrote that he was "much

concerned to find that this ingenious young woman is yet a slave." He castigated Phillis Wheatley's neighbors as hypocrites for all their railing against the tyranny of the Crown. "The people of Boston boast themselves chiefly on their principles of liberty. One such act as the purchase of her freedom would, in our opinion, have done them more honour than hanging a thousand trees with ribbons and emblems."[30]

"By the time Phillis Wheatley was able to read the reviews and see a copy of the book itself, she was free," notes Carretta.[31]

"Meanwhile," Robinson adds, "Phillis would readjust to Boston and the Wheatley household, tending her mistress even more closely than ever; it was clear to all that Mrs. Wheatley was now dangerously ill. Whenever possible, there were more visits to area first families who would listen to Phillis tell of her recent trip. She continued with her writing, of course."[32]

She had been back in Boston for nearly six weeks when she wrote her October 18 letter to Colonel Wooster declaring that "My Master has at the desire of my friends in England, given me my freedom."[33]

The Wheatleys allowed Phillis to live in their house as a free woman but they no longer had the legal obligation to support her. "With freedom came new responsibilities," writes Isani.[34]

For Phillis Wheatley, "Freedom meant that she became fully responsible for her literary career and for her finances," declared Dr. Gates.[35]

It was a precarious position for a newly freed woman living in a world where economic opportunities for people of African descent were severely limited.

According to Professor Hairston, "There is evidence that Wheatley was not only a gifted poet but also reasonably astute in the legal and financial ways of the world."[36]

In her October 18 letter to Colonel Wooster, "one notes more than a passing concern for the economics of publication," Isani observes. "The business sense of Wheatley is evident in this letter."[37]

Julian Mason comes to the same conclusion. "In this and other letters she appears alertly active and apparently astute in the business of selling her books and both promoting and protecting her own work and interests."[38]

Phillis had a clear idea of the steps she needed to take in order to protect her financial well-being. "The instrument is drawn so as to secure me

and my property from the hands of the Executrs, administrators & c. of my master," she told Wooster, "and secure whatsoever should be given me as my own."[39]

"Her concern for protecting the profits from her book reveals a young woman of extraordinary business acumen," says Carretta.[40]

Phillis the poet became Phillis the businesswoman. "I beg the favour that you would honour the enclos'd proposals, & use your interest with gentlemen & ladies of your acquaintance to subscribe also," she appealed to Wooster. "For the more subscribers there are, the more it will be for my advantage as I am to have half the sale of the books."[41]

She got her friend Obour Tanner to help sell her books. "I enclose proposals for my book and beg you to use your interest to get subscriptions as it is for my benefit."[42]

Now that she was free, she could keep her earnings. She knew she would have to work to support herself and she was ready for it. "This I am the more solicitous for," she proclaimed, "as I am now upon my own footing and whatever I get by this is entirely mine, & it is the chief I have to depend upon."[43]

Phillis was determined to master the nuts and bolts of the publishing game. "Wheatley seemed interested in the basic economics of publication," Hairston notes. "She was personally invested in the marketing of the poems, because she would gain half of the proceeds."[44]

The level of confidence she displayed in her knowledge of book industry economics convinced Professor Carretta that Phillis had been a vigorous participant in her business decisions all along. This evidence "increases the likelihood that she had played quite an active role in the marketing of her earlier works," he writes.[45]

"She was worried about protecting herself against unauthorized copies of her book and unabashedly concerned about the impact bootleg copies would have on her profits," says Hairston.[46]

Phillis showed her astute business sense by recruiting Wooster to make sure local printers would treat her fairly. "I must also request you would desire the printers in New Haven, not to reprint that Book," she asked Wooster, explaining that "it will be a great hurt to me, preventing any further benefit that I might receive from the sale of my copies from England."[47]

"She was doing what she could to ensure that the sales of her English edition would not be undercut by American reprinting," explains Isani.[48]

Phillis had a strategy to prevent unauthorized sales. "Should anyone be so ungenerous as to reprint them," she wrote, "the genuine copy may be known for it is sign'd in my own handwriting."[49]

It was an astute move for a business-minded author—signed copies of her book would limit pirated editions that would surely cost her income.

Finally, like a true marketing maven, she touts the bottom line for consumers: "The price is 2/6.d Bound or 2/ Sterling Sewed."[50]

Even though she had not seen a single copy, Phillis knew that her book had just rolled off the presses in London. Since returning to Boston, she must have been on pins and needles as she waited for her shipment of her books to arrive. After years of dedication and work, Phillis Wheatley could experience the thrill and satisfaction of seeing her work in print.

"I expect my Books which are published in London in Capt. Hall, who will be here I believe in 8 or 10 days," Phillis told Wooster in her letter of October 18.[51]

Captain Hall and her books did arrive, not in "8 or 10 days" but nearly six weeks later.

On Sunday morning, November 28, 1773, the *Dartmouth* under Captain Hall anchored in Boston harbor. Unfortunately for Phillis, she was not able to retrieve her books. That night the town of Boston placed the ship under twenty-four-hour armed guard to make sure no merchandise was removed. Phillis Wheatley's books were held on the ship along with some nefarious cargo—114 chests of East India Tea.

# CHAPTER 31

## "On board are 114 chests of much detested East India Company's tea."

DRINKING TEA BECAME SOMETHING OF a religious ritual among British nobility in the eighteenth century. Speaking for nearly all civilized Britons, Dr. Samuel Johnson admitted that he was "a hardened and shameless tea-drinker...who with tea amuses the evening, with tea solaces the midnight, and with tea welcomes the morning."[1]

The tea craze spread across the Atlantic to the colonies. "Tea had become the rage among wealthy ladies in America after London magazines described it as the favorite beverage of the royal family and British aristocrats of note," writes historian Harlow Giles Unger.[2] "It was inevitable that tea acquired a symbolic value that far exceeded its economic importance."[3]

The oppressive 1767 Townshend Acts imposed taxes on items not produced in North America, like paper, paint, lead, glass, and tea. These products could only be purchased from Britain. The colonists resisted by encouraging economic boycotts of imported British goods. On top of the list of items to spurn was Chinese tea from Britain. "Tea now entered the collective American mind as a symbol of British wealth and power," says Unger.[4]

"Tea must be universally renounced," John Adams declared to his wife, "and the sooner, the better."[5]

The *Boston Gazette* reported on February 12, 1770 that three hundred of the most respectable "ladies of this town" signed a solemn oath "against drinking tea until the Revenue Acts are repealed..."

> At a time when our invaluable rights and privileges are attacked in an unconstitutional and most alarming manner...we join with the respectable body of merchants and other inhabitants of this town...in their resolutions to totally abstain from the use of tea...

We the subscribers do strictly engage that we will totally abstain from the use of that article (sickness excepted); not only in our respective families but that we will absolutely refuse it if it should be offered to us upon any occasion whatsoever. This agreement we cheerfully come into as we believe the very distressed situation of our country requires it.[6]

Did the ladies of the Wheatley family join the tea boycott? Surely they were aware of it—tea was a hot topic in Boston.

After fierce resistance to the Townshend Acts brought British troops to Boston in 1768 and led to the tragic Boston Massacre two years later, most of the objectionable laws were repealed. However, Parliament retained the duty on tea. Lord North, the new Chancellor of the Exchequer, explained that tea taxes should remain as a "mark of the supremacy of Parliament and an efficient declaration of their right to govern the colonies."[7]

In 1773 tea was in the news again. On April 27 Parliament passed the Tea Act. Its purpose was to prop up the sagging fortunes of one of the largest corporations in the British Empire, the East India Company. The new law gave the company a monopoly on all tea sold in the colonies. Only merchants licensed by the East India Company could sell tea directly to consumers.

When the colonies learned of this new law, they took it as another poke in the eye. "The Tea Tax, small as it was, marked the fourth time in forty years that Parliament had tried to tax Americans without their consent," writes Unger.[8] With the Molasses Act of 1733, the Grenville Acts of 1764, the Stamp Act of 1765, and the Townshend Acts of 1767, Parliament continued to squeeze money out of the colonies with unreasonable tax demands, angering the Americans more and more each time. "I truly can have no property which another can by right take from me when he pleases," Samuel Adams complained. "If our trade may be taxed, why not our lands? Why not the produce of our lands and everything we possess or make use of?"[9]

The news broke on October 11, 1773—British tea was coming to America. "The East India Company have come to a resolution to send 600 chests of tea to Philadelphia and the like quantity to New York and Boston," the *Boston Gazette* reported.[10]

The report ran in the *New York Journal* on October 7 and the *Connecticut Journal* the next day. The news spread throughout the colonies that East India tea was on its way.

On October 18 the *Boston Gazette* revealed the names of the tea consignees, local merchants who contracted with the East India Company to sell the tea in Boston. The newspaper printed a letter warning all agents of the East India Company that dire consequences would follow if the tea ever landed in the colonies.

> I have told several of the company that the tea and the ships will all be burnt which I really believe will be the case as I think you will never suffer an act of Parliament to be so crowded down your throats, for if you do, it is all over with you.[11]

On November 1 the *Boston Gazette* reprinted a more ominous threat that had appeared in the *New York Journal* ten days earlier. It was addressed directly to the merchants who agreed to become tea agents for the East India Company.

> Gentlemen:
>
> You have lately been addressed ...upon the disagreeable subject of your nomination as commissioners for the sale of tea charged with duty payable upon importation for the express purpose of raising a revenue in America. Which tea is intended to be shipped to this country by the East India Company under the sanction and auspices of the British government.
>
> The execution of your office will have a worse tendency and operate more powerfully against the freedom of America than that of the late odious and detestable Stamp Masters, as its mischievous effects will be more sensible felt and more extensive; and thereby you will most certainly become the base and instruments of enslaving your country and introducing tyranny and oppression.
>
> For though you should be guarded by myriads of troops and surrounded with the strongest and impregnable fortifications which the art and ingenuity of man can possibly invent, yet, will not all this render you invulnerable. ... It will be impossible to shield or screen yourselves from the many darts that will be incessantly leveled against your persons.

Should you (contrary to the hopes and expectations of your American brethren) so lost to patriotism and a regard for the liberties of your country as rashly to persist in the design of executing your hateful office, you will doubtless be chargeable and accountable for all the confusion and bloodshed which it may occasion.[12]

On November 17 Captain James Scott arrived from England on John Hancock's ship the *Hayley*. Soon after his ship docked in Boston, Captain Scott shared the news that several ships carrying East India tea were getting ready to depart from London.[13] The November 18 *Boston Newsletter* and the November 22 *Boston Post Boy* reported that four tea ships, *Dartmouth*, *Eleanor*, *Beaver*, and *William*, would soon arrive in Boston;[14] the *Polly* was heading to Philadelphia, the *Nancy* to New York, and the *London* to Charleston, South Carolina.[15]

The tea arrived in Boston Harbor on Sunday morning, November 28, when the *Dartmouth* dropped anchor off the Long Wharf, surrounded by two British warships and the sixty-four-gun H. M. S. *Captain*. The news spread quickly. On November 29, the *Boston Gazette* reported:

> Yesterday morning, Capt. Hall in the ship Dartmouth came to anchor near the castle in about 8 weeks from the same place; on board of whom it is said are 114 chests of much detested East India Company's tea, the expected arrival of which pernicious article has for some time past put all these northern colonies in a very great ferment.

The article added ominously:

> Two or three other vessels were to sail from London to this place soon after Captain Hall and may be daily expected, having each of them on board a quantity of this said poisonous weed.[16]

The *Dartmouth* was the first of the tea-bearing ships to reach America. With more tea expected soon in New York, Philadelphia, and Charleston, the people of Boston knew that the other colonies were waiting to see how they handled this crisis.

"Whatever was to be done had to be done quickly," writes Boston Tea Party historian Benjamin Woods Labaree. "Under a long-standing rule, customs officers could seize dutiable goods if payment were not made within twenty days. The deadline would expire for the *Dartmouth's* cargo of tea on December 17."[17]

Customs Agents were eager to claim the tea, let the consignees pay the duties, and let them take possession of it. Then Boston would have its tea.

The next morning, posters appeared all over town calling for an emergency meeting at Faneuil Hall later that day.

> Friends! Brethren! Countrymen!—That worst of plagues, the detested tea, shipped for this port by the East India Company, is now arrived in the harbor; the hour of destruction, or manly opposition to the machinations of tyranny, stares you in the face.[18]

All residents of Boston were invited. No special qualifications were required, no previous government experience, no conditions for attendance. Anyone could come. This would not be a gathering of elected representatives. The assembly had no legitimate authority and no legal power. It was an ad hoc gathering of Bostonians outraged by Parliament's brazen bullying. Quickly, they issued a proclamation:

> Every friend to his country, to himself and to posterity, is now called upon to meet at Faneuil Hall, at nine o'clock THIS DAY (at which time the bells will ring), to make united and successful resistance to this last, worst, and most destructive measure of administration.[19]

That morning, pealing church bells roused the town. People made their way to Faneuil Hall by the hundreds. They packed the building until it was filled beyond capacity.

A broadside appeared two days later to inform citizens about the assembly.

> At a meeting of the PEOPLE of Boston, and the neighbouring towns at Faneuil Hall in said Boston, on Monday the 29th of November 1773, Nine o'clock A.M. and continued by

adjournment to the next day; for the purpose of consulting, advising and determining upon the most proper and effectual method to prevent the unloading, receiving or vending the detestable TEA sent out by the East India Company, part of which being just arrived in this harbour.[20]

Patriot leaders quickly realized they needed a larger site and voted to move to the Old South Meeting House. Soon twenty-five hundred people crammed into Old South. Although it was not a lawful town meeting, those present referred to themselves as "The Body" and claimed to be the voice of the city of Boston.

The Question be put, whether this Body are absolutely determined that the Tea now arrived in Capt. Hall shall be returned to the Place from whence it came at all events. And the question being accordingly put, it passed in the affirmative.[21]

Captain Hall and *Dartmouth* owner Francis Rotch were summoned to the meeting. The two men stood before the assembly while the resolution voted by the "Body of the People" was read to them. The town of Boston declared in no uncertain terms "that if they suffered the Tea to be landed it would be at their peril," wrote Boston Tea Party historian Benjamin Carp.[22]

The "Body of the People" then voted to place the ship under twenty-four-hour guard to enforce the resolution and make sure the tea remained on board.

A motion was made, that in order for the security of Captain Hall's ship and cargo, a Watch may be appointed — and it was voted that a Watch be accordingly appointed to consist of 25 Men.[23]

They added a provision to alert the entire population of Boston in the event of a surprise attack on the security team so a backup force could come quickly to their aid.

Upon a motion made, voted, that in the case it should happen that the Watch should be any ways molested in the night, while on duty, they give the alarm to the inhabitants by the

tolling of the bells — and that if anything happens in the day time, the alarm be by ringing of the bells.[24]

That night, November 29, the Town Watch took over the ship. It was duly noted in the ship's journal: "The Captain went on shore there being a great disturbance about the tea. A town meeting was held which came to a resolution the tea should never be landed. Had a guard of 25 men come on board this night at 9 PM."[25]

Before adjourning for the day, The Body passed a declaration of purpose.

> RESOLVED, that in thus importing said Tea, they have justly incurr'd the displeasure of our brethren in the other colonies. And resolved further, that if any person or persons shall hereafter import Tea from Great-Britain, or if any Master or Masters of any vessel or vessels in Great-Britain shall take the same on board to be imported to this place, until the said unrighteous Act shall be repeal'd, he or they shall be deem'd by this Body, an Enemy to his Country; and we will prevent the landing and sale of the same, and the payment of any duty thereon. And we will effect the return thereof to the place from whence it shall come.[26]

Captain Hall was directed to move the *Dartmouth* to Rowe's Wharf, putting the ship some distance away from the watchful eye of the Royal Navy warships.

From the Journal of the *Dartmouth*, Tuesday, November 30: "Got underway and turned up to Rowe's wharf. A watch of 25 men on board this night to see that the tea is not landed."[27]

*Dartmouth* owner Francis Rotch was growing concerned about his business interests. The Rotch family was one of the principal dealers in New England whale oil, a popular product in Britain used for manufacturing clean, radiant, long-burning candles. Francis Rotch "wanted to load his cargo of whale oil and clear his vessel outward as soon as possible," Labaree says.[28] Already Rotch was committed to picking up the next load of cargo in London for delivery to the Boston merchants who ordered the goods.

Rotch was eager to keep his merchandise moving—but he was stuck.

The *Dartmouth* and its valuable cargo were trapped in commercial limbo. He was facing possible ruin. "All Rotch wanted to do was unload his cargo, load the *Dartmouth* with his family's whale oil, and send the ship back to London," says Carp. "Every day's delay potentially cost the family hundreds of pounds worth of business."[29]

People in Boston were clamoring for their merchandise, items they had paid for and expected to receive. "On board besides the tea was a mixed cargo of winter goods for various Boston merchants. Rotch and Hall were responsible for its delivery," Labaree writes.[30]

"Merchants of the time argued that people should not do anything drastic to the ships because they contained other cargo and the ships themselves had nothing to do with the tea tax," says J. L. Bell.[31]

One Bostonian was especially eager to pick up her long awaited merchandise. "Copies of Wheatley's book first arrived in late November 1773 with Capt. Hall on the *Dartmouth*," Carretta says.[32]

This fact was confirmed by Carp. "It's unambiguous that Wheatley's books were aboard the *Dartmouth* along with the tea."[33]

It had to be immensely frustrating for Phillis, knowing that her books had finally arrived and were now sitting on board the ship. Two years after starting her search for a publisher in Boston, then crossing the ocean to finalize the arrangements, the book would soon be in her hands. She longed to flip through the pages, read her verses in print, and begin selling her work. The only thing preventing it was the turmoil of the tea.

# CHAPTER 32

## "They, the Indians, immediately hoisted out the chests of tea, and emptied the tea overboard."

ON OCTOBER 18, WHEN PHILLIS wrote that she expected her books to be delivered by Captain Hall "in 8 or 10 days," she was probably repeating what she had been told. Nathaniel Wheatley most likely worked out an arrangement with Francis Rotch to transport Phillis's books to Boston.

Nathaniel Wheatley and Francis Rotch were both serious players in their families' commercial enterprises. Their fathers, John Wheatley and Joseph Rotch, were longtime business associates and co-owners of the three-masted schooner that made regular runs across the Atlantic and carried Phillis Wheatley to London and back. "In partnership with Joseph Rotch, the American co-owner of the *London Packet*, Wheatley imported a wide range of raw materials and manufactured good from London," says Carretta.[1]

Phillis was acquainted with the Rotch family through the Wheatley business connections. She knew them well enough to write a poem for Joseph Rotch Jr., Francis' older brother. "Young Rotch sailed from Boston at the end of 1772 for a trip to London that he hoped would help him regain his failing health," says Robinson. "He died in London shortly after landing there."[2] *To A Gentleman On His Voyage to Great Britain For the Recovery of His Health* appeared in Phillis's 1773 published volume.

As Quakers, the Rotch family was sympathetic to the plight of African slaves. Elizabeth Rotch Rodman, Francis Rotch's sister, was described by contemporaries as "a friend of the slave and interested in every cause of humanity."[3]

Several years earlier, Francis's brother William Rotch had paid full wages to a slave who served as a crewman on one of his whaling ships. It became a legal issue when his master sued, claiming the wages for himself.

A Nantucket court not only ruled that the slave was entitled to keep the money, but also granted him his freedom.

When she heard that Captain Hall and the *Dartmouth* had arrived in Boston on November 28, Phillis had every reason to believe that she would be able to retrieve her books and bring them home. We imagine her walking from the Wheatley mansion to the docks, where she could see the *Dartmouth* at anchor. Maybe John Wheatley was among the group of merchants clamoring to claim their merchandise from the ship.

On December 1 the town leaders had Captain Hall move the *Dartmouth* to Griffin's Wharf. "Hall then began to unload all of his cargo except the tea," writes Labaree.[4]

Professor Carp confirms it. "On Wednesday, December 1, Hall warped around to Griffin's Wharf, where his crew put the sails and cables ashore and over the coming days, stevedores unloaded all the ship's cargo except for the tea."[5]

Labaree and Carp based their finding on the same primary source document. The *Dartmouth* journal entry for Thursday, December 2 notes: "Began to deliver our goods and continued to land them from day to day, till Saturday, Dec. 11, having a guard of 25 men every night."[6]

According to the official report by the recording officer on the *Dartmouth,* almost all the merchandise was offloaded under the watchful eye of the Town Security Force, between December 2 and December 11, 1773. At some point during that period, dockhands carried the barrel containing Phillis Wheatley's books off the ship. But they left 114 chests of tea behind.

"If you're picturing the men who destroyed the tea on December 16, 1773 carefully bypassing Wheatley's books during that event, that almost certainly didn't happen," says J. L. Bell.[7] Phillis managed to take possession of her books just days before the Patriots dumped the remaining cargo into the harbor in what history came to glorify as the Boston Tea Party.

They made strange companions in the annals of American history—the exquisite poetry of Phillis Wheatley and the dreaded tea, held together in the bowels of a ship for the journey across the Atlantic. A dozen years earlier, she had lived the nightmare of her own ocean voyage, suffering as human cargo, one among tens of millions hoarded like animals in unimaginable

misery. Now the ship carrying her creative offspring, her poems, was making the same transatlantic journey.

Poetry and tea, traveling side by side, came to America to meet their very different fates. The words of Phillis Wheatley, savored and celebrated through the centuries as a shining testament to the power of human potential, and a poignant witness to the creativity and accomplishment that was lost to the abomination of slavery, went on to launch an American literary tradition.

The tea was another story. Despised in America as a symbol of oppression, trashed and ravaged and fed to the sea, it never reached American soil. But her sublime poetry and the scorned tea, together on the *Dartmouth*, will forever link Phillis Wheatley to one of the most iconic moments in American history to mark the start of the convulsive throes that gave birth to the nation.

When the *Dartmouth* docked at Griffin's Wharf, it was outside the zone of protection provided by the Royal Navy. The Town Watch assumed control of the ship. Legally, however, "the tea was now in limbo," says Carp.[8] No one had clear authority over the tea, not the consignees who were the designated agents for the East India Company, not the *Dartmouth's* owner nor its captain, and not the British warships in the harbor. "The only group that could plausibly claim some control over the tea," Carp writes, "was the 'Body of the People.'"[9]

More tea arrived. On December 2 the ship *Eleanor* came with its cargo of 114 chests of tea. The next day Captain James Bruce was summoned to a meeting of "The People" in Faneuil Hall and ordered to dock at Griffin's Wharf beside the *Dartmouth*. They confronted him as they had Captain Hall and ordered him to discharge all his cargo but the tea.

On December 7 a third tea ship, the *Beaver* approached Boston harbor carrying 112 chests of tea. They reported smallpox on board, so the ship kept its distance until the disease could be smoked out. Word came that a fourth tea ship, the *William*, had struck a sand bar off Cape Cod and was disabled.

The *Beaver* joined the other tea ships at Griffin's Wharf on December 15. Now three ships, all carrying East India tea, were docked in Boston harbor. The Patriots vowed they would never let the tea land. With the

December 17 deadline looming, when customs agents could legally seize the tea, time was running out.

Reports came from New York, Philadelphia, and Charleston that the tea consignees and agents for the East India Company had all resigned. No tea would come ashore there because no one was willing to receive it.

In Boston the tea crisis was coming to a head. The consignees remained adamant and refused to resign. Their intransigence was supported by a stubborn Governor Hutchinson, still seething over the abuse he had suffered during the Stamp Act riots of 1765, when his house was destroyed. Governor Hutchinson was determined to hold firm—angry mobs would not sway him.

"In none of the other ports to which the Company's tea was dispatched had the consignees and the government officials combined to offer a united front against the patriots' demands," says Labaree. "If a showdown on the tea issue were to come at all, it would have to come at Boston."[10]

The consignees knew they had time and the law on their side. All they had to do was wait for the December 17 deadline when they were legally authorized to take possession of the tea. Meanwhile, the Customs Commissioners and consignees retreated for their own safety to the fortified Castle William, a small island in Boston Harbor where they would be protected by British troops.

"The East India Company Tea Commissioners still remain immured at Castle William," the *Boston Gazette* reported on December 13. "Their obstinacy has rendered them even more obnoxious to their countrymen than even the Stamp Masters were."[11]

"Thursday, December 16 was the last day that Boston's leaders could call people together to speak out against the East India Company's tea," writes Carp.[12] Everyone was aware of the legal requirement to land the tea on December 17. They fully expected that one minute after midnight customs officers backed by British troops would swoop down on the three ships anchored at Griffin's Wharf and take the tea.

"No one doubted that the consignees would then gladly pay the duties and the tea would be landed," says Labaree. "What should be done?"[13]

"A cold rain was falling over Boston," wrote Carp. "Once again, thousands of people packed the Old South Meeting House. It was 10 a.m.

Many had come through muck and mud and miserable weather from the countryside."[14]

One way or another, the tea had to go.

Patriot firebrand Samuel Adams rose to tell he crowd that there was "nothing further to be done—that they had now done all they could for the salvation of their country."[15]

George R. T. Hewes reported that "One of the last things he heard said, in the final excitement, was Hancock's cry, 'Let every man do what is right in his own eyes!'"[16]

Shouts filled the Old South Meeting House: "Boston harbor a tea-pot tonight!" "Hurrah for Griffin's Wharf!" "The Mohawks are come!" "Every man to his tent!"[17]

"Who knows how tea will mingle with salt water?" John Rowe cracked to great applause.[18]

"There was a confused murmur among the members," recalled Hewes, "and the meeting was immediately dissolved, many of them crying out, 'Let every man do his duty, and be true to his country' and there was a general huzza for Griffin's wharf."[19]

Phillis's friend John Andrews witnessed the scene from outside Old South. "The house was so crowded that I could get no further than the porch," he said. "I found the moderator was just declaring the meeting to be dissolved. This caused another general shout outdoors and inside, and three cheers." The Old South Meeting House quickly emptied to catcalls, whooping, and hollering. "What with that and the consequent noise of breaking up the meeting," recalled Andrews, "you'd have thought the inhabitants of the infernal regions had broken loose."[20]

The following week, on December 23, 1773, the *Massachusetts Gazette and Boston Weekly Newsletter* published a full account of the events that night.

> Just before the dissolution of the meeting, a number of brave and resolute men, dressed in the Indian manner, approached near the door of the Assembly, gave the war whoop, which rang through the house and was answered by some in the galleries, but silence being commanded, and a peaceable deportment was again enjoined till the dissolution.[21]

Years later, eyewitnesses came forward, participants and bystanders, to reveal what happened that night in Boston harbor.

> SAMUEL COOPER: "Immediately after a detachment of about 20 men disguised as Indians was seen to approach in single file by the west door of the Church. They marched with silent steps down the aisle and so passed by the south door brandishing their tomahawks in that direction."[22]
>
> BENJAMIN SIMPSON: "We repaired to the wharf."[23]
>
> JOSHUA WYETH: "To prevent discovery we agreed to wear ragged clothes and disfigure ourselves, dressing to resemble Indians. Our most intimate friends among the spectators had not the least knowledge of us."[24]
>
> JOHN ANDREWS: "They say the actors were Indians from Narragansett. Whether they were or not, to a transient observer they appeared such. They were clothed in blankets, with their heads muffled and copper colored faces. Each was armed with a hatchet or axe or pair of pistols."[25]
>
> GEORGE R. T. HEWES: "It was now evening, and I immediately dressed myself in the costume of an Indian, equipped with a small hatchet, which I and my associates denominated the tomahawk and a club, after having painted my face and hands with coal dust in the shop of a blacksmith, I repaired to Griffin's wharf, where the ships lay that contained the tea."[26]
>
> PETER EDES: "Before they reached there they were joined by hundreds."[27]

From the *Massachusetts Gazette and Boston Weekly Newsletter:*

> The Indians, as they were then called, repaired to the wharf where the ships lay that had the tea on board, and were followed by hundreds of people to see the event of the transactions of those who made so grotesque an appearance.[28]
>
> JOSHUA WYETH: "We surely resembled devils from the bottomless pit rather than men."[29]

GEORGE R. T. HEWES: "When we arrived at the wharf, there were three of our number who assumed an authority to direct our operations, to which we readily submitted. They divided us into three parties, for the purpose of boarding the three ships which contained the tea at the same time."[30]

JOSHUA WYETH: "We placed a sentry at the end of the wharf, another in the middle, and one on the bow of each ship as we took possession. We boarded the ship moored by the wharf, and our leader, in a very stern and resolute manner, ordered the captain and crew to open the hatchways, and hand us the hoisting tackle and rope, assuring them that no harm was intended them."[31]

JOSHUA WYETH: "Some of our number then jumped into the hold, and passed the chests to the tackle.[32]

ROBERT SESSIONS: "The chests were drawn up by a tackle—one man bringing them forward, another putting a rope around them and others hoisting them to the deck and carrying them to the vessel's side.[33]

JOSHUA WYETH: As they were hauled on deck others knocked them open with axes, and others raised them to the railings and discharged their contents overboard."[34]

From the *Massachusetts Gazette and Boston Weekly Newsletter:*

They, the Indians, immediately repaired on board Captain Hall's ship, where they hoisted out the chests of tea, and when upon deck stove the chests and emptied the tea overboard; having cleared this ship they proceeded to Captain Bruce's and then to Captain Coffin's brig.[35]

SAMUEL COOPER: "No noise was heard except the occasional clink of the hatchet in opening the boxes and the whole business was performed with so much expedition that before 10 o'clock that night the entire cargo of the three vessels were deposited in the docks."[36]

ROBERT SESSIONS: "Everything was as light as day, by the means of lamps and torches; a pin might be seen lying on the wharf."[37]

JOSHUA WYETH: "We were merry, in an undertone, at the idea of making so large a cup of tea for the fishes but we used not more words than absolutely necessary... I never worked harder in my life."[38]

GEORGE R. T. HEWES: "No disorder took place during that transaction, and it was observed at that time that the stillest night ensued that Boston had enjoyed for many months."[39]

JOSHUA WYETH: "While we were unloading, the people collected in great numbers about the wharf to see what was going on. They crowded around us."[40]

ROBERT SESSIONS: "Perfect regularity prevailed during the whole transaction. Although there were many people on the wharf, entire silence prevailed—no clamor, no talking. Nothing was meddled with but the teas on board. After having emptied the whole, the deck was swept clean, and everything put in its proper place. An officer on board was requested to come up from the cabin and see that no damage was done except to the tea."[41]

From the *Massachusetts Gazette and Boston Weekly Newsletter:*

It is worthy of remark that although a considerable quantity of goods were still remaining on board the vessels, no injury was sustained. Such attention to private property was observed that a small padlock belonging to the captain of one of the ships being broke, another was procured and sent to him.[42]

GEORGE R. T. HEWES: "In about three hours from the time we went on board, we had thus broken and thrown overboard every tea chest to be found in the ship, while those in the other ships were disposing of the tea in the same way, at the same time."[43]

From the *Massachusetts Gazette and Boston Weekly Newsletter:*

They applied themselves so dexterously to the destruction of this commodity that in the space of three hours they broke up 342 chests, which was the whole number in those vessels, and discharged the contents into the dock.[44]

JOHN ANDREWS: "Before nine o'clock in the evening every chest on board the three vessels was knocked to pieces and flung over the sides."[45]

From the *Massachusetts Gazette and Boston Weekly Newsletter:*

When the tide rose it floated the broken chests and the tea insomuch that the surface of the water was filled therewith a considerable way from the south part of the town to Dorchester Neck, and lodged on the shores.[46]

GEORGE R. T. HEWES: "The next morning, after we had cleared the ships of the tea, it was discovered that very considerable quantities of it were floating upon the surface of the water; and to prevent the possibility of any of its being saved for use, a number of small boats were manned by sailors and citizens, who rowed them into those parts of the harbor wherever the tea was visible, and by beating it with oars and paddles so thoroughly drenched it as to render its entire destruction inevitable."[47]

From the *Massachusetts Gazette and Boston Weekly Newsletter:*

The town was very quiet during the whole evening and night following. Those persons who were from the country returned with a merry heart; and the next day joy appeared in almost every countenance, some on occasion of the destruction of the tea, others on account of the quietness with which it was effected.[48]

Writing in his diary the next day, John Adams applauded the daring and heroic actions by his Boston compatriots. "Last night 3 Cargoes of Bohea Tea were emptied into the sea. This is the most magnificent movement of all. There is a dignity, a majesty, a sublimity, in this last effort of the Patriots that I greatly admire."[49]

Even then, the future president knew that Americans would look back at this gallant raid as the start of their counterattack against British oppression. It would not become known as "the Boston Tea Party" until 1834 and 1835, when two separate biographies came out celebrating the shoemaker

George Robert Twelves Hewes, the last participant known to be alive.[50] But John Adams was certain that this momentous event was "something to be remembered, something notable and striking" that would resonate in the nation's soul for generations to come. "This destruction of the tea is so bold, so daring, so firm, intrepid and inflexible, and it must have so important consequences, and so lasting, that I can't but consider it as an Epocha in History."[51]

Like all Bostonians, John Adams was on edge, nervously anticipating the severe British response they knew was sure to come. "What measures will the ministry take in consequence of this?" he asked. The question weighed heavily on the minds of everyone in Boston. "Will they punish us? How? By quartering troops upon us? By annulling our charter? By laying on more duties? By restraining our trade? By sacrifice of individuals? Or how?"[52]

# CHAPTER 33

*"I have lately met with a great trial in the
death of my mistress."*

NOW THAT PHILLIS HAD GOTTEN her books, the marketing campaign could begin. The first American advertisement for *Poems on Various Subjects Religious and Moral* appeared in the *Boston Gazette* on January 24, 1774.

> THIS DAY IS PUBLISHED
>
> Adorn'd with an Elegant Engraving of the Author
>
> Price: 3s. 4d.
>
> POEMS On Various Subjects Religious and Moral
>
> By PHILLIS WHEATLEY, A Negro Girl
>
> Sold by Messers' Cox & Berry At their King Street store, Boston
>
> N. B. The subscribers are requested to apply for their copies.[1]

There was one significant change in her advertisement. The author was no longer described as "A Negro Servant to John Wheatley." Instead she was "Phillis Wheatley, a Negro Girl." She was a free woman now.

Subscribers began receiving the books they had paid for. "After so long a time, have at last got Phillis's poems in print," John Andrews told his friend. He was already looking forward to her next book. "These don't seem to be near all her productions," he marveled. "She's an artful jade, I believe & intends to have the benefit of another volume."[2]

The advertisement for Wheatley's book ran again in the *Boston Gazette* on January 31 and February 7 and in the *Boston Weekly News-Letter* on February 3, 10, and 17.

"It's notable that Wheatley didn't start to advertise her books until the new year," J. L. Bell points out. Considering the turmoil in Boston

throughout December, Bell believes that Phillis's booksellers made a strategic decision to postpone advertising the books "until the tea crisis had settled down, especially since the Wheatley family was close to the Rotches. It might not have been a good time generally to try new business ventures, or to get space in the newspapers."[3] A marketer could easily see that potential readers in Boston were distracted. "People might not have been interested in poetry," he said, "and the newspapers full of other matters."[4]

Soon after her book came out in January 1774, it became something of a hot item. "By the end of the year, Wheatley's book was also on sale in New York, Pennsylvania, Connecticut, Rhode Island and Nova Scotia, Canada," says Carretta.[5]

Sales of her book benefitted from a "book market consisting of capitalist booksellers and a new middle-class reading audience," writes Rowan Ricardo Phillips, aided by "the institutionalization of free libraries and a growing common habit of book borrowing."[6]

"The rising middle class, with its increasingly voracious appetite for books, especially novels, portended a new mass patronage of books based not on a work's appeal to the gentry but on its general popularity," scholar Cathy Davidson explains. "There is evidence that those of modest to low income increasingly read many books."[7]

One of those who enjoyed Phillis Wheatley's poems was New Jersey teacher Philip Vickers Fithian. His diary entry on March 5, 1774 describes a conversation with a student about her poetry.

> I was reading in the evening to Bob in the Monthly Review the remarks on the poetry and writings of Phillis Wheatley of Boston; at which he seem'd in astonishment; sometimes wanting to see her, then to know if she knew grammar, Latin &c. At last he expressed himself in a manner very unusual for a boy of his turn & suddenly exclaimed, 'Good God! I wish I was in Heaven!'

He added his own commentary praising her verses.

> Like Bob, I am at once fill'd with pleasure & surprise when I see the remarks of the reviewers confirmed as to the writings of that ingenious African Phillis Wheatley of Boston. Her

verses seem to discover that she is tolerably well acquainted with poetry, learning & religion.[8]

Now that Phillis Wheatley was "a free, responsible black woman, she realized, for instance, that it would be largely up to her to sell copies of her book for her support," says Robinson.[9] "Phillis was unusually active on her own behalf in trying to survive."[10]

Making use of marketing strategies she had picked up from the entre-preneurial-minded Wheatleys, Phillis was serious about her own commer-cial enterprise—her book. "She busily promoted its sale, enlisting in this the help of her friend Miss Tanner," says Merle Richmond.[11]

Even before her books arrived she wrote to Obour to "beg you'd use your interest to get subscriptions as it is for my benefit."[12]

Phillis sought out other friends to drum up support as well. On February 9 she wrote to Reverend Samuel Hopkins of Newport, a leader of Rhode Island's abolitionist movement and her friend Obour Tanner's pas-tor. "I take with pleasure the opportunity by the post to acquaint you of the arrival of my books from London." In a brisk, businesslike memorandum she acknowledged payment for twenty copies of her book. "I received some time ago 20 sterling upon them by the hands of your son, in a letter from Obour Tanner. I have seal'd up a package containing 17 for you, 2 for Mr. Tanner [Obour's owner] and one for Mrs. Mason and only wait for you to appoint some proper person by whom I may convey them to you."[13]

Writing on March 21, she informed Obour that "I shall send the 5 books you wrote for, the first convenient opportunity." Then she added a polite sales pitch. "If you want more they shall be ready for you."[14]

In May she informed Obour that "I have recd the money you sent for the 5 books & 2/6 (two shillings, six pence) more for another which I now send." Phillis expressed her deepest appreciation for the help and support from her dear friend. "Assist me, dear Obour!" she wrote. "Your tenderness for my welfare demands my gratitude."[15]

"Tanner subsequently acted as an agent for Wheatley's book sales in Newport," says Joanna Brooks.[16]

"Obour would dutifully sell at least a known half-dozen copies to her fellow Newporters, black and white," writes Robinson.[17]

Since the early days of her writing career, Phillis could count on a wide group of supporters. "Networks of white and black women also acted as sales agents for Wheatley's published poems in New England," Professor Brooks notes. "The largest known order for her Poems came out of Newport, Rhode Island" with its "active evangelical women's networks, an 'Ethiopian Society,' and independent African American Sunday schools" sponsored by Reverend Hopkins' First Congregational Church of Newport, "where two-thirds of the members were women, a significant number of them black."[18]

Phillis recruited her friend Reverend Samson Occom to help her sell books in Connecticut. An ad offering the books appeared in the *Connecticut Gazette* on June 17. "To be sold by T. Green, *Poems on Various Subjects Religious and Moral,* by Phillis Wheatley, Negro Servant to Mr. John Wheatley, of Boston in New England. A few of the above are likewise to be sold by Samson Occom."[19]

Taking advantage of the popular salon culture, "Wheatley performed her poems before groups of women gathered in private homes in Boston," says Brooks. "These women purchased her books for themselves and commissioned original works on personal or occasional topics."[20]

"Obliged to redouble her efforts to sell her poems for her livelihood, Phillis may have carried her volumes from door to door," writes Robinson.[21]

Deborah Fletcher Cushing, a member of the Old South Church in Boston with Phillis, sent a copy of her *Poems* to her husband Thomas Cushing, then in Philadelphia as Massachusetts delegate to the First Continental Congress. "Sent you one of Phillis Wheatley's books which you will wonder at," she wrote on September 19, 1774. She described a salon gathering for a poetry reading with her circle of friends, where the star attraction was Phillis Wheatley. "Mrs. Dickerson and Mrs. Clymer, Mrs. Bull with some other Ladys were so pleased with Phillis and her performances that they bought her books and got her to compose some pieces for them."[22]

A copy of Wheatley's *Poems on Various Subjects Religious and Moral* found its way to South Carolina. "Wheatley's poems were indeed known among the prominent families of Charleston," says Julian Mason. "In the rare book collection of Duke University there is a copy of Wheatley's *Poems* given to Mary Eveleigh by Wheatley."[23]

Mary Eveleigh was the wife of Nicholas Eveleigh of South Carolina, the first comptroller of the United States Treasury. After her husband died, Mary married Edward Rutledge of Charleston, a Founding Father who attended the first and second Continental Congresses and signed the Declaration of Independence. "The book of her poems which Wheatley had given to Mary Eveleigh also bears the bookplate of Edward Rutledge's law partner, Charles Pinkney of Charleston, another signer of the Constitution," says Mason, adding that two volumes of the works of William Shenstone currently held at the Schomburg Center in New York contain inscriptions noting that "they were given to Phillis by Mary Eveleigh on September 24, 1774." Mason believes that the women made a "face-to-face exchange, since Mary Eveleigh was in New England that summer."[24]

Throughout the winter of 1773-1774, even as she worked to promote her book, Phillis served as caregiver and nurse to the dying Susanna Wheatley. Finally, on March 3, 1774, Mrs. Wheatley died at the age of sixty-five. "Phillis was at the bedside during the death watch," says Robinson.[25] Oddell described Phillis gently ministering to Mrs. Wheatley as she took her last breath. It was "her mournful duty to close the eyes of her indulgent mistress and unwearied friend."[26]

"She was a part of the procession of mourners who wound down to the Old Granary Burial Place on Tremont Street," writes Robinson, "where her mistress and long-doting friend and benefactor was laid to rest with her three children who had died young."[27]

Susanna Wheatley was so highly respected in Boston that "the honourd John Hancock delivered an oration" at her funeral, a family member reported.[28]

Phillis wrote no poetry about the death of Susanna Wheatley. There was no elegy, no requiem, and no memorial to honor her most intimate friend and tireless advocate, the woman most responsible for her literary success. There was a good reason for this—Phillis felt bound to honor Susanna Wheatley's last wish. "On her deathbed, she requested that nothing might be written upon her decease," Oddell explained. "Indeed, Phillis was forbidden this indulgence of her grief."[29]

"We are told, by one of the very few individuals who have any recollection of Mrs. Wheatley or Phillis, that the former was a woman distinguished

for good sense and discretion," her great grand-niece wrote. "Her Christian humility induced her to shrink from the thought of those good deeds being blazoned forth to the world, which were performed in the privacy of her own happy home."[30]

The loss hit Phillis deeply. As a sensitive and compassionate woman, Phillis could not help sharing her profound sorrow with two of her closest friends. Three weeks after Susanna Wheatley's death, Phillis described her grief to Obour Tanner. "Her March 21, 1774 letter is the most reliable evidence we have of the familial relationship Phillis felt she had with the Wheatleys," says Carretta.[31]

"The poet's sorrow was expressed in a letter to Miss Tanner," writes Richmond, "and the emotion is the more authentic for the privacy of it, for the absence of the constraints and embellishments of the heroic couplet."[32]

"I have lately met with a great trial in the death of my mistress," Phillis wrote. "Let us imagine the loss of a parent, sister or brother. The tenderness of all these were united in her." It was the first time Phillis allowed herself to express her true feelings toward her mistress. "I was a poor little outcast & a stranger when she took me in; not only into her house but I presently became a sharer in her most tender affections."[33]

Susanna Wheatley, the only maternal figure Phillis ever knew, made her feel accepted as part of the family. "I was treated by her more like her child than her servant," Phillis said.

> No opportunity was left unimprov'd of giving me the best of advice, but in terms, how tender! How engaging! This I hope ever to keep in remembrance. Her exemplary life was a greater monitor than all her precepts and instruction, thus we may observe of how much greater force example is than instruction.[34]

Despite the outrageous arrogance that allows one person to claim to own another in the inherently oppressive master-slave relationship, "Wheatley was not unique in expressing such sentiments about a humane mistress," Richmond writes. "Even the militant Frederick Douglass recalled that one of his mistresses was so 'kind, gentle and cheerful' that he 'soon learned to regard her as something more akin to a mother than a slaveholding mistress.'"[35]

Phillis offered her fullest account of Susanna Wheatley's death in her March 29 letter to John Thornton, a man she regarded as spiritual mentor.

> Much honoured sir:
>
> I should not so soon have troubled you with the second letter but the mournful occasion will sufficiently apologize. It is the death of Mrs. Wheatley. She has been laboring under a languishing illness for many months past and has at length took her flight from hence to those blissful regions which need not the light of any but the Sun of Righteousness.
>
> O, could you have been present to see how she long'd to drop the tabernacle of clay and to be freed from the cumbrous shackles of a mortal body which had so many times retarded her desires when soaring upward. She has often told me how your letters have quicken'd her in the spiritual course; when she has been in darkness of mind they have rais'd and enliven'd her insomuch that she went on, with cheerfulness and alacrity in the path of her duty.
>
> She did truly run with patience the race that was set before her and hath, at length, obtained the celestial goal. She is now sure that the afflictions of this present time were not worthy to be compared to the Glory, which is now, revealed in her, seeing they have wrought out for her, a far more exceeding and eternal weight of Glory.[36]

Phillis recounted Susanna Wheatley's poignant final moments.

> About half an hour before her death she spoke with a more audible voice than she had for three months before. She calld her friends & relations around her and charg;d them not to leave their great work undone till that hour, but to fear God and keep his commandments, being ask'd if her faith failed her, she answe'd, No. Then spread out her arms crying "Come! Come quickly! Come! Come! O pray for an easy and quick passage!"
>
> She eagerly longed to depart to be with Christ. She retained her senses till the very last moment when "Farewell, fare well" with a very low voice were the last words she utter'd.[37]

In her deep anguish and personal bereavement, the devout Phillis saw the occasion of death as proof of the Divine Glory of the Heavenly Father.

> I sat the whole time by her bedside and saw with grief and wonder the effects of sin on the human race. Had not Christ taken away the envenom'd sting, where had been our hopes? What might we not have fear'd, what might we not have expected from the dreadful King of Terrors? But this is matter of endless praise, to the King eternal immortal, invisible, that it is finished.[38]

Phillis offered a sisterly appeal for God's Grace on behalf of Nathaniel Wheatley, making Divine entreaties for a young man she had come to regard as a brother. Carretta sees this as "further evidence of Phillis's place in the Wheatley family."[39]

> I hope her son will be interested in your closet duties & that the prayers which she was continually putting up & which are recorded before God in the Book of his remembrance for her son & for me may be answer'd. I can scarcely think that an object of so many prayers will fail of the blessings implor'd for him ever since he was born.[40]

Phillis wrote to Thornton again that fall, confessing that she was still in mourning. With the pain of her mentor's passing still raw, she reflected on the impact Susanna Wheatley had on her life and revealed how profoundly she missed her.

> By the great loss I have sustain'd of my best friend, I feel like one forsaken by her parent in a desolate wilderness, for such the world appears to me, wandring thus without my friendly guide. I fear lest every step should lead me into error and confusion. She gave me many precepts and instructions'; which I hope I shall never forget.[41]

Phillis could not help but notice a strange phenomenon, which she pointed out to Thornton. Now that Susanna Wheatley was gone, a number of people she thought were friends had grown distant. Thornton had

warned her about this. "I attended and find exactly true your thoughts on the behavior of those who seem'd to respect me while under my mistresses patronage: you said right, for some of those have already put on a reserve."[42]

It was a hard lesson for Phillis Wheatley. "The world is a severe schoolmaster," she wrote, "for its frowns are less dang'rous than its smiles and flatteries and it is a difficult task to keep in the path of wisdom."[43]

Phillis would find that her life was about to change dramatically. Without Susanna Wheatley in her corner, her literary output shrank. "Whether Phillis then realized it or not, her poetic career was also practically ended," says Robinson. "Between Mrs. Wheatley's death and her own death ten years later, Phillis erratically composed a total of only eight known poems. She was able to publish just six of those."[44]

Phillis Wheatley, natural poetic genius, the prodigy called a "wonder of the age," continued her valiant efforts to build on her literary success. "Although she tried to sustain her career," says Robinson, "she was simply unable to succeed without the insistently determined and financially influential exertions of the resolved Susanna Wheatley."[45]

# CHAPTER 34

"Are not your hearts also hard when you hold them in slavery who are entitled to liberty, by the law of nature?"

CONSIDERING THE SOCIAL AND POLITICAL turmoil around her, Phillis Wheatley had every reason to follow the news in Boston. A voracious reader, she was regularly exposed to the many pamphlets, books, broadsides, and newspapers featuring the momentous issues that so distressed her neighbors and agitated the population.

Passionate discussions and debates surely reached the Wheatley home. Phillis had ample opportunity to absorb the ideological arguments that formed the basis of the colonists' complaints.

Mercy Otis Warren later summed up the tenor of the time in her *History of the Rise, Progress and Termination of the American Revolution:* "The people trembled for their liberties."[1]

Boston firebrand Sam Adams hailed the town's resolve in the fight for freedom. "Perhaps there never was a people who discovered themselves more strongly attached to their natural and constitutional rights and liberties than the British colonists on the American continent," he wrote in the *Boston Gazette.* "Their united and successful struggles against that slavery with which they were threatened by the Stamp Act will undoubtedly be recorded by future historians to their immortal honor."[2]

As cries for liberty and natural rights advanced, the colonists clamoring for an end to British tyranny had to confront the striking reality that forcing Africans into a lifetime of slavery was utterly incompatible with their cherished ideal of freedom. "The dissemination of Enlightenment thought in the Anglo-American world encouraged more white men to embrace antislavery ideas," says scholar Emily Blanck.[3]

"The link between the rights of the colonists and those of the slaves was demonstrated at the very outset of the great debate of the Revolutionary era," observes historian Phillip Foner.[4] "For over a decade the air had been

filled with sermons and speeches pointing up the fact that the claims put forward by the colonists for freedom based on 'natural rights' smacked of hypocrisy as long as they denied the same freedom to their slaves."[5]

As early as 1764, the fiery James Otis opened the door for the colonists to recognize the injustice suffered by those living among them against their will. "Colonists are by the law of nature free born, as indeed all men are, white or black," he charged. Calling slavery "the most shocking violation of the law of nature," he arrived at the damning conclusion that "Those who every day barter away other men's liberty will soon care little for their own."[6]

In 1772 James Swan, one of the Sons of Liberty who a year later would participate in the Boston Tea Party, published a thoughtful antislavery essay declaring that "No country can be called free where there is one slave."[7] His pamphlet, *A Dissuasion to Great Britain and the Colonies from the Slave Trade to Africa* was printed by Ezekiel Russell, who published Phillis Wheatley's first book proposal that year, as well as her elegy to George Whitefield in 1770.

Swan urged compassion for the plight of "the poor Africans who fall into the hands of the men-wolves that prowl on their coasts," compelled against their will "to serve their lifetime and their children after them."[8]

> I would sincerely advise every man who is in this abominable trade not to persist in it, feeling the many threats and commands against him in God's laws....[9] No person can buy these people and oblige them and their children to serve as slaves without incurring the displeasure of God and his punishments for disobeying his just commands.[10]

Boston Tea Party historian Benjamin Carp notes that some colonists acknowledged that their yearning for liberty and that of the enslaved Africans came from the same passion for freedom. "Swan's pamphlet demonstrates that at least one man at the Tea Party was thinking about freedom, not just in terms of ending taxation without representation, but in terms of ending human bondage as well."[11]

James Swan's antislavery tract was distributed to the governor and each lawmaker. The legislature considered the petition briefly before setting it aside for what they considered to be more important business.

As a newly freed slave, Phillis Wheatley was surely aware of the plight of the black community. Of the 15,520 residents of Boston in 1765, nearly 1,000 were slaves. The census counted only eighteen free blacks.[12]

Enslaved Africans were everywhere, performing their day-to-day functions as the economic engine that allowed Boston to prosper. There were slave auctions and slave sales. Advertisements for the capture of runaways appeared regularly in newspapers. The city's biggest slave-owners were their town leaders, John Hancock and Thomas Hutchinson. Phillis Wheatley knew them both personally.

Surrounded by a spirited chorus of colonists calling for freedom from the tyranny of slavery, Boston's black community was emboldened to stand up for themselves. "Public discussion of slavery—of both the reality and the metaphor—mobilized the black population in Massachusetts," writes Professor Blanck.[13]

Enterprising slaves took advantage of their unique access to the Massachusetts courts to sue their owners for their right to freedom. "In the history of slave societies, very few slaves outside of New England felt empowered even to challenge their own enslavement," says Blanck.[14]

Many of these so-called freedom suits were successful. "Between 1764 and 1774, seventeen slaves appeared in Massachusetts courts to sue their owners for freedom. These freedom suits drove a wedge into the wall of slavery, creating an opening for slaves to escape from their bondage," writes Blanck.[15] "The juries in freedom suits demonstrated how deeply antislavery sentiments pervaded the white population. The environment of the pre-Revolutionary era made it easier for the general white population to free individual blacks."[16]

Years later, after a court case abolished slavery in Massachusetts, John Adams declared that "I never knew a jury by a verdict to determine a negro to be a slave. They always found them free."[17]

Massachusetts slaves and free blacks used their literacy skills and legal sophistication to write persuasive tracts, pamphlets, and petitions invoking concepts such as "natural rights," "justice," and "divine law" to demand the same freedoms white citizens were pining for. On January 6, 1773 a slave named Felix Holbrook submitted a "Slave Petition for Freedom" directly to "His Excellency Thomas Hutchinson, and the Honorable House of

Representatives in General Court assembled at Boston."[18]

Felix Holbrook, born in Africa about 1743, was kidnapped as a child and endured the Middle Passage to Boston, where he was sold around 1750. His owner, Abiah Holbrook, was a prominent schoolmaster in Boston, which may account for how his slave acquired his reading and writing skills.

Felix Holbrook's letter to the Massachusetts government argued for nothing less than freedom for all of Massachusetts Bay's 5,000 slaves. It was the "first black collective plea for freedom to an American legislature," according to the editors of the *Dictionary of Afro-American Slavery*, and "demonstrates with rage and irony that during the American Revolution, Boston bondsmen had successfully appropriated their patriot master's political tools, the ad-hoc committee and the petition as well as their political rhetoric."[19]

Holbrook drew a heartrending picture of the awful burdens placed on slaves "who have had every day of their lives embittered with this most intolerable reflection....Neither they nor their children to all generations shall ever be able to...possess and enjoy anything, no, not even life itself, but in a manner of the beasts that perish."[20]

Several months later, on April 20, 1773, three slaves joined Felix Holbrook to submit a second petition.

> The divine spirit of freedom seems to fire every humane breast on this continent, except such as are bribed to assist in executing the execrable plan....We cannot but expect your house will again take our deplorable case into serious consideration, and give us that ample relief which, as men, we have a natural right to.[21]

The men, all Boston slaves, had the gumption to sign their full names: "In behalf of our fellow slaves in this province: Peter Bestes, Sambo Freeman, Felix Holbrook, Chester Joie."[22] Their petition was printed and distributed as a pamphlet by Ezekiel Russell.[23]

That same year, an anonymous pamphlet circulated around Boston supporting the slaves' appeal for freedom. *The Appendix: Or Some Observations on the Expediency of the Petition of the Africans, Boston, 1773* issued a challenge to the colonists: "I would ask those mighty sticklers for slavery

whether the Africans were not born as free as British subjects? If so, are they not justly entitled to, and may they not expect, both by the laws of God and man, to inherit and possess every privilege which Americans enjoy?"[24]

In Newburyport, thirty-five miles from Boston, former slave Caesar Sartor published an "Essay on Slavery" in the *Essex Journal and Merrimack Packet* on August 17, 1773 that challenged readers to confront the irrational contradiction between the colonists' principled love of liberty and their practice of denying it to others.[25] He reminded those who supported slavery while agitating for their own freedom of the "Absurdity of your exertions for liberty while you have slaves in your houses."[26]

Phillis was still in London on July 21, 1773, when Harvard College hosted their traditional debate between two graduating seniors on a controversial topic of the day. The question under consideration was: "Whether the slavery, to which Africans are in the province, by the permission of law, subjected, be agreeable to the law of nature?" The debate on slavery elicited so many comments by supporters and abolitionists, a transcript was quickly printed that ran to forty-eight pages.[27]

The year 1774 saw antislavery sentiments accelerating in New England. Nathaniel Niles, a lawyer and politician from Vermont, gave a powerful sermon on liberty at the North Church in Newburyport, Massachusetts on June 5, 1774. "Liberty is a precious pearl," he said.[28] "Would we enjoy liberty? Then we must grant it to others. For shame, let us either cease to enslave our fellow-men, or else let us cease to complain of those that would enslave us."[29]

In a personal letter to her husband, John Adams, Abigail Adams wrote on September 22, 1774, "I wish most sincerely there was not a slave in the province; it always appeared a most iniquitous scheme to me to fight ourselves for what we are daily robbing and plundering from those who have as good a right to freedom as we have." Clearly, it was a topic she and the future president had discussed many times. "You know my mind upon this subject," she insisted.[30]

In New Hampshire, Dr. Jeremy Belknap, who recorded "Phillis Wheatley's first effort" in 1765, appealed for an end to slavery in a July 1774 sermon. "Would it not be astonishing to hear that a people who are contending so earnestly for liberty are not willing to allow liberty to others?"[31]

Benjamin Rush, one of our most accomplished Founding Fathers, physician, writer, philosopher, a major figure in the American Enlightenment and signer of the Declaration of Independence, lent his highly respected voice to the antislavery movement. His 1773 book, *An Address to the Inhabitants of the British Settlements in America, on the slavery of Negroes in America*, published in Philadelphia and reprinted in New York and Boston, called for an immediate end to the slave trade and the gradual dismantling of the institution of slavery. "Rush may be credited with a decisive influence on the formation of attitudes against slavery and the slave trade, not only in Pennsylvania but everywhere in the Northern colonies," says Foner.[32]

His thoughtful annihilation of every rationale offered by pro-slavery advocates highlighted the extraordinary accomplishments of Phillis Wheatley to demonstrate how Africans are perfectly capable of wonderful things when given the opportunity. "Rush may have learned of Wheatley through his wife Julia Stockton Rush, who apparently owned at least one of her manuscript poems," says Carretta. "Wheatley is the only individual enslaved African Rush refers to in his argument against slavery."[33]

In his acclaim for the African poet, Rush made some factual errors—she was not free at the time he wrote his essay but still a slave; and she was several years older and had been in the colonies at least two years longer than he says. Despite the misstatements, his point is clear.

> There is now in the town of Boston a Free Negro Girl, about 18 years of age, who has been but 9 years in the country, whose singular genius and accomplishments are such as not only do honor to her sex but to human nature. Several of her poems have been printed and read with pleasure by the public.[34]

Rush demolished the erroneous belief that Africans were somehow intellectually and morally inferior to Europeans.

> I need hardly say anything in favour of the intellects of the Negroes or of their capacities for virtue and happiness, although these have been supposed by some to be inferior to those of the inhabitants of Europe. The accounts which travelers give us of their ingenuity, humanity and strong attachment to their parents, relations, friends and country, show us that they are

equal to Europeans... We have many well attested anecdotes of as sublime and disinterested virtue among Negroes as ever adorned a Roman or a Christian character."[35]

Phillis Wheatley was probably aware of the Benjamin Rush antislavery treatise. She may have responded to his comments in a letter she wrote to him. We know they were in communication because her letter to Dr. Rush was advertised in her proposed second book.

Finally, in January 1774, the Massachusetts Legislature passed a resolution abolishing slavery in the colony of Massachusetts. But it never became law because Governor Hutchinson vetoed it.

On February 10, 1774, the *Massachusetts Spy* published a letter signed by "A Son of Africa." The author commiserated with the colonists over their claim to be victims of British tyranny. "You are taxed without your consent, (I grant that a grievance.) and have petitioned for relief and cannot get any," he said. This brave writer challenged the colonists to see the strivings of Africans for freedom as an extension of their own struggle. "Are not your hearts also hard," he asked, "when you hold them in slavery who are entitled to liberty, by the law of nature, equal as yourselves?"[36]

Another petition written by an anonymous slave was directed to the new governor, Thomas Gage, on May 25, 1774.

> The Petition of a Grate Number of Blackes of this Province who by divine permission are held in a state of Slavery within the bowels of a free and christian Country, Humbly Shewing That your Petitioners apprehind we have in common with all other men a naturel right to our freedoms without Being depriv'd of them by our fellow men as we are a freeborn Pepel and have never forfeited this Blessing by aney compact or agreement whatever.
>
> But we were unjustly dragged by the cruel hand of power from our dearest frinds and sum of us stolen from the bosoms of our tender Parents and from a Populous Pleasant and plentiful country and Brought hither to be made slaves for Life in a Christian land. Thus are we deprived of every thing that hath a tendency to make life even tolerable.

Despite the writer's poor spelling, nobody could possibly misunderstand his message. The petition concluded: "We therefor Beg your Excellency and Honours will give this its due weight and consideration and that you will accordingly cause an act of the legislative to be pessed that we may obtain our Natural right our freedoms and our children be set at lebety [liberty]."[37]

Did Phillis Wheatley know any of the authors of the Boston freedom petitions? Did she play any role in drafting or editing these antislavery writings?

Surely, every black person in Boston knew the black poet by reputation. With such an accomplished writer living among them, we should not be surprised if one or more of the slave petitioners sought her help in composing their manifesto.

In his ground-breaking study of *The Slave Community*, history professor John Blassingame found that the aggrieved Africans developed a reliable network of mutual cooperation that served as a source of strength within the community. "Having a distinctive culture helped the slaves to develop a strong sense of group solidarity," Blassingame writes. "They united to protect themselves from the most oppressive features of slavery and to preserve their self-esteem. Despite their weakness as isolated individuals, they found some protection in the group from their masters."[38]

Throughout the history of slavery, every slave community developed a covert communication system to share news, to spread the word about secret gatherings, celebrations, dances, and prayer meetings. It served their need for self-preservation, a way to warn each other if a master or overseer was coming or to share strategies for escaping. In their solidarity, slaves created opportunities that allowed them to talk freely and honestly, away from the onerous presence of white folks. By necessity, these interactions had to take place "under the radar," undetected by any white person. Their conversations would be quiet, personal and private. There would be no record and no witnesses. "Although not documented, as is the case with practically all accounts of the largely unrecorded early black colonial life...whatever casual black social contacts Phillis might have enjoyed would have to have been developed almost surreptitiously," notes Robinson.[39]

Evidence suggests that Phillis Wheatley and Felix Holbrook probably knew each other. Like Phillis, Felix Holbrook was African-born, and

had arrived in Boston after an excruciating Middle Passage about ten years before Phillis. Purchased by Boston schoolteacher Abiah Holbrook, he was "well-educated."[40] Holbrook lived several blocks from the Wheatleys, on Tremont Street opposite Boston Common, and was a member of Old South Church along with Phillis.[41] If Felix attended worship service there on any given Sunday, he would almost certainly have encountered Phillis, perhaps in the balcony reserved for "negroes." They could have met each other in passing on the street. If Felix Holbrook wanted to talk to Phillis Wheatley in 1773 Boston, he would have had no difficulty finding her. It seems likely that an intelligent and determined Felix Holbrook would want to share his draft in progress with another highly skilled writer. Perhaps he showed Phillis his letter with the eighteenth century version of "What do you think?"

After the 1772 Somerset decision, the fervent calls for freedom coming from white patriots and reverberating in the Boston slave community— and most significantly, after her own liberation—Phillis Wheatley was undoubtedly heartened and hopeful for the future of freedom. "She was well aware of the rapidly evolving attitude about slavery in Massachusetts," says Carretta. "The legal end of slavery in Massachusetts probably appeared imminent to her in 1773."[42]

# CHAPTER 35

## "In every human breast God has implanted a principle, which we call Love of Freedom."

IN 1774 THE MOST FAMOUS African in the world was living in Boston. Now that Phillis Wheatley was a free woman, did she lend her voice to the rising chorus crying out for freedom for those trapped in slavery?

Boston Tea Party historian Benjamin Carp insists that Phillis Wheatley did, indeed, speak up in support of her aggrieved brothers and sisters by forcefully calling for an end to slavery. "The African-Americans of Massachusetts had their own muse," he writes, "in the form of a young woman named Phillis Wheatley."[1]

"Wheatley, like the angry colonists around her, was as ready to insist on her freedom as she was to denounce the tyranny of those who deprived her of this right," says Paula Bennett.[2]

In February 1774, Phillis Wheatley was "feeling the headiness of almost six months of freedom," says William Robinson,[3] "a free black woman, no longer a slave or even a servant to anyone."[4]

About a month before her mentor and mistress Susanna Wheatley died, Phillis read a printed version of a sermon delivered by her friend and frequent correspondent Reverend Samson Occom, the Mohegan Indian and Christian minister who often stayed at the Wheatley home when he preached in Boston. It was a bold antislavery statement. Reverend Occom exposed the moral bankruptcy and intellectual dishonesty of those Christian ministers who supported liberty for the colonies while owning slaves themselves. Occom used biblical teachings to support his argument that anyone who claimed ownership of another human being was committing a sin. He charged slaveholding church leaders with gross hypocrisy.

"I will tell you who they are," Occom thundered. "They are the preachers or ministers of the Gospel of Jesus Christ."

> It has been very fashionable for them to keep Negroe Slaves, which I think is inconsistent with their characters and function. If I understand the Gospel aright, I think it is a dispensation of Freedom and Liberty, both temporal and spiritual, and if the preachers of the Holy Gospel of Jesus do preach it according to the mind of God, they preach True Liberty; and how can such keep Negroes in slavery?

He challenged his fellow Gospel preachers: "If ministers are true Liberty men, let them preach Liberty for the poor Negroes fervently and with great zeal and those ministers who have Negroes set an example before their people by freeing their Negroes. Let them show their faith by their works."[5]

Phillis was so inspired by his sermon that she felt moved to respond. It was "her best-known and most direct statement against slavery," says Professor Blanck, and it came "in a letter, not a poem."[6]

On February 11, 1774 Phillis took time from her caretaking duties for Mrs. Wheatley to write a remarkable treatise to support Reverend Occom's argument. Carretta, too, believes it was "Phillis Wheatley's most direct condemnation of slavery and the hypocrisy of self-styled freedom fighters."[7]

Mason called it "Wheatley's strongest and most direct publication against slavery."[8]

"It remains the most forceful of the several antislavery remarks that she composed," says Robinson.[9] "It stands as a documented testimony of her racial awareness and concern."[10]

The letter was a polemic designed to make the case that not only was slavery unjust and immoral, it was ridiculous and nonsensical. The poet chose her words with great care, artfully crafting her points to sway her white readers. Robinson describes the tone of the letter as "genuinely genteel" and "restrained."[11]

In typical Wheatley style, Phillis remained reasonable and gracious, true to her character, while guided by Christian teaching. Her meditation on the abomination of slavery was deeply spiritual.

Phillis Wheatley had a serious point to make and she delivered her truth with penetrating intellect and moral authority. But her message came straight from the heart. "Phillis Wheatley, speaking as a free black woman, was being quite personal," says Robinson, "and meant exactly what

she said."[12] It was "the most subtly biting piece of Black protest Phillis Wheatley ever published," he writes,[13] and "the first so widely distributed black-written antislavery letter in Afro-American literature."[14]

In the nimble hands of a poet, Phillis's muted antislavery manifesto became a gleaming stiletto blade. "No agonizing cry, perhaps," observes literary scholar Barbara Johnson, "but controlled and devastating irony."[15]

Wheatley opened by declaring her hearty agreement with the sentiments offered by Reverend Occom. "I have this day received your obliging kind epistle, and am greatly satisfied with your reasons respecting the negroes and think highly reasonable what you offer in vindication of their natural rights."[16]

Phillis described the dynamic forces at work in America, how the sacred ideal of freedom was changing America. "Those that invade" the "natural rights" of their fellow man—the slave-owners—can surely hear the piercing calls for liberty advancing throughout the land. Even those who own slaves "cannot be insensible that the divine light is chasing away the thick darkness which broods over the land of Africa," she wrote. If this movement toward national virtue is allowed to continue, "the chaos which has reigned so long, is converting into beautiful order."[17]

This new vision of America, according to Phillis Wheatley, is a society that values true freedom—freedom of the body and freedom of the soul. "The glorious dispensation of civil and religious liberty, which are so inseparably united, that there is little or no enjoyment of one without the other."[18]

The Christian poet used biblical imagery to illustrate her argument in a way she knew her readers would understand. "Wheatley anticipated one of the most common metaphors found in nineteenth-century African American resistance to slavery," Carretta notes. "She was an African American pioneer in the development of what would come to be called liberation theology, the belief that God favored the oppressed."[19]

Pointing to the Old Testament Israelites enslaved in Egypt, she connects their bondage to that of her people, making the case that the slaves of the ancient world were indistinguishable from the slaves her readers knew in their everyday lives. Just as the ancient Israelites hated their slavery and threw their chains away, she wanted her readers to know that their own

slaves in America hated their slavery just as much. "Perhaps, the Israelites had been less solicitous for their freedom from Egyptian slavery; I do not say they would have been contented without it, by no means."[20]

In one of the most eloquent lines she ever wrote, Phillis Wheatley stands on the authority of Divine Law to speak for all humankind as she issues her most damning rebuke of the atrocity of slavery. Her Christian readers would be familiar with the universal principles St. Paul described in Romans 2:15: "They show that the work of the law is written on their hearts, while their conscience also bears witness."

From the gospel according to Phillis: "In every human breast God has implanted a principle, which we call Love of Freedom," she wrote. "It is impatient of oppression, and pants for deliverance."[21]

Addressing her white New England readers, she reinforced the simple truth that slaves who lived in biblical times and their own slaves, those who lived and worked among them every day—slaves like herself—share the same "Love of Freedom."

"And by the leave of our modern Egyptians," she added, "I will assert, that the same principle lives in us."[22]

"And now," writes Robinson, "in February 1774, before the flushed faces of Boston's 'modern Egyptians', she could point to the reality of her London-published volume of *Poems* as physical proof of her abilities not only to fathom such bigoted contradictions but even to rise in something close to serene triumph above them."[23]

She closed with a prayer. It was a petition for the Almighty to intercede for the benefit of those "modern Egyptians," that they might be granted the wisdom to see the foolishness of their behavior, to realize that they are being ensnared by their own greed when they force their brothers to suffer in bondage. "God grant deliverance in his own way and time, and get him honour upon all those whose avarice impels them to countenance and help forward the calamities of their fellow creatures."[24]

Phillis assured her readers that her motives arise from a pious and compassionate heart and she wishes slaveholders no harm. She desires only to protect faithful Christians from error; so she must remind them that they are in violation of the teachings of Jesus. To Phillis Wheatley, the issue could not be any clearer—following Christ while keeping slaves

is a "strange" position for a Christian, a transgression so flagrant that any attempt to defend it is ludicrous.

"This I desire not for their hurt, but to convince them of the strange absurdity of their conduct, whose words and actions are so diametrically opposite."[25]

She concluded with one last parting shot, a single thrust from her keen-edged blade of reason, blowing their cover to shreds, exposing their arguments as silly and fraudulent. It is a blast of mockery that leaves defenders of slavery naked and defenseless before God.

The poet's gentle words sting; biting censure sung in sweet-natured tones shames her subjects. She intended to shake them awake, rouse them from their stupor so they can see what is plainly obvious: that their own cries for liberty and cries for liberty by their slaves arise from the same principle that God has implanted in every human breast, "which we call Love of Freedom."

Phillis Wheatley had known slavery and freedom. Now liberated, she felt emboldened to indict all slave owners in a tone drenched in sarcasm. "How well the cry for liberty and the reverse disposition for the exercise of oppressive power over others agree," Phillis wrote before delivering the final line with a touch so soft it kills with its lethality: "I humbly think it does not require the penetration of a philosopher to determine."[26]

Phillis did not believe it should take "the penetration of a philosopher" to see the "strange absurdity" of the slaveholders' position. "She presents her reader with something like the schoolbook exercise," writes Barbara Johnson, "What's wrong with this picture?"[27]

Today, the challenge posed by Phillis Wheatley seems bizarre to us, a "no-brainer." That slavery is a blatant violation of basic human dignity is so obvious it should not even need to be pointed out. To her way of thinking, the moral depravity of slavery was self-evident. Two and a half centuries later, we still wonder how our forebears could cry out for their own liberty while depriving others of that same liberty.

In Robinson's paraphrase of Wheatley, the solution to the problem of slavery was so clear, "even a twenty-year-old, African-born female domestic could penetrate such matters."[28]

Reverend Occom was so impressed by the letter he arranged to have it

published in the *Connecticut Gazette* on March 11. Soon the letter gained a wider audience. "It is her boldest antislavery protest in print," said Robinson. "Phillis's letter would be reprinted in at least eleven New England newspapers throughout March and into April."[29]

After it appeared in the *Connecticut Gazette* on March 11, the *Boston Evening Post* and the *Boston Post-Boy* published it on March 21. The *Essex Gazette* of Salem followed on March 22 and 29, the *Boston News-Letter* and the *Massachusetts Spy* on March 24, the *Providence Gazette* on March 26, the *Essex Journal and Merrimack Packet* on March 30, the *Connecticut Journal* on April 1, and the *Newport Mercury* on April 11. Her letter even reached a Canadian audience in the *Nova Scotia Gazette and Weekly Chronicle* on May 3.[30]

Years of unofficial apprenticeship under the Wheatleys had served to sharpen her business sense; Phillis Wheatley was attuned to the market forces that could impact her literary career. Keenly aware of the lowly status of Africans in the social hierarchy, she had to know that "the colonial press was not amenable to publication of forceful antislavery protests, especially those written by Black persons, and that there was not a violable Black community to support or buy any privately printed protest broadsides that Phillis or any other 18th century Black might have composed," Robinson writes.[31]

"Colonists were not ready to make antislavery ideology a part of mass culture. Too many of them benefited economically from slave labor," writes Kathrynn Seidler Engberg.[32]

Like the other black writers who published their antislavery protests in white-owned newspapers, Phillis Wheatley was mindful of her audience—white folks. "If Phillis Wheatley had been of a fiery, militant persuasion, the colonial press would not have welcomed her written charges," says Robinson.[33] "She may have feared that publication of the letter would cause her to lose future assistance, at a time when the writing of verses was meaningful both for her vanity and for her self-styled sense of her 'missioned identity.'"[34]

As a poet seeking to build a relationship with her audience, Phillis Wheatley sought respect, the kind of recognition that would lead to profitable book sales. "Her book appeared nonthreatening to readers, since the

politics are not blatant," says Engberg. "Wheatley, herself, appears non-threatening to readers since she appears to stay within her prescribed role." From a marketing standpoint, the main focus of Phillis's branding campaign was her own surprising genius. "By acting as though she has joined 'th'angelic train," Engberg says, "she gained the agency needed to promote and sell her book."[35]

Phillis Wheatley found herself steering through uncharted waters. Writes Kirsten Wilcox, the "unprecedented participation of a black slave in the white and propertied sphere of print" saw her struggling to find her way with no map, no compass, and no guiding star.[36]

"Wheatley had to navigate difficult linguistic terrain, seeking approval from whites while at the same time remaining true to her own opinions," says Blanck.[37]

"It is easy as a contemporary reader to quickly dismiss Wheatley's poems and see her as a 'sell out,'" suggests Engberg. "But to dismiss her is to miss the subtlety of her work. Such cursory readings overlook the way in which Wheatley coyly 'fashions' herself to gain agency with her audience."[38]

"Wheatley knew how to be direct and voiced her position with disdain," Professor Engberg contends. "Yet in her poetry, she chose to approach her audience much more subtly."[39]

Phillis Wheatley's antislavery letter to Reverend Occom was a thoughtful, well-reasoned essay, rich in biblical symbolism, reflecting high moral principle, and addressing one of the most controversial issues of the time. The letter publicly aligned her with the abolitionist cause.

Her influence in the antislavery movement, though subtle and understated, was now certain. "The poet was indeed a strong force among contemporary abolitionist writers," writes Professor Sondra O'Neale.[40]

> Wheatley was the major Black presence in eighteenth century America, and a nagging thorn in the conscience of American power brokers (such as George Washington, Thomas Jefferson, Benjamin Franklin, Thomas Hutchinson, John Hancock and Mather Byles), all of whom either knew her personally or read and commented on her works. These men had to confront her genius and enslavement as a representative of all African slaves.[41]

Throughout the eighteenth and nineteenth centuries, with a deeply troubled nation careening toward civil war, the foundation of the abolitionist movement rested on Christian theology and the Bible. At the core of Phillis Wheatley's antislavery arguments was her religious faith. "The most eloquent antislavery speakers were evangelical preachers," O'Neale says, and "Phillis was personally acquainted with many of them....The evangelical church was the only functioning social institution that desired to put the issue of slavery on the national agenda."[42]

Antislavery writers like Phillis Wheatley continued to rely on the moral authority of Christ to support their censure of slavery. "Through the use of biblical symbolism in her poems and prose, Wheatley made the most comprehensive antislavery statements possible for a writer whom society had pre-condemned on three counts: she was a woman, she was an African, and she was a slave."[43]

As Professor O'Neale puts it, "there was no other 'game' in town."[44]

# CHAPTER 36

## "Poor unhappy Boston. God knows only thy wretched fate."

JOHN HANCOCK'S SHIP, THE *HAYLEY*, left Boston a week after the Tea Party. Soon after reaching England on January 19, 1774, the American crew shared the stunning news about the destruction of the tea in Boston. London newspapers carried the account of the Tea Party that had appeared earlier in the *Boston Gazette*.

Parliament was outraged. On March 14 British Prime Minister Lord North proposed a course of action "to enable his Majesty to put an end to the present disturbances in America" and "to secure the just dependence of the colonies on the Crown of Great Britain." He proposed a strategy to attack the root of the problem. "Boston had been the ringleader in all riots," he charged. "The present disorders originated in Boston, in the Province of Massachusetts Bay." As a result, he said, "the inhabitants of the town of Boston deserved punishment."[1]

Parliament passed a series of new laws designed to chasten their unruly colony in Massachusetts Bay. In America they were known as "The Intolerable Acts." The Boston Port Act would close Boston Harbor on June 1, 1774. All shipping and much of the region's economic activity would come to a halt until town officials reimbursed the East India Company for its losses.

The Massachusetts Government Act required the Boston Town Council be appointed by Parliament, effectively ending the Massachusetts tradition of self-rule. Now their governing body would be under British control. The Administration of Justice Act allowed the Royal Governor to move trials to Great Britain. Colonists believed this would encourage British officials to abuse them, even kill them, and escape justice. The Quartering Act allowed British soldiers to lodge in town buildings.

Soon, warnings about Parliament's drastic new laws reached Boston. "About a fortnight ago, an act of Parliament of a most extraordinary kind

to shut up the port of Boston was passed in a most extraordinary manner," the *Boston Gazette* reported on May 23.

> It is given out that severe measures are only intended against Boston to punish their refractory conduct; but depend on it, if they succeed against Boston, the like measures will extend to every colony in America. They only begin with Boston... but you are all to be visited in turn and to be devoured one after another.[2]

Phillis Wheatley must have been greatly alarmed by the news. She was expecting another delivery of her books to arrive by ship at any time. When they came just weeks before the blockade was to take effect, she could breathe a sigh of relief. "I have rec'd by some of the last ships 300 more of my poems," she told Obour Tanner on May 6.[3]

That same day she dashed off a letter to Reverend Samuel Hopkins, letting him know about the arrival of her books. Putting her business acumen to good use, she recruited him as a salesman. "I have rec'd in some of the last ships from London 300 more copies of my Poems and wish to dispose of them as soon as possible. If you know of any being wanted I flatter myself you will be pleas'd to let me know it."[4]

Due to Parliament's harsh restrictions, she knew that no more books would be coming from London. By the end of May, dozens of British warships appeared, taking positions around Boston Harbor in preparation for the blockade on June 1. Phillis could step out of her house on King Street and look toward the harbor to see Admiral Montagu's flagship, the *Captain,* the largest and most intimidating vessel in the fleet, anchored at Long Wharf with her massive firepower trained ominously on the Boston waterfront.

On May 17 General Thomas Gage arrived as the newly appointed military governor of the Province of Massachusetts Bay, replacing Thomas Hutchinson, who departed for England. When June 1 arrived and the Boston Harbor was officially closed for business, church bells throughout Boston announced a time of mourning.

Merchant John Rowe took note of that notorious date in his diary. "This is the last day any vessel can enter this harbor until this fatal act

of Parliament is repealed. Poor unhappy Boston. God knows only thy wretched fate. I see nothing but misery will attend thy inhabitants."[5]

Two weeks later Rowe went to the harbor to see the effects of the blockade for himself. "After church I walked round the wharfs. Tis impossible to describe the distressed situation of this poor town—not one topsail merchantman to be seen."[6]

"Our wharfs are entirely deserted, not a topsail vessel to be seen, either there or in the harbour, save the ships of war," John Andrews wrote to his brother-in-law in Philadelphia. He felt he had to apologize for his depressing tone. "If my last was in a desponding stile, I'm sure I have much more reason to be so now; as ought else but poverty & distress stares us in the face."[7]

The dread of every Bostonian had come to pass. The bitter humiliations that boiled over at the 1770 Massacre had returned like a recurring nightmare.

"Boston, thy fate is very distressing!" wrote John Rowe on June 14. "The Fourth Regiment landed this morning and pitched their tents in the Common." The following day, they were joined by the Forty-third Regiment.[8]

"Four regts. are already arrivd, & four more are expected," Andrews wrote. "How they are to be disposd of cant say; it gave out, that if ye General Court dont provide barracks for em, they are to be quarterd on ye inhabitants."[9]

Hundreds of British soldiers occupied The Common, one of Boston's most treasured spaces, a pastoral refuge where Bostonians could while away leisurely hours rambling along tree-lined paths. "Our camp is pitched in an exceedingly pleasant situation on the gentle descent of a large common, hitherto the property of the Bostonians," one soldier wrote. "The richest herbage I ever saw." He noted that the land was also "used for the purpose of grazing their cows." It annoyed the troops that those "poor creatures, from custom, often attempt to force their way into their old pastures," so they kept chasing them off. "For now they are driven away by stones flung at them."[10]

With commerce at a standstill, the people of Boston faced food shortages and soaring prices for critical items. Towns throughout New England

sent food and supplies to help sustain the suffering Bostonians in their time of need. A flock of more than two hundred sheep arrived in Boston from Windham, Connecticut.[11]

Groton, Connecticut sent forty bushels of rye and corn, a hundred sheep, and some cattle. Over the coming months, sheep, grain and produce arrived from towns throughout the colonies to help feed the people of Boston. Relief came from as far away as Charleston, South Carolina. Because of the blockade, all relief supplies came to Boston by land. The train of wagons used to transport food and supplies were called "Lord North's coasters."[12]

Days of fasting were organized throughout New England to protest the cruel policy of starving a population, and the movement spread to New York, New Jersey, and Virginia. When the province of Massachusetts held its own fast day on July 14, no doubt the pious Wheatleys, and Phillis, joined.

"You can have no just conception of the spirit now prevalent in town and country," John Andrews told his brother-in-law in Philadelphia. "Lord North," he said, "is cursed from morn to noon and from noon to morn by every denomination of people."[13]

In the summer of 1774, twelve of the thirteen colonies voted to send a delegation to Philadelphia for the First Continental Congress. It was the first time since the Stamp Act Congress of 1765 that the American colonies sent representatives to plan concerted action against Britain. When the First Continental Congress opened for business on September 5, 1774, they represented twelve separate and independent colonies with very little connection to each other. The delegates were all leaders in their own colonies, and few had ever met in person before. Now with George Washington and Patrick Henry from Virginia and John and Samuel Adams from Massachusetts in attendance, they recognized the seriousness of their purpose—they had to find a way to mount an effective response to the Intolerable Acts of Parliament.

"The cause of Boston, the despotick measures in respect to it, I mean now is and ever will be considered as the cause of America," George Washington wrote. He felt compelled to voice his criticism of the patriots of Boston: "not that we approve their conduct in destroying the Tea."[14]

Patrick Henry gave a rousing speech calling for unity among the

colonies. "The distinction between Virginians, Pennsylvanians, New Yorkers and New Englanders are no more," Henry bellowed. "I am not a Virginian but an American."[15]

Congress voted to boycott British goods and cut off all trade between the colonies and Great Britain until Parliament abolished the Intolerable Acts. Before adjourning on October 26, they resolved to convene again the following May.

In November 1774 King George acknowledged the need for a strong British military response to subdue the colonies. "The New England Governments are in a state of rebellion," he wrote to Lord North. "Blows must decide whether they are to be subject to this country or independent."[16]

Through all the turbulence in Boston, Phillis Wheatley remained comfortable in the Wheatley mansion on King Street. John Wheatley had "allowed her to continue to live with him after Susanna's death," says Carretta. "Friends and relatives of the Wheatleys considered her still part of the family."[17]

Carretta points to a letter to Phillis by Wheatley cousin Thomas Wallcut, son of Susanna Wheatley's niece Elizabeth, acknowledging her as a member of the Wheatley clan. Wallcut, then living in Montreal, "wrote her a playful letter on November 17, 1774 in response to some admonitions she had sent him. He closed by asking her to remember him 'to all your dear family.'"[18]

For several years, friendly Christian ministers in her life had been actively encouraging Phillis to return to Africa as a missionary. Reverend Occom had suggested this to Susanna Wheatley in a letter on March 5, 1771. "Pray, Madam," he wrote, "what harm would it be to send Phillis to her native country as a female preacher to her kindred."[19]

Nothing came of it then, but several years later, the devout John Thornton, a member of the Countess of Huntingdon's religious Connexion, made the same suggestion to Phillis in a letter from London. Replying to Thornton on October 30, 1774, she turned him down politely, carefully enumerating her reasons. "You propose my returning to Africa with Bristol Yamma and John Quamine," she began, mentioning the two members of Reverend Samuel Hopkins's First Congregational Church in Newport, both kidnapped into slavery from Africa as children and both converted to Christianity. They were now being groomed to return to Africa as

Christian missionaries. "I believe they are either of them good enough, if not too good for me, or they would not be fit for missionaries," she said. "But why, do you, hon'd Sir, wish those poor men so much trouble as to carry me on so long a voyage?" she wondered, implying that she would only be a burden to them.

Understandably, she was wary of traveling with people she did not know. "I am also unacquainted with those missionaries in person," she said.

Her several objections were eminently reasonable, and she offered them with a light-hearted touch. Even though she was African by birth, she believed she would be woefully out of place in Africa. "Upon my arrival, how like a barbarian should I look to the natives. I can promise that my tongue shall be quiet for a strong reason, indeed being an utter stranger to the language."

She had more compelling objections. "Now, to be serious," she continued, "this undertaking appears too hazardous." Transatlantic voyages were inherently dangerous, adventures not to be taken lightly. There was the threat of exposure to unknown diseases and dangers in a strange new land. She did not mention her precarious health and chronic asthma, which could act up at any time.

There were personal reasons not to go. Phillis admitted that she was reluctant to "leave my British & American friends." Clearly, her circle of friendships in Boston was important to her.

She concluded her letter to Thornton as a young Christian woman should, by surrendering to God on this matter. "Be that as it will, I resign it all to God's all wise governance; I thank you heartily for your generous offer."[20]

Throughout 1774, her first year as a free woman on American soil, Phillis Wheatley showed that she was perfectly capable of making her own decisions about her future. At this point in her life, she saw herself as a talented poet just beginning to establish an international reputation. Her clear-eyed decision to reject the suggestion that she leave for Africa made by one of her strongest supporters solidified Phillis Wheatley's determination to pursue her calling as a writer in America.

As 1774 was coming to a close, Phillis exchanged a series of light-hearted poems with a member of the Royal Navy. Twenty-four-year-old

Seaman John Prime Iron Rochfort from Dublin, Ireland was assigned to the *Preston* under the command of Admiral Samuel Graves, whose fleet had arrived in Boston that summer to enforce the blockade of Boston Harbor. Serving on the *Preston* along with Seaman Rochfort was Lieutenant John Graves, the admiral's nephew.

William Robinson advances the notion that both Rochfort and Graves spent considerable time with Phillis, sharing stories of their naval experiences and talking of poetry. "These officers, young men both, may have been billeted in the Wheatley mansion," he suggests, "and young men both, they may have tried to impress the popular black poetess of that address with romantic stories of their past service in Africa."

"Graves," he points out, "had served aboard the *Edgar* off the coast of Africa only recently."[21]

Phillis wrote her poem *To a Gentleman of the Navy* on October 30, 1774 in Boston. It was a fond and affectionate literary tribute to the friendship of Rochfort and Graves.

> *Celestial muse! For sweetness fam'd inspire*
> *My wondrous theme with true poetic fire,*
> *Rochfort, for thee! And Greaves deserve my lays,*
> *The sacred tribute of ingenius praise....*
>
> *Cerulean youth! Your joint assent declare*
> *Virtue to rev'rence, more than mortal fair;*
> *A crown of glory, which the muse will twine,*
> *Immortal trophy! Rochfort shall be thine!*
> *Thine too, O Greaves! For virtue's offspring share,*
> *Celestial friendship and the muse's care.*[22]

Rochfort composed his own poem for Phillis on December 2. It was, declares Carretta, "the greatest public praise Wheatley received during her lifetime."[23]

> *Celestial muse! Sublimest of the nine,*
> *Assist my song and dictate every line.*
> *Inspire me once, now with imperfect lays,*
> *To sing this great, this lovely virgin's praise.*

*But yet, alas! What tribute can I bring,*
*WH-TL-Y but smiles, whilst I thus faintly sing.*
*Behold, with reverence and with joy adore,*
*The lovely daughter of the Afric shore,*
*Where every grace and every virtue join*
*That kindles friendship and makes love divine...*
*Th' immortal wreathe, the muse's gift to share,*
*Which heav'n reserv'd for this angelic fair...*[24]

*For softer strains we quickly must repair*
*To Wheatly's song, for Wheatly is the fair*
*That has the art, which art could ne'er acquire,*
*To dress each sentence with seraphic fire.*
*Her wondrous virtues I could ne'er express!*
*To paint her charms, would only make them less.*[25]

Both poems, Phillis's *To a Gentleman of the Navy* and Rochfort's *The Answer,* appeared together in Boston's *Royal American Magazine* in December 1774. "The editorial comment that prefaces the exchange indicates that publication of the poems...could not have been done without Wheatley's cooperation," Carretta notes.[26]

From the *Royal American Magazine*:

> By particular request we insert the following poem addressed by Phillis, (a young African of surprising genius) to a gentleman of the navy, with his reply.

> By this single instance may be seen, the importance of education. Uncultivated nature is much the same in every part of the globe. It is probably Europe and Africa would be alike savage or polite in the same circumstances; though, it may be questioned whether men who have no artificial wants are capable of becoming so ferocious as those who by faring sumptuously every day, are reduced to a habit of thinking it necessary to their happiness to plunder the whole human race.[27]

After reading Rochfort's warm and affectionate tribute, Phillis composed her response on December 5. *Phillis's Reply to the Answer in our last*

*by the Gentleman in the Navy* was published in the January 1775 edition of the *Royal American Magazine.*

> *For one bright moment, heavenly goddess! Shine;*
> *Inspire my song and form the lays divine.*
> *Rochford, attend. Beloved of Phoebus! Hear;*
> *A truer sentence never reach'd thine ear...*
>
> *In fair description are thy powers display'd*
> *In artless grotto, and the sylvan shade;*
> *Charm'd with thy painting, how my bosom burns!*
> *And pleasing Gambia on my soul returns.*[28]

# CHAPTER 37

## "We were surrounded with such incessant fire as it's impossible to conceive."

BY EARLY 1775 THE BRITISH military presence in Boston was growing. A steady flow of reinforcements were arriving by sea, expanding the force to more than 4,000 men.

"Swarming masses of British troops may have immensely pleased resident Boston Loyalists but they absolutely galled town Patriots," says Robinson. "The troops even got on each other's nerves. Scuffles and fights, drunken brawls between soldiers and sailors and civilian inhabitants were almost daily occurrences."[1]

As Abigail Adams fretted to her husband, "The distresses of the inhabitants of Boston are beyond the power of language to describe."[2]

"This town a Garrison," Reverend Andrew Eliot lamented, after seeing the misery in his neighbors' eyes. "Every face gathering paleness," he said. "All hurry & confusion, one going this way & another that, others not knowing where to go....Everything distressing."

Reverend Eliot grieved for his town. "Poor Boston," he cried in sorrow. "May God sanctify our distresses which are greater than you can conceive. Such a Sabbath of melancholy and darkness I never knew."[3]

Under the terms of the Massachusetts Government Act, General Gage dissolved the Massachusetts Assembly. Instead, he assembled a General Court consisting of loyalist appointees. The fired members of the former assembly ignored the bogus General Court and convened their own meeting, calling themselves the Provincial Congress. They had no legitimate legal authority but they did have the support of many in the colony—it became the de facto government of Massachusetts.

The first priority of the new Provincial Congress was to raise an army to defend against the British. The Committee of Safety under John Hancock acquired forty-five cannons, two mortars, fifteen thousand canteens, one

thousand tents, ten tons of lead balls, three hundred bushels of pork and beans, one thousand pounds of candles, and fifteen chests of medicine.[4] They formed the Minutemen, a young, mobile, rapid-deployment force capable of responding immediately to threats. Hancock arranged to ship supplies of gunpowder from London to Salem.

Nobody was surprised when Parliament extended the trade restrictions to the other colonies. Now, in addition to Massachusetts, New Jersey, Pennsylvania, Maryland, Virginia, and South Carolina were forbidden to trade with any nation but Britain. In Virginia, the colonial government in Williamsburg was disbanded by the Royal Governor. Like the citizens of Massachusetts, the fired Virginia representatives met in Richmond instead. On March 23, 1775, with George Washington, Thomas Jefferson, and Richard Henry Lee looking on, the Virginia delegates heard Patrick Henry deliver his stirring call to arms.

"Our brethren are already in the field!" Patrick Henry thundered. "Is life so dear, or peace so sweet, as to be purchased at the price of chains and slavery? Forbid it, Almighty God!"

Then he delivered the immortal cry that immediately fixed itself in the American soul: "I know not what course others may take; but as for me, give me liberty or give me death!"[5]

All too soon, death on the battlefield came to America, beginning in Massachusetts.

General Gage had received his instructions from Lord Dartmouth on January 27. "The first step to be taken toward reestablishing government would be to arrest and imprison the principle actors and abettors in the Provincial Congress whose proceedings appear in every light to be acts of treason and rebellion."[6] The leaders of the rebellion, John Hancock and Samuel Adams, were to be arrested and brought to England to be tried and hanged.

Dartmouth knew Boston was a powder keg, recognizing "a determination among the people to commit themselves at all events in open rebellion." It had to be crushed. "The King's dignity and the safety of the Empire require that in such a situation, force should be repelled by force," he told General Gage.[7]

Now Gage had the authority to strike. He learned from his intelligence sources that the rebels stored their arsenal in the town of Concord and that

John Hancock and Sam Adams had fled to nearby Lexington. He planned a two-stage assault: one force would seize or destroy the patriots' weapons in Concord and a second would swoop into Lexington to arrest Hancock and Adams.

But the rebels had an intelligence network of their own. At midnight on April 15, Patriot spies noticed suspicious activity among the troops in Boston. "About 12 o'clock at night, the boats belonging to the transports were all launched & carried under the sterns of the Men of War," Paul Revere reported. "We likewise found that the Grenadiers and light Infantry were all taken off duty. From these movements, we expected something serious was to be transacted."[8]

On Tuesday night, April 18, Patriot spies "observed that a number of soldiers were marching towards the bottom of the Common." [9] British troops were on the move. The towns and villages surrounding Boston were about to be invaded.

That night Paul Revere began his famous midnight ride. Revere and his confederates agreed on a signal that could be seen from a great distance, a way to communicate to him what route the British troops were taking out of Boston. "If the British went out by water, we would shew two Lanthorns in the North Church Steeple; & if by Land, one, as a signal," he wrote years later.[10]

Paul Revere lit out for Lexington. "I set off upon a very good horse. It was then about 11 o'clock, & very pleasant," he recalled. All along the way he alerted the citizens that the British were coming. "In Medford, I awaked the Captain of the Minutemen," he said, "and after that, I alarmed almost every house till I got to Lexington. I found Messrs. Hancock & Adams at the Rev. Mr. Clark's."[11]

At dawn on April 19, Hancock and Adams made their escape in Hancock's carriage. Meanwhile, some two hundred rebel militiamen gathered on Lexington Green, a grassy triangle at the intersection of the road leading east to Boston and west to Concord, while a British force of seven hundred men was fast approaching.

The contrast between the polished professional British soldiers and the citizen-fighters of Massachusetts was striking. "The regulars wore heavy red coats and white breeches," writes historian Nathaniel Philbrick, "their

chests crisscrossed by belts burdened with cartridge boxes, swords and bay-onets....The country people posed a very different picture of the 'soldier' in their floppy-brimmed hats, baggy, dark-colored coats, gray homespun stockings, and buckled cowhide shoes as they strode through the dim light with their powder horns slung from their shoulders."[12]

Early in the morning on April 19, British troops confronted the rebels at Lexington Green. The British commander Major John Pitcairn ordered his men into battle formation. They formed three staggered lines, each sol-dier positioned to fire over the shoulder of the man in front of him. The rebel militia, under Captain John Parker, could see that they were outnum-bered. "There are so few of us," one man said. "It is folly to stand here." Captain Parker responded: "Stand your ground. Don't fire unless fired upon. But if they want to have a war let it begin here."[13]

As the assault started, the outnumbered rebels quickly retreated. "When I came within about one hundred yards of them, they began to file off toward some stone walls on our right flank," reported Major Pitcairn. "The light infantry observing this ran after them."[14]

From a distance Paul Revere knew the shooting had begun. "I saw and heard a gun fired, which appeared to be a pistol. Then I could distinguish two guns," he said. "And then, a continual roar of musketry."[15]

When it was over, eight rebels were killed, including Captain Parker, with ten wounded. One British soldier was wounded, and Major Pitcairn's horse was shot. For the Patriots, the bloody toll was even more devastating than the 1770 Boston Massacre.

Triumphant after their first skirmish, British forces marched to Concord, six miles away, pressing ahead with their search for Patriot weap-ons. Fifes blaring, drummers beating, "the army of the king was coming up in fine order," one resident said. "Their red coats were brilliant and their bayonets glistening in the sunlight."[16]

When the British arrived in Concord, they found no weapons. Major Pitcairn quickly realized that the Patriots had removed their arsenal. He ordered the troops back to Lexington. But first they had to cross the North Bridge outside Concord.

This was a pivotal moment in the American Revolution. Ralph Waldo Emerson's father witnessed what happened from his home just three

hundred feet from the North Bridge. In 1836 Emerson wrote his poem *Concord Hymn* to commemorate the battle.

> *By the rude bridge that arched the flood,*
> *Their flag to April's breeze unfurled,*
> *Here once the embattled farmers stood*
> *And fired the shot heard round the world.*[17]

Nathaniel Philbrick writes: "Even though many men had already been killed at Lexington, many later looked to what was about to happen at the North Bridge as the start of the American Revolution."[18]

As British regulars approached the bridge, the rebel fighters stalked them. They exchanged fire. Men fell on both sides. Then British troops fled across the bridge and the militia stormed after them. "Something truly momentous had just occurred," Philbrick says. "They had done much more than fire on the British troops. They had forced three companies of light infantry to retreat."[19]

The six-mile trek from Concord back to Lexington turned out to be a bloodbath for the British. "Unlike the morning, when the regulars had arrived in Concord accompanied by fife and drum, no music was played that afternoon," says Philbrick.[20]

"The battle now began," one Minuteman wrote, "and was carried on with little or no military discipline and order on the part of the Americans."[21]

Rebel bullets rained down on the British regulars. "We were fired on from all sides," recalled British Lieutenant John Barker. "The country was an amazing strong one, full of hills, woods, stone walls, etc., which the rebels did not fail to take advantage of, for they were all lined with people who kept an incessant fire upon us."

The British fought back but it was like shooting at phantoms. "They were so concealed there was hardly any seeing them," Barker said. "We were surrounded with such incessant fire as it's impossible to conceive."[22]

The British infantry kept marching through "a growing rain of sniper fire," writes Harlow Giles Unger. "Minuteman ranks had swelled into the thousands. Musket barrels materialized behind every tree, every boulder, every stone wall."[23]

"In this way, we marched nine or ten miles, their numbers increasing from all parts while ours was reducing by deaths, wounds and fatigue," Lieutenant Barker wrote. "Our ammunition was near expended."[24]

The British officers knew they were facing annihilation unless they could make it back quickly to their main garrison in Boston. The retreat from Concord was a humiliating debacle for the British. The ferocious rebel assault, though haphazard and improvised, was deadly: 73 British soldiers killed, 174 wounded. The Patriots lost 49 men with 42 wounded.

It was a stunning outcome. "A disorganized group of untrained, ill-equipped farmers had defeated crack troops from the world's most powerful, best trained, best equipped, professional army," writes Unger. The Patriots were now suddenly "confident they could win the war against Britain and end Parliament's rule over America."[25]

By the morning of April 20, rebel fighters from all over New England converged in the towns surrounding Boston. The Provincial Army, now ten to fifteen thousand strong, effectively sealed Boston shut. All routes in and out of Boston were blocked. Occupying British forces could no longer receive material or supplies over land. The siege of Boston had begun.

# CHAPTER 38

*"Even I, a mere spectator, am in anxious suspense
concerning the fortune of this unnatural civil contest."*

THE BLOODSHED AT LEXINGTON AND Concord deeply
unnerved Boston and the surrounding towns. News spread quickly.
"Wednesday the fatal 19th April, before I had quitted my chamber, one after
another came running up to tell me that the King's troops had fired upon &
killed eight of our neighbors at Lexington in their way to Concord," Boston
resident Sarah Winslow Deming wrote in her journal that night. "All the
intelligence of this day was dreadful. Almost every countenance expressing
anxiety & distress."[1]

Reverend Andrew Eliot acknowledged their dire situation. Boston was
"filled with the troops of Britain & surrounded with a provincial Army,"
he wrote. "All communication with the country is cut off, & we wholly
deprived of the necessaries of life. This principal mart of America is become
a poor garrison town. The inhabitants have been confined to the city more
than a week & no person suffer'd to enter."[2]

They felt trapped. "I was Genl Gage's prisoner," Mrs. Deming com-
plained, "all egress, & regress being cut off between the town & country.
Here again description fails. No words can paint my distress."[3]

Beleaguered Boston was completely hemmed in on all sides.
Geographically, it was a peninsula, nearly an island surrounded by water
except for a narrow strip called Boston Neck, their only connection to the
mainland. After the battles at Lexington and Concord, six thousand British
troops occupied the town. Even though colonial forces held the ground
around Boston, the powerful British navy controlled the waterways and
could resupply and reinforce the British military almost indefinitely.

The mass exodus from Boston began. "The General hath consented
that if the inhabitants would deliver their arms they should be suffered
to depart," Reverend Eliot explained. "This proposal humiliating as it is,
hath been complied with. In consequence of this agreement almost all are

leaving their pleasant habitations & going they know not whither."[4]

Boston quickly emptied. "Inhabitants flocking out of town," said John Rowe.[5]

"Out of Boston, out of Boston at almost any rate," Sarah Winslow Deming wailed, "away as far as possible from the infection of small pox, & the din of drums & martial musick as its call'd, & horrors of war."[6]

Reverend Eliot bemoaned "the unhappy situation of this town, which by the late cruel & oppressive measures gone into by the British Parliament is now almost depopulated."[7]

A bustling town of more than fifteen thousand residents in 1770 shrank to less than three thousand by 1776. "Much the greater parts of the inhabitants gone out of the town," said Reverend Eliot, "the rest following as fast as the Genl will give leave."[8]

Residents left in a panic, some with only the clothes on their backs. "Most are obliged to leave their furniture & effects of every kind, & indeed their all to the uncertain chance of war or rather to certain ruin & destruction," Eliot said.[9]

Boston became a ghost town. "Grass growing in the public walks & streets of this once populous & flourishing place," Reverend Eliot wrote. "Shops & warehouses shut up. Business at an end. Everyone in anxiety & distress."[10]

Sometime in June, General Gage and his staff began plotting to break the siege and end the colonial militia's hold on the countryside surrounding Boston. The British devised a plan to seize the high ground around Charlestown, separated from Boston by the Charles River. Taking control of the hills overlooking Charlestown, the 110-foot-high Bunker's Hill, as the locals called it, and the smaller Breed's Hill, close to the river, would prevent any attacks on Boston and serve as a base for a British inland offensive.

The colonial army command got word of General Gage's plan and acted quickly to take the hills first. "On the 16th of June it was determined that a fortified post should be established at or near Bunker's Hill," said Captain Henry Dearborn, a physician who came from New Hampshire to join the fight.[11]

The British attack came early in the morning on June 17, 1775 with the

relentless bombing of Charlestown. It was a clear, sunny summer day. All of Boston could see the barrage of shells darting across the sky to the incessant roar of cannon fire. Thousands gathered on hills, perched on housetops, and climbed church steeples to watch the action in Charlestown across the river about a half mile away.

Nine years later, in her poem *Liberty and Peace*, Phillis wrote about the bombing of Charlestown. She opened her depiction of the scene with a command: "Witness," she instructed her readers. The stark imperative establishes a dramatic "you-are-there" feel—the poet wants us to see and hear the brutal reality of the exploding inferno before them. Her imagery is so detailed, so vivid, it seems as though she was describing what she had observed with her own eyes. Perhaps she was one of the distressed Bostonians unable to avoid the sights, sounds, and smells of the massive fireballs and trembling earth in the neighboring town on the other side of the Charles River.

> *Witness how Charlestown's curling Smoaks arise,*
> *In sable columns to the clouded skies!*
> *The ample dome, high-wrought with curious toil,*
> *In one sad hour, the savage troops despoil.*[12]

"The battle began upon our entrenchments upon Bunker's Hill, Saturday morning about 3 o'clock and has not ceased yet and tis now three o'clock Sabbath afternoon," Abigail Adams wrote. "The constant roar of the cannon is so distressing that we cannot eat, drink or sleep."[13]

"I saw with my own eyes those fires and heard Britannia's thunders in the Battle of Bunker's Hill," said future president John Quincy Adams, then a child.[14]

What they saw was chilling. "Soon after the commencement of the action, a detachment from the British force in Boston was landed in Charlestown and within a few moments the whole town appeared in a blaze," Captain Dearborn reported. "A dense column rose to a great height and there being a gentle breeze to the southwest, it hung like a thunder-cloud over the contending armies."[15]

"I cannot compose myself to write any further at present," a shaken Abigail Adams confided to her husband John, then in Philadelphia for the

Second Continental Congress. "Charlestown is laid in ashes."[16]

"My mother, with her children, lived in unintermitted danger of being consumed with them all in a conflagration kindled by a torch in the same hands which on the 17th of June lighted the fires of Charlestown," wrote John Quincy Adams.[17]

At noon, twenty-eight barges carrying fifteen hundred British troops rowed across the Charles River. The Navy continued their bombardment of Charlestown to give the landing troops cover. "The smoke from all these guns drifted over the water accompanied by a nearly constant roar and flash," writes historian Robert Middlekauff.[18]

Onlookers in Boston could only watch in horror. "Smoak and flames were seen to arise from the town of Charlestown, which had been set on fire by the enemy, that the smoak might cover their attack upon our lines," stated the Boston Committee of Safety's account of the battle. "The Town of Charlestown, the buildings of which were in general large and elegant, and which contained effects belonging to the unhappy sufferers in Boston, to a very great amount, was entirely destroyed."[19]

By one o'clock, the British assault force grew to twenty-two hundred men. Charging up Breed's Hill, they ran right at the rebels who were waiting for them behind the earthen walls of their fort. Colonel William Prescott, commander of the rebel forces, knew his men were exhausted after working all night to build their fort and that their gunpowder was running out. To make every shot count he directed his men to hold their fire until he gave the order. "Take good aim," one of his men remembers him saying. "Be particularly careful not to shoot over their heads," he commanded. "Aim at their hips."[20]

"Perhaps," said Philbrick, "one provincial officer even used an expression that had been in common usage for decades and told his men to hold their fire until they could see the whites of the enemy's eyes."[21]

The rebels waited until the British came within 150 feet of their position. Then, the guns of New England exploded. Standing one behind the other at the wall on the hill, they fired, stepped back to reload as a comrade fired, then moved to the front again to get off another shot in what became a hail of bullets.

"As we approached an incessant stream of fire poured from the rebel

lines," a British officer wrote. "It seemed a continued sheet of fire for near thirty minutes."[22]

"Our men were intent on cutting down every officer they could distinguish in the British line," said Captain Dearborn. "When any of them discovered one he would instantly exclaim, 'There!' 'See that officer!' 'Let us have a shot at him,' when two or three would fire at the same moment; and as our soldiers were excellent marksmen and rested their muskets over the fence, they were sure of their object."[23]

This was a new tactic in warfare. The usual method was to shoot in a general direction. Now the Americans were aiming their shots, and the results were lethal. "Among the dead are many British officers owing to the Americans taking sight when they fire," wrote John Harrower.[24]

A wall of bullets stopped the British advance in its tracks. "We received a check, though without retreating an inch, from the very heavy and severe fire from the enemy in the redoubt," wrote a British marine.[25]

The British regrouped and charged again—and again their offense stalled. Later that afternoon they tried a third assault on the hill. This time British forces overwhelmed the fort when the patriots ran out of gunpowder.

"We fired till our ammunition began to fail," said one rebel soldier, "then our firing began to slacken—and at last it went out like an old candle."[26]

As the British stormed over the wall, the desperate rebels hurled stones in a futile attempt to stop the onslaught. Some grabbed their guns by the barrel, turning their empty muskets into clubs and swinging wildly at the oncoming rush.

"I cannot pretend to describe the horror of the scene within the redoubt, when we entered it," wrote a British soldier. "T'was streaming with blood & strew'd with dead & dying men, the soldiers stabbing some and dashing out the brains of another was a sight too dreadful for me to dwell any longer on."[27] The British took heavy casualties and their commanding officer was killed. "In this spot we lost a number of men, besides the irreparable loss of poor Major Pitcairn, whose worth I never was sensible of till that day."[28]

Revolutionary War historians now accept that it was a free African-American soldier named Salem Poor who killed Major Pitcairn. A primary source document cites him by name, praising his bravery in battle. While it

does not mention Major Pitcairn, historians infer that it was a fact generally known at the time and did not need to be specified in the official document.

On December 5, 1775 the Continental Army submitted a petition to the Massachusetts General Court requesting that the soldier in question be rewarded for his battlefield exploits.

> The Subscribers begg leave to Report to your Honble. House, (which wee do in Justice to the Character of So Brave a Man) that under Our Own observation, Wee declare that A Negro Man Called Salem Poor of Col. Fryes Regiment Capt. Ames. Company in the late Battle at Charlestown, behaved like an Experienced officer, as Well as an Excellent Soldier, to Set forth Particulars of his Conduct Would be Tedious, Wee Would Only begg leave to Say in the Person of this Sd. Negro Centers a Brave & gallant Soldier. The Reward due to so great and Distinguisht a Caracter, Wee Submit to the Congress.[29]

It was signed by Colonel William Prescott, commander of the Provincial forces on Breed's Hill, and twelve other officers who were on the battlefield that day. "It's absolutely extraordinary to see high-ranking white gentlemen in 1775 compare a black man to "an experienced officer," writes J. L. Bell.[30]

From Beacon Hill in Boston, stunned onlookers watched as British forces overran the fort on Breed's Hill, chasing the New Englanders away. One witness described how they "heard the shouts of the British army whom we now saw entering the breastworks and soon they entered and a most terrible slaughter began upon the rebels who now were everyone shifting for himself."[31]

Another Bostonian thought the retreating rebels reminded him of "a swarm of bees in a beehive. Our brave men ran through with their bayonets, such of them as had not time to run away."[32]

When the battle was over, the toll was heartbreaking on both sides. 115 Americans killed, 305 wounded. The British suffered 226 killed and over 800 wounded, more than half their attack force. "Never before had Britain suffered so many casualties in a single day's battle," says historian Harlow Giles Unger.[33]

British General Henry Clinton wryly noted that "A few more such victories would have shortly put an end to British dominion in America." [34]

Soon after the carnage at Lexington and Concord, the Wheatleys joined the exodus from Boston, abandoning their King Street mansion for Providence, Rhode Island. "Nathaniel Wheatley moved his business to Providence after the British occupied Boston," says Carretta. "Wheatley advertised a house and various products for sale during the first three weeks of October 1775 in the *Providence Gazette*." [35]

"Reverend John and Mary Wheatley Lathrop were among the refugees who moved to Providence, Rhode Island during the 1775-76 British occupation of Boston," he adds. "Phillis Wheatley probably accompanied them." [36]

"She spent some time with the Lathrops in Providence, especially, with her old friend and childhood tutor, Mary Wheatley Lathrop," says Robinson. Reverend Lathrop "was invited to fill an empty pulpit of the First Congregational Church there." [37] The *Providence Gazette and Country Journal* reported on May 6 that Reverend Lathrop delivered "an animated and excellent sermon" at the church. [38]

The refugees from Boston surely heard the stories of hardship and deprivation afflicting those who stayed. "Several thousand inhabitants in town who are suffering the want of bread and every necessary of life," Timothy Newell wrote from Boston on October 10, 1775. "Many people turned out of their houses for troops to enter....Houses, fences, trees &c, pulled down and carried off for fuel. My wharf and barn pulled down." [39]

"Almost every house whose owner has gone out of town is taken up for the troops," said William Cheever. "Fresh provisions have been very scarce and high for some time past. Sheep selling at 6 or 8 dolls apiece, ducks 2 dolls a pair," said Cheever. [40]

New England winters were notoriously brutal. For the besieged in Boston, the British occupation made it downright cruel. "Fuel is now the scarcest article and to supply the troops they take down the oldest houses and buildings in town," Isaac Winslow wrote in January 1776. "Tis all a scene of desolation. You would not know your own town scarcely." [41]

When Phillis heard the appalling reports of the British destruction of her beloved Old South Meeting House, she must have felt horrified. The devastation was nearly total. "The spacious Old South Meeting House,

taken possession of by the Light horse 17th Regiment of Dragoons," Timothy Newell wrote on October 27, 1775. "The pulpit, pews and seats, all cut to pieces and carried off in the most savage manner as can be expressed and destined for a riding school." The soldiers lined the floor with dung to soften the surface for the horses and now the place stank to high heaven. It was "made a hog stye."[42]

Repurposing the Old South Meeting House served British military needs. "The meeting-house's primary appeal was probably that it was the largest interior space in Boston, with no pillars to get in the way of the horses," says Bell. "As winter approached, the dragoons and mounted officers needed a place to exercise themselves and their steeds."[43]

But the Old South Meeting House had special significance in Boston, and the British knew it. For years it was the scene of the most intense anti-British rhetoric. The soldiers saw the Old South Meeting House as the heart and nerve center of the rebellion. That revered building stood as an irritant to the British who surely "appreciated the dramatic irony of carpeting Old South with dung," J. L. Bell notes.[44]

Reverend Lathrop had to be deeply pained when he learned the fate of his own church—like Old South, it was destroyed by the British. "The Old North Meeting House pulled down by order of General Howe for fuel," said Newell.[45]

"Many of the other places of worship are turned into barracks," said Cheever.[46]

"Social life is almost at the last gasp," lamented Winslow.[47]

Phillis Wheatley was in still Providence, Rhode Island when she wrote a letter to her friend Obour Tanner on February 14, 1776. Until then only nineteen Wheatley letters were known to exist. "This letter is an entirely new discovery," Jeremy Markowitz, representing a New York auction house, told the *New York Times* in 2005. "Scholars were unaware of this two-page letter she wrote to her friend Obour Tanner, a slave in Newport, R.I." the *Times* reported.[48]

On November 22, 2005, the letter signed by Phillis Wheatley sold for a record-setting $253,000. The *New York Times* reported that it was "the highest ever paid at auction for a letter written by an African-American, and appears to have set an auction record for a letter written by a woman."[49]

Obour Tanner outlived Phillis Wheatley by more than fifty years. In 1834 she gave the letter to abolitionist Katherine Edes Beecher, sister-in-law of Harriet Beecher Stowe, famed author of the antislavery novel *Uncle Tom's Cabin*. Around 1860 Beecher gave the letter to Massachusetts politician Amasa Walker, founder of the antislavery Free Soil Party. The letter remained in the Walker family for 165 years, until they offered it for sale.

"Dear Obour," Phillis began. She writes about the turmoil that has overwhelmed New England, certainly aware of the precarious situation in Newport. Three years earlier Newport had become one of the first in the colonies to attack property belonging to the Crown. In a preview of the Tea Party in Boston, a gang of Rhode Islanders boarded a British naval vessel, the *HMS Gaspee,* and burned it to ashes. "I doubt not that your present situation is extremely unhappy, nor that you with wonder exclaim on the proceedings of nations that are fav.d with the divine revelation of the Gospel."[50]

Writing from the safety of Providence, a hundred miles from the bombs and bullets, she remained keenly aware of the misery in her hometown, revealing her own fears about the escalating strife. "Even I, a mere spectator, am in anxious suspense concerning the fortune of this unnatural civil contest."[51]

She ventured an opinion of the chaos that chased her and her neighbors from their homes. As Phillis Wheatley saw it, the cause of the conflict was "ambition," a "thirst of dominion" perpetrated by the British Parliament "as the punishment of the national views of others."[52]

Already in her young life she had witnessed scenes of violence in Boston—the Stamp Act Riots, the deadly Boston Massacre, and the destruction of Charlestown. In her moral view, the bedlam and bloodshed erupting all around them "bears the appearance of greater barbarity than that of the uncivilz'd part of mankind."[53]

She left no doubt where her sympathies lay. "Phillis seemed resolved even then to live out the rest of her life as a black American," writes Robinson.[54]

Phillis Wheatley was a free woman now, and the ideal of liberty became her guiding star. Her faith led her to believe that God's blessings would surely fall on the side of the conflict that favored liberty. "He is infinitely

superior to all the craftiness of the enemies of this seemingly devoted country," she wrote.[55]

"This seemingly devoted country." What a strange phrase. She personally knew many in her adopted country who were good and decent Christians, devoted to love and charity, who found themselves in a fight to the death for the cause of freedom. But why did she say the country was only "seemingly devoted"? In her pointed but gentle way, Phillis Wheatley challenges those Christians who took a stand for liberty but continued to deny liberty to their Africans slaves.

Now, with two massive armies facing each other around the city of Boston, the largest military force North America had ever seen, some terrible cataclysm seemed inevitable. Phillis Wheatley ends her letter to her dear friend with a prayer, offering the outcome of their perilous position to a higher authority. "Let us leave the event to him whose wisdom alone can bring good out of evil."[56]

# V. Providence 1775.
# Cambridge 1776.

*"I thank you most sincerely for your polite notice of me, in the elegant lines you enclosed....The style and manner exhibit a striking proof of your great poetical talents."*

~ George Washington to Phillis Wheatley, February 28, 1776

# CHAPTER 39

## "I have taken the freedom to address your Excellency in the enclosed poem."

IN JULY 1775, NEARLY THREE months into the dreadful siege, Boston received a jolt of good news. The Second Continental Congress meeting in Philadelphia chose John Hancock as president. More important, they authorized the start of a military campaign, voting to merge the local militia groups already on the battlefield, most of them from New England, into a unified fighting force. To command the newly formed Continental Army, Congress chose George Washington.

Finally the people of Boston could see an end to their nightmare. For the first time since 1768 when they watched redcoats marching up King Street, Boston could anticipate the appearance of an American army that would stand up to the British.

General Washington arrived in Cambridge on July 2, 1775, and the next day he met his troops in a ceremony marked by "a great deal of grandeur," an eyewitness said, with "one and twenty drummers and as many fifers a beating and playing round the parade ground."[1]

Dr. James Thacher, a medic assigned to the army hospital at Cambridge, was thoroughly impressed by the new commander-in-chief. "I have been much gratified this day with a view of General Washington. His Excellency was on horseback, in company with several military gentlemen," he wrote in his journal. "His dress is a blue coat with buff colored facings, a rich epaulet on each shoulder, buff underdress, and an elegant small sword, a black cockade in his hat."[2]

One of the general's first tasks was to find a suitable site to use as his headquarters. On July 8, the Massachusetts Provincial Congress declared that "the house of Mr. John Vassall, ordered by Congress for the residence of his Excellency General Washington, should be immediately put in such condition as may make it convenient for that purpose."[3]

The dignified three-story Georgian style mansion was built by wealthy merchant John Vassall on a ninety-acre estate, a haven of green meadows overlooking the Charles River about a half-mile from the village of Cambridge. The grand Vassall House, situated among the vacation homes of Boston's upper class known as "Tory Row," was the most imposing mansion of them all.

In September 1774, after the British blockaded the port of Boston, the Vassall family had abandoned the house and joined the surge of loyalists from all over New England who moved to safety in Boston under the security of British forces. "Col. Vassall, of Cambridge, from intolerable threats, and insolent treatment to his friends and himself, has left his elegant seat there, and retired to Boston, with his amiable family, for protection," the *Boston News-Letter* reported on February 23, 1775.[4]

With so many opulent loyalist homes left vacant after the fighting at Lexington and Concord, the Massachusetts Militia commandeered them to use as their barracks. Records of the Massachusetts Committee of Safety show three companies from Marblehead, Massachusetts stationed at the Vassall mansion in Cambridge. "Three companies would mean about 150 men squeezed into the Vassall House," says J. L. Bell.[5]

The troops found that the Vassall House wasn't entirely empty. "When John and Elizabeth Vassall departed Cambridge in September 1774, they left their home in the care of their enslaved servants....All the while, the Vassalls' slaves remained on site, trying to figure out their best course in the new social order," Bell writes.[6]

Bell believes that the Vassall estate was particularly appealing to Washington. "With its manor house surrounded by outbuildings, fields, meadows, orchards, and other lands (worked, at least in part, by enslaved people), all overlooking a river, the estate was more like his home at Mount Vernon than any other place in Cambridge."[7]

When the new general took stock of his troops it was a rather rude awakening. One observer described the army as "the most wretchedly clothed and as dirty a set of mortals as ever disgraced the name of a soldier...They would rather let their clothes rot upon their backs than be at the trouble of cleaning 'em themselves."[8]

It was essentially a New England Army, about 14,000 men strong, and

the largest military force ever assembled on the continent. Their ragged, ungainly encampments, spread haphazardly throughout Cambridge, looked nothing like those of a disciplined fighting machine. "Tents and shelters were mainly patched together concoctions of whatever could be found," writes historian David McCullough.[9] "It was the first American army and an army of everyone." They were "men of every shape and size and makeup, different colors, different nationalities, different ways of talking, and all degrees of physical condition. Many were missing teeth or fingers, pitted by smallpox or scarred by past wars or the all-too-common hazards of life and toil in the eighteenth century. Some were not even men but smooth-faced boys of fifteen or less."[10]

Washington's assessment of their fighting prowess was not encouraging. On July 10 his first report to Congress conveyed his alarm "upon finding the number of men to fall so far short of the establishment, & below all expectation....All the General Officers agree that no dependence can be put on the Militia." The general complained about the quality of his men; what he saw did not convince him that they would make good soldiers. "From the Number of Boys, Deserters, & Negroes which have been listed in Troops of this Province, I entertain some Doubts whether the Number required can be raised here."[11]

From the day General Washington arrived in Cambridge, he was forced to confront an issue he had never faced before. For the first time in his life he saw substantial numbers of black men with guns. He was now commanding black troops. "The regiment at the John Vassall house in early July 1775—Col. John Glover's men from Marblehead—contained at least a few black soldiers," Bell reports.[12]

By the end of his first month as commander-in-chief, "Washington learned how much worse things were than he knew," writes McCullough.[13] There was an ammunition crisis. "To our great surprise, discovered that we had not powder enough to furnish half a pound a man," wrote New Hampshire General John Sullivan. A stunned Washington could not hide his dismay. "The General was so struck," said Sullivan, "that he did not utter a word for half an hour."[14]

Phillis Wheatley was in Providence, Rhode Island in the fall of 1775 when she sat down to write probably the most consequential poem of her

career. Her latest inspiration was a tribute to the new "Generalissimo of the armies of North America," His Excellency George Washington.

It was a bold step for the confident young poet. She took it upon herself to be the voice of Boston, welcoming the general to the fight, showering him with accolades, crowning him with glory befitting the savior of a city. On behalf of her community, Phillis Wheatley wanted the general to know that the hopes of Boston were riding on his shoulders.

In her accompanying letter, Phillis confessed that the encouraging news of the coming of the "Generalissimo" had filled her with the excitement of anticipation, "sensations not easy to suppress." She knew she was speaking for all Bostonians when she expressed a yearning for "all possible success in the great cause," an outcome that would allow them to return home.

The poem and letter were dated October 26, 1775 from Providence.

> SIR.
>
> I have taken the freedom to address your Excellency in the enclosed poem, and entreat your acceptance, though I am not insensible of its inaccuracies. Your being appointed by the Grand Continental Congress to be Generalissimo of the armies of North America, together with the fame of your virtues, excite sensations not easy to suppress. Your generosity, therefore, I presume, will pardon the attempt. Wishing your Excellency all possible success in the great cause you are so generously engaged in. I am, Your Excellency's most obedient humble servant,
>
> PHILLIS WHEATLEY[15]

With this literary initiative, Phillis Wheatley marched directly into the thick of the war effort, bolstering the Patriots' Glorious Cause with the best weapon at her disposal—her soaring verses. "Wheatley's poem and the letter that accompanied it established her claim to the status of the unofficial poet laureate of the new nation-in-the-making," Carretta declares.[16]

The poem offered something new, an allegorical innovation that can be credited to Phillis Wheatley. She appropriated the Greek-influenced name "Columbia" (Land of Columbus), then commonly used by the British press to refer to the British colonies in America, in contrast to the Mother Country, "Britannia."

Wheatley refashioned the name Columbia to give it an entirely new and richer meaning. The poet imagined Columbia as a vivid visual character endowed with mythical celestial qualities. In her artistic vision, Columbia became a woman, a Goddess with Divine Authority, a powerful warrior wrapped in heavenly light who came to lead the fight for freedom. With this novel touch, Phillis Wheatley gave us the first personification of America as a nation.

> *Celestial choir, enthron'd in realms of light,*
> *Columbia's scenes of glorious toils I write...*
> *The Goddess comes, she moves divinely fair,*
> *Olive and laurel binds Her golden hair:*
> *Wherever shines this native of the skies,*
> *Unnumber'd charms and recent graces rise.*[17]

It was an unprecedented image at the time, but soon the Wheatley depiction of Columbia became an iconic figure. Lady Columbia, portrayed as a shining Goddess draped in classical garments, sometimes carrying the American flag, sometimes the torch of liberty, became the leading symbol for America.

"At the height of the American Revolution, Miss Columbia came to represent the spirit of the country and American ideals," says Professor Ellen Berg.[18]

"Phillis Wheatley constructed the figure of Columbia in her poem *To His Excellency George Washington* in such a way as to create a personification of America which combined both her own and the General's ideal leading traits," writes Thomas J. Steele in *The New England Quarterly.*

> Wheatley created the personification of Columbia both from Apollo—the god of Poetry and poets and thus a representation of the poetess herself in a masculine embodiment—and from Athene, the goddess of strategy and generals and thus a representation of Washington in a feminine embodiment. The figure Columbia, two deities joined into a single new character thereby serves as an adept unification of two historical figures, George Washington and Phillis Wheatley, the "father of his country" and the mother of black American literature.[19]

"For the young poet," says Shields, "America—which she, probably for one of the first times in the history of American poetry, calls Columbia—is now 'The land of freedom's heaven-defended race!'"[20]

From the time she wrote the poem until the middle of the twentieth century, the image of Lady Columbia was recognized as the heavenly figure representing all that is America. King's College in New York City changed its name to Columbia College in 1784, and later to Columbia University. The patriotic song "Hail Columbia," composed in 1789 for the inauguration of President Washington, was the unofficial national anthem until that designation was given to the "The Star-Spangled Banner" in 1931. In 1801, the capital of the new nation was named "The District of Columbia." Soon dozens of towns across the country took the name Columbia.

During the Civil War, Miss Columbia, representing the Union, was a common figure in political cartoons. World War I saw posters depicting Miss Columbia imploring Americans to buy war bonds. Twentieth-century businesses used the gravitas of Miss Columbia to enhance their brand: Columbia Bicycles, Columbia Records, and the Columbia Broadcasting Company.

About the time of World War II, Miss Columbia fell out of favor as a stand-in for America, replaced by the Statue of Liberty and Uncle Sam. But for a century and a half after Wheatley's Miss Columbia appeared as a virtuous goddess in a flowing robe, the image had a glorious run as the symbol of the land of liberty. It was perhaps Phillis Wheatley's most enduring gift to the American spirit.

Wheatley's 1775 poem was notable for another reason. "The poet anticipated the Washington legend," Merle Richmond writes, "the effulgent tones of her poem seeming more in harmony with the successful conclusion of the war than with its uncertain beginning."[21]

"Indeed," Mason notes, "both Washington and his army had done little yet to deserve such praise."[22] The poet dangled an appealing future reward before the general—he would earn the undying gratitude of his countrymen, the adulation of a nation, and honors befitting a king, "a crown, a mansion, and a throne that shine with gold unfading," if his highly anticipated rescue of Boston proved successful.

"*To His Excellency George Washington* came at a defining moment in American literary history and in the military leaders' career," writes

professor Kenny J. Williams. "Before much of the patriotic and nationalistic verse had been written in the colonies, Phillis Wheatley not only had commemorated the greatness of the coming nation but also had praised the man who was to become known as the Father of the new country."[23]

### *TO HIS EXCELLENCY GEORGE WASHINGTON*

*Celestial choir, enthron'd in realms of light,*
*Columbia's scenes of glorious toils I write.*
*While freedom's cause her anxious breast alarms,*
*She flashes dreadful in refulgent arms.*

*See mother earth her offspring's fate bemoan,*
*And nations gaze at scenes before unknown;*
*See the bright beams of heaven's revolving light*
*Involved in sorrows and the veil of night!*

*The Goddess comes, she moves divinely fair,*
*Olive and laurel binds Her golden hair:*
*Wherever shines this native of the skies,*
*Unnumber'd charms and recent graces rise.*

*Muse! Bow propitious while my pen relates*
*How pour Her armies through a thousand gates,*
*As when Eolus heaven's fair face deforms,*
*Enwrapp'd in tempest and a night of storms;*

*Astonish'd ocean feels the wild uproar,*
*The refluent surges beat the sounding shore;*
*Or think as leaves in Autumn's golden reign,*
*Such, and so many, moves the warrior's train.*

*In bright array they seek the work of war,*
*Where high unfurl'd the ensign waves in air.*
*Shall I to Washington their praise recite?*
*Enough thou know'st them in the fields of fright.*

*Thee, first in place and honors—we demand*
*The grace and glory of thy martial band.*

*Fam'd for thy valour, for thy virtues more,*
*Hear every tongue thy guardian aid implore!*

*One century scarce perform'd its destined round,*
*When Gallic powers Columbia's fury found;*
*And so may you, whoever dares disgrace*
*The land of freedom's heaven-defended race!*

*Fix'd are the eyes of nations on the scales,*
*For in their hopes Columbia's arm prevails.*
*Anon Britannia droops the pensive head,*
*While round increase the rising hills of dead.*

*Ah! Cruel blindness to Columbia's state!*
*Lament thy thirst of boundless power too late.*
*Proceed, great chief, with virtue on thy side,*
*Thy ev'ry action let the Goddess guide.*

*A crown, a mansion, and a throne that shine,*
*With gold unfading, Washington! Be thine.*[24]

# CHAPTER 40

*"Request that my people may be at their work
as soon as it is light, work 'till it is dark, and
be diligent while they are at it."*

IN HIS GROUNDBREAKING 1997 STUDY *George Washington
and Slavery: A Documentary Portrayal,* Fritz Hirschfeld observes that "No
history of racism in America can be considered complete without taking
into account the role that George Washington—the principal founding
Father—played in helping to mold the racist cast of the new nation."[1]

> It was Washington's male and female slaves, adults and chil-
> dren, who plowed the fields, tended the crops, harvested the
> wheat and corn, dried the tobacco, cured the hams, picked
> the apples, built the barns, mended the fences, milked the
> cows, collected the eggs, operated the distillery, fished the
> Potomac, drained the swamps, herded the cattle, sheared the
> sheep, loaded the cargoes, and carried out the other menial
> tasks associated with the upkeep and operation of a large and
> mainly self-sufficient plantation—and that it was the profit
> from their toil that resulted in the creation of the luxury and
> great beauty, only the broad outlines of which can be seen and
> appreciated today, that made Washington's ancestral home a
> magnificent showplace during much of his lifetime.[2]

In his instructions to his overseer, the master of Mount Vernon
required "that my people may be at their work as soon as it is light—work
'till it is dark—and be diligent while they are at it....The presumption
being that every labourer (male or female) does as much in the 24 hours
as their strength, without endangering their health, or constitution, will
allow."[3]

Washington was a hard taskmaster. "Lost labour can never be regained,"
he warned, reminding his overseers to keep a close watch on the laborers to

make sure they did their jobs.[4] "There are few Negroes who will work unless there be a constant eye on them," he wrote.[5]

It is a crucial question, and Hirschfeld posed it directly: "What kind of a slave-master was George Washington?"

After examining the written record left by Washington, his instructions to farm managers and overseers "on managing a slave labor force—describing techniques that he had developed and refined over a period of nearly four decades and that had proved to be both efficient and effective," Hirschfeld concludes that "Washington treated his slaves as well as was necessary in order to keep them disciplined and productive."

"But," added Hirschfeld, "he was not concerned with their personal happiness."[6]

Washington had a clear sense of his role as master of his human help in the economy of the plantation. "It has always been my aim to feed & cloath them well, & be careful of them in sickness," he wrote.[7] "In return, I expect such labour as they ought to render," adding that "I expect to reap the benefit of the labour myself."[8]

Washington maintained a disciplined, no-nonsense workforce. "Although Washington did not actively encourage whipping," asserts Hirschfeld, "he certainly countenanced it."[9]

Professor Peter Henriques points out that "there is no record that he ever personally administered it."[10]

The master of Mount Vernon held that occasional beatings were justified and he expected his overseers to carry them out. "Mr. Stuart (the overseer) ought to be informed if ever Fowlers Ben comes on the farm you are to give him a good whipping and forbid his ever returning," he instructed his Mount Vernon estate manager.[11]

When his overseer reported that he had to give the seamstress Charlotte "a very good whipping" with a hickory switch, adding that he was "determined to lower spirit or skin her back,"[12] Washington assured him that "Your treatment of Charlotte was very proper, and if she, or any other of the servants will not do their duty by fair means, or are impertinent, correction (as the only alternative) must be administered," adding that "They must be compelled to do it."[13]

"At the same time," says Hirschfeld, "he recognized that certain overseers

had to be watched carefully lest they resort too readily to flogging."[14]

"Washington's attitude toward blacks was typical of his time," writes historian John Ferling. "No evidence exists that he was troubled by slavery at any time before the American Revolution, nor does he seem to have ever questioned the prevailing notion of white supremacy. It would have been extraordinary had he puzzled much over these matters."[15]

Ferling notes that while Washington expressed no hatred for his human property, he exhibited no empathy for their plight. "They were simply business propositions...and his comments regarding these unfortunate people were recorded with about as much passion as were his remarks on wheat rust or the efficacy of a new fertilizer."[16]

In George Washington's Virginia, approximately 40 percent of the population was enslaved African-Americans. "Slavery was such an intricate and crucial aspect of the plantation economy and social system of the hierarchical gentry-dominated colony," says Henriques.[17]

"It was an inescapable presence that enveloped his day-by-day experience," remarked Washington scholar Joseph J. Ellis.[18]

"From the day he was born until the day he died, Washington relied almost exclusively on slaves for his creature comforts," writes Hirschfeld.

> Slaves washed his linens, sewed his shirts, polished his boots, saddled his horse, chopped the wood for his fireplaces, powdered his wig, drove his carriage, cooked his meals, served his table, poured his wine, posted his letters, lit the lamps, swept the porch, looked after the guests, planted the flowers in the gardens, trimmed the hedges, dusted the furniture, cleaned the windows, made the beds, and performed the myriad domestic chores necessary to maintain an extensive household. Washington took all of this for granted, of course, for it was in the natural order of things for a gentleman of wealth and standing in the aristocratic plantation society of eighteenth-century Tidewater Virginia to be waited on by his slaves.[19]

George Washington became a slave owner at the age of eleven. His father died in 1743 and left him the 280-acre family farm near Fredericksburg, Virginia, along with ten slaves. When Washington was twenty, in 1752,

his half-brother Laurence died; ownership of the family's 2,650-acre estate Mount Vernon with its eighteen slaves fell to him.

After his marriage to Martha Custis in 1759, Washington's slaveholdings increased dramatically. The new Mrs. Washington brought her eighty-four slaves to Mount Vernon. By 1774 he owned 135 slaves.[20] At the time of his death, there were 318 enslaved people living at Mount Vernon.[21]

Throughout his life Washington's thinking on slavery was contradictory and ambivalent, gradually evolving over time. His views toward the enslaved population began to shift during the Revolution. The fiery rhetoric of "the Glorious Cause" and its focus on freedom certainly had its effect. The antislavery advocates who were close to him, such as John Laurens, Alexander Hamilton, and Lafayette, helped to soften his views. It is important to recognize that it was the abundant courage and dedication to the cause of liberty by the black troops fighting under his command that served to open his eyes.

In his private communications, Washington often expressed deep reservations about the institution of slavery and he moderated his policies accordingly. "I never mean (unless some particular circumstances should compel me to it) to possess another slave by purchase," he wrote, "it being among my first wishes to see some plan adopted, by which slavery in this country may be abolished by slow, sure, and imperceptible degrees."[22]

"To disperse families I have an utter aversion," he admitted.[23] "It is against my inclination... to hurt the feelings of those unhappy people by a separation of man and wife, or of families."[24]

"I am principled agt.(against) selling negros as you would do cattle in the market."[25]

"I can only say that there is not a man living who wishes more sincerely than I do, to see a plan adopted for this abolition of (slavery)."[26]

"I wish from my soul that the legislature of this state could see the policy of a gradual abolition of slavery. It would prevent much mischief."[27]

"No man desires more heartily than I do [the end of slavery]. Not only do I pray for it on the score of human dignity, but I can clearly foresee that nothing but the rooting out of slavery can perpetuate the existence of our union."[28]

He declared that it was his desire "to liberate a certain specie of property," his slaves, "which I possess very repugnantly to my own feelings."[29]

"He wanted to end slavery," says Henriques. But for Washington, "it was never a top priority." Henriques notes that "all of his antislavery quotes were expressed in private correspondence or conversations....During his lifetime, the President never took a public stance against slavery or called for its end."[30]

George Washington's famous Farewell Address, reprinted in every major newspaper in the country and widely discussed at the time, made no mention of slavery. Addressing his "Friends and Fellow Citizens"—the audience he envisioned was the population of adult white male property-owners—the president spoke to the nation as "the disinterested warnings of a parting friend" concerning what he saw as the greatest threats to the new nation. In Washington's view, of all the future problems the new nation would likely face, the institution of slavery was not among them.

"One could read the entire document and not even know that slavery existed in the United States," writes Henriques.[31]

"Silence, of course, can speak volumes," writes Ellis in his Pulitzer-Prize-winning *Founding Brothers: The Revolutionary Generation*. "In Washington's case, the unspoken message was that a moratorium had been declared on this most controversial topic, which more than any other issue possessed the potential to destroy the fragile union."[32]

Washington dealt with the fraught issue of slavery in the way most of our national leaders did at the time of our nation's founding—by ignoring it. "I shall frankly declare that I do not like to think, much less talk about it," he admitted.[33]

"Whether one regards slavery as the proverbial elephant in the center of the room or the ever-hovering ghost at the banquet, the etiquette of political conversation in Virginia forbade any candid discussion of the subject," says Ellis.[34]

Washington avoided the explosive topic in his thoughtful counsel to the young nation, according to Professor Ellis, because "he wanted slavery off the American political agenda."[35]

"The ultimate legacy of the American Revolution on slavery," he concludes, "was not an implicit compact that it be ended or a gentlemen's agreement between the two sections that it be tolerated but rather a calculated obviousness that it not be talked about at all."[36]

Finally, nearing the end of his life, George Washington took his first and only public stand on the national problem of slavery. "Washington faced this issue head on," says Henriques, "in his remarkable last will and testament that he wrote completely by himself during the summer before his death."[37]

Knowing this would be a defining moment of his legacy, he stipulated in his will that all slaves he owned were to be freed. Of the 318 slaves living at Mount Vernon at the time, only those who were the legal property of George Washington, 123 slaves, were set free under the terms of his will.

To stress the importance he gave of his stated wish to free his slaves, he placed it near the beginning of his will, immediately following the provisions for his beloved Martha, adding emphatically "that this clause respecting Slaves, and every part thereof be religiously fulfilled."[38]

"His action on this score, as usual, spoke louder than his words, for they suggested an obligation beyond the grave to assist his former slaves in the transition to freedom within the borders of the United States," Ellis writes.[39]

Of all the Founding Fathers, the only one who took the complicated legal steps to free every slave he could was George Washington.

# CHAPTER 41

*"It has been represented to me that the free
Negroes who have served in this army are very
much dissatisfied at being discarded."*

BLACK SOLDIERS IN CAMBRIDGE WERE not there in great
numbers but they were enough of a presence to be noticed. "Washington
had to reckon with the tolerance of his New England men who had accepted
blacks as stout-hearted comrades at Lexington and Concord and Bunker
Hill," writes Washington biographer Ron Chernow.[1]

Massachusetts commander General John Thomas reported that "In the
regiments at Roxbury we have some Negroes; but I look on them, in gen-
eral, equally serviceable with other men for fatigue & in action; many of
them have proved themselves brave."[2]

"After the action at Bunker Hill, neighboring towns such as Plymouth
and Andover sent their minutemen or militia to assist in the siege of
Boston," says historian Benjamin Quarles. "A sprinkling of colored men
were included."[3]

Three black soldiers fought with the New Hampshire regiment. An
officer described them as "effective able bodied men but they are slaves
inlisted with the consent of their masters."[4]

"The spirit of '76 found new outlets among blacks. The Revolutionary
War as a black declaration of independence took on a power of its own,"
Quarles writes.[5] "It spurred black Americans to seek freedom and equality."[6]

Quarles goes on to explain that "All blacks during the Revolutionary
era shared a common goal—the pursuit of freedom and equality....Such
patriotic exhortations as 'Give me liberty or give me death' carried special
meaning to people in bondage."[7]

"For the enslaved African Americans, the slavery rhetoric of the white
revolutionaries had its own special meaning," says Hirschfeld. "The slaves
were not particularly interested in the ideological issues being argued by

the white advocates on either side. Their overriding concern was with their personal freedom, with eliminating the legal chains that bound them to a condition of enforced lifelong servitude."[8]

"Of the 289 identifiable blacks in the Connecticut army," says Quarles, "five reported 'Liberty' as their surname when they signed on and eighteen reported 'Freedom' or 'Freeman.'"[9]

African-Americans fought stoutly during the June 1775 battles on Breed's Hill and Bunker's Hill. Black soldiers won the confidence of their comrades and praise from their commanders for valor. No one doubted their commitment to the cause. On December 5, 1775 thirteen Continental Army officers petitioned the Massachusetts legislature to honor "a negro man called Salem Poor" who "behaved like an experienced officer, as well as an excellent soldier."[10]

According to Samuel Swett, whose 1825 *History of Bunker Hill: Battle with a Plan* was the first complete history of the battle, another black soldier distinguished himself in combat. "Cuffee Whittemore fought bravely in the redoubt. He had a ball through his hat at Bunker Hill, fought to the last, and when compelled to retreat, though wounded, the splendid arms of the British officers were prizes too tempting for him to come off empty-handed. He seized the sword of one of them slain in the redoubt and came off with the trophy."[11]

One young volunteer from Boston, John Greenwood, who signed up for military service after the bloodshed at Bunker Hill, wrote of the horrors of war he witnessed first-hand.

> As I passed through Cambridge common I saw a number of wounded who had been brought from the field of conflict. Everywhere the greatest terror and confusion seemed to prevail. ... Never having beheld such a sight before, I felt very much frightened and would have given the world if I had not enlisted as a soldier. I could positively feel my hair stand on end.[12]

The frightened young man told of his encounter with one of the brave black fighters whose indomitable spirit inspired him to transcend his own fears.

Just as I came near the place, a Negro man, wounded in the back of his neck, passed me and his collar being open and he not having anything on except his shirt and trousers, I saw the wound quite plainly and the blood running down his back. I asked him if it hurt him much, as he did not seem to mind it. He said no, that he was only to get a plaster put on it and meant to return. You cannot conceive what encouragement this immediately gave me. I began to feel brave and like a soldier from that moment, and fear never troubled me afterward during the whole war.[13]

Colonel Swett noted that despite the woeful lack of manpower, the Continental Army continued to resist black troops. "Many northern blacks were excellent soldiers but southern troops could not brook an equality with negroes," he wrote. "Washington prohibited their enlistment."[14]

"The orders that issued from Washington's headquarters at Cambridge after he had taken command of the continental army in July 1775 demonstrated a continuing low regard for African Americans," says Quarles.[15]

At his War Council on October 8, 1775, Washington and his generals voted unanimously "to reject all slaves and by a great majority to reject Negroes altogether."[16]

Washington restated his policy of exclusion in his General Orders of November 12. "Neither Negroes, boys unable to bear arms, nor old men unfit to endure the fatigues of the campaign are to be enlisted."[17]

The wealthy Virginian came to Cambridge with the hardwired belief in white supremacy and black subservience typical of southern planters. "He was used to being waited on by people of African origin, and he distrusted the notion of black soldiers," Bell writes. "Even as he guarded his own political liberties, he was content with a lifestyle that depended on the forced labor of many others." Bell points out that "Washington did not object to black men, even enslaved black men, being part of a military force—as long as they were laborers, not soldiers."[18]

Even with British forces bottled up in Boston, encircled by Americans, and no military engagements on the horizon, General Washington faced an existential crisis for the new Continental Army. "By late November, as snow blanketed the American camp, Washington's spirits drooped along

with the temperature," Chernow says. "He felt himself sinking in a quicksand from which he might never escape."[19]

The troops holding the British under siege were mostly part-time New England volunteers who rushed to defend their towns after the first exchange of gunfire at Lexington and Concord in April. After the battle was over and the danger passed, the citizen-militia melted away; many fighters simply went home.

Even after the Continental Congress in Philadelphia authorized the creation of the Continental Army, recruitment numbers were far below what a fighting force would need. "By the end of November, a paltry 3500 men had agreed to stay with the dwindling army," says Chernow.[20]

"Could I have foreseen what I have and am like to experience, no consideration upon earth should have induced me to accept this command," a despairing Washington wrote.[21]

One reason for Washington's gloomy outlook was the troubling news from his home colony of Virginia. On November 7, 1775 the Royal Governor Lord Dunmore issued a proclamation declaring that any slaves fleeing from their rebel masters could join his Royal Ethiopian Regiment and gain their freedom. At least eight hundred slaves joined, including Washington's trusted slave Harry, and soon they were marching in British uniforms with sashes emblazoned with the motto "Liberty to Slaves."

Washington was enraged at Dunmore. "If one of our bullets aimed for him, the world would be happily rid of a monster," he wrote.[22]

The General immediately recognized the military significance of Dunmore's audacious move to recruit slaves to the British cause. "Lord Dunmore, should be instantly crushed, if it takes the force of the whole colony to do it," he wrote to his chief military aide, "otherwise, like a snowball, in rolling, his army will get size."[23]

He warned the Continental Congress: if "that man is not crushed before spring he will become the most formidable enemy America has."[24]

"As he mulled over various schemes to strengthen his frail army, Washington wrestled with the vexed question of whether to accept blacks into the Continental Army, not as an instrument of social policy but as a matter of stark military necessity," says Chernow.

"The Revolution forced him to contemplative thoughts that would have seemed unthinkable a year earlier."[25]

"Within a few months, as it became clear that there would not be enough new recruits to fill the ranks as the militia units disbanded, he was forced to change his mind," Ellis writes.[26]

On December 30, 1775 Washington authorized a new General Order for his officers.

"As the General is informed, that numbers of Free Negroes are desirous of inlisting, he gives leave to the recruiting officers to entertain them and promises to lay the matter before the congress, who he doubts not will approve of it."[27]

The next day he wrote to John Hancock, president of the Continental Congress, to inform him of his change in policy. "It has been represented to me that the free Negroes who have served in this army are very much dissatisfied at being discarded. As it is to be apprehended that they may seek employ in the ministerial army, I have presumed to depart from the resolution respecting them and have given licence for their being enlisted."[28]

"Plainly, Washington had acted under duress," writes Chernow. "He urgently needed more men before enlistments expired at year's end and feared that black soldiers might defect to the British. At the same time, he was forced to recognize the competence of black soldiers."[29]

"Washington showed himself at his best," says Hirschfeld. "Having overcome his initial inhibitions about blacks in the army, he acted without further equivocation to bring them into the Continental ranks."[30]

"Whatever his motivations," says Chernow, "it was a watershed moment in American history, opening the way for approximately five thousand blacks to serve in the Continental Army, making it the most integrated American fighting force before the Vietnam War. At various times, blacks would make up anywhere from 6 to 12 percent of Washington's army."[31]

"In this backhanded fashion," writes Ellis, "Washington established the precedent for a racially integrated Continental Army.[32]

"Once the commander in chief had opened the door, officially acknowledging the acceptance of African Americans into military service, their

active recruitment turned into a spirited business, irrespective of their slave or free status," says Hirschfeld. "As a pragmatic and down-to-earth leader, he was well aware that the war would have to be fought and won with every man and method available to him."[33]

> The orders went down to the commanders in the field, who promptly received the new African American recruits and welcomed them as badly needed additions to their depleted ranks. The African American soldiers were integrated into regular fighting regiments, given muskets and bayonets, taught to use them, drilled and officered, and prepared for military action. The era of the professional African American combat veteran had begun.[34]

"Colored combatants were interspersed with white in what today might be called unsegregated units," writes Quarles.[35]

Black soldiers distinguished themselves nobly in the fight for independence. "The combat records of the African American fighting men in the Revolution bear adequate testimony to their valor and bravery," says Hirschfeld.

> From beginning to end, they participated in the armed encounters with the enemy and they shared the victories and glory—and the sacrifices and bloodshed—with their white comrades. It is fair to say that the African American combat veterans earned their freedom and the esteem of their countrymen by their wartime feats.[36]

Quarles notes the considerable presence of African-American fighters. "It has been estimated...that 5,000 Negro soldiers served in the patriot forces."[37]

One soldier observed that "No regiment is to be seen in which there are not Negroes in abundance and among them are able-bodied, strong and brave fellows."[38]

Black soldiers fought in every great battle, and Washington himself was keenly aware of their valor. "Two Negroes, Prince Whipple and Oliver

Cromwell, were with General Washington when he crossed the Delaware on Christmas Day 1776," writes Hirschfeld.[39]

As Washington's Continental Army joined French forces under General Rochambeau in White Plains, New York for the final push that would end the war, Rochambeau's aide-de-camp Baron Ludwig von Closen described the substantial contingent of black troops marching with them. "I had a chance to see the American army man for man," he wrote after reviewing the troops on July 9, 1781. "It was really painful to see these brave men, almost naked, with only some trousers and little linen jackets, most of them without stockings. But would you believe it? Very cheerful and healthy in appearance. A quarter of them were Negroes, merry, confident and sturdy."[40]

Baron von Closen was duly impressed by the battle-readiness and military discipline of the Rhode Island militia. "Three quarters of the Rhode Island regiment consists of Negroes and that regiment is the most neatly dressed, the best under arms, and the most precise in its maneuvers."[41]

After the British surrender at Yorktown on October 19, 1781, a French soldier noted the gruesome evidence of the supreme sacrifice made by African-American fighters. "All over the place and wherever you looked, corpses...lying about that had not been buried; the larger part of these were Mohren [Moors, blacks]."[42]

George Washington's fateful change of heart on black soldiers was one of those decisions that changed the course of the war and contributed mightily to helping the Americans outlast the British. Washington seemed to sense this. After the war, when he returned to civilian life as a gentleman farmer at Mount Vernon, his outlook on slavery had changed.

"That shift to accepting a racially integrated enlisted corps was Washington's first step toward rethinking slavery as a whole," writes Bell. "At the end of his life, he decided to posthumously free all his own slaves, an extraordinarily rare act for a Virginia planter. Washington's journey to that decision started with his experiences in Cambridge."[43]

# CHAPTER 42

*"I thank you most sincerely for your polite notice of me,
in the elegant lines you enclosed."*

As 1776 BEGAN, WASHINGTON'S TROOPS had the British forces boxed in. Since the British retreat in April 1775, Boston was encircled by the Continental Army in what Ellis calls "a marathon staring match."[1]

There was no actual fighting, yet dire circumstances were decimating the Continental Army without a shot being fired. Mother Nature struck a devastating blow—the brutal New England winter that paralyzed Washington's troops. It was so cold, sentries could not stand on guard duty for more than an hour. Soldiers deserted in droves, leaving dangerous gaps in the army's defenses. "On Christmas Day 1775 Cambridge was gripped by freezing temperatures and covered with a foot of snow, only deepening Washington's gloom," writes Ron Chernow.[2]

For General Washington, the beginning of 1776 brought only brooding anxiety and sleepless nights. "On January 14, two weeks into the new year, George Washington wrote one of the most forlorn, despairing letters of his life," says David McCullough.[3]

"The reflection upon my situation and that of this army produces many an uneasy hour when all around me are wrapped in sleep," he confided to his trusted aide Joseph Reed. "Few people know the predicament we are in."[4]

"He was downcast and feeling quite sorry for himself," McCullough writes, admitting to Reed that if he had "known what he was getting into, he would never have accepted the command."[5]

"I have often thought, how much happier I should have been, if, instead of accepting the command under such circumstances, I had taken my musket on my shoulder and entered the ranks," Washington groused. He felt he could have justified himself to "posterity and my own conscience" if only he had "retired to the back country and lived in a wigwam."[6]

As winter wore on, the bucolic haven of Cambridge became "a bleak, denuded landscape" as the troops cut down whole forests for firewood to keep warm.[7]

"We have burned up all the fences and cut down all the trees for a mile around the camp," said a distressed General Nathanael Greene. "Our suffering has been inconceivable.... Many regiments have been obliged to eat their provisions raw for want of firing to cook."[8]

"The bitter cold continued," McCullough writes. "On January 27, the thermometer dropped to 4 degrees. The low on January 28 was 1 degree, then 2 degrees on January 30."[9]

The general was not optimistic about how well his army would perform when it came time for the real fighting to start. "To expect then the same service from raw and undisciplined recruits as from veteran soldiers is to expect what never did and perhaps never will happen," he told Hancock.[10]

When Washington arrived as commander-in-chief, he brought along his fighting spirit. Throughout the Siege of Boston, "George Washington was restless and all too eager to pounce," says Chernow. "He wanted to be done with this devilish stalemate and return to Mount Vernon."[11]

"Standing still and waiting were not the way to win a war and not in Washington's nature," writes McCullough.[12]

The stalemate was frustrating to him. "The inactive state we lie in is exceedingly disagreeable," he told his brother John.[13]

As much as he chafed at his impotence in the situation, Washington knew that he had no real choice. The gunpowder shortage was so dire that he could not take the bold action he wanted. "It would not be prudent in me to attempt a measure which would necessarily bring on a consumption of all the ammunition we have, thereby leaving the army at the mercy of the enemy," he explained to Virginia Congressman Richard Henry Lee.[14]

Most disheartening for Washington was the burden of carrying the desperate hopes of the American people now looking to him to drive away the British. "I know by not doing it that I shall stand in a very unfavorable light in the opinion of those who expect much and will find little done," he said.[15] "To have the eyes of the whole continent fixed with anxious expectation of hearing of some great event, & to be restrain'd in every Military Operation for want of the necessary means of carrying it on, is not very pleasing."[16]

Then, in early February, Washington received a surprising morale boost. The general was catching up on his voluminous correspondence when he came upon a letter from Providence, Rhode Island. "In searching over a parcel of papers the other day, in order to destroy such as were useless, I brought it to light again," he told Joseph Reed on February 10. The letter, sent by a young woman at the end of October, so impressed him that he forwarded a copy to Reed. "You can be amused by reading a letter and poem addressed to me by Miss Phillis Wheatley."[17]

"Sir," she began, "I have taken the freedom to address your Excellency in the enclosed poem, and entreat your acceptance...Your being appointed by the Grand Continental Congress to be Generalissimo of the armies of North America, together with the fame of your virtues, excite sensations not easy to suppress."[18]

Phillis Wheatley included her poem *To His Excellency General Washington.*

> *Fix'd are the eyes of nations on the scales,*
> *For in their hopes Columbia's arm prevails.*
> *Anon Britannia droops the pensive head,*
> *While round increase the rising hills of dead.*
>
> *Ah! Cruel blindness to Columbia's state!*
> *Lament thy thirst of boundless power too late.*
> *Proceed, great chief, with virtue on thy side,*
> *Thy ev'ry action let the Goddess guide.*
>
> *A crown, a mansion, and a throne that shine,*
> *With gold unfading, Washington! Be thine.*[19]

At the time, Washington was at a low point in his military command, aware of the serious limitations of his army and nearly overwhelmed by the daunting expectations of his countrymen. He was undoubtedly grateful to receive such a glowing declaration of support.

Washington was impressed. "At first, with a view of doing justice to her poetical genius, I had a great mind to publish the poem," he said, "but not knowing whether it might not be considered rather as a mark of my own vanity, than as a compliment to her, I laid it aside till I came across it again in the manner just mentioned."[20]

It was Reed who took the general's hint and sent the poem and let-
ter, along with his own introductory remarks, to the editors of the *Virginia
Gazette* who published them on March 20, 1776. Thomas Paine, editor of
the *Pennsylvania Magazine or American Monthly Museum,* reprinted them
in April 1776.

Meanwhile, on February 16, Washington called his generals together
for a council of war. The time had come to attack, Washington insisted. "The
severe freezing weather formed some pretty strong ice from Dorchester to
Boston Neck, and from Roxbury to the Common. This I thought (know-
ing the ice could not last) a favourable opportunity to make an assault upon
the troops in town," he wrote.[21]

The war council voted against a direct attack but agreed on an alternate
plan. "We are making every necessary preparation for taking possession of
Dorchester Heights as soon as possible, with a view of drawing the enemy
out," Washington told John Hancock on February 26, 1776.[22]

Dorchester Heights was a strategic bluff looming more than a hundred
feet over Boston from the south. Controlling the high ground so close to
British forces would be decisive in ending the siege. The summit offered
a commanding view of the harbor, where the British fleet lay almost two
miles away, well within range of rebel cannons.

Washington issued new general orders to all regimental commanders
"to order all the axes, pick-axes, spades, shovels, and other intrenching tools,
now in their possession, to be forthwith sent to the Qr Master General's
Store in Cambridge."[23]

On February 27, the general addressed his troops to prepare them for
the battle to come.

> As the season is now fast approaching, when every man must
> expect to be drawn into the field of action, it is highly nec-
> essary that he should prepare his mind, as well as everything
> necessary for it. It is a noble cause we are engaged in, it is the
> cause of virtue and mankind, every temporal advantage and
> comfort to us, and our posterity, depends upon the vigour of
> our exertions; in short, freedom, or slavery must be the result
> of our conduct, there can therefore be no greater inducement
> to men to behave well.[24]

Now that Washington had settled on a course of action and was deeply engaged in preparation for war, he took a startling and unprecedented step. On February 28, 1776, the Commander-in-Chief of the Continental Army, a Virginia aristocrat and slave-owner, sat down to write what was arguably the most extraordinary letter of his career. General Washington composed a personal letter to Phillis Wheatley, thanking her for her letter and poem of October 26.

"His cordial, respectful letter is little short of astonishing for a large Virginia slave owner replying to a young woman in bondage," says Chernow. "It didn't seem to bother Washington that Wheatley was a slave and it evidently didn't bother Wheatley that Washington was a substantial slave owner."[25]

According to Joseph Ellis, it was "the only occasion in his correspondence when he directly addressed a slave."[26]

Washington addressed the letter to "Mrs. Phillis."

"The general wrote a personal letter to the young black poetess, using her first name, as was common practice when addressing a slave," Hirschfeld writes, "but prefixing it with the title of Mrs. as a gesture of respect."[27]

He began with an apology. Washington expressed his regret for his apparent rudeness in taking so much time to reply. He admitted receiving her letter in mid-December, at a time when a "variety of important occurrences" understandably distracted him.

When he came across Wheatley's letter and poem again on February 10, many of those crucial issues—creating an effective fighting force out of farmers and tradesmen, a severe gunpowder shortage, a manpower crisis, Lord Dunmore's move to recruit black troops for the British, and his own reservations about accepting black soldiers into the Continental Army—were on their way to being resolved.

> Your favour of the 26th of October did not reach my hands 'till the middle of December. Time enough, you will say, to have given an answer ere this. Granted. But a variety of important occurrences, continually interposing to distract the mind and withdraw the attention, I hope will apologize for the delay, and plead my excuse for the seeming, but not real neglect.[28]

As so many of his contemporaries did, Washington responded to the poetry of Phillis Wheatley with generous praise.

> I thank you most sincerely for your polite notice of me, in the elegant lines you enclosed; and however undeserving I may be of such encomium and panegyrick, the style and manner exhibit a striking proof of your great poetical talents.[29]

Washington made it clear that her poem deserved to be widely read and should be shared with the public. In a characteristic display of modesty, however, he explained why he could not be the one to submit her poem for publication. He did not mention that he had already forwarded her poem to his aide, who would arrange for it to be printed in the *Virginia Gazette* the following month.

> In honour of which, and as a tribute justly due to you, I would have published the poem, had I not been apprehensive, that, while I only meant to give the world this new instance of your genius, I might have incurred the imputation of vanity. This and nothing else, determined me not to give it place in the public prints.[30]

Then Washington offered Phillis Wheatley a startling proposal: "If you should ever come to Cambridge, or near Head Quarters, I shall be happy to see a person so favoured by the Muses, and to whom Nature has been so liberal and beneficent in her dispensations."

His closing was warm and gracious. "I am, with great Respect, your obedient humble servant."[31]

In his landmark 1932 study *George Washington and the Negro,* Walter H. Mazyck concluded, "This is probably the first time in his life that he ever accorded the civility of 'Mrs.' or 'Miss' to one of her race, or gave a Negro the unusual distinction of an invitation to pay him a social visit."[32]

George Washington was no stranger to black people, that "certain species of property which I possess" as he called them.[33] They surrounded him all his life, always subservient and compliant, burdened by the dehumanizing force of white supremacy, people whose harsh circumstances he once confessed "I do not like to think, much less talk about it."[34]

The respect Washington gave to this particular African-American woman was a unique phenomenon. "Certainly, there were Mount Vernon slaves whom Washington knew intimately and some to whom he spoke in a friendly manner," says Chernow. "But he never met any black person on such terms of social equality."[35]

"Against all the odds," writes Merle Richmond, "the Father of His Country did grant a civil audience to the slave poet who just as fittingly may be christened the Mother of Black Literature in North America."[36]

Says Chernow, "Few incidents in the early days of the war suggest how powerfully Revolutionary ideals were transforming George Washington as his reaction to Phillis Wheatley."[37]

# CHAPTER 43

"She passed half an hour with the commander-in-chief, from whom, and his officers, she received marked attention."

IT HAD TO BE ONE of the greatest thrills of her life. The twenty-three-year-old poet who arrived in Boston as a child, and was sold to a wealthy family as its personal property, had just received an official communication from General George Washington. We can imagine her elation as she read the letter. The General liked her poem! And now he wanted to meet her in person!

We don't know how the letter was delivered. We do know that George Washington wrote the letter to Phillis Wheatley on February 28, 1776, because a copy of the letter can be found among his papers. There was no mail service then—messages and letters were hand-delivered by courier. With the entire Continental Army at his disposal, the General could have dispatched any one of his troops to carry the message on horseback for the forty-mile ride to Providence. The soldier entrusted with the responsibility of delivering a letter from George Washington would certainly carry out the order with dutiful dispatch.

We can assume that Phillis Wheatley received the letter. A personal invitation from General Washington was a high honor for any American. Did Phillis Wheatley ever actually meet George Washington? Surely she would try to move heaven and earth to make the journey to Cambridge.

The answer remains hidden in the shadows of history. "Events leading up to the curious encounter are shrouded with choice ambiguities," says Merle Richmond. "The opening shot, however, clearly was fired by Miss Wheatley with a letter and poem."[1]

When Washington read Phillis Wheatley's letter and her poem, did he have any idea who she was?

"Phillis Wheatley had by then achieved fame as a slave poet," says Professor Richmond, "but it is also true that Washington's interest in poetry

was so slight that she might have escaped his notice." Perhaps Washington's "reference to her 'poetical genius' could rest on the one poem rather than on a knowledge of her prior work."[2]

Clearly, Washington was deeply affected by her poem. As a matter of course he would want to know more about the poet. "As plausible a speculation as any," says Richmond, "is that between February 10, when he wrote to Reed and February 28, when he wrote to Phillis Wheatley, Washington was briefed by someone, possibly Reed, about his correspondent's identity, thus accounting for the striking change in attitude."[3]

"The country had no poets as yet," writes McCullough. "Yet he, a soldier and planter—a slave master—despite all that bore heavily on his mind, took time now to write to her in his own hand."[4]

The existence of the letter is all the more stunning when we consider what was going on in Cambridge at the time. General Washington was an extremely busy man; certainly he had his hands full with his untested and ill-equipped army, facing a well-fortified enemy poised to attack at any time. Why would General Washington make the effort to welcome as his guest a slave woman and a poet?

One of the most pressing issues Washington faced from the moment he took command of the Continental Army in July 1775 was the quandary of what to do about black patriots who wanted to fight for the cause. In October, shortly before Phillis Wheatley composed her poem, Washington and his generals had voted to bar blacks from the military. Then came the shock of Lord Dunmore's November 7 proclamation offering freedom to black slaves willing to fight for the Crown. By December 30, Washington had changed his mind and reversed his previous restrictions. Black soldiers were now welcome to join the Revolution.

"What effect, if any, did this have on creating the climate for Washington's gracious note to Miss Wheatley?" Richmond wonders. "Granted, this is a question of conjecture," she admits, "but it is not farfetched. Presumably, in his position, Washington was guided by considerations of state in small matters as well as large, and a modification of policy toward blacks in general would have influenced the relationship with one particular black poet."[5]

The imposing Vassall mansion was now the bustling nerve center for the Patriot military effort. "Here Washington mapped strategy, held war

councils, and conducted his voluminous correspondence with Congress. Washington's aides also slept in the house, with several crammed into a single room, while the general commandeered one drawing room as his office," says Chernow.[6]

"It was there," writes McCullough, "that Washington conferred with his highest ranking officers, convened his councils of war, and with staff help, coped with the numberless problems of organization, issued orders, and labored over correspondence—paperwork without end, letters to Congress, appeals to the governors of the New England states, and the legislature of Massachusetts."[7]

"Gen. Washington recognized the power that came from invitations to dine at headquarters, and his responsibility to spread that honor around," says Bell.[8]

"He received or entertained local dignitaries and politicians and their wives, always in elegant fashion, as was both his pleasure and part of the role he felt he must play," says McCullough. "And as with everything connected with that role—his uniform, the house, his horses and equipage, the military dress and bearing of his staff—appearances were of great importance: a leader must look and act the part."[9]

Martha Washington arrived at the Cambridge mansion in December and took charge of the general's hospitality program. "Since Washington had a good deal of entertaining to do, Martha oversaw the social side of headquarters," says Chernow. "At these gatherings, Washington experienced relief from his burdensome labors and enjoyed his favorite Madeira wine combined with the camaraderie of several pretty young women. A particular favorite was the fetching Caty Greene, wife of Nathanael."[10]

"To judge by surviving household accounts, Virginia hospitality more than lived up to its reputation at Cambridge," McCullough writes. "Purchases included quantities of beef, lamb, roasting pig, wild ducks, geese, turtle, and a variety of fresh fish, of which Washington was especially fond; plums, peaches, barrels of cider, brandy and rum by the gallon."[11]

"Madeira flowed plentifully," writes James Flexner, "the largest single item in the headquarters accounts." He noted that 108 bottles of wine were delivered on October 11 and 109 more on October 22. "Washington believed that wine brought 'cheerfulness' to his table."[12]

"Most of the general's dinner guests appear to have been army officers or politicians, and the conversation probably focused on issues of the war," says Bell. Massachusetts Congressional delegate John Adams was a frequent dinner guest. "As with most of Washington's other dinners while commander-in-chief, this meal was part sustenance and part business."[13]

Washington also invited prominent citizens to Cambridge, people who had nothing to do with the war effort but were strong supporters of the Patriot cause. The Reverend Samuel Cooper came to dine at Washington's headquarters, the same Reverend Cooper who baptized Phillis Wheatley at the Old South Meeting House on August 18, 1771.

Another poet was invited to visit the Cambridge headquarters as the guest of General and Mrs. Washington. "I took a ride to Cambridge and waited on Mrs. Washington at 11 o'clock," wrote Mercy Otis Warren. "I was received with that politeness and respect shown in a first interview among the well-bred and with the ease and cordiality of friendship."[14] Some years later, Warren would dedicate a poem to President Washington in her 1790 book *Poems, Dramatic and Miscellaneous*.

What evidence do we have that Phillis Wheatley was among the many guests who met George Washington at his headquarters in Cambridge?

The only known account of a meeting between the black slave poet and the general was written seventy-four years later. "Washington invited her to visit him at Cambridge, which she did a few days before the British evacuated Boston," journalist Benson Lossing wrote in 1850. "She passed half an hour with the commander-in-chief, from whom, and his officers, she received marked attention."[15]

William Robinson insists that because no independent verification of the meeting has been found, "Lossing should be used with caution."[16]

"Lossing offered no evidence for this statement," says Bell in his exhaustive 2012 study of George Washington's headquarters. "There is no confirmation for such a visit in the records of Washington, his aides, or other people in Cambridge. If Wheatley did indeed receive 'marked attention' from the general and his staff, it went entirely unremarked at the time." Bell concludes that "Phillis Wheatley's visit to the Cambridge headquarters is most likely a myth."[17]

Scholars differ on the degree of credibility to give Lossing's report. The Mount Vernon Ladies' Association, whose mission since 1853 has been "to preserve, restore and manage the estate of George Washington to the highest standards and to educate visitors and people throughout the world about the life and legacies of George Washington," features a Phillis Wheatley page on their website.[18] Taking Lossing's account at face value, the Mount Vernon Ladies see the Washington connection to Phillis Wheatley as a significant part of legacy of our first president.

> Although George Washington met her only once for a period of around half an hour, the kindness and respect that he showed toward Phillis Wheatley, a female African slave, serves as a telling example of his moral complexity and capacity for humanitarian understanding.[19]

Richmond also accepts Lossing's report: "In March, four months before independence was declared, the General and the poet met in Cambridge."[20]

Ron Chernow offers probably the most honest assessment we have. "Washington appears to have received Phillis Wheatley at his Cambridge headquarters in March with a 'very courteous reception,'" he writes.[21]

Unless we find a lost letter reporting on the meeting, a reference in a journal, a remembered conversation, or a note written at the time by someone who was actually present at Washington's Cambridge headquarters that day, the only definitive statement we can make about the Wheatley-Washington meeting is that we can make no definitive statement.

Nineteenth-century standards of journalism were looser than they are today, so Lossing was not in the habit of crediting his sources. Every indication suggests that in keeping faith with his mission as a journalist, he made an effort to give his readers an accurate report on the information he learned from the person he interviewed when he visited the Cambridge house for his story.

So how did Lossing get the information about Phillis Wheatley's visit to George Washington? Was it reliable? And who was his source?

# CHAPTER 44

*"It will be very pleasant to read here in Head-
Quarters the letters he wrote sixty-six years ago,
perhaps here in this very room."*

IN 1848 JOURNALIST AND GRAPHIC artist Benson Lossing
began writing a series of narrative sketches of locations made famous by
the American Revolution. Lossing's idea for his book, *The Pictorial Field
Book of the Revolution,* was to create a kind of "You-Are-There" travelogue
designed to take readers to the historic sites that played such an important
role in the birth of the nation.

"To collect the pictorial and other materials for this work I traveled
more than thirteen thousand miles in the old thirteen states and Canada
and visited every important place made memorable by the events of the
war," Lossing explained. "I accordingly determined to make a record of the
tour to the important localities of the Revolution a leading feature of the
work."[1]

Lossing's research brought him to Cambridge, Massachusetts and the
mansion George Washington used as his military headquarters from July
1775 to April 1776. Lossing wrote about his visit to Washington's head-
quarters in the November 1850 issue of *Harper's New Monthly Magazine.*
In the course of his article, he revealed a fascinating episode in the glorious
history of the house, one that had never been reported before.

"I cannot refrain however, from noticing the visit of one, who, though
a dark child of Africa and a bond-woman, received the most polite atten-
tion from the commander-in-chief," Lossing wrote. "This was Phillis, a slave
of Mr. Wheatley of Boston."

He introduced his readers to Phillis Wheatley with a brief biographi-
cal sketch. "She was brought from Africa when between seven and eight
years old. She seemed to acquire knowledge intuitively; became a poet of
considerable merit."

Then Lossing supplied details of the extraordinary encounter. "Washington invited her to visit him at Cambridge, which she did a few days before the British evacuated Boston....She passed half an hour with the commander-in-chief, from whom, and his officers, she received marked attention."[2]

Is the story true? Is Lossing's report credible?

Benson Lossing was one of the most popular American history writers in the mid-nineteenth century, publishing more than forty books, including best-sellers on the American Revolution and the Civil War. His biographer, Harold Mahan, calls him a "historical popularizer,"[3] while making "no pretension that Lossing was a great scholar."[4]

Although some contemporary reviewers considered him "a mere hack," one wrote: "No writer has done more to popularize the history of his own country than Mr. Lossing."[5] Another critic told Lossing that "You have invested history with a charm which has captivated many thousands of your countrymen."[6]

In his introduction to *The Pictorial Field Book of the Revolution*, Lossing made a pact with his readers, assuring them that he intended to stick to the facts. "The woof of our history is too sacred to be interwoven with the tinsel filling of fiction," he declared. "We should have too high a regard for truth to seek the potential aid of its counterfeit in gaining audience of the ear of the million."[7]

He adopted an admirable standard for truthfulness in his reporting. "It has been said that 'diligence and accuracy are the only merits which a historical writer may ascribe to himself.' Neither labor nor care has been spared in the collection of materials and in endeavors to produce a work as free from grave errors as possible."[8]

Even though Lossing was not a trained historian, he did make a conscientious effort in good faith to give an honest account of his travels throughout America. Since the only mention of a Wheatley-Washington meeting came from Benson Lossing, a closer look at his assertions in historical context can shed new light on our evaluation of his claims. What can we make of Lossing's Phillis Wheatley story?

First, consider exactly what he stated. His report on Wheatley contains several specific elements, and each one appears to be credible on its

face. Since Lossing's article appeared in 1850, no information has surfaced to contradict any of his points:

- That Washington invited Phillis Wheatley to visit him at Cambridge.
- That she visited Washington a few days before the British evacuated Boston.
- That she and General Washington met for half an hour.
- That she received the most polite attention from the commander-in-chief and the other officers present.

Lossing was a professional journalist so he certainly knew how to communicate. He constructed his report in direct declarative sentences. "Washington invited her...she passed half an hour...she received marked attention." He could have used qualifying phrases like: "perhaps she visited...she probably stayed for a half hour... they may have given her marked attention." His choice of straightforward unequivocal language left no room for ambiguity. Evidently, Lossing had complete confidence in whoever gave him his Phillis Wheatley scoop. He felt comfortable presenting his information on Phillis Wheatley as established fact.

How did he come by the Phillis Wheatley story? Who was Lossing's source?

In Lossing's account of his visit to the house in Cambridge that Washington used as his headquarters, he revealed that he spoke to one person there, someone he called "the proprietor." This was a reference to the owner of the house. Lossing described him as a man he admired: "Henry Wadsworth Longfellow, professor of Modern Languages in Harvard University, and widely known in the world of literature as one of the most gifted men of his age."[9]

On Friday, October 6, 1848, Longfellow noted the visit in his journal: "In the afternoon, Mr. Lossing came to make a sketch of the house for a work he is going to publish with the Harpers on Revolutionary Times."[10]

We can imagine the poet and the journalist strolling through the rooms of the mansion to Longfellow's running commentary on the notable events that took place within those walls. "Here are General Washington's private chambers," he might have said, happy to point out that he, himself,

occupied the very same rooms. "Here was his office, where he wrote his official communications...and this is the dining room where the general entertained his guests, which also served as the meeting room where he convened his councils of war."

The tour must have gone well, since Lossing made a point of expressing his appreciation for the cooperation and courtesy of "the proprietor," Professor Longfellow.

> My tarry was brief and busy, for the sun was rapidly descending... but the cordial receptions and polite attentions which I received from the proprietor, and his warm approval of and the expressed interest in the success of my labors, occupy a space in my memory like that of a long bright summer day.[11]

If somehow we could obtain a record of their conversation, contemporaneous notes, a journal entry, or a letter referring to the incident, maybe we would discover whether it was Longfellow who gave Lossing the details about Phillis Wheatley's visit that he used in his report. Unfortunately, we can't solve that mystery. But we can examine certain evidence that allows us to build a case that Henry Wadsworth Longfellow had access to individuals who were in a position to know about the Wheatley visit, people who could easily have been Lossing's source.

Longfellow grew up with a profound reverence for George Washington. His biographer, Charles C. Calhoun, indicated that "Longfellow's own family was a case in point in its sacralization of the Father of the Country." Above the entrance to the parlor of their home in Portland, Maine, displayed "in a place of honor," was "an engraving of *The Apotheosis of Washington*," a fresco painted on the dome in the rotunda of the United States Capitol.[12]

Longfellow's grandfather had served with Washington as a general in the Continental Army and later served in Congress while Washington was president. Longfellow's aunt acquired "a lock of the late General Washington's hair" from Martha Washington herself and "the hair became a Longfellow family heirloom" that the poet "encased in a gold locket."[13]

Stephen Longfellow, the poet's father, served in Congress as a representative of Maine and once "sent his sons a fragment of cedar from the site of Washington's tomb at Mount Vernon."[14]

By the time Lossing came to visit, Longfellow had already been living in the house in Cambridge for eleven years, first as a boarder and later as its owner. He made it his business to learn everything he could about the history of his illustrious home and cherished its association with George Washington.

"The house was clearly more than just a dwelling to him," says Calhoun. "The Washington connection was a powerful one."[15] It was, "perhaps the most famous link between an American writer and an American house."[16]

"I live in a great house," Longfellow told his friend George Washington Greene soon after he moved in, "which looks like an Italian villa, have two large rooms opening into each other. They were once Gen. Washington's chambers."[17]

Longfellow so valued his special Washington connection that he spent a pretty penny to acquire a copy of the lifelike bust of Washington made by French sculptor Jean-Antoine Houdon from a plaster life mask the general himself once modeled for at Mount Vernon.

Evidence shows that Longfellow was actively engaged in collecting information about his house, then called the Craigie House. Two years after acquiring ownership, he wrote to someone whose distant relative once lived there, asking for "anything that might be interesting" about the house.

> Cambridge, June 4, 1845.
>
> My Dear Sir:
>
> Perhaps you remember some conversation we had together a year or two ago about an ancestor of yours who once occupied the Craigie House. I am now making a little record of the persons who have lived here and should be much obliged to you if you would send me some account of him; when and how long he lived here &c., —anything that might be intereseting, in short, about his residence here.
>
> Yours Very Truly,
> Henry W. Longfellow[18]

When Longfellow came to live at the Craigie House as a boarder in August 1837, one of the other residents boarding there was history professor

and future Harvard president Jared Sparks. At the time Sparks was finishing his monumental work, editing Washington's letters for publication.

"It is ten years since the papers of Washington were put in my hands," Sparks wrote on July 22, 1837, shortly before Longfellow moved in. "For the last five years I have been almost wholly devoted to it, an undertaking in magnitude and importance vastly beyond what I anticipated."[19]

Sparks had immersed himself in the project and sometimes found it overwhelming. "The entire mass of Washington's papers, amounting to forty thousand letters sent and received, is now in the room where I am writing," he complained shortly after he began.[20]

When Sparks moved into the Craigie House on April 2, 1833, he expressed his delight at the unique opportunity. "This day began to occupy Mrs. Craigie's house in Cambridge. It is a singular circumstance that while I am engaged in preparing for the press the letters of General Washington which he wrote at Cambridge after taking command of the American army, I should occupy the same rooms he did at the time."[21]

Among the "forty thousand letters" in Sparks's possession was the letter to "Mrs. Phillis" from Cambridge, February 28, 1776, in which the general extended his invitation to Phillis Wheatley: "If you should ever come to Cambridge, or near Headquarters, I shall be happy to see a person so favoured by the Muses." The letter was included in his 1837 collection, *The Writings of George Washington.*[22]

Since both Longfellow and Sparks were living in that very house in Cambridge, the two men would certainly have taken a keen interest in that letter. Is there any evidence that Longfellow knew about the letter and the Wheatley visit?

The two Harvard professors were friends and talked often. "I see Dr. Palfrey frequently, Mr. Sparks every day," Longfellow wrote.[23]

Conversation with Sparks was part of his daily routine. "In the evening I walk on the Common with Hillard or alone, then go back to Cambridge on foot," said Longfellow. "If not very late, I sit an hour with Felton or Sparks. ...[24] Sparks always makes me laugh."[25]

The two scholars discussed all manner of issues, personal and professional. "Sparks passed the evening with me," Longfellow wrote on another occasion. "We discussed the professorship of History which has been

offered to him. We all hope he will accept."[26]

They enjoyed leisurely suppers together. "Dined with Charles Amory," Longfellow wrote in his journal. "Sparks, Prescott and William Amory were present. We had a very pleasant time—literary converse, sprinkled with broken banks and broken characters."[27]

Whenever the professors got together, any topic was ripe for examination. "Tea at Mrs. Eliot's and evening with Sparks and Giles in Felton's room, discussing everything," Longfellow said.[28] One area of mutual fascination surely was the history of the house they shared.

We have testimony from Longfellow that Sparks gave him access to Washington's papers. In a letter to his father on July 5, 1841, Longfellow confessed his eagerness to dive into this amazing historical treasure trove.

> I began yesterday to read Washington's letters from Cambridge, as yesterday was the date of the first of them. He came to Cambridge July 2, 1775, took command of the army on the 3rd and wrote his first letter on the 4th. It will be very pleasant to read here in Head-Quarters the Letters he wrote sixty-six years ago, perhaps here in this very room—certainly in this very house.[29]

This primary source document puts the original letters of George Washington directly into Longfellow's hands. It seems unthinkable that Washington scholar Sparks would fail to show his friend the letter the general wrote to Phillis Wheatley so Longfellow could see for himself the historic invitation announcing the prospect that the black slave poet once stood under the same roof as the Bard of Brattle Street.

We have Washington's own words confirming that he invited Phillis Wheatley to visit him. Did she actually make it to Cambridge? And what about the particulars of the meeting?

Lossing offers several specific details: he notes the date of her visit in relation to a known historical event, the duration of the meeting, and he characterizes the behavior of the others present. These fine points could only be known by someone who was in the room at the time—in other words, an eyewitness.

We can safely assume that Lossing did not fabricate these details.

He came to Longfellow's house looking for interesting stories about the house during the time Washington spent there. Clearly, the only person who could have fed him those details was Henry Wadsworth Longfellow. If Longfellow was Lossing's source, we must ask: how was it possible for him to learn the details of an event that had occurred seventy-four years earlier?

# CHAPTER 45

*"I have been reading this morning, with much pleasure,
the new chapter of your book in Harper's New Monthly."*

BEFORE GEORGE WASHINGTON MOVED INTO the
Cambridge mansion he used as his first headquarters in the Revolutionary
War, it was home to an African-American family. In his comprehensive
2012 account of George Washington's Cambridge headquarters, historian
J. L. Bell uncovered their presence in the house and managed to identify
them.

The historical record shows that wealthy businessman John Vassall
built the Cambridge mansion on the Charles River in 1759. Shortly after
the British blockaded the port of Boston, the Loyalist Vassall family aban-
doned the house for Boston and British protection, eventually settling
in England. "When John and Elizabeth Vassall departed Cambridge in
September 1774, they left their home in the care of their enslaved servants,"
Bell writes.[1]

When Washington arrived in July 1775, the black Vassall family was
living in a house near the mansion. The Vassall slaves had been there since
long before Washington arrived. Several members of the family easily could
have witnessed the visit of Phillis Wheatley. If nobody on Washington's all-
white staff thought the appearance of a young black woman poet was sig-
nificant, surely the African-Americans who lived there would have noticed.

Bell identified them as "married couple Anthony (Tony) and Cuba,
and their children. They were all the legal property of John Vassall or his
aunt." In a revelation with significant implications for the transmission of
the Phillis Wheatley story, Bell points out that "These Vassalls maintained
a connection to Cambridge for the next several decades."[2] Details of Phillis
Wheatley's visit and other stories about the goings-on at Washington's busy
headquarters easily could have spread by word of mouth as "statements
from people who had actually been in the house in 1775-76 and remained

in greater Boston into the next generation, such as Tony and Cuba Vassall or their children," Bell says.[3]

When the Massachusetts militia commandeered the house after the Battle of Bunker Hill in June 1775, the Vassall slaves had to leave the mansion, but they didn't go far. "Tony and Cuba and their remaining family were on the properties, maintaining the gardens and fields to the best of their ability, through most of the siege of Boston," writes Bell. "They probably stayed in their usual quarters while the main houses were used as barracks, a hospital, and military headquarters."[4]

At the time of Phillis Wheatley's visit, Bell believes that "the family maintained themselves by working in parts of the Vassall estates beyond Washington's headquarters building—the outbuildings, fields, and hospital across the road. It is also possible that the Vassall family served the general but were never paid because all the men in charge perceived them as amenities that came with the house."[5]

Bell notes that "The departure of the slave-owning Vassalls had left Tony Vassall and his family in a legal limbo. They were still legally slaves, but their masters (John Vassall at least) were unwelcome in Massachusetts. That situation offered some measure of freedom."[6]

The black Vassalls had five children, including Darby Vassall, who was born in the Vassall mansion in 1769. Years later Darby Vassall became well-known in Boston as a civil rights leader and was one of the founders of the Boston African Society.

Although Darby Vassall was a young boy when George Washington lived in the house, he had vivid memories of the general. Bell relates how "Vassall probably told the story of his encounter with Gen. Washington" many times.[7] He loved to recount how "one of the first people Gen. George Washington met as he came to his new headquarters was a young boy who had been born in that house as a slave."[8]

Longfellow probably knew Darby Vassall well because of his connection to the house. The former slave was sixty-eight years old when Longfellow arrived in 1837. Longfellow wrote of one occasion when Darby Vassall returned to the house. On March 22, 1855, Longfellow noted in his diary that "old Mr. Vassall, (born a slave in this house in 1769) come to see me and stay so long."[9] His endearing reference to "old Mr. Vassall" indicates

a level of familiarity, even affection, for the elderly gentleman.

Darby Vassal was only seven in March 1776, when Phillis Wheatley was supposed to have visited, so he is not an ideal witness. His parents, Tony and Cuba, were certainly in a better position to observe her arrival. We can picture one or the other, whoever happened to be working nearby, stopping to gawk at the young black woman bounding out of her carriage and confidently marching up to the front door of the mansion to be greeted warmly by General Washington. That would have been a striking moment. Surely the utter uniqueness of it would spark their curiosity—who was that woman?

We can see how that strange sight could become a story they would eagerly share with Darby and all their children, friends, and anyone willing to listen: "Do you know who we saw? The African poet from Boston, Miss Phillis Wheatley, came to call on General Washington," they might say.

The account of Phillis Wheatley's visit to Cambridge could have been passed on through the years and become part of the lore of the house. No doubt Darby Vassall would have been happy to repeat the Phillis Wheatley story to the "proprietor" of the house. Longfellow could have learned of the Wheatley visit from Darby Vassall.

It seems clear that Lossing received his information on Wheatley by oral transmission. Most likely his source told him what he himself had been told after it had been repeated over the seventy-two years from the day it supposedly occurred in 1776 until 1848, when Lossing heard the story and wrote it down.

Traditional historians are reluctant to accept the reliability of oral narratives that come down through the years, diminishing their value as authoritative history. "They feel that written history is the only reliable base," Elinor Des Verney Sinnette writes in *The Harvard Guide to African-American History*.

> Professional historians are trained early on to trust a stable form of evidence; the document is an artifact, it is there and it repeats itself precisely. Writing leaves a fixed trace, and chronology is easy to follow. On these grounds, oral traditions often do poorly, and some scholars dismiss the evidence provided by the oral traditions as tangential.[10]

African-American history presents unique challenges. Enslaved people of African descent were systematically barred from acquiring the reading and writing skills necessary to record their own experiences, making the effort to recover their history quite problematic. But any study of African-American history based solely on the scattered and incomplete documentary evidence available does not allow us to see the whole picture. There is more to the story.

"The oral tradition not only has a long and revered history in African and African-American society but it is fundamental to understanding the African-American experience," write scholars Leslie M. Alexander and Curtis J. Austin. "The oral tradition has an ancient and illustrious history among African peoples....In fact, evidence of oral culture among West African people dates back more than seven hundred years."[11]

"Culture was transmitted through this oral tradition," says Professor Janice Hamlet. "The people's cultural mores, values, histories and religions were transmitted from generation to generation by elderly individuals known as griots."[12] As a proverb from Ghana teaches, "Ancient things remain in the ear."[13]

"Messages from the past exist, are real," writes anthropologist Jan Vansina in his groundbreaking study of the African oral tradition, "and yet are not continuously available to the senses."

> For fleeting moments they can be heard but most of the time they dwell in the minds of the people. The utterance is transitory but the memories are not. No one in oral societies doubts that memories can be faithful repositories which contain the sum total of past human experience and explain the how and why of present day conditions.[14]

Alexander and Austin conclude that "It is virtually impossible to grasp the essence of the African-American experience without utilizing and acknowledging the centrality of oral history and oral culture."[15]

Personal reminiscences recalling past events are a common tradition in many families. Children have always enjoyed hearing Grandpa and Grandma tell stories from their youth. One of Longfellow's great friends was the grandson of a member of Washington's inner circle, a man who was

on the scene in Cambridge the entire time Washington was there and who may well have been in the room for that half-hour meeting.

Henry Wadsworth Longfellow was a twenty-year-old student in France when he met G. W. Greene, beginning a friendship that would last fifty years. Greene was the grandson of Nathanael Greene, one of Washington's most trusted generals. Immediately after the Battles of Lexington and Concord, Nathanael Greene rushed to Cambridge with his Rhode Island regiment, ready to fight the British. He and his men were already in Cambridge when General Washington arrived.

General Greene was a constant presence at Washington's side and a trusted member of his Council of War. In March 1776, around the time Lossing says Phillis Wheatley came to Cambridge, Nathanael Greene was busy helping Washington plan and carry out the takeover of Dorchester Heights that would bring the Siege of Boston to an end.

Raised in a Quaker family known for their abolitionist convictions—his cousin Colonel Christopher Greene would later be killed in action leading Rhode Island's 1st Regiment, called the "Black Regiment" for its contingent of over two hundred black soldiers—Nathanael Greene would have been sympathetic to the black slave poet. Perhaps he was eager to meet Phillis Wheatley himself. It is entirely possible that General Nathanael Greene was one of Washington's officers from whom "she received marked attention."

Another possible source of the report on the Wheatley visit was Nathanael Greene's wife, Caty Greene, who was with him in Cambridge. Just weeks earlier she had given birth to her first son. General Washington was delighted when they named him George Washington Greene. It was this child who would later become the father of Longfellow's friend G. W. Greene. "Sociable" and "high-spirited," Caty Greene was Washington's "particular favorite," according to Chernow. The General "seemed enchanted by her company, and teased her good-naturedly about her 'Quaker preacher' husband."[16] As a valuable member of Martha Washington's social planning staff, it would have been natural for Caty Greene to be in the room for the Wheatley-Washington rendezvous, serving as part of the welcoming committee for their guest.

If either Nathanael Greene or Caty Greene, or maybe both, witnessed the poet and the general together for that half-hour meeting, we can see how

the story would become part of the Greene family history. Since General Greene had died twenty-five years before Longfellow's friend G.W. Greene was born, the Wheatley story could have been transmitted to him by his grandmother, Caty Greene, or by his father. When G.W. Greene heard the news that his friend had moved into the house where George Washington had his headquarters, the house where his grandfather had conferred and strategized with General Washington, the very house Phillis Wheatley came to visit, Longfellow's friend would naturally be inspired to pass along the story of the connection between Washington and the black poet.

The most powerful and persuasive argument that it was Longfellow who fed Lossing the information about Phillis Wheatley came from Longfellow himself. After he read Lossing's article describing his visit to the Longfellow House in the November 1850 issue of *Harper's New Monthly*, Longfellow dashed off an appreciative note to the author.

> To Benson John Lossing
>
> Cambridge, Nov. 1, 1850.
>
> Dear Sir:
>
> I have been reading this morning, with much pleasure, the new chapter of your book in Harper's New Monthly; and write to thank you for all the handsome things you say of me; and to make one or two suggestions which may be in season for the more permanent shape the chapter will assume in your book.[17]

Longfellow admits reading Lossing's article "with much pleasure" and thanks the author for his generous treatment. He offers "one or two suggestions" for revisions in the name of accuracy. Actually, Longfellow made five suggestions, all minor; this indicates how carefully he read the article. Longfellow had a strong incentive to scrutinize Lossing's piece closely— after all, it was about his own home. Surely he would want to see refinements made before the article appeared in a book. Longfellow even offers his own poetry: "some lines appropriate to the Washington headquarters," from his verse *To a Child:*

*Once, ah, once, within these walls,*
*One whom memory oft recalls,*
*The Father of his Country, dwelt.*
*And yonder meadows broad and damp*
*The fires of the besieging camp*
*Encircled with a burning belt.*
*Up and down these echoing stairs,*
*Heavy with the weight of cares,*
*Sounded his majestic tread;*
*Yes, within this very room*
*Sat he in those hours of gloom,*
*Weary both in heart and head.* [18]

What is most telling in his communication with Lossing is the fact that Longfellow offered not one word of objection to the Phillis Wheatley story. There were no corrections, no recommendations; he gave no indication that anything was amiss. If Longfellow disagreed with any aspect of the Wheatley report, if he believed it was unfounded, untrue, or illegitimate, we can safely assume that he would have taken the opportunity in his letter to Lossing to seek to rectify it. Instead, he said nothing.

On the subject of a Phillis Wheatley visit to Cambridge, Longfellow's silence spoke loudly. We know that Longfellow cared deeply about what happened in the house between July 1775 and April 1776, when George Washington lived there. By allowing Lossing's report on Phillis Wheatley to pass without comment, Longfellow gave his tacit approval. The practical effect of his silence was to confirm the story.

Three years later Longfellow had another opportunity to weigh in on Lossing's writing, including the segment on the Wheatley visit. After his book *The Pictorial Field-Book of the Revolution* was published, Lossing wrote to Longfellow seeking an endorsement he could use for marketing purposes. Longfellow responded with an enthusiastic blurb: "Certainly I should think '*The Pictorial Field-Book*' particularly adapted to school libraries. It could not fail to be interesting and profitable, I should say, both to instructor and pupil."[19]

The Lossing-Longfellow communication leads us to two conclusions:

1.  Lossing believed his informant's assertion that Phillis Wheatley visited George Washington at what later would become Longfellow's home and stated it confidently as fact.

2.  This did not bother Henry Wadsworth Longfellow in the slightest. He read it, as he knew many thousands of readers, present and future would, and he let it stand.

Since we have no eyewitness testimony confirming a Wheatley-Washington meeting, some historians claim the story is one more myth among many sprouting up about the Father of Our Country. But even a cursory comparison to some of the most prominent Washington whoppers—Washington chopping down a cherry tree, throwing a silver dollar across the Potomac River, and that he had wooden teeth—shows that characterizing a Wheatley-Washington meeting as simply a "myth" is unconvincing.

There exists a significant body of evidence to back up Lossing's assertions, and the most crucial piece of supporting testimony is the kind no myth can claim, the gold standard of historical authority—a primary source document. George Washington's letter to Wheatley, dated February 28, 1776, indicates that he expected Phillis Wheatley to show up in Cambridge.

Lossing's statements, coming seven decades later and flawed as they are, count as evidence, although they must be subject to critical evaluation. Are the assertions in his report possible? Are they probable? Do they conform to established facts? Is the source credible? Is there a reason to suspect that the story was shaped, fabricated, or misstated?

In considering the elusive March 1776 visit of Phillis Wheatley to Cambridge, we are bound to follow the evidence where it leads. We have Longfellow's well-established interest in Washington, his fascination with the history of the house, and his access to individuals who were in a position to know about the meeting. The accumulating circumstantial evidence, while far from conclusive, certainly points to a probable outcome: it is more likely than not that Phillis Wheatley actually did visit George Washington at Cambridge.

In addition, no affirmative evidence exists suggesting that the story was contrived, invented, or cooked up. While the lack of a conclusive verdict leaves room for speculation and doubt, there is nothing to support the claim that it is a myth.

Readers can form their own conclusions. It seems clear from the substantial body of evidence that in our quest to determine what actually happened, we owe Lossing's report serious consideration. However, we just can't say for sure.

"The conclusion must remain," says David Daly, curator at the Longfellow House—Washington's Headquarters, National Historic Site, "that the story about Wheatley and Washington meeting face-to-face cannot be taken as indisputable fact."[20]

Longfellow House historian Garrett Cloer offers some valuable perspective on the question of a possible face-to-face meeting between Phillis Wheatley and George Washington. "In the grand scheme of things, the actual visit is unimportant. It does not diminish Wheatley's career as a writer, or the accomplishment of overcoming the tragedy of her station."[21]

What we already know about the fleeting Wheatley-Washington connection enhances the reputation of both. We see the general demonstrating grace, magnanimity, and leadership, while the poet showcases her literary gifts to uplift and inspire. Her verses affected him so deeply that he wanted to meet the author in person. He took steps to make sure her poem would be shared with all Americans.

We have testimony from both Washington and Wheatley, in their very own words, proclaiming their robust esteem for each other, their passion for independence, and their appreciation for the art of poetry itself.

This much is beyond dispute. "Her work touched Washington enough to stimulate him to invite her to his headquarters," says Cloer. "Whether it was in person or over a distance, the meaning of their interaction does not change."[22]

It is most telling that at this decisive point in American history, with the embryonic nation about to emerge from the throes of violent and bloody convulsions, Phillis Wheatley and George Washington began the campaign by reaching out to each other. For a brief moment, these two immortal luminaries, a slave-owner and a slave, a general and a poet, a Founding Father and a Founding Mother, came together to forge an unlikely bond as new Americans, united in the hope of a nation born in freedom.

Phillis Wheatley and George Washington were in accord; both saw the fight against Britain as a noble American stand for freedom. Did they hold

each other in high regard? Yes. Did they communicate? Yes. Did they meet face to face? Considering all the evidence, we can accept the assessment of Ron Chernow: "Washington appears to have received Phillis Wheatley at his Cambridge headquarters."[23]

# VI. Boston 1776 – 1784

*Seated with angels in that blissful place,*
*Where she now joins in her Creator's praise,*
*Where harmony with louder notes is swell'd*
*Where her soft numbers only are excell'd.*
*But O! how vain the wish that friendship*
*pays,*
*Since her own volumes are her greatest*
*praise.*

~ "Elegy on the Death of a Late Celebrated Poetess" by
Anonymous, December 1784

# CHAPTER 46

*"The bells of the town were rung on the occasion and festivity cheered and brightened every face."*

"GREAT PREPARATIONS ARE MAKING IN our army for some important event," Continental Army medic Dr. James Thacher wrote in late February 1776, right around the time General Washington sent his letter to Phillis Wheatley.

The crowded Cambridge garrison came alive. Something big was coming. "Several regiments of militia have arrived from the country," Dr. Thacher reported. "Great activity and animation are observed among our officers and soldiers who manifest an anxious desire to have a conflict with the enemy."

An ominous sign was the urgent call for medics to expect mass casualties. "Orders have been received for surgeons and mates to prepare lint and bandages to the amount of two thousand for fractured limbs and other gunshot wounds," Dr. Thacher said.

Speculation was rampant. Like everyone else in Cambridge, James Thacher sensed what was about to happen. "Either a general assault on the town of Boston or the erection of works on the Heights of Dorchester, or both is generally supposed to be in contemplation."[1]

Washington and his generals devised a daring plan to occupy Dorchester Heights in a single night, taking control of the high ground before the British knew what happened. Key to the strategy was an aggressive bombing campaign targeting British positions in Boston. This would serve as a distraction so the rebels could construct fortifications and move their artillery into position under the cover of darkness.

Late on March 2, 1776, bombs began raining down on Boston. "About 11 o'clock at night, upon a signal being given at Cambridge, the rebels began to bombard the town of Boston," wrote British Lieutenant John Barker. "They continued throwing in shot and shells 'till daybreak."[2]

Abigail Adams wrote about it from her home in Boston. "The house this instant shakes with the roar of cannon. I have been to the door and find tis a cannonade from our Army." Wearily she concluded, "No sleep for me tonight."[3]

On March 3, Boston merchant John Rowe described the destruction he saw in his city. "This night the people from the battery at Phipps Farm threw many shells into town which put the inhabitants into great fear and they have done damage to many houses."[4]

"I went to bed after 12 but got no rest," Abigail Adams complained the next day. "The cannon continued firing and my heart beat pace with them all night. We have had a pretty quiet day, but what tomorrow will bring forth God only knows."[5]

The third night brought more artillery fire. Timothy Newell wrote on March 4, "Monday, soon after candle light, came on a most terrible bombardment and cannonade, on both sides, as if heaven and earth were engaged."[6]

That night Abigail Adams wrote, "I have been sitting to hear the amazing roar of cannon and from whence I could see every shell which was been thrown." Knowing that the barrage came courtesy of the Continental Army thrilled her deeply. "The sound I think is one of the grandest in nature and is of the true species of the sublime. Tis now an incessant roar."[7]

John Rowe noted the toll from the rebel assault. "All the proceeding night the town has been fired at by people from without from every quarter....The guns from Cobble Hill on Charlestown side have thrown these shots the farthest into town. One of them struck Wheatley's in King Street."[8]

The Wheatley mansion was badly damaged "by bombs accidentally lobbed across the bay by American soldiers," says William Robinson. The house was vacant at the time, he pointed out. "Phillis was not in the Wheatley place on King Street."[9]

The third night of bombing, when "the roar of the guns from both sides became more furious by far," was the most crucial night of the campaign, according to David McCullough.[10] On that night, March 4, the main action was taking place on Dorchester Heights.

"The men toiled steadily with picks and shovels, breaking the frozen ground for earth and stone to fill the chandeliers and barrels," writes

McCullough. "By the first faint light before dawn, everything was ready, with at least 20 cannon in place. It was an utterly phenomenal achievement."[11]

An American general later wrote, "Perhaps there never was so much work done in so short a space of time."[12]

As the troops transformed the hills above Boston into a battery of lethal weapons, General Washington exhorted his troops by recalling the martyrs of their Glorious Cause. "Remember it is the fifth of March and avenge the death of your brethren," he said, reminding his men of the Boston Massacre.[13]

"It was immediately asked what the general said by those that were not near enough to hear," one of his men recalled. Washington's message was passed along, "from one to another through all the troops, which added fresh fuel to the martial fire."[14]

At dawn on March 5, British commanders looked toward the Heights and could hardly believe their eyes. Washington's strategy counted on the element of surprise and it worked perfectly. One British officer was so stunned he thought the sudden appearance of a threat so close was due to magic. "This morning, at day break, we discovered two redoubts on the hills of Dorchester Point and two smaller works on their flanks. They were all raised during the night, with an expedition equal to that of the genie belonging to Aladdin's wonderful lamp."

The strategic significance of this development was glaring and ominous. "From these hills they command the whole town, so that we must drive them from their post or desert the place," the officer said.[15]

General Howe was dumbfounded. "I know not what I shall do," he remarked. "The rebels have done more in one night than my whole army would have done in weeks."[16]

With this audacious move by Washington and the Continental Army, the British occupation of Boston was clearly endangered, and General Howe knew it. "His admirals soon assured him that if the rebels were permitted to hold possession, he should not be able to keep a single ship in the harbor in safety," Thacher said.[17]

"'Tis now out of doubt that Gen. Howe will leave this town with his troops which has put the inhabitants of this town into great disorder, confusion and much distress," John Rowe wrote on March 6. The next day he

observed "The troops and inhabitants very busy in getting all the goods and effects on board the shipping in the harbor." Two days later, he described a city in near panic. "Nothing but hurry and confusion, every person striving to get out of this place."[18]

On March 8, Washington received an urgent message from the Selectmen of Boston, the town's governing board. "His Excellency General Howe is determined to leave the town with the troops under his command," they told Washington. The Selectmen assured Washington that Howe "has no intention of destroying the town unless the troops under his command are molested during their embarkation, or at their departure by the armed force without." They wanted Washington to know that "if such an opposition should take place we have the greatest reason to expect the town will be exposed to entire destruction."

The leaders of Boston, "being very anxious for its preservation & safety" implored General Washington to stand down. "We beg we may have some assurances that so dreadful a calamity may not be brought on by any measures without."[19]

The next day Washington wrote to Continental Congress President John Hancock to share the latest developments from Boston. "Our bombardment and cannonade caused a good deal of surprise and alarm in town as many of the soldiery said they never heard or thought we had mortars or shells," the general reported. "They made much distress and confusion."

Washington informed Hancock that "the Army is preparing to leave Boston and that they will do it in a day or two" and that "the transports necessary for their embarkation were getting ready with the utmost expedition."

Washington's spies in Boston described "great movements & confusion among the troops the night & day preceding." The British were "hurrying down their cannon, artillery & other stores to the wharfs with the utmost precipitation, and were putting em on board the ships in such haste that no account or memorandum was taken of them."[20]

It was the first great victory for the Americans. Boston was liberated without a battle. "So there it was," says David McCullough. "The widespread apprehension that the British Army was invincible had just been disproved."[21]

During those twelve days from March 5 to March 17, when the British finally departed, General Washington and his men watched the harried scene play out as the enemy beat their hasty retreat from Boston, loading military supplies and weaponry aboard their ships. Since General Howe invited Loyalists and their families to evacuate as well, hundreds of civilians carried their personal belongings and household furniture, anything they could salvage, onto the transports.

"The entire waterfront of Boston lay open to our observation and we saw the embarkation of troops from the various wharves," an exultant American soldier wrote from his perch atop Dorchester Heights. "We were in high spirits."[22]

The entire Continental Army could breathe a sigh of relief as the expected British counterassault never materialized. Instead, they were preparing to sail away.

That was the situation in Cambridge at the time Phillis Wheatley arrived to visit General Washington, as Lossing reported, "a few days before the British evacuated Boston."[23]

Dr. Thacher described the feeling among the Americans as they realized the British were going. "Nothing of consequence occurred to observation till Sunday morning, March 17th when at an early hour it was perceived that the Royal army commenced their embarkation on board of transports. In the course of the forenoon we enjoyed the unspeakable satisfaction of beholding their whole fleet under sail, wafting from our shores the dreadful scourge of war."[24]

Timothy Newell noted in his diary on March 17, 1776: "Lord's Day. This morning at 3 o'clock the troops began to move....They all embarked about 9 o'clock and the whole fleet came to sail. Every vessel they did not carry off they rendered unfit for use."[25]

That day Abigail Adams wrote to her husband John: "We have a view of the largest fleet ever seen in America. You may count upwards of 100 & 70 Sail. They look like a forrest."[26]

"This was an unhappy and distressed town," Selectman Newell wrote, "relieved from a set of men whose unparalleled wickedness, profanity, debauchery and cruelty is inexpressible, enduring a siege for April 19, 1775 to March 17, 1776."[27]

"Many people are elated with their quitting Boston," said Abigail Adams. "I feel glad however that Boston is not destroyed." She remained hopeful that things would soon return to normal. "Our people I hear will have liberty to enter Boston."[28]

Over the next several days, many of Boston's citizens came home after months living as refugees. "Numbers of people belonging to Boston are daily coming in," said Rowe.[29]

Dr. Thacher entered Boston with the Continental Army troops and described the emotional scene. "People from the country are crowding into town, full of friendly solicitude....

> It is truly interesting to witness the tender interviews and fond embraces of those who have been long separated....While marching through the streets, the inhabitants appeared at their doors and windows. Though they manifested a lively joy on being liberated from a long imprisonment, they were not altogether free from a melancholy gloom which ten tedious months' siege has spread over their countenances.[30]

Later he explored the town, heartbroken at the wanton destruction he saw. "I went to view the Old South Church, a spacious brick building near the center of town. It has been for more than a century consecrated to the service of religion and many eminent divines have in its pulpit labored in teaching the ways of righteousness and truth."

> But during the late siege the inside of it was entirely destroyed by the British and the sacred building occupied by a riding school for Burgoyne's regiment of dragoons. The pulpit and pews were removed, the floor covered with earth, and used for the purpose of training and exercising their horses. A beautiful pew, ornamented with carved work and silk furniture was demolished.[31]

Boston was decimated. Nearly every tree was cut down for firewood, including the storied elm at the corner of Essex and Orange Streets known as the Liberty Tree. More than a hundred houses were dismantled. Barns, unused wharves, old ships, almost anything that could burn had been

chopped up and used for fuel. Reverend John Lathrop's Old North Church was demolished for firewood.

"After the evacuation of Boston by the British troops, Phillis returned thither," Oddell reported.[32]

We don't know exactly when, but "eventually John Wheatley, Phillis, and the Lathrops returned to Boston," Mason writes, joining thousands of displaced Bostonians eager to go home.[33]

Phillis was back in Boston four months later. Perhaps she was mingling with the crowd in the plaza in front of the Town House on King Street, around the corner from the Wheatley home, to witness the historic occasion of the first public reading of the Declaration of Independence, which had just arrived from the Continental Congress in Philadelphia.

It was July 18, 1776, and John Rowe made a note of it in his diary: "This day independency was declared in Boston from the balcony of the council Chamber."[34]

*The Continental Journal and Weekly Advertiser* reported on July 25, 1776:

> Thursday last, pursuant to the orders of the honourable Council, was proclaimed from the Balcony of the State House in this town the DECLARATION of the AMERICAN CONGRESS, absolving the United States from the allegiance to the British Crown and declaring them FREE and INDEPENDENT STATES.[35]

"The Declaration of Independence was read by William Greenleaf, my father, then sheriff," Daniel Greenleaf recalled years later.[36]

From *The Continental Journal and Weekly Advertiser:*

> At one o'clock the Declaration was proclaimed by the Sheriff of the County of Suffolk, which was received with great joy, expressed by three Huzzas from a great concourse of the people assembled on the occasion.[37]

Sheriff Greenleaf's son added a striking detail, one that would surely stand out in the memory of those present. "As his voice was rather weak he requested Colonel Crafts to act as his herald," he wrote. The artillery

regiment under Colonel Crafts' command was arrayed in the street below the Town House balcony, along with other military units. "As sheriff," notes Bell, Greenleaf "did indeed have the duty of reading important proclamations," but apparently he "needed Craft's stentorian help."[38]

So the two men read the Declaration of Independence in turn. "They stood together at the front of the balcony," said the younger Greenleaf. "My father read a sentence which was immediately repeated by Crafts, and so continued to the end when was the huzza."[39]

Immediately after the reading concluded, the celebration began. "On a signal given, thirteen pieces of cannon were fired," according to *The Continental Journal and Weekly Advertiser.* "Then the detachment of artillery fired their cannon thirteen times."

Thirteen shots from thirteen guns. The newspaper explained the symbolism, but by then everyone there already knew it. "These firings corresponded to the number of American states united."[40]

It is likely that all of Boston was present for the momentous occasion, including the twenty-three-year-old poet who lived just around the corner and whose writings condemned British tyranny. After more than a decade of civil unrest, protest marches, riots, armed skirmishes, a bloody massacre, and a military occupation that forced them to flee their homes, the city of Boston could now relish the joy of freedom.

"The bells of the town were rung on the occasion," the newspaper reported, "and undissembled festivity cheered and brightened every face."[41]

For the poet who believed with a passion that "In every human breast God has implanted a principle, which we call Love of Freedom," it would have been a moment she could cherish.[42]

# CHAPTER 47

## "The following thoughts on his Excellency Major General Lee being betray'd into the hands of the enemy..."

"WHEATLEY WAS BACK IN BOSTON by the end of 1776," Professor Carretta says, "probably living again with John Wheatley."[1]

Late in December she got wind of some rather discouraging news from the wartime grapevine: General Washington's second-in-command, General Charles Lee, had been captured by British troops. It was a serious setback for the Americans. Phillis was moved to compose her first poem since her majestic tribute to General Washington fourteen months earlier. According to her handwritten manuscript, she finished *On the Capture of General Lee* on December 30, 1776 in Boston.[2]

Washington's generals were well known in New England. As the Continental Army was gathering in Cambridge, the entire region eagerly awaited news of an impending move against the British that would be led by the generals.

In December 1775 Washington had sent General Lee to Rhode Island to shore up the defense of Newport, a Tory stronghold. Reverend Ezra Stiles, pastor of the Second Congregational Church in Newport, met General Lee and was impressed by his revolutionary spirit. "General Leigh passed through this town to Boston last week. He is European but talks high for American liberty, and seems to endeavor to enspirit the people to take arms. He says the king is a fool & his ministers rogues & villains."[3]

Phillis Wheatley was in Providence at the time and may have heard the news about General Lee from her friends in Newport.

*On the Capture of General Lee* gave Phillis Wheatley another opportunity to declare her support for the American cause. Once again the poet hailed General Washington, this time in a fictionalized narrative depicting the unfortunate seizure of a Continental Army general. She opened the poem with a prayer for the success of America's hopes.

*O friend belov'd! may heaven its aid afford,*
*And spread yon troops beneath thy conquering sword!*
*Grant to America's united prayer*
*A glorious conquest on the field of war.*[4]

Wheatley drew on her imagination to describe the moment Lee was cornered by British forces. "The deed perfidious" was "the Hero's fate," she wrote. Fabricating dialogue between General Lee and his captors, Phillis portrayed him as a noble warrior who boldly proclaimed America's unassailable righteousness while condemning his foes as morally bankrupt.

*Great as thou art, thou shun'st the field of fame*
*Disgrace to Brittain, and the British name!*
*When offer'd combat by the noble foe,*
*(Foe to mis-rule,) why did thy sword forgo*
*The easy conquest of the rebel-land?*
*Perhaps too easy for thy martial hand.*
*What various causes to the field invite!*
*For plunder you, and we for freedom fight:*
*Her cause divine with generous ardor fires,*
*And every bosom glows as she inspires!*[5]

She closed with a glorious salute to the commander-in-chief, the virtuous, "Godlike" Washington, in an eloquent speech delivered by her imagined General Charles Lee.

*Yet those brave troops innum'rous as the sands*
*One soul inspires, one General Chief commands*
*Find in your train of boasted heroes, one*
*To match the praise of Godlike Washington.*
*Thrice happy Chief! in whom the virtues join,*
*And heaven-taught prudence speaks the man divine!*[6]

Getting her poems into print was more difficult, now that the dedicated Susanna Wheatley was no longer around to serve as Phillis's literary agent. Always looking to find ways to publish, Phillis used whatever connections were available to her. Fortunately she sent her manuscript to

longtime supporter James Bowdoin, one of the eighteen signers of her 1772 "Attestation" and author of the poem *A Rebus* which she followed with her own *An Answer to the Rebus,* both of which appeared in her 1773 book. At the time, James Bowdoin, as president of the Massachusetts Provincial Congress, was defacto head of the Massachusetts government.

Phillis sent her poem to Bowdoin hoping he would arrange for its publication. In her cover letter she wrote:

> The following thoughts on his Excellency Major General Lee being betray'd into the hands of the enemy by the treachery of a pretended friend; to the Honourable James Bowdoin Esqr. Are most respectfully inscripb'd by his most obedient and devoted humble servant, Phillis Wheatley[7]

*On the Capture of General Lee* was not published during her lifetime. It was the only Phillis Wheatley poem to be purposely suppressed—and for good reason. "Bowdoin," says Robinson, "more aware of Lee's genuine feelings than Phillis, kept the manuscript among his papers and out of public print, thereby sparing Phillis considerable embarrassment."[8]

As Phillis was composing her General Lee-inspired-poem, she had no idea how wrong she was about his character. She knew nothing about his deep-seated disdain for Washington or his unsavory efforts to undermine Washington's authority. She had no way to know the dreadful story behind his capture. It is not known whether she ever learned that two years later he would be court-martialed and removed from the military. Even his contemporaries never knew the extent of his treachery in betraying the American cause.

The Charles Lee of her poem was a literary invention. Phillis Wheatley created the fictional character as a mouthpiece to articulate her intense patriotic feelings. Her fabricated General Lee was so far removed from reality that we can imagine James Bowdoin cringing as he read her extravagant praise.

Charles Lee was born in England to a military family. He fought for the British in the French and Indian War along with Virginia's Colonel Washington and British Lieutenant Colonel Thomas Gage and was wounded on American soil. In 1755, he married a Seneca woman, the daughter of the chief, and was adopted into the Mohawk tribe. They

gave him a name to suit his temperament, "Ounawaterika," which means "Boiling Water."[9]

After the British victory over the French in 1763, Lee's military adventures led him to Portugal where he served with British General John Burgoyne to help the Portuguese army repel an invasion by Spain. For that service Lee was promoted to Major General by the king of Portugal. In 1765 he fought in Poland and became a military advisor to King Stanislaus in the Russo-Turkish War.

"In October 1773, Lee landed in Philadelphia, carrying a letter of recommendation from Benjamin Franklin," says J. L. Bell.[10]

After the fighting at Lexington and Concord, General Lee offered his military services to the rebels. His extensive military experience was so well known that his campaign to lead the American military received serious consideration. "Of the viable alternatives to George Washington, Charles Lee presented the strongest credentials in 1775," writes Lee's biographer, Dominick Mazzagetti.[11]

"Many people thought he was the greatest expert on military affairs in the American colonies," says Bell.[12]

"Charles Lee possessed a gift," Mazzagetti explains. "Some might call Lee's gift 'charm,'" he added, admitting that "Lee was anything but a charming person."[13]

But his brash manner and seemingly endless font of knowledge generated a certain appealing charisma. "Influential men were drawn to him," says Mazzagetti. "He had traveled extensively in Europe, spoke several languages, and the apparent confidence of kings."[14]

In May 1775 the *Pennsylvania Journal* called him "a gentleman whose steady attachment to the rights of human nature, and to the principles of the British constitution in particular, hath endeared him to all the colonies."[15]

During the Siege of Boston, Colonel William Thompson of Pennsylvania wrote: "I am every day more pleased with General Lee. Our country owes much to him; and happy we are that a man of his great knowledge assists in the command of our army."[16]

"General Lee is a perfect original," wrote Dr. Jeremy Belknap, "a good scholar and soldier and an odd genius full of fire and passion."[17]

Lee consulted regularly with leaders of the new American Revolution, who he counted among his friends —John Hancock, John Adams, Samuel

Adams, Benjamin Franklin, Benjamin Rush, Richard Henry Lee, and Thomas Paine.

"We want you at N. York. We want you at Cambridge. We want you in Virginia!" John Adams gushed.[18]

After Washington was chosen as commander-in-chief, Lee was named major general, his second-in-command. Although he was highly regarded as a military strategist, Lee had his flaws. He was highly opinionated, headstrong, egotistical, and coarse. Lee never overcame his resentment of George Washington and was constantly scheming to force his resignation so he could take over. Lee complained to his colleagues that Washington was "not fit to command a sergeant's guard."[19]

Phillis Wheatley had no inkling of any of this when she heard that General Lee was captured on December 13, 1776. The notorious "fog of war" obscured what really happened. It was a sordid affair that turned out to be disastrous for the young Continental Army. General Charles Lee held the ignominious honor of being the highest-ranking American officer to be captured by the enemy until World War II.

James Bowdoin had been informed of Lee's capture by George Washington himself two weeks before he read Phillis Wheatley's *On the Capture of General Lee.* As head of the Massachusetts government, Bowdoin was one of Washington's regular correspondents—during the war they exchanged at least forty letters. On December 18, Washington wrote to Bowdoin explaining how General Lee was captured. "Unhappily, on Friday last, the Genl having left his division and proceeded on the flanks, three or four miles nearer the enemy, then 18 miles from him, of which they were informed by some Tories, was surprised and carried off about eleven o'clock by a party of seventy light horse."

Because Bowdoin was a public official, Washington had to be circumspect in his report on the incident. "I will not comment upon this unhappy accident," he said, adding tactfully that "I feel much for his misfortune, and am sensible that in his captivity, our country has lost a warm friend and an able officer."[20]

Washington's letter to his brother that same day was more revealing. "You will no doubt have heard of the captivity of Genl Lee....He was taken,

going three miles out of his own camp for the sake of a little better lodging & within 20 of the enemy. A rascally Tory gave information in the night and a party of light horse in the morning seiz'd and carried him off with every mark of triumph and indignity."

He could barely conceal his disgust with General Lee. "This is an additional misfortune, and the more vexatious as it was the effect of folly & imprudence without a view to answer any good."[21]

In his biography of Washington, Ron Chernow, uncovered new details exposing what really happened on the night of December 12, 1776. General Lee "spent the night at an inn near Basking Ridge, New Jersey, enjoying the company of a woman of easy virtue," says Chernow. After local Tories informed the British of the general's whereabouts, the inn was surrounded by British cavalry in the early hours of the morning. "Lee surrendered in slippers and a filthy shirt to the derisory cheers of his captors," Chernow writes. "To make his degradation complete, the British didn't allow him to don a coat or a hat in the wintry weather."[22]

Eighteen months later, on June 28, 1778, Lee experienced a soldier's ultimate disgrace. An enraged General Washington relieved him of his command in front of his troops during the Battle of Monmouth. After Washington ordered an attack, he saw Lee's men retreating instead. The Battle of Monmouth was a victory for the Americans—no thanks to General Lee.

It was not until 1858 that the full depth of his treachery was revealed. An eight page letter to British General William Howe in Charles Lee's handwriting turned up at the New York Historical Society. Written on March 29, 1777, while still in British custody, Charles Lee composed a detailed plan designed to defeat the Americans. The British released General Lee in May 1778, and he rejoined Washington at Valley Forge, a month before the Battle of Monmouth.

Of course in December 1776, when Phillis Wheatley composed her poem celebrating someone she thought was a patriot, the insubordination of Charles Lee, his dishonorable discharge from the military, and his shameful treason, remained for the great future to uncover. But even at the time of Lee's capture, James Bowdoin probably sensed that Lee was untrustworthy and a first class scoundrel. That would be reason enough for him to

stash Phillis Wheatley's mistaken tribute in a drawer in a valiant effort to protect her reputation.

The poem remained hidden for decades. *On the Capture of General Lee* was discovered among Bowdoin's papers and published in 1863 by the Massachusetts Historical Society.

Although Phillis Wheatley was wildly off-base in her misguided glorification of such a controversial figure, she was not the only one of his contemporaries who became infatuated with Charles Lee. The most significant and influential American to offer honor and praise for Lee was his nemesis, George Washington himself. In early March 1776, days before the end of the Siege of Boston, Washington dispatched General Lee to Charleston, South Carolina to prevent a British takeover of that important southern port. "He is the first officer in military knowledge and experience we have in the whole Army," he told his brother. "He is zealously attached to the cause."[23]

On June 28 the British sent their fleet of more than fifty ships, including two fifty-gun warships and over two thousand troops into battle against Fort Sullivan protecting Charleston Harbor. The Americans successfully thwarted the attack. "The defense of Charleston, South Carolina represents the high point in Lee's career as an American soldier," says Mazzagetti.[24]

When Lee rejoined Washington's army in New York in October 1776, the commander-in-chief was happy to have his help. At the time, General Washington was desperate to keep control of the strategically important Hudson River. General Lee realized how crucial it was to prevent the British navy from being able to navigate freely up and down the Hudson. "Whoever commands the sea commands the town," he wrote.[25]

The Americans built forts on the bluffs overlooking the river on both sides, Fort Washington in New York and Fort Constitution in New Jersey. "Washington well knew the quirks and vanity of his old military friend and was glad to have him back," writes McCullough. "As a gesture of appreciation, he gave Fort Constitution a new name, Fort Lee."[26]

In 1904, when the borough of Fort Lee was incorporated by the state of New Jersey, nobody raised any objections. Today Fort Lee stands proudly atop the majestic cliffs of the Palisades, connected to New York City by the

George Washington Bridge, the busiest bridge in the world, notorious for its traffic jams.

In a review of Mazzagetti's biography of Charles Lee, the *Star-Ledger*, New Jersey's largest newspaper, speculates that "Perhaps residents of Fort Lee would petition to change their municipality's name if they were more familiar with the treacherous behavior of the Revolutionary War figure whose legacy they bear."[27]

Although she lionized Charles Lee, unwittingly fabricating the virtues of a man history showed to be utterly undeserving, Phillis Wheatley had plenty of company.

# CHAPTER 48

*"Pray be so good as put the enclosed into the hands of the celebrated Phillis the African Favorite of the Nine and of Apollo."*

LATE IN 1777 PHILLIS WHEATLEY had an opportunity to connect with another one of the heroes of the American Revolution. Captain John Paul Jones, leader of the newly-founded Continental Navy, reached out to "Phillis, the African Favorite of the Nine and of Apollo," whose book and separately published poems made her widely known throughout the English-speaking world.[1] Captain Jones sent her some of his own poetry along with a letter.

Two years later, John Paul Jones earned his status as a military icon in "one of the great battles in American naval history," according to Revolutionary War historian Robert Middlekauff.[2] On September 23, 1779, Captain Jones, commanding the forty-two-gun *Bon Homme Richard*, flagship of the Navy's first fleet, faced off against the fifty-gun British frigate *HMS Serapis* just off England's Yorkshire coast. Hours into the moonlight battle between the gunships, the *Richard* was aflame and filling with water. The crew had suffered heavy losses and some of his men begged Captain Jones to give up. The captain of the *Serapis* called to the *Bon Homme Richard* demanding surrender. Captain John Paul Jones responded with what became an enduring emblem of American audacity and courage. He hollered back, "I have not yet begun to fight!"[3]

John Paul Jones was in Boston in December 1776 commanding the *USS Ranger*, one of the first warships made in America, and he remained in Boston for the next fourteen months. During that time he was introduced to the poems of Phillis Wheatley—someone probably gave him a copy of her book. Perhaps they met. If Captain Jones wanted to find the acclaimed African poet in the town of Boston, it would not have been hard.

Before leaving Boston for France on November 1, 1777, he addressed a note to Phillis and made a point of including some of his own original poems. He passed his message to a fellow officer with instructions for delivery. "I am on the point of sailing," he wrote to his colleague. "Pray be so good as put the enclosed into the hands of the celebrated Phillis the African Favorite of the Nine and of Apollo." Like any striving poet, Captain John Paul Jones desired feedback on his verses from a prominent literary figure. He was hoping the African poet would read his work and favor him with her assessment. "Should she reply," he instructed his friend, "I hope you will be the bearer."[4]

The poems Captain Jones was eager for Phillis to read, as well as his letter, have been lost. Phillis would have been honored and flattered to receive a request for her literary judgment from such a distinguished American military figure. Whatever Phillis Wheatley wrote back to John Paul Jones has never been found.

From the way Jones addressed his note to "the celebrated Phillis the African," we gather that she needed no further description—she was that well-known in Boston. Phillis Wheatley was particularly eminent in the black community. "Phillis's colonial contemporaries included a surprising number of literate blacks, several of whom read and wrote French, Latin and Greek," William Robinson notes. Because of their limited access to publication opportunities, hardly any written reference to Phillis Wheatley by an African-American exists. "Most of them were at first otherwise too preoccupied to comment on the Boston slave poetess," he says.[5] "If early American blacks did not mention Phillis often in their writings, they were certainly aware and proud of her."[6]

The first person of African descent to publicly acknowledge the poetry of Phillis Wheatley was Jupiter Hammon. Born into servitude in 1711, he was the property of the wealthy Lloyd family on Long Island, New York and lived his whole life as a slave. The Lloyds sent Jupiter Hammon to school, where he was taught to read the scriptures.

Like Phillis Wheatley, Jupiter Hammon "was a beneficiary of the Great Awakening, with its Protestant emphases on the need for literacy because of the primacy of the Bible, on the need for spiritual self-reflection and self-assessment, and on the Christian duty to evangelize to white as well as black audiences," writes Vincent Carretta.[7]

It was Jupiter Hammon who became the first black poet published in America. His poem appeared as a broadside in 1760, a year before the Middle Passage brought Phillis Wheatley to Boston. *An Evening Thought: Salvation by Christ with Penitential Cries,* a reflection on devotion, opens with a heartfelt prayer:

> *Salvation comes by Jesus Christ alone,*
> *The only Son of God;*
> *Redemption now to every one,*
> *That love his holy Word.*[8]

His 1786 essay *An Address To The Negroes Of The State Of New York* was widely published in New York newspapers. Here Hammon expressed the viewpoint of an elderly Christian slave who believed that servitude was God's will. "Let me beg of you my dear African brethren," Jupiter Hammon advised his fellow captives, "think very little of your bondage in this life; for your thinking of it will do you no good. If God designs to set us free, he will do it in his own time and way."

Hammon saw no blame or condemnation for those whose earthly lives were bound in servitude. "If we should ever get to Heaven," he wrote, "we shall find nobody to reproach us for being black or for being slaves."[9]

In 2013 a previously unknown poem by Jupiter Hammon was found buried among documents at the Yale University Library. "For a 200-plus-year-old manuscript, it was in perfect condition," says Professor Cedrick May, whose University of Texas at Arlington graduate student made the stunning discovery. "I took one look at it and I said, 'This looks pretty authentic.' It's either a great hoax or this is the real deal. This is a poem that we've never seen before."[10]

The poem, dated 1786, was written at nearly the same time as Hammon's *Address to the Negroes of the State of New York,* which counsels the acceptance of slavery. This newly discovered poem shows a very different view. Hammon writes with forceful antislavery passion that white folks, including the Lloyds, would have seen as inflammatory. In this poem, Jupiter Hammon clearly censures the institution of slavery as an immoral affront to God's Will brought about by man's colossal arrogance.

*Dark and dismal was the Day*
*when slavery began;*
*All humble thoughts were put away;*
*Then slaves were made by Man.*[11]

Hammon's poem was never published. "I think Jupiter Hammon's masters thought they were going to keep that out of the public eye and they put [the poem] away," Professor May says. The Lloyds, who maintained complete control over the fruits of Jupiter Hammon's labors, whether physical or artistic, chose to suppress the poem—but they did not destroy it.

"This is an important discovery for three reasons," says Sandra Gustafson, editor of *Early American Literature*. "It expands the very small number of known works by enslaved African Americans written in the 18th century. The poem voices a strong, direct critique of slavery. And it shows Hammon's ongoing poetic dialogue with Phillis Wheatley on matters of Christian faith and social justice."[12]

In August 1778 Jupiter Hammon's poem *An Address to Miss Phillis Wheatly, Ethiopian Poetess, in Boston, who came from Africa at eight years of age, and soon became acquainted with the gospel of Jesus Christ* was published as a broadside in Hartford, Connecticut.

The poem came with a comment drawing attention to its significance. "Composed by Jupiter Hammon, a Negro man belonging to Mr. Joseph Lloyd of Queen's Village on Long Island, now in Hartford," readers learned, "the above lines are published by the author and a number of his friends, who desire to join with him in their best regards to Miss Wheatly."[13]

Jupiter Hammon addressed his lovely and gracious salutation to Phillis Wheatley directly. "Miss Wheatly; pray give leave to express as follows..."

*O, come you pious youth: adore*
*The wisdom of thy God.*
*In bringing thee from distant shore,*
*To learn His holy word.*

*Thou mightst been left behind,*
*Amidst a dark abode;*
*God's tender Mercy still combin'd,*
*Thou hast the holy word....*

*God's tender mercy brought thee here,*
*tost o'er the raging main;*
*In Christian faith thou hast a share,*
*Worth all the gold of Spain.*

*While thousands tossed by the sea,*
*And others settled down,*
*God's tender mercy set thee free,*
*From dangers still unknown.*

*That thou a pattern still might be,*
*To youth of Boston town,*
*The blessed Jesus set thee free,*
*From every sinful wound.*

*Come you, Phillis, now aspire,*
*And seek the living God,*
*So step by step thou mayst go higher,*
*Till perfect in the word.*

*While thousands mov'd to distant shore,*
*And others left behind,*
*The blessed Jesus still adore,*
*Implant this in thy mind.*

*Thou hast left the heathen shore;*
*Thro' mercy of the Lord,*
*Among the heathen live no more,*
*Come magnify thy God.*

*I pray the living God may be,*
*The sheperd of thy soul;*
*His tender mercies still are free,*
*His mysteries to unfold.*

*Thou, Phillis, when thou hunger hast,*
*Or pantest for thy God;*
*Jesus Christ is thy relief,*
*Thou hast the holy word...*

*These bounteous mercies are from God,*
*The merits of his Son;*
*The humble soul that loves his word,*
*He chooses for his own.*

*Come, dear Phillis, be advis'd,*
*To drink Samaria's flood;*
*There nothing is that shall suffice,*
*But Christ's redeeming blood.*

*When thousands muse with earthly toys,*
*And range about the street,*
*Dear Phillis, seek for heaven's joys,*
*Where we do hope to meet.*[14]

Also appearing in 1760 was a fourteen page pamphlet with the ungainly title: *A Narrative of the Uncommon Sufferings and Surprizing Deliverance of Briton Hammon, A Negro Man, Servant to General Winslow of Marshfield in New England; Who Returned to Boston After Having Been Absent Almost Thirteen Years.* It was the first slave narrative by an African-American writer. The only information we have about the author, Briton Hammon (no relation to Jupiter Hammon), is contained in his short narrative.

In 1782 the first deeply personal response to Phillis Wheatley written by a native African and former slave was published. *The Letters of the Late Ignatius Sancho, an African* appeared in London after his death in 1780. The book contained 160 letters, including one to an American friend describing his reaction to reading Phillis Wheatley's poems.

Ignatius Sancho was born on a slave ship crossing the Atlantic from Africa to the West Indies in 1729. Taken to England as a child, he became the property of the wealthy Duke of Montagu of Greenwich. The young slave displayed such keen intellect that his master encouraged his reading, supplying him with books in much the same way the Wheatleys supported education for Phillis. He became the Montagu's butler in London where he had the opportunity to immerse himself in literature, music, theater and poetry.

In 1768, Ignatius Sancho became the only African whose portrait was painted by Thomas Gainsborough, the greatest British artist. Sancho was

celebrated as the first person of African descent to vote in a British election. When his collection of letters came out in 1782 it became a best seller.

In his letter to Jabez Fisher, a Quaker of Philadelphia, Sancho writes movingly of his appreciation for Phillis Wheatley. Fisher had sent Sancho several books by antislavery writers, such as Anthony Benezet and Granville Sharp, and included a copy of Phillis Wheatley's 1773 *Poems on Various Subjects, Religious and Moral*. Sancho wrote to Fisher on January 27, 1778 to express his profound gratitude.

> Full heartily and most cordially do I thank thee, good Mr. F—, for your kindness in sending the books, that upon the unchristian and most diabolical usage of my brother Negroes, the illegality, the horrid wickedness of the traffic, the cruel carnage and depopulation of the human species, is painted in such strong colors that I think would (If duly attended to) slash conviction and produce remorse in every enlightened and candid reader.[15]

Sancho wrote the most poignant and passionate response to Phillis Wheatley's poetry ever recorded by one of her contemporaries. "The perusal affected me more than I can express," he wrote, revealing a powerful jumble of emotions—outrage at the cruelty of the massive oppression of people like him and Phillis Wheatley, intense pride in her accomplishments, and great appreciation for the white men and women who supported her literary efforts, as well as antislavery activists willing to publicly challenge their society's dominant beliefs.

> Indeed, I felt a double or mixed sensation—for while my heart was torn for the sufferings, which, for aught I know, some of my nearest kin have undergone—my bosom at the same time, glowed with gratitude and praise toward the humane, the Christian, the friendly, and learned author of that most valuable book.[16]

He acknowledged Phillis Wheatley's poetry as fine art but remains highly critical of the white society that praised her while she was still enslaved.

Phyllis's poems do credit to nature and put art, merely as art to the blush. It reflects nothing either to the glory or generosity of her master, if she is still his slave, except he glories in the low vanity of having in his wanton power a mind animated by Heaven, a genius superior to himself.[17]

Sancho aimed his most stinging rebuke for the eighteen of the "most respectable characters in Boston," who lent their names to assure the world that "Phillis, a young Negro girl" was "examined by some of the best judges" and was deemed "qualified" to write the poems she wrote.

The list of splendid titled learned names, in confirmation of her being the real authoress. Alas! Shews how very poor the acquisition of wealth and knowledge are without generosity, feeling and humanity. These good great folks, all know, and perhaps admired, nay praised genius in bondage. And then, like the Priests and the Levites in sacred write, passed by, not one good Samaritan amongst them."[18]

When Ignatius Sancho wrote his letter on Phillis Wheatley in 1778, he did not know that she had been free for nearly five years. Sancho's withering criticism of the prevailing culture of white supremacy in the colonies was well-founded, and for Phillis Wheatley it was tragically prescient. The "good great folks" who "admired" and "praised" the literary work of this "genius in bondage," the very people who subscribed to her book, supported her efforts, and encouraged her writing, those she considered as friends, now seemed to vanish.

# CHAPTER 49

"The vast variety of scenes that have passed before us these three years past will serve to convince us of the uncertain duration of all things temporal."

JOHN WHEATLEY WAS SEVENTY-FIVE AND sickly when he drew up his will on February 14, 1778. At the time he was living in Boston's North End with his daughter Mary and her husband, Reverend John Lathrop, along with Phillis Wheatley. Several years earlier, when the wealthy businessman retired, he had transferred ownership of much of his estate to his son Nathaniel. His will left all his remaining possessions to Mary Wheatley Lathrop, and designated Reverend Lathrop as executor. John Wheatley never mentioned Phillis in his will. He left his former slave nothing.

John Wheatley died on March 12, 1778. His headstone at the Granary Burial Ground states: "An industrious member of society." Three weeks later, full of hope for an auspicious future, Phillis Wheatley made a fateful decision. "On April 1, 1778, Phillis Wheatley and John Peters announced their intention to marry," says Carretta.[1]

Professor Carretta is careful to note the persistent confusion about when Phillis Wheatley was actually married. "I, along with every other editor and critic of Wheatley, mistakenly assumed that April 1 was the date of their marriage rather than simply the date they announced their intentions," he observes, pointing out that "she continued to use her maiden name after April 1, 1778."[2]

"Although Wheatley and Peters did not marry until the end of November 1778," Carretta states, "they started living together soon after John Wheatley's death."[3]

Phillis received a letter from her friend Obour Tanner, then living in Worcester, Massachusetts, and responded on May 29. "I am exceedingly glad to hear from you," she began. "Next to that is the pleasure of hearing that you are well."[4]

It was the first communication between them in several years. Although so much had happened since their last letters, Phillis avoided the details, glossing over such momentous life-changing events as winning her freedom, the deaths of Susanna and John Wheatley, and her blossoming relationship with John Peters. She described her whirlwind of transformative developments as a "vast variety of scenes," while maintaining a cool philosophical distance. Clearly she was not ready to share with her friend what was really in her heart.

> The vast variety of scenes that have passed before us these 3 years past will to a reasonable mind serve to convince us of the uncertain duration of all things temporal, and the proper result of such a consideration is an ardent desire of, & preparation for... enjoyments which are more suitable to the immortal mind.[5]

The only mention of her upcoming marriage was the passing hint that her living arrangement had changed. "You will do me a great favour if you'll write me by every Oppy. Direct your letters under cover to Mr. John Peters in Queen Street."

Acknowledging her all-too-brief reply, she explained that "I have but half an hour's notice and must apologize for this hasty scrawl." In closing, she signed her name. "I am most affectionately, my dear Obour your sincere friend, Phillis Wheatley."[6]

Richmond believes that Phillis was aware of the uncomfortable fact that "her closest (and probably only) black friend Obour Tanner disapproved of the marriage."[7]

Obour Tanner certainly knew John Peters. Phillis had made a comment to Obour after meeting him for the first time four years earlier. He was in Boston then and agreed to deliver her letter to Obour Tanner in Newport. "The young man by whom this is handed you seems to me to be a very clever man," she told Obour, adding that he "knows you very well." Phillis described her new acquaintance as "very complaisant and agreeable."[8]

Even though Phillis did not identify the "young man," Obour Tanner knew exactly who she was talking about. Many years later this brief reference to John Peters came up in a conversation between Obour and

Katherine Edes Beecher, sister of abolitionists Reverend Henry Ward Beecher and Harriet Beecher Stowe. Mrs. Beecher recalled the letter of October 30, 1773, one of six of the letters by Phillis Wheatley that Obour Tanner passed to her. "Phillis speaks of Mr. John Peters," she said, calling him "'a complaisant and agreeable young man,' and 'an acquaintance' of Obour's, & c. This was the man she married."[9]

When Obour Tanner gave her the letters of a long-departed dear friend, the old woman would have lingered over each treasured missive, recalling her cherished memories of a young Phillis Wheatley, reliving scenes and circumstances from fifty years earlier, accompanied by her own poignant commentary. No doubt it was Obour Tanner who identified the mystery man as John Peters.

In their conversation about the letters, Obour Tanner shared her thoughts on the relationship between Phillis Wheatley and John Peters. "Obour informed me, pious soul as she was," Mrs. Beecher said, "that poor Phillis let herself down by marrying," punctuating her blunt assessment with an emphatic "Yes, ma'am."[10]

Mrs. Beecher was able to confirm Obour's verdict on John Peters. "I heard the same thing expressed frequently by old people in Newport who remembered the circumstances."[11]

In her 1834 biography of Phillis Wheatley, Margaretta Oddell reinforced this notion of John Peters as a good-for-nothing scoundrel. "He proved utterly unworthy of the distinguished woman who honored him by her alliance," she wrote. "Hence his unfortunate wife suffered much from this ill-omened union."[12]

Carretta reports that "Rev. Lathrop performed the marriage between John Peters and Phillis Wheatley on November 26, 1778 at Boston's Second Congregational Church."[13] In one more distressing blow for Phillis, her longtime friend and teacher Mary Wheatley Lathrop was not around to see her get married. She had died on September 24, 1778 at the age of thirty-five.

Phillis Wheatley surely attended her funeral, listening through her tears as Reverend Lathrop delivered the eulogy. "She viewed her dissolution coming on with a calmness," Mary's grieving husband intoned solemnly. "She did not wish to recover health and be exposed again to the temptations

of this evil world, unless it were to honor her Lord and Redeemer more than ever before she had done."[14]

The death of someone held dear is always one of life's most painful trials. "The world is a severe schoolmaster," Phillis wrote after the death of Susanna Wheatley.[15] Now, four years later, John Wheatley died, followed by Mary Wheatley. "Phillis Wheatley left no record of her feelings about these losses," says Wheatley scholar Merle Richmond. "But they must have troubled her deeply. She had grown up with the Wheatleys and had always depended on them for guidance. Now three of them were gone."[16]

Suddenly the family had disappeared from her life, all dead but for Nathaniel Wheatley, who was still in London. "For the first time in her protected life, Phillis Wheatley found herself without the help of the friends who had reared and educated her," says Robinson.[17]

"Phillis Wheatley was alone, with nothing and no one to catch her if she stumbled," says Richmond.[18]

More than ever, she found herself "upon my own footing," as she put it after earning her freedom.[19]

What could be more natural for a lovely, attractive, intelligent young woman than to find a husband and start a family? The decision to marry carries far-reaching consequences. For Phillis Wheatley, an African and former slave living in a white world, finding a suitable mate was a complicated issue. Richmond wondered about her motivation. Was her decision to marry John Peters "her first self-determined act as a freedwoman?" Was it "a bid for security?" Or possibly "an affirmation of defiant rebellion?"[20]

Growing up in the Wheatley household, Phillis never had to concern herself with the basic needs of life. They were a family of wealthy entrepreneurs who were well respected in the community, and some practical Wheatley business sense certainly rubbed off on Phillis. Certainly her decision to marry was prompted by the need for economic security.

As 1778 drew to a close, Phillis Wheatley's social status had changed. She was a married woman now. "Free, black and twenty-five, the poet hazarded or sacrificed much on the wedding altar: friendship, values, patronage," writes Richmond. "All that for this man named Peters, an elusive figure."[21]

Who was this man? "Peters left no written record and no one saw any reason to search for traces of his life," Richmond notes.[22]

Wheatley family memoirist Margaretta Oddell described John Peters as "a respectable colored man of Boston" who "kept a grocery in Court Street," the common term for a retail store selling food, clothing, household items, tools, furniture, and assorted miscellaneous merchandise. She described him as "a man of handsome person and manners; he wore a wig, carried a cane, and quite acted out 'the gentleman.'"[23]

In 1810 French abolitionist Henri Gregoire characterized John Peters in his chapter on Phillis Wheatley: "In the superiority of his understanding, to that of other Negroes, was also a kind of phenomenon."[24]

Jane Tyler Lathrop, Mary Wheatley's daughter and granddaughter of Susanna Wheatley, knew Peters as "not only a very remarkable looking man, but a man of letters and information who wrote with fluency and propriety and at one time read law."[25]

John Peters was one of the few black men in New England, or anywhere else, whose impressive intellect and drive to succeed could match that of Phillis. "Handsome" and "remarkable looking," a "gentleman," and a "man of letters," he was a "kind of phenomenon." John Peters was just the kind of man who could catch the eye of a young poet and win her heart. "The description can account for the poet's attraction to him and her apparent rashness in marrying him," Richmond says. "In her particular condition of slavery, she could not have been exposed to many black suitors and most likely to none with his talents and intellectual achievements."[26]

In her 1826 *Biographical Sketches and Interesting Anecdotes of Persons of Colour to which is Added a Selection of Pieces in Poetry,* Abigail Mott touched on Peters in her discussion of Phillis Wheatley, noting that he "officiated as a lawyer, under the title of Doctor Peters, pleading the cause of his brethren the Africans, before the tribunals of the state."[27]

The 1864 Massachusetts Historical Society report on the recently acquired Wheatley letters recounts how "the venerable Josiah Quincy, who was present at this meeting—the last meeting of this society which he ever attended—expressed much interest in the letters of Phillis Wheatley."[28]

Josiah Quincy was a prominent figure in Massachusetts politics, elected to the U. S. House of Representatives and later as mayor of Boston before serving as president of Harvard. After examining Phillis Wheatley's letters, he told his colleagues that "he well remembered the man (Peters) whom she

married; that he, at one time practiced law, or professed to, and Mr. Quincy had met him in the courtroom."[29]

Richmond could not help but point out the snide, demeaning judgement meant to belittle John Peters's law career. "Practiced law—or professed to...." she hisses, repeating Quincy's observation. "What a nice disdain," she adds with biting irony. "The white barrister perceiving presumption or impertinence in the black freedman, lacking the proper academic trappings, attempting the practice of law."[30]

Few blacks had sufficient legal experience to serve as advocates in a court of law. Certainly none graduated from Harvard Law School as Josiah Quincy had. "In these circumstances, Peters' venture into the breach, with whatever handicaps, may be interpreted as an example of admirable enterprise and initiative," says Richmond. Viewing John Peters's various endeavors through the lens of the dominant belief in white supremacy, we can easily see how a gutsy go-getter who shows gumption, a black man like John Peters, can be mischaracterized. Belief in racial stereotypes was the norm. "It is not novel, of course, that what might seem like enterprise and initiative from the black viewpoint could appear as presumption and impertinence from the prevailing white vantage point."[31]

Besides his turn as a lawyer, he owned a retail store, and worked as a barber, a baker, and a physician. "Peters achieved some success in a variety of occupations," writes Richmond.[32] "In another context, such vocation-hopping might have been taken as a sign of brilliant versatility. In Peters, according to the prevailing judgments, it denoted an instability bordering on the shiftless." Richmond sees John Peters' employment struggles as a product of the times. "Actually, Peters' vocational pattern might not have been due to any inherent character trait, either shiftlessness or versatility, but to practical circumstance."[33]

"Perhaps 'daring' and 'ambitious' might have been better words for him," she submits.[34]

The Revolutionary War brought widespread economic instability and hardship. "The difficulties between the colonies and the mother country had by this time increased to open hostilities. Universal distress prevailed," Oddell said. "The families of those who were fighting for their country, most of whom had been cherished in the lap of plenty, were glad to obtain their daily bread."[35]

"The ailing economy worked its greatest cruelty upon blacks," says Richmond. Former slaves, now free, had to sell their own labor in a tight job market, putting them in direct competition with white workers. "They had to do it, on occasion, in the face of insults, threats, and violence by white mobs in the streets of Boston." For free blacks, the economic situation must have been catastrophic, "especially one who sought an alternative to menial labor. Frustrated in one venture, Peters might have been driven to another in an upward—or downward—spiral of desperation."[36]

Since before the founding of the American nation, history shows that free black men striving to achieve success, who aspire to respectability in the eyes of their community, were commonly debased, disparaged, and discredited, physically intimidated, assaulted, and even killed. Richmond asks pointedly: "What allowances for white prejudice are to be made in assessing the dominant image of him that endures after almost two centuries?"[37]

"The most influential account of John Peters has been the very negative one in Oddell's 1834 *Memoir*," says Carretta. "She attributes much of her information to unnamed relatives and friends of the Wheatley family."[38]

"He was disagreeable in his manners," Oddell wrote. "On account of his improper conduct, Phillis became entirely estranged from the immediate family of her mistress."[39]

Always protective of Phillis and her connection to the family, the Wheatleys laid the blame for her tragic end squarely on her husband. "He was unsuccessful in business and failed soon after their marriage," Oddell wrote, "and he is said to have been both too proud and too indolent to apply himself to any occupation below his fancied dignity."[40]

Hannah Mather Crocker, who grew up with Phillis Wheatley in Boston—her father, Reverend Samuel Mather, and her uncle, Governor Thomas Hutchinson, knew Phillis and were signers of the attestation verifying the authorship of her poems—offered a quick summary of what she thought about her marriage. "She (Phillis Wheatley) married at twenty one a man of notoriety by the name of Peters. He did not treat her well. She soon fell a prey to disappointment and her keen sensibility proved a sudden decline and she died."[41]

# CHAPTER 50

*"I wish you much happiness and am, Dear Obour,
your friend & sister, Phillis Peters."*

"THE MARRIAGE SEEMS TO HAVE begun well enough," says
Robinson.[1]

"Much of the first year of Phillis and John Peters's marriage was pros-
perous and promising," Carretta adds.[2]

Carretta found court documents confirming that in the spring of 1779
John Peters entered into a business partnership with a white man named
Josias Byles. The merchants sold rye, wheat, tea, nails, sugar, and other
assorted household products in western Massachusetts. Boston records
from 1780 show that John Peters paid the considerable sum of 150 pounds
in real estate taxes for his grocery store and private home on Queen Street
(today's Court Street), in one of Boston's most prestigious neighborhoods.

"At one time or another during Phillis's Boston lifetime, such promi-
nent men as John Adams, General Howe, and Josiah Quincy lived on that
street, each with a retinue of servants," says Robinson. "Indeed, John and
Phillis Peters may at one time have had their own servants."[3]

"Peters was one of a handful of free blacks who owned property in
Boston," writes Richmond. "But judging from real-estate records of the
time, his was by far the most expensive house."[4]

We know of two letters Phillis wrote shortly after she moved in with
John Peters. She was already living in his Queen Street home when she
dashed off her quick note to Obour Tanner on May 29, 1778. Then, on July
15, she sent her poem *On the Death of General Wooster* to his widow after
learning that her friend David Wooster had been killed on the battlefield
against the British.

It was her clearest assessment yet of what she believed the War for
Independence was all about. In the eyes of Phillis Wheatley, the noble cause
for the supreme sacrifice of blood and treasure was freedom.

The poet embedded her insight within an elegy to honor her friend, the New Haven merchant to whom she wrote in October 1773 to share her marketing strategy for her book and tell him all about her London adventures. It was to David Wooster that Phillis Wheatley revealed that she was now legally free.

"He nobly perish'd in his Country's cause," Phillis wrote to his widow. "He fell a martyr in the Cause of Freedom."[5]

Wheatley imagines the scene as General Wooster lay mortally wounded on the battlefield. With his last breath, he implores the Great Divine Authority to grant him the opportunity to offer a prayer for "his Country's Cause," the "Cause of Freedom."

> *Inly serene the expiring hero lies*
> *And thus (while heav'nward roll his swimming eyes)*
> *Permit, great power while yet my fleeting breath*
> *And Spirits wander to the verge of Death*[6]

The poet's voice speaks through the dying Wooster, identifying the "celestial prize" leading the nation "Columbia" through "the toils of war." As the entire "continent shines bright in arms," she points to the root of it, "fair freedom's charms."

> *Permit me yet to point fair freedom's charms*
> *For her the Continent shines bright in arms*
> *By thy high will, celestial prize she came —*
> *For her we combat on the field of fame*
> *Without her presence vice maintains full sway*
> *And social love and virtue wing their way*
> *O still propitious be thy guardian care*
> *And lead Columbia thro' the toils of war.*[7]

As she does so often in her poetry, Phillis Wheatley sharply challenges the hypocrisy of American patriots who stake their claim to morality by fighting bravely for their freedom to keep slaves.

*But how presumptuous shall we hope to find*
*Divine acceptance with th' Almighty mind—*
*While yet (O deed ungenerous!) they disgrace*
*And hold in bondage Afric's blameless race?*
*Let virtue reign—And thou accord our prayers*
*Be victory our's, and generous freedom theirs.[8]*

The pressing question she put to the leaders of the Revolution was "whether the American victory in independence would include the gift of freedom for her much-oppressed race," says Shields.[9]

The poem was accompanied by a gracious expression of condolence. Phillis also used the opportunity to talk business with Mrs. Wooster. Five years earlier her husband had agreed to serve as sales agent for her books. "I beg the favour that you would honour the enclos'd proposals & use your interest with gentlemen & ladies of your acquaintance to subscribe," she wrote to Colonel Wooster on October 18, 1773. "The more subscribers there are, the more it will be for my advantage as I am to have half the sale of the books."[10] Both letters, to Colonel Wooster in 1773 and to his widow in 1778, highlight Phillis Wheatley's keen business instincts. "There is evidence that Wheatley was not only a gifted poet but also reasonably astute in the legal and financial ways of the world," writes Eric Ashley Hairston.[11]

Acting on her own, with no Wheatleys looking over her shoulder, Phillis had no qualms about taking care of her financial interests and claiming what was rightfully hers. "You will do me a great favour by returning to me by the first oppy (opportunity) those books that remain unsold and remitting the money for those that are sold," Phillis told Mrs. Wooster. Thinking like an entrepreneur, she added, "I can easily dispose of them here for 12 shillings each." She closed the letter to Mrs. Wooster by signing off with her maiden name at her new address: "Your friend & very humble servt. Phillis Wheatley, Queen Street, Boston."[12]

Five years after it was published she remained confident that she could sell her book "easily." It shows that her poems were still very much in demand and that she was deeply engaged in the business of marketing her works.

Like everyone in the wartime colonies, Phillis was aware of the volatile economic situation. "Her assertion that she could easily sell her volume for

twelve shillings a copy, when the original price just five years earlier was two shillings and sixpence, is indicative of the worsening inflation picture in the colonies," writes Robinson.[13]

After her 1778 letter written in a "hasty scrawl," she did not communicate with Obour Tanner for nearly a year. Her next letter, dated May 10, 1779, was quite revealing. "Dr. Obour," she began. "By this opportunity I have the pleasure to inform you that I am well and hope you are so....Tho' I have been silent, I have not been unmindful of you." Phillis gave a vague excuse for the delay in writing, and hinted at her mounting problems. "A variety of hindrances was the cause of my not writing to you," she said.[14]

Robinson adds some context to the situation. "Phillis Wheatley Peters was pregnant, and there are indications of strain....For a happy change, Phillis does not write of feeling sickly but it is clear that all is otherwise not well."[15]

Phillis assured Obour that she wanted to continue their friendship and promised to be a more faithful letter writer. "In time to come I hope our correspondence will revive—and revive in better times. Pray write me soon for I long to hear from you—you may depend on constant replies."

She ended with an affectionate hug. "I wish you much happiness and am, Dr. Obour, your friend & sister, Phillis Peters."[16] It was the first time she acknowledged to Obour the fact of her new status as a married woman. "Despite her expressed wish for a revival of their correspondence, this is the last extant letter from Phillis to Obour," Robinson writes.[17]

Support for Robinson's theory that one of those "hindrances" was a difficult pregnancy came from Phillis herself. "Always delicate and sickly, Phillis composed a fervid prayer on the 'Sabbath, June 13, 1779' on the eve of her first pregnancy," he notes.[18]

This handwritten prayer is "the closest we come to having a reference by Phillis herself to any of her own children," says Carretta.[19]

These pen and ink lines carefully crafted in fine script show a very pregnant Phillis in a quiet moment alone in her Queen Street home, expressing the normal doubts and apprehensions that plague first-time mothers everywhere. Clearly, this handwritten prayer by Phillis was not meant for publication. Composed in a rush of spiritual fervor, her words convey a deep personal expression of worship, a spontaneous outpouring from a

passionate seeker, and her heartfelt appeal for God's grace and mercy. It is a meditation on faith, a petition for deliverance, and a hymn of praise. It is a poem that could stand among the Bible's Psalms.

The new mother-to-be issued a striking petition to "my Gracious Preserver" that she may be granted "strength" to "bringest to the birth" a "perfect being" so that the child will "be greatly instrumental in promoting thy glory."

Deeply immersed in the New England Puritan belief in the wickedness of sex, she accepts without question the idea that her new baby was "conceived in sin & brot forth in iniquity." She prays for redemption so that God will "bring a clean thing out of an unclean" and her baby may become "a vessel of honor filled for thy glory."

### PRAYER, SABBATH, JUNE 13, 1779

*Oh my Gracious Preserver!*
*Hitherto thou hast brot me*
*Be pleased when thou bringest*
*To the birth to give me strength*
*To bring forth living & perfect a Being*
*Who shall be greatly instrumental*
*In promoting thy glory.*

*Tho conceived in sin & brot forth in iniquity*
*Yet thy infinite wisdom*
*Can bring a clean thing out of an unclean,*
*A vessel of honor filled for thy glory.*
*Grant me to live a life of gratitude to thee*
*For the innumerable benefits.*

*O Lord, my God!*
*Instruct my ignorance& enlighten my darkness.*
*Thou art my King;*
*Take thou the entire possession of all my powers & faculties*
*& let me be no longer under the dominion of sin.*

*Give me a sincere & hearty repentance*
*For all my grievous offences*
*& strengthen by thy grace my resolutions*
*On amendment & circumspection for the time to come.*
*Grant me also the spirit of prayer and supplication*
*According to thy own most gracious promises.*[20]

The only information we have about Phillis Wheatley's children comes from Margaretta Matilda Oddell. "She became the mother of three infants, who inherited the frail health of their parent," Oddell wrote, "and thus to her other cares was added the anxiety of a mother, watching the flickering flame glowing in the bosom of her offspring, and trembling every moment lest the breath of adversity should extinguish a life so dear to her."[21]

As a member of the Wheatley family who kept in touch with those who knew Phillis during her lifetime, Oddell was in a position to know about her three children. However, the historical reality is that no records have ever been found documenting a birth, baptism, or burial for any of these children.

The unfortunate truth is that Phillis Wheatley's children will always remain invisible, a ghostly presence. We can presume from Oddell's report that her children lived and died, one after another, probably before they could speak. These three black babies born in Massachusetts toward the end of the Revolutionary War will always be nameless, gender unknown, their birthdays and their deaths forever lost to history.

We can only wonder: did they possess the intense intellectual gifts so richly displayed by their mother? Did they learn to use language with the same skill and resourcefulness? Did they suffer from a weak constitution and chronic asthma like their mother? We will never know. The only thing we can say for sure is that their mother loved them dearly and longed for them to become a "vessel of honor filled for thy glory."

# CHAPTER 51

### "Proposals for printing by subscription: A volume of poems and letters on various subjects by Phillis Peters."

SOMETIME IN THE FALL OF 1779, probably after the birth of her baby, Phillis decided to concentrate on the business of poetry. With one more mouth to feed, she returned to her chosen profession to help support her growing family. Writing and selling her work was the only vocation she knew.

"Phillis Wheatley was facing hard times," Richmond writes. "She was no longer an exotic African child prodigy. She was a free black woman in her mid-twenties with no marketable skills. There were no more prominent white patrons to sponsor her, no more wealthy intellectuals to invite her to tea and celebrate her talent for reflecting their safe, civilized and God-fearing world."[1]

She had been writing continually since her first book was published in 1773. Six years later she had dozens of new poems ready for her second book. Already experienced in the painstaking process of selecting poems to showcase her talent and appeal to readers, she chose thirty-two previously unpublished poems along with her highly regarded tribute to Washington, already in print, plus thirteen of her letters.

Having gone through the arduous process to publish her first book, she knew how to go about it. Boston publishers White and Adams, who had done business with the Wheatley family and "recently published the sermon Rev. John Lathrop delivered at the funeral of his wife," agreed to print her book if she was able to get the required number of subscribers.[2]

She needed to produce a book proposal. Without her mistress and mentor Susanna Wheatley to guide her, Phillis sat down and wrote the text for the advertisement herself. She had to have help from her husband, John Peters, a bow to custom and the law since she needed a male to legitimize the project.

According to law, Phillis Peters was the property of her husband who could claim ownership of everything she possessed, including her manuscripts. Since women were not permitted to sign contracts on their own, the former Phillis Wheatley had to rely on John Peters to guide her through any legal issues.

Just as Phillis had John Wheatley's business connections to facilitate her publication, now John Peters could lend his successful entrepreneurial expertise. Carretta believes that "he may also have been responsible for pricing the book. It was to be significantly more expensive than Phillis's first book, even after accounting for the difference in the size and scope of the proposed larger volume as well as the depreciation of continental currency."[3]

Her 1773 proposal had advertised her 124-page book selling for two shillings, six pence bound or two shillings sewn. Five years later, with the economy crashing, she was confident that she could sell her book for 12 shillings. Now in 1779, with her new book more than twice as long at three hundred pages, they planned to sell it for twelve pounds bound and nine pounds sewn.

Carretta takes pains to explain the British currency system adopted by the colonies. "British money was counted in pounds sterling, shillings and pence or pennies and farthings. One pound sterling = 20 shillings.... Adjusted for inflation, the price in Massachusetts pounds asked by John Peters for Phillis's proposed second volume was still approximately three times the value in pounds sterling asked for her 1772 volume."[4]

At the time each colony was issuing its own paper money. Robinson offers some examples to help us understand the value of Massachusetts currency. "A loaf of bread cost two shillings; potatoes cost between nine and ten shillings a bushel; blacksmiths charged 6 pounds ten shillings for shoeing a horse all around; tailors got fifteen pounds for making a suit for a man."[5] Thus in 1778, Phillis believed her 1773 book would sell for more than a bushel of potatoes. The price for her 1779 book would be more than a manservant's yearly salary.

"John Peters may have been the one who made the mistake of overpricing the proposed book in a period of economic depression and wartime turmoil," says Carretta.[6] The entrepreneurial-minded Peters certainly knew the merchant's strategy of offering consumers a bargain. "Those who subscribe

for six, will have a seventh gratis," the ad read.[7]

The author is identified as "Phillis Peters." The name "Phillis Wheatley" appears nowhere in the 1779 proposal for her new book. As a marketing strategy, failing to take advantage of the celebrity status of the author is a curious move since Phillis Wheatley was widely known as "the African poet" and had a substantial fan base. "The absence of any reference in the advertisement to Phillis's maiden name probably indicates that her husband played a dominant role in the planning of the proposed book," writes Carretta. "He was probably responsible for the decision to use only their surname."[8]

Even though they did not use the Wheatley name, they strongly identified the author by her race, gender, and social status. It was her main selling point.

> The subjects are various and curious and the author, a female African, whose lot it was to fall into the hands of a generous master and great benefactor. The learned and ingenuous as well as those who are pleased with novelty are invited to encourage the publication by a generous subscription, the former, that they may fan the sacred fire which, is self-enkindled in the breast of this young African.[9]

For her entire career as a published poet, beginning with Susanna Wheatley's shrewd marketing campaigns, the most noteworthy feature used to attract readers, her brand identity, had always been her unique standing as an African slave woman. Once again, Phillis Wheatley and her publishers relied on this device to boost her book sales.

"Those who are always in search of some new thing, that they may obtain a sight of this *rara avis in terra*," the advertisement read, using a classical Latin expression found in the work of the early second-century Roman poet Juvenal meaning "a rare bird in the land."

The advertisement concluded with an appeal to the conscience of sympathetic readers who acknowledged the injustice the author had suffered by her enslavement and wished to support her continued growth and integration into society by purchasing her book so "the ingenious author may be encouraged to improve her own mind, benefit and please mankind."[10]

In a bold stroke aimed at claiming the mantle of "America's Poet," Phillis Wheatley made an audacious move. The opening sentence of the proposal declares that her book will be "Dedicated to the Right Honourable, Benjamin Franklin, Esq., one of the Ambassadors of the United States at the Court of France."[11]

For a writer aspiring to be a leading voice in the brash chorus of a new America, it was an exquisite decision to dedicate her book to a man who became known as "The First American." As a marketing strategy, Phillis could hardly have picked a more potent name. "Phillis hoped that her dedication of her projected 1779 book to Benjamin Franklin would attract subscribers," says Robinson.[12]

Phillis felt that the passion for independence featured in her poems would surely earn Franklin's approval. She had had the distinct privilege of meeting Benjamin Franklin in person when he called on her in London in July 1773.

"There is no evidence that anyone had approached Benjamin Franklin about having the book dedicated to him," says Carretta. "Her apparent conviction that he would have been agreeable to such a gesture reflects an impressive amount of confidence on her part."[13]

An advertisement for Phillis Wheatley's second book appeared on the front page of the *Boston Evening Post and General Advertiser* on October 30. 1779 and ran again on November 6 and 27 and December 4, 11, and 18.

PROPOSALS,

FOR PRINTING, BY SUBSCRIPTION:

A VOLUME OF POEMS AND LETTERS, ON VARIOUS SUBJECTS,

Dedicated to the Right Honourable, BENJAMIN FRANKLIN, Esq;

One of the Ambassadors of the United States, at the Court of France,

By PHILLIS PETERS.[14]

Wheatley had determined that her second collection of writings would be her best yet, displaying her growth as a poet with greater depth and maturity. This book would show the self-assured artistry of an accomplished poet, a writer of sophistication and polish in promoting the grand theme of freedom for all. It would be Phillis Wheatley's strongest effort to apply for the unofficial role of America's "Poet Laureate."

Her second book would be very different from her first. Many poems in her 1773 book had been written when she was a teenager and still a legal slave. In stark contrast, nearly all poems in her 1779 collection were written by a free woman in her early twenties. She did not use any of her earlier works. Not one poem listed in her 1772 Proposals and left out of her 1773 book was selected for her 1779 book. This would be a collection of entirely new material. She wanted to showcase her literary gifts at their finest. "Miss Wheatley was a careful craftsperson, as her revisions reveal," writes scholar Gregory Rigsby. "Changes in language and punctuation and grammar show an artist seeking precision in thought and meaning."[15]

Of the thirty-three poems listed in her 1779 Proposals, only seven have survived.[16]

*To His Excellency General Washington* was published in the *Virginia Gazette* on March 30, 1776 and the *Pennsylvania Magazine* in April 1776.

*To A Gentleman of the Navy* and *Phillis's Reply to the Answer in Our Last by the Gentleman in the Navy* appeared in the *Royal American Magazine* in December 1774 and January 1775.

The poem listed in her Proposal as *To P. N. S. On the Death of Their Infant Son* was published under the title *To Mr. and Mrs. – On the Death of Their Infant Son* and featured in an advertisement in the *Boston Magazine*, September 1784. It was her final attempt to find a publisher for her Proposals and the last poem she published.

The three remaining poems that we know of were not published during her lifetime. *On the Capture of General Lee* was published in 1864 by the Massachusetts Historical Society after it was discovered among the papers of James Bowdoin. *On the Death of General Wooster* was first published by Wheatley scholar Mukhtar Ali Isani in the February 1980 issue of *Modern Philology*.

Phillis wrote her poem *Ocean* during the sea voyage home to Boston in

July 1773, making it one of the earliest poems in her book. The title in her 1779 Proposal was all we knew of the poem until her original handwritten manuscript was discovered in 1998 and sold at auction for $68,500.

The remaining twenty-six poems in her proposed 1779 book have been lost to history. All we have are the titles and some tantalizing hints about their content.

*Thoughts on the Times.* What exactly were Phillis Wheatley's thoughts on those turbulent times? What would she have to say about the momentous circumstances surrounding her? Could this poem be her defining statement on the War for Independence?

*A Complaint.* Surely Phillis Wheatley had grounds to complain. Is this her ultimate rebuke of slavery?

*To Mr. A M'B – of the Navy,*
*To Lt. R – D – of the Navy.*
*To the Hon. John Montague Esq; Rear Admiral of the Blue.*

Since Boston was an occupied town though the early 1770s, it is likely that these were officers in the Royal Navy. Admiral Montague was the commander of the British fleet in December 1773, when citizens of Boston, dressed as Mohawks, boarded three cargo ships in the harbor to dump the tea just days before Phillis claimed her books from the *Dartmouth*. What would inspire Phillis Wheatley to write a poem to the Commander of the Royal Navy in North America? Could it be a ringing defense of the Boston Tea Party?

*Farewell to England, 1773.* This must be Phillis reflecting on her life-changing experiences in England. We can only wonder: did she make any poetic allusions to her newly won freedom?

*The Choice and Advantages of a Friend—to Mr. T. M.* gives Phillis an opportunity to expound on the art of friendship. And who was Mr. T.M.? Is her poem *To T.M. Esq. of Granada* addressed to the same individual?

More poems to individuals:

*To I B. Esq.,*
*To Mr. A.I.M. on Virtue*
*An Address to Dr. –*
*To Sir E. L. —— Esq.*

*To Sophia of South Carolina*
*To Mrs. W – ms on Anna Eliza*
*To Mr. A. McB –d*

One poem celebrates a wedding, her *Epithalamium to Mrs. H —* . An epithalamium is a nuptial song or poem in honor of a bride and bride-groom. In ancient Greece it was the traditional way to bless a marriage with good fortune.

Seven poems are elegies:

*To Mr. El — on the death of his Lady.*
*On the Death of Lt. L – ds*
*To Mr. & Mrs L – on the Death of Their Daughter*
*To Dr. L – d and Lady on the Death of Their Son Aged 5 Years.*
*To Mr. L – g on the Death of His Son.*
*To Capt. F – on the Death of His Granddaughter*
*To Philandra, an Elegy*

The remaining poems appear to have classical themes.

*Chloe to Calliope* could be an intriguing reference to Phillis as a poet. She frames it as a message from *Chloe*, the Greek goddess in the form of a young and green shoot growing from a plant, addressed to *Calliope*, daughter of Zeus and Mnemosyne, the muse of epic poetry who was Homer's muse for the *Iliad* and the *Odyssey*. Phillis certainly knew the reference to Chloe in First Corinthians 1:11. It was Chloe's family who warned Paul of the quarreling among the Christians in Corinth. The title suggests that Chloe, the young maturing poet, writes to Calliope, the Divine Literary Muse. What could it reveal about Phillis Wheatley and her poetry?

*To Musidora on Fiorello* is another reference to her literary art. Musidora is Greek for "gift of the muses."

*To Penelope* may be Phillis's comment on marriage, possibly her own. Penelope is the wife of Odysseus who remains faithful during his long absence and eventually they are reunited.

Her poem *Niagara* is a mystifying addition. She rarely wrote about the natural world—*Ocean* is one exception. Niagara is of course the great falls on the border of Canada and New York. What inspired Phillis to write this poem?

Her 1779 Proposal listed thirteen letters to be included in her book. Today we have four of those letters. Three letters that Phillis wrote to the Countess of Huntingdon from Boston on October 25, 1770 and London on June 27 and July 17, 1773 were found among the countess's papers. The letter and the poem she wrote to the Earl of Dartmouth on October 10, 1772 turned up in Dartmouth's papers.

Nine remaining letters are lost.

"If they are ever found and published it will likely be seen that they were all composed years earlier, during the lifetime of Susanna Wheatley," says Robinson.[17]

Mason believes he has figured out the identity of several recipients of Phillis's letters. "Some of the initials given for other letters we can assign with reasonable certainty," he says.[18]

*To the Rev. Mr. T. P. Farmington.* Reverend Timothy Pitkin was a Congregationalist Minister in Farmington, Connecticut and associate of Wheatley friend Samson Occom. Phillis dedicated an elegy to him, which she included in her 1773 book: *To a Clergyman on the Death of His Lady*.

*To Mr. T. W – Dartmouth College.* Thomas Wallcut was a longtime friend of Phillis Wheatley and a grandnephew of Susanna Wheatley. Phillis sent him two poems on February 2, 1773 while he was a student at Dartmouth College: *To the University of Cambridge in New England* and *On the Death of the Rev. Dr. Sewell, 1769*.

*To the Hon. T. H. Esq.* Thomas Hubbard was a Boston merchant, treasurer of Harvard College, and deacon in the Old South Church. Hubbard was one of the eighteen signers of the attestation in Phillis's book. The Hubbards were neighbors of the Wheatleys, and Thomas's daughter, Thankfull Hubbard Leonard, was a friend of Phillis. She wrote *To the Honourable T. H, Esq; On the Death of His Daughter*, her friend Thankfull, which appeared in her 1773 book.

*To I. M. Esq., London.* Israel Mauduit was the British official to whom Phillis sent a copy of her freedom papers in 1773. This letter would almost certainly contain a reference to her changed legal status.

*To Mrs. W—e in the County of Surry.* Hannah Wilberforce was John Thornton's sister and the aunt of abolitionist and statesman William

Wilberforce. In her letter to John Thornton on December 1, 1773, Phillis mentions that "I have written to Mrs. Wilberforce."[19]

*To Mrs. S. W.* This is a letter Phillis wrote to her mistress Susanna Wheatley.

Phillis Wheatley's 1779 book was never published. "It was a poor time for poetry, the public mind being preoccupied with other things," says Richmond. "These were times of conflict and passion, much too intense to be contained in the ornate vaults of her imitation of Pope's classical style."[20]

The War for Independence was heating up and the economic climate was growing more desperate. "It must be remembered that this was a season of general poverty," Oddell wrote. "The successful patriots, during the seven years' contention, had not only lost the profits which would have arisen from their industry, but were obliged to strain every nerve to meet the exigencies of the war. The depreciation of the currency added greatly to the general distress."[21]

"Prices for all goods in Boston were greatly magnified throughout the late 1770's. The inflation rate jumped 200 percent from 1775 to 1778," says Robinson.[22]

"Times were hard that year," Richmond writes, "hard enough for ordinary whites and immeasurably harder for a newly freed black woman proficient only in intellectual pursuits and lacking any marketable skill other than the writing of poetry."[23]

Even the wealthiest among them found it difficult to meet their day-to-day needs. It was not a time for cultural pursuits. "People had other things to attend to than prose and poetry," said Oddell, "when their own children were clamorous for bread."[24]

Phillis's circle of support simply vanished. The Wheatleys were dead and Nathaniel was in Britain. "Phillis's friends of former days were scattered far and wide," Oddell wrote. "Many of them, attached to the royal interest, had left the country."[25]

"Gone too were her readers who were among the elite of colonial society. Some literally gone, fled behind the British lines, many then proceeding to Canada or beyond, to some haven of the Crown; and those remaining, most of them, being equally remote from the poet's voice, beset by anxieties, uncertainties, perils," writes Richmond.[26]

"Even Captain Calef, skipper and by now a part owner of the schooner *London,* had returned in 1774 to his Homerton, England family roots and would remain there until after the war," Robinson notes.[27]

"Of the 18 men who had signed the statement vouching for her authorship, nearly half were dead," says Richmond. "The rest were too deeply involved in the war to worry about poets or poetry."[28]

Marketing opportunities for her book dwindled and disappeared. In 1772 no American publisher would take her first book so they had to go to England. Now the war had ended all commercial contacts between the colonies and Britain.

"She was on her own with her blackness and her formerly sheltered existence," writes Richmond. "The warm fire in her bedroom of a winter night, the lamp and pen at hand, was a poor apprenticeship for being cast adrift on the inflation-ridden, disordered economic waters of a country three years at war."[29]

# CHAPTER 52

"Black folk of that day were full of hope.
Soon it seemed all men would be free and equal."

SOON AFTER THE PROPOSAL FOR her second book ran in the *Boston Evening Post and General Advertiser,* Phillis Wheatley disappeared. For the next four years, from December 18, 1779, when the last in a series of advertisements for her book appeared, until her poem *An Elegy, Sacred to the Memory of That Great Divine The Reverend and Learned Dr. Samuel Cooper* was read at Cooper's funeral on January 2, 1784, she lived under the radar. There was no sign of Phillis in any public forum—no official records, no litigation, no newspaper accounts, and no poems or personal letters have turned up. During that period we have nothing to confirm Phillis Wheatley's existence. Between 1779 and 1784 her life remains a mystery.

One reason Phillis Wheatley became invisible during this period was due to her newly changed legal status. "Wheatley's marriage compounds the problems her biographer faces in trying to reconstruct her life," Carretta explains. "Once her identity was submerged beneath that of her husband, she becomes even more difficult to trace than before."

> Records of eighteenth century people of African descent are often difficult, if not impossible, to find. Paradoxically, we often know more about them when they were enslaved than when they were free because as slaves they were considered property.

> Human property was usually recorded in various ways for purposes of taxation, inheritance and manumission. And human property was normally identified in official records by ethnicity or phenotype (complexion). Free people of color, however, often left few, or no, official records unless they were substantial property owners or were involved in some way with the legal system.[1]

Determined to uncover what happened to Phillis and her husband, Carretta dug through public records and found evidence that John Peters was named in several lawsuits. In July 1780, the widow of "the wholesaler who supplied the goods Peters sold" won a significant judgment against him. "The court awarded her the impressive amount of nearly four hundred pounds," writes Carretta.[2]

Three months later, Peters successfully sued his business partner and gained control of all the company's stock. Still, it was not enough to pay his creditors and end his financial woes. "Not even liquidating all of his known assets would have covered that judgment against Peters," Carretta says.[3]

The only information we have on Phillis Wheatley during those years came from her first biographer, Margaretta Matilda Oddell. "Phillis accompanied her husband to Wilmington," she wrote, "an obscure country village" sixteen miles north of Boston.[4]

We do not know exactly why Peters and his wife left Boston. "He had probably been forced to move because of financial troubles," Richmond speculates.[5] With the prospect of debtors' prison ominously hanging over his family's future, Peters might have wanted to relocate to an obscure town where he would not be easily found.

Debtors' prison had long been an established institution in Britain and the colonies. Twelve-year-old Charles Dickens saw his father thrown into debtors' prison in London; this forced the future novelist to leave school to work ten backbreaking hours a day in order to earn the money to pay his creditors. That harsh experience became a driving force for Dickens as he used his fiction to shine a light on the unjust conditions facing the poorest of his countrymen.

Founding Fathers James Wilson and Robert Morris, both signers of the Declaration of Independence and the Constitution, spent time in debtors' prison.

In the eighteenth century, debtors faced stark choices: pay the debt, go to jail until the debt is paid, or skip town. Peters chose to flee.

"The Peters family moved out of Boston in the early 1780s," Richmond writes. "The family, now consisting of John, his wife, Phillis and a child born after the death of their first infant in 1779, settled in the village of Wilmington, north of the city."[6]

Wilmington was a small country town, relatively undeveloped, even primitive. For a highly refined, intellectually vibrant poet who regularly conversed with the cultural elite of Boston, the isolation had to be onerous. "The resulting change in lifestyle must have been drastic," says Merle Richmond. "Gone was the excitement of life in Boston, a sophisticated and lively city even in wartime. Gone was the elegant house on Queen Street along with the ease it provided....That the poet had once been a 'Wheatley' counted for little in Wilmington. Now she was just Mrs. John Peters, a poor black freedwoman little different on the surface from many others.... The harshness of life in the village took its toll, leaving Wheatley in increasingly fragile health."[7]

"Grim life in an inland village was simply too demanding for one of her previous lifestyle," said Robinson.[8]

"The necessaries of life are always obtained with more difficulty than in a populous town," Oddell wrote, "and in this season of scarcity, Phillis suffered much from privation—from absolute want—and from painful exertions to which she was unaccustomed, and for which her frail constitution unfitted her."[9]

"Her already fragile health began to deteriorate," says Robinson.[10]

During the time Phillis Wheatley was in Wilmington, two momentous events transformed life for all Americans. The Articles of Confederation was ratified by all thirteen states in a formal ceremony in Congress on March 1, 1781, establishing for the first time the government of the United States. On October 19, 1781, British General Cornwallis surrendered his entire force of 8,000 men to George Washington and the Continental Army at Yorktown, Virginia. The long war for independence was over.

Another notable milestone in our nation's history surfaced around this time. Evidence shows a sense of national identity emerging among free Africans who began to consider themselves "African-American." A newly-discovered item in the May 15, 1782 issue of *The Pennsylvania Journal,* a Philadelphia weekly newspaper, offered two printed sermons for sale. The author was identified only as an "African-American." It is the first known appearance of the term "African-American." Previously that term was thought to have originated in 1835 when it was used by William Lloyd Garrison in his abolitionist newspaper *The Liberator*. "It's a very striking usage to see back

in 1782," says Fred Shapiro, associate director at the Yale Law School Library, who found the article and later unearthed one of the sermons.[11]

The African-American sermonizer surely knew of the black slave poet. "With the publication of her book," says Dr. Gates, "Phillis Wheatley, almost immediately, became the most famous African on the face of the earth, the Oprah Winfrey of her time."[12]

As one of the few literate blacks in the colonies, the anonymous author of the sermons would have had good reason to take an interest in the impressive writing of a fellow African. He may have come across Wheatley's stirring tribute *To His Excellency General Washington* in the April 1776 issue of the *Pennsylvania Magazine*. If the African-American sermon writer had the opportunity to read her book, he would have seen the striking portrait of Phillis Wheatley on the first page. He could have taken pride in the dignified image of a young woman of intelligence and learning, though still a slave— a woman who was clearly and unmistakably black.

Phillis Wheatley's poems were well-known in Philadelphia. One of Wheatley's admirers was Julia Rush, wife of prominent Philadelphian, Founding Father, and signer of the Declaration of Independence Dr. Benjamin Rush. Dozens of Wheatley poems intended for publication before her death—most likely the missing poems listed in her 1779 Proposal—were held by the Rush family.

When Wheatley wrote her 1772 elegy, *A Poem on the Death of Charles Eliot, Aged 12 Months*, the boy's uncle, John Andrews, was so impressed by the "flowry language that runs through the whole of it" that he sent the poem to his brother-in-law, a Philadelphia merchant.[13] According to Joanna Brooks, "The infant's mother and her sister Ruthy Barrell Andrews circulated the manuscript among family and friends of the Eliot and Andrews families in Boston and Philadelphia."[14]

Wheatley poems have turned up in the personal possession of some highly educated Philadelphians. The poet Hannah Griffitts, lifelong Philadelphian and contemporary of Phillis Wheatley, kept a copy of her poem *Atheism*.[15] The same poem was found in one of the journals of a student at a Philadelphia Quaker school in the 1770's.[16]

So many of Phillis Wheatley's poems were circulating around Philadelphia at the time, the sermon writer had to know about them.

Evidence linking both Phillis Wheatley and the anonymous African-American to the city of Philadelphia makes it easy to suppose that when the sermon writer composed his discourse, the famous poet who charmed readers with "heavn'nly tidings from the Afric muse" could not have been far from his mind.[17]

In 1782, when the unnamed preacher claimed an African-American identity, he was not alone. The five thousand black soldiers who served in the Continental Army made the ultimate commitment to fight and die for the sake of freedom, standing shoulder to shoulder with their countrymen as proud African-Americans.

What solidified Phillis Wheatley's claim to an African-American identity was her fateful decision in July 1773 to return to Boston after a short stay in London, where she was legally free. Her owner, John Wheatley, granted her freedom soon afterward. Clearly, she saw her future as an African-American poet.

"The world of Phillis Wheatley lay around the American Revolution and the beginnings of a new United States," writes W. E. B. Du Bois. "Black folk of that day were full of hope." Black soldiers, barred from the fight at first, were welcomed into the ranks. One by one, the colonies of New England abolished slavery and Pennsylvania quickly followed. "Soon it seemed all men would be free and equal," says Du Bois.[18]

In her 1784 poem *Liberty and Peace*, Phillis Wheatley laid out her vision for a new American nation. The sacred virtue of Freedom would herald a new era of prosperity for all.

> *So Freedom comes array'd with Charms divine,*
> *And in her Train, commerce and plenty shine.*[19]

After the Revolution, "the situation of black folk in the United States changed. Slavery was no longer dying. It was increasingly excused and defended," says DuBois. "Restriction and discrimination increasingly surrounded the Negro and the iron entered his soul."[20]

During her lifetime and for more than two centuries since, the historic fact that Phillis Wheatley was able to write, publish, and win acclaim as "the Afric Muse" remains an enduring source of pride and inspiration for all Americans. Although she never used the term "African-American," Phillis

Wheatley, the most celebrated African of her time, became the first widely known person of African descent to embrace an American identity. Two years before thousands of black New Englanders, slave and free, put their lives on the line at Lexington and Concord and Bunker Hill to fight for freedom in America, Phillis Wheatley became the first African-American.

# CHAPTER 53

## "As she sits, she writes, and weeps, by turns…"

WHILE SHE WAS IN WILMINGTON, Phillis may have gotten wind of two historic court cases that lifted the spirits of the entire black community in Massachusetts. "Very few slaves outside of New England felt empowered even to challenge their own enslavement," writes Emily Blanck.[1]

The code of laws, written by the Puritans and adopted by the Massachusetts Bay Colony in 1641, proved to be consequential. "Slaves in Massachusetts had access to the same legal system as whites," Blanck says. "Increasingly throughout the eighteenth century, they began to see the court as a place that protected their interests above those of the owner."[2]

These two separate legal decisions rendered slavery in Massachusetts null and void. They were a heartening answer to Phillis Wheatley's prayer for liberty in the new American nation:

> But how, presumptuous shall we hope to find
> Divine acceptance with th'Almighty mind,
> While yet (O deed ungenerous!) they disgrace
> And hold in bondage Afric's blameless race?
> Let virtue reign—and thou accord our prayer.
> Be victory ours and generous freedom theirs.[3]

A jury in Great Barrington heard a case brought by two slaves owned by Colonel John Ashley. Elizabeth, known as Betty or Mum Bett, had no surname so she sued for her freedom under the name "Bett." A second slave, a man called "Brom," joined her suit.

Mum Bett had run from her master and sought help from Theodore Sedgwick, a young lawyer active in the antislavery cause. "I have heard her say, with an emphatic shake of the head: 'Any time while I was a slave, if one minute's freedom had been offered to me and I had been told I must die at

432

the end of that minute, I would have taken it—just to stand one minute on God's earth a free woman—I would," his daughter Catharine Sedgwick wrote.[4]

"She chanced at the village meeting house, in Sheffield, to hear the Declaration of Independence read," according to Catherine Sedgwick, who recalled how Mum Bett approached her father. "I heard that paper read yesterday that says, all men are born equal, and that every man has a right to freedom," Mum Bett told Theodore Sedgwick. "I am not a dumb critter. Won't the law give me my freedom?"[5]

On August 21, 1781, the jury found that according to the Constitution of the Commonwealth of Massachusetts, Mum Bett and Brom could not be considered the property of John Ashley. The court awarded the plaintiffs thirty shillings in damages and declared them free.

One of her first acts as a free woman was to take a new and more dignified name. Mum Bett became Elizabeth Freeman. For the remainder of her life she was hired as caretaker and nurse for the Sedgwicks and became a trusted member of the family.

Elizabeth Freeman earned enough money to purchase her own home in Stockbridge, Massachusetts. She died on December 28, 1829 and was buried in the Sedgwick family cemetery in Stockbridge, between the graves of Theodore Sedgwick and his wife; she is the only African-American and non-Sedgwick interred there. The marble inscription on her headstone reads:

> Elizabeth Freeman, (known by the name of Mum-Bett), died Dec. 28th, 1829. Her supposed age was 85 years. She was born a slave and remained a slave for nearly thirty years: She could neither read nor write; yet in her own sphere she had neither superior or equal. She neither wasted time, or property. She never violated a trust, nor failed to perform a duty. In every situation of domestic trial she was the most efficient helper and the tenderest friend. Good mother, farewell![6]

About the same time Mum Bett and Brom won their freedom, another case brought by an aggrieved slave found its way to a Massachusetts court. In 1781 Quock Walker ran away from his owner, Nathaniel Jennison, after a brutal beating. He sued Jennison for assault and battery. On December 6,

1781, the jury awarded Quock Walker his freedom and ordered Jennison to pay him 50 pounds in damages.

Two years later, the case of the Commonwealth of Massachusetts v. Jennison reached the Supreme Court of Massachusetts. Chief Justice William Cushing instructed the jury to regard slavery as incompatible with the new Massachusetts Constitution:

> These sentiments that are favorable to the natural rights of mankind led the framers of our constitution of government— by which the people of this commonwealth have solemnly bound themselves to each other—to declare that all men are born free and equal; and that every subject is entitled to liberty, and to have it guarded by the laws as well as his life and property.[7]

Judge Cushing left no doubt where the Commonwealth of Massachusetts stood on the institution of slavery.

> Slavery is in my judgment as effectively abolished as it can be by the granting of rights and privileges wholly incompatible and repugnant to its existence. The court are therefore fully of the opinion that perpetual servitude can no longer be tolerated in our government, and that liberty can only be forfeited by some criminal conduct or relinquished by personal consent or contract.[8]

Chief Justice Cushing later commented, "The preceding case was the one in which by the foregoing charge, slavery in Massachusetts was forever abolished."[9]

"The case held so much power that freedom suits ended," Blanck writes. "Slaves stopped having to sue their owners for freedom. Between 1765 and 1783, suits were brought almost annually. After Jennison, no more slaves sued their masters. Mum Bett's case was pulled from appeal because of the Jennison case." Even though no law explicitly abolished slavery, the institution effectively ended. "Slaveowners understood that the courts would not uphold their property rights in owning slaves," says Blanck.[10]

By the 1790 census, Massachusetts became the first state in the United

States to report the number of slaves as zero. Years later, as vice-president, John Adams observed that the downfall of slavery in Massachusetts came because the decision was left for juries to decide. "I never knew a jury by a verdict to determine a Negro to be a slave. They always found them free."[11]

Even though Phillis Wheatley was out of the public eye during her years in Wilmington, she was not forgotten in Boston. A reproduction of her portrait from her 1773 book appeared in *Bickerstaff's Boston Almanack* in 1782.

Small town life apparently weighed heavily on a couple used to the vibrant lifestyle and economic opportunities available in the city. "John Peters apparently found it impossible to support his family in Wilmington," says Richmond, "and soon after the end of the war they decided to return to Boston."[12]

"Phillis returned to Boston with her three children to live for six weeks under the care of Mrs. Elizabeth Wallcutt, a niece of her mistress," says Robinson.[13]

The source for this report was Margaretta Matilda Oddell. "A niece of Mrs. Wheatley's, whose son had been slain in battle, received her beneath her own roof," she wrote.[14]

Mrs. Wallcut's son Christopher, killed fighting the British in 1777, was two years older than his brother Thomas, Phillis's close friend and frequent correspondent.

"This lady was a widow, and not wealthy," Oddell added. "She kept a small day school to increase her narrow income."[15]

"Wallcut operated a day school for 'young Misses,' where the poet may have given lessons to help pay for her room and board," says Richmond.[16]

"They ministered to Phillis and her three suffering children, for six weeks," Oddell wrote. "At the end of that period, Peters came for his wife, and, having provided an apartment, took her thither with her little family."[17]

Phillis was back in Boston by December 29, 1783 when she suffered another devastating loss. The Reverend Dr. Samuel Cooper, one of her strongest supporters, a valued counselor, an inspiration for her art, and a brilliant light in her life, died.

The grieving poet composed her elegy to be read four days later before his congregation at the Brattle Street Church. Mourners attending his

funeral on January 2, 1784 could read her heartfelt poem titled: *An Elegy Sacred to the Memory of that Great Divine, The Reverend And Learned Dr. Samuel Cooper Who Departed This Life December 29, 1783, Aetatis (at the age of) 59,* featured in the eight-page funeral program. The author used her married name, Phillis Peters.

Of the nineteen elegies she composed honoring the lives of dear departed ones and to comfort the living, this one was the most difficult for her. "As she sits, she writes, and weeps, by turns," wrote Phillis. "The hapless Muse, her loss in COOPER mourns."[18]

> *A Friend sincere, whose mild indulgent grace*
> *Encourag'd oft, and oft approv'd her lays.*[19]

Professor John Shields calls these lines "perhaps the most personal remark about another person in her extant oeuvre."[20]

Phillis Wheatley the poet, the woman, the mother, the Christian, was heartbroken at the loss of the minister who baptized her and became her friend. Yet, her faith would not allow even death to break the enduring spiritual bond between them.

> *Still live thy merits, where thy name is known,*
> *As the sweet Rose, its blooming beauty gone*
> *Retains its fragrance with a long perfume:*
> *Thus COOPER! thus thy death-less name shall bloom.*[21]

Phillis Wheatley had known Reverend Samuel Cooper since she was eighteen. They met on August 18, 1771, when the popular pastor of the Brattle Street Church came to the Old South Church to baptize new Christians including Phillis. Over the next two years he came to know her well enough to join the eighteen "most respectable characters in Boston" who signed the "Attestation" for Phillis in her 1773 book.

Reverend Samuel Cooper was known as a strong patriot, even though he avoided politics in the pulpit. His sermons taught spiritual lessons from the Bible. But he was a friend and confidant to Boston firebrands John and Sam Adams and John Hancock, who were parishioners at the Brattle Street Church. Since his church became known as a hotbed of patriotic fervor,

Reverend Cooper was targeted by British authorities and forced to flee Boston to avoid arrest shortly before hostilities broke out at Lexington and Concord in April 1775.

During the Siege of Boston, Reverend Cooper visited General Washington at his headquarters in Cambridge. On December 19, 1775 he wrote in his diary: "Went with Mrs. C. in my horse and chaise to Cambridge. We waited on General Washington, his Lady, Mrs. Gates &c. at Head Quarters. Treated with oranges and a glass of wine."[22]

He returned to Washington's headquarters on March 11, 1776, about a week before the British evacuation, and right around the time of Phillis Wheatley's visit. "Waited on Genl. Washington and Lady, Gates &c," he wrote. "Convers'd with the Genl. and Gates about the Manner of our taking possession of Boston s'd the enemy leave it."[23]

Phillis's outpouring of grief, which inspired such an affectionate portrait shows that they enjoyed a warm friendship. Reverend Cooper remained a strong admirer and supporter of her literary gifts in the years after her baptism. In her own words, Phillis told us that she was "encourag'd" by Reverend Cooper who "oft approv'd her lays."

Professor Shields points out the striking contrast between the elegies she wrote for the two prominent spiritual mentors in her life. "Perhaps of greatest interest in this poem is how vastly different is her treatment of Cooper as a minister from that she gave to Sewall fifteen years earlier."[24]

She was twelve when she wrote *On the Death of the Rev. Dr. Sewell When Sick,* 1765. She had been in America for only four years at the time, navigating the troubled waters of culture shock, learning a new language, and adapting to a strange new world, all without her family, her village, and her natural support system. And most problematic for Phillis was that she was a slave, her body and her being regarded as a piece of property.

When Reverend Samuel Cooper died in December 1783, Phillis Wheatley was a thirty-year-old-woman, a married young mother who had endured the sorrow of burying at least one of her children. She was an acclaimed poet and published author with international stature—and she was free.

She began her elegy to Reverend Cooper expressing her own personal pain.

*O Thou whose exit wraps in boundless woe,*
*For Thee the tears of various Nations flow;*
*For Thee the floods of virtuous sorrows rise*
*From the full heart and burst from streaming eyes...*[25]

Her private heartache comes through as she shares her grief with so many others who were touched and enlightened by Reverend Cooper's goodness and faith.

*What deep-felt sorrow in each kindred breast,*
*With keen sensation rends the heart distress'd!*
*Fraternal love sustains a tenderer part,*
*And mourns a BROTHER with a BROTHER'S heart.*[26]

The standards she used to pay tribute to her departed mentor came not from Christian theology but classical philosophy. "The Virtuous lov'd Thee," she wrote. "The Wise admir'd." She praised him as a teacher whose skillful eloquence and gentle inspiration lifted everyone, particularly nonbelievers.

*And all thy words with rapt attention heard!*
*The Sons of Learning on thy lessons hung,*
*While soft persuasion mov'd th' illit'rate throng...*[27]

*Thy every sentence was with grace inspir'd.*
*And every period with devotion fir'd;*
*Bright Truth thy guide without a dark disguise,*
*And penetration's all-discerning eyes.*[28]

"Cooper has in death achieved no sainthood, nor does the poet make any mention of Jesus, of rebirth in the blood, or of the miracles of Christ," notes Shields.[29]

Compared to her youthful elegy for Reverend Sewall, the poem for Samuel Cooper shows maturity and depth, marked refinement in technical skill, and firm confidence in her mastery as a poet. She allows herself a rare opportunity to bare her emotions. Now she is willing to expose her interior self, even the pain. As 1784 began, Phillis Wheatley was entering a new phase in her evolution as a poet. She was approaching her prime.

# CHAPTER 54

*"So Freedom comes array'd with Charms divine;*
*And in her Train, commerce and plenty shine."*

THE YEAR 1784 WAS PIVOTAL in American history. Peace nego-
tiations with Great Britain, which began six months after the surrender
of Cornwallis at Yorktown in 1781, finally concluded with the Treaty of
Paris on September 3, 1783. When Congress ratified the Treaty of Paris in
January 1784, American independence became a reality.

On Friday, February 27, 1784, a jubilant Boston commemorated the
peace treaty with a day of celebration. "The morning was ushered in with
the ringing of bells and the firing of cannon," a historian for the Old South
Church reported. A parade of dignitaries marched through the streets to
the Old South Meeting House, where the assembly recited prayers, sang
hymns, and heard speeches. "The procession then returned to the State
House from the balcony of which the Secretary of State Mr. Avery made
proclamation of the ratification of the treaty of peace. After this, a salute of
thirteen guns was fired by the artillery company."[1]

Phillis Wheatley "may have been among the Boston spectators at the
February 1784 ceremony that hailed the signing of the Treaty of Peace,"
Robinson believes.[2]

For Phillis Wheatley, and for Boston and all Americans, the turmoil
they had suffered for nearly twenty years was over. Starting with the Stamp
Act riots in 1765, Phillis Wheatley witnessed some of the most disturbing
episodes leading to the American Revolution. These incidents affected her
so deeply she was inspired to compose a number of patriotic poems to cel-
ebrate the courageous American heroes fighting for freedom.

She was fifteen in 1768 when she wrote her first patriotic verses.
*America* portrayed the rising tension between Great Britain and the colo-
nies as an allegory—the Mother Country was depicted as a "certain lady,"
the American colonies the "only son."[3]

That same year she wrote *On the Arrival of the Ships of War and Landing of the Troops,* her account in verse of the British military occupation of Boston, a poem now lost; she also composed her grateful salute to King George, praising his sympathy for the colonies in *To the King's Most Excellent Majesty on His Repealing the American Stamp Act.*

Her angry protest poems reflected the shock of an enraged community. *On the Death of Mr. Snider Murder'd By Richardson,* the first poem of the Revolution, celebrated the "first martyr for the cause."[4]

Phillis Wheatley was probably at home the night of March 5, 1770, when all hell broke loose in the public square around the block from the Wheatley mansion. The raw sounds of chaos, and cursing, stampeding crowds, and the barrage of gunfire that left four dead in the street might have seemed as if it was happening outside her window.

Like all Boston, seventeen-year-old Phillis was deeply troubled by the bloody Boston Massacre that traumatized her city. She was moved to memorialize the valiant honor of the brave martyrs who died for "Freedom's Cause" in her poem *On the Affray in King Street on the Evening of the 5th of March.*

In 1774, after British troops closed the port of Boston, thousands fled, including Phillis. On behalf of all Bostonians, she took it upon herself to welcome the new "Generalissimo of the armies of North America" to the fight. Her poem *To His Excellency George Washington* was an exhilarating tribute showering him with accolades, crowning him with glory, bestowing honors befitting the savior of a city. Phillis Wheatley wanted General Washington to know that the hopes of Boston were riding on his shoulders.

As the war for independence dragged on, Phillis Wheatley wrote two private tributes that were not published in her lifetime: *On the Capture of General Lee* and *On the Death of General Wooster.* They praised two men she believed were American heroes whose sacrifice elevated the ideal of freedom.

With these literary salvos, Phillis Wheatley marched directly into the thick of the war effort. She reinforced the patriots' Glorious Cause with the best weapon at her disposal—her eloquent verses.

After Boston celebrated the Treaty of Paris, ushering in a free and independent nation, Phillis Wheatley wrote her most triumphal ode to

America. In February 1784, *Liberty and Peace* was published as a four-page pamphlet under the name Phillis Peters. Exuding triumphal optimism and reveling in the new hope of freedom, "she jubilantly praised the end of the American Revolutionary War and proudly hailed the birth of the United States of America," says Robinson.[5]

The poem begins with a shout of joy. The exultant poet proclaims the good news: the long bloody war is finally over. The most cherished aim of the patriots has been realized.

"LO!" she cries. "Freedom comes!"[6]

Phillis took the opportunity to remind her countrymen that she had forecast the American triumph in an earlier poetic vision. "Wheatley proudly quotes her own description of Columbia from her 1775 poem to Washington," says Mason.[7]

She lifted her own words and brought them back nine years later, knowing that they were approved by Washington himself. Now she was reminding him, rather brazenly, that since those words were written before the new Continental Army had ever left camp, she had remained strong and resolute in her hope for America. Her faith in Washington never wavered, even as the fight for independence was just beginning.

Phillis returned to the audacious prediction she made while Boston was still an occupied city, recalling what the "prescient Muse foretold" so that "all eyes th' accomplish'd Prophecy behold."[8]

"The goddess comes; she moves divinely fair. Olive and Laurel bind her golden hair," she wrote in 1775.[9] Now she wanted America to know that her prediction of glorious victory had come true in 1784. Just as the ancient Greeks placed the crown of olive leaves upon the heads of victorious Olympians, now that triumphal laurel adorned the head of Columbia, the goddess Wheatley imagined as the sacred symbol of America.

> *She, the bright Progeny of Heaven, descends,*
> *And every Grace her sovereign step attends;*
> *For now kind Heaven, indulgent to our Prayer,*
> *In smiling Peace resolves the din of War.*
>
> *Fix'd in Columbia, her illustrious line,*
> *And bids in thee her future councils shine.*[10]

The fervent prayers of all Americans had been answered. God granted them peace. For Columbia, Child of Heaven, prosperity and good fortune seemed to be America's destiny.

> *Descending Peace and Power of War confounds;*
> *From every tongue celestial, Peace resounds:*
> *As for the east, th' illustrious King of Day,*
> *With rising Radiance drives the shades away;*
> *So Freedom comes array'd with Charms divine,*
> *And in her Train, commerce and plenty shine.*[11]

In the eleven years since her own liberation, Wheatley used her poetry repeatedly to testify for the primal need for freedom. "In every human breast God has implanted a principle, which we call Love of Freedom," she wrote, six months after earning her own freedom. Speaking for her enslaved African brothers and sisters in relating her own personal experience, she declared: "It is impatient of oppression, and pants for deliverance."[12]

Phillis showed how closely she followed news of the war by presenting a retrospective on the war effort seasoned with historical context to explain how the Americans achieved their stunning victory over the most powerful military the world had ever known.

> *E'en great Brittania sees with dread Surprize,*
> *And from the dazzling Splendor turns her eyes!*
> *Britain, whose Navies swept th' Atlantic o'er,*
> *And Thunder sent to every distant shore;*[13]

Bullied by a tyrant, America fought back gallantly. Phillis's reference to "fair Hibernia" (the Irish people) probably means the timely declaration by General Washington after a bleak and bitter winter that his troops should celebrate the festive holiday of St. Patrick's Day on March 17, 1780. St. Patrick's Day was particularly significant for Washington and for all Bostonians. It was on March 17, 1776 that the British evacuated the city and the Continental Army had its first victory.

> *With heartfelt pity, fair Hibernia saw*
> *Columbia menac'd by the Tyrant's Law.*[14]

She described the battles, the frenzied killings, and the deranged animosity between English-speaking brothers.

> *On hostile fields, fraternal Arms engage,*
> *And mutual deaths, all death with mutual rage:*[15]

She herself, by "the Muse's Ear," heard "Mother Earth's" lament at the tragedy playing out in blood on her own fertile fields.

> *The Muse's Ear hears Mother Earth deplore*
> *Her ample surface smoak with kindred Gore:*[16]

America was devastated while her enemy, the contemptuous British, plundered and wreaked destruction.

> *Columbia mourns, the haughty Foes deride,*
> *Her Treasures plunder'd, and her Towns destroy'd:*[17]

The poet described the horrific scene as the town of Charlestown burned during the ferocious fighting at the Battle of Bunker Hill on June 17, 1775, an event she probably witnessed. The exploding inferno lit up the sky all over Boston as buildings across the river were incinerated and reduced to ashes in an hour.

> *Witness how Charlestown's curling Smoaks arise,*
> *In sable columns to the clouded skies!*
> *The ample dome, high-wrought with curious toil,*
> *In one sad hour, the savage troops despoil.*[18]

Acknowledging the crucial military assistance of France—it was the French navy who trapped Cornwallis in Yorktown—Phillis hailed the new friendship with a special salute to King Louis XVI.

> *For Galia's Power espous'd Columbia's Cause,*
> *And newborn Rome shall give Britannia Law,*
> *Nor unremember'd in the grateful strain,*
> *Shall princely Louis' friendly deeds remain;*[19]

Now that it was over, she was clear about who was to blame for the fight. Pinpointing the cause of this great conflagration, she declared that the poison at the source of such brutal oppression had been pulled out by the roots.

> *Perish that thirst of boundless Power that drew*
> *On Albion's Head the Curse to Tyrants due...*
> *Now sheathe the Sword that bade the Brave attone*
> *With guiltless Blood for Madness not their own.*[20]

She used the ancient Latin term "Albion," from *albus*, meaning "white" (suggesting the English white cliffs of Dover), to describe a chastened, defeated Britain, now made to abide by the terms of surrender. It was God's will that Great Britain must now and forevermore live among nations including a free America.

> *But thou appeas'd submit to Heaven's decree,*
> *That bids this Realm of Freedom rival thee!*[21]

She honors the success of the American Revolution by recognizing that the real victory belongs to the Power of Peace. Light has come and destroyed the darkness.

> *Descending Peace and Power of War confounds;*
> *From every tongue celestial, Peace resounds:*
> *As for the east, th' illustrious King of Day,*
> *With rising Radiance drives the shades away;*[22]

In her vision for a new America, the virtue of Freedom rests at its core, bringing an era of prosperity for all.

> *So Freedom comes array'd with Charms divine,*
> *And in her Train, commerce and plenty shine.*[23]

From where she stood in 1784, it must have appeared to Phillis Wheatley that the momentum of history was moving the new nation toward an ideal of freedom that would include all enslaved Africans. When Phillis visited General Washington at his headquarters, she could see black soldiers and

white soldiers marching side by side preparing for battle. She saw the law opening doors to freedom, including her own. She was certainly aware of Justice Cushing's ruling that "all men are born free and equal; and that every subject is entitled to liberty" under the Massachusetts Constitution.[24] She had to be thrilled every time she recalled that the moral foundation for the Revolution rested on the immortal words of the American Declaration of Independence:

> We hold these truths to be self-evident, that all men are created equal, that they are endowed by their Creator with certain unalienable Rights, that among these are Life, Liberty and the Pursuit of Happiness.[25]

In 1784 Phillis Wheatley was confident that the nation's disgrace, the vicious atrocity of slavery, was on its way to extinction. "Black folk of that day were full of hope," wrote W. E. B. Du Bois. "Soon it seemed all men would be free and equal."[26]

Phillis Wheatley wrote to exalt this sacred promise, "Heavenly Freedom... array'd with Charms Divine" that filled her with boundless hope for America.[27]

The last lines of *Liberty and Peace* call up the image of a flaming torch, the sacred light of freedom. That "Golden Ray" touches every part of the nation, bathing its people in Divine Glory. It is the source of her unshakeable faith in the advent of freedom, the reason for her deep conviction that the new American nation was sanctified by God.

> *Auspicious Heaven shall fill with fav'ring Gales,*
> *Where e'er Columbia spreads her swelling Sails:*
> *To every Realm shall Peace her charms display,*
> *And Heavenly Freedom spread her Golden Ray.*[28]

"Wheatley has captured, perhaps for the first time in poetry, America's ideal mission to the rest of the world," writes John Shields, "a mission which the country pursues now with the most profound sense of duty and urgency in its two hundred years of participation in world affairs."[29]

Phillis Wheatley had been writing poetry to honor and inspire American patriots for sixteen years. "Wheatley's straightforward and

forceful political poems chronicle with dutiful loyalty important moments of the American Revolution and should grant her recognition as certainly the most ardent female poet of the Revolution," argues Shields.[30]

Even if Phillis Wheatley had not written any other poem, if *Liberty and Peace* was her only contribution to the American Revolution, it would merit serious consideration as one of the great literary achievements of this young nation. Celebrating the dawn of a new era, *Liberty and Peace* was Phillis Wheatley's last known poem.

# CHAPTER 55

"But oh! Suppress the clouds of grief that roll;
Invading peace and dark'ning all the soul…"

1784 WAS ALSO A BANNER year for Phillis Wheatley. Nine of her poems were published that year. Not since 1773, when her book had appeared, did she see more of her works in print.

Pennsylvania poet Charles Crawford included *To a Clergyman on the Death of His Lady* in his book *Observations Upon Negro Slavery* that year. "The celebrated Phillis Wheatley may be produced as an instance of extraordinary genius," Crawford wrote. "It would be difficult perhaps to name any living person as being endowed with superior talents for poetry."[1]

Phillis herself arranged for three new poems to be published: *Elegy Sacred to the Memory of That Great Divine, The Reverend and Learned Dr. Samuel Cooper* on January 2; *To Mr. and Mrs. – On the Death of Their Infant Son* featured in the advertisement for her next book in September; and *Liberty and Peace* after Boston celebrated the Treaty of Paris.

That year five poems from her 1773 book appeared in London's *Arminian Magazine*, a Methodist journal. "Methodists in England appeared to have retained an admiration for her work," writes Wheatley scholar Mukhtar Ali Isani.[2] "Although Wheatley's visit to London had occurred ten years before, there were many who could have remembered her, especially those in Methodist circles."[3]

Her long association with the British Methodist movement began in 1770, when she was a teenage slave, with her *Elegiac Poem on the Death of George Whitefield*. Her Methodist connections included some of the most influential religious figures in Britain: her patron, the Countess of Huntingdon, and John Thornton, a mentor to Phillis—she called them "my friends in England."[4]

Isani suggests that the publication of these Wheatley poems indicates that "Methodist dignitaries in England might have stayed in touch with her longer than has been assumed."[5]

Sometime after her London visit in 1773, Anglican priest and theologian John Wesley, one of the founders of Methodism, became enamored with her poetry. Wesley started the *Arminian Magazine* in 1778 to spread the Methodist gospel in England. His stated mission was "to publish some of the most remarkable tracts on the Universal Love of God and His willingness to save all men from sin."[6]

Wesley picked up three poems from Wheatley's book for his December 1781 issue: *On the Death of a Young Miss, Aged 5 years; On the Death of a Young Gentleman;* and *Thoughts on the Works of Providence.* Isani points out that Wesley published Wheatley's poems in 1781 and again three years later. "The dates of the publication raise the possibility that some well-wisher was forwarding the poems at the times of Wheatley's need," he says. First, 1781 was "a year after Wheatley had tried and failed to interest Americans in a second collection of her poems, the proposals for which appeared for six weeks in the *Boston Evening Post.*" Then in 1784, when "Wheatley was appealing for subscriptions in America, this time in the *Boston Magazine,* the *Arminian* published more of her poems."[7]

Isani concludes that the mix of poems Wesley chose to publish "is plausible evidence that he received the verses from someone associated with Wheatley's efforts to publish *Poems on Various Subjects* or one who was still in correspondence with the poet."[8]

In 1784, Wesley ran these Phillis Wheatley poems in the *Arminian*:

- *To The Honourable T.H. Esq. on the Death of His Daughter,* February 1784.
- *To S. M. a Young African Painter on Seeing His Works,* April, 1784.
- *To the Right Honourable William, Earl of Dartmouth, His Majesty's Principal Secretary of State for North America,* July, 1784.
- *On the Death of J.C. An Infant,* November, 1784.
- *On Imagination,* December, 1784.

"We do not know if she even knew that they were going to be published, much less had some direct hand in bringing that about," Mason

writes, although he points to the "fact that no other of her poems were published in the London *Arminian* after her death in December 1784."[9]

Isani believes that Wesley had access to Phillis's manuscript drafts , which remained in London after she returned to Boston. "Among the manuscripts she left behind, possibly a choice of versions, was available to Archibald Bell, the printer, and to others overseeing the project."[10]

One poem Wesley published in the *Arminian* was inadvertently misattributed to Phillis Wheatley. In 1986 Isani discovered *An Elegy on Leaving* in the July 1784 issue. "There is no uncertainty in the editor's attribution of the poem to Wheatley," he says. "It is the second of two poems by Wheatley. Having identified the first work as 'the work of Phillis Wheatley, a Negro,' the editor was content to mark the second as 'by the same.'"[11]

Isani believed it was "Phillis Wheatley's last publication during her lifetime."[12] "The poem's importance is mainly historical," he said and it has been included in every recent collection of Wheatley poems.[13]

In 2012, University of Mississippi Professor Caroline Wigginton discovered that very poem, *An Elegy on Leaving,* in a book by English poet Mary Whateley (1738-1825). Reading through Whateley's collection, *Original Poems on Several Occasions*, published in 1764, Wigginton found the verses mistakenly credited to Phillis Wheatley right there on page 34.

> *Farewell! Ye friendly bowers, ye streams, adieu,*
> *I leave with sorrow each sequestered seat:*
> *The lawns, where oft I swept the morning dew,*
> *The groves, from noon-tide rays a kind retreat...*[14]

Wigginton did not fault Isani nor subsequent Wheatley scholars for taking John Wesley at his word. The confounding of the names Wheatley/ Whately likely played a role in what appears to be an honest mistake. "The source of the current misattribution of Whateley's poem as Wheatley's lies in the eighteenth century," she writes. "In identifying *An Elegy on Leaving* as a 'New Poem by Phillis Wheatley,' Isani follows the *Arminian Magazine.*"[15]

Meanwhile, Phillis was not entirely forgotten in Boston. On May 20, 1784, the *Independent Chronicle and Universal Advertiser* published a poem by Mr. Heman Harris with a salute to the black poet.

*And to delight the studious mind,*
*I'd in the next gradation find*
*The Poets in a pleasing throng,*
*From the great source of Grecian Song*
*That shines in the page*
*Down to the Phillis of our age.*[16]

Carretta reports that Phillis and her husband "were definitely back in Boston by June 1784" when John Peters won a legal judgment against Joseph Scott, a Boston merchant with whom he had been wrangling in the courts for eight years. It was an effort by Peters "to try to get back on his feet."[17]

John Peters kept trying to make a go of it. On July 28, 1784, he petitioned town officials for permission to sell liquor at his shop on Prince Street in Boston's North End. "Since such stores rented for nearly 30 pounds a year, his fortunes had obviously taken a turn for the better," says Richmond.[18]

Carretta notes that the original petition written and signed by John Peters stated that he was applying for a business permit "for the purpose of supporting himself & family."[19] It was the only known occasion John Peters ever referred to his marriage to Phillis Wheatley.

Peters's petition for a business license was granted by Boston town clerk William Cooper, whose brother Samuel Cooper had baptized Phillis thirteen years earlier. This primary source document provides official testimony vouching for the upright character of John Peters.

> The selectmen of Boston hereby certify that the within named petitioner as a person of sober life & conversation suitably qualified & provided for the exercise of the employment of a retailer of spirituous liquors. By order of the Selectmen, William Cooper, Town Clerk.[20]

Before summer was over, the business that Peters started "for supporting himself and his family" suddenly crashed. His precarious financial situation finally caught up with him. Town records for September 1, 1784 list "Jno Peters Negro" as owning one "Dwellg House" in Ward 7, adding a chilling note: "In prison for debt."[21]

In his essay "Phillis Wheatley, the Negro Slave Poet" published in the 1864 *Journal of the Massachusetts Historical Society*, Dr. Nathaniel B. Shurtleff, later to become mayor of Boston, confirmed that John Peters did a stint in prison. "In 1784," Shurtleff wrote, "he was forced to relieve himself of debt by an imprisonment in the county jail."[22]

The disastrous meltdown of the American economy after the Revolutionary War took its toll on the Peters family. "From September 1784 until early 1788 Peters was frequently imprisoned in the Suffolk County, Massachusetts jail for debt, at least occasionally for weeks at a time," says Carretta.[23]

Phillis was now alone. Her support system had completely vanished. The death of Nathaniel Wheatley in the summer of 1783 marked the end of her connection to the Wheatley family. He was "the last of her natural protectors," said Shurtleff. "Sadder times, however, came to Phillis," he wrote. "About this time she lost two of the three children born to her and her husband in the days of extreme poverty and distress."[24]

With her husband out of the picture, Phillis Wheatley had to find a way to support herself and her one remaining child. So she turned to what she did best. Using her Boston connections she placed an advertisement for another proposal for a second volume of her writings in the September 1784 issue of the *Boston Magazine*.

The advertisement featured a previously unpublished poem, *To Mr. and Mrs. – On the Death of Their Infant Son*. "It is a typical Wheatley elegy," says Robinson, "such as she has been writing for almost fifteen years."[25]

Her poem appeared with a short paragraph advertising her proposed book in the "Poetical Essays" section of the *Boston Magazine* for September 1784:

> The poem in page 488 of this number was selected from a manuscript volume of poems written by Phillis Peters, formerly Phillis Wheatley, and is inserted as a specimen of her work; should this gain the approbation of the publick and sufficient encouragement given, a volume will be shortly published by the printers hereof, who receive subscriptions for said work.[26]

The difference between her sophisticated and self-assured 1779 Proposal and her 1784 Proposal is striking. Her previous marketing effort was a well-crafted promotion filled with strategic product details taking up more than a full column on the front page of one of Boston's leading newspapers. It ran once a week for six weeks. This latest effort seemed rushed, almost desperate. There was little advertising copy and only one poem to attract the reading public.

Her 1784 book proposal showed that her ambition to publish was still there. "She took her poetry writing and publication quite seriously," says Robinson. "She was just as anxious to display a talented black poet's wares to a doubting white public. Towards these ends, she preserved her manuscripts for years, waiting for the opportunity to publish them."[27]

A fascinating pattern emerges in the progress of her poetic career, particularly after she was married. Carretta observes that Phillis Wheatley took the initiative to place advertisements for her new book only when her husband was absent. "During her marriage to Peters, Phillis most actively publicly pursued her calling as a poet when he was probably either out of town in 1779 or incarcerated in 1784."[28] "When she was on her own, she showed some of the same business acumen she had displayed in the production and distribution of her *Poems* before she married Peters."[29]

Of the thirty-three new poems in her proposed book, why did she choose that particular poem, *To Mr. and Mrs. – On the Death of Their Infant Son,* as a marketing tool to attract potential readers?

The fact that she featured an elegy to represent her work is not surprising. "One of the reasons for her many elegies was the prevalence of the genre in her place and time, and she was good at writing it," says Mason. "In her elegies, hope and love and faith usually firmly triumph over death—there can be no doubt about that. She knew what was wanted and needed in such circumstances."[30]

Writing elegies was her strong suit. "She possessed a near perfect pitch when it came to pitting poem to circumstance; she wrote about the right people and with the right tone—dignitaries, the famous dead, grand public figures, and sympathy-inducing grievers," says Rowan Ricardo Phillips.[31]

Phillis knew that her most popular poems were elegies; many of them had been written by request. "The combination of her firm and forthright

religious faith and a lively, pleasing and gentle personality also contributed to her being called on so much for this service," Mason writes. "Of the forty-six poems we know were published during her lifetime, twenty were on death. Apparently, her first poem dealt with death and her last one may have also."[32]

Her new book was supposed to contain nine new elegies. Why would she feature this particular elegy in her advertisement?

One possible explanation is that at the time she submitted her work to the *Boston Magazine* in September 1784, this poem may have struck a personal chord that resonated deeper than any of the others.

The poem opens with a dramatic confrontation. The departed child's grieving parents address Death itself.

> *O Death! Whose scepter, trembling realms obey,*
> *And weeping millions mourn thy savage sway;*
> *Say, shall we call thee by the name of friend,*
> *Who blasts our joys and bids our glories end?*[33]

As any parents would, they fondly recalled their dear baby boy, reliving precious moments filled with delight and looking toward a hopeful future.

> *Behold, a child who rivals op'ning morn,*
> *When its first beams the eastern hills adorn;*
> *So sweetly blooming once that lovely boy,*
> *His father's hope, his mother's only joy;*[34]

Then the poet watches in horror as "the beauteous infant lays his weary head" and the life oozes out of him. She laments that all his "charms" and "innocence" failed to save him "from the grim monarch of the gloomy grave!"

Witnessing helplessly as he takes his last struggling breath, she sees the child's eternal spirit rising to heaven's gate while hearing celestial choirs announce the arrival of "his guardian angel" who will carry her blessed son to "his immortal throne." She imagines her child, in death, as "his heart expands" in wonder.

> *He sinks—he dies—celestial muse, relate,*
> *His spirit's entrance at the sacred gate.*

*Methinks I hear the heav'nly courts resound,*
*The recent theme inspires the choirs around.*

*His guardian angel with delight unknown,*
*Hails his bless'd charge on his immortal throne;*
*His heart expands at scenes unknown before,*
*Dominions praise, and prostrate thrones adore;*[35]

Celestial angels accompany "his entrance," taking the boy by "his soft hand," and sitting him "on his throne." "Smiling" at him, they speak, welcoming the innocent child to "glad heaven" where he will remain forever "exempt from pain and woes," and will be "born to new life."

*"Hail: thou! Thrice welcome to this happy shore,*
*Born to new life where changes are no more;*
*Glad heaven receives thee, and thy God bestows,*
*Immortal youth exempt from pain and woes.*
*Sorrow and sin, those foes to human rest,*
*Forever banish'd from thy happy breast."*[36]

The grieving young mother can rest in comfort knowing that her dear departed son is in a place where "all heav'n rejoices." The child can now sing "heavenly airs."

*All heav'n rejoices as your ——- sings,*
*To heavenly airs he tunes the sounding strings;*[37]

But the poet has to acknowledge the reality of mourning: broken hearts are not easily healed. The despondent parents cannot escape thinking of their beloved child. They long to see him again, reaching out in a desperate attempt to hold him once more, soon finding that they can't. Their dear lost child has become an "illusive fancy," disappearing into the night.

*Meantime, on earth, the hapless parents mourn,*
*"Too quickly fled, ah! Never to return."*
*Thee, the vain visions of the night restore,*
*Illusive fancy paints the phantom o'er;*
*Fain would we clasp him, but he wings his flight;*
*Deceives our arms, and mixes with the night;*[38]

The poet ends with a plea for the grieving parents to accept the divine order. Even if their most fervent wish was granted and heaven did "restore him to your arms again," what would be gained? Their precious son would be "oppress'd with woes" in "a painful endless train." She comes to the comforting realization that through the grace of eternal life, their sweet darling child is not really dead but alive in spirit where he belongs.

> *But oh! Suppress the clouds of grief that roll,*
> *Invading peace and dark'ning all the soul.*
> *Should heaven restore him to your arms again,*
> *Oppress'd with woes, a painful endless train,*
> *How would your prayers, your ardent wishes rise,*
> *Safe to repose him in his native skies.*[39]

Is this poem something of a personal statement by Phillis Wheatley, a young mother who suffered the premature deaths of her own children? Was the poet expressing her own private grief over the painful loss of her dear babies?

Words bubbling up from a writer's subconscious mind take form as ideas and images. For Phillis Wheatley, still mourning her own lost children, it is inconceivable that her profound sense of loss would not rise up from the swirl of emotions as she composed the final version of this poem. We can easily see how her throbbing anguish would come flooding back into her awareness as she relived the last moments of her own dying babies.

As Toni Morrison points out, the creative process is universal. Surely this applied as much to eighteenth-century writers as it does today. "The act of imagination is bound up with memory," the Nobel Laureate explains. "Writers are like that, remembering where we were, what valley we ran though, what the banks were like, the light that was there and the route back to our original place. It is emotional memory—what the nerves and the skin remember as well as how it appeared. And a rush of imagination is our 'flooding.'"[40]

We cannot read Phillis Wheatley's last poem *To Mr. and Mrs. – On the Death of Their Infant Son* without acknowledging the role the death of her own infant children may have played in its composition as it appeared in September 1784. "Suppress the clouds of grief that roll/Invading peace

and dark'ning all the soul," she wrote as a way of healing the wounds of her own heartbreak. It was the poem she chose to represent her collected works. And it was the last poem she ever published.

# CHAPTER 56

*"Last Lord's Day, died Mrs. Phillis Peters, formerly
Phillis Wheatley, aged 31, known to the literary world by
her celebrated miscellaneous Poems."*

PHILLIS WHEATLEY'S FINAL PUSH FOR her second book of
poems went nowhere. Once again the poet's long and arduous effort to see
her work in print was dashed. "This would represent the thirteenth time
she had printed solicitations for Boston subscribers for two of her volumes
of writings," says Robinson. "As in 1772 and 1773, so in 1779 and finally in
1784, her proposals were rejected."[1]

Three months after the advertisement for her book appeared, Phillis
Wheatley was dead. She had been writing and publishing poems since 1767
in a career spanning seventeen years. Her body of work was now complete.
"She had published at least forty-six poems during her lifetime," Mason
says, "and had written a good many more (of which ten have now been pub-
lished)....In her brief life of thirty-one years, she had accomplished a great
deal despite circumstances that would have suggested that she either could
not or would not be able to do so."[2]

By the time she died, Phillis Wheatley had established herself as a
widely respected African-American poet. Nowhere was she more popular
than in New England where her poems appeared in newspapers, magazines,
broadsides, and pamphlets, and she was highly regarded in Britain as well.

But despite her popularity and much critical praise, no American pub-
lisher was willing to support her literary efforts. In 1784 the United States of
America was not ready for a book by a black woman. Now with her husband
in prison, Phillis Wheatley was the only means of support for herself and her
children. She would have to find employment in an economically depressed
market that limited free blacks to the most degrading menial work.

"Poor Phillis!" Nathaniel Shurtleff lamented, "was obliged to earn her own
subsistence in a common negro boarding house at the west part of the town."[3]

"It was probably a dismal neighborhood," says Richmond. "By the late 18th century, segregated black ghettos had already begun to sprout up in many New England communities."[4]

While she was a Wheatley slave, the family was tolerant of Phillis's infirmities and sought the best medical help for her disabling asthma. Her tasks were limited to light housework and her primary role in the Wheatley house was to create poetry.

But now that she was on her own, tough circumstances demanded that she find work wherever she could. Employers would soon see the poet struggling with the routine chores of household maintenance, cooking, cleaning, laundering, and running errands. "It was menial work, the kind of hard drudgery she had been spared in the Wheatley household," says Richmond. "And now there was no dispensation to drop the broom or dust-cloth when she was struck by a poetic line or image."[5]

The demands of working and caring for her only remaining child took their toll. Her health continued to deteriorate. Winters were always difficult for Phillis Wheatley. The brutal cold often triggered her asthma condition.

According to Oddell, members of the Wheatley family got wind of Phillis's plight and made it their business to find her. "At length a relative of her lamented mistress heard of her illness, and sought her out," said Oddell. "She was also visited by several other members of that family."[6]

Oddell identified them as "grand-nieces" of Susanna Wheatley who were still around fifty years later to share their recollections. Although these surviving Wheatley family members were quite elderly when she interviewed them, Oddell assured us that they "have a distinct and vivid remembrance both of their excellent relative and her admired protégée (Phillis)." Their statements were corroborated "by a grand-daughter of that lady (Susanna Wheatley), now residing in Boston."[7]

Robinson later identified Susanna Wheatley's granddaughter as Jane Tyler Lathrop, daughter of Mary Wheatley Lathrop and Rev. John Lathrop.[8]

Oddell went on to describe what she heard from the Wheatley grand-nieces who visited Phillis.

> They found her in a situation of extreme misery. Two of her children were dead, and the third was sick unto death. She was

herself suffering for want of attention, for many comforts, and that greatest of all comforts in sickness—cleanliness. She was reduced to a condition too loathsome to describe.

"It is painful to dwell upon the closing scene," she moaned.

In a filthy apartment, in an obscure part of the metropolis, lay the dying mother, and the wasting child. The woman who had stood honored and respected in the presence of the wise and good of that country which was hers by adoption, or rather compulsion, who had graced the ancient halls of Old England, and rolled about in the splendid equipages of the proud nobles of Britain, was now numbering the last hours of life in a state of the most abject misery, surrounded by all the emblems of squalid poverty![9]

"As she lay dying in her squalid lodgings, her one intimate companion was her third-born infant, also mortally ill," writes Richmond. "Her husband was not at her side. The only clue as to his possible whereabouts when his wife and child were on their deathbed appears in the records of the Massachusetts Historical Society: In 1784...he was forced to relieve himself of debt by an imprisonment in the county jail."[10]

In his lyrical meditation on Phillis Wheatley's enduring impact on African-American literature, W. E. B. Du Bois imagined the horror of her final moments.

Boston lay still freezing beneath a blanket of soiled snow. Phillis looked out of her attic window on black and staggering buildings, through broken panes and fog. Within was cold and hunger. On a pallet her last child lay dying, moaning and rolling her little head. All others were gone—family, husband, friends. Phillis leaned against the wall back of the bed, fronting the window. Her body was wracked with pain, the child became a gasp. The falling snow without grew whiter and thicker, until it seemed to take the form of Death.[11]

December in Boston is a time when the weather becomes highly volatile, changing rapidly from unseasonably warm to blustery and frigid.

Roaring blizzards can dump a foot of snow. Knowing that brutal cold was coming, Phillis Wheatley surely expected a dangerous surge in her chronic asthma. The attacks came suddenly. The passages in her lungs swelled and tightened, restricting the flow of air. The simple urge to inhale and exhale became a massive effort, accompanied by a rough and rasping wheeze. Each moment brought a new wave of dread as the young woman succumbed to the crushing fear that her very next breath could be her last.

One recent asthma sufferer described an attack this way:

> Everything was closing in around my throat and chest; I felt a frightening internal claustrophobia, a sense of metabolic urgency rapidly mounting toward panic...a sudden, overwhelming assault that stormed through my whole body, seizing my throat and suffocating me...My sinuses were now completely solid and swelling, further pressing against my cheeks and eyes. My face, ears and neck were burning...I felt my chest and throat tightening around my windpipe. My upper body had BECOME panic.[12]

As she struggled for each gulp of air, Phillis Wheatley could see her baby, so beautiful, so tiny, so frail, who lay dying beside her. The excruciating intensity of the moment had to be truly horrific. She was thoroughly incapacitated, with every last ounce of her life's energy consumed by her own desperate battle to breathe. Helpless and broken herself, there was nothing she could do to save her child.

The tormented young mother would want to force her head up enough to catch a glimpse of her fading little angel. She might try calling her baby's name but even that feeble effort would defeat her. The only sound she could manage was a low unintelligible growl barely more than a whisper.

> *Behold, a child who rivals op'ning morn,*
> *When its first beams the eastern hills adorn;*
> *So sweetly blooming once that lovely boy,*
> *His father's hope, his mother's only joy,*[13]

Phillis would pray fervently, feverishly, airing an urgent appeal for divine salvation, calling on supernatural forces to help her and her child. As her life slipped away, it was the only thing she could do.

*Nor charms nor innocence prevail to save,*
*From the grim monarch of the gloomy grave!*
*Two moons revolve when lo! among the dead*
*The beauteous infant lays his weary head.*[14]

Huddled in the cold, soulless room, Phillis and her baby faced the end. Nobody knows who passed away first. Either way, it had to be a moment of unimaginable anguish. What tragedy could be more searing than looking on helplessly as your own child dies? Or, knowing that soon you will be gone, maybe even with your next failed breath, and you will have to abandon your sweet, lovely baby.

*For long he strove, the tyrant to withstand,*
*And the dread terrors of his iron hand;*
*Vain was his strife, with the relentless power,*
*His efforts weak; and this his mortal hour;*
*He sinks—he dies—celestial muse, relate,*
*His spirit's entrance at the sacred gate.*[15]

"The child died," W. E. B. Du Bois wrote. "And it was as if Death took Phillis up into his mighty arms where she lay black and frail with star-shine in her uncurbed hair, with crimson drops on her lips. Her great black eyes were straining upwards."[16]

It was Sunday, December 5, 1784. Du Bois drew a ghastly picture of the poet's tragic final verse.

She lay stark and stiff, thin as a skeleton, worn to a shadow, her little dark hands crossed on her flat chest, clasping three lilies. Her crinkled hair formed a dim halo about her head.[17]

Nobody knows how long the bodies lay rotting in the room before somebody discovered them. "The friends of Phillis, who had visited her in her sickness, knew not of her death," said Oddell.[18]

The Wheatleys, unaware that her husband was in prison, complained that "Peters did not see fit to acquaint them with the event, or to notify them of her interment."[19]

Only by happenstance did a relative of Susanna Wheatley come upon the funeral as it was taking place. "A grand-niece of Phillis's benefactress,

passing up Court Street, met the funeral of an adult and a child," Oddell wrote. "A bystander informed her they were bearing Phillis Wheatley to that silent mansion where the wicked cease from troubling, and the weary are at rest. They laid her away in her solitary grave, without a stone to tell that one so good and so gifted sleeps beneath."[20]

"Her child was buried beside her," says Richmond. "No gravestone has ever been found."[21]

A brief funeral notice ran in the *Massachusetts Centinel* and the *Massachusetts Independent Chronicle and Universal Advertiser* on December 8, 1784. "Her obituary was reprinted in Boston and Connecticut newspapers for December 9, 14, 15 and 16, 1784 and in the *Boston Magazine* for December 1784," notes Robinson.[22]

> Last Lord's Day, died Mrs. Phillis Peters, formerly Phillis Wheatley, aged 31, known to the literary world by her celebrated miscellaneous Poems. Her funeral is to be this afternoon at 4 o'clock, from the house lately improved by Mr. Todd, nearly opposite Dr. Bulfinch's at West Boston, where her friends and acquaintances are desired to attend.[23]

We do not know where Phillis Wheatley was buried, but Robinson uncovered some telling clues. Her obituary identifies the site of her funeral as "the house lately improved by Mr. Todd, nearly opposite Dr. Bulfinch's at West Boston." According to Robinson, "This newly renovated home was situated in one of the most prestigious of 18th century Boston's neighborhoods" located on "the westerly end of Court Street."

> But as her funeral was reportedly viewed by "a grandniece of Phillis's benefactress who was passing up Court Street (Queen Street, in Phillis's day), and as it was a cold December, she was probably carried to the Old Granary Burial Grounds on Tremont Street, for it was only a few blocks from Court Street (Queen Street).[24]

Robinson believes that it was the "Old Granary Burial Grounds on the corner of today's Tremont and Park Streets...where Phillis was probably buried on December 8, 1784, in an unmarked grave."[25]

Carretta adds that Dr. Thomas Bulfinch, brother-in-law of Reverend Samuel Cooper, a man dear to Phillis, owned a mansion close to the cemetery. "The proximity of Bulfinch's house to the Granary Burial Ground suggests that Phillis may have been buried close to her former owners and their daughter Sarah."[26]

The Granary Burial Ground was the final resting place for the Wheatley family. John Wheatley was buried there in 1778 and his headstone can be seen there today. It was where Susanna Wheatley was laid to rest, although the headstone no longer exists, and also where the Wheatley's young daughter Sarah was buried in 1752.

During her lifetime Phillis Wheatley came to that cemetery numerous times for funerals of Boston notables. She was probably there to witness the burial of the martyrs of the Boston Massacre in 1770, including the boy Christopher Seider, to whom Phillis dedicated a poem, and Crispus Attucks, the African-American who was the first man shot dead that night. No doubt she attended Susanna Wheatley's funeral there in 1774 and John Wheatley's four years later.

Today the Granary Burial Ground is one of the most celebrated sites in historic Boston. Established in 1660, with a row of large elm trees along the entrance on Tremont Street, it was the burial site of some of the Revolutionary War's most notable heroes. Three signers of the Declaration of Independence are buried there: John Hancock, Samuel Adams, and Robert Treat Paine. The graves of patriots James Otis and Paul Revere can be found there, along with that of Peter Faneuil, benefactor of Boston's Faneuil Hall. James Bowdoin, one of Phillis's staunchest supporters who signed her attestation and inspired her to write her most whimsical poem, *A Rebus,* which she included in her book, was buried there six years after Phillis.

We can presume that Phillis Wheatley was laid to rest at the Granary Burial Ground. Like most African-Americans, she was buried in an unmarked grave. Her final resting place remains unknown.

# CHAPTER 57

"O that the muse, dear spirit! own'd thy art;
To soften grief and captivate the heart;
Then should these lines in numbers soft array'd;
Preserve thy mem'ry from oblivion's shade."

SHORTLY AFTER HER DEATH, *The Boston Magazine* published one of the most stirring and glorious tributes ever written for Phillis Wheatley. The heartfelt *Elegy on the Death of a Late Celebrated Poetess* appeared in the December 1784 issue, a fifty-four line poem dedicated to the sublime artistry of Boston's Queen of the Elegy. The anonymous author was identified as "Horatio" of "State Street."

State Street in Boston was a new name. For many years it was known as King Street, where Phillis Wheatley lived from 1761 until 1778 when she left with John Peters. The 1784 name change was part of the city's makeover as the citizens of the newly independent United States of America began removing unsavory reminders of their former connection to British Royalty—Queen Street became Court Street and King Street was now State Street.

"Horatio" of "State Street" was probably a longtime neighbor and friend of Phillis Wheatley. Man or woman? We do not know. Horatio was most certainly white.

The poem offered soaring literary praise wrapped in the tenderness of a warm embrace. The writer broadcasts a deep affection for Phillis. Surely the two poets from King Street would have had much to talk about while she was alive.

It is entirely fitting that a poet known for grace and compassion in her poignant elegies would herself be the subject of a graceful and compassionate and poignant elegy. "She would have been pleased with such last praise from another poet, who could best understand what the most important part of her life had been," writes Mason.[1]

Horatio revealed his purpose—he wrote so that Phillis Wheatley would never be forgotten.

> *O that the muse, dear spirit! own'd thy art,*
> *To soften grief and captivate the heart,*
> *Then should these lines in numbers soft array'd*
> *Preserve thy mem'ry from oblivion's shade;*

Phillis's eloquent elegist compared her to Orpheus, the ancient Greek archetype of an inspired musician whose beautiful playing on the lyre charmed even stones, trees, and wild animals.

> *As Orpheus play'd the list'ning herds among,*
> *They own'd the magic of his powerful song;*
> *Mankind no more their savage nature kept,*
> *And foes to music, wonder'd how they wept.*
> *So Phillis tun'd her sweet mellifluous lyre;*
> *Harmonious numbers bid the soul aspire,*

This final elegy to Phillis Wheatley acknowledges the fact that she was honored and respected and even loved as an African woman and creative artist.

> *While Afric's untaught race with transport heard,*
> *They lov'd the poet and the muse rever'd.*

Horatio delivers a striking rebuttal to those who pushed the predominant and entirely spurious attitudes toward race. Clearly drawing on personal knowledge of Phillis Wheatley, as one who knew her character and her soul, the elegist demonstrates how the perception of superficial appearances melts into insignificance before the ultimate truth of the universal spirit.

> *What tho' her outward form did ne'er disclose,*
> *The lilly's white or blushes of the rose;*
> *Shall sensibility regard the skin,*
> *If all be calm, serene and pure within?*

Now Horatio can celebrate the sacred passing of a dear friend from this troubled world to divine glory.

> *Tho' now the business of her life is o'er,*
> *Tho' now she breathes and tunes her lyre no more;*
> *Tho' now the body mixes with the clay;*
> *The soul wings upward to immortal day;*
> *Free'd from a world of woe and scene of cares,*
> *A lyre of gold she tunes, A crown of glory wears.*

Horatio wants us to know that the esteemed "Afric Muse" is now at eternal rest.

> *Seated with angels in that blissful place,*
> *Where she now joins in her Creator's praise,*
> *Where harmony with louder notes is swell'd*
> *Where her soft numbers only are excell'd.*

For Horatio, the loss is personal, charged with the fleeting hope that somehow their cherished friendship will go on. Then comes a sad realization—such a haughty wish is impossible. Horatio assures us that although Phillis may be gone from this earth, we are left with a comforting reminder that Phillis Wheatley is still with us—her presence remains alive in her literary art. The heart of the poet will keep on beating in the timeless wisdom of her verses.

> *But O! how vain the wish that friendship pays,*
> *Since her own volumes are her greatest praise.*[2]

At the time of her death, the manuscripts for her poems, including thirty-three poems and thirteen letters planned for her second book, were being held for Phillis by a friend who was also a member of the Wheatley family. "Previous to Phillis' departure for Wilmington," Oddell explained, "she entrusted her papers to a daughter of the lady who received her on her return from that place."[3]

Carretta identifies that person as Elizabeth Wallcutt's daughter.[4]

Elizabeth Wallcutt was Susanna Wheatley's niece, the mother of

Phillis's great friend Thomas Wallcutt. Phillis lived with the Wallcutt family for a time while her life with John Peters was still unsettled. "She had left all of her manuscripts with Mrs. Elizabeth Wallcutt and her daughter, Lucy, in Boston, for safekeeping," says Robinson.[5]

Peters, ever the entrepreneur, would have picked up on the renewed interest in his late wife's work. Surely he would see the publication of Phillis's poems as the solution to his financial problems.

Peters published a notice in the *Independent Chronicle and Universal Advertiser* on February 10, 1785, claiming his wife's manuscripts. "The person who borrowed a volume of manuscript poems of Phillis Peters, formerly Phillis Wheatley, deceased, would very much oblige her husband, John Peters, by returning it immediately." He offered assurances that "the whole of her works are intended to be published."[6]

John Peters managed to acquire all his deceased wife's poems. "It is known that, since Phillis' death in 1784, John Peters had been in possession of the whole of her works," says Robinson.[7]

The manuscript has since disappeared. The only clue to the fate of Phillis Wheatley's lost manuscript came from Oddell. "Some years after," she wrote, "he went to the South, and we have not been able to ascertain what eventually became of the manuscripts."[8]

Carretta found an obituary for "Dr. John Peters, aged 55" in the March 9-12, 1801 issue of Boston's *Independent Chronicle and Advertiser*. A list of his property included a sorrel horse, a sleigh, a feather bed, leather-bottomed chairs, thirteen books including a Bible and two small mahogany tables. "One of the tables may be the writing desk now at the Massachusetts Historical Society believed to have belonged to Phillis Wheatley before her marriage," Carretta says.[9]

Evidence suggests that Phillis Wheatley's unpublished poems were still around sixty-five years after her death. In 1849 American literary critic Rufus Wilmot Griswold made a startling claim about the missing Wheatley manuscripts. In his book, *The Female Poets of America*, he asserted that "the MSS, however, are still in existence. They are owned by an accomplished citizen of Philadelphia, whose mother was one of the patrons of the author."[10]

Robinson believes that Griswold's source was "Dr. James Rush, son of the more distinguished Dr. Benjamin Rush of Philadelphia; the mother

who 'was one of the patrons of the author' was Mrs. Julia Stockton Rush, wife of Benjamin."[11]

John Peters's need for cash gave him all the incentive he needed to sell his wife's work. "Knowing of Dr. Benjamin Rush's marked fondness for things African or Afro-American, he may have given, or more probably sold, the papers to the Rush family," Robinson writes.[12]

Writing for the *Pittsburgh Courier* in 1931, reporter T. T. Fletcher disclosed that he found manuscripts for three Wheatley poems, *America*, *Atheism*, and *To the Right Honorable Commodore Hood on His Pardoning a Deserter*, in the collection of the Historical Society of Pennsylvania. The manuscripts "were given to that institution in 1869 by the will of Dr. James Rush, a son of Dr. Benjamin Rush."[13]

In 1970 a staff member at the Library Company of Philadelphia named Robert Kuncio made a remarkable discovery while examining the papers of Benjamin Rush donated by his son. "In preparing an exhibition of Negro history at the Library Company of Philadelphia, I found in our collection and in the collection of the Historical Society of Pennsylvania five manuscript poems by the talented Boston slave," he reports.[14]

The five Wheatley poems Kuncio found were all written between 1768 and 1770.

- *To the King's Most Excellent Majesty On His Repealing the American Stamp Act*
- *America*
- *Atheism*
- *To the Honble Commodore Hood on His Pardoning a Deserter*
- *On the Death of Mr. Snider Murder'd by Richardson*

Only one of the poems had ever been seen before — *To the King's Most Excellent Majesty* appeared in Phillis's 1773 book. Kuncio published all five poems in 1970, four of them for the first time.

Will we ever find Phillis Wheatley's lost poems? We can only hope that they might turn up someday. "I think in trunks and attics, and in basements and closets, so much of the African American tradition is still buried," says Dr. Henry Louis Gates.[15] "They keep finding Mayan cities and tombs of pharaohs. They've got to find more manuscripts from black people in the 19th century. I'm confident of it. It's just the way it has to be."[16]

Phillis Wheatley's second life began in Philadelphia in 1786, when *Poems on Various Subjects, Religious and Moral* was published for the first time in America. A second edition of her *Poems* appeared in London the following year. The demand for her *Poems* in America proved to be so great they were reprinted nine times by 1838. Since her death her poetry has remained in print almost constantly.

However, the critical reception for her work has been mixed. "From the 18th century to well into the 20th, the poet has had her ever increasing arrays of adversaries and advocates, each group finding only what it wished to see in this precocious New England slave poet," Robinson writes, "neither group viewing all of her writing or considering the pressures of her times."[17]

Recent Wheatley scholarship offers a fuller, fairer, and more accurate assessment of Phillis Wheatley and her writings. Wheatley authority William Robinson, professor at Harvard and Howard Universities and Director of Black Studies at Rhode Island College, wrote *Phillis Wheatley in the Black American Beginnings* in 1975. It was the first of five books in his lifelong quest to apply meticulous research and academic rigor to the study of Phillis Wheatley. His crowning achievement in Wheatley scholarship was the magnificent *Phillis Wheatley And Her Writings* in 1984, a comprehensive examination of her life and work. Now unfortunately out of print, it is regarded by academics almost as sacred text on Wheatley. Robinson's sweeping review includes the complete collection of her poems, published and unpublished, drafts and variants of poems, and all her known letters. His book features a reprint of Oddell's 1834 memoir and an authoritative seventy-page biography with invaluable insight and literary analysis.

In 1984 Professor Robinson declared that "Phillis Wheatley's slim volume *Poems on Various Subjects, Religious and Moral* has been reprinted more than two dozen times since it was first published in London in 1773."[18]

Professor John Shields published his insightful *Phillis Wheatley's Poetics of Liberation* in 2008, in which his "incisive analysis of more than two hundred years of complicated and often misinformed scholarship" refutes many false assumptions and myths about her and her work.[19]

The ultimate rebuke to Thomas Jefferson and his half-baked white supremacist rants on Phillis Wheatley and race came from Vincent Carretta in 2011. Nearly two hundred thirty years after her death, he published the

first book-length biography of Phillis Wheatley. The title alone serves as a powerful affirmation of the great truth about her life and artistry: *Phillis Wheatley: Biography of a Genius in Bondage.*

That year Professor Babacar M'Baye established a standard for a new appreciation of the black poet. "Phillis Wheatley was an eighteenth-century African American writer who strongly identified with Africa's suffering from the Atlantic slave trade," he writes. M'Baye asserts that Wheatley "developed sustained criticism against slavery, racism and other injustices against blacks in America and Africa....[20] By vehemently criticizing the impact of slavery on the enslaved Africans, Wheatley used her poetic skills as weapons of resistance against slavery."[21]

Supported by Wheatley's own words in her poems and letters, Shields builds a persuasive case that the black poet's "use of poetry as a means to achieve freedom constitutes poetics of liberation."[22] He identifies four ways "Wheatley articulates the theme of freedom."[23] First was her eloquent support of the Americans' Glorious Cause, the yearning for freedom, which she repeatedly insisted was a fervent desire shared by her people.

> *But how, presumptuous shall we hope to find*
> *Divine acceptance with th' Almighty mind —*
> *While yet (O deed ungenerous!) they disgrace*
> *And hold in bondage Afric's blameless race;*
> *Let virtue reign — And those accord our prayers*
> *Be victory ours, and generous freedom theirs.[24]*

In one of her last poems, she wrote of a new nation blessed by the Divine in freedom:

> *Auspicious Heaven shall fill with fav'ring Gales,*
> *Where e'er Columbia spreads her swelling Sails:*
> *To every Realm shall Peace her Charms display,*
> *And Heavenly Freedom spread her golden Ray.[25]*

Second, according to Shields, was "the psychological attempt to discover freedom from chaos."[26] Or, as Robinson puts it: "She used her gifts for verse-making as a means of psychological survival."[27]

"What Wheatley essentially does," says Shields, "is to decide that this

world, which allows slavery to remain legitimate, is unsatisfactory to her; so she manipulates the conventions of neoclassicism to build in her poems another, acceptable world."[28]

Third, Shields contends, "was the writing of contemplative elegies" as a "conscious escape from slavery," a way "Wheatley achieved freedom, not in this world but in the next."[29] Her numerous elegies reflect "the poet's conviction that the next world holds far greater appeal than the present."[30]

> *Where contemplation finds her sacred spring,*
> *Where heav'nly music makes the arches ring,*
> *Where virtue reigns unsully'd and divine,*
> *Where wisdom thron'd and all the graces shine...*
> *Amid the seats of heav'n a place is free,*
> *And angels ope their bright ranks for thee.*[31]

The fourth way Phillis Wheatley expressed her love for freedom was in her deep religious faith and her search for God. "This young poet's intense longing for the spiritual world motivated her to use her poetry as a means of escaping an unsatisfactory, temporal world," says Shields. "The imagination and the sublime become tools by which she accomplishes her short-lived escape."[32]

"For her," says Robinson, "the writing of poetry was a very real way of asserting her being, of documenting her Christian testimony, of declaring her aesthetic and human and racial worth in a world that could often seem like a menacing, impenetrable forest."[33]

Poetry was her freedom. "In the sheer process of writing a poem," says Shields, "Wheatley doubtless experienced the dynamic, autonomous power inherent in the act of creation."[34]

"Phillis Wheatley did indeed manage, in various ways, to have much more Black consciousness, much more concern for her fellow Blacks, than many readers will admit," says Robinson. "She shows this awareness, this concern, both in her poetry, which was designed, it must be remembered, for a public (white) consideration, and more readily in her letters, designed for private attention."[35]

Writes Shields: "Deciding that she must pursue the calling of poet and responding to her personal predicament as slave and to the shared

predicament of her fellow Black brothers and sisters along with those of her sex, Wheatley strikes out boldly in her writings as a political activist who was more than merely eager to assist the promises of freedom for all which she believed attended the American revolutionary cause."[36]

"The poet was indeed a strong force among contemporary abolitionist writers," asserts Professor Sondra O'Neale. "Through the use of biblical imagery, she incorporated antislavery statements in her work within the confines of her era and her position as a slave."[37]

"As the first significant black writer in North America she faced a problem that her successors were to face," Richmond observes. "She wrote for a white audience."[38]

"Because she was a black female slave, she knew that she had to be careful about what she had said and how she said it," writes Professor Devona Mallory. "Therefore, Wheatley's poetry, composed in the late eighteenth century, a time before aggressive antislavery activism, does not allow her blatant freedom of expression."[39]

"The great question, then, facing Phillis and the handful of other free blacks," says Robinson, "was what to do about finding one's black self living in a racially prejudiced and segregated society...[40] If Phillis Wheatley had been of a fiery, militant persuasion, the colonial press would not have welcomed her written charges."[41]

"To phrase it bluntly," O'Neale declares, "there was no other game in town."[42]

The struggle for Phillis Wheatley was to write creatively and passionately about her own longings and insights in a society that refused to acknowledge her human dignity. "One ever feels his two-ness," W. E. B. Du Bois wrote in his 1907 essay *The Souls of Black Folk*.

> An American, a Negro; two souls, two thoughts, two unreconciled strivings; two warring ideals in one dark body, whose dogged strength alone keeps it from being torn asunder....It is a peculiar sensation, this double-consciousness, this sense of always looking at one's self through the eyes of others, of measuring one's soul by the tape of a world that looks on in amused contempt and pity.[43]

"The story she tells in her poetry," says Shields, "is that of a struggling but undaunted young black woman who creates works that will be read almost exclusively by a white audience; in short, her work speaks of a Black woman determined to survive, with dignity, as an author in a white world."[44]

"Wheatley sought to legitimize herself as a poet in a culture that refused to grant her legitimacy on the basis of her talent and accomplishments alone," says Professor Paula Bennett.[45] Her poem "*To Maecenas*" speaks powerfully of Wheatley's determination to participate in Western culture.... [Wheatley] deploys her knowledge of the Latin classics to plead her case as a poet enslaved...She wanted to be acknowledged, even in her difference, as a legitimate member of the society in which she lived."[46]

"The history of the American Negro is the history of this strife — this longing to attain self-conscious manhood, to merge his double self into a better and truer self," Du Bois wrote. "He simply wishes to make it possible for a man to be both a Negro and an American without being cursed and spit upon by his fellows, without having the doors of opportunity closed roughly in his face."[47]

When Dr. Henry Louis Gates wrote his critically acclaimed essay *The Trials of Phillis Wheatley* in 2003, he offered an opportunity to reexamine the legacy and meaning of the Boston slave poet. "I hope that readers will accept my challenge to recuperate Phillis Wheatley," he wrote in his introduction.[48] "What would happen if we ceased to stereotype Wheatley but, instead, read her, read her with all the resourcefulness that she herself brought to her craft?" he wonders.[49] "And so we're reminded of our task as readers: to learn to read Wheatley anew, unblinkered by the anxieties of her time and ours."[50]

"Even now," he contends, "the imperative remains: to cast aside the mine-and-thine rhetoric of cultural ownership. For cultures can no more be owned than people can."[51]

Gates offers the example of the brilliant black philosopher and social critic Du Bois:

> I sit with Shakespeare and he winces not. Across the color line
> I move arm in arm with Balzac and Dumas, where smiling
> men and welcoming women glide in gilded halls. From out the

caves of evening that swing between the strong-limbed earth
and the tracery of the stars, I summon Aristotle and Aurelius
and what soul I will, and they come all graciously with no scorn
nor condescension. So, wed with Truth, I dwell above the Veil.
Is this the life you grudge us, O knightly America?"[52]

"The challenge," says Dr. Gates, "isn't to read white or read black; it is
to read. If Wheatley stood for anything, it was the creed that culture was,
could be, the equal possession of all humanity."[53]

# Afterword

## Boston 2003

IT WAS A GLORIOUS FALL morning in Boston. More than a hundred people gathered at the leafy Commonwealth Avenue Mall on October 25, 2003 to dedicate the city's three newest statues at the Boston Women's Memorial. "It took centuries for the likenesses of Abigail Adams, Phillis Wheatley, and Lucy Stone to be cast in brilliant bronze and set upon a granite tableau under the elm and maple trees," the *Boston Globe* reported. "But it took only seconds yesterday for people to embrace Boston's newest landmark."[1]

Everyone took their seats on folding chairs provided for the occasion as Mayor Thomas Menino welcomed everyone to the festivities in the park. Schoolchildren invited to the historic event were bubbling over with excitement.

Each statue was covered by a white sheet. A line of spirited women waited beside each statue, holding the ropes that secured the sheets. They were the dedicated force behind the noble idea of a monument to great Boston women, working tirelessly for a decade to make sure it would actually come to pass.

On cue the women gave the ropes a gentle tug and the veils over the statues fell. One by one the dignified bronze ladies revealed themselves. Frozen in time, yet almost lifelike, the women appeared to be experiencing a moment of serene meditation, collecting their thoughts before diving back into the crucible of their life's work.

"For each of these women, life was a passionate struggle against both the external controls of society and the internal limitations of their own imaginations, conducted amidst a host of chores and cares," said sculptor Meredith Bergmann. "Reading their vivid words, I realized that this struggle was the story about women that I wanted to tell."[2]

What makes the three new statues at the Boston Women's Memorial

so unique and memorable is that they are placed on the same level as the viewers. Instead of posing on pedestals high overhead, the women appear down to earth, ready to engage anyone who comes by. Visitors can look them in the eye, touch them, speak to them, commune with them.

"I suddenly realized that I could portray the women as having come down off their pedestals," Ms. Bergmann said. "These women are not standing in heroic idleness. They have come down to work."[3]

The three statues seem to be keenly aware of each other, forging their own connection among themselves. "They are arranged in a circle so that a kind of conversation can take place among them in our minds," says Ms. Bergmann.[4]

Abigail Adams (1744-1818), wife of the second president of the United States, and mother of the sixth, was a perceptive social critic and political commentator. Carved into the stone behind her is a passage from one of her letters to her husband: "Remember the Ladies," she admonished John Adams as the patriots were meeting to form a new government. "Be more generous and favorable to them than your ancestors. Do not put such unlimited power into the hands of the husbands."

Lucy Stone (1818-1893), one of the first women to earn a college degree in Massachusetts, was an ardent abolitionist, renowned orator, and accomplished journalist. Her words are engraved on her pedestal: "Let woman's sphere be bounded only by her capacity," she wrote. "The legal right for woman to record her opinion wherever opinions count is the tool for whose ownership we ask."

Phillis Wheatley (1753-1784) is sitting at her desk. Her left elbow rests on the desk as she holds her chin in her hand, an index finger pointing up against her cheek. Her right hand is holding a quill pen. Although the young woman is wearing the pleated lace bonnet of a simple house servant, we can see her true character shining through. She is a woman of grace, dignity and intelligence, the epitome of learning and refinement, a true poet.

"Phillis Wheatley was portrayed only once in her lifetime, in an extremely conventionalized profile engraved for her book of poetry," says Bergmann. "She is shown with kinky hair and round eyes, an implausibly

high, flat forehead to signify a noble mind, studiously pursed lips and a thoughtfully melancholy pose."[5]

The figure depicts an artist in the act of creation. Phillis pauses for a moment, taking a breath as she contemplates the profound ideas and mystical imagery flowing through her fertile mind. Her writing hand relaxes as the pen hovers over the words she has just now composed. Eyes wide, gazing upward toward the heavens, she awaits her inspiration from the muse. Below the quill pen the inscription reads:

> In every human breast God has implanted a Principle
> Which we call love of freedom
> It is impatient of oppression
> And pants for deliverance
> The same principle lives in us.
>
> ~Letter to the Reverend Samson Occom, February 14, 1774

A short biography is carved on one side of the pedestal below her name. "Born in West Africa and sold as a slave from the ship Phillis in colonial Boston, she was a literary prodigy whose 1773 volume *Poems on Various Subjects, Religious and Moral* was the first book published by an African writer in America."

Inscribed on the other side of the granite block:

> I, young in life, by seeming cruel fate
> Was snatch'd from Afric's fancy'd happy seat:
> What pangs excruciating must molest,
> What sorrows labour in my parent's breast?
> Steel'd was that soul and by no misery mov'd
> That from a father seiz'd his babe belov'd:
> Such, such my case. And can I then but pray
> Others may never feel tyrannic sway?
>
> ~To The Right Honorable William Earl of Dartmouth

The front of her pedestal carries the text to one of her finest poems:

*Imagination: Who can sing thy force?*
*Or who describe the sweetness of thy course?*
*Soaring through air to find the bright abode*
*Th' empyreal palace of the thund'ring God*
*We on thy pinions can surpass the wind*
*And leave the rolling universe behind*
*From star to star the mental optics rove,*
*Measure the skies and range the realms above*
*There in one view we grasp the mighty whole*
*Or with new world amaze th'unbounded soul.*

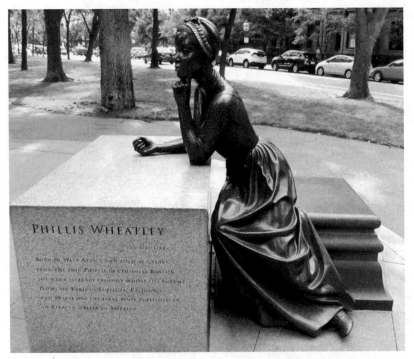

"Only in her descriptions of the potential of a free inner life could I experience a deep sense of recognition, when she expressed her ambition, yearning and sense of profound injustice in metaphors of soaring flight," the sculptor said. [6]

"Over the years, the Boston Women's Memorial has become a beloved feature on Commonwealth Avenue Mall," the *Boston Globe* reported in 2013.[7]

These magnificent women seem to come alive. Visitors treat them as if they are real. People approach the women, offering tokens of affection and respect. They talk to them, call them by their first names. They mount their pedestals to sit beside them. Sometimes they offer sips from their coffee cups.

"Someone placed a Red Sox cap on Phillis in 2004 when the Red Sox won the World Series for the first time in 86 years," said Marie Turley, one of the members of the Boston Woman's Memorial Task Force.[8]

"You never know what gifts you will find left with these women," wrote Penny Cherubino for Boston Zest. "As the weather turned cooler a couple of weeks ago, someone gave Phillis a sweater. A few days later, a bouquet of flowers was added. They've had offerings of shawls, teddy bears and used scratch tickets."[9]

"People often react to the memorial figures with what seems to be a need to acknowledge them, even to demonstrate an impulse of empathy for the women," observes Marilyn Richardson, former curator of the Museum of African-American History in Boston. "I've seen coins left in Phillis Wheatley's cupped hand," she says.[10]

"People love to pose with them for photographs," Ms. Cherubino added. "It's fun to see women mimicking the poses while their friends snap pictures.... [11] And, in warm weather, it's not unusual to see someone having lunch with one of the sculptures."[12]

"When I visited the memorial a week after the unveiling I saw that a large bouquet of flowers had been placed at Abigail's feet," said Bergmann. "The next day someone had broken off two red carnations and stuck them under Lucy's fingers and behind Phillis's ear. Members of the public have started to add their own symbolism to mine."[13] That kind of personal bond is exactly what the sculptor hoped to inspire. "Although each figure is engrossed in her thoughts and her work, they invite approach, contemplation and touch," she said.[14]

The women seem to have the ability to draw people out of their individual private worlds, encouraging them to share their thoughts with those around them. "Strangers approaching from either end of the mall, always speak to each other before they leave the space. It is as if it's impossible to share such an unexpected experience and not comment upon it," says Ms. Richardson.[15]

Sculptor Bergmann noticed how people seem to want to connect with the women through the sense of touch. "Passersby stop to see the figures," she says, "then step intimately close to trace the carved quotations, closing the distance between legend and life."[16]

Children love the Phillis Wheatley statue, probably because she is engaged in writing, an activity they do every day in school. "What is amazing," says Susan Wilson of the Boston History and Innovation Collaborative, "is to see little kids, little boys and girls come here and hold her pen, touching her face, touching the words."[17]

"I've watched children climb onto Phillis Wheatley's pedestal, stare into her eyes and touch her nose in wonder," says Ms. Bergmann.[18] Students often come to sit beside Phillis. Pens-in-hand, they open their own notebooks and use Phillis' stone pedestal as their writing desk.

Phillis Wheatley has long been one of the most obscure and least-celebrated figures in American history. Her name barely registers in our national consciousness. Who can even recite a line from her poetry? Now that is changing.

The appearance of the Phillis Wheatley statue at the Commonwealth Avenue Mall opens a new chapter in her story. This enduring tribute in bronze marks the beginning of a new look at the contributions of the Boston slave poet, spurring a re-examination of her legacy. More than two centuries after the War for Independence, this sickly little black girl, snatched from home and family, a Middle Passage survivor and gifted literary artist regarded as a genius in her time, can now take her place among the nation's Founding Mothers as "Poet Laureate" of the American Revolution.

# Sources

## PART I

1.  Phillis Wheatley, *Complete Writings*, Vincent Carretta, ed., Penguin Books, 2001, p. 77.

## CHAPTER 1

1.  Olaudah Equiano, *The Interesting Narrative of the Life of Olaudah Equiano or Gustavus Vassa, the African,* from *Classic Slave Narratives*, Henry Louis Gates, ed., Penguin Books, 1987, p. 36.

2.  W. E. B. Dubois, *Black Reconstruction in America: An Essay Toward a History of the Part Which Black Folk Played in the Attempt to Reconstruct Democracy in America, 1860-1880*, Harcourt, Brace and Company, 1935, p. 727.

3.  "Voyage for Timothy Fitch by Peter Gwin, Boston, November 8, 1760: The Medford Slave Trade Letters," *Medford Historical Society and Museum*, <http://www.medfordhistorical.org/collections/slave-trade-letters/peter-gwinns-first-voyage-record-behalf-timothy-fitch/>.

4.  Vincent Carretta, *Phillis Wheatley: Biography of a Genius in Bondage*, University of Georgia Press, 2011, p. 7.

5.  William Robinson, *Phillis Wheatley and Her Writings*, Garland Publishing Inc., 1984, p. 7.

6.  Carretta, *Phillis Wheatley: Biography of a Genius in Bondage,* p. 12.

7.  Carretta, *Phillis Wheatley: Biography of a Genius in Bondage,* p. 13.

8.  "Voyage by Captain Peter Gwin to Senegal, Boston, September 4, 1761: The Medford Slave Trade Letters," *Medford Historical Society and Museum*, <http://stage.medfordhistorical.org/collections/slave-trade-letters/voyage-capt-peter- gwinn-senegal/>.

9.  Ira Berlin, *The Making of African America: The Four Great Migrations*, Viking, 2010, p. 14.

10. Vincent Carretta, *Equiano, the African: Biography of a Self-made Man*, Penguin, 2006, p. 299.

11. *Equiano,* Carretta, ed., p. 32.

12. *Equiano,* Carretta, ed., p. 47.

13. *Equiano,* Carretta, ed., p. 48.

14. *Equiano,* Carretta, ed., p. 54, 55.

15. *Equiano,* Carretta, ed., p. 55.

16. *Equiano,* Carretta, ed., p. 56.

17. *Equiano,* Carretta, ed., p. 55.

18. *Equiano,* Carretta, ed., p. 56.

19. *Equiano,* Carretta, ed., p. 58.

20. *Ibid.*

21. *Ibid.*

22. *Equiano,* Carretta, ed., p. 59.

23. *Equaino,* Carretta, ed., p. 56.

24. Robinson, *Phillis Wheatley And Her Writings,* p. 6.

25. *Ibid.*

## CHAPTER 2

1.  Vincent Carretta, *Phillis Wheatley: Biography of a Genius in Bondage,* University of Georgia Press, 2011, p. 6.

2.  Margaretta Oddell, *The Poems of Phillis Wheatley: With Letters and a Memoir,* Dover Publications, 2010, p. 61. (Unabridged replication of *Memoir and Poems of Phillis Wheatley,* Geo. W. Light, Boston, 1834).

3.  John Shields, *Phillis Wheatley's Poetics of Liberation,* University of Tennessee Press, 2008, p. 54.

4.  Oddell, p. 76.

5.  Oddell, p. 61.

6.  "Journal of C. J. Stratford," *Proceedings of the Massachusetts Historical Society,* Volume 15, Massachusetts Historical Society, 1878, p. 389.

7.  Oddell, p. 61.

8.  "Journal of C. J. Stratford," *Proceedings of the Massachusetts Historical Society,* Volume 15, Massachusetts Historical Society, 1878, p. 389.

9.  Oddell, p. 61.

10. Carretta, *Phillis Wheatley: Biography of a Genius,* p. 14.

11. *Ibid.*

12. Dr. Nathaniel B. Shurtleff, *Boston Daily Advertiser,* December 21, 1863, in *Letters of Phillis Wheatley, The Negro Slave Poet of Boston,* Proceedings of the Massachusetts Historical Society, 1863, p. 9.

13. Carretta, *Phillis Wheatley: Biography of a Genius*, p. 17.

14. Robinson, *Phillis Wheatley and Her Writings,* p. 13.

15. Robinson, *Phillis Wheatley and Her Writings,* p. 14.

16. Carretta, *Phillis Wheatley: Biography of a Genius*, p. 9.

17. Carretta, *Phillis Wheatley: Biography of a Genius*, p. 8.

18. Carretta, *Phillis Wheatley: Biography of a Genius*, p. 8, 9.

19. Oddell, p. 62.

20. John C. Shields, *Phillis Wheatley's Poetics of Liberation*, University of Tennessee Press, 2008, p. 97.

21. Oddell, p. 62.

22. Shields, *Phillis Wheatley's Poetics of Liberation*, p. 85.

23. Shields, *Phillis Wheatley's Poetics of Liberation*, p. 100.

24. Shields, *Phillis Wheatley's Poetics of Liberation*, p. 97.

25. Shields, *Phillis Wheatley's Poetics of Liberation*, p. 98.

26. Phillis Wheatley, *Phillis's Reply to the Answer in our Last by the Gentleman in the Navy*, published in the *Royal American Magazine,* January, 1775, *Complete Writings of Phillis Wheatley*, Vincent Carretta, ed., Penguin Books, 2001, p. 87.

27. Shields, *Phillis Wheatley's Poetics of Liberation*, p. 85.

28. Robinson, *Phillis Wheatley and Her Writings,* p. 286.

29. Robinson, *Phillis Wheatley and Her Writings,* p. 459.

30. Shields, *Phillis Wheatley and Her Writings,* p. 99.

31. Shields, *Phillis Wheatley and Her Writings,* p. 100.

## CHAPTER 3

1. "First Slaves Arrive in Massachusetts, February 26, 1638," Mass Moments, *The Massachusetts Foundation for the Humanities,* <http://massmoments.org/moment.cfm?mid=64>.

2. "Excerpts from Massachusetts Body of Liberties, 1641," *Constitution Society,* <http://www.constitution.org/bcp/mabodlib.htm>.

3. *Ibid.*

4. *Ibid.*

5. Vincent Carretta, *Phillis Wheatley: Biography of a Genius in Bondage*, University of Georgia Press, 2011, p. 15.

6.  "Slavery in the United States," *Economic History Association*, <http://eh.net/encyclopedia/article/wahl.slavery.us>.

7.  William Robinson, *Phillis Wheatley and Her Writings*, Garland Publishing Inc., 1984, p. 110.

8.  "First Slaves Arrive in Massachusetts, February 26, 1638," Mass Moments, *The Massachusetts Foundation for the Humanities,* <http://massmoments.org/moment.cfm?mid=64>.

9.  Carretta, *Phillis Wheatley: Biography of a Genius in Bondage*, p. 19.

10. Slavery in the United States, *Economic History Association*, <http://eh.net/encyclopedia/article/wahl.slavery.us>.

11. Carretta, *Phillis Wheatley: Biography of a Genius in Bondage*, p. 18.

12. *Ibid.*

13. Carretta, *Phillis Wheatley: Biography of a Genius in Bondage*, p. x.

14. Annette Gordon-Reed, *The Hemingses of Monticello: An American Family*, W. W. Norton & Company, 2008, p. 290.

15. John W. Blassingame, *The Slave Community: Plantation Life in the Antebellum South,* New York, Oxford University Press, 1979, p. 284.

16. *Ibid.*

17. Blassingame, *The Slave Community,* p. 290.

18. Blassingame, *The Slave Community,* p. 294.

19. Frederick Douglass, *My Bondage and My Freedom*, 1857, James McCune Smith, introduction, p. xx.

20. Blassingame, *The Slave Community,* p. 294.

21. Carretta, *Phillis Wheatley: Biography of a Genius in Bondage*, p. 22.

22. Julian Mason, *The Poems of Phillis Wheatley*, University of North Carolina Press, 1989, p. 4.

23. John Shields, *Phillis Wheatley's Poetics of Liberation,* University of Tennessee Press, 2008, p. 126.

24. W. E. B. DuBois, "Phillis Wheatley and African American Culture" *The Oxford W. E. B. DuBois Reader,* Eric J. Sundquist, ed., 1996, p. 329.

25. Carretta, *Phillis Wheatley: Biography of a Genius in Bondage*, p. 51.

26. Carretta, *Phillis Wheatley: Biography of a Genius in Bondage*, p. 117.

27. W. E. B. DuBois, "Phillis Wheatley and African American Culture," p. 329.

28. Carretta, *Phillis Wheatley: Biography of a Genius in Bondage*, p. 138.

29. Mukhtar Ali Isani, *"Gambia on My Soul": Africa and the African in the Writings*

*of Phillis Wheatley*, MELUS, Vol. 6, No. 1, Oppression and Ethnic Literature (Spring, 1979) p. 64.

30. Robinson, *Phillis Wheatley And Her Writings,* p. 125.

31. Phillis Wheatley, *Complete Writings*, Carretta, ed., p. 61.

32. Mason, *The Poems of Phillis Wheatley*, p. 4.

33. Blassingame, *The Slave Community,* p. 303.

34. Blassingame, *The Slave Community,* p. 305.

35. Blassingame, *The Slave Community,* p. 308.

36. W. E. B. Du Bois, "Phillis Wheatley and African American Culture," p. 329.

37. Oddell, p. 63.

38. *Ibid.*

39. Oddell, p. 64.

40. William H. Robinson, *Phillis Wheatley in the Black American Beginnings*, Broadside Press, 1975, p. 67.

41. Blassingame, *The Slave Community,* p. 297.

42. Oddell, p. 63.

43. Phillis Wheatley, *Complete Writings,* Carretta, ed., p. 153.

44. Blassingame, *The Slave Community,* p. 291.

45. *Ibid.*

46. *Ibid.*

47. Blassingame, *The Slave Community,* p. 293.

48. *Ibid.*

49. Frederick Douglass, *Life and Times of Frederick Douglass: Written by Himself,* Crowell-Collier Publishing Company, 1962 (originally published 1892) p. 76, 77.

## CHAPTER 4

1. Peter Oliver, *Origin and Progress of American Rebellion*, Adair and Schutz, Stanford University Press, 1961, p. 52.

2. Peter Oliver, *Origin & Progress of the American Rebellion,* 1781, p. 9.

3. Theodore Draper, *A Struggle For Power: The American Revolution,* Vintage, 1996, p. 216.

4. William Robinson, *Phillis Wheatley and Her Writings*, Garland Publishing Inc., 1984, p. 15.

5. *Ibid.*

6. "Letter from Cyrus Baldwin to Loammi Baldwin, August 15, 1765: The Coming of the American Revolution, 1764-1776," *Massachusetts Historical Society*, <http://www.masshist.org/revolution/doc-viewer.php?old=1&mode=nav&item_id=641.

7. *Ibid.*

8. Robinson, *Phillis Wheatley and Her Writings,* p. 15.

9. Robinson, *Phillis Wheatley and Her Writings,* p. 16.

10. Peter Oliver, *Origin and Progress of American Rebellion*, Adair and Schutz, Stanford University Press, 1961, p. 54. Robinson, *Phillis Wheatley and Her Writings,* p. 16.

11. *Ibid.*

12. James Kendall Hosmer, *The Life of Thomas Hutchinson, Royal Governor of Massachusetts Bay,* Houghton and Mifflin and Company, 1896, p. 91-93.

13. Robinson, *Phillis Wheatley and Her Writings,* p. 16.

14. Peter Oliver, *Origin and Progress of American Rebellion*, Adair and Schutz, Stanford University Press, 196, p. 52.

15. Oliver, p. 53.

16. Gary B. Nash, *The Unknown American Revolution: The Unruly Birth of Democracy and the Struggle to Create America,* Viking, 2005, p. 48.

17. Robinson, *Phillis Wheatley and Her Writings,* p. 16.

18. Hosmer, *The Life of Thomas Hutchinson,* p. 92-93.

19. Hosmer, *The Life of Thomas Hutchinson,* p. 95.

20. *Ibid.*

21. Hosmer, *The Life of Thomas Hutchinson,* p. 94.

22. Hosmer, *The Life of Thomas Hutchinson,* p. 96.

23. Hosmer, *The Life of Thomas Hutchinson,* p. 95.

24. Oliver, *Origin and Progress of American Rebellion,* p. 54.

25. Harlow Giles Unger, *American Tempest: How the Boston Tea Party Sparked a Revolution,* Da Capo Press, 2011, p. 82.

26. *Ibid.*

## CHAPTER 5

1. Margaretta Oddell, *The Poems of Phillis Wheatley: With Letters and a Memoir,* Dover Publications, 2010, p. 61. (Unabridged replication of *Memoir and Poems of Phillis Wheatley,* Geo. W. Light, Boston, 1834.)

2. John Shields, *Phillis Wheatley's Poetics of Liberation,* University of Tennessee Press, 2008, pp. 102-103.

3. Oddell, p. 62.

4. Vincent Carretta, *Phillis Wheatley: Biography of a Genius in Bondage,* University of Georgia Press, 2011, p. 37.

5. William Robinson, *Phillis Wheatley and Her Writings*, Garland Publishing Inc., 1984, p. 22.

6. Robinson, *Phillis Wheatley and Her Writings,* p. 19.

7. Robinson, *Phillis Wheatley and Her Writings,* p. 22.

8. *Ibid.*

9. Carretta, *Phillis Wheatley: Biography of a Genius in Bondage*, p. 46.

10. *Ibid.*

11. *Ibid.*

12. Carretta, *Phillis Wheatley: Biography of a Genius in Bondage*, p. 48.

13. Carretta, *Phillis Wheatley: Biography of a Genius in Bondage*, p. 49.

14. *Ibid.*

15. Oddell, p. 67.

16. Robinson, *Phillis Wheatley and Her Writings,* p. 19.

17. Robinson, *Phillis Wheatley and Her Writings,* p. 22.

18. Carretta, *Phillis Wheatley: Biography of a Genius in Bondage*, p. 37.

19. Oddell, p. 62.

20. Oddell, p. 64.

21. Oddell, p. 66.

22. Carretta, *Phillis Wheatley: Biography of a Genius in Bondage*, p. 37.

23. *Ibid.*

24. Oddell, p. 66.

25. *Ibid.*

26. Oddell, p. 65.

27. Oddell, p. 67.

28. Carretta, *Phillis Wheatley: Biography of a Genius in Bondage*, p. 37.

29. Oddell, p. 74.

30. Carretta, *Phillis Wheatley: Biography of a Genius,* p. 38.

31. William Robinson, *Phillis Wheatley in the Black American Beginnings,* Broadside Press, 1975, p. 15.

32. Phillis Wheatley, *Complete Writings,* Carretta, ed., p. 73.

33. Phillis Wheatley, *Complete Writings*, Carretta, ed., p. 74.

**CHAPTER 6**

1.  Phillis Wheatley, *Complete Writings*, Vincent Carretta, ed., Penguin Books, 2001, p. 14.

2.  Phillis Wheatley, *Complete Writings*, Carretta, ed., p. 13.

3.  Phillis Wheatley, *Complete Writings*, Carretta, ed., p. 11.

4.  Phillis Wheatley, *Complete Writings*, Carretta, ed., p. 11-12.

5.  Vincent Carretta, *Phillis Wheatley: Biography of a Genius in Bondage*, University of Georgia Press, 2011, p. 59.

6.  Carretta, *Phillis Wheatley: Biography of a Genius*, p. 88.

7.  *Ibid.*

8.  *Ibid.*

9.  *Ibid.*

10. John Shields, *Phillis Wheatley's Poetics of Liberation*, University of Tennessee Press, 2008, p. 76.

11. Phillis Wheatley, *Complete Writings*, Carretta, ed., p. 13.

12. Shields, *Phillis Wheatley's Poetics of Liberation*, p. 59.

13. Henry Louis Gates, *The Trials of Phillis Wheatley*, Basic Civitas Books, 2003, p. 82.

14. Gates, *The Trials of Phillis Wheatley*, p. 71.

15. Julian Mason, *The Poems of Phillis Wheatley*, University of North Carolina Press, 1989, p. 18.

16. William Robinson, *Phillis Wheatley and Her Writings*, Garland Publishing Inc., 1984, p. 272.

17. Shields, *Phillis Wheatley's Poetics of Liberation*, p. 79.

18. Shields, *Phillis Wheatley's Poetics of Liberation*, p. 108.

19. Shields, *Phillis Wheatley's Poetics of Liberation*, p. 106.

20. Shields, *Phillis Wheatley's Poetics of Liberation*, p. 108.

21. Robinson, *Phillis Wheatley and Her Writings*, p. 272.

22. Shields, *Phillis Wheatley's Poetics of Liberation*, p. 107.

23. *Ibid.*

## CHAPTER 7

1. *New England Magazine*, vol. 42, March 12, 1910, p. 570-571.

2. Harlow Giles Unger, *American Tempest: How the Boston Tea Party Sparked a Revolution,* Da Capo Press, 2011, p. 93.

3. The Crafts Family, *The Genealogical and Biographical History of the Descendants of Griffin and Alice Crafts of Roxbury,* Mass, Gazette Printing Company, 1894, p. 114.

4. Phillis Wheatley, *Complete Writings*, Vincent Carretta, ed., Penguin Books, 2001, p. 13.

5. Wheatley, *Complete Writings*, Carretta, ed., p. 12.

6. *Ibid.*

7. Wheatley, *Complete Writings*, Carretta, ed., p. 13.

8. Vincent Carretta, *Phillis Wheatley: Biography of a Genius in Bondage,* University of Georgia Press, 2011, p. 70.

9. "The Declaratory Act, March 18, 1766," The Constitution Society, <http://www.constitution.org/bcp/decl_act.htm>.

10. Kathleen Burk, *Old World, New World: Great Britain and America From the Beginning,* Grove Press, 2007, p. 126.

11. Samuel Adams, *The Writings of Samuel Adams,* Vol. 1, 1764-1769, G. P. Putnam Sons, 1904, p. 184-186.

12. "From George Washington to George Mason, 5 April 1769," Founders Online, National Archives, <http://founders.archives.gov/documents/Washington/02-08-02-0132>. Source: *The Papers of George Washington,* Colonial Series, vol. 8, *24 June 14. 1767–25 December 1771,* ed. W. W. Abbot and Dorothy Twohig. Charlottesville: University Press of Virginia, 1993, pp. 177–181.

13. William Robinson, *Phillis Wheatley and Her Writings,* Garland Publishing Inc., 1984, p. 16.

14. Peter Oliver, *Origin and Progress of American Rebellion,* Adair and Schutz, Stanford University Press, 1961, p. 70.

15. Robinson, *Phillis Wheatley and Her Writings,* p. 17.

16. Richard Archer, *As If An Enemy's Country: The British Occupation of Boston and the Origins of Revolution,* Oxford University Press, 2010, p. xvi.

17. Archer, *As If An Enemy's Country,* p. 133.

18. Archer, *As If An Enemy's Country,* p. xiv.

19. Charles Francis Adams, *The Works of John Adams, Second President of the United States*, Vol. 2, Little and Brown Company, p. 213-214.

20. Julian Mason, *The Poems of Phillis Wheatley*, University of North Carolina Press, 1989, p. 126.

21. Mason, *The Poems of Phillis Wheatley*, p. 125.

22. Mason, *The Poems of Phillis Wheatley*, p. 126.

23. Mason, *The Poems of Phillis Wheatley*, p. 125.

24. Mason, *The Poems of Phillis Wheatley*, p. 126.

25. Wheatley, *Complete Writings*, Carretta, ed., p. 13.

26. Archer, *As If An Enemy's Country*, p. 64.

27. Unger, *American Tempest: How the Boston Tea Party Sparked a Revolution*, p. 139.

## CHAPTER 8

1. William Robinson, *Phillis Wheatley and Her Writings*, Garland Publishing Inc., 1984, p. 13.

2. John Shields, *Phillis Wheatley's Poetics of Liberation*, University of Tennessee Press, 2008, p. 116.

3. Reverend A. S. Billingsley, *George Whitefield, Prince of Pulpit Orators, With the Secret of His Success and Specimens of His Sermons*, P. W. Ziegler and Co., 1878, p. 413.

4. Billingsley, *George Whitefield, Prince of Pulpit Orators*, p. 186.

5. Benjamin Franklin, *Autobiography of Benjamin Franklin*, Houghton Mifflin and Company, 1888, p. 135.

6. *Ibid.*

7. Olaudah Equiano, *The Interesting Narrative of the Life of Olaudah Equiano or Gustavus Vassa, the African*, from *Classic Slave Narratives*, Henry Louis Gates, ed., Penguin Books, 1987, p. 97.

8. David Addison Harsha, *Life of Rev. George Whitefield*, J. Munsell, 1866, p. 49.

9. Stephen Mansfield, *Forgotten Founding Father: The Heroic Legacy of George Whitefield*, Cumberland House Publishing, 2001, p. 123.

10. James Boswell, *Life of Samuel Johnson Vol. 1*, Oxford University, 1820, p. 269.

11. Stephen Mansfield, *Forgotten Founding Father: The Heroic Legacy of George Whitefield*, Cumberland House Publishing, 2001, p. 123.

12. Robinson, *Phillis Wheatley and Her Writings*, p. 26.

13. Julian Mason, *The Poems of Phillis Wheatley*, University of North Carolina Press, 1989, p. 56-57.

14. Robinson, *Phillis Wheatley and Her Writings*, p. 371.

15. Mukhtar Ali Isani, "The Contemporaneous Reception of Phillis Wheatley: Newspaper and Magazine Notices During the Years of Fame, 1765-1774," *The Journal of Negro History*, Vol. 85. No. 4, Autumn, 2000, p. 261.

16. Mason, *The Poems of Phillis Wheatley*, p. 133.

17. Faith Cook, *Selina, Countess of Huntingdon*, The Banner of Truth Trust, 2001, p. 115.

18. Mason, *The Poems of Phillis Wheatley*, p. 56.

19. Robinson, *Phillis Wheatley and Her Writings*, p. 306.

20. Sara Dunlap Jackson, "Documents Letters of Phillis Wheatley and Susanna Wheatley," *The Journal of Negro History*, Vol. 57, No. 2, April 1972, p. 211.

21. Robinson, *Phillis Wheatley and Her Writings*, p. 26.

22. Vincent Carretta, *Phillis Wheatley: Biography of a Genius in Bondage*, University of Georgia Press, 2011, p. 35.

23. Email from David Powell to author, January 3, 2012.

24. *Ibid.*

25. Carretta, *Phillis Wheatley: Biography of a Genius*, p. 35.

26. Email from David Powell to author, January 3, 2012.

27. Carretta, *Phillis Wheatley: Biography of a Genius*, p. 35.

28. Carretta, *Phillis Wheatley: Biography of a Genius*, p. 51-52.

29. Carretta, *Phillis Wheatley: Biography of a Genius*, p. 35.

30. *Ibid.*

31. Carretta, *Phillis Wheatley: Biography of a Genius*, p. 5.

## CHAPTER 9

1. William Robinson, *Phillis Wheatley and Her Writings*, Garland Publishing Inc., 1984, p. 18.

2. Vincent Carretta, *Phillis Wheatley: Biogrpahy of a Genius in Bondage*, University of Georgia Press, 2011, p. 24.

3. Robinson, *Phillis Wheatley and Her Writings*, p. 25.

4. Phillis Wheatley, *Complete Writings*, Carretta, ed., p. 69.

5. Phillis Wheatley, *Complete Writings*, Carretta, ed., p. 72.

6. Carretta, *Phillis Wheatley: Biography of a Genius*, p. 57.

7. John Shields, *Phillis Wheatley's Poetics of Liberation*, University of Tennessee Press, 2008, p. 129.

8. Shields, *Phillis Wheatley's Poetics of Liberation*, p. 24.

9. John Shields, *Phillis Wheatley's Poetics of Liberation*, University of Tennessee Press, 2008, p. 166.

10. Shields, *Phillis Wheatley's Poetics of Liberation*, p. 167.

11. Carretta, *Phillis Wheatley: Biography of a Genius in Bondage*, p. 34.

12. Robinson, *Phillis Wheatley and Her Writings*, p. 11.

13. Robinson, *Phillis Wheatley and Her Writings*, p. 18.

14. Robinson, *Phillis Wheatley and Her Writings*, p. 11.

15. Carretta, *Phillis Wheatley: Biography of a Genius in Bondage*, p. 34.

16. William Robinson, *Phillis Wheatley and the Origins of African American Literature*, Limited Commemorative Edition, Old South Meeting House, 1999, p. 13.

17. Carretta, *Phillis Wheatley: Biography of a Genius in Bondage*, p. 34.

18. Julian Mason, *The Poems of Phillis Wheatley*, University of North Carolina Press, 1989, p. 15.

19. Mason, *The Poems of Phillis Wheatley*, p. 16-17.

20. Benjamin E. Mays, *The Negro's God as Reflected in His Literature*, New York, 28. 1938, p. 105.

21. Mason, *The Poems of Phillis Wheatley*, p. 188.

22. Mason, *The Poems of Phillis Wheatley*, p. 15.

23. Mason, *The Poems of Phillis Wheatley*, p. 190.

24. Robinson, *Phillis Wheatley and Her Writings*, p. 342.

25. Shields, *Phillis Wheatley's Poetics of Liberation*, p. 31.

26. Shields, *Phillis Wheatley's Poetics of Liberation*, p. 130.

27. Mason, *The Poems of Phillis Wheatley*, p. 191.

28. Robinson, *Phillis Wheatley and Her Writings*, p. 24.

29. Merle A. Richmond, *Bid The Vassal Soar: Interpretive Essays on the Life and Poetry of Phillis Wheatley and George Moses Horton*, Howard University Press, 1974, p. 32.

30. Mason, *The Poems of Phillis Wheatley*, p. 204.

31. Mason, *The Poems of Phillis Wheatley*, p. 202.

32. Robinson, *Phillis Wheatley and Her Writings*, p. 24.

33. Mason, *The Poems of Phillis Wheatley*, p. 199.

34. Robinson, *Phillis Wheatley and Her Writings*, p. 25.

35. Mason, *The Poems of Phillis Wheatley*, p. 191.

36. Robinson, *Phillis Wheatley and Her Writings*, p. 314.

37. "Phillis Wheatley, Nov., 1863," *Proceedings of the Massachusetts Historical Society*, Vol. 7, The Society, 1864, p. 268.

38. "Phillis Wheatley, Nov., 1863," *Proceedings of the Massachusetts Historical Society*, Vol. 7, The Society, 1864, p. 267.

39. "Slave Poet's 1776 Letter, 'New Discovery' Is For Sale," *New York Times*, November 11, 2005.

40. *Ibid.*

41. "Letter by 18th-Century Slave Fetches Record Price," *New York Times*, November 24, 2005.

## CHAPTER 10

1. Phillis Wheatley, *Complete Writings*, ed. Carretta, p. 77.

2. Margaretta Oddell, *The Poems of Phillis Wheatley: With Letters and a Memoir,* Dover Publications, 2010, p. 63. (Unabridged replication of *Memoir and Poems of Phillis Wheatley,* Geo. W. Light, Boston, 1834.)

3. William Robinson, *Phillis Wheatley and Her Writings*, Garland Publishing Inc., 1984, p. 25.

4. John C. Shields, *Phillis Wheatley and the Romantics*, University of Tennessee Press, 2010, p. 126.

5. Robinson, *Phillis Wheatley and Her Writings*, p. 23.

6. Shields, *Phillis Wheatley and the Romantics*, p. 99.

7. Shields, *Phillis Wheatley's Poetics of Liberation*, p. 127.

8. Merle A. Richmond, *Bid The Vassal Soar: Interpretive Essays on the Life and Poetry of Phillis Wheatley and George Moses Horton,* Howard University Press, 1974, p. 18.

9. Richmond, *Bid The Vassal Soar,* p. 19.

10. Phillis Wheatley, *Complete Writings*, ed. Carretta, p. 77.

11. Oddell, p. 67.

12. Oddell, p. 63.

13. Robinson, *Phillis Wheatley and Her Writings*, p. 24.

14. Oddell, p. 63.

15. Robinson, *Phillis Wheatley and Her Writings*, p. 24.

16. Carretta, *Phillis Wheatley: Biography of a Genius*, p. 40.

17. Paula Bennett, "Phillis Wheatley's Vocation and the Paradox of the 'Afric Muse," *PMLA,* Vol. 113, No. 1, January 1998, p. 65.

18. Shields, *Phillis Wheatley's Poetics of Liberation*, p. 126.

19. Oddell, p. 67.

20. Carretta, *Phillis Wheatley: Biography of a Genius,* p. 51.

21. Shields, *Phillis Wheatley's Poetics of Liberation*, p. 127.

22. Oddell, p. 67.

23. Carretta, *Phillis Wheatley: Biography of a Genius,* p. 51.

24. *Ibid.*

25. Shields, *Phillis Wheatley's Poetics of Liberation*, p. 126.

26. Shields, *Phillis Wheatley's Poetics of Liberation*, p. 82.

27. Shields, *Phillis Wheatley's Poetics of Liberation*, p. 127.

28. Shields, *Phillis Wheatley's Poetics of Liberation*, p. 128.

29. Carretta, *Phillis Wheatley: Biography of a Genius,* p. 51.

30. Oddell, p. 75.

## CHAPTER 11

1. Eileen Razzari Elrod, *Phillis Wheatley's Abolitionst Text: The 1834 Edition*, in *Imagining Transatlantic Slavery,* Cora Kaplan and John Oldfield, ed., Palgrave, Macmillan, 2010, p. 97.

2. Oddell, *The Poems of Phillis Wheatley: With Letters and a Memoir,* p. 64.

3. Oddell, *The Poems of Phillis Wheatley: With Letters and a Memoir,* p. 61.

4. Oddell, *The Poems of Phillis Wheatley: With Letters and a Memoir,* p. 63.

5. Oddell, *The Poems of Phillis Wheatley: With Letters and a Memoir,* p. 62.

6. Oddell, *The Poems of Phillis Wheatley: With Letters and a Memoir,* p. 67.

7. Vincent Carretta, *Phillis Wheatley: Biography of a Genius in Bondage,* University of Georgia Press, 2011, p. 92.

8. William Robinson, *Phillis Wheatley and Her Writings*, Garland Publishing Inc., 1984, p. 42.

9. Robinson, *Phillis Wheatley and Her Writings*, p. 95.

10. Oddell, *The Poems of Phillis Wheatley: With Letters and a Memoir,* p. 67.

11. William Henry Robinson, *Phillis Wheatley and the Origins of African*

*American Literature*, Limited Commemorative Edition, Old South Meeting House, 1999, p. 13.

12. Oddell, *The Poems of Phillis Wheatley: With Letters and a Memoir*, p. 68.

13. Phillis Wheatley, *Complete Writings*, Vincent Carretta, ed., Penguin Books, 2001, p. 142.

14. Phillis Wheatley, *Complete Writings*, p. 148.

15. Phillis Wheatley, *Complete Writings*, p. 154.

16. Merle A. Richmond, *Bid The Vassal Soar: Interpretive Essays on the Life and Poetry of Phillis Wheatley and George Moses Horton*, Howard University Press, 1974, p. 19.

17. Richmond, *Bid The Vassal Soar*, p. 20.

18. W. E. B. Du Bois, "Phillis Wheatley and African American Culture"; (original title: "The Vision of Phillis the Blessed: An Allegory of Negro American Literature in the Eighteenth and Nineteenth Centuries," Fisk News 14, May 1941) *The Oxford W. E. B. DuBois Reader*, Eric J. Sundquist, ed., Oxford University Press, 1996, p. 329.

19. Carretta, *Phillis Wheatley: Biography of a Genius in Bondage*, p. 98.

20. Oddell, *The Poems of Phillis Wheatley: With Letters and a Memoir*, p. 68.

21. *Ibid.*

22. Carretta, *Phillis Wheatley: Biography of a Genius in Bondage*, p. 100.

23. Richmond, *Bid The Vassal Soar*, p. 21.

24. Carretta, *Phillis Wheatley: Biography of a Genius in Bondage*, p. 148.

25. Julian Mason, *The Poems of Phillis Wheatley*, University of North Carolina Press, 1989, p. 160.

26. Carretta, *Phillis Wheatley: Biography of a Genius in Bondage*, p. 149.

27. Mason, *The Poems of Phillis Wheatley*, p. 160.

28. Mason, *The Poems of Phillis Wheatley*, p. 162.

29. *Ibid.*

30. Mason, *The Poems of Phillis Wheatley*, p. 160.

31. Mason, *The Poems of Phillis Wheatley*, p. 159.

32. Mason, *The Poems of Phillis Wheatley*, p. 161.

33. Mason, *The Poems of Phillis Wheatley*, p. 162.

34. Mason, *The Poems of Phillis Wheatley*, p. 163.

35. *Ibid.*

36. *Ibid.*

37. Mukhtar Ali Isani, *Far From Gambia's Golden Shore: The Black in the Late Eighteenth Century American Imaginative Literature,* The William and Mary Quarterly, Third Series, Vol. 36, No. 3, July 1979, p. 364.

38. Mason, *The Poems of Phillis Wheatley*, p. 163.

39. William H. Robinson, *Phillis Wheatley in the Black American Beginnings*, Broadside Press, 1975, p. 60.

40. Mason, *The Poems of Phillis Wheatley*, p. 163.

41. Mason, *The Poems of Phillis Wheatley*, p. 162.

42. Mason, *The Poems of Phillis Wheatley*, p. 160.

43. *Ibid.*

44. Mason, *The Poems of Phillis Wheatley*, p. 162.

45. Annette Gordon-Reed, *The Hemingses of Monticello: An American Family*, W. W. Norton & Company, 2008, p. 272.

46. Annette Gordon-Reed, *The Hemingses of Monticello*, p. 299.

47. *Ibid.*

48. *Ibid.*

## PART II.

1. Julian Mason, *The Poems of Phillis Wheatley*, University of North Carolina Press, 1989, p. 149.

## CHAPTER 12.

1. Neil L. York, *The Boston Massacre: A History with Documents*, Routledge, 2010, p. 85.

2. *Ibid.*

3. *Ibid.*

4. William Robinson, *Phillis Wheatley and Her Writings*, Garland Publishing Inc., 1984, p. 139.

5. *Ibid.*

6. "The Diary of John Rowe, A Boston Merchant, 1764-1779," A Paper read by Edward L. Pierce before the Massachusetts Historical Society, March 14, 1895, John Wilson and Son, 1895, p. 73.

7. Diary of John Adams, Vol. 1, "1770. Monday Feby. 26. or Thereabouts," *Founding Families: Digital Editions of the Papers of the Winthrops and the Adamses*, C.

James Taylor, ed., Massachusetts Historical Society, 2015; http://www.masshist.org/publications/apde2/view?id=ADMS-01-01-02-0014-0002-0001.

8. *Ibid.*

9. Robinson, *Phillis Wheatley and Her Writings*, p. 139.

10. Robinson, *Phillis Wheatley and Her Writings*, p. 140.

11. *Ibid.*

12. *Ibid.*

13. Robinson, *Phillis Wheatley and Her Writings*, p. 139.

14. Robinson, *Phillis Wheatley and Her Writings*, p. 140.

15. Robinson, *Phillis Wheatley and Her Writings*, p. 93.

16. Robinson, *Phillis Wheatley and Her Writings*, p. 139.

17. John Shields, *Phillis Wheatley's Poetics of Liberation,* University of Tennessee Press, 2008, p. 104.

18. Robert C. Kuncio, "Some Unpublished Poems of Phillis Wheatley," *The New England Quarterly*, Vol. 43, No. 2, June 1970, p. 288.

19. "Testimony from the 1770 Boston Massacre Trial," *Docstoc;* <http://www.docstoc.com/docs/60615997/Testimony-from-Boston-Massacre-Trial>.

20. *Ibid.*

21. *Ibid.*

22. *Ibid.*

23. *Ibid.*

24. *Short Narrative of the Horrid Massacre,* Printed by Order of the Town of Boston, 1770, p. 57.

25. *Short Narrative of the Horrid Massacre,* Printed by Order of the Town of Boston, 1770, p. 28.

26. *Short Narrative of the Horrid Massacre,* Printed by Order of the Town of Boston, 1770, p. 38.

27. *Short Narrative of the Horrid Massacre,* Printed by Order of the Town of Boston, 1770, p. 28.

28. *Short Narrative of the Horrid Massacre,* Printed by Order of the Town of Boston, 1770, p. 38.

29. *Short Narrative of the Horrid Massacre,* Printed by Order of the Town of Boston, 1770, p. 29.

30. William Bruce Wheeler and Susan D. Becker, eds. *Discovering the American Past: A Look at the Evidence,* 6th ed. Houghton Mifflin Company, 2006, p. 80.

31. "Anonymous Summary of Defense Evidence: 25–27 October 1770," Founders

Online, National Archives, <http://founders.archives.gov/documents/Adams/05-03-02-0001-0003-0006>.

32. "Anonymous Summary of Defense Evidence: 25–27 October 1770," Founders Online, National Archives, <http://founders.archives.gov/documents/Adams/05-03-02-0001-0003-0006>.

33. *Ibid.*

34. *Ibid.*

35. *The Trial of the British Soldiers of the 29th Regiment of Foot for the Murder of Crispus Attucks, Samuel Gray, Samuel Maverick and Patrick Carr on the Evening of Monday, March 5, 1770, Before the Honorable Justices of the Superior Court, Held at Boston by Adjournment, November 27, 1770,* Published by William Emmons, Boston, 1824, p. 17.

36. "Anonymous Summary of Defense Evidence: 25–27 October 1770," Founders Online, National Archives, <http://founders.archives.gov/documents/Adams/05-03-02-0001-0003-0006>.

37. *Ibid.*

38. *Ibid.*

39. *Short Narrative of the Horrid Massacre,* Printed by Order of the Town of Boston, 1770, p. 29.

40. *Short Narrative of the Horrid Massacre,* Printed by Order of the Town of Boston, 1770, p. 58.

41. *Short Narrative of the Horrid Massacre,* Printed by Order of the Town of Boston, 1770, p. 39.

42. Neil L.York, *The Boston Massacre: A History with Documents,* Routledge, 2010, p. 112.

43. Bernard Bailyn, *The Ordeal of Thomas Hutchinson,* Harvard University Press, 1974, p. 158.

44. Neil L.York, *The Boston Massacre: A History with Documents,* Routledge, 2010, p. 100.

45. *Ibid.*

46. Robert J. Allison, *The Boston Massacre,* Commonwealth Editions, 2006, p. 18.

47. Neil L. York, *The Boston Massacre: A History with Documents,* Routledge, 2010, p. 92.

48. John Shields, "Phillis Wheatley's Struggle for Freedom in Her Poetry and Prose," *The Collected Works of Phillis Wheatley,* Oxford University Press, 1988, p. 324.

49. "Boston Massacre as Reported in the Boston Gazette," *Boston Massacre Historical Society*, <http://www.bostonmassacre.net/gazette/>.

50. *Ibid.*

51. John Rowe, *Letters and Diary of John Rowe*, Boston Merchant, Ann Rowe Cunningham, ed., W. B. Clarke Co., 1903, p. 199.

52. Robinson, *Phillis Wheatley and Her Writings*, p. 19.

53. *The Critical Review or Annals of Literature*, by A Society of Gentlemen, Vol. 29, A. Hamilton, Falcon Court, Fleet Street, London, 1770, p. 391.

54. Robinson, *Phillis Wheatley and Her Writings*, p. 17.

55. Robinson, *Phillis Wheatley and Her Writings*, p. 455.

56. Neil L. York, *The Boston Massacre: A History with Documents,* Routledge, 2010, p. 3.

## CHAPTER 13

1. Vincent Carretta, *Phillis Wheatley: Biography of a Genius in Bondage,* University of Georgia Press, 2011, p. 46.

2. Paula Bennett, "Phillis Wheatley's Vocation and the Paradox of the 'Afric Muse'," *PMLA,* Vol. 113, No. 1, January 1998, p. 69.

3. Mukhtar Ali Isani, *Phillis Wheatley and the Elegiac Mode;* In: *Critical Essays on Phillis Wheatley*, William Robinson, 1982, p. 208.

4. Samuel Taylor Coleridge, *Complete Works of Samuel Taylor Coleridge*, Vol. 6, 4th ed. Professor W. G. T. Shedd, Harper and Brothers, Franklin Square, 1884, p. 491.

5. William Robinson, *Phillis Wheatley in the Black American Beginnings*, Broadside Press, 1975, p. 49.

6. Margaretta Matilda Oddell, *The Poems of Phillis Wheatley: With Letters and a Memoir,* Dover Publications, 2010, p. 65. (Unabridged replication of *Memoir and Poems of Phillis Wheatley,* Geo. W. Light, Boston, 1834.)

7. Vernon Loggins, *The Negro Author: His Development in America to 1900*, Columbia University Press, 1931, p. 23.

8. Robinson, *Phillis Wheatley in the Black American Beginnings,* p. 50.

9. Robinson, *Phillis Wheatley in the Black American Beginnings,* p. 29.

10. Isani, *Phillis Wheatley and the Elegiac Mode;* In: *Critical Essays on Phillis Wheatley*, p. 210.

11. John Shields, "Phillis Wheatley's Struggle For Freedom In Her Poetry and Prose," *The Collected Works of Phillis Wheatley*, Oxford University Press, 1988, p. 251.

12. Isani, *Phillis Wheatley and the Elegiac Mode;* in: *Critical Essays on Phillis Wheatley,* p. 212.

13. John Shields, *Phillis Wheatley's Poetics of Liberation,* University of Tennessee Press, 2008, p. 171.

14. Isani, "Phillis Wheatley and the Elegiac Mode;" In: *Critical Essays on Phillis Wheatley,* p. 210.

15. Shields, *Phillis Wheatley's Poetics of Liberation,* 2008, p. 21.

16. Isani, *Phillis Wheatley and the Elegiac Mode;* In: *Critical Essays on Phillis Wheatley,* p. 212.

17. *Ibid.*

18. William Robinson, *Phillis Wheatley and Her Writings,* Garland Publishing Inc., 1984, p. 101.

19. Gregory Rigsby, "Phillis Wheatley's Craft as Reflected in Her Revised Elegies," *The Journal of Negro Education,* Vol. 47, No. 4 (Autumn, 1978,) p. 403.

20. Rigsby, "Phillis Wheatley's Craft as Reflected in Her Revised Elegies," p. 407.

21. Robinson, *Phillis Wheatley and Her Writings,* p. 91.

22. Isani, "Phillis Wheatley and the Elegiac Mode;" in: *Critical Essays on Phillis Wheatley,* p. 211.

23. Robinson, *Phillis Wheatley and Her Writings,* p. 98.

24. Carretta, *Phillis Wheatley: Biography of a Genius in Bondage,* p. 78.

25. Isani, "Phillis Wheatley and the Elegiac Mode;" in: *Critical Essays on Phillis Wheatley,* p. 208.

26. Julian Mason, *The Poems of Phillis Wheatley,* University of North Carolina Press, 1989, p. 59.

27. Robinson, *Phillis Wheatley and Her Writings,* p. 374.

28. Robinson, *Phillis Wheatley and Her Writings,* p. 390.

29. Mason, *The Poems of Phillis Wheatley,* p. 151-152.

30. Bennett, "Phillis Wheatley's Vocation and the Paradox of the 'Afric Muse,'" p. 65.

31. Shields, *Phillis Wheatley's Poetics of Liberation,* p. 171.

32. Mason, *The Poems of Phillis Wheatley,* p. 152.

33. Bennett, "Phillis Wheatley's Vocation and the Paradox of the 'Afric Muse,'" p. 74.

34. Shields, *Phillis Wheatley's Poetics of Liberation,* p. 82.

35. Mason, *The Poems of Phillis Wheatley,* p. 146.

36. Robinson, *Phillis Wheatley and Her Writings*, p. 381.

37. *Ibid.*

38. *Ibid.*

39. Mason, *The Poems of Phillis Wheatley*, p. 80-81.

40. Mason, *The Poems of Phillis Wheatley*, p. 140-141.

41. Mason, *The Poems of Phillis Wheatley*, p. 146.

42. Mason, *The Poems of Phillis Wheatley*, p. 72.

43. Mason, *The Poems of Phillis Wheatley*, p. 106.

44. Bennett, "Phillis Wheatley's Vocation and the Paradox of the 'Afric Muse,'" p. 69.

45. *Ibid.*

46. Isani, "Phillis Wheatley and the Elegiac Mode;" in: *Critical Essays on Phillis Wheatley*, p. 213.

47. Mason, *The Poems of Phillis Wheatley*, p. 106.

## CHAPTER 14

1. Julian Mason, *The Poems of Phillis Wheatley*, University of North Carolina Press, 1989, p. 142.

2. Zach Petrea, "An Untangled Web: Mapping Phillis Wheatley's Network of Support in America and Great Britain," *New Essays on Phillis Wheatley*, John C. Shields and Eric D. Lamore, ed., University of Tennessee Press, 2011, p. 297.

3. *Ibid.*

4. Petrea, *An Untangled Web*, p. 298.

5. Karin A. Wulf, Introduction, "Milcah Martha Moore's Book: Documenting Culture and Connection in the Revolutionary Era," *Milcah Martha Moore's Book: A Commonplace Book From Revolutionary America*, Catherine La Courreye Blecki and Karin A. Wulf, eds., Penn State Press, 1997, p. 23.

6. *Ibid.*

7. Karin Wulf, *Not All Wives: Women of Colonial Phladephia*, Cornell University Press, 2000, p. 45.

8. Margaretta Matilda Oddell, *The Poems of Phillis Wheatley: With Letters and a Memoir*, Dover Publications, 2010, p. 65. (Unabridged replication of *Memoir and Poems of Phillis Wheatley*, Geo. W. Light, Boston, 1834.)

9. Mason, *The Poems of Phillis Wheatley*, p. 142.

10. *Ibid.*

11. Mason, *The Poems of Phillis Wheatley*, p. 141.

12. Mason, *The Poems of Phillis Wheatley*, p. 142.

13. Mason, *The Poems of Phillis Wheatley*, p. 141.

14. Carretta, *Phillis Wheatley: Biography of a Genius in Bondage*, p. 85.

15. Carretta, *Phillis Wheatley: Biography of a Genius in Bondage*, p. 84.

16. Carretta, *Phillis Wheatley: Biography of a Genius in Bondage*, p. 85.

17. Mason, *The Poems of Phillis Wheatley*, p. 76.

18. *Ibid.*

19. *Ibid.*

20. Mason, *The Poems of Phillis Wheatley*, p. 77.

21. Joanna Brooks, *Our Phillis, Ourselves*, American Literature, Volume 82, Number 1, March 2010, p. 8.

22. *Ibid.*

23. Brooks, *Our Phillis, Ourselves*, p. 9.

24. Rufus Wilmot Griswold, *The Female Poets of America*, Carey and Hart, Philadelphia, 1849, p. 31.

25. Robert C. Kuncio, "Some Unpublished Poems of Phills Wheatley," *The New England Quarterly*, Vol. 43, No. 2, June 1970, p. 288.

26. Brooks, *Our Phillis, Ourselves*, p. 24.

27. Carretta, *Phillis Wheatley: Biography of a Genius in Bondage*, p. 89.

28. Phillis Wheatley, "1779 Proposal," *Phillis Wheatley: Complete Writings*, Vincent Carretta, ed., Penguin Books, 2001, p. 168.

29. William Robinson, *Phillis Wheatley and Her Writings*, Garland Publishing Inc., 1984, p. 381.

30. Brooks, *Our Phillis, Ourselves*, p. 8.

31. *Ibid.*

32. *Ibid.*

33. *Ibid.*

34. James Levernier, "Phillis Wheatley and the New England Clergy," *Early American Literature* 26:1 (1991), p. 23.

35. John Shields, *The American Aeneas: Classical Origins of the American Self*, University of Tennessee Press, 2004, p. 374.

36. Mason, *The Poems of Phillis Wheatley*, p. 19.

37. Carretta, *Phillis Wheatley: Biography of a Genius in Bondage*, p. 106.

38. Mason, *The Poems of Phillis Wheatley*, p. 78.

39. John Shields, *Phillis Wheatley's Poetics of Liberation,* University of Tennessee Press, 2008, p. 252.

40. Mason, *The Poems of Phillis Wheatley*, p. 78.

41. Mason, *The Poems of Phillis Wheatley*, p. 79.

42. Robinson, *Phillis Wheatley and Her Writings*, p. 96.

43. Mason, *The Poems of Phillis Wheatley*, p. 67.

44. *Ibid.*

45. *Ibid.*

46. Mason, *The Poems of Phillis Wheatley*, p. 68.

47. Mason, *The Poems of Phillis Wheatley*, p. 70.

48. Mason, *The Poems of Phillis Wheatley*, p. 95.

49. Mason, *The Poems of Phillis Wheatley*, p. 96.

50. Mason, *The Poems of Phillis Wheatley*, p. 111.

51. Robinson, *Phillis Wheatley and Her Writings*, p. 275.

## CHAPTER 15

1. Phillis Wheatley, April 21, 1772, *Complete Writings,* Vincent Carretta, ed., Penguin Books, 2001, p. 140.

2. Phillis Wheatley, October 30, 1773, *Complete Writings*, p. 148.

3. Mark Jackson, *Asthma: The Biography*, Oxford University Press, 2009, p. 4.

4. Jackson, *Asthma: The Biography,* p. 152.

5. Phillis Wheatley, *Complete Writings,* Vincent Carretta, ed., p. 142.

6. Phillis Wheatley, *Complete Writings,* Vincent Carretta, ed., p. 141.

7. Julian Mason, *The Poems of Phillis Wheatley*, University of North Carolina Press, 1989, p. 186.

8. Mukhtar Ali Isani, "Wheatley's Departure for London and Her 'Farewel to America,'" *South Atlantic Bulletin* 42, November 1979, p. 124.

9. William Robinson, *Phillis Wheatley and the Origins of African American Literature*, Limited Commemorative Edition, Old South Meeting House, 1999, p. 14.

10. *Ibid.*

11. Julian Mason, *The Poems of Phillis Wheatley*, University of North Carolina Press, 1989, p. 188.

12. Mason, *The Poems of Phillis Wheatley*, p. 186.

13. Mason, *The Poems of Phillis Wheatley*, p. 188.

14. Vincent Carretta, *Phillis Wheatley: Biography of a Genius in Bondage*, University of Georgia Press, 2011, p. 83.

15. Mason, *The Poems of Phillis Wheatley*, p. 186.

16. Carretta, *Phillis Wheatley: Biography of a Genius in Bondage*, p. 83.

17. Carretta, *Phillis Wheatley: Biography of a Genius in Bondage*, p. 80.

18. Carretta, *Phillis Wheatley: Biography of a Genius in Bondage*, p. 83.

19. William Robinson, *Phillis Wheatley and Her Writings*, Garland Publishing Inc., 1984, p. 25.

20. Robinson, *Phillis Wheatley and Her Writings*, p. 26.

21. William Robinson, "Phillis Wheatley: On Black in Boston Lace Gloves," in *Black New England Letters: The Uses of Writings in Black New England*, Trustees of the Public Library of the City of Boston, 1977, p. 51.

22. Robinson, *Phillis Wheatley and Her Writings*, Garland Publishing Inc., 1984, p. 27.

23. Mason, *The Poems of Phillis Wheatley*, p. 186.

24. *Ibid.*

25. William Robinson, "Phillis Wheatley: On Black in Boston Lace Gloves," in *Black New England Letters: The Uses of Writings in Black New England*, Trustees of the Public Library of the City of Boston, 1977, p. 51.

26. Kathrynn Seidler Engberg, *The Right to Write: The Literary Politics of Anne Bradstreet and Phillis Wheatley*, University Press of America, 2010, p. 45.

27. William Robinson, *Phillis Wheatley and Her Writings*, p. 27.

28. Engberg, *The Right to Write*, p. 45.

29. J. L. Bell, *Boston 1775*, "Was Three Shillings Too Much to Ask?," October 27, 2011, <http://boston1775.blogspot.com/2011/10/was-three-shillings-too-much-to-ask.html>.

30. Engberg, *The Right to Write*, p. 45.

31. Robinson, *Phillis Wheatley and Her Writings*, p. 28.

32. Robinson, *Phillis Wheatley in the Black American Beginnings*, p. 53.

## CHAPTER 16

1. William Robinson, "Phillis Wheatley: On Black in Boston Lace Gloves," in *Black New England Letters: The Uses of Writings in Black New England*, Trustees of the Public Library of the City of Boston, 1977, p. 52.

2.  William Robinson, Phillis Wheatley and Her Writings, Garland Publishing Inc., 1984, p. 28.

3.  Robinson, *Black New England Letters,* p. 52.

4.  Julian Mason, The Poems of Phillis Wheatley, University of North Carolina Press, 1989, p. 186.

5.  Robinson, *Phillis Wheatley and Her Writings*, p. 26.

6.  Robinson, *Phillis Wheatley and Her Writings*, p. 26.

7.  Mason, *The Poems of Phillis Wheatley*, p. 187.

8.  *Ibid.*

9.  Robinson, *Phillis Wheatley and Her Writings*, p. 30.

10. Robinson, Phillis Wheatley and Her Writings, p. 26.

11. Mason, *The Poems of Phillis Wheatley*, p. 47.

12. Vincent Carretta, *Phillis Wheatley: Biography of a Genius in Bondage,* University of Georgia Press, 2011, p. 91.

13. Mason, *The Poems of Phillis Wheatley*, p. 185.

14. Robinson, *Black New England Letters,* p. 53.

15. Mason, *The Poems of Phillis Wheatley*, p. 186.

16. Robinson, *Black New England Letters,* p. 53.

17. Mason, *The Poems of Phillis Wheatley*, p. 48.

18. Mason, *The Poems of Phillis Wheatley*, p. 48.

19. Robinson, *Phillis Wheatley and Her Writings*, p. 270.

20. Robinson, *Phillis Wheatley and Her Writings*, p. 405.

21. Robinson, *Phillis Wheatley and Her Writings*, p. 271.

## CHAPTER 17

1.  Joanna Brooks, *Our Phillis, Ourselves*, American Literature, Volume 82, Number 1, March 2010, p. 3.

2.  J. L. Bell, *Boston 1775*, "Assessing a Big Test," October 19, 2011; <http://boston1775.blogspot.com/2011/10/assessing-big-test.html>.

3.  Brooks, *Our Phillis, Ourselves*, p. 1.

4.  Gay Gibson Cima, *Early American Women Critics: Performance, Religion, Race,* Cambridge University Press, 2006, p. 89.

5.  Vincent Carretta, *Phillis Wheatley: Biography of a Genius in Bondage,* University of Georgia Press, 2011, p. 102.

6.  Cima, *Early American Women Critics,* p. 90.

7.  J. L. Bell, *Boston 1775,* "Was Three Shillings Too Much to Ask?," October 27, 2011, <http://boston1775.blogspot.com/2011/10/was-three-shillings-too-much-to-ask.html>.

8.  Brooks, *Our Phillis, Ourselves,* p. 7.

9.  Brooks, *Our Phillis, Ourselves,* p. 4.

10. Brooks, *Our Phillis, Ourselves,* p. 3.

11. Robert Middlekauff, *The Glorious Cause: The American Revolution, 1763-1789,* Oxford University Press, 2005, p. 222.

12. Harlow Giles Unger, *American Tempest: How the Boston Tea Party Sparked a Revolution,* Da Capo Press, 2011, p. 156.

13. Brooks, *Our Phillis, Ourselves,* p. 5.

14. Julian Mason, *The Poems of Phillis Wheatley,* University of North Carolina Press, 1989, p. 187.

15. Brooks, *Our Phillis, Ourselves,* p. 7.

16. Brooks, *Our Phillis, Ourselves,* p. 5.

17. Carretta, *Phillis Wheatley: Biography of a Genius in Bondage,* p. 93.

18. William Robinson, *Phillis Wheatley and Her Writings,* Garland Publishing Inc., 1984, p. 29.

19. Robinson, *Phillis Wheatley and Her Writings,* p. 270.

20. J. L. Bell, *Boston 1775,* "Phillis Wheatley Gathers Testimonials," May 5, 2007, <http://boston1775.blogspot.com/2007/05/phillis-wheatley-gathers-testimonials.html\>.

21. Henry Louis Gates, *The Trials of Phillis Wheatley: America's First Black Poet and Her Encounters With The Founding Fathers,* Basic Civitas Books, 2003, p. 5.

22. Gates, *The Trials of Phillis Wheatley,* p. 23.

23. Henry Louis Gates, Jr., Foreword: In Her Own Write, *The Collected Works of Phillis Wheatley,* John Shields, ed., Oxford University Press, 1988, p. ix.

24. Gates, *The Trials of Phillis Wheatley,* p. 23.

25. Gates, *The Trials of Phillis Wheatley,* p. 25.

26. Gates, Foreword: In Her Own Write, *The Collected Works of Phillis Wheatley,* p. x.

27. Cima, *Early American Women Critics,* p. 91.

28. Cima, *Early American Women Critics,* p. 90.

29. Cima, *Early American Women Critics,* p. 83.

30. *Ibid.*

31. Gates, *The Trials of Phillis Wheatley*, p. 27.

## CHAPTER 18

1. Vincent Carretta, *Phillis Wheatley: Biography of a Genius in Bondage*, University of Georgia Press, 2011, p. 128.

2. Carretta, *Phillis Wheatley: Biography of a Genius in Bondage*, p. 122.

3. Carretta, *Phillis Wheatley: Biography of a Genius in Bondage*, p. 129.

4. Alfred W. Blumrosen & Ruth G. Blumrosen, *Slave Nation: How Slavery United the Colonies and Sparked the American Revolution*, Sourcebooks, 2005, p. 277.

5. Blumrosen, *Slave Nation: How Slavery United the Colonies and Sparked the American Revolution*, p. 15.

6. Blumrosen, *Slave Nation: How Slavery United the Colonies and Sparked the American Revolution*, p. 6.

7. Kirsten Wilcox, "The Body into Print: Marketing Phillis Wheatley," *American Literature*, Vol. 71, No. 1. March 1999, Wilcox p. 5.

8. Carretta, *Phillis Wheatley: Biography of a Genius in Bondage*, p. 130.

9. Carretta, *Phillis Wheatley: Biography of a Genius in Bondage*, p. 139.

10. *Ibid.*

11. "Freedom Petition of Massachusetts Slaves April 1773, *Columbia American History Online*, <http://caho-test.cc.columbia.edu/ps/10186.html>.

12. "Long Road to Justice: The African-American Experience in Massachusetts Courts," *Massachusetts Historical Society,* http://www.masshist.org/longroad/01slavery/walker.htm>.

13. Julian Mason, *The Poems of Phillis Wheatley*, University of North Carolina Press, 1989, p. 149.

14. William Robinson, *Phillis Wheatley and Her Writings*, Garland Publishing Inc., 1984, p. 388.

15. Mason, *The Poems of Phillis Wheatley*, p. 149.

16. J. L. Bell, *Boston 1775,* "I asked if she could write on any subject," October 22, 2011, <http://boston1775.blogspot.com/2011/10/i-asked-if-she-could-write-on-any.html>.

17. Robinson, *Phillis Wheatley and Her Writings*, p. 403.

18. Mason, *The Poems of Phillis Wheatley*, p. 47.

19. Robinson, *Phillis Wheatley and Her Writings*, p. 403.

20. *Ibid.*

21. Mason, *The Poems of Phillis Wheatley*, p. 192.

22. *Ibid.*

23. Harlow Giles Unger, *American Tempest: How the Boston Tea Party Sparked a Revolution*, Da Capo Press, 2011, p. 196.

24. Harlow Giles Unger, *American Tempest: How the Boston Tea Party Sparked a Revolution*, p. 197.

## CHAPTER 19

1.  William Robinson, *Phillis Wheatley and Her Writings*, Garland Publishing Inc., 1984, p. 92.

2.  Vincent Carretta, *Phillis Wheatley: Biography of a Genius in Bondage*, University of Georgia Press, 2011, p. 131.

3.  Julian Mason, *The Poems of Phillis Wheatley*, University of North Carolina Press, 1989, p. 149.

4.  Rafia Zafar, *We Wear the Mask: African Americans Write American Literature, 1760-1870*, Columbia University Press, 1997, p. 21.

5.  Vincent Carretta, *Phillis Wheatley, Complete Writings*, Vincent Carretta, ed., Penguin Books, 2001, p. xxviii

6.  Carretta, *Phillis Wheatley: Biography of a Genius in Bondage*, p. 132.

7.  Mason, *The Poems of Phillis Wheatley*, p. 83.

8.  William H. Robinson, *Phillis Wheatley in the Black American Beginnings*, Broadside Press, 1975, p. 40.

9.  Kathrynn Seidler Engberg, *The Right to Write: The Literary Politics of Anne Bradstreet and Phillis Wheatley*, University Press of America, 2010, p. 64.

10. Carretta, *Phillis Wheatley, Complete Writings*, p. xxviii

11. Engberg, *The Right to Write*, p. 60.

12. Mason, *The Poems of Phillis Wheatley*, p. 150.

13. Shields, "Phillis Wheatley's Struggle For Freedom In Her Poetry and Prose," *The Collected Works of Phillis Wheatley*, p. 235.

14. Mason, *The Poems of Phillis Wheatley*, p. 83.

15. Margaretta Matilda Oddell, *The Poems of Phillis Wheatley: With Letters and a Memoir*, Dover Publications, 2010, p. 62. (Unabridged replication of *Memoir and Poems of Phillis Wheatley*, Geo. W. Light, Boston, 1834.)

16. John Shields, *Phillis Wheatley's Poetics of Liberation,* University of Tennessee Press, 2008, p. 98.

17. Mason, *The Poems of Phillis Wheatley*, p. 83.

18. *Ibid.*

19. Arthur P. Davis, "The Personal Elements in the Poetry of Phillis Wheatley," *Phylon: The Atlantic University Review of Race and Culture,* Vol. 12, No. 2, Second Quarter, 1953, in *Critical Essays on Phillis Wheatley*, William H. Robinson, ed., G. K. Hall & Co., 1982, p. 97.

20. Mason, *The Poems of Phillis Wheatley*, p. 83.

## CHAPTER 20

1. William Robinson, *Phillis Wheatley and the Origins of African American Literature,* Commemorative Edition, Old South Meeting House, 1999, p. 14.

2. William Robinson, *Phillis Wheatley and Her Writings*, Garland Publishing Inc., 1984, p. 31.

3. Vincent Carretta, *Phillis Wheatley: Biography of a Genius in Bondage,* University of Georgia Press, 2011, p. 92.

4. Robinson, *Phillis Wheatley and Her Writings,* p. 31.

5. Carretta, *Phillis Wheatley: Biography of a Genius in Bondage*, p. 93.

6. *Ibid.*

7. Kathrynn Seidler Engberg, *The Right to Write: The Literary Politics of Anne Bradstreet and Phillis Wheatley*, University Press of America, 2010, p. 48.

8. Carretta, *Phillis Wheatley: Biography of a Genius in Bondage*, p. 93.

9. Robinson, *Phillis Wheatley and Her Writings,* p. 31.

10. Mason, *The Poems of Phillis Wheatley*, p. 7.

11. Carretta, *Phillis Wheatley: Biography of a Genius in Bondage*, p. 104.

12. Mason, *The Poems of Phillis Wheatley*, p. 104.

13. *Ibid.*

14. Mason, *The Poems of Phillis Wheatley*, p. 105.

15. *Ibid.*

16. Margaretta Matilda Oddell, *The Poems of Phillis Wheatley: With Letters and a Memoir,* Dover Publications, 2010, p. 68. (Unabridged replication of *Memoir and Poems of Phillis Wheatley,* Geo. W. Light, Boston, 1834.)

17. *Ibid.*

18. Mason, *The Poems of Phillis Wheatley*, p. 8.

19. Richard H. Saunders and Ellen G. Miles, *American Colonial Portraits 1700-1776*, Smithsonian Institution Press, 1987, p. 44.

20. Gwendolyn DuBois Shaw, *Portraits of a People: Picturing African Americans in the Nineteenth Century*, University of Washington Press, 2006, p. 27.

21. Betsy Erkkila, "Phillis Wheatley and the Black American Revolution," *A Mixed Race: Ethnicity in Early America*, Frank Shuffleton, ed., Oxford University Press, 1993, p. 229.

22. Robert Kendrick, "Other Questions: Phillis Wheatley and the Ethics of Interpretation," *Cultural Critique*, University of Minnesota Press, No. 38 (Winter 1997-98), p. 62.

23. Shaw, *Portraits of a People: Picturing African Americans in the Nineteenth Century*, p. 32.

24. Shaw, *Portraits of a People: Picturing African Americans in the Nineteenth Century*, p. 33.

25. Marilyn Richardson, "Recovering Phillis Wheatley, Recovering Ourselves," *Phillis Wheatley and the Origins of African American Literature*, commemorative Edition, Old South Meeting House, 1999, p. 8.

26. Shaw, *Portraits of a People: Picturing African Americans in the Nineteenth Century*, p. 41.

27. Mason, *The Poems of Phillis Wheatley*, p. 187.

28. Mason, *The Poems of Phillis Wheatley*, p. 6.

29. *Ibid.*

30. Robinson, *Phillis Wheatley and Her Writings*, p. 33.

31. Sara Jackson Dunlap, "Documents Letters of Phillis Wheatley and Susanna Wheatley," *The Journal of Negro History*, Vol. 57, No. 2 (April 1972), p. 212.

32. Dunlap, "Documents Letters of Phillis Wheatley and Susanna Wheatley," p. 213.

33. *Ibid.*

34. *Ibid.*

35. *Ibid.*

36. Carretta, *Phillis Wheatley: Biography of a Genius in Bondage*, p. 92.

## CHAPTER 21

1. Zora Neale Hurston letter to Edwin Osgood Grover, December 13, 1934; *Zora Neale Hurston: A Life in Letters,* Carla Kaplan, ed., Random House, 2007, p. 325.

2. Vincent Carretta, *Phillis Wheatley: Biography of a Genius in Bondage*, University of Georgia Press, 2011, p. 95.

3. William Robinson, *Phillis Wheatley and Her Writings*, Garland Publishing Inc., 1984, p. 22.

4. Sara Jackson Dunlap, Documents Letters of Phillis Wheatley and Susanna Wheatley, *The Journal of Negro History*, Vol. 57, No. 2 (April 1972), p. 214.

5. Phillis Wheatley, letter to David Wooster, Boston, October 18, 1773, *Complete Writings*, Vincent Carretta, ed., Penguin Books, 2001, p. 146.

6. Kirsten Wilcox, "The Body Into Print: Marketing Phillis Wheatley," *American Literature*, Vol. 71, No. 1 (March 1999), p. 16.

7. Wilcox, "The Body Into Print: Marketing Phillis Wheatley," p. 28.

8. John Shields, *Phillis Wheatley's Poetics of Liberation,* University of Tennessee Press, 2008, p. 25.

9. Shields, *Phillis Wheatley's Poetics of Liberation,* p. 26.

10. Shields, *Phillis Wheatley's Poetics of Liberation,* p. 40.

11. *Ibid.*

12. Wilcox, "The Body Into Print: Marketing Phillis Wheatley," p. 18.

13. Phillis Wheatley, *Phillis Wheatley: Complete Writings*, Carretta, ed., p. 9.

14. Shields, *Phillis Wheatley's Poetics of Liberation,* p. 178.

15. Phillis Wheatley, *Phillis Wheatley: Complete Writings*, Carretta, ed., p. 9.

16. Shields, *Phillis Wheatley's Poetics of Liberation,* p. 178.

17. Phillis Wheatley, *Phillis Wheatley: Complete Writings*, Carretta, ed., p. 9.

18. *Ibid.*

19. Shields, *Phillis Wheatley's Poetics of Liberation,* p. 149.

20. Phillis Wheatley, *Phillis Wheatley: Complete Writings*, Carretta, ed., p. 9.

21. *Ibid.*

22. Shields, *Phillis Wheatley's Poetics of Liberation,* p. 179.

23. Shields, *Phillis Wheatley's Poetics of Liberation,* p. 150.

24. Phillis Wheatley, *Phillis Wheatley: Complete Writings*, Carretta, ed., p. 10.

25. *Ibid.*

26. Eric Ashley Hairston, "The Trojan Horse: Classics, Transformation and Afric Ambition in *Poems on Various Subjects Religious and Moral*," *New Essays on Phillis Wheatley*, John C. Shields and Eric D. Lamore, ed., University of Tennessee Press, 2011, p. 71.

27. Phillis Wheatley, *Phillis Wheatley: Complete Writings*, Carretta, ed., p. 10.

28. *Ibid.*

29. Maya Angelou, "The Art of Fiction" No. 119. *The Paris Review*, Fall 1990, <http://www.theparisreview.org/interviews/2279/the-art-of-fiction-no-119-maya-angelou>.

30. Phillis Wheatley, *Phillis Wheatley: Complete Writings*, Carretta, ed., p. 10.

31. *Ibid.*

32. *Ibid.*

33. Hairston, "The Trojan Horse," p. 72.

34. Hairston, "The Trojan Horse," p. 73.

35. Babacar M.Baye, "The Pan-African and Puritan Dimensions of Phillis Wheatley's Poems and Letters," *New Essays on Phillis Wheatley*, John C. Shields and Eric D. Lamore, ed., University of Tennessee Press, 2011, p. 285.

36. John Shields, "Introduction," *New Essays on Phillis Wheatley*, John C. Shields and Eric D. Lamore, ed., University of Tennessee Press, 2011, p. xvi.

37. Hairston, "The Trojan Horse," p. 89.

38. Hairston, "The Trojan Horse," p. 75.

39. Paula Bennett, "Phillis Wheatley's Vocation and the Paradox of the 'Afric Muse'," *PMLA*, Vol. 113, No. 1, January 1998, p. 69.

40. Phillis Wheatley, *Phillis Wheatley: Complete Writings*, Carretta, ed., p. 10.

41. Gay Gibson Cima, *Early American Women Critics: Performance, Religion, Race,* Cambridge University Press, 2006, p. 99.

42. Carretta, *Phillis Wheatley: Biography of a Genius in Bondage*, p. 106.

43. Hairston, "The Trojan Horse," p. 74.

## CHAPTER 22

1. Julian Mason, *The Poems of Phillis Wheatley*, University of North Carolina Press, 1989, p. 14.

2. Mason, *The Poems of Phillis Wheatley*, p. 154.

3. Margaretta Matilda Oddell, *The Poems of Phillis Wheatley: With Letters and a Memoir,* Dover Publications, 2010, p. 69. (Unabridged replication of *Memoir*

*and Poems of Phillis Wheatley,* Geo. W. Light, Boston, 1834.)

4. Kirsten Wilcox, "The Body into Print: Marketing Phillis Wheatley," *American Literature,* Vol. 71, No. 1 (March 1999), p. 3.

5. Kathrynn Seidler Engberg, *The Right to Write: The Literary Politics of Anne Bradstreet and Phillis Wheatley,* University Press of America, 2010, p. 62.

6. Phillis Wheatley, *Complete Writings,* Vincent Carretta, ed., Penguin Books, 2001, p. 62.

7. Phillis Wheatley, *Complete Writings,* Carretta, ed., p. 62.

8. Engberg, *The Right to Write,* p. 63.

9. Vincent Carretta, *Phillis Wheatley: Biography of a Genius in Bondage,* University of Georgia Press, 2011, p. 135.

10. Phillis Wheatley, *Complete Writings,* Carretta, ed., p. 62.

11. Engberg, *The Right to Write,* p. 63.

12. Phillis Wheatley, *Complete Writings,* Carretta, ed., p. 62-63.

13. Wilcox, "The Body Into Print: Marketing Phillis Wheatley," p. 6.

14. Phillis Wheatley, *Complete Writings,* Carretta, ed., p. 63.

15. Wilcox, "The Body Into Print: Marketing Phillis Wheatley," p. 6.

16. Phillis Wheatley, *Complete Writings,* Carretta, ed., p. 63.

17. Engberg, *The Right to Write,* p. 64.

18. Phillis Wheatley, *Complete Writings,* Carretta, ed., p. 64.

19. Wilcox, "The Body Into Print: Marketing Phillis Wheatley," p. 4.

20. Engberg, *The Right to Write,* p. 64.

21. Phillis Wheatley, *Complete Writings,* Carretta, ed., p. 64.

22. Phillis Wheatley, *Complete Writings,* Carretta, ed., p. 137.

23. Wilcox, "The Body Into Print: Marketing Phillis Wheatley," p. 5.

## PART III.

1. Phillis Wheatley, October 18, 1773; Carretta, ed. *Phillis Wheatley: Complete Writings,* p. 147.

## CHAPTER 23

1. "*The Boston Gazette and Country Journal,* May 10, 1773," The Annotated Newspapers of Harbottle Dorr, jr., Massachusetts Historical Society, <http://www.masshist.org/dorr/volume/4/sequence/366>.

2.  William Robinson, *Phillis Wheatley and the Origins of African American Literature*, Old South Meeting House, 1999, p. 17.

3.  Mukhtar Ali Isani, "The Contemporaneous Reception of Phillis Wheatley: Newspaper and Magazine Notices During the Years of Fame, 1765-1774," *The Journal of Negro History*, Vol. 85. No. 4, Autumn, 2000, p. 268.

4.  Robinson, *Phillis Wheatley and the Origins of African American Literature*, p. 17.

5.  Isani, "The Contemporaneous Reception of Phillis Wheatley," p. 262.

6.  Mukhtar Ali Isani, "Wheatley's Departure for London and Her 'Farewel to America,'" *South Atlantic Bulletin* 42, November 1979, p. 123.

7.  J. L. Bell, *Boston 1775*, "Phillis Wheatley, The Extraordinary Poetical Genius," October 29, 2011, <http://boston1775.blogspot.com/2011/10/phillis-wheatley-extraordinary-poetical.html>.

8.  Vincent Carretta, *Phillis Wheatley: Biography of a Genius in Bondage*, University of Georgia Press, 2011, p. 96.

9.  William Robinson, *Phillis Wheatley and Her Writings*, Garland Publishing Inc., 1984, p. 33.

10. Carretta, *Phillis Wheatley: Biography of a Genius in Bondage*, p. 216.

11. Kirsten Wilcox, *The Body into Print: Marketing Phillis Wheatley*, American Literature, Vol. 71, No. 1 (March 1999), p. 3.

12. William Robinson, *Phillis Wheatley and Her Writings*, Garland Publishing Inc., 1984, p. 34.

13. Wilcox, *The Body Into Print: Marketing Phillis Wheatley*, p. 3.

14. Julian Mason, *The Poems of Phillis Wheatley*, University of North Carolina Press, 1989, p. 154.

15. Isani, "Wheatley's Departure for London and Her 'Farewel to America,'" p. 124.

16. Isani, "Wheatley's Departure for London and Her 'Farewel to America,'" p. 123.

17. Rowan Ricardo Phillips, *When Blackness Rhymes with Blackness*, Dalkey Archive Press, 2010, p. 15.

18. Phillips, *When Blackness Rhymes with Blackness*, p. 16.

19. Isani, "Wheatley's Departure for London and Her 'Farewel to America,'" p. 125.

20. Wilcox, *The Body into Print: Marketing Phillis Wheatley*, p. 28.

21. Carretta, *Phillis Wheatley: Biography of a Genius in Bondage*, p. 97.

22. Carretta, *Phillis Wheatley: Biography of a Genius in Bondage*, p. 96.

23. Julian Mason, *The Poems of Phillis Wheatley*, University of North Carolina Press, 1989, p. 38.

24. Susanna Wheatley, April 30, 1773; Sara Jackson Dunlap ed.," Documents Letters of Phillis Wheatley and Susanna Wheatley," *The Journal of Negro History*, Vol. 57, No. 2 (April 1972), p. 214.

25. Carretta, *Phillis Wheatley: Biography of a Genius in Bondage*, p. 116.

26. Phillis Wheatley, *Phillis Wheatley: Complete Writings*, Carretta, ed., p. 150.

27. Phillis Wheatley, *Phillis Wheatley: Complete Writings*, Carretta, ed., p. 151.

28. Carretta, *Phillis Wheatley: Biography of a Genius in Bondage*, p. 116.

29. Carretta, *Phillis Wheatley: Biography of a Genius in Bondage*, p. 96.

30. William Robinson, "Phillis Wheatley: On Black in Boston Lace Gloves," in *Black New England Letters: The Uses of Writings in Black New England*, Trustees of the Public Library of the City of Boston, 1977, p. 53.

31. Phillis Wheatley, June 27, 1773; Sara Jackson Dunlap ed., "Documents Letters of Phillis Wheatley and Susanna Wheatley," *The Journal of Negro History*, Vol. 57, No. 2 (April 1972), p. 214.

32. Carretta, *Phillis Wheatley: Biography of a Genius in Bondage*, p. 97.

33. Susanna Wheatley, April 30, 1773; Sara Jackson Dunlap ed.," Documents Letters of Phillis Wheatley and Susanna Wheatley," *The Journal of Negro History*, Vol. 57, No. 2 (April 1972), p. 214.

34. Robinson, *Phillis Wheatley and Her Writings*, p. 37.

## CHAPTER 24

1. Mukhtar Ali Isani, "Phillis Wheatley in London: An Unpublished Letter to David Wooster," *American Literature*, Vol. 51, No. 2 (May, 1979), p. 255.

2. Julian Mason, *The Poems of Phillis Wheatley*, University of North Carolina Press, 1989, p. 196.

3. Vincent Carretta, *Phillis Wheatley: Biography of a Genius in Bondage*, University of Georgia Press, 2011, p. 115.

4. William Robinson, *Phillis Wheatley and Her Writings*, Garland Publishing Inc., 1984, p. 34.

5. Phillis Wheatley, October 30, 1773; Phillis Wheatley, *Complete Writings*, Vincent Carretta, ed., Penguin Books, 2001, p. 148.

6. James Boswell, *Life of Samuel Johnson Vol. 2*, London, 1791 p. 160.

7. Boswell, *Life of Samuel Johnson Vol. 1*, p. 311.

8.    Peter Ackroyd, *London, The Biography*, Anchor Books, 2000, p. 299.

9.    "Boston Massacre in Facts and Numbers," *Boston Massacre Historical Society*, <http://www.bostonmassacre.net/facts-and-numbers.htm>.

10.   Carretta, *Phillis Wheatley: Biography of a Genius in Bondage*, p. 110.

11.   *Ibid.*

12.   *The Works of Samuel Johnson: An Essay on His Life and Genius,* Vol 3., by Arthur Murray, E. Blackador, 1806, p. 153.

13.   *Ibid.*

14.   Ackroyd, *London, The Biography*, p. 177.

15.   Ackroyd, *London, The Biography*, p. 172.

16.   *Ibid.*

17.   *The Works of Samuel Johnson: An Essay on His Life and Genius,* Vol 3., by Arthur Murray, E. Blackador, 1806, p. 153-154.

18.   A. N. Wilson, *London: A History,* Modern Library, 2006, p. 74.

19.   Wilson, *London: A History,* p. 74-75.

20.   Wilson, *London: A History,* p. 75.

21.   Wilson, *London: A History,* p. 76.

22.   James Boswell, *Life of Samuel Johnson Vol. 2*, London, 1791 p. 237.

23.   William Hutton, "Miscellaneous Observations and Reflections Made in a Tour Through London, in December 1784," *Freemason's Magazine Or General and Complete Library*, Volume 6, Publisher: J.W. Bunney, 1796, p. 173.

24.   Ackroyd, *London, The Biography*, p. 437.

25.   Hutton, "Miscellaneous Observations and Reflections Made in a Tour Through London, in December 1784," p. 173.

26.   Carretta, *Phillis Wheatley: Biography of a Genius in Bondage*, p. 111.

27.   Gay Gibson Cima, *Early American Women Critics: Performance, Religion, Race,* Cambridge University Press, 2006, p. 92.

## CHAPTER 25

1.    Phillis Wheatley, October 18, 1773, *Phillis Wheatley: Complete Writings*, Carretta, ed., p. 146.

2.    Isani, "Phillis Wheatley in London," p. 258.

3.    Isani, "Phillis Wheatley in London," p. 255.

4.    Julian Mason, *The Poems of Phillis Wheatley*, University of North Carolina Press, 1989, p. 196.

5. *Ibid.*

6. Phillis Wheatley, October 18, 1773, *Phillis Wheatley: Complete Writings*, Carretta, ed., p. 146.

7. Isani, "Phillis Wheatley in London," p. 255.

8. Phillis Wheatley, October 18, 1773, *Phillis Wheatley: Complete Writings*, Carretta, ed., p. 146.

9. Robinson, *Phillis Wheatley and the Origins of African American Literature*, Old South Meeting House, 1999, p. 17.

10. Henry Louis Gates, *The Trials of Phillis Wheatley*, Basic Civitas Books, 2003, p. 33.

11. Mason, *The Poems of Phillis Wheatley*, p. 197.

12. Phillis Wheatley, October 18, 1773, *Phillis Wheatley: Complete Writings*, Carretta, ed., p. 146.

13. Gwendolyn DuBois Shaw, *Portraits of a People: Picturing African Americans in the Nineteenth Century*, University of Washington Press, 2006, p. 42.

14. *Ibid.*

15. Phillis Wheatley, Carretta, ed., *Complete Writings*, p. 53.

16. Phillis Wheatley, Carretta, ed., *Complete Writings*, p. 54.

17. Phillis Wheatley, Carretta, ed., *Complete Writings*, p. 55.

18. Phillis Wheatley, Carretta, ed., *Complete Writings*, p. 58.

19. *Ibid.*

20. Kirsten Wilcox, *The Body Into Print: Marketing Phillis Wheatley,* American Literature, Vol. 71, No. 1 (March 1999), p. 28.

21. Phillis Wheatley, October 18, 1773, *Phillis Wheatley: Complete Writings*, Carretta, ed., p. 146.

22. *Ibid.*

23. *Ibid.*

24. William Robinson, *Phillis Wheatley and Her Writings*, Garland Publishing Inc., 1984, p. 322.

25. Phillis Wheatley, October 18, 1773, *Phillis Wheatley: Complete Writings*, Carretta, ed., p. 146.

26. Vincent Carretta, *Phillis Wheatley: Biography of a Genius in Bondage*, University of Georgia Press, 2011, p. 116.

27. Phillis Wheatley, October 18, 1773, *Phillis Wheatley: Complete Writings*, Carretta, ed., p. 146.

28. Robert J. Taylor, "Israel Maudit," *The New England Quarterly*, Vol. 24, No. 2, June 1951, p. 208.

29. *Ibid.*

30. *Ibid.*

31. Phillis Wheatley, October 18, 1773, *Phillis Wheatley: Complete Writings*, Carretta, ed., p. 146.

32. Robinson, *Phillis Wheatley and Her Writings*, p. 34.

33. Robinson, *Phillis Wheatley and the Origins of African American Literature,* Old South Meeting House, 1999, p. 17.

34. Carretta, *Phillis Wheatley: Biography of a Genius in Bondage*, p. 117.

35. Robinson, *Phillis Wheatley and Her Writings*, p. 36.

36. Carretta, *Phillis Wheatley: Biography of a Genius in Bondage*, p. 117.

37. Eric Ashley Hairston, "The Trojan Horse: Classics, Transformation and Afric Ambition in *Poems on Various Subjects Religious and Moral,*" *New Essays on Phillis Wheatley*, John C. Shields and Eric D. Lamore, ed., University of Tennessee Press, 2011, p. 63.

38. *Ibid.*

39. Isani, "Phillis Wheatley in London," p. 258.

40. Carretta, *Phillis Wheatley: Biography of a Genius in Bondage*, p. 118.

41. "Benjamin Franklin Petitions Congress," National Archives, The Center for Legislative Archives, <http://www.archives.gov/legislative/features/franklin>.

42. Robinson, *Phillis Wheatley and Her Writings*, p. 36.

43. Mason, *The Poems of Phillis Wheatley*, p. 212.

44. Phillis Wheatley, October 18, 1773, *Phillis Wheatley: Complete Writings*, Carretta, ed., p. 146.

45. *Ibid.*

46. Isani, "Phillis Wheatley in London," p. 258.

## CHAPTER 26

1. Phillis Wheatley, October 30, 1773; Carretta, ed. *Phillis Wheatley: Complete Writings*, p. 148.

2. William Robinson, *Phillis Wheatley and Her Writings*, Garland Publishing Inc., 1984, p. 34.

3. Phillis Wheatley, October 30, 1773; Carretta, ed. *Phillis Wheatley: Complete Writings*, p. 146.

4. *African History at the Tower of London*, Tower Hamlets African and Caribbean Mental Health Organisation, 2008, p. 16.

5. *A New and Improved History and Description of the Tower of London,* J. King, College Hill, 1827, <http://www.carolineshenton. co.uk/a-visit-to-the-tower-of-london-zoo-in-1827/>.

6. Phillis Wheatley, October 30, 1773; Carretta, ed. *Phillis Wheatley: Complete Writings*, p. 146.

7. Westminster Abbey History: Geoffrey Chaucer, <http://www.westminster-abbey.org/our-history/people/geoffrey-chaucer>.

8. Westminster Abbey History: Edmund Spenser, <http://www.westminster-abbey.org/our-history/people/edmund-spenser>.

9. Westminster Abbey History: William Shakespeare, <http://www.westmin-ster-abbey.org/our-history/people/william-shakespeare>.

10. Walter Jerrold, *Highways and Byways in Middlesex*, Macmillan, 1909, p. 65.

11. *Sadler's Wells, London Dance House, A Complete History,* <http://www.sadlerswells.com/?page=complete-history>.

12. *Ibid.*

13. Dennis Arundell, *The Story of Sadler's Wells, 1683-1964*, Theatre Arts Books, 1965, p. 29.

14. Mukhtar Ali Isani, "Phillis Wheatley in London: An Unpublished Letter to David Wooster," *American Literature*, Vol. 51, No. 2 (May, 1979), p. 258.

15. *The Contemporary Review*, Volume 67, A. Strahan, 1895, p. 318.

16. *Ibid.*

17. Arundell, *The Story of Sadler's Wells, 1683-1964*, p. 29.

18. *The songs, choruses, etc. in Vineyard Revels; or Harlequin Bacchanal ... performed at Sadler's Wells,* British Library, Historical Print Editions, 2011.

19. *Sadler's Wells: Complete History,* "Part 3—A New Theatre for the People (1746-1790"), <http://www.sadlerswells.com/about-us/history/complete-history/>.

20. Vincent Carretta, *Phillis Wheatley: Biography of a Genius in Bondage*, University of Georgia Press, 2011, p. 114.

21. Robert D. Altick, *The Shows of London,* Harvard University Press, 1978, p. 69.

22. Clare Le Corbeiller, "James Cox and his Curious Toys," *The Metropolitan Museum of Art Bulletin*, June 1960, p. 319.

23. Clare Vincent and J. H. Leopold, "James Cox (ca. 1723-1800): Goldsmith and Entrepreneur" in Heilbrunn Timeline of Art History, The Metropolitan

Museum of Art, New York, 2000.http://www.metmuseum.org/toah/hd/jcox/hd_jcox.htm.

24. Le Corbeiller, "James Cox and his Curious Toys," p. 319.

25. Altick, *The Shows of London*, p. 69.

26. Le Corbeiller, "James Cox and his Curious Toys," p. 319.

27. Le Corbeiller, "James Cox and his Curious Toys," p. 320.

28. *Ibid.*

29. Le Corbeiller, "James Cox and his Curious Toys," p. 321.

30. Altick, *The Shows of London,* p. 70.

31. Carretta, *Phillis Wheatley: Biography of a Genius in Bondage*, p. 114.

32. Altick, *The Shows of London,* p. 69.

33. Phillis Wheatley, October 30, 1773; Carretta, ed. *Phillis Wheatley: Complete Writings*, p. 146.

## CHAPTER 27

1.  W. E. B. DuBois, "Phillis Wheatley and African American Culture" *The Oxford W. E. B. DuBois Reader,* Eric J. Sundquist, ed., 1996, p. 329.

2.  Phillis Wheatley, October 18th, 1773, Carretta, ed., *Phillis Wheatley: Complete Writings*, p. 146.

3.  Julian Mason, *The Poems of Phillis Wheatley*, University of North Carolina Press, 1989, p. 197.

4.  William Robinson, *Phillis Wheatley and Her Writings*, Garland Publishing Inc., 1984, p. 323.

5.  Mason, *The Poems of Phillis Wheatley*, p. 197.

6.  Robinson, *Phillis Wheatley and Her Writings*, p. 323.

7.  *Ibid.*

8.  Mason, *The Poems of Phillis Wheatley*, p. 197.

9.  Phillis Wheatley, October 18th, 1773, Carretta, ed., *Phillis Wheatley: Complete Writings*, p. 146.

10. Eric Ashley Hairston, "The Trojan Horse: Classics, Transformation and Afric Ambition in *Poems on Various Subjects Religious and Moral*," *New Essays on Phillis Wheatley*, John C. Shields and Eric D. Lamore, ed., University of Tennessee Press, 2011, p. 63.

11. Hairston, "The Trojan Horse: Classics, Transformation and Afric Ambition in *Poems on Various Subjects Religious and Moral*," p. 65.

12. Gay Gibson Cima, *Early American Women Critics: Performance, Religion, Race,* Cambridge University Press, 2006, p. 94.

13. Robinson, *Phillis Wheatley and Her Writings*, p. 35.

14. Phillis Wheatley, July 17, 1773, Carretta, ed., *Phillis Wheatley: Complete Writings*, p. 145.

15. Robinson, *Phillis Wheatley and Her Writings*, p. 37.

16. Phillis Wheatley, July 17, 1773, Carretta, ed., *Phillis Wheatley: Complete Writings*, p. 145.

17. Vincent Carretta, *Phillis Wheatley: Biography of a Genius in Bondage*, University of Georgia Press, 2011, p. 97.

18. Carretta, *Phillis Wheatley: Biography of a Genius in Bondage*, p. 128.

19. Carretta, *Phillis Wheatley: Biography of a Genius in Bondage*, p. 130.

20. Phillis Wheatley, *Complete Writings,* Carretta, ed., p. 62.

21. Mukhtar Ali Isani, "Phillis Wheatley in London: An Unpublished Letter to David Wooster," *American Literature*, Vol. 51, No. 2 (May, 1979), p. 255.

22. Zach Petrea, "An Untangled Web: Mapping Phillis Wheatley's Network of Support in America and Great Britain," *New Essays on Phillis Wheatley*, John C. Shields and Eric D. Lamore, ed., University of Tennessee Press, 2011, p. 306.

23. Cima, *Early American Women Critics: Performance, Religion, Race,* p. 92.

24. Phillis Wheatley, October 18, 1773, Carretta, ed., *Phillis Wheatley: Complete Writings*, p. 147.

25. Phillis Wheatley, October 30, 1774, Carretta, ed., *Phillis Wheatley: Complete Writings*, p. 159.

26. Isani, "Phillis Wheatley in London: An Unpublished Letter to David Wooster," p. 259.

27. Barbara Johnson, *The Feminist Difference: Literature, Psychoanalysis, Race and Gender*, Harvard University Press, 1998, p. 100.

## CHAPTER 28

1. Vincent Carretta, *Phillis Wheatley: Biography of a Genius in Bondage*, University of Georgia Press, 2011, p. 137.

2. Phillis Wheatley, Ocotber 18, 1773, *Phillis Wheatley: Complete Writings*, Vincent Carretta, ed., Penguin Books, 2001, p. 147.

3. Phillis Wheatley, December 1, 1773, *Phillis Wheatley: Complete Writings*, Carretta, ed., p. 151.

4.  Phillis Wheatley, December 1, 1773, *Phillis Wheatley: Complete Writings*, Carretta, ed. p. 169.

5.  Carretta, *Phillis Wheatley: Biography of a Genius in Bondage*, p. 195.

6.  Zach Petrea, "An Untangled Web: Mapping Phillis Wheatley's Network of Support in America and Great Britain," *New Essays on Phillis Wheatley*, John C. Shields and Eric D. Lamore, ed., University of Tennessee Press, 2011, p. 321.

7.  Carretta, *Phillis Wheatley: Biography of a Genius in Bondage*, p. 195.

8.  Petrea, "An Untangled Web: Mapping Phillis Wheatley's Network of Support in America and Great Britain," p. 321.

9.  Mukhtar Ali Isani, "Phillis Wheatley in London: An Unpublished Letter to David Wooster," *American Literature*, Vol. 51, No. 2 (May, 1979), p. 259.

10. Granville Sharp, *An Essay on Slavery*, Burlington, 1773, p. 22.

11. Phillis Wheatley, October 18, 1773, *Phillis Wheatley: Complete Writings*, Carretta, ed., p. 147.

12. Carretta, ed., *Phillis Wheatley: Complete Writings*, p. xxxiii.

13. William Robinson, *Phillis Wheatley and Her Writings*, Garland Publishing Inc., 1984, p. 322.

14. Isani, "Phillis Wheatley in London: An Unpublished Letter to David Wooster," *American Literature*, p. 260.

15. Phillis Wheatley, October 18, 1773, *Phillis Wheatley: Complete Writings*, Carretta, ed., p. 147.

16. *Ibid.*

17. *Ibid.*

18. Carretta, *Phillis Wheatley: Biography of a Genius in Bondage*, p. 152.

19. Carretta, *Phillis Wheatley: Biography of a Genius in Bondage*, p. 117.

20. Phillis Wheatley, October 18, 1773, *Phillis Wheatley: Complete Writings*, Carretta, ed., p. 147.

21. William Robinson, *Phillis Wheatley and Her Writings*, Garland Publishing Inc., 1984, p. 37.

22. Phillis Wheatley, October 30, 1774, *Phillis Wheatley: Complete Writings*, Carretta, ed., p. 159.

23. Julian Mason, *The Poems of Phillis Wheatley*, University of North Carolina Press, 1989, p. 209.

24. Frederick Douglass, *Life and Times of Frederick Douglass, Written by Himself,*

Collier Books, 1962, (originally published 1892), p. 202.

25. Sarah Bradford, *Harriet Tubman, The Moses of Her People,* Dover Publications, 2004 (originally published 1886), p. 17.

26. *Ibid.*

27. Phillis Wheatley, *Complete Writings,* Carretta, ed., p. 63.

**CHAPTER 29**

1. Julian Mason, "A New Poem by Phillis Wheatley," *Early American Literature,* Vol. 34, No. 1, 1999, p. 78.

2. *Ibid.*

3. Mason, "A New Poem by Phillis Wheatley," p. 80.

4. *Ibid.*

5. Phillis Wheatley, *Complete Writings*, Vincent Carretta, ed., Penguin Books, 2001, p. 78.

6. Mason, *Early American Literature*, p. 81.

7. Julian Mason, *The Poems of Phillis Wheatley*, University of North Carolina Press, 1989, p. 217.

8. *Ibid.*

9. Mason, "A New Poem by Phillis Wheatley," p. 81.

10. Phillis Wheatley, *Complete Writings*, Carretta, ed., p. 79.

11. *Ibid.*

12. Phillis Wheatley, *Complete Writings*, Carretta, ed., p. 80.

13. Mason, "A New Poem by Phillis Wheatley," p. 82.

14. *Ibid.*

15. Rowan Ricardo Phillips, *When Blackness Rhymes With Blackness*, Dalkey Archive Press, 2010, p. 15.

16. Phillips, *When Blackness Rhymes With Blackness*, p. 16.

17. Phillis Wheatley, October 30, 1774, Carretta, ed., *Phillis Wheatley: Complete Writings*, p. 159.

18. Jennifer Rene Young, "Marketing a Sable Muse: Phillis Wheatley and the Antebellum Press," *New Essays on Phillis Wheatley*, John C. Shields and Eric D. Lamore, ed., University of Tennessee Press, 2011, p. 222.

19. Gay Gibson Cima, *Early American Women Critics: Performance, Religion, Race,* Cambridge University Press, 2006, p. 92.

20. Annette Gordon-Reed, *The Hemingses of Monticello: An American Family*, W. W. Norton & Company, 2008, p. 324.

21. Gordon-Reed, *The Hemingses of Monticello,* p. 326.

22. Gordon-Reed, *The Hemingses of Monticello,* p. 327.

23. Vincent Carretta, *Phillis Wheatley: Biography of a Genius in Bondage,* University of Georgia Press, 2011, p. 137.

24. Gordon-Reed, *The Hemingses of Monticello,* p. 342.

25. Gordon-Reed, *The Hemingses of Monticello,* p. 361.

**PART IV**

1. Phillis Wheatley, October 30, 1774, *Phillis Wheatley: Complete Writings,* Carretta, ed., p. 159.

**CHAPTER 30**

1. Mukhtar Ali Isani, "The Contemporaneous Reception of Phillis Wheatley: Newspaper and Magazine Notices During the Years of Fame, 1765-1774," *The Journal of Negro History,* Vol. 85. No. 4, Autumn, 2000, p. 263.

2. Isani, "Contemporaneous Reception," p. 269.

3. *Ibid.*

4. *Ibid.*

5. Isani, "Contemporaneous Reception," p. 270.

6. *Ibid.*

7. *Ibid.*

8. Isani, "Contemporaneous Reception," p. 260.

9. Vincent Carretta, *Phillis Wheatley: Biography of a Genius in Bondage,* University of Georgia Press, 2011, p. 142.

10. *Ibid.*

11. Phillis Wheatley, October 18, 1773, *Phillis Wheatley: Complete Writings,* Vincent Carretta, ed., Penguin Books, 2001, p. 146.

12. Phillis Wheatley, December 1, 1773, *Phillis Wheatley: Complete Writings,* Carretta, ed., p. 150.

13. Phillis Wheatley, October 30, 1773, *Phillis Wheatley: Complete Writings,* Carretta, ed., p. 149.

14. Phillis Wheatley, December 1, 1773, *Phillis Wheatley: Complete Writings,* Carretta, ed., p. 150.

15. Phillis Wheatley, October 30, 1773, Carretta, ed., *Phillis Wheatley: Complete Writings,* p. 148.

16. Phillis Wheatley, February 9, 1774, *Phillis Wheatley: Complete Writings*, Carretta, ed., p. 151.

17. William Robinson, *Phillis Wheatley and Her Writings*, Garland Publishing Inc., 1984, p. 38.

18. Carretta, *Phillis Wheatley: Biography of a Genius in Bondage*, p. 98.

19. Isani, "Contemporaneous Reception," p. 269.

20. *Ibid.*

21. *Ibid.*

22. *Ibid.*

23. *Ibid.*

24. Robinson, *Phillis Wheatley and Her Writings*, p. 39.

25. Isani, "Contemporaneous Reception," p. 263.

26. Carretta, *Phillis Wheatley: Biography of a Genius in Bondage*, p. 108.

27. *Ibid.*

28. *Ibid.*

29. *Ibid.*

30. *Ibid.*

31. *Ibid.*

32. Robinson, *Phillis Wheatley and Her Writings*, p. 40.

33. Phillis Wheatley, October 18, 1773, *Phillis Wheatley: Complete Writings*, Carretta, ed., p. 147.

34. Mukhtar Ali Isani, "Phillis Wheatley in London: An Unpublished Letter to David Wooster," *American Literature*, Vol. 51, No. 2 (May, 1979), p. 260.

35. Henry Louis Gates, *The Trials of Phillis Wheatley*, Basic Civitas Books, 2003, p. 35.

36. Eric Ashley Hairston, "The Trojan Horse: Classics, Transformation and Afric Ambition in *Poems on Various Subjects Religious and Moral*," *New Essays on Phillis Wheatley*, John C. Shields and Eric D. Lamore, ed., University of Tennessee Press, 2011, p. 61.

37. Mukhtar Ali Isani, "Phillis Wheatley in London: An Unpublished Letter to David Wooster," *American Literature*, Vol. 51, No. 2 (May, 1979), p. 260.

38. Julian Mason, *The Poems of Phillis Wheatley*, University of North Carolina Press, 1989, p. 197.

39. Phillis Wheatley, October 18, 1773, *Phillis Wheatley: Complete Writings*, Carretta, ed., p. 147.

40. Carretta, *Phillis Wheatley: Biography of a Genius in Bondage*, p. 141.

41. Phillis Wheatley, October 18, 1773, *Phillis Wheatley: Complete Writings*, Carretta, ed., p. 147.

42. Phillis Wheatley, October 30, 1773, *Phillis Wheatley: Complete Writings*, Carretta, ed., p. 149.

43. Phillis Wheatley, October 18, 1773, *Phillis Wheatley: Complete Writings*, Carretta, ed., p. 147.

44. Hairston, "The Trojan Horse," p. 62.

45. Carretta, *Phillis Wheatley: Biography of a Genius in Bondage*, p. 141.

46. Hairston, "The Trojan Horse," p. 62.

47. Phillis Wheatley, October 18, 1773, *Phillis Wheatley: Complete Writings*, Carretta, ed., p. 147.

48. Mukhtar Ali Isani, "Phillis Wheatley in London: An Unpublished Letter to David Wooster," *American Literature*, Vol. 51, No. 2 (May, 1979), p. 260.

49. Phillis Wheatley, October 18, 1773, *Phillis Wheatley: Complete Writings*, Carretta, ed., p. 147.

50. Phillis Wheatley, October 18, 1773, *Phillis Wheatley: Complete Writings*, Carretta, ed., p. 147.

51. *Ibid.*

## CHAPTER 31

1. Samuel Johnson, Review of "A Journal of Eight Days' Journey," *The Literary Magazine* 2, no. 13, 1757.

2. Harlow Giles Unger, *American Tempest: How the Boston Tea Party Sparked a Revolution*, Da Capo Press, 2011, p. 101.

3. Unger, *American Tempest: How the Boston Tea Party Sparked a Revolution*, p. 121.

4. Unger, *American Tempest: How the Boston Tea Party Sparked a Revolution*, p. 101.

5. Letter from John Adams to Abigail Adams, 6 July 1774, *Adams Family Papers: An Electronic Archive*. Massachusetts Historical Society, <http://www.masshist.org/digitaladams/archive/doc?id=L17740706jasecond>.

6. The *Boston Gazette and Country Journal*, February 12, 1770, The Annotated Newspapers of Harbottle Dorr Jr., Massachusetts Historical Society; http://www.masshist.org/dorr/volume/3/sequence/75.

7. Unger, *American Tempest: How the Boston Tea Party Sparked a Revolution*, p. 131.

8.  Unger, *American Tempest: How the Boston Tea Party Sparked a Revolution*, p. 8.

9.  *Ibid.*

10. The *Boston Gazette and Country Journal*, October 11, 1773, The Annotated Newspapers of Harbottle Dorr, Jr., Massachusetts Historical Society, <http://www.masshist.org/dorr/volume/4/sequence/457>.

11. The *Boston Gazette and Country Journal*, October 18, 1773, The Annotated Newspapers of Harbottle Dorr, Jr., Massachusetts Historical Society, <http://www.masshist.org/dorr/volume/4/sequence/461>.

12. The *Boston Gazette and Country Journal*, November 1, 1773, The Annotated Newspapers of Harbottle Dorr, Jr., Massachusetts Historical Society, <http://www.masshist.org/dorr/volume/4/sequence/467>.

13. Benjamin Woods Labaree, *The Boston Tea Party*, Northeastern University Press, 1964, p. 113.

14. Labaree, *The Boston Tea Party*, p. 291.

15. Robert J. Allison, *The Boston Tea Party*, Commonwealth Editions, 2007, p. 10.

16. *Boston Gazette and Country Journal*, November 29, 1773; The Annotated Newspapers of Harbottle Dorr, Jr., Massachusetts Historical Society. <http://www.masshist.org/dorr/volume/4/sequence/483>.

17. Labaree, *The Boston Tea Party*, p. 119.

18. Unger, *American Tempest: How the Boston Tea Party Sparked a Revolution*, p. 162.

19. *Ibid.*

20. "Boston, December 1, 1773, At a Meeting of the people..." *The Coming of the American Revolution, 1764-1776*, The Massachusetts Historical Society, <http://www.masshist.org/revolution/doc-viewer.php?old=1&mode=nav&item_id=553>.

21. *Ibid.*

22. Benjamin L. Carp, *Defiance of the Patriots: The Boston Tea Party & the Making of America*, Yale University Press, 2010, p. 95.

23. "Boston, December 1, 1773, At a Meeting of the people..." *The Coming of the American Revolution, 1764-1776*, The Massachusetts Historical Society, <http://www.masshist.org/revolution/doc-viewer.php?old=1&mode=nav&item_id=553>.

24. *Ibid.*

25. Benjamin Bussey Thatcher, ed., "Extract from the Journal of the ship Dartmouth from London to Boston, 1773," *Traits of the Tea Party: being a memoir of George R.T. Hewes, one of the last of its survivors : with a history of that transaction, reminiscences of the massacre, and the siege, and other stories of old times,* Harper & Brothers, 1835, p. 260.

26. "Boston, December 1, 1773, At a Meeting of the people…" *The Coming of the American Revolution, 1764-1776,* The Massachusetts Historical Society, <http://www.masshist.org/revolution/doc-viewer.php?old=1&mode= nav&item_id=553>.

27. Thatcher, "Extract from the Journal of the ship Dartmouth from London to Boston, 1773," *Traits of the Tea Party,* p. 260.

28. Labaree, *The Boston Tea Party,* p. 134.

29. Carp, *Defiance of the Patriots: The Boston Tea Party & the Making of America,* p. 97.

30. Labaree, *The Boston Tea Party,* p. 131.

31. J. L. Bell, email to author, May 31, 2013.

32. Professor Vincent Carretta, email to author, June 6, 2013.

33. Professor Benjamin Carp, email to author, June 17, 2013.

## CHAPTER 32

1. Vincent Carretta, *Phillis Wheatley: Biography of a Genius in Bondage,* University of Georgia Press, 2011, p. 17.

2. William Robinson, *Phillis Wheatley and Her Writings,* Garland Publishing Inc., 1984, p. 273.

3. William Robinson, *Phillis Wheatley in the Black American Beginnings,* Broadside Press, 1975, *Black American Beginnings,* p. 51.

4. Benjamin Woods Labaree, *The Boston Tea Party,* Northeastern University Press, 1964, p. 129.

5. Benjamin L. Carp, *Defiance of the Patriots: The Boston Tea Party & the Making of America,* Yale University Press, 2010, p. 108.

6. Benjamin Bussey Thatcher, ed., "Extract from the Journal of the ship Dartmouth from London to Boston, 1773," *Traits of the Tea Party: being a memoir of George R.T. Hewes, one of the last of its survivors : with a history of that transaction, reminiscences of the massacre, and the siege, and other stories of old times,* Harper & Brothers, 1835, p. 260.

7. J.L. Bell, email to author, May 16, 2013.

8. Carp, *Defiance of the Patriots,* p. 108.

9. Carp, *Defiance of the Patriots,* p. 109.

10. Labaree, *The Boston Tea Party,* p. 125.

11. *Boston Gazette and Country Journal,* December 13, 1773, The Annotated Newspapers of Harbottle Dorr, Jr., Massachusetts Historical Society, <http://www.masshist.org/dorr/volume/4/sequence/493>.

12. Carp, *Defiance of the Patriots,* p. 115.

13. Labaree, *The Boston Tea Party,* p. 138.

14. Carp, *Defiance of the Patriots,* p. 115.

15. Carp, *Defiance of the Patriots,* p. 121.

16. Thatcher, *Traits of the Tea Party,* p. 178.

17. Labaree, *The Boston Tea Party,* p. 141.

18. Francis S. Drake, *Tea Leaves: A collection of letters and documents relating to the shipment of tea to the American Colonies in the year 1773 by the East India Tea Company,* University of Michigan, 1884, p. 75.

19. A Citizen of New York (James Hawkes), *A Retrospective of the Boston Tea Party with a Memoir of George R. T. Hewes, a Survivor of the Little Band of Patriots Who Drowned the Tea in Boston Harbor in 1773,* S. Bliss, Publisher, NY, 1834, p. 37.

20. Drake, *Tea Leaves,* p. 73.

21. Drake, *Tea Leaves,* p. 70.

22. "Eyewitness Account by Samuel Cooper," Boston Tea Party Historical Society, <http://www.boston-tea-party.org/participants/Samuel-Cooper.html>.

23. Drake, *Tea Leaves,* p. 82

24. Drake, *Tea Leaves,* p. 76.

25. Drake, *Tea Leaves,* p. 74.

26. Hawkes, *Memoir of George R. T. Hewes,* p. 38.

27. Drake, *Tea Leaves,* p. 83.

28. Drake, *Tea Leaves,* p. 70.

29. Drake, *Tea Leaves,* p. 76.

30. Hawkes, *Memoir of George R. T. Hewes,* p. 38.

31. Drake, *Tea Leaves,* p. 76.

32. Drake, *Tea Leaves,* p. 77.

33. Drake, *Tea Leaves,* p. 84.

34. Drake, *Tea Leaves*, p. 77.

35. Drake, *Tea Leaves*, p. 70.

36. "Eyewitness Account by Samuel Cooper," Boston Tea Party Historical Society, <http://www.boston-tea-party.org/participants/Samuel-Cooper.html>.

37. Drake, *Tea Leaves*, p. 84.

38. Drake, *Tea Leaves*, p. 77.

39. Hawkes, *Memoir of George R. T. Hewes*, p. 40.

40. Drake, *Tea Leaves*, p. 77.

41. Drake, *Tea Leaves*, p. 84.

42. Drake, *Tea Leaves*, p. 71.

43. Hawkes, *Memoir of George R. T. Hewes*, p. 39.

44. Drake, *Tea Leaves*, p. 71.

45. Drake, *Tea Leaves*, p. 74.

46. Drake, *Tea Leaves*, p. 71.

47. Hawkes, *Memoir of George R. T. Hewes*, p. 41.

48. Drake, *Tea Leaves*, p. 71.

49. John Adams, Dec. 17, 1773, Diary of John Adams, vol. 2; *Founding Families: Digital Editions of the Papers of the Winthrops and the Adamses,* ed., C. James Taylor, Boston; Massachusetts Historical Society, 2007, <https://www.masshist.org/publications/apde/portia.php?id=DJA02d100>.

50. Alfred F. Young, *The Shoemaker and the Tea Party*, Beacon Press, 1999, p. 88.

51. John Adams, Dec. 17, 1773, Diary of John Adams, vol. 2; *Founding Families: Digital Editions of the Papers of the Winthrops and the Adamses,* ed., C. James Taylor, Boston; Massachusetts Historical Society, 2007, <https://www.masshist.org/publications/apde/portia.php?id=DJA02d100>.

52. *Ibid.*

## CHAPTER 33

1. *Boston Gazette and Country Journal*, January 31, 1774; The Annotated Newspapers of Harbottle Dorr, Jr., Massachusetts Historical Society, <http://www.masshist.org/dorr/volume/4/sequence/521>.

2. Vincent Carretta, *Phillis Wheatley: Biography of a Genius in Bondage*, University of Georgia Press, 2011, p. 146.

3. J.L. Bell, email to author, May 16, 2013.

4.   J.L. Bell, email to author, June 7, 2013.

5.   Carretta, *Phillis Wheatley: Biography of a Genius in Bondage*, p. 145.

6.   Rowan Ricardo Phillips, *When Blackness Rhymes With Blackness,* Dalkey Archive Press, 2010, p. 36.

7.   Cathy N. Davidson, *Revolution and the Word: The Rise of the Novel in America*, Oxford, 1986.p. 16.

8.   Carretta, *Phillis Wheatley: Biography of a Genius in Bondage*, p. 146.

9.   William Robinson, *Phillis Wheatley and Her Writings*, Garland Publishing Inc., 1984, p. 42.

10.  William Robinson, *Phillis Wheatley in the Black American Beginnings*, Broadside Press, 1975, p. 69.

11.  Merle A. Richmond, *Bid the Vassal Soar: Interpretive Essays on the Life and Poetry of Phillis Wheatley and George Moses Horton,* Howard University Press, 1974, p. 35.

12.  Phillis Wheatley, October 30, 1773, *Phillis Wheatley: Complete Writings*, Carretta, ed., p. 149.

13.  Phillis Wheatley, February 9, 1774, *Phillis Wheatley: Complete Writings*, Carretta, ed., p. 151.

14.  Phillis Wheatley, March 21, 1774, *Phillis Wheatley: Complete Writings*, Carretta, ed., p. 154.

15.  Phillis Wheatley, May 6, 1774, *Phillis Wheatley: Complete Writings*, Carretta, ed., p. 156.

16.  Joanna Brooks, *Our Phillis, Ourselves*, American Literature, Volume 82, Number 1, March 2010, p. 10.

17.  Robinson, *Phillis Wheatley and Her Writings*, p. 42.

18.  Brooks, *Our Phillis, Ourselves*, p. 10.

19.  Robinson, *Phillis Wheatley and Her Writings*, p. 43.

20.  Brooks, *Our Phillis, Ourselves*, p. 8.

21.  Robinson, *Phillis Wheatley in the Black American Beginnings*, p. 69.

22.  Carretta, *Phillis Wheatley: Biography of a Genius in Bondage*, p. 147.

23.  Julian Mason, *The Poems of Phillis Wheatley*, University of North Carolina Press, 1989, p. 9.

24.  *Ibid.*

25.  Robinson, *Phillis Wheatley and Her Writings*, p. 45.

26.  Margaretta Matilda Oddell, *The Poems of Phillis Wheatley: With Letters and a*

*Memoir,* Dover Publications, 2010, p. 69. (Unabridged replication of *Memoir and Poems of Phillis Wheatley,* Geo. W. Light, Boston, 1834.)

27.  Robinson, *Phillis Wheatley and Her Writings,* p. 45.

28.  William Robinson, *Black New England Letters: The Uses of Writings in Black New England,* Trustees of the Public Library of the City of Boston, 1977, p. 33.

29.  Oddell, p. 69.

30.  *Ibid.*

31.  Carretta, *Phillis Wheatley: Biography of a Genius in Bondage,* p. 143.

32.  Richmond, *Bid the Vassal Soar,* p. 36.

33.  Phillis Wheatley, March 21, 1774, *Phillis Wheatley: Complete Writings,* Carretta, ed., p. 153.

34.  *Ibid.*

35.  Richmond, *Bid the Vassal Soar,* p. 36.

36.  Phillis Wheatley, March 29, 1774, *Phillis Wheatley: Complete Writings,* Carretta, ed., p. 154.

37.  Phillis Wheatley, March 29, 1774, *Phillis Wheatley: Complete Writings,* Carretta, ed., p. 155.

38.  *Ibid.*

39.  Carretta, *Phillis Wheatley: Biography of a Genius in Bondage,* p. 143.

40.  Phillis Wheatley, March 29, 1774, *Phillis Wheatley: Complete Writings,* Carretta, ed., p. 155.

41.  Phillis Wheatley, October 30, 1774, *Phillis Wheatley: Complete Writings,* Carretta, ed., p. 158.

42.  Phillis Wheatley, October 30, 1774, *Phillis Wheatley: Complete Writings,* Carretta, ed., p. 159.

43.  *Ibid.*

44.  William Robinson, *Phillis Wheatley and the Origins of African American Literature,* Limited Commemorative Edition, Old South Meeting House, 1999, p. 21

45.  *Ibid.*

## CHAPTER 34

1.  Mercy Otis Warren, *History of the Rise, Progress and Termination of the American Revolution,* Manning and Loring, For E. Larkin, No. 47, Cornhill, 1805, p. 157.

2. Samuel Adams, *The Writings of Samuel Adams, 1770-1773*, G. P. Putnam Sons, 1906, p. 204.

3. Emily Blanck, *Tyrannicide: Forging an American Law of Slavery in Revolutionary South Carolina and Massachusetts,* The University of Georgia Press, 2014, p. 36.

4. Phillip S. Foner, *Blacks in the American Revolution: Contributions in American History,* No. 55, Greenwood Press, 1976, p. 25.

5. Foner, *Blacks in the American Revolution,* p. 27.

6. Benjamin L. Carp, *Defiance of the Patriots: The Boston Tea Party & the Making of America,* Yale University Press, 2010, p. 207.

7. James Swan, *A Dissuasion to Great Britain and the Colonies from the Slave Trade to Africa,* E. Russell, Boston, 1772, p. viii.

8. Swan, *A Dissuasion to Great Britain and the Colonies from the Slave Trade to Africa,* p. 33.

9. Swan, *A Dissuasion to Great Britain and the Colonies from the Slave Trade to Africa,* p. 34.

10. Swan, *A Dissuasion to Great Britain and the Colonies from the Slave Trade to Africa,* p. 33.

11. Carp, *Defiance of the Patriots,* p. 207.

12. William Robinson, *Phillis Wheatley and Her Writings*, Garland Publishing Inc., 1984, p. 9.

13. Blanck, *Tyrannicide,* p. 34.

14. Blanck, *Tyrannicide,* p. 35.

15. Blanck, *Tyrannicide,* p. 34.

16. Blanck, *Tyrannicide,* p. 35.

17. John Adams to Jeremy Belknap, March 21, 1795, Blanck, *Tyrannicide,* p. 35.

18. *Voices of a People's History of the United States*, Howard Zinn, Anthony Arnove, eds., Seven Stories Press, 2011, p. 54.

19. "Holbrook, Felix," *Dictionary of Afro-American Slavery,* Randall M. Miller, John David Smith, ed., Greenwood Publishing Group, 1997, p. 336.

20. *Voices of a People's History of the United States*, Howard Zinn, Anthony Arnove, eds., Seven Stories Press, 2011, p. 54.

21. *Voices of a People's History of the United States*, Howard Zinn, Anthony Arnove, eds., Seven Stories Press, 2011, p. 55.

22. *Voices of a People's History of the United States*, Howard Zinn, Anthony Arnove, eds., Seven Stories Press, 2011, p. 56.

23. Blanck, *Tyrannicide*, p. 179.

24. Milton Cantor, "The Image of the Negro in Colonial Literature," The New England Quarterly, Vol. 36, No. 4 (December 1963), p. 475.

25. Jill Lepore, *The Whites of Their Eyes: The Tea Party's Revolution and the Battle Over American History*, Princeton University Press, 2010, p. 76.

26. Blanck, *Tyrannicide*, p. 37.

27. Phillip S. Foner, *Blacks in the American Revolution: Contributions in American History*, No. 55, Greenwood Press, 1976, p. 27.

28. *Nathaniel Niles 1741-1821: "Two Discourses on Liberty," American Political Writing During the Founding Era: 1760-1805*, Vol. 1, Charles S. Hyneman and Donald Lutz, ed., Indianapolis, Liberty Fund, 1983, Vol. 1, p. 270.

29. Niles, p. 275.

30. Abigail Adams to John Adams, September 22, 1774, *Adams Family Papers: An Electronic Archive*. Massachusetts Historical Society, <https://www.masshist.org/digitaladams/archive/doc?id=L17740922aa&bc=%2Fdigitaladams%2Farchive%2Fbrowse%2Fletters_1774_1777.php>.

31. Foner, *Blacks in the American Revolution*, p. 30.

32. Foner, *Blacks in the American Revolution*, p. 31.

33. Vincent Carretta, *Phillis Wheatley: Biography of a Genius in Bondage*, University of Georgia Press, 2011, p. 89.

34. *Ibid.*

35. *From Many, One: Readings in American Political and Social Thought*, Richard C. Sinopoli, ed., Georgetown University Press, 1997, p. 250.

36. Frank Shuffleton, "On Her Own Footing: Phillis Wheatley in Freedom," *Genius in Bondage: Literature of the Early Black Atlantic*, Vincent Carretta, Philip Gould, ed., University Press of Kentucky, 2001, p. 185.

37. *Voices of a People's History of the United States*, Howard Zinn, Anthony Arnove, eds., Seven Stories Press, 2011, p. 56.

38. John W. Blassingame, *The Slave Community: Planation Life in the Antebellum South*, New York, Oxford University Press, 1979, p. 284.

39. Robinson, *Phillis Wheatley and Her Writings*, p. 24-25

40. "Holbrook, Felix," *Dictionary of Afro-American Slavery*, Randall M. Miller, John David Smith, ed., Greenwood Publishing Group, 1997, p. 336.

41. "Four Boston Families," *The New England Historical and Genealogical Register, Volume 58,* The Society, 1904, p. 306.

42. Carretta, *Phillis Wheatley: Biography of a Genius in Bondage*, p. 154.

## CHAPTER 35

1. Benjamin L. Carp, *Defiance of the Patriots: The Boston Tea Party & the Making of America,* Yale University Press, 2010, p. 210.

2. Paula Bennett, "Phillis Wheatley's Vocation and the Paradox of the 'Afric Muse,'" PMLA, Vol. 113, No. 1, January 1998, p. 68.

3. William Robinson, *Phillis Wheatley and Her Writings*, Garland Publishing Inc., 1984, p. 44.

4. William Robinson, *Black New England Letters: The Uses of Writings in Black New England,* Trustees of the Public Library of the City of Boston, 1977, p. 57.

5. Robinson, *Phillis Wheatley and Her Writings*, p. 44.

6. Emily Blanck, *Tyrannicide: Forging an American Law of Slavery in Revolutionary South Carolina and Massachusetts,* The University of Georgia Press, 2014, p. 73.

7. Vincent Carretta, *Phillis Wheatley: Biography of a Genius in Bondage*, University of Georgia Press, 2011, p. 159. 8. Julian Mason, *The Poems of Phillis Wheatley*, University of North Carolina Press, 1989, p. 203.

9. William Robinson, *Phillis Wheatley and the Origins of African American Literature*, Limited Commemorative Edition, Old South Meeting House, 1999, p. 21.

10. William Robinson, *Phillis Wheatley in the Black American Beginnings*, Broadside Press, 1975, p. 63.

11. Robinson, *Black American Beginnings*, p. 63.

12. Robinson, *Black New England Letters,* p. 57.

13. Robinson, *Black American Beginnings*, p. 63.

14. Robinson, *Phillis Wheatley and Her Writings*, p. 119.

15. Barbara Johnson, *The Feminist Difference: Literature, Psychoanalysis, Race and Gender*, Harvard University Press, 1998, p. 100.

16. Phillis Wheatley, February 11, 1774, *Phillis Wheatley: Complete Writings*, Carretta, ed., p. 152.

17. Phillis Wheatley, February 11, 1774, *Phillis Wheatley: Complete Writings*, Carretta, ed., p. 153.

18. *Ibid.*

19. Vincent Carretta, *Phillis Wheatley: Biography of a Genius in Bondage*, University of Georgia Press, 2011, p. 159.

20. Phillis Wheatley, February 11, 1774, *Phillis Wheatley: Complete Writings*, Carretta, ed., p. 153.

21. *Ibid.*

22. *Ibid.*

23. Robinson, *Black New England Letters,* p. 57.

24. Phillis Wheatley, February 11, 1774, *Phillis Wheatley: Complete Writings*, Carretta, ed., p. 153.

25. *Ibid.*

26. Phillis Wheatley, February 11, 1774, *Phillis Wheatley: Complete Writings*, Carretta, ed., p. 153.

27. Barbara Johnson, *The Feminist Difference: Literature, Psychoanalysis, Race, and Gender,* Harvard University Press, 1998, p. 99.

28. Robinson, *Black New England Letters,* p. 57.

29. Robinson, *Phillis Wheatley and Her Writings*, p. 47.

30. Carretta, *Phillis Wheatley: Biography of a Genius in Bondage*, p. 227.

31. Robinson, *Black American Beginnings*, p. 48.

32. Kathrynn Seidler Engberg, *The Right to Write: The Literary Politics of Anne Bradstreet and Phillis Wheatley*, University Press of America, 2010, p. 50.

33. Robinson, *Black American Beginnings*, p. 39.

34. Robinson, *Phillis Wheatley and the Origins of African American Literature*, p. 21.

35. Engberg, *The Right to Write,* p. 50.

36. Kirsten Wilcox, *The Body Into Print: Marketing Phillis Wheatley,* American Literature, Vol. 71, No. 1 (March 1999), p. 19.

37. Blanck, *Tyrannicide,* p. 73.

38. Engberg, *The Right to Write,* p. 50.

39. Engberg, *The Right to Write,* p. 55.

40. Sondra A. O'Neale, "Challenge to Wheatley's Critics: There Was No Other 'Game' in Town"; *The Journal of Negro Education*, Vol. 54, No. 4 (Autumn 1985), p. 500.

41. O'Neale, "Challenge to Wheatley's Critics: There Was No Other 'Game' in Town," p. 506.

42. O'Neale, "Challenge to Wheatley's Critics: There Was No Other 'Game' in Town," p. 503.

43. O'Neale, "Challenge to Wheatley's Critics: There Was No Other 'Game' in Town," p. 501.

44. O'Neale, "Challenge to Wheatley's Critics: There Was No Other 'Game' in Town," p. 503.

## CHAPTER 36

1. "Message and Papers Considered, Speech of Lord North: The Order of the Day Read," v1:37; *American Archives: Documents of the American Revolution 1774-1776;* Northern Illinois University, Digital Collections and Collaborative Projects <http://amarch.lib.niu.edu/islandora/object/niu-amarch%3A93471>.

2. *Boston Gazette,* May 23, 1774; The Annotated Newspapers of Harbottle Dorr, Jr., Massachusetts Historical Society, <http://www.masshist.org/dorr/volume/4/sequence/581>.

3. Phillis Wheatley, May 6, 1774, *Phillis Wheatley: Complete Writings,* Vincent Carretta, ed., Penguin Books, 2001, p. 157.

4. *Ibid.*

5. John Rowe, Edward Lillie Pierce; *Letters and Diary of John Rowe, Boston Merchant, 1759-1762, 1764-1779,* Anne Rowe Cunningham, ed., W. B. Clarke, 1908, p. 273.

6. *Letters and Diary of John Rowe,* p. 275.

7. Letter from John Andrews to William Barrell, June 12, 1774, *Proceedings of the Massachusetts Historical Society,* Volume 8, Massachusetts Historical Society, 1866, p. 330.

8. *Letters and Diary of John Rowe,* p. 275.

9. John Andrews to William Barrell, June 12, 1774, *Proceedings of the Massachusetts Historical Society,* p. 330.

10. Stephen Rumbold Lushington, *The Life and Services of General Lord Harris, G. C. B.: During His Campaigns in America, the West Indies, and India,* J. W. Parker, 1840, p. 44.

11. Harlow Giles Unger, *American Tempest: How the Boston Tea Party Sparked a Revolution,* Da Capo Press, 2011, p. 190.

12. Benjamin Woods Labaree, *The Boston Tea Party,* Northeastern University Press, 1964, p. 238.

13. John Andrews, August 11, 1774, "Letters of John Andrews" *Proceedings of the Massachusetts Historical Society,* Volume 8, Massachusetts Historical Society, 1868, p. 341.

14. "From George Washington to George William Fairfax, 10–15 June 1774," Founders Online, National Archives <http://founders.archives.gov/documents/Washington/02-10-02-0067>, ver. 2013-09-28. Source: *The Papers of George Washington*, Colonial Series, vol. 10, *21 March 1774–15 June 1775*, ed. W. W. Abbot and Dorothy Twohig. Charlottesville: University Press of Virginia, 1995, pp. 94–101.

15. John Adams, *The Works of John Adams, Second President of the United States, With a Life of the Author*, Charles Francis Adams, ed., Vol, 2, Little Brown, 1850, p. 367.

16. Benjamin L. Carp, *Defiance of the Patriots: The Boston Tea Party & the Making of America,* Yale University Press, 2010, p. 200.

17. Vincent Carretta, *Phillis Wheatley: Biography of a Genius in Bondage*, University of Georgia Press, 2011, p. 146.

18. *Ibid.*

19. Carretta, *Phillis Wheatley: Biography of a Genius in Bondage*, p. 163.

20. Phillis Wheatley, October 30, 1774; *Phillis Wheatley: Complete Writings*, Carretta, ed., p. 159.

21. William Robinson, *Phillis Wheatley and Her Writings*, Garland Publishing Inc., 1984, p. 49.

22. Phillis Wheatley, *Phillis Wheatley: Complete Writings*, Carretta, ed., p. 83.

23. Carretta, *Phillis Wheatley: Biography of a Genius in Bondage*, p. 149.

24. Phillis Wheatley, *Phillis Wheatley: Complete Writings*, Carretta, ed., p. 84.

25. Phillis Wheatley, *Phillis Wheatley: Complete Writings*, Carretta, ed., p. 86.

26. Carretta, *Phillis Wheatley: Biography of a Genius in Bondage*, p. 149.

27. Phillis Wheatley, *Phillis Wheatley: Complete Writings*, Carretta, ed., p. 83.

28. Julian Mason, *The Poems of Phillis Wheatley*, University of North Carolina Press, 1989, p. 162, 163.

## CHAPTER 37

1. William Robinson, *Phillis Wheatley and Her Writings*, Garland Publishing Inc., 1984, p. 50.

2. Abigail Adams, May 7, 1775, "Adams Family Papers," *Massachusetts Historical Society,* <http://www.masshist.org/digitaladams/aea/cfm/doc.cfm?id=L17750507aa>.

3. Letter from Andrew Eliot to his son, 23 April 1775, "Siege of Boston: Eyewitness Accounts From the Collections of the Massachusetts

Historical Society." <http://www.masshist.org/online/siege/doc-viewer. php?item_id=1906>.

4. Nathaniel Philbrick, *Bunker Hill: A City, A Siege, A Revolution*, Viking, 2013, p. 88.

5. "Give Me Liberty Or Give Me Death." *The Colonial Williamsburg Foundation*, <http://www.history.org/almanack/life/politics/giveme.cfm>.

6. "Jan. 27, Secretary Lord Dartmouth to Gen. Gage," *Proceedings of the Massachusetts Historical Society*, The Society, 1876, p. 346.

7. "Jan. 27, Secretary Lord Dartmouth to Gen. Gage," *Proceedings of the Massachusetts Historical Society*, The Society, 1876, p. 345.

8. Letter from Paul Revere to Jeremy Belknap, circa 1798, *Massachusetts Historical Society*, <https://www.masshist.org/database/99>.

9. *Ibid.*

10. *Ibid.*

11. *Ibid.*

12. Philbrick, *Bunker Hill,* p. 124.

13. Philbrick, *Bunker Hill,* p. 126.

14. Harlow Giles Unger, *American Tempest: How the Boston Tea Party Sparked a Revolution,* Da Capo Press, 2011, p. 210.

15. Letter from Paul Revere to Jeremy Belknap, circa 1798, *Massachusetts Historical Society*, <https://www.masshist.org/database/99>.

16. Philbrick, *Bunker Hill,* p. 132.

17. "Concord Hymn, by Ralph Waldo Emerson," *Poetry Foundation*, <http:// www.poetryfoundation.org/poem/175140>.

18. Philbrick, *Bunker Hill,* p. 140.

19. Philbrick, *Bunker Hill,* p. 143.

20. Philbrick, *Bunker Hill,* p. 146.

21. *Ibid.*

22. *The British in Boston: The Diary of Lieutenant John Barker 1774-1776,* Elizabeth Ellery Dana, ed., Harvard University Press, 1927, p. 35.

23. Unger, *American Tempest,* p. 211.

24. *The British in Boston: The Diary of Lieutenant John Barker 1774-1776,* Elizabeth Ellery Dana, ed., Harvard University Press, 1927, p. 35.

25. Unger, *American Tempest,* p. 211.

## CHAPTER 38

1. "Sarah Winslow Deming journal, 1775," p. 3, *Massachusetts Historical Society, Collections Online,* <http://www.masshist.org/database/viewer. php?item_id=1898&img_step=3&mode=transcript#page3>.

2. Reverend Andrew Eliot April 25, 1775; *Massachusetts Historical Society, Collections Online,* <http://www.masshist.org/database/531>.

3. "Sarah Winslow Deming journal, 1775," p. 3, *Massachusetts Historical Society, Collections Online,* <http://www.masshist.org/database/viewer.php?item_ id=1898&img_step=3&mode=transcript#page3>.

4. Andrew Eliot, May 31, 1775; *Massachusetts Historical Society, Collections Online,* <http://www.masshist.org/database/viewer.php?item_id=531& img_step=4&mode=transcript#page4>.

5. "John Rowe, May 5, 1775," p. 5, *Life During the Seige of Boston: Document Packet.* http://www.masshist.org/education/resources/fernandez/fernandez_ document_packet.pdf

6. "Sarah Winslow Deming journal, 1775," p. 1, *Massachusetts Historical Society, Collections Online,* <http://www.masshist.org/database/viewer. php?item_id=1898&mode=transcript&img_step=1#page1>.

7. Reverend Andrew Eliot April 25, 1775; *Massachusetts Historical Society, Collections Online,* <http://www.masshist.org/database/531>.

8. "Andrew Eliot, May 31, 1775," *Massachusetts Historical Society, Collections Online,* <http://www.masshist.org/database/viewer.php? item_id=531&img_step=4&mode=transcript#page4>.

9. "Reverend Andrew Eliot April 25, 1775," *Massachusetts Historical Society, Collections Online;*<http://www.masshist.org/database/531>.

10. "Andrew Eliot, May 31, 1775," *Massachusetts Historical Society, Collections Online,* <http://www.masshist.org/database/viewer.php?item_id=531&img_ step=4&mode=transcript#page4>.

11. *History of the Battle of Breed's Hill,* by Major Generals William Heath, Henry Lee, James Wilkinson, Henry Dearborn, Charles Coffin, ed., Published by William J. Condon, 1831, p. 17.

12. Phillis Wheatley, *Complete Writings,* Vincent Carretta, ed., Penguin Books, 2001, p. 102.

13. "Letter from Abigail Adams to John Adams, 18 - 20 June 1775," *Adams Family Papers: An Electronic Archive, Massachusetts Historical Society,* <http://www. masshist.org/digitaladams/archive/doc?id=L17750618aa>.

14. March 1846 Letter from John Quincy Adams, Massachusetts Historical Society, <http://www.masshist.org/bh/jqap3text.html>.

15. *History of the Battle of Breed's Hill,* p. 21.

16. "Letter from Abigail Adams to John Adams, 18 - 20 June 1775," *Adams Family Papers: An Electronic Archive, Massachusetts Historical Society,* <http://www.masshist.org/digitaladams/archive/doc?id=L17750618aa>.

17. "March 1846 Letter from John Quincy Adams to Joseph Sturge," p. 3, *Massachusetts Historical Society,* <http://www.masshist.org/bh/jqap3text.html>.

18. Robert Middlekauff, *The Glorious Cause: The American Revolution, 1763-1789,* Oxford University Press, 2005, p. 294.

19. "The Committee of Safety's Account of The Battle of Bunker Hill," A true Extract from the Minutes Att. Saml. Freeman Secry; Massachusetts Historical Society, Watertown 25th July 1775, <http://www.masshist.org/publications/apde/portia.php?id=PJA03d058>.

20. Nathaniel Philbrick, *Bunker Hill: A City, A Siege, A Revolution,* Viking, 2013, p. 220.

21. *Ibid.*

22. Proceedings of the Massachusetts Historical Society, The Society, Vol. 44, 1911, p. 101.

23. *History of the Battle of Breed's Hill,* p. 22.

24. John Harrower, *American Historical Review,* Vol. VI., October 1900 to July 1901, The Macmillan Company, 1901, p. 99.

25. Letter from J. Waller to unidentified recipient, 21 June 1775, Massachusetts Historical Society, <http://www.masshist.org/revolution/image-viewer.php?item_id=726&img_step=1&tpc=&pid=2&mode=transcript&tpc=&pid=2#page1>.

26. Philbrick, *Bunker Hill,* p. 228.

27. "Letter from J. Waller to unidentified recipient, 21 June 1775," p. 2, The Coming of the American Revolution, 1764-1776, Massachusetts Historical Society, <ww.masshist.org/revolution/image-viewer.php?item_id=726&mode=transcript&img_step=2&tpc=#page2>.

28. J. L. Bell, *Boston 1775,* "Salem Poor: "a Brave & Gallant Soldier;" February 12, 2009, <http://boston1775.blogspot.com/2009/02/salem-poor-brave-gallant-soldier.html>.

29. *Ibid.*

30. *Ibid.*

31. Philbrick, *Bunker Hill,* p. 229.

32. *Ibid.*

33. Harlow Giles Unger, *American Tempest: How the Boston Tea Party Sparked a Revolution,* Da Capo Press, 2011, p. 222.

34. Andrew Jackson O'Shaughnessy, *The Men Who Lost America:* British Leadership, the American Revolution, and the Fate of the Empire, Yale University Press, 2013, p. 86.

35. Vincent Carretta, *Phillis Wheatley: Biography of a Genius in Bondage,* University of Georgia Press, 2011, p. 153.

36. *Ibid.*

37. William Robinson, *Phillis Wheatley and Her Writings,* Garland Publishing Inc., 1984, p. 50.

38. Carretta, *Phillis Wheatley: Biography of a Genius in Bondage,* p. 154.

39. Timothy Newell, October 10, 1775; *Life During the Siege of Boston: Document Packet,* Massachusetts Historical Society database, <http://www.masshist. org/education/resources/fernandez/fernandez_document_packet.pdf.

40. "William Cheever Diary, 1775-1776," Siege of Boston: Eyewitness Accounts From the Collections of the Massachusetts Historical Society, <http://www.masshist.org/online/siege/img-viewer.php?item_id=1909 &mode=transcript&img_step=5&tpc=&pid=21#page5>.

41. Isaac Winslow, January 13, 1776; *Life During the Siege of Boston: Document Packet,* Massachusetts Historical Society database, <http://www.masshist. org/education/resources/fernandez/fernandez_document_packet.pdf>.

42. Excerpts from the Journal of Timothy Newell, Massachusetts Historical Society, Series 4, Vol. 1, (1852), <http://www.masshist.org/education/ resources/fernandez/fernandez_document_packet.pdf>.

43. J. L. Bell, "Old South Meeting-House Dragooned," Boston 1775 Blogspot, October 27, 2007, <http://boston1775.blogspot.com/2007/10/old-south-meeting-house-dragooned.html>.

44. *Ibid.*

45. Timothy Newell, January 8, 1776; *Life During the Siege of Boston: Document Packet,* Massachusetts Historical Society database, <http://www.masshist. org/education/resources/fernandez/fernandez_document_packet.pdf>.

46. "William Cheever Diary, 1775-1776," Siege of Boston: Eyewitness Accounts From the Collections of the Massachusetts Historical Society,

<http://www.masshist.org/online/siege/img-viewer.php?item_id=1909&mode=transcript&img_step=5&tpc=&pid=21#page5>.

47. Isaac Winslow, January 15, 1776; *Life During the Siege of Boston: Document Packet,* Massachusetts Historical Society database, <http://www.masshist.org/education/resources/fernandez/fernandez_document_packet.pdf>.

48. "Slave Poet's 1776 Letter, 'New Discovery,' Is for Sale," *New York Times,* November 11, 2005.

49. Felicia R. Lee, "Arts, Briefly: Letter by 18th-Century Slave Fetches Record Price," *New York Times,* November 25, 2005.

50. Phillis Wheatley to Obour Tanner, Feburary 14, 1776, "The Hand of America's First Black Female Poet," *NPR,* November 21, 2005, <http://www.npr.org/templates/story/story.php?storyId=5021077>.

51. *Ibid.*

52. *Ibid.*

53. *Ibid.*

54. Robinson, *Phillis Wheatley and Her Writings*, p. 113.

55. Phillis Wheatley to Obour Tanner, February 14, 1776, "The Hand of America's First Black Female Poet," *NPR,* November 21, 2005, <http://www.npr.org/templates/story/story.php?storyId=5021077>.

56. *Ibid.*

**PART V**

1. George Washington to Phillis Wheatley, February 28, 1776, *The Writings of George Washington: Being His Correspondence, Addresses,Messages, And Other Papers Official and Private,* Jared Sparks, ed., American Stationers' Company, John B. Russell, 1837; Vol. III, p, 297.

**CHAPTER 39**

1. David McCullough, *1776*, Simon & Schuster, 2005, p. 33.

2. "From the Military Journal of Dr. James Thacher," *American Heritage, American Voices,* David C. King, ed., John Wiley & Sons, 2003, p. 82.

3. J. L. Bell, *George Washington's Headquarters and Home, Cambridge Massachusetts: Longfellow House-Washington's Headquarters National Historic Site, Historic Resource Study,* National Park Service, U.S. Department of the Interior, February 29, 2012, p. 86.

4. Bell, *George Washington's Headquarters and Home, Cambridge Massachusetts,* p. 17.

5. Bell, *George Washington's Headquarters and Home, Cambridge Massachusetts,* p. 48.

6. Bell, *George Washington's Headquarters and Home, Cambridge Massachusetts,* p. 31.

7. Bell, *George Washington's Headquarters and Home, Cambridge Massachusetts,* p. 86.

8. McCullough, *1776,* p. 32.

9. McCullough, *1776,* p. 28.

10. McCullough, *1776,* p. 34.

11. Bell, *George Washington's Headquarters and Home, Cambridge Massachusetts,* p. 235, 236.

12. Bell, George Washington's Headquarters and Home, Cambridge Massachusetts, p. 287.

13. McCullough, *1776,* p. 28.

14. Thomas C. Amory, *The Military Services and Public Life of Major-General John Sullivan,* Wiggin and Lunt, Boston, 1868, p. 16.

15. Phillis Wheatley, *Complete Writings,* Vincent Carretta, ed., Penguin Books, 2001, p. 88.

16. Carretta, *Phillis Wheatley: Biography of a Genius in Bondage,* p. 155.

17. Phillis Wheatley, *Complete Writings,* Carretta, ed., p. 89.

18. "Hail, Miss Columbia: Once a U.S. symbol, she's lost out to Uncle Sam, Lady Liberty," *Pittsburgh Post-Gazette,* March 18, 2008, <http://www.post-gazette.com/ae/2008/03/18/Hail-Miss-Columbia-Once-a-U-S-symbol-she-s-lost-out-to-Uncle-Sam-Lady-Liberty/stories/200803180240>.

19. Thomas J. Steele, "The Figure of Columbia: Phillis Wheatley plus George Washington," *The New England Quarterly,* Vol. 54. No. 2, June 1981, p. 264, 266.

20. John Shields, "Phillis Wheatley's Struggle For Freedom In Her Poetry and Prose," *The Collected Works of Phillis Wheatley,* Oxford University Press, 1988, p. 237.

21. M. A. Richmond, *Bid the Vassal Soar: Interpretive Essays on the Life and Poetry of Phillis Wheatley and George Moses Horton,* Howard University Press, 1974, p. 7.

22. Mason, *The Poems of Phillis Wheatley,* p. 165.

23. Kenny J. Williams, "The Poet and the General: Phillis Wheatley and George Washington," *The Faculty Forum*, Vol. 9, No. 5: January, 1998; https://web.duke.edu/FacultyForum/vol9/ffjan98.htm

24. Phillis Wheatley, *Complete Writings*, Carretta, ed., p. 89.

## CHAPTER 40

1. Fritz Hirschfeld, *George Washington and Slavery, A Documentary Portrayal*, University of Missouri Press, 1997, p. xi.

2. Hirschfeld, *George Washington and Slavery, A Documentary Portrayal*, p. 226.

3. Hirschfeld, *George Washington and Slavery, A Documentary Portrayal*, p. 30.

4. George Washington to John Fairfax, January 1, 1789; Peter R. Henriques, *Realistic Visionary: A Portrait of George Washington*, University of Virginia Press, 2006, p. 149.

5. George Washington to Lawrence Lewis, August 14, 1797; Henriques, *Realistic Visionary: A Portrait of George Washington*, p. 149.

6. Hirschfeld, *George Washington and Slavery, A Documentary Portrayal*, p. 52.

7. George Washington to James Anderson, February 20, 1797; Henriques, *Realistic Visionary: A Portrait of George Washington*, p. 148.

8. George Washington to overseers at Mount Vernon, July 14, 1793; Henriques, *Realistic Visionary: A Portrait of George Washington*, p. 149.

9. Hirschfeld, *George Washington and Slaver,y A Documentary Portrayal*, p. 37.

10. Henriques, *Realistic Visionary: A Portrait of George Washington*, p. 150.

11. George Washington to William Pearce, March 1, 1795; Hirschfeld, *George Washington and Slavery A Documentary Portrayal*, p. 37.

12. Anthony Whiting to George Washington, January 16, 1793; Anthony Whiting to George Washington, January 20, 1793; "Slave control," George Washington's Mount Vernon, <http://www.mountvernon.org/educational-resources/encyclopedia/slave-control>.

13. George Washington to Anthony Whitting, January 20, 1793; Henriques, *Realistic Visionary: A Portrait of George Washington*, p. 150.

14. Hirschfeld, *George Washington and Slavery, A Documentary Portrayal*, p. 37.

15. John Ferling, *First of Men*, Knoxville, 1988, p. 68.

16. *Ibid.*

17. Henriques, *Realistic Visionary: A Portrait of George Washington*, p. 146.

18. Joseph J. Ellis, *His Excellency: George Washington*, Vintage Books, 2004, p. 256.

19. Hirschfeld, *George Washington and Slavery, A Documentary Portrayal*, p. 225.

20. Hirschfeld, *George Washington and Slavery, A Documentary Portrayal*, p. 12.

21. "Ten Facts About Washington & Slavery," George Washington's Mount Vernon, <http://www.mountvernon.org/george-washington/slavery/ten-facts-about-washington- slavery/>.

22. George Washington to John F. Mercer, September 9, 1786; Hirschfeld, *George Washington and Slavery, A Documentary Portrayal*, p. ix.

23. George Washington to Robert Lewis, August 17, 1790; Henriques, *Realistic Visionary: A Portrait of George Washington*, p. 152.

24. George Washington to John Francis Mercer, November 24, 1786; Henriques, *Realistic Visionary: A Portrait of George Washington*, p. 152.

25. George Washington to Alexander Spotswood, November 23, 1794; Hirschfeld, *George Washington and Slavery, A Documentary Portrayal*, p. 16.

26. George Washington to Robert Morris, April 12, 1786; Henriques, *Realistic Visionary: A Portrait of George Washington*, p. 158.

27. George Washington to Lawrence Lewis, August 4, 1797; Henriques, *Realistic Visionary: A Portrait of George Washington*, p. 158.

28. Henriques, *Realistic Visionary: A Portrait of George Washington*, p. 158.

29. George Washington to Tobias Lear, May 6, 1794; Henriques, *Realistic Visionary: A Portrait of George Washington*, p. 159.

30. Henriques, *Realistic Visionary: A Portrait of George Washington*, p. 161.

31. Henriques, *Realistic Visionary: A Portrait of George Washington*, p. 162.

32. Joseph Ellis, *Founding Brothers: The Revolutionary Generation*, Vintage Books, 2002, p. 157.

33. George Washington to Alexander Spotswood, November 23, 1794; Henriques, *Realistic Visionary: A Portrait of George Washington*, p. 162.

34. Joseph Ellis, *American Creation: Triumphs and Tragedies at the Founding of the Republic*, Vintage Books, 2008, p. 174.

35. Ellis, *Founding Brothers: The Revolutionary Generation*, p. 157.

36. Ellis, *Founding Brothers: The Revolutionary Generation*, p. 102.

37. Henriques, *Realistic Visionary: A Portrait of George Washington*, p. 163.

38. *Ibid.*

39. Ellis, *Founding Brothers: The Revolutionary Generation,* p. 158.

## CHAPTER 41

1. Ron Chernow, *Washington, A Life*, Penguin Press, 2010, p. 212.

2. General John Thomas to John Adams, October 24, 1775; Benjamin Quarles, *The Negro in the American Revolution*, University of North Carolina Press, 1961, p. 12.

3. Quarles, *The Negro in the American Revolution*, p. 12.

4. *Ibid.*

5. Benjamin Quarles, *Black Mosaic: Essays in Afro-American History and Historiography*, University of Massachusetts Press, 1988, p. 57.

6. Quarles, *Black Mosaic: Essays in Afro-American History and Historiography*, p. 63.

7. Quarles, *Black Mosaic: Essays in Afro-American History and Historiography*, p. 48, 49.

8. Fritz Hirschfeld, *George Washington and Slavery: A Documentary Portrayal*, University of Missouri Press, 1997, p. 141.

9. Quarles, *Black Mosaic: Essays in Afro-American History and Historiography*, p. 55.

10. J. L. Bell, *Boston 1775*, "Salem Poor: "a Brave & Gallant Soldier;" February 12, 2009, <http://boston1775.blogspot.com/2009/02/salem-poor-brave-gallant-soldier.html>.

11. Samuel Swett, *History of Bunker Hill Battle with a Plan*, Munroe & Francis, 1826, p. 25.

12. *The Revolutionary Services of John Greenwood of Boston and New York, 1775-1783*, Isaac J. Greenwood, ed., De vine Press, 1922, p. 12.

13. *Ibid.*

14. Swett, *History of Bunker Hill Battle with a Plan*, p. 25.

15. Quarles, *Black Mosaic: Essays in Afro-American History and Historiography*, p. 144.

16. Chernow, *Washington, A Life*, p. 212.

17. *Ibid.*

18. Bell, George Washington's Headquarters and Home, Cambridge Massachusetts, p. 287.

19. Chernow, *Washington, A Life*, p. 211.

20. *Ibid.*

21. George Washington to Joseph Reed, November 28, 1775; *Life and Correspondence of Joseph Reed*, William Bradford Reed, ed., Lindsay and Blakiston, 1847, p. 131.

22. George Washington to Richard Henry Lee, November 27, 1775; Chernow, *Washington, A Life*, p. 212.

23. George Washington to Joseph Reed, December 15, 1775; *Reprint of the Original Letters from Washington to J. Reed during the American Revolution;* William Bradford Reed ed., The British Library, 1852, p. 30.

24. George Washington to Richard Henry Lee, December 26, 1775; Founders Online, National Archives, <http://founders.archives.gov/documents/Washington/03-02-02-0568, ver. 2014-02-12>. Source: *The Papers of George Washington*, Revolutionary War Series, vol. 2, Philander D. Chase, ed., University Press of Virginia, 1987, pp. 610–613.

25. Chernow, *Washington, A Life*, p. 211, 212.

26. Joseph J. Ellis, *His Excellency: George Washington*, Vintage Books, 2004, p. 84.

27. Hirschfeld, *George Washington and Slavery: A Documentary Portrayal*, p. 146.

28. George Washington to John Hancock, December 31, 1775; Chernow, *Washington, A Life*, p. 213.

29. Chernow, *Washington, A Life*, p. 213.

30. Hirschfeld, *George Washington and Slavery A Documentary Portrayal*, p. 231.

31. Chernow, *Washington, A Life*, p. 213.

32. Ellis, *His Excellency: George Washington,* p. 84.

33. Hirschfeld, *George Washington and Slavery A Documentary Portrayal*, p. 147.

34. Hirschfeld, *George Washington and Slavery A Documentary Portrayal*, p. 154.

35. Quarles, *The Negro in the American Revolution*, p. ix.

36. Hirschfeld, *George Washington and Slavery A Documentary Portrayal*, p. 154.

37. Quarles, *The Negro in the American Revolution*, p. ix.

38. John Hope Franklin, *Mirror to America: The Autobiography of John Hope Franklin,* Macmillan, 2007, p. 279.

39. Hirschfeld, *George Washington and Slavery A Documentary Portrayal*, p. 158.

40. Alan Gilbert, *Black Patriots and Loyalists: Fighting for Emancipation in the War for Independence,* University of Chicago Press, 2012, p. 174.

41. *Ibid.*

42. Gilbert, *Black Patriots and Loyalists,* p. 175.

43. Bell, *George Washington's Headquarters and Home,* Cambridge Massachusetts, p. 279.

## CHAPTER 42.

1. Joseph J. Ellis, *Revolutionary Summer: The Birth of American Independence,* Alfred A. Knopf, 2013, p. 3.

2. Ron Chernow, *Washington, A Life,* Penguin Press, 2010, p. 213.

3. David McCullough, *1776,* Simon & Schuster, 2005, p. 78.

4. George Washington to Joseph Reed, January 14, 1776; McCullough, *1776,* p. 79.

5. McCullough, *1776,* p. 79.

6. George Washington to Joseph Reed, January 14, 1776; McCullough, *1776,* p. 79.

7. Chernow, *Washington, A Life,* p. 213.

8. Nathanel Greene to Samuel Ward, December 31, 1775; McCullough, *1776,* p. 67.

9. McCullough, *1776,* p. 86.

10. George Washington to John Hancock, President of Congress, February 9, 1776; Ellis, *His Excellency: George Washington,* p. 77.

11. Chernow, *Washington, A Life,* p. 206.

12. McCullough, *1776,* p. 51.

13. George Washington to John Washington, September 10, 1775; McCullough, *1776,* p. 51.

14. George Washington to Richard Henry Lee, August 29, 1775; Chernow, *Washington, A Life,* p. 207.

15. *Ibid.*

16. "From George Washington to John Hancock, 18–21 February 1776," Founders Online, National Archives, <http://founders.archives.gov/documents/Washington/03-03-02-0238, ver. 2013-12-27>. Source: *The Papers of George Washington,* Revolutionary War Series, vol. 3, *1 January 1776–31 March 1776,* ed. Philander D. Chase. Charlottesville: University Press of Virginia, 1988, pp. 335–337.

17. "From George Washington to Lieutenant Colonel Joseph Reed, 10 February 1776," Founders Online, National Archives, <http://founders.archives.gov/documents/Washington/03-03-02-0209> Source: *The Papers of George*

*Washington*, Revolutionary War Series, vol. 3, *1 January 1776–31 March 1776*, ed. Philander D. Chase. Charlottesville: University Press of Virginia, 1988, pp. 286–291.

18. Phillis Wheatley to George Washington, October 26, 1775; Phillis Wheatley, *Complete Writings*, Vincent Carretta, ed., Penguin Books, 2001, p. 160.

19. Phillis Wheatley, *Complete Writings*, Carretta, ed., p. 89.

20. "From George Washington to Lieutenant Colonel Joseph Reed, 10 February 1776," Founders Online, National Archives, <http://founders.archives. gov/documents/Washington/03-03-02-0209> Source: *The Papers of George Washington*, Revolutionary War Series, vol. 3, *1 January 1776–31 March 1776*, ed. Philander D. Chase. Charlottesville: University Press of Virginia, 1988, pp. 286–291.

21. "From George Washington to Lieutenant Colonel Joseph Reed, 26 February–9 March 1776," Founders Online, National Archives, <http:// founders.archives.gov/documents/Washington/03-03-02-0274 [last update: 2015- 12-30]>. Source: *The Papers of George Washington*, Revolutionary War Series, vol. 3, *1 January 1776–31 March 1776*, ed. Philander D. Chase. Charlottesville: University Press of Virginia, 1988, pp. 369–379.

22. "From George Washington to John Hancock, 26 February 1776," *Founders Online, National Archives,* <http://founders.archives.gov/documents/ Washington/03-03-02-0271> Source: *The Papers of George Washington*, Revolutionary War Series, vol. 3, *1 January 1776–31 March 1776*, ed. Philander D. Chase. Charlottesville: University Press of Virginia, 1988, pp. 364–366.

23. Bell, *George Washington's Headquarters and Home, Cambridge Massachusetts,* p. 573.

24. *Ibid.*

25. Chernow, *Washington, A Life*, p. 220.

26. Ellis, *His Excellency: George Washington*, p. 77.

27. Fritz Hirschfeld, *George Washington and Slavery: A Documentary Portrayal*, University of Missouri Press, 1997, p. 92.

28. George Washington to Phillis Wheatley, Cambridge, February 28, 1776; *The Writings of George Washington: Being His Correspondence, Addresses, Messages, And Other Papers Official and Private,* Jared Sparks, ed., American Stationers' Company, John B. Russell, 1837; Vol. III, p, 297.

29. *Ibid.*

30. *Ibid.*

31. *Ibid.*

32. Walter H. Mazyck, *George Washington and the Negro*, Associated Publishers, 1932, p. 55.

33. George Washington to Tobias Lear, May 6, 1794; Ellis, *His Excellency*, p. 257.

34. George Washington to Alexander Spotswood, November 23, 1794; Ellis, *His Excellency*, p. 256.

35. Chernow, *Washington, A Life*, p. 221.

36. M. A. Richmond, *Bid the Vassal Soar: Interpretive Essays on the Life and Poetry of Phillis Wheatley and George Moses Horton*, Howard University Press, 1974, p. 4.

37. Chernow, *Washington, A Life*, p. 220.

## CHAPTER 43

1. Merle A. Richmond, *Bid the Vassal Soar: Interpretive Essays on the Life and Poetry of Phillis Wheatley and George Moses Horton,* Howard University Press, 1974, p. 4.

2. Richmond, *Bid the Vassal Soar: Interpretive Essays on the Life and Poetry of Phillis Wheatley and George Moses Horton*, p. 5.

3. Richmond, *Bid the Vassal Soar: Interpretive Essays on the Life and Poetry of Phillis Wheatley and George Moses Horton*, p. 6.

4. McCullough, *1776*, p. 90.

5. Richmond, *Bid the Vassal Soar: Interpretive Essays on the Life and Poetry of Phillis Wheatley and George Moses Horton*, p. 10.

6. Ron Chernow, *Washington, A Life*, Penguin Press, 2010, p. 217.

7. McCullough, *1776*, p. 42.

8. J. L. Bell, *Headquarters and Home Cambridge Massachusetts, Longfellow House- Washington's Headquarters National Historic Site, Historic Resource Study,* National Park Service, U.S. Department of the Interior, February 29, 2012, p. 187.

9. McCullough, *1776*, p. 42.

10. Chernow, *Washington, A Life*, p. 219.

11. McCullough, *1776*, p. 42.

12. James Thomas Flexner, *George Washington in the American Revolution (1775-1783),* Little, Brown and Company, 1967, p. 60, 62.

13. Bell, *George Washington's Headquarters and Home, Cambridge Massachusetts,* p. 188, 189.

14. Chernow, *Washington, A Life*, p. 219.

15. Benson J. Lossing, "A Pilgrimage to the Cradle of American Liberty With Pen and Pencil," *Harper's New Monthly Magazine*, No. VI, Vol. I, November 1850, p. 725.

16. William Robinson, *Phillis Wheatley and Her Writings*, Garland Publishing Inc., 1984, p. 452.

17. Bell, *George Washington's Headquarters and Home, Cambridge Massachusetts*, p. 305.

18. "Our Mission," *George Washington's Mount Vernon*, <http://www.mountvernon.org/about/our-mission>.

19. "Phillis Wheatley (1753-1784)," *George Washington's Mount Vernon*; Mount Vernon Ladies' Association, <http://www.mountvernon.org/educational-resources/encyclopedia/people/phillis- wheatley>.

20. Richmond, *Bid the Vassal Soar: Interpretive Essays on the Life and Poetry of Phillis Wheatley and George Moses Horton*, p. 10.

21. Chernow, *Washington, A Life*, p. 219.

## CHAPTER 44

1. Benson J. Lossing, *Pictorial Field Book of the Revolution*, Harper & Brothers, 1860, Vol. 1, p. ix.

2. Benson J. Lossing, "A Pilgrimage to the Cradle of American Liberty with Pen and Pencil," *Harper's New Monthly Magazine*, No. VI, Vol. I, November 1850, p. 725.

3. Harold E. Mahan, *Benson J. Lossing and Historical Writing in the United States: 1830-1890*, Greenwood Publishing Group, 1996, p. 1.

4. Mahan, *Benson J. Lossing*, p. 7.

5. Mahan, *Benson J. Lossing*, p. 2.

6. Mahan, *Benson J. Lossing*, p. 3.

7. Lossing, *Pictorial Field Book*, p. viii.

8. Lossing, *Pictorial Field Book*, p. ix.

9. Benson J. Lossing, "A Pilgrimage to the Cradle of American Liberty With Pen and Pencil," *Harper's New Monthly Magazine*, No. VI, Vol. I, November 1850, p. 724.

10. *Life of Henry Wadsworth Longfellow*, Vol. 2, Samuel Longfellow, ed., Houghton, Mifflin and Company, 1891, p. 133.

11. Benson J. Lossing, "A Pilgrimage to the Cradle of American Liberty With Pen and Pencil," *Harper's New Monthly Magazine,* No. VI, Vol. I, November 1850, p. 724.

12. Charles C. Calhoun, *Longfellow: A Rediscovered Life*, Beacon Press, 2004, p. 127.

13. *Ibid.*

14. *Ibid.*

15. Charles C. Calhoun, *Longfellow: A Rediscovered Life*, Beacon Press, 2004, p. 127.

16. Charles C. Calhoun, *Longfellow: A Rediscovered Life*, Beacon Press, 2004, p. 124.

17. Henry Wadsworth Longfellow to George Washington Greene, August 6, 1838; Charles C. Calhoun, *Longfellow: A Rediscovered Life*, Beacon Press, 2004, p. 124.

18. Henry Wadsworth Longfellow, June 4, 1845, #868; *The Letters of Henry Wadsworth Longfellow*, Volume III, 1844-1856, Andrew Hilen, ed., The Belknap Press of Harvard University Press, 1972, p. 77.

19. *The Life and Writings of Jared Sparks*, Volume II, Herbert Baxter Adams, ed., Houghton, Mifflin and Company, 1893, p. 278.

20. *The Life and Writings of Jared Sparks*, Volume II, Herbert Baxter Adams, ed., Houghton, Mifflin and Company, 1893, p. 274.

21. *The Life and Writings of Jared Sparks*, Volume II, Herbert Baxter Adams, ed., Houghton, Mifflin and Company, 1893, p. 277.

22. *The Writings of George Washington: Being His Correspondence, Addresses, Messages, and Other Papers Official and Private,* Jared Sparks, ed., American Stationers' Company, John Russell, 1837; Vol. III, p, 297.

23. *Life of Henry Wadsworth Longfellow: With Extracts from His Journals and Correspondence,* Volume 1, Samuel Longfellow, ed., Houghton, Mifflin and Company, 1891, p. 260.

24. Henry Wadsworth Longfellow to George Washington Greene, August 6, 1838; Charles C. Calhoun, *Longfellow: A Rediscovered Life*, Beacon Press, 2004, p. 124.

25. *Life of Henry Wadsworth Longfellow: With Extracts from His Journals and Correspondence,* Volume 1, Samuel Longfellow, ed., Houghton, Mifflin and Company, 1891, p. 291.

26. *Life of Henry Wadsworth Longfellow: With Extracts from His Journals and Correspondence,* Volume 1, Samuel Longfellow, ed., Houghton, Mifflin and Company, 1891, p. 308.

27. *Life of Henry Wadsworth Longfellow: With Extracts from His Journals and Correspondence,* Volume 1, Samuel Longfellow, ed., Houghton, Mifflin and Company, 1891, p. 289.

28. *Life of Henry Wadsworth Longfellow: With Extracts from His Journals and Correspondence,* Volume 1, Samuel Longfellow, ed., Houghton, Mifflin and Company, 1891, p. 288.

29. *Life of Henry Wadsworth Longfellow: With Extracts from His Journals and Correspondence,* Volume 1, Samuel Longfellow, ed., Houghton, Mifflin and Company, 1891, p. 394.

**CHAPTER 45**

1. J. L. Bell, *Washington's Headquarters and Home, Cambridge Massachusetts, Longfellow House, Washington's Headquarters National Historic Site, Historic Resource Study* National Park Service, U.S. Department of the Interior, February 29, 2012, p. 31.

2. *Ibid.*

3. Bell, *George Washington's Headquarters and Home,* p. 183.

4. Bell, *George Washington's Headquarters and Home,* p. 35.

5. Bell, *George Washington's Headquarters and Home,* p. 192.

6. Bell, *George Washington's Headquarters and Home,* p. 36.

7. Bell, *George Washington's Headquarters and Home,* p. 40.

8. Bell, *George Washington's Headquarters and Home,* p. 38.

9. Bell, *George Washington's Headquarters and Home,* p. 40.

10. Elinor Des Verney Sinnette, "Oral History," *The Harvard Guide to African-American History,* Evelyn Brooks Higginbotham, editor in chief, Leon F. Litwack, Darlene Clark Hine, Randall K. Burkett, associate editors, Vol. 1, Harvard University Press, 2001, p. 113.

11. Leslie M. Alexander and Curtis J. Austin, "Africana Studies and Oral History: A Critical Assessment," in *African American Studies,* Jeanette Davidson, ed., Edinburgh University Press, 2010, p. 171, 172.

12. Janice D. Hamlet, "Word! The African American Oral Tradition and its Rhetorical Impact on American Popular Culture," *Black History Bulletin,* Vol. 74, No. 1, Spring 2011, p. 27.

13. Jan M. Vansina, *Oral Tradition as History,* University of Wisconsin Press, 1985, p. xi.

14. *Ibid.*

15. Leslie M. Alexander and Curtis J. Austin, "Africana Studies and Oral History: A Critical Assessment," in *African American Studies*, Jeanette Davidson, ed., Edinburgh University Press, 2010, p. 173.

16. Ron Chernow, *Washington, A Life*, Penguin Press, 2010, p. 219.

17. Henry Wadsworth Longfellow to Benson John Lossing, November 1, 1850, #1138; *The Letters of Henry Wadsworth Longfellow*, Volume III, 1844-1856, Andrew Hilen, ed., The Belknap Press of Harvard University Press, 1972, p. 277.

18. Henry Wadsworth Longfellow, *Poems and Other Writings*, Library of America, 2000, p. 39.

19. Henry Wadsworth Longfellow to Benson John Lossing, February 7, 1853, # 1276; *The Letters of Henry Wadsworth Longfellow*, Volume III, 1844-1856, Andrew Hilen, ed., The Belknap Press of Harvard University Press, 1972, p. 372.

20. David R. Daly, Curator, Longfellow House—Washington's Headquarters, National Historic Site, email to author, January 14, 2014.

21. Garrett Cloer, Staff Historian, Longfellow House—Washington's Headquarters, National Historic Site, email to author, January 14, 2014.

22. *Ibid.*

23. Ron Chernow, *Washington, A Life*, Penguin Press, 2010, p. 219.

## PART VI

1. Anonymous, "Elegy on the Death of a Late Celebrated Poetess," *Boston Magazine,* December 1784; William H. Robinson, ed., *Critical Essays on Phillis Wheatley*, G. K. Hall & Co., 1982, p. 39.

## CHAPTER 46

1. James Thacher, *Military Journal, During the American Revolutionary War, from 1775 to 1783: Describing the Events and Transactions of this Period, with Numerous Historical Facts and Anecdotes To which is Added, an Appendix, Containing Biographical Sketches of Several General Officers*, Cottons & Barnard, 1827, p. 40.

2. J. L. Bell, Boston1775, "A Deadly Barrage From the Continental Artillery," March 2, 2008, <http://boston1775.blogspot.com/2008/03/first-barrage-from-dorchester-heights.html>.

3. Letter from Abigail Adams to John Adams, 2 - 10 March 1776; Adams Family

Papers: *An Electronic Archive,* Massachusetts Historical Society, <http://www.masshist.org/digitaladams/>.

4.  Letters and Diary of John Rowe: Boston Merchant, 1759-1762, 1764-1779, Anne Rowe Cunningham, ed., W. B. Clarke Company, 1903, p. 299.

5.  Letter from Abigail Adams to John Adams, 2 - 10 March 1776; Adams Family Papers: *An Electronic Archive,* Massachusetts Historical Society, <http://www.masshist.org/digitaladams/>.

6.  J. L. Bell, Boston1775, "A Deadly Barrage From the Continental Artillery," March 2, 2008, <http://boston1775.blogspot.com/2008/03/first-barrage-from-dorchester-heights.html>.

7.  Letter from Abigail Adams to John Adams, 2 - 10 March 1776; Adams Family Papers: *An Electronic Archive,* Massachusetts Historical Society, <http://www.masshist.org/digitaladams>.

8.  Letters and Diary of John Rowe: Boston Merchant, 1759-1762, 1764-1779, Anne Rowe Cunningham, ed., W. B. Clarke Company, 1903, p. 300.

9.  William Robinson, *Phillis Wheatley and Her Writings,* Garland Publishing Inc., 1984, p. 50.

10. David McCullough, *1776,* Simon & Schuster, 2005, p. 91.

11. McCullough, *1776,* p. 93.

12. *Ibid.*

13. McCullough, *1776,* p. 95.

14. *Ibid.*

15. McCullough, *1776,* p. 93.

16. Thacher, *Military Journal,* p. 43.

17. *Ibid.*

18. Letters and Diary of John Rowe: Boston Merchant, 1759-1762, 1764-1779, Anne Rowe Cunningham, ed., W. B. Clarke Company, 1903, p. 300, 301.

19. George Washington from the Boston Selectmen, 8 March 1776, Founders Online, National Archives, <http://founders.archives.gov/documents/Washington/03-03-02-0314>.

20. George Washington to John Hancock, 7–9 March 1776, Founders Online, National Archives, <http://founders.archives.gov/documents/Washington/03-03-02-0309>.

21. McCullough, *1776,* p. 26.

22. McCullough, *1776*, p. 95.

23. Benson J. Lossing, "A Pilgrimage to the Cradle of American Liberty With Pen and Pencil," *Harper's New Monthly Magazine,* No. VI, Vol. I, November 1850, p. 725.

24. Thacher, *Military Journal,* p. 43.

25. J. L. Bell, Boston1775 Blogspot, "The Continentals Take Possession of the Town," March 17, 2008, < http://boston1775.blogspot.com/2008/03/continentals-take-possession-of-town.html>.

26. Letter from Abigail Adams to John Adams, 16 - 18 March 1776; Adams Family Papers: *An Electronic Archive,* Massachusetts Historical Society, <http://www.masshist.org/digitaladams/>.

27. J. L. Bell, Boston1775 Blogspot, "The Continentals Take Possession of the Town," March 17, 2008, <http://boston1775.blogspot.com/2008/03/continentals-take-possession-of-town.html>.

28. Letter from Abigail Adams to John Adams, 16 - 18 March 1776; Adams Family Papers: *An Electronic Archive,* Massachusetts Historical Society, <http://www.masshist.org/digitaladams/>.

29. Letters and Diary of John Rowe: Boston Merchant, 1759-1762, 1764-1779, Anne Rowe Cunningham, ed., W. B. Clarke Company, 1903, p. 304.

30. Thacher, *Military Journal,* p. 43, 44.

31. Thacher, *Military Journal,* p. 44.

32. Margaretta Oddell, *The Poems of Phillis Wheatley: With Letters and a Memoir,* Dover Publications, 2010, p. 69. (Unabridged replication of *Memoir and Poems of Phillis Wheatley,* Geo. W. Light, Boston, 1834), p. 71.

33. Julian Mason, *The Poems of Phillis Wheatley,* University of North Carolina Press, 1989, p. 10.

34. Letters and Diary of John Rowe: Boston Merchant, 1759-1762, 1764-1779, Anne Rowe Cunningham, ed., W. B. Clarke Company, 1903, p. 313.

35. *The Continental Journal and Weekly Advertiser,* July 25, 1776; The Annotated Newspapers of Harbottle Dorr, Jr., <http://www.masshist.org/dorr/volume/4/sequence/1061>.

36. J.L. Bell, Boston1775 Blogspot, "Sherriff Greenleaf and Col. Crafts Read the Declaration," July 4 2007, <http://boston1775.blogspot.com/2007/07/sheriff-greenleaf-and-col-crafts-read.html>.

37. *The Continental Journal and Weekly Advertiser,* July 25, 1776; The Annotated Newspapers of Harbottle Dorr, Jr., <http://www.masshist.org/dorr/volume/4/sequence/1061>.

38. J.L. Bell, Boston1775 Blogspot, "Sherriff Greenleaf and Col. Crafts Read the Declaration," July 4 2007, http://boston1775.blogspot.com/2007/07/sheriff-greenleaf-and-col-crafts-read.html.

39. *Ibid.*

40. *The Continental Journal and Weekly Advertiser,* July 25, 1776; The Annotated Newspapers of Harbottle Dorr, Jr., <http://www.masshist.org/dorr/volume/4/sequence/1061>.

41. *Ibid.*

42. Phillis Wheatley, February 11, 1774, *Phillis Wheatley: Complete Writings,* Carretta, ed., p. 152.

## CHAPTER 47

1. Vincent Carretta, *Phillis Wheatley: Biography of a Genius in Bondage,* University of Georgia Press, 2011, p. 158.

2. Phillis Wheatley, *Complete Writings,* Vincent Carretta, ed., Penguin Books, 2001, p. 92.

3. *The Literary Diary of Ezra Stiles, Vol. 1,* Franklin Bowditch Dexter, ed., Charles Scribner's Sons, 1901, p. 453.

4. Wheatley, *Complete Writings,* Vincent Carretta, ed., p. 90.

5. Wheatley, *Complete Writings,* Vincent Carretta, ed., p. 91.

6. Wheatley, *Complete Writings,* Vincent Carretta, ed., p. 92.

7. Wheatley, *Complete Writings,* Vincent Carretta, ed., p. 90.

8. William Robinson, *Phillis Wheatley and Her Writings,* Garland Publishing Inc., 1984, p. 51.

9. Dominick Mazzagetti, *Charles Lee: Self Before Country,* Rutgers University Press, 2013, p. 16.

10. J. L. Bell, *Headquarters and Home Cambridge Massachusetts, Longfellow House- Washington's Headquarters National Historic Site, Historic Resource Study,* National Park Service, U.S. Department of the Interior, February 29, 2012, p. 108.

11. Mazzagetti, *Charles Lee: Self Before Country,* p. 5.

12. Bell, *George Washington's Headquarters and Home,* p. 110.

13. Mazzagetti, *Charles Lee: Self Before Country,* p. 6.

14. *Ibid.*

15. Bell, *George Washington's Headquarters and Home,* p. 109.

16. Bell, *George Washington's Headquarters and Home,* p. 112.

17. Jane Belknap Marcou, ed., *Life of Jeremy Belknap, D. D.: The Historian of New Hampshire. With Selections from His Correspondence and Other Writings,* Harper, 1847, p. 94.

18. Mazzagetti, *Charles Lee: Self Before Country,* p. 108.

19. Ron Chernow, *Washington, A Life,* Penguin Press, 2010, p. 339.

20. "From George Washington to James Bowdoin, 18 December 1776," Founders Online, National Archives, <http://founders.archives.gov/documents/Washington/03-07-02-0294> Source: *The Papers of George Washington,* Revolutionary War Series, vol. 7, *21 October 1776–5 January 1777,* ed. Philander D. Chase. Charlottesville: University Press of Virginia, 1997, pp. 364–366.

21. "From George Washington to Samuel Washington, 18 December 1776," Founders Online, National Archives, <http://founders.archives.gov/documents/Washington/03-07-02-0299, ver. 2014-02-12> Source: *The Papers of George Washington,* Revolutionary War Series, vol. 7, *21 October 1776–5 January 1777,* ed. Philander D. Chase. Charlottesville: University Press of Virginia, 1997, pp. 369–372.

22. Chernow, *Washington, A Life,* p. 267.

23. "From George Washington to John Augustine Washington, 31 March 1776," Founders Online, National Archives, <http://founders.archives.gov/documents/Washington/03-03-02-0429> Source: *The Papers of George Washington,* Revolutionary War Series, vol. 3, *1 January 1776–31 March 1776,* ed. Philander D. Chase. Charlottesville: University Press of Virginia, 1988, pp. 566–571.

24. Mazzagetti, *Charles Lee: Self Before Country,* p. 114.

25. Joseph J. Ellis, *Revolutionary Summer: The Birth of American Independence,* Alfred A. Knopf, 2013, p. 34.

26. David McCullough, *1776,* Simon & Schuster, 2005, p. 230.

27. Jonathan E. Lazarus, "Charles Lee: Self Before Country: Book Review," Star-Ledger, November 24, 2013, <http://blog.nj.com/perspective/2013/11/charles_lee_-_self_before_coun.html>.

## CHAPTER 48

1. Vincent Carretta, *Phillis Wheatley: Biography of a Genius in Bondage,* University of Georgia Press, 2011, p. 165.

2.  Robert Middlekauff, *The Glorious Cause: The American Revolution, 1763-1789*, Oxford University Press, 2005, p. 541.

3.  Middlekauff, *The Glorious Cause: The American Revolution, 1763-1789*, p. 542.

4.  Carretta, *Phillis Wheatley: Biography of a Genius in Bondage*, p. 165.

5.  William Robinson, *Phillis Wheatley and Her Writings*, Garland Publishing Inc., 1984, p. 42.

6.  Robinson, *Phillis Wheatley and Her Writings*, p. 43.

7.  Carretta, *Phillis Wheatley: Biography of a Genius in Bondage*, p. 44.

8.  *An Evening Thought: Salvation by Christ with Penitential Cries*, by Jupiter Hammon, 1760, <http://poetry.about.com/od/poemsbytitlee/l/blhammoneveningthought.htm>.

9.  Milton C. Sernett, *African American Religious History: A Documentary Witness*, Duke University Press, 1999, p. 42.

10. "UT Arlington Professor, Graduate Student Discover Poem Written by 18th Century Slave," University of Texas at Arlington News Center, February 5, 2013, <http://www.uta.edu/news/releases/2013/02/Jupiter%20Hammon%20poem.php>.

11. *Ibid.*

12. *Ibid.*

13. Vincent Carretta, *Unchained Voices: An Anthology of Black Authors in the English- Speaking World of the Eighteenth Century*, University of Kentucky Press, 2013, p. 31.

14. *Ibid.*

15. Ignatius Sancho, *Letters of the Late Ignatius Sancho, An African*, Cosimo Classics, 2005, p. 125. (originally published 1782.)

16. *Ibid.*

17. *Ibid.*

18. Sancho, *Letters of the Late Ignatius Sancho, An African*, p. 126.

## CHAPTER 49

1.  Vincent Carretta, *Phillis Wheatley: Biography of a Genius in Bondage*, University of Georgia Press, 2011, p. 173.

2.  Carretta, *Phillis Wheatley: Biography of a Genius in Bondage*, p. 228.

3.  Carretta, *Phillis Wheatley: Biography of a Genius in Bondage*, p. 173.

4.  Phillis Wheatley, May 29, 1778, *Phillis Wheatley: Complete Writings*, Carretta, ed., p. 161.

5.  *Ibid.*

6.  *Ibid.*

7.  M. A. Richmond, *Bid the Vassal Soar: Interpretive Essays on the Life and Poetry of Phillis Wheatley and George Moses Horton*, Howard University Press, 1974, p. 43.

8.  Phillis Wheatley, October 30, 1773, *Phillis Wheatley: Complete Writings*, Carretta, ed., p. 149.

9.  Proceedings of the Massachusetts Historical Society, Volume 7, Massachusetts Historical Society, 1864, p. 269.

10. *Ibid.*

11. *Ibid.*

12. Margaretta Oddell, *The Poems of Phillis Wheatley: With Letters and a Memoir*, Dover Publications, 2010, p. 70. (Unabridged replication of *Memoir and Poems of Phillis Wheatley*, Geo. W. Light, Boston, 1834.

13. Carretta, *Phillis Wheatley: Biography of a Genius in Bondage*, p. 173.

14. William Robinson, *Phillis Wheatley and Her Writings*, Garland Publishing Inc., 1984, p. 54.

15. Phillis Wheatley, October 30, 1774, *Phillis Wheatley: Complete Writings*, Carretta, ed., p. 159.

16. Merle Richmond, *Phillis Wheatley*, Harcourt Brace & Company by special arrangement with Chelsea House Publishers, 1988, p. 85.

17. William Robinson, *Phillis Wheatley in the Black American Beginnings*, Broadside Press, 1975, p. 70.

18. Richmond, *Phillis Wheatley*, p. 85.

19. Phillis Wheatley, October 18, 1773, *Phillis Wheatley: Complete Writings*, Carretta, ed., p. 147.

20. Richmond, *Bid the Vassal Soar,* p. 43.

21. Richmond, *Bid the Vassal Soar,* p. 45.

22. *Ibid.*

23. Oddell, *The Poems of Phillis Wheatley: With Letters and a Memoir,* p. 70.

24. Henri Gregoire, *An Enquiry Concerning the Intellectual and Moral Faculties, and Literature of Negroes*, M. E. Sharpe, 1810, p. 103.

25. Richmond, *Phillis Wheatley*, p. 90.

26. Richmond, *Bid the Vassal Soar,* p. 47.

27. *Biographical Sketches and Interesting Anecdotes of Persons of Colour to which is Added a Selection of Pieces in Poetry,* Abigail Mott, ed., Printed and Sold by Mahlon Day, No. 376, Pearl Street, New York, 1826, p. 12.

28. Proceedings of the Massachusetts Historical Society, Volume 7, Massachusetts Historical Society, 1864, p. 279.

29. *Ibid.*

30. Richmond, *Bid the Vassal Soar,* p. 46.

31. *Ibid.*

32. Richmond, *Phillis Wheatley*, p. 91.

33. Richmond, *Bid the Vassal Soar,* p. 47.

34. Richmond, *Phillis Wheatley*, p. 91.

35. Oddell, *The Poems of Phillis Wheatley: With Letters and a Memoir,* p. 70.

36. Richmond, *Bid the Vassal Soar,* p. 47.

37. Richmond, *Bid the Vassal Soar,* p. 45.

38. Carretta, *Phillis Wheatley: Biography of a Genius in Bondage*, p. 175.

39. Oddell, *The Poems of Phillis Wheatley: With Letters and a Memoir,* p. 76.

40. Oddell, *The Poems of Phillis Wheatley: With Letters and a Memoir,* p. 70.

41. Carretta, *Phillis Wheatley: Biography of a Genius in Bondage*, p. 175.

## CHAPTER 50

1. William Robinson, *Phillis Wheatley and Her Writings*, Garland Publishing Inc., 1984, p. 54.

2. Vincent Carretta, *Phillis Wheatley: Biography of a Genius in Bondage*, University of Georgia Press, 2011, p. 178.

3. Robinson, *Phillis Wheatley and Her Writings*, p. 54.

4. Merle Richmond, *Phillis Wheatley*, Harcourt Brace & Company by special arrangement with Chelsea House Publishers, 1988, p. 93.

5. Phillis Wheatley, *Complete Writings*, Vincent Carretta, ed., Penguin Books, 2001, p. 92.

6. Wheatley, *Complete Writings*, Vincent Carretta, ed., p. 93.

7. *Ibid.*

8. Wheatley, *Complete Writings*, Vincent Carretta, ed., p. 93.

9. Shields, *Phillis Wheatley's Poetics of Liberation,* p. 16.

10. Phillis Wheatley, October 18, 1773, *Phillis Wheatley: Complete Writings*, Vincent Carretta, ed., p. 147.

11. Eric Ashley Hairston, "The Trojan Horse: Classics, Memory, Transformation and Afric Ambition in Poems on Various Subjects Religious and Moral," *New Essays on Phillis Wheatley*, John C. Shields and Eric D. Lamore, ed., University of Tennessee Press, 2011, p. 61.

12. Phillis Wheatley, July 15, 1778, *Phillis Wheatley: Complete Writings*, Carretta, ed., p. 93, 94.

13. Robinson, *Phillis Wheatley and Her Writings*, p. 56.

14. Phillis Wheatley, May 10, 1779, *Phillis Wheatley: Complete Writings*, Carretta, ed., p. 162.

15. Robinson, *Phillis Wheatley and Her Writings*, p. 55.

16. Phillis Wheatley, May 10, 1779, *Phillis Wheatley: Complete Writings*, Carretta, ed., p. 162.

17. Robinson, *Phillis Wheatley and Her Writings*, p. 55.

18. *Ibid.*

19. Carretta, *Phillis Wheatley: Biography of a Genius in Bondage*, p. 184.

20. Phillis Wheatley, *Phillis Wheatley: Complete Writings*, Carretta, ed., p. 96.

21. Margaretta Oddell, *The Poems of Phillis Wheatley: With Letters and a Memoir*, Dover Publications, 2010, p. 70. (Unabridged replication of *Memoir and Poems of Phillis Wheatley*, Geo. W. Light, Boston, 1834).

## CHAPTER 51

1. Merle Richmond, *Phillis Wheatley*, Harcourt Brace & Company by special arrangement with Chelsea House Publishers, 1988, p. 85.

2. Carretta, *Phillis Wheatley: Biography of a Genius in Bondage*, p. 181.

3. *Ibid.*

4. *Phillis Wheatley, Complete Writings*, Vincent Carretta, ed., Penguin Books, 2001, p. xliii.

5. Robinson, *Phillis Wheatley and Her Writings*, p. 56.

6. Carretta, *Phillis Wheatley: Biography of a Genius in Bondage*, p. 190.

7. Phillis Wheatley, *Complete Writings*, Carretta, ed., p. 169.

8. Carretta, *Phillis Wheatley: Biography of a Genius in Bondage*, p. 181.

9. Phillis Wheatley, *Complete Writings*, Carretta, ed., p. 169.

10. *Ibid.*

11. Phillis Wheatley, *Complete Writings*, Carretta, ed., p. 167.

12. Robinson, *Phillis Wheatley and Her Writings*, p. 57.

13. Carretta, *Phillis Wheatley: Biography of a Genius in Bondage*, p. 189.

14. Phillis Wheatley, *Complete Writings*, Vincent Carretta, ed., Penguin Books, 2001, p. 167.

15. Gregory Rigsby, "Phillis Wheatley's Craft as Reflected in Her Revised Elegies," *The Journal of Negro Education*, Vol. 47, No. 4 (Autumn, 1978,) p. 403, 407.

16. Julian Mason, *The Poems of Phillis Wheatley*, University of North Carolina Press, 1989, p. 212-214.

17. William Robinson, *Phillis Wheatley and the Origins of African American Literature*, Limited Commemorative Edition, Old South Meeting House, 1999, p. 22.

18. Mason, *The Poems of Phillis Wheatley*, p. 214.

19. Mason, *The Poems of Phillis Wheatley*, p. 201.

20. M. A. Richmond, *Bid the Vassal Soar: Interpretive Essays on the Life and Poetry of Phillis Wheatley and George Moses Horton*, Howard University Press, 1974, p. 37.

21. Margaretta Oddell, *The Poems of Phillis Wheatley: With Letters and a Memoir*, Dover Publications, 2010, p. 71. (Unabridged replication of *Memoir and Poems of Phillis Wheatley*, Geo. W. Light, Boston, 1834.

22. William Robinson, *Phillis Wheatley and Her Writings*, Garland Publishing Inc., 1984, p. 56.

23. Richmond, *Bid the Vassal Soar: Interpretive Essays on the Life and Poetry of Phillis Wheatley and George Moses Horton*, p. 42.

24. Oddell, *The Poems of Phillis Wheatley: With Letters and a Memoir*, p. 72.

25. Oddell, *The Poems of Phillis Wheatley: With Letters and a Memoir*, p. 71.

26. Richmond, *Bid the Vassal Soar: Interpretive Essays on the Life and Poetry of Phillis Wheatley and George Moses Horton*, p. 37.

27. Robinson, *Phillis Wheatley and Her Writings*, p. 52.

28. Richmond, *Phillis Wheatley*, p. 85.

29. Richmond, *Bid the Vassal Soar: Interpretive Essays on the Life and Poetry of Phillis Wheatley and George Moses Horton*, p. 42.

**CHAPTER 52**

1. Vincent Carretta, *Phillis Wheatley: Biography of a Genius in Bondage*, University of Georgia Press, 2011, p. 175.

2. Carretta, *Phillis Wheatley: Biography of a Genius in Bondage*, p. 182.

3. *Ibid.*

4. Margaretta Oddell, *The Poems of Phillis Wheatley: With Letters and a Memoir,* Dover Publications, 2010, p. 70. (Unabridged replication of *Memoir and Poems of Phillis Wheatley,* Geo. W. Light, Boston, 1834.)

5. Merle Richmond, *Phillis Wheatley,* Harcourt Brace & Company by special arrangement with Chelsea House Publishers, 1988, p. 97.

6. *Ibid.*

7. *Ibid.*

8. William Robinson, *Phillis Wheatley and Her Writings,* Garland Publishing Inc., 1984, p. 57.

9. Oddell, *The Poems of Phillis Wheatley: With Letters and a Memoir,* p. 70.

10. Robinson, *Phillis Wheatley and Her Writings,* p. 57.

11. Jennifer Schuessler, "Use of 'African-American' Dates to Nation's Early Days," *New York Times,* April 21, 2015.

12. Henry Louis Gates, *The Trials of Phillis Wheatley,* Basic Civitas Books, 2003, p. 33.

13. William Robinson, *Phillis Wheatley and Her Writings,* Garland Publishing Inc., 1984, p. 381.

14. Joanna Brooks, *Our Phillis, Ourselves,* American Literature, Volume 82, Number 1, March 2010, p. 8.

15. *Ibid.*

16. *Ibid.*

17. Phillis Wheatley, *Phillis Wheatley: Complete Writings,* Carretta, ed., p. 61.

18. W. E. B. Du Bois, "Phillis Wheatley and African American Culture"; (original title: "The Vision of Phillis the Blessed: An Allegory of Negro American Literature in the Eighteenth and Nineteenth Centuries," Fisk News 14, May 1941) *The Oxford W. E. B. DuBois Reader,* Eric J. Sundquist, ed., Oxford University Press, 1996, p. 332.

19. Phillis Wheatley, *Phillis Wheatley: Complete Writings,* Carretta, ed., p. 102.

20. W. E. B. Du Bois, "Phillis Wheatley and African American Culture," p. 333.

## CHAPTER 53

1. Emily Blanck, *Tyrannicide: Forging an American Law of Slavery in*

*Revolutionary South Carolina and Massachusetts,* The University of Georgia Press, 2014, p. 35.

2.  Blanck, *Tyrannicide,* p. 111.

3.  Phillis Wheatley, *Phillis Wheatley: Complete Writings*, Carretta, ed., p. 93.

4.  Catharine Maria Sedgwick, "Slavery in New England," *Bentley's Miscellany,* Volume 34, Charles Dickens, William Harrison Ainsworth, Albert Smith, et al, published by Richard Bentley, London, New Burlington Street, 1853, p. 421.

5.  *Ibid.*

6.  Catharine Maria Sedgwick, "Slavery in New England," *Bentley's Miscellany,* p. 424.

7.  "The Quock Walker Case: Massachusetts Court System," The Official Website of the Massachusetts Judicial Branch, <http://www.mass.gov/courts/court-info/sjc/edu-res-center/abolition/abolition-5-gen.html>.

8.  *Ibid.*

9.  Blanck, *Tyrannicide,* p. 124.

10. Blanck, *Tyrannicide,* p. 126.

11. Blanck, *Tyrannicide,* p. 35.

12. Merle Richmond, *Phillis Wheatley*, Harcourt Brace & Company by special arrangement with Chelsea House Publishers, 1988, p. 98.

13. William Robinson, *Phillis Wheatley and Her Writings*, Garland Publishing Inc., 1984, p. 58.

14. Oddell, *The Poems of Phillis Wheatley: With Letters and a Memoir,* p. 71.

15. *Ibid.*

16. Richmond, *Phillis Wheatley*, p. 98.

17. Oddell, *The Poems of Phillis Wheatley: With Letters and a Memoir,* p. 71.

18. Phillis Wheatley, *Phillis Wheatley: Complete Writings*, Vincent Carretta, ed., Penguin Books, 2001, p. 98.

19. *Ibid.*

20. John C. Shields, *Phillis Wheatley's Poetics of Liberation*, The University of Tennessee Press, 2008, p. 147.

21. Phillis Wheatley, *Phillis Wheatley: Complete Writings*, Vincent Carretta, ed., p. 98.

22. J. L. Bell, *George Washington's Headquarters and Home*, p. 220.

23. *Ibid.*

24. Shields, *Phillis Wheatley's Poetics of Liberation*, p. 147.

25. Phillis Wheatley, *Phillis Wheatley: Complete Writings*, Vincent Carretta, ed., Penguin Books, 2001, p. 99.

26. Phillis Wheatley, *Phillis Wheatley: Complete Writings*, Carretta, ed., p. 100.

27. Phillis Wheatley, *Phillis Wheatley: Complete Writings*, Carretta, ed., p. 99.

28. Phillis Wheatley, *Phillis Wheatley: Complete Writings*, Carretta, ed., p. 100.

29. Shields, *Phillis Wheatley's Poetics of Liberation*, p. 147.

## CHAPTER 54

1. Hamilton Andrews Hill, *History of the Old South Church, Boston, 1669-1884*, Houghton, Mifflin and Company, 1889, p. 228.

2. William Robinson, *Phillis Wheatley and Her Writings*, Garland Publishing Inc., 1984, p. 54.

3. Phillis Wheatley, *Complete Writings*, Vincent Carretta, ed., Penguin Books, 2001, p. 75.

4. Phillis Wheatley, *Complete Writings*, Carretta, ed., p. 77.

5. William Robinson, *Phillis Wheatley and the Origins of African American Literature*, Limited Commemorative Edition, Old South Meeting House, 1999, p. 25.

6. Phillis Wheatley, *Complete Writings*, Carretta, ed., p. 101.

7. Julian Mason, *The Poems of Phillis Wheatley*, University of North Carolina Press, 1989, p. 175.

8. Phillis Wheatley, *Complete Writings*, Carretta, ed., p. 101.

9. Phillis Wheatley, *Complete Writings*, Carretta, ed., p. 89.

10. Phillis Wheatley, *Complete Writings*, Carretta, ed., p. 101.

11. Phillis Wheatley, *Complete Writings*, Carretta, ed., p. 102.

12. Phillis Wheatley, February 11, 1774, *Complete Writings*, Vincent Carretta, ed., p. 153.

13. Phillis Wheatley, *Complete Writings*, Carretta, ed., p. 101.

14. Phillis Wheatley, *Complete Writings*, Carretta, ed., p. 102.

15. *Ibid.*

16. *Ibid.*

17. *Ibid.*

18. *Ibid.*

19. Phillis Wheatley, *Complete Writings*, Carretta, ed., p. 101.

20. *Ibid.*

21. *Ibid.*

22. Phillis Wheatley, *Complete Writings*, Carretta, ed., p. 102.

23. *Ibid.*

24. "The Quock Walker Case: Massachusetts Court System," The Official Website of the Massachusetts Judicial Branch, <http://www.mass.gov/courts/court-info/sjc/edu-res-center/abolition/abolition-5-gen.html

25. "The Charters of Freedom: Declaration of Independence," National Archives and Records Administration, <http://www.archives.gov/exhibits/charters/declaration_transcript.html>.

26. W. E. B. Du Bois, "Phillis Wheatley and African American Culture"; (original title: "The Vision of Phillis the Blessed: An Allegory of Negro American Literature in the Eighteenth and Nineteenth Centuries," Fisk News 14, May 1941) *The Oxford W. E. B. DuBois Reader*, Eric J. Sundquist, ed., Oxford University Press, 1996, p. 332.

27. Phillis Wheatley, *Complete Writings*, Vincent Carretta, ed., p. 102.

28. *Ibid.*

29. John Shields, "Phillis Wheatley's Struggle for Freedom in Her Poetry and Prose," *The Collected Works of Phillis Wheatley*, Oxford University Press, 1988, p. 239.

30. *Ibid.*

## CHAPTER 55

1. Vincent Carretta, *Phillis Wheatley: Biography of a Genius in Bondage*, University of Georgia Press, 2011, p. 198.

2. Mukhtar Ali Isani, "The Methodist Connection: New Variants of Some Phillis Wheatley Poems," *Early American Literature* Vol. 22, No. 1 (Spring 1987), p. 108.

3. Muktar Ali Isani, "'An Elegy on Leaving –,' A New Poem by Phillis Wheatley," *American Literature* Vol. 58 No. 4, December 1986, p. 611.

4. Phillis Wheatley, October 18, 1773, *Phillis Wheatley: Complete Writings*, Carretta, ed., p. 147.

5. Isani, "The Methodist Connection: New Variants of Some Phillis Wheatley Poems," *Early American Literature*, p. 108.

6. Isani, "The Methodist Connection: New Variants of Some Phillis Wheatley Poems," *Early American Literature,* p. 109.

7. Isani, "The Methodist Connection: New Variants of Some Phillis Wheatley Poems," *Early American Literature,* p. 110.

8. Isani, "The Methodist Connection: New Variants of Some Phillis Wheatley Poems," *Early American Literature,* p. 109.

9. Julian Mason, *The Poems of Phillis Wheatley*, University of North Carolina Press, 1989, p. 79.

10. Isani, "The Methodist Connection: New Variants of Some Phillis Wheatley Poems," *Early American Literature,* p. 108.

11. Isani, "'An Elegy on Leaving –,' A New Poem by Phillis Wheatley," *American Literature,* p. 610.

12. Isani, "'An Elegy on Leaving –,' A New Poem by Phillis Wheatley," *American Literature,* p. 611.

13. Isani, "'An Elegy on Leaving –,' A New Poem by Phillis Wheatley," *American Literature,* p. 612.

14. Mary Whateley, *Original Poems on Several Occasions*, Printed for R. and J. Dodsley at Tully's Head, Pall Mall, London, 1764, p. 34.

15. Caroline Wigginton, "A Chain of Misattribution: Phillis Wheatley, Mary Whateley, and 'An Elegy on Leaving,'" *Early American Literature,* Volume 47, Number 3 (2012), p. 679-84.

16. Vincent Carretta, *Phillis Wheatley: Biography of a Genius in Bondage*, University of Georgia Press, 2011, p. 187.

17. Carretta, *Phillis Wheatley: Biography of a Genius in Bondage*, p. 184.

18. Merle Richmond, *Phillis Wheatley*, Harcourt Brace & Company by special arrangement with Chelsea House Publishers, 1988, p. 99.

19. Carretta, *Phillis Wheatley: Biography of a Genius in Bondage*, p. 184.

20. William Robinson, *Phillis Wheatley and Her Writings*, Garland Publishing Inc., 1984, p. 59.

21. Carretta, *Phillis Wheatley: Biography of a Genius in Bondage*, p. 186.

22. *Proceedings of the Massachusetts Historical Society*, Volume 7, Charles Deane, Ed., Boston, 1864, p. 272.

23. Carretta, *Phillis Wheatley: Biography of a Genius in Bondage*, p. 191.

24. *Proceedings of the Massachusetts Historical Society*, Volume 7, Charles Deane, Ed., Boston, 1864, p. 272.

25. Robinson, *Phillis Wheatley and Her Writings*, p. 63.

26. *Ibid.*

27. Robinson, *Phillis Wheatley and Her Writings*, p. 122.

28. Carretta, *Phillis Wheatley: Biography of a Genius in Bondage*, p. 188.

29. Carretta, *Phillis Wheatley: Biography of a Genius in Bondage*, p. 190.

30. Mason, *The Poems of Phillis Wheatley*, p. 11.

31. Rowan Ricardo Phillips, *When Blackness Rhymes With Blackness,* Dalkey Archive Press, 2010, p. 14.

32. Mason, *The Poems of Phillis Wheatley*, p. 11.

33. Phillis Wheatley, *Complete Writings*, Vincent Carretta, ed., Penguin Books, 2001, p. 94.

34. *Ibid.*

35. Phillis Wheatley, *Complete Writings*, Carretta, ed., p. 95.

36. *Ibid.*

37. *Ibid.*

38. *Ibid.*

39. *Ibid.*

40. Toni Morrison, "The Site of Memory," *Inventing the Truth: The Art and Craft of Memoir,* William Zinsser, ed., Houghton Mifflin, 1987, p. 119.

**CHAPTER 56**

1. William Robinson, *Phillis Wheatley and Her Writings*, Garland Publishing Inc., 1984, p. 64.

2. Julian Mason, *The Poems of Phillis Wheatley*, University of North Carolina Press, 1989, p. 13.

3. *Proceedings of the Massachusetts Historical Society*, Volume 7, Charles Deane, Ed., Boston, 1864, p. 272.

4. Merle Richmond, *Phillis Wheatley*, Harcourt Brace & Company by special arrangement with Chelsea House Publishers, 1988, p. 99.

5. M. A. Richmond, *Bid the Vassal Soar: Interpretive Essays on the Life and Poetry of Phillis Wheatley and George Moses Horton*, Howard University Press, 1974, p. 50.

6. Margaretta Oddell, *The Poems of Phillis Wheatley: With Letters and a Memoir,* Dover Publications, 2010, p. xx. (Unabridged replication of *Memoir and Poems of Phillis Wheatley,* Geo. W. Light, Boston, 1834), p. 72.

7. Oddell, *The Poems of Phillis Wheatley: With Letters and a Memoir,* p. 76.

8. Robinson, *Phillis Wheatley and Her Writings*, p. 450.

9. Oddell, *The Poems of Phillis Wheatley: With Letters and a Memoir,* p. 72.

10. Richmond, *Bid the Vassal Soar: Interpretive Essays on the Life and Poetry of Phillis Wheatley and George Moses Horton*, p. 51.

11. W. E. B. Du Bois, "Phillis Wheatley and African American Culture"; (original title: "The Vision of Phillis the Blessed: An Allegory of Negro American Literature in the Eighteenth and Nineteenth Centuries," Fisk News 14, May 1941) *The Oxford W. E. B. DuBois Reader*, Eric J. Sundquist, ed., Oxford University Press, 1996, p. 339.

12. Tim Brookes, *Catching My Breath: An Asthmatic Explores his Illness*, Vintage, 1995, p. 3-5.

13. Phillis Wheatley, *Complete Writings*, Vincent Carretta, ed., Penguin Books, 2001, p. 94.

14. *Ibid.*

15. *Ibid.*

16. W. E. B. Du Bois, "Phillis Wheatley and African American Culture," p. 339.

17. W. E. B. Du Bois, "Phillis Wheatley and African American Culture," p. 341.

18. Oddell, *The Poems of Phillis Wheatley: With Letters and a Memoir,* p. 73.

19. *Ibid.*

20. *Ibid.*

21. M. A. Richmond, *Bid the Vassal Soar: Interpretive Essays on the Life and Poetry of Phillis Wheatley and George Moses Horton*, Howard University Press, 1974, p. 52.

22. William Robinson, *Phillis Wheatley and the Origins of African American Literature*, Limited Commemorative Edition, Old South Meeting House, 1999, p. 26.

23. Robinson, *Phillis Wheatley and Her Writings*, p. 61.

24. Robinson, *Phillis Wheatley and Her Writings*, p. 62.

25. Robinson, *Phillis Wheatley and Her Writings*, p. 72.

26. Carretta, *Phillis Wheatley: Biography of a Genius in Bondage*, p. 190.

## CHAPTER 57

1. Julian Mason, *The Poems of Phillis Wheatley*, University of North Carolina Press, 1989, p. 12.

2.  Anonymous, "Elegy on the Death of a Late Celebrated Poetess," *Boston Magazine*, December 1784; William H. Robinson, ed., *Critical Essays on Phillis Wheatley*, G. K. Hall & Co., 1982, p. 39.

3.  Margaretta Matilda Oddell, "Memoir," *Phillis Wheatley and Her Writings*, William Robinson, ed., Garland Publishing Inc., 1984, p. 450.

4.  Vincent Carretta, *Phillis Wheatley: Biography of a Genius in Bondage*, University of Georgia Press, 2011, p. 191.

5.  William Robinson, *Phillis Wheatley and Her Writings*, Garland Publishing Inc., 1984, p. 65.

6.  Robinson, *Phillis Wheatley and Her Writings*, p. 65.

7.  Robinson, *Phillis Wheatley and Her Writings*, p. 67.

8.  Margaretta Matilda Oddell, "Memoir," *Phillis Wheatley and Her Writings*, William Robinson, ed., Garland Publishing Inc., 1984, p. 450.

9.  Carretta, *Phillis Wheatley: Biography of a Genius in Bondage*, p. 194.

10. Rufus Wilmot Griswold, *The Female Poets of America*, Volume 3, Carey and Hart, 1849, p. 31.

11. Robinson, *Phillis Wheatley and Her Writings*, p. 66.

12. Robinson, *Phillis Wheatley and Her Writings*, p. 67.

13. *Ibid.*

14. Robert C. Kuncio, *The New England Quarterly*, Vol. 43, No. 2, June 1970, p. 288.

15. Henry Louis Gates Interview with Gwen Ifill, "Conversation: The Bondwoman's Narrative," *PBS Newshour*, July 23, 2002, <http://www.pbs.org/newshour/bb/entertainment-july-dec02-gates_07-23/>.

16. Timothy Davis, "Who was Hannah Crafts?" *Salon*, April 24, 2002, <http://www.salon.com/2002/04/24/bondwoman/>.

17. William Robinson, *Phillis Wheatley in the Black American Beginnings*, Broadside Press, 1975, p. 11.

18. William Robinson, *Phillis Wheatley and Her Writings*, Garland Publishing Inc., 1984, p. 87.

19. John Shields, *Phillis Wheatley's Poetics of Liberation*, University of Tennessee Press, 2008, book jacket.

20. Babacar M'Baye, The Pan-African and Puritan dimensions of Phillis Wheatley's Poems and Letters, *New Essays on Phillis Wheatley*, John C. Shields and Eric D. Lamore, ed., University of Tennessee Press, 2011, p. 271.

21. M'Baye, The Pan-African and Puritan dimensions of Phillis Wheatley's Poems and Letters, *New Essays on Phillis Wheatley*, p. 291.

22. Shields, *The Collected Works of Phillis Wheatley*, p. xxx.

23. Shields, "Phillis Wheatley's Struggle For Freedom In Her Poetry and Prose," *The Collected Works of Phillis Wheatley*, p. 230.

24. Phillis Wheatley, *Complete Writings*, Vincent Carretta, ed., Penguin Books, 2001, p. 93.

25. Phillis Wheatley, *Complete Writings*, Vincent Carretta, ed., Penguin Books, 2001, p. 102.

26. Shields, "Phillis Wheatley's Struggle For Freedom In Her Poetry and Prose," *The Collected Works of Phillis Wheatley*, p. 231.

27. Robinson, *Phillis Wheatley and Her Writings*, p. 126.

28. Shields, *The Collected Works of Phillis Wheatley*, p. xxix.

29. Shields, "Phillis Wheatley's Struggle For Freedom In Her Poetry and Prose," *The Collected Works of Phillis Wheatley*, p. 231.

30. Shields, "Phillis Wheatley's Struggle For Freedom In Her Poetry and Prose," *The Collected Works of Phillis Wheatley*, p. 247.

31. Phillis Wheatley, *Complete Writings*, Vincent Carretta, ed., Penguin Books, 2001, p. 30.

32. Shields, "Phillis Wheatley's Struggle For Freedom In Her Poetry and Prose," *The Collected Works of Phillis Wheatley*, p. 231.

33. Robinson, *Phillis Wheatley and Her Writings*, p. 126.

34. John Shields, *Phillis Wheatley's Poetics of Liberation,* University of Tennessee Press, 2008, p. 39.

35. Robinson, *Phillis Wheatley in the Black American Beginnings*, p. 30.

36. John Shields, *Phillis Wheatley's Poetics of Liberation,* University of Tennessee Press, 2008, p. 33.

37. Sondra A. O'Neale, "Challenge to Wheatley's Critics: There Was No Other 'Game' in Town"; *The Journal of Negro Education*, Vol. 54, No. 4 (Autumn 1985), p. 500.

38. M. A. Richmond, *Bid the Vassal Soar: Interpretive Essays on the Life and Poetry of Phillis Wheatley and George Moses Horton*, Howard University Press, 1974, p. 64.

39. Devona Mallory, "I Remember Mama: Honoring the Goddess-Mother While Denouncing the Slaveowner-God in Phillis Wheatley's Poetry," *New Essays on Phillis Wheatley*, John C. Shields and Eric D. Lamore, ed., University of Tennessee Press, 2011, p. 19.

40. Robinson, *Phillis Wheatley and Her Writings*, p. 110.

41. Robinson, *Phillis Wheatley in the Black American Beginnings*, p. 39.

42. O'Neale, "Challenge to Wheatley's Critics: There Was No Other 'Game' in Town," *The Journal of Negro Education*, p. 503.

43. W. E. B. DuBois, *The Souls of Black Folk: Essays and Sketches*, A. C. McClurg & Co., 1907, p. 3.

44. Shields, *Phillis Wheatley's Poetics of Liberation*, p. 9.

45. Paula Bennett, "Phillis Wheatley's Vocation and the Paradox of the 'Afric Muse,'" *PMLA*, Vol. 113, No. 1, Jan. 1998; p. 64.

46. Bennett, "Phillis Wheatley's Vocation and the Paradox of the 'Afric Muse,'" *PMLA*, p. 69.

47. DuBois, *The Souls of Black Folk: Essays and Sketches*, p. 4.

48. Gates, *The Trials of Phillis Wheatley*, p. 3.

49. Gates, *The Trials of Phillis Wheatley*, p. 87.

50. Gates, *The Trials of Phillis Wheatley*, p. 89.

51. Gates, *The Trials of Phillis Wheatley*, p. 85.

52. W. E. B. Du Bois, "The Souls of Black Folk," originally published 1903, *The Oxford W. E. B. DuBois Reader*, Eric J. Sundquist, ed., Oxford University Press, 1996, p. 157.

53. Gates, *The Trials of Phillis Wheatley*, p. 89.

## AFTERWORD

1.  "Women Pioneers Take a Bow: Dedication of Memorial Underscores Contributions," *Boston Globe*, October 26, 2003, p. B1.

2.  Meredith Bergmann, "The Boston Women's Memorial," *American Arts Quarterly*, Summer 2005, Volume 22, Number 3, Newington-Cropsey Cultural Studies Center, <http://www.nccsc.net/essays/boston-women%E2%80%99s-memorial>.

3.  *Ibid.*

4.  Meredith Bergmann, "Boston Women's Memorial: A Collaboration Between Artists, Historians, and the Public," *Public History News*, Vol. 24, No. 2, Winter 2004, p. 3.

5.  Meredith Bergmann, "The Boston Women's Memorial," *American Arts Quarterly*, Summer 2005, Volume 22, Number 3, Newington-Cropsey Cultural Studies Center, <http://www.nccsc.net/essays/boston-women%E2%80%99s-memorial>.

6. *Ibid.*

7. "Boston Women's Memorial looks back on a decade on Comm Ave," *Boston Globe,* October 22, 2013.

8. *Ibid.*

9. Penny Cherubino, "Take a Boston Women's History Walk this Weekend," *Boston Zest,* October 10, 2008; <http://www.bostonzest.com/2008/10/take-a-boston-womens-history-walk-this- weekend.html>.

10. Email to author from Marilyn Richardson, 10/19/2014.

11. Penny Cherubino, "Take a Boston Women's History Walk this Weekend," Boston Zest, October 10, 2008; <http://www.bostonzest.com/2008/10/take-a-boston-womens-history-walk-this- weekend.html>.

12. Penny Cherubino, "Get to Know the Boston Women's Memorial," *Boston Zest,* March 30, 2009.

13. Meredith Bergmann, "Boston Women's Memorial: A Collaboration Between Artists, Historians, and the Public," *Public History News,* Vol. 24., No. 2, Winter 2004, p. 3.

14. Penny Cherubino, "Get to Know the Boston's Women's Memorial," *Boston Zest,* March 30, 2009.

15. Email to author from Marilyn Richardson, 10/19/2014.

16. Meredith Bergmann, "The Boston Women's Memorial,"

American Arts Quarterly, Summer 2005, Volume 22, Number 3, Newington-Cropsey Cultural Studies Center; <http://www.nccsc.net/essays/boston-women%E2%80%99s-memorial>

17. "Boston Women's Memorial", uploaded on Feb 2, 2010; Filmed during Primary Source's summer conference about the Picturing America collection from the National Endowment for the Humanities; Videography by Gifford Productions. <https://www.youtube.com/watch?v=sDamS7ZxeXI>.

18. Meredith Bergmann, "The Boston Women's Memorial," American Arts Quarterly, Summer 2005, Volume 22, Number 3, Newington-Cropsey Cultural Studies Center; <http://www.nccsc.net/essays/boston-women%E2%80%99s-memorial>.

# About the Author

Author Richard Kigel visiting the Phillis Wheatley
statue at the Boston Women's Memorial

RICHARD KIGEL brings the practical skills of a veteran educator to his work. "My aim as a teacher was always to support and encourage my students and inspire them to become eager and hungry learners," he says.

During the thirty years Mr. Kigel taught in Brooklyn schools with mostly African-American students, he immersed himself in the richness of Black History. "My first introduction came during my college days," Kigel says. "What opened my eyes was the 1968 TV special *Black History: Lost, Stolen or Strayed.* It was one of the first programs on Black History and it intrigued me so much I went out and bought the book."

As the social upheavals of the 1960s heated up, he turned to *The Autobiography of Malcom X,* Richard Wright's devastating novel *Native Son,* and Ralph Ellison's classic *Invisible Man* to gain some perspective on the racial issues raging through the country. When the groundbreaking TV series *Roots* captivated the nation in 1977, Kigel saw how Black History could inform and inspire his teaching and his writing. "We can't begin to understand the American character unless we take full account of Black History," he says. "Black History is American History."

Kigel's novel, *On the Wings of the Wind: The Untold Story of History's First Flight* is a fictional narrative by a young slave who escaped to freedom on a homemade flying machine, a story of courage, ingenuity, and perseverance in the face of the most oppressive conditions, a triumph of human spirit. His latest biography, *Becoming Abraham Lincoln,* is a vivid authentic account of Lincoln's most formative years in the actual words of those who knew him.

Mr. Kigel fell in love with Phillis Wheatley and her poetry and realized that this obscure eighteenth century poet is so disconnected from our cultural awareness that hardly anybody knows anything about her. Who can cite even the title of one of her poems? Says Mr. Kigel, "When I tell people I wrote a biography of Phillis Wheatley, I get a quizzical look, the raised eyebrow, and then, 'Who?'"

That is why we need this biography of Phillis Wheatley. *Heav'nly Tidings from the Afric Muse: The Grace and Genius of Phillis Wheatley* is the story of a unique young woman who began her life in America as a lowly slave and managed to launch two literary traditions at once, African-American literature and women's literature. Now Phillis Wheatley can take her place among the nation's Founding Mothers as "Poet Laureate" of the American Revolution.

For the author's website, visit www.philliswheatleybio.com.